Gardens in France

Jardins de France en fleurs
Gärten in Frankreich

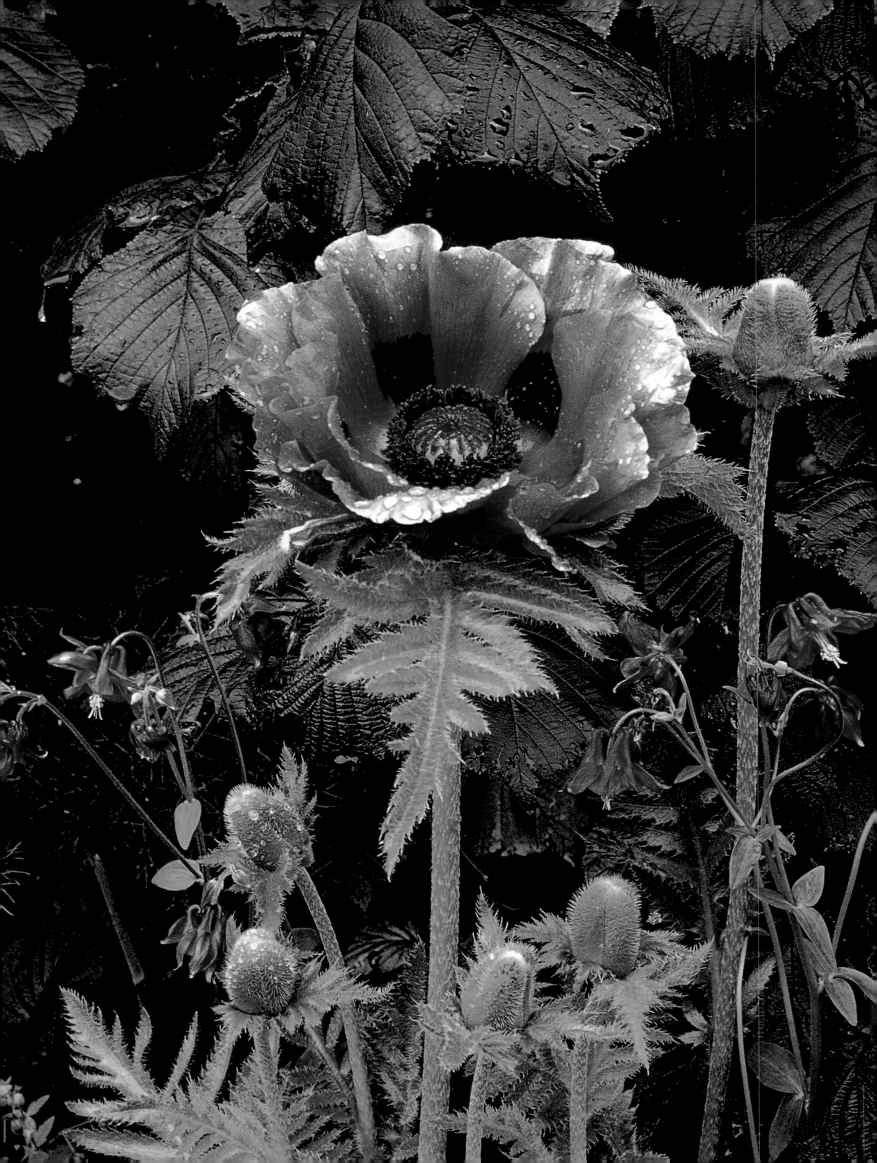

Gardens in France

Jardins de France en fleurs
Gärten in Frankreich

Edited by / Sous la direction de / Herausgegeben von
Angelika Taschen
Photos / Fotos Deidi von Schaewen
Text / Texte Marie-Françoise Valéry

TASCHEN

Illustration page 2 | Reproduction page 2 | Abbildung Seite 2:
A poppy *(Papaver orientale* 'Patty's Plum')
Un pavot *(Papaver orientale* 'Patty's Plum')
Ein Türkenmohn *(Papaver orientale* 'Patty's Plum')
Un jardin à Varengeville-sur-Mer (Normandie)

Illustration page 6–7 | Reproduction page 6–7 | Abbildung Seite 6–7:
Map of France
Carte de France
Karte von Frankreich
Drawing | Dessin | Zeichnung: Hervé van der Straeten, Paris

EACH AND EVERY TASCHEN BOOK PLANTS A SEED!
TASCHEN is a carbon neutral publisher. Each year, we offset our
annual carbon emissions with carbon credits at the Instituto Terra, a
reforestation program in Minas Gerais, Brazil, founded by Lélia and
Sebastião Salgado. To find out more about this ecological partnership,
please check: www.taschen.com/zerocarbon
Inspiration: unlimited. Carbon footprint: zero.

To stay informed about TASCHEN and our upcoming titles, please
subscribe to our free magazine at www.taschen.com/magazine, down-
load our magazine app for iPad, follow us on Twitter and Facebook,
or e-mail your questions to contact@taschen.com.

© 2015 TASCHEN GmbH
Hohenzollernring 53, D–50672 Köln
www.taschen.com

Original edition: © 1997 Benedikt Taschen Verlag GmbH
Edited and designed by Angelika Taschen, Cologne
Cover designed by Birgit Eichwede, Cologne
English translation by Chris Miller, Oxford
German translation by Birgit Lamerz-Beckschäfer, Datteln
Plans: Erik Heckens, Bonn

Printed in China
ISBN 978–3–8365–5655–2

Sommaire | Contents | Inhalt

Île- de France
Normandie
Centre
Provence
Côte d'Azur

N

O E

S

Ile-de-France

On aime son ciel mouvant, son paysage reposant où la Seine dessine un ruban d'argent, les fastes de sa capitale peuplée depuis toujours d'esprits brillants, et ses parcs célèbres, où les plus grands paysagistes ont exercé leur talent. L'Ile-de-France fit rayonner la tradition du jardin à la française. Puis elle connut la mode anglaise. Aujourd'hui, ses jardins sont classiques, intimes ou romantiques. Ils sont divers et se permettent toutes les audaces tout en respectant les règles de l'harmonie.

Memorable for its changing cloudscapes, for the gentle landscape through which the Seine traces its glittering course, for the splendours of its capital where the most brilliant minds have always dwelt, and for its famous parks, on which the greatest landscape gardeners have lavished their talents, it inspires intense affection. From the Ile-de-France the reputation of the classical French garden spread out into the world. Later, the English garden made its influence felt. Today, its gardens are classical, intimate and romantic. They are extremely varied, whilst respect for harmony has not excluded the most audacious inventions.

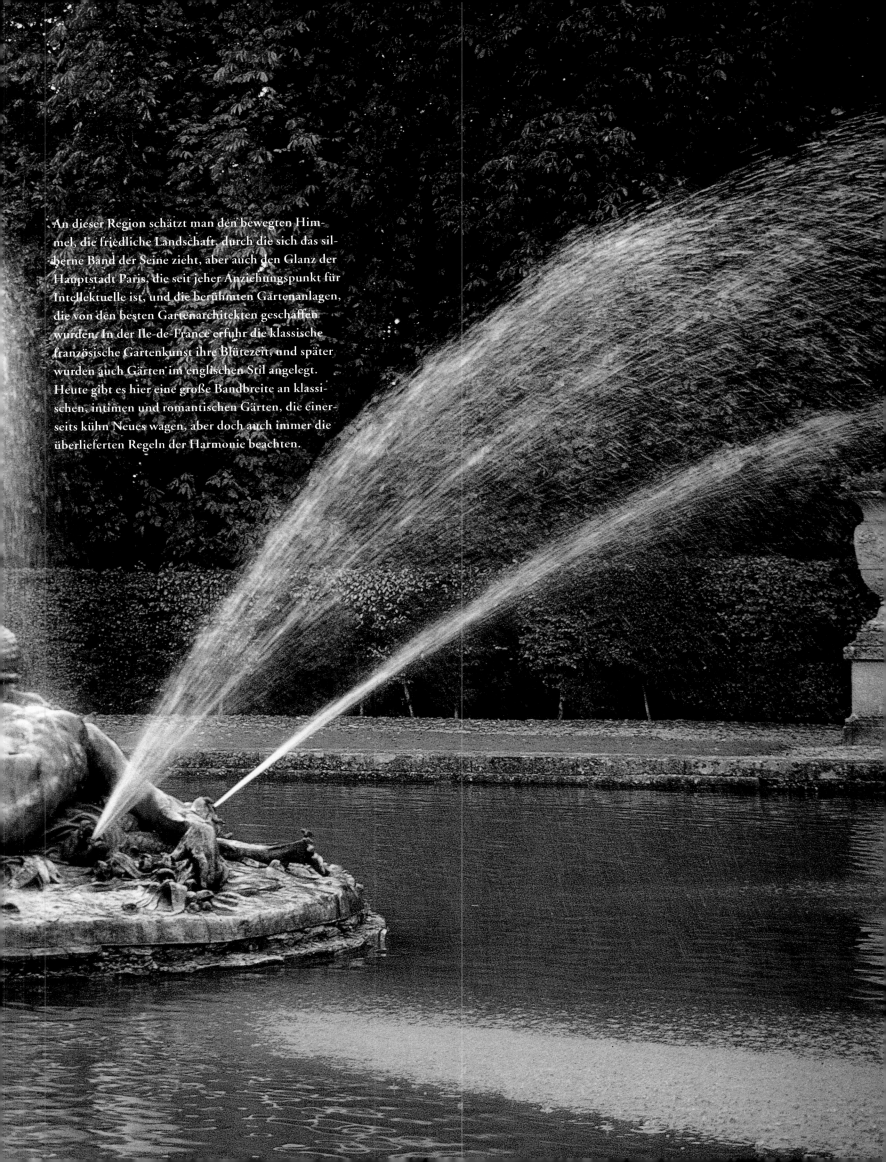

An dieser Region schätzt man den bewegten Himmel, die friedliche Landschaft, durch die sich das silberne Band der Seine zieht, aber auch den Glanz der Hauptstadt Paris, die seit jeher Anziehungspunkt für Intellektuelle ist, und die berühmten Gartenanlagen, die von den besten Gartenarchitekten geschaffen wurden. In der Ile-de-France erfuhr die klassische französische Gartenkunst ihre Blütezeit, und später wurden auch Gärten im englischen Stil angelegt. Heute gibt es hier eine große Bandbreite an klassischen, intimen und romantischen Gärten, die einerseits kühn Neues wagen, aber doch auch immer die überlieferten Regeln der Harmonie beachten.

Vaux est par excellence l'archétype du jardin à la française. Conçu pour être admiré du château qui symbolise l'autorité du maître des lieux, son tracé offre, autour d'une perspective unique, un sentiment d'unité, d'équilibre parfait et une rigueur qui soumet la nature tout en l'exaltant. Les jardins de Vaux furent commandés au jardinier André Le Nôtre (1613-1700) par Nicolas Fouquet (1615-1680), brillant surintendant des finances sous le règne de Louis XIV. Le 17 août 1661, au cours d'une fête restée célèbre, Fouquet reçut le roi. Ce dernier avait déjà décidé de briser son ministre et les fastes de Vaux confirmèrent sa volonté. Ils inspirèrent au jeune souverain l'idée de créer à Versailles un palais et des jardins qui surpasseraient ceux de Vaux par leur beauté. Vaux est un chef-d'œuvre de proportions. La grande perspective qui traverse le château met en scène, successivement, des parterres en broderies de buis, des pièces d'eau comme le Rond d'eau, les canaux, l'Arpent d'eau, la Poêle ou la Gerbe, passe par des cascades et des tapis verts et s'achève au loin sur la statue surélevée en plomb doré d'Hercule Farnèse. Vaux fut réhabilité à la fin du 19e siècle par Alfred Sommier. Aujourd'hui, grâce à son arrière petit-fils Patrice de Vogüe qui le maintient en vie, il nous est donné de l'admirer dans son état d'origine, tel que Fouquet fut obligé de l'abandonner.

Vaux-le-Vicomte

Vaux is the paradigm of the French garden. Designed to be admired from a chateau that symbolises the authority of the chatelain, its layout around a single vista offers the spectator a sense of rigorous unity and symmetry which both subordinates and embellishes the work of nature. The gardens at Vaux were commissioned from the gardener André Le Nôtre (1613-1700) by Nicolas Fouquet (1615-1680), Louis XIV's brilliant financial secretary. On 17 August 1661, Fouquet received the king with a pomp and ceremony famous to this day. The festivities sealed Fouquet's doom. Louis had already planned the downfall of his minister, and the luxury of Vaux confirmed him in his judgement. They also inspired in him the desire to create a palace and gardens at Versailles that would be still more beautiful and impressive than Vaux. The proportions of Vaux are masterly. The great vista which traverses the castle presents first embroidered box parterres, then lakes such as the circular pool, the canals, the Arpent d'eau (so-called because it occupies one hectare), the Poële and the Gerbe (fountain). Beyond them are waterfalls and lawns. The vista closes with the gilt lead statue of the Farnese Hercules raised high above the garden. Vaux was rehabilitated at the end of the 19th century by Alfred Sommier. Today, thanks to the devoted attention of his great-grandson Patrice de Vogüe, we can admire Vaux in the state in which Fouquet was forced to abandon it.

Vaux ist der Inbegriff des französischen Barockparks. Er wurde von vornherein so angelegt, daß man ihn vom Schloß aus – dem Symbol der Macht – am besten bewundern kann. Von der zentralen Blickachse aus vermittelt seine Linienführung Einheitlichkeit, vollkommenes Gleichgewicht und eine Strenge, die die Natur zugleich unterwirft und zur Geltung bringt. Der Park von Vaux entstand unter der Leitung des Landschaftsarchitekten André Le Nôtre (1613-1700) im Auftrag von Nicolas Fouquet (1615-1680), dem genialen Finanzminister Ludwigs XIV. Am 17. August 1661 hatte Fouquet bei einem rauschenden Ball hier den König zu Gast. Doch dieser war bereits entschlossen, seinen Minister fallen zu lassen, und der in Vaux entfaltete Pomp bestätigte ihn in seiner Entscheidung. Aber Schloß und Park regten den jungen Monarchen an, auch in Versailles einen Palast mit Gärten zu schaffen, die die Anlage in Vaux in den Schatten stellen sollten. Vaux ist ein Meisterwerk der Proportionen. Die große Blickachse verläuft durch das Schloß; von hier aus streift der Blick nacheinander die Broderie-Parterres mit ihren Buchsbaumfiguren, die Wasserspiele und -flächen wie das große runde Becken, die Kanäle, der Arpent d'eau, die Poële oder die Gerbe (Fontäne), wandert über Kaskaden und Rasenflächen bis zu der in der Ferne erhöht stehenden Statue des Herkules Farnese aus vergoldetem Blei. Vaux wurde Ende des 19. Jahrhundert von Alfred Sommier umfassend restauriert. Dessen Urenkel Patrice de Vogüe, der den Park instand hält, ist es zu verdanken, daß wir ihn heute wieder in der Pracht vor uns sehen, in der Fouquet ihn einst zurücklassen mußte.

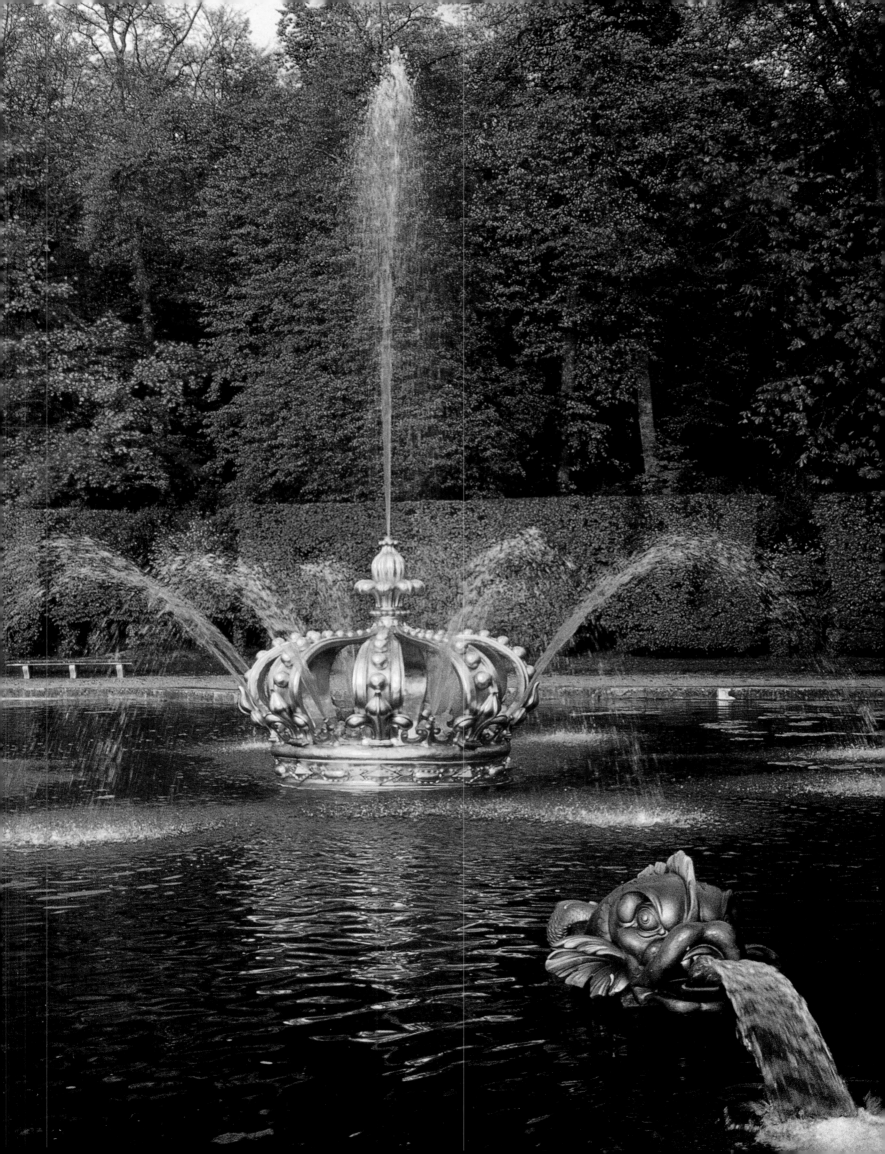

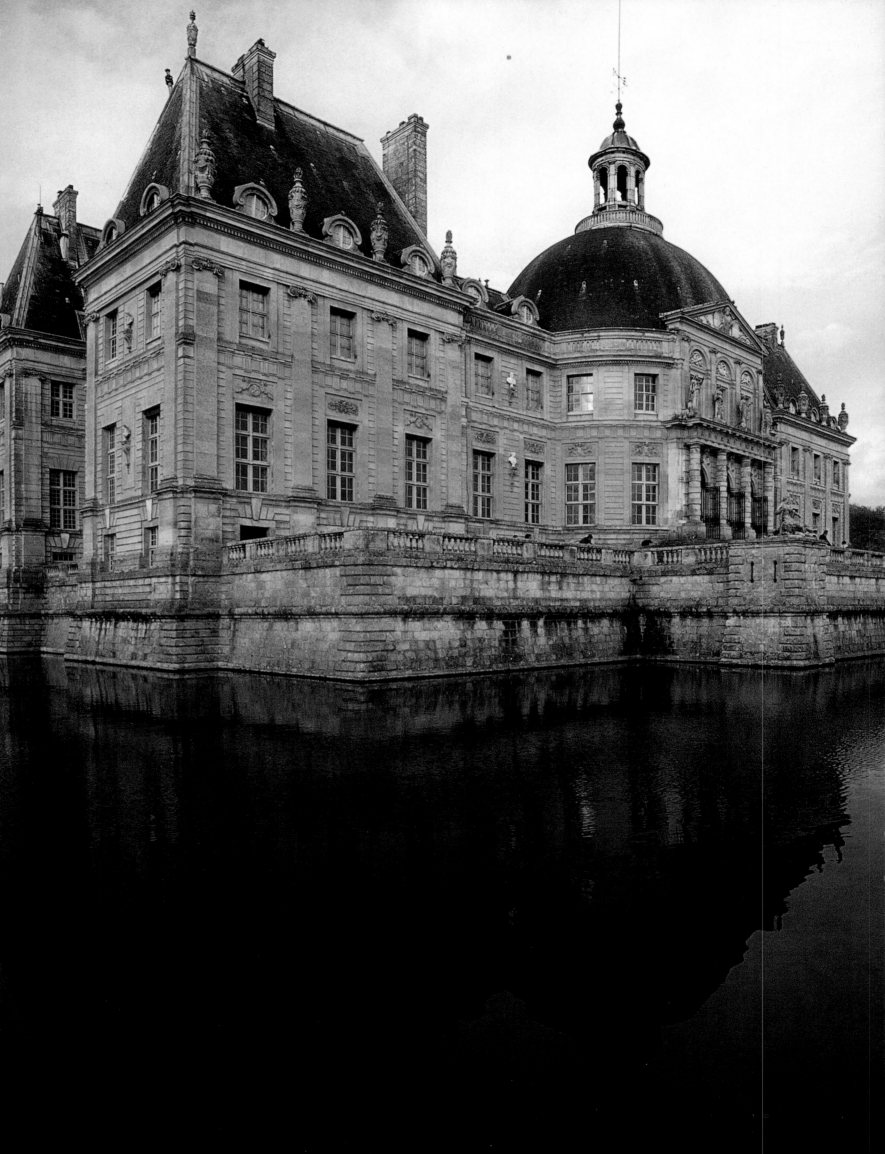

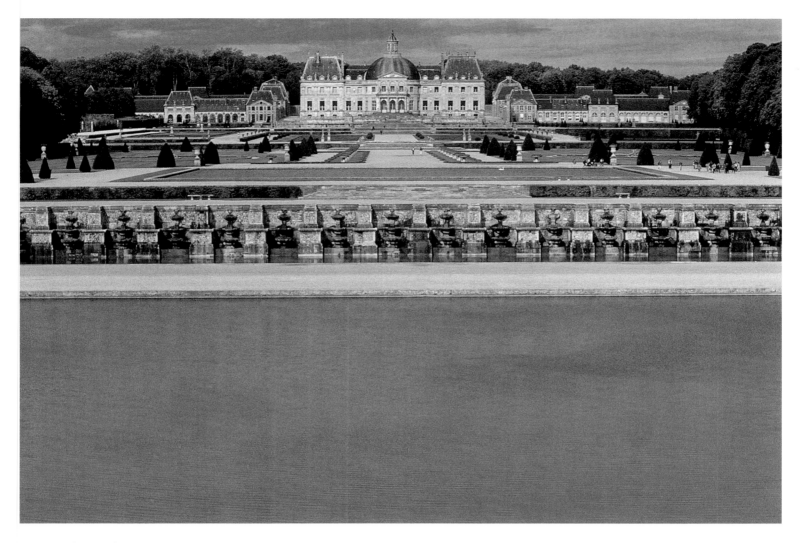

Page précédente: Le bassin de la Couronne est situé non loin du château.
Page de gauche: Construit en grès de Fontainebleau et en pierre de Creil, installé en hauteur, le chateau domine les jardins.
Ci-dessus: C'est surtout lorsqu'on admire le château et les jardins dans l'axe de la grande perspective que l'on peut apprécier au mieux l'harmonie de l'ensemble.
A droite: Les grilles d'eau sont ornées de sculptures évoquant des personnages mythologiques.

Previous page: The Crown fountain is not far from the chateau.
Facing page: The chateau is constructed in Fontainebleau sandstone and Creil stone; built on a rise, it dominates the garden.
Above: The harmony of the overall design is especially evident when one looks down the grand vista over the gardens towards the chateau.
Right: The Grilles d'eau are decorated with sculptures of figures from mythology.

Vorhergehende Seite: Das Bassin de la Couronne liegt nahe am Schloß.
Linke Seite: Das Wasserschloß liegt etwas erhöht und beherrscht die ganze Gartenanlage. Baumaterialien waren Sandstein aus Fontainebleau sowie Werkstein aus Creil.
Oben: Betrachtet man Schloß und Garten in der Perspektive der Hauptachse, erschließt sich die Harmonie der gesamten Anlage am besten.
Rechts: Die Grilles d'eau sind mit mythologischen Skulpturen geschmückt.

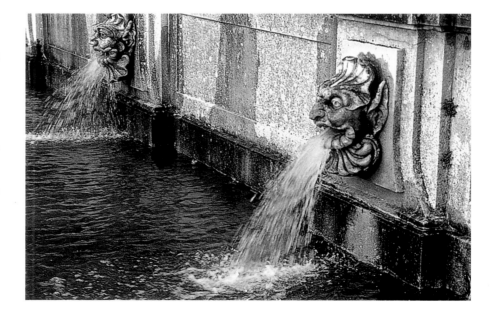

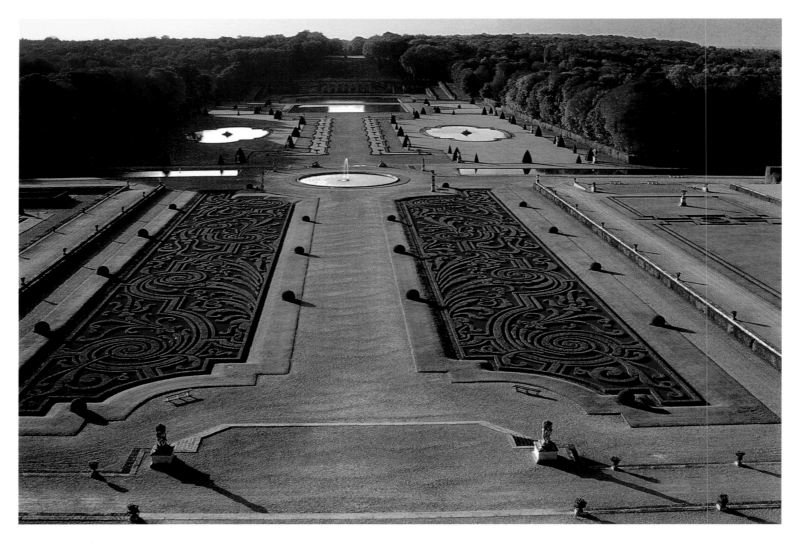

Ci-dessus: vue du château sur la grande perspective qui s'achève sur la statue d'Hercule Farnèse, avec les parterres de broderies, le Rond d'eau, les deux bassins symétriques des Tritons et l'Arpent d'eau.
A droite: détail des massifs de broderies. Les buis dessinent des arabesques sur fond de brique pilée.
Page de droite: un des bassins des Tritons, serti dans un tapis vert orné d'ifs taillés en cônes.

Above: view from the chateau of the great vista whose end point is the Farnese Hercules: the embroidered parterres, the circular pool, the two symmetrical Triton ponds and the Arpent d'eau.
Right: detail of the embroidered parterre. The box hedges form arabesques against a background of crushed brick.
Facing page: one of the Triton ponds, set in a lawn ornamented with topiary yews.

Oben: Vom Schloß aus schweift der Blick über die Broderie-Parterres, das runde Becken, die beiden symmetrisch angelegten Tritonenbrunnen und den Arpent d'eau bis zur Statue des Herkules Farnese.
Rechts: Detail aus den Broderie-Beeten. Die Arabesken sind aus Buchsbaum gestaltet, die Zwischenräume mit Ziegelmehl bestreut.
Rechte Seite: eines der Tritonenbecken, die von einem grünen Teppich eingefaßt werden. Ringsum stehen kegelförmig beschnittene Eiben.

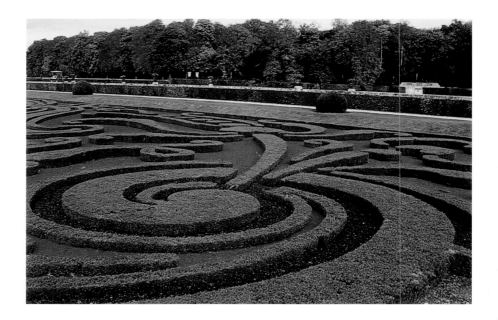

Vaux-le-Vicomte *Ile-de-France*

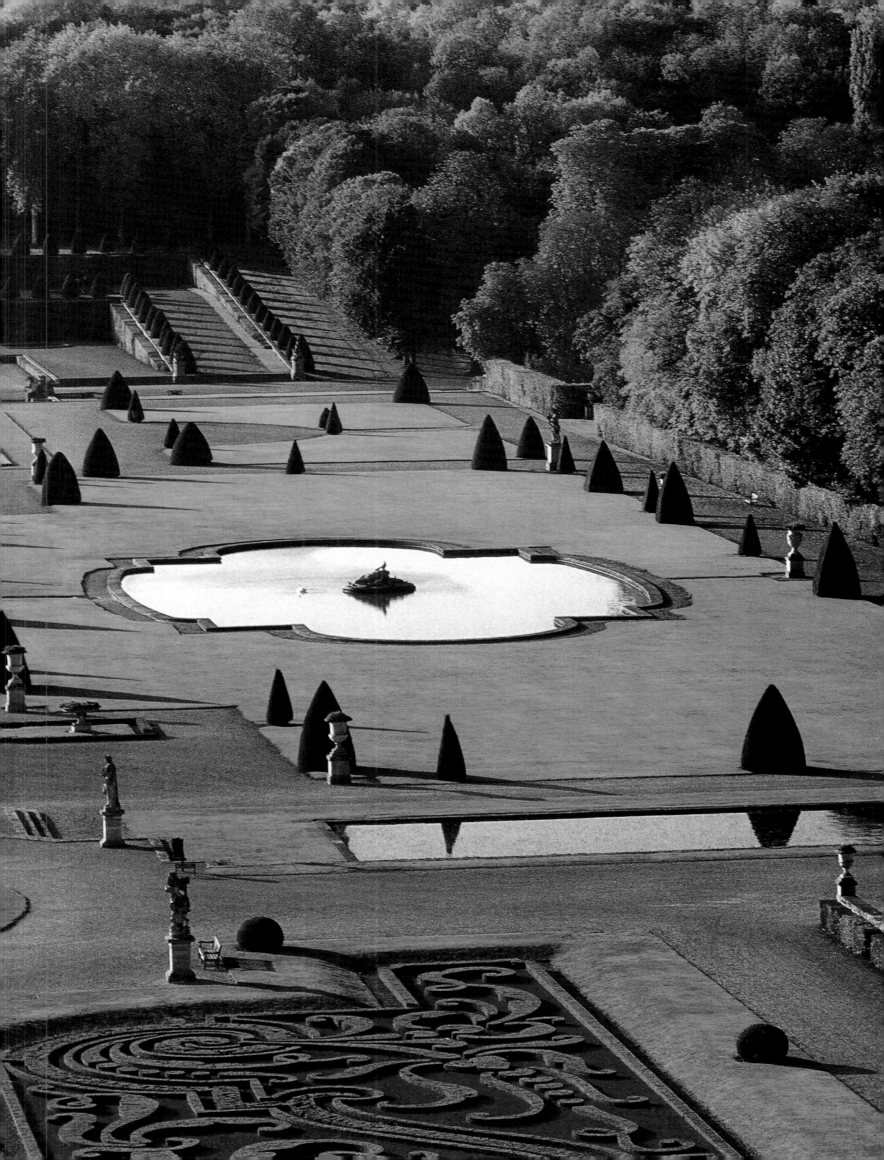

Vaux-le-Vicomte *Ile-de-France*

Page de gauche et ci-dessus: Les tapis verts sont ponctués d'ifs sculptés, de vases et de statues qui apportent du relief. Les haies taillées et les formes topiaires tissent les lignes et les rythmes imaginés par le créateur de ces jardins.
A droite: une des nombreuses figures mythologiques.

Facing page and above: The lawns are dotted with topiary yews, vases and statues which impart relief. The clipped hedges and topiary create the lines and rhythms dear to the heart of Le Nôtre.
Right: one of the numerous mythological figures.

Linke Seite und oben: Die Rasenflächen sind mit beschnittenen Eiben geschmückt und werden durch Vasen und Statuen strukturiert. Die beschnittenen Hecken und Sträucher zeichnen die vom Gartenarchitekten erdachten Linien und Rhythmen nach.
Rechts: eine der zahlreichen mythologischen Figuren.

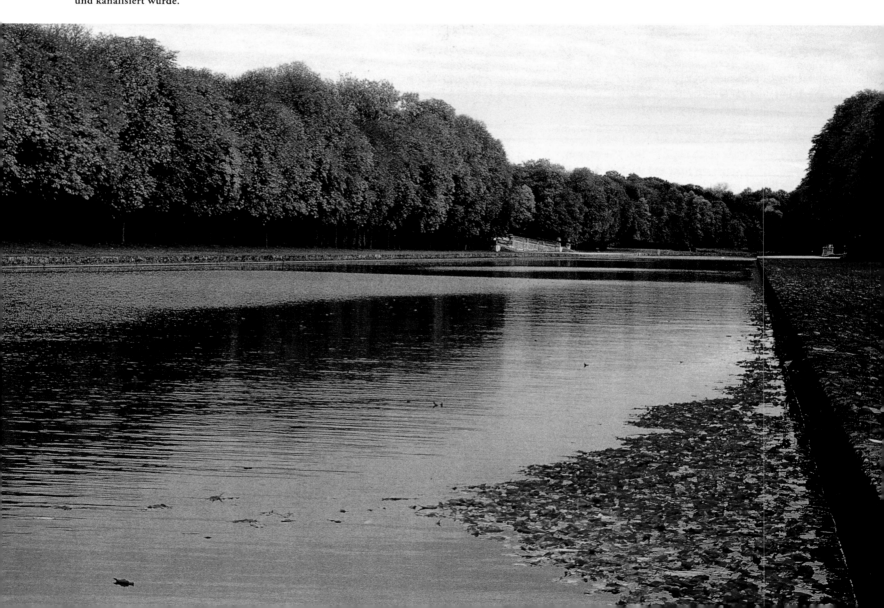

A droite: Les allées suivent parfois de légères élévations vers l'est et l'ouest afin que la promenade permette de découvrir le château et les jardins sous des angles différents.
Ci-dessous: La Poële et son miroir d'eau sont alimentés par une rivière, l'Anqueuil, qui a été domestiquée et canalisée.

Right: The garden walks slope gently upwards in the east and west of the garden so as to allow the castle and gardens to be viewed from different angles.
Below: The Poële and its miroir d'eau are fed by a river, the Anqueuil, which has been redirected and canalised.

Rechts: Die Wege steigen nach Osten und Westen hin teilweise leicht an, damit man von dort das Schloß und die Gartenanlage aus unterschiedlichen Blickwinkeln sehen kann.
Unten: Die Poële und das Wasserbecken werden durch das Flüßchen Anqueuil gespeist, das an dieser Stelle begradigt und kanalisiert wurde.

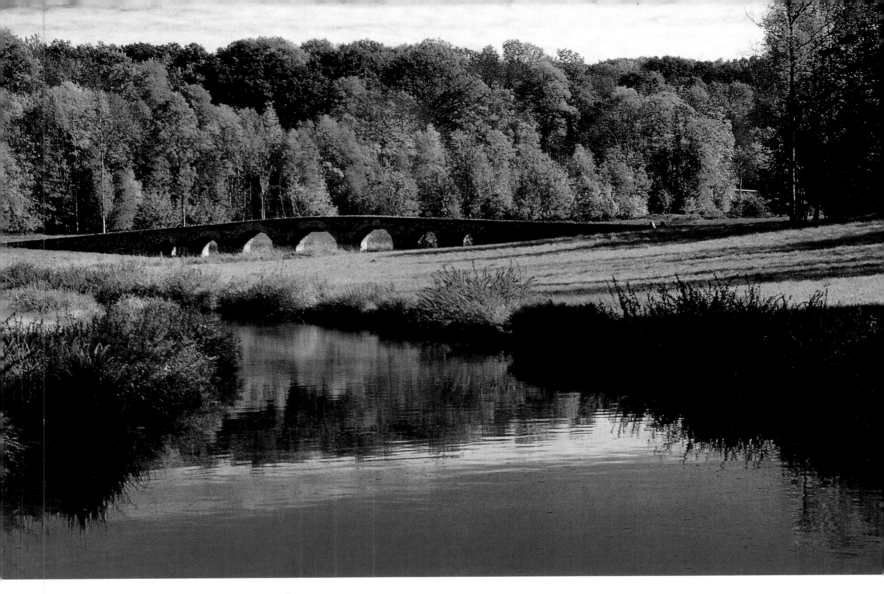

Ci-dessus: Ce vieux pont met en valeur l'Anqueuil là où son cours sinueux n'a pas encore été maîtrisé, exprimant ce qu'était la nature avant l'intervention de Le Nôtre.
A droite: les grilles d'eau, avec leurs miroirs et la perspective qu'elles ouvrent dans le parc.

Above: This old bridge enhances the beauty of the Anqueuil, where its sinuous course has yet to be altered, offering one a vision of the landscape as it was before Le Nôtre's intervention.
Right: The Grilles d'eau, with their "miroirs d'eau", open up a vista through the garden.

Oben: Die alte Brücke überspannt den Fluß an einer Stelle, an der seine Biegungen noch nicht begradigt wurden. Man sieht, wie die Landschaft vor dem Eingriff Le Nôtres aussah.
Rechts: die Wasserbecken der Grilles d'eau. Von hier aus eröffnet sich die große Blickachse durch den Garten.

On la visite pour se détendre, se divertir, enivrer son regard de tous les dégradés de rose, humer des parfums, prendre des idées pour son jardin, s'instruire, rechercher des variétés rares, faire des travaux d'hybridation. Du promeneur au professionnel en passant par l'amateur, chacun peut s'y délecter. Elle fut imaginée en 1894 par Jules Gravereaux qui devint le plus grand collectionneur de roses de la Belle Epoque. Il fut le premier à créer une véritable roseraie. En 1899, afin de mettre sa fleur préférée en valeur, il demanda à l'architecte paysagiste Edouard François André (1840-1911) de dessiner un jardin composé de plusieurs parties où chacune développperait un thème de collection. Ainsi naquit une composition très architecturée qui prit la forme d'un triangle. En 1910, la roseraie s'agrandit sous la houlette des Gravereaux et s'articula autour d'un bassin qui est encore aujourd'hui le centre d'un motif en fer à cheval. La roseraie comprend treize collections. On y découvre un jardin de roses à bouquets, une allée qui retrace l'histoire de la rose, celle des rosiers botaniques, rugueux et primprenelles, les roses de La Malmaison et d'autres jardins présentant des galliques, des roses d'Extrême-Orient, horticoles anciennes, horticoles étrangères et françaises modernes, des roses à odeur de thé et enfin des rosiers de Banks. Chaque groupe a ses particularités. La roseraie du Val-de-Marne, Conservatoire national de roses anciennes, permet de mieux les connaître et les aimer.

La Roseraie du Val-de-Marne à l'Haÿ-les-Roses

People come here to relax, to enjoy themselves, to luxuriate in the nuances of the colours and the balmy scents, to pick up ideas for their own gardens, to find out about rare varieties or to work on hybridisation. There is something for everyone here: for the professional, the amateur, and those merely out for a stroll. It was conceived in 1894 by Jules Gravereaux, who became the greatest rose-breeder of the "Belle Epoque". He was the first man to create a true rose garden. In 1899, he paid his favourite flower the compliment of requesting the architect and landscape gardener Edouard François André (1840-1911) to design a garden in several parts, each of which would be devoted to a particular theme in his collection. The result was a very formal triangular composition. In 1910, the rose garden was expanded under the auspices of the Gravereaux family, and organised around a pond which still exists within the horseshoe motif of which it forms the centrepiece. The rose garden comprises thirteen collections. There is a garden for scented roses, a garden walk laying out the history of the rose, species, rugosa, burnet and Malmaison collection roses, and other gardens exhibiting gallicas, roses from the Far East, old garden roses, modern foreign and French garden roses, tea roses, and finally banksia roses. Each group has its own characteristics. The rose garden of the Val-de-Marne National Conservatoire provides for a better understanding and appreciation of rare old roses.

Manch einer kommt hierher, um sich zu entspannen, andere nur zum Vergnügen, um sich am Anblick von Rosen aller Valeurs sattzusehen, die Düfte zu schnuppern, Ideen für den eigenen Garten zu erhaschen, seltene Sorten zu erforschen oder die Zucht neuer Kreuzungen vorzubereiten – vom müßigen Spaziergänger über den Gartenliebhaber bis zum Fachmann findet hier jeder, was er sucht. Die Idee für den Rosengarten hatte 1894 Jules Gravereaux, der zum größten Rosensammler der Belle Epoque werden sollte. Er kam als erster auf den Gedanken, ein richtiges Rosarium zu schaffen, um seine Lieblingsblumen zur Geltung zu bringen: 1899 beauftragte er den Landschaftsarchitekten Edouard François André (1840-1911), einen mehrteiligen Park zu entwerfen, bei dem jeder Teil einem Thema seiner Rosensammlung vorbehalten sein sollte. So entstand eine sehr strenge im Dreieck angelegte Komposition. 1910 wurde das Rosarium unter Federführung der Familie Gravereaux vergrößert und um ein Wasserbecken ergänzt, das noch heute das Zentrum einer hufeisenförmigen Anlage bildet. Die Roseraie du Val-de-Marne umfaßt dreizehn Einzelsammlungen, darunter einen Schnittrosengarten, einen Lehrweg zur Geschichte der Rose, einen Teil mit Wild-, Kartoffel- und Bibernellrosen, Rosen aus der Sammlung Malmaison. Weitere Gärten sind den Essigrosen, fernöstlichen Rosensorten, alten Gartenrosen, modernen ausländischen und französischen Rosen, Teehybriden sowie schließlich den Banksrosen gewidmet. Jede Gruppe hat ihre Besonderheiten. Und das Conservatoire Nationale des Roses Anciennes von Val-de-Marne gibt uns Gelegenheit, sie kennen- und lieben zu lernen.

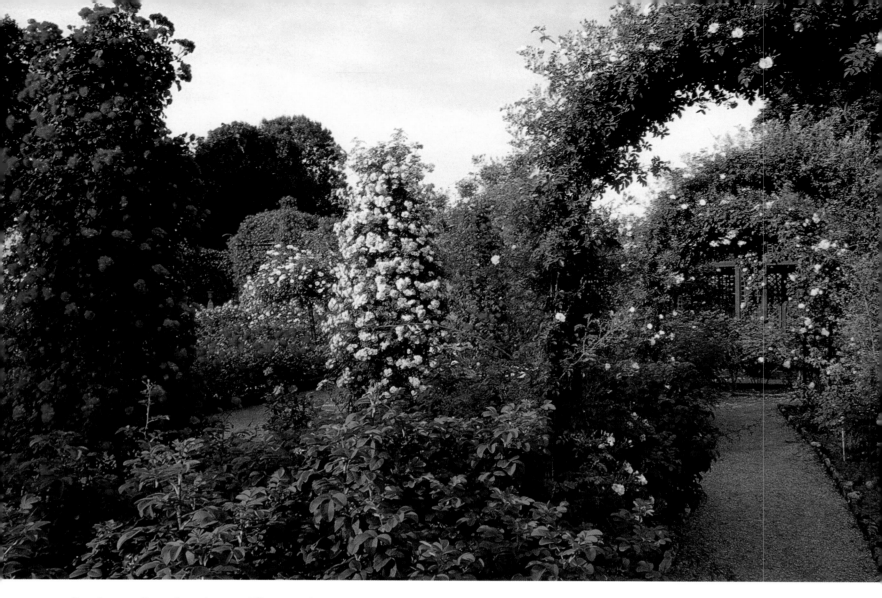

Première page: Des rosiers grimpants s'élèvent sur des supports pyramidaux – chaque espèce a le sien. On peut aujourd'hui admirer plus de trois mille variétés de rosiers à L'Haÿ-les-Roses.
Ci-dessus: le jardin des roses d'Orient. Au premier plan, *Rosa rugosa x microphylla.* Sur le pylône: 'Paul's Scarlet Climber'.
A droite: Les arceaux de cette allée sont recouverts de rosiers grimpants. Au premier plan: 'Blush Rambler'.

First page: Rose trees rambling on pyramid-shaped supports – a different variety on each one. There are more than three thousand varieties to be admired in the collection of L'Haÿ-les-Roses.
Above: the garden of oriental roses. In the foreground, *Rosa rugosa x microphylla.* On the column: 'Paul's Scarlet Climber'.
Right: Over the arches of this path are trained climbing roses. In the foreground: 'Blush Rambler'.

Eingangsseite: Rosen ranken an pyramidenförmigen Stützen – an jeder Stütze eine andere Sorte. Mehr als dreitausend Sorten kann man heute in der Sammlung von L'Haÿ-les-Roses bewundern.
Oben: der Garten der orientalischen Rosen. Im Vordergrund *Rosa rugosa x microphylla.* An den Stützen klettert 'Paul's Scarlet Climber'.
Rechts: Die Bögen über diesem Weg sind mit Kletterrosen überwuchert. Im Vordergrund 'Blush Rambler'.

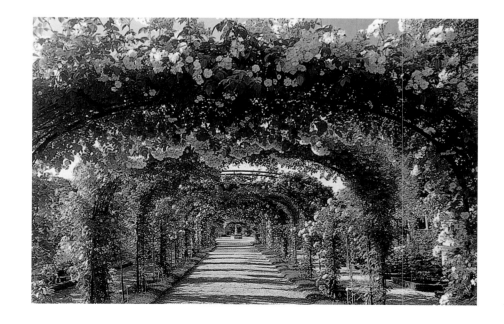

La Roseraie du Val-de-Marne à l'Haÿ-les-Roses *Ile-de-France*

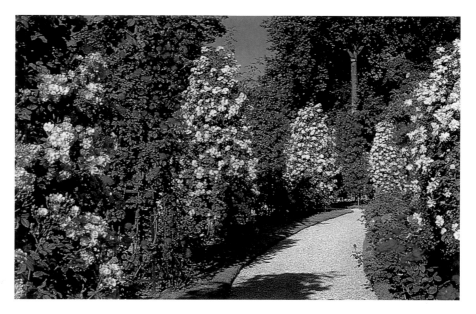

A droite: les supports de forme pyramidale du jardin à la française. Au premier plan, 'Paul's Scarlet Climber' (rouge), puis, 'Mrs F.W. Flight' (rose).
Ci-dessous: vue latérale du dôme. Au premier plan, 'Queen Elizabeth' (rose) et 'Sarabande' (rouge).
Double page suivante: Le centre de la composition s'articule autour d'un bassin entouré d'un motif en fer à cheval qui prend appui d'un côté sur un dôme encadré par deux ailes de treillage. Sur le dôme, 'Alexandre Girault' dont les branches peuvent atteindre huit mètres (rose soutenu).
Dernières pages, à gauche: le charme des roses composées de nombreux pétales ('La Pucelle', collection de la Malmaison).
Dernières pages, à droite: une rose simple disposée en bouquets.

Right: the pyramid-shaped climbing frames of the French garden. In the foreground, 'Paul's Scarlet Climber' (red), then 'Mrs F.W. Flight' (pink).
Below: a side view of the dome's trellised wings. In the foreground, 'Queen Elizabeth' (pink) and 'Sarabande' (red).
Following pages: The centre of the garden is formed by an ornamental pond surrounded by a horseshoe motif; on one side stands a domed gazebo with two trellised wings. On the dome, 'Alexandre Girault' (dark pink), whose branches can reach eight metres in lenght.
Last pages, left: the charm of double roses with many petals ('La Pucelle', from the Malmaison collection).
Last pages, right: a single cluster-flowered rose.

Rechts: die pyramidenförmigen Stützen des im französischen Stil angelegten Gartens. Im Vordergrund: 'Paul's Scarlet Climber' (scharlachrot), dahinter 'Mrs F.W. Flight' (rosa).
Unten: seitlicher Blick auf die Kuppel. Im Vordergrund 'Queen Elizabeth' (rosa) und 'Sarabande' (rot).
Folgende Doppelseite: Den Mittelpunkt des Gartens bildet ein Wasserbecken, um das sich eine hufeisenförmige Anlage legt. An der Kuppel mit den beiden Laubengängen, die eine Seite der Anlage bildet, sieht man 'Alexandre Girault' (dunkelrosa), dessen Ranken acht Meter lang werden können.
Letzte Seiten, links: 'La Pucelle' aus der Sammlung Malmaison, eine reizvolle, doppelt gefüllte Rose.
Letzte Seiten, rechts: eine einfach blühende Strauchrose.

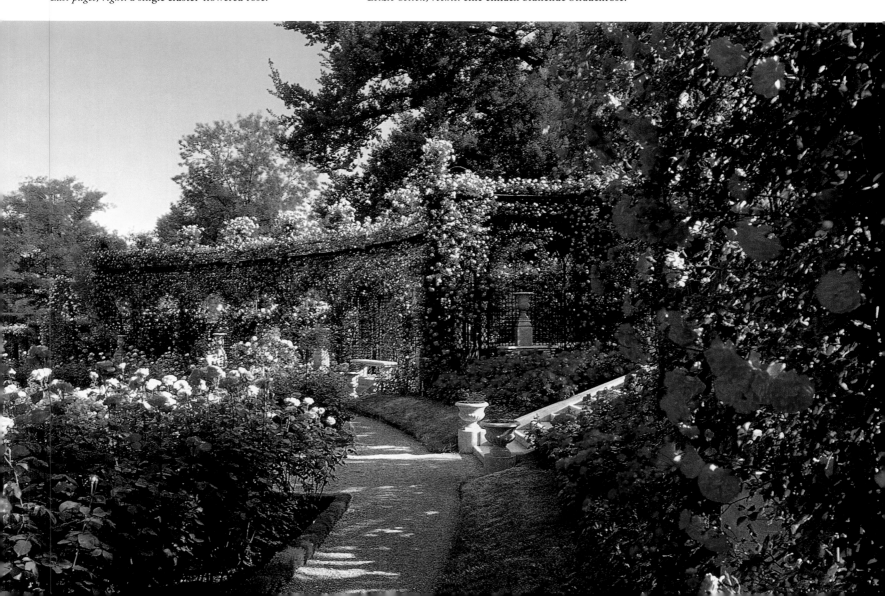

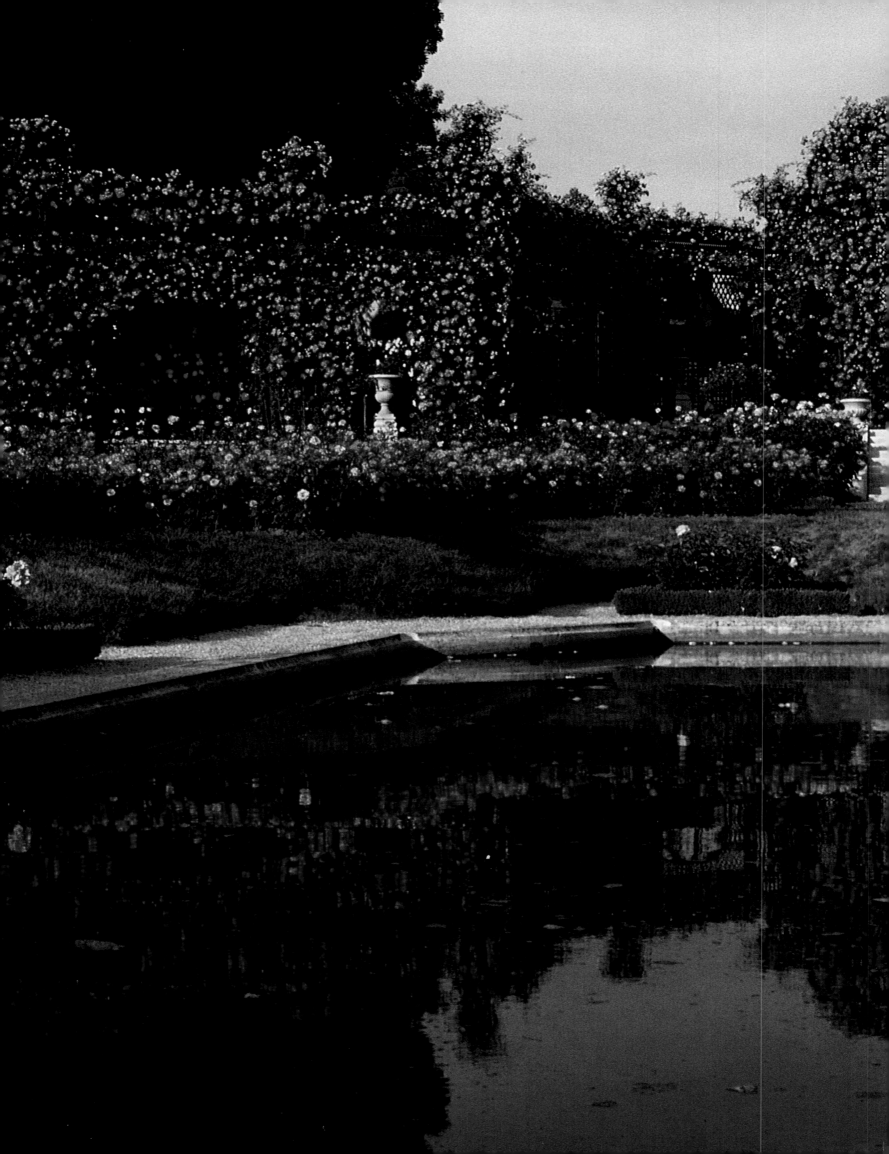

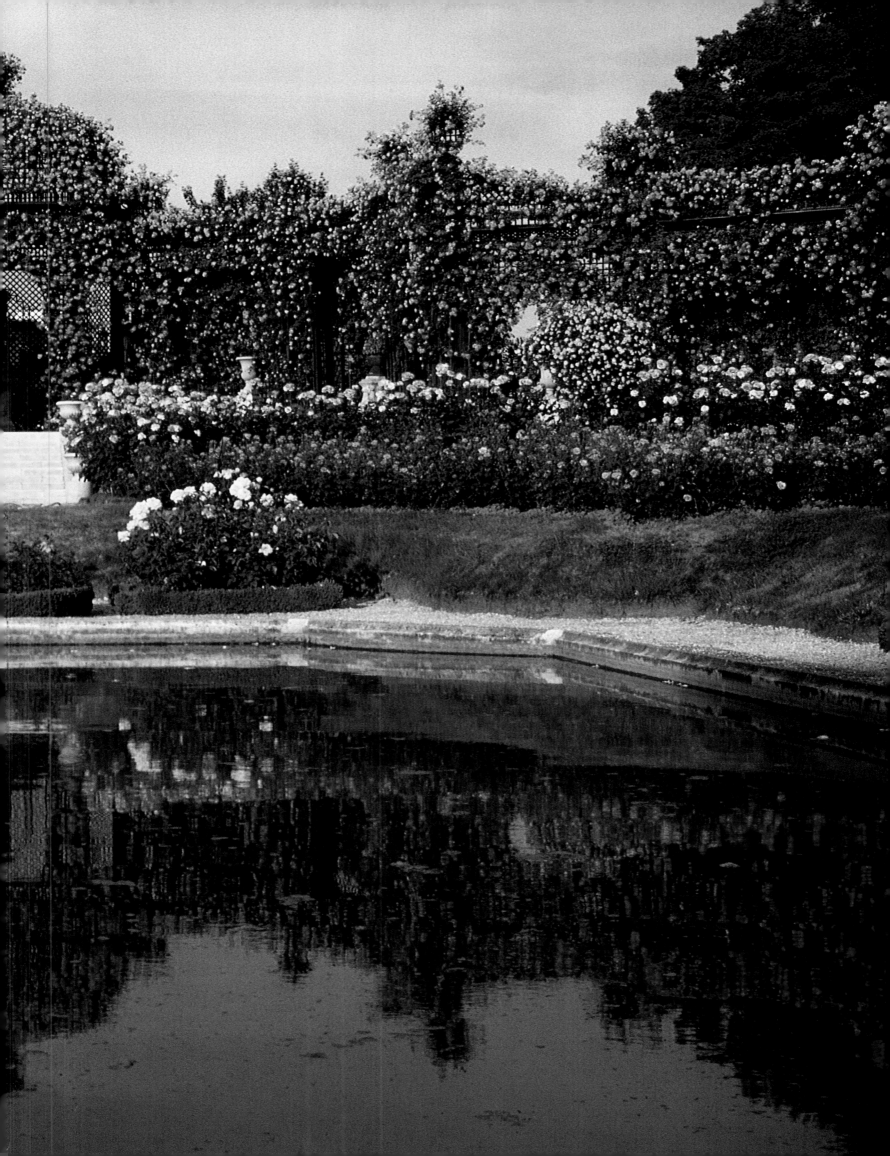

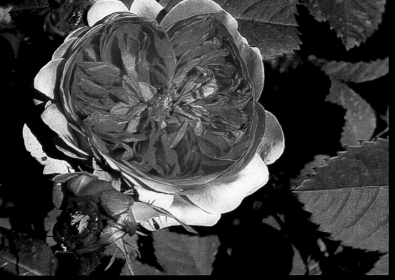

Détail de gauche: 'Duchesse de Buccleugh'.

Detail left: 'Duchesse de Buccleugh'.

Detail links: 'Duchesse de Buccleugh'.

Détail de droite: 'Veilchen-blau'.

Detail right: 'Veilchenblau'.

Detail rechts: 'Veilchenblau'.

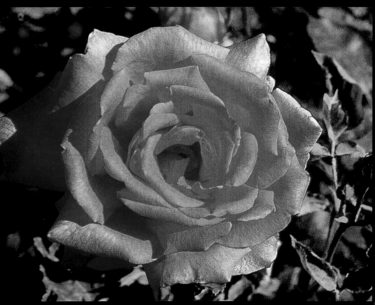

Détail de gauche: 'Adrian von Fröhlich'.

Detail left: 'Adrian von Fröhlich'.

Detail links: 'Adrian von Fröhlich'.

Détail de droite: 'Seguier'.

Detail right: 'Seguier'.

Detail rechts: 'Seguier'.

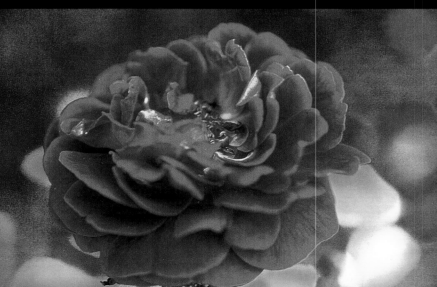

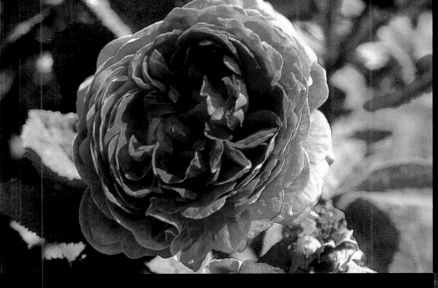

Détail de gauche: 'John Ingram'.

Detail left: 'John Ingram'.

Detail links: 'John Ingram'.

Détail de droite: 'Françoise de Solignac'.

Detail right: 'Françoise de Solignac'.

Detail rechts: 'Françoise de Solignac'.

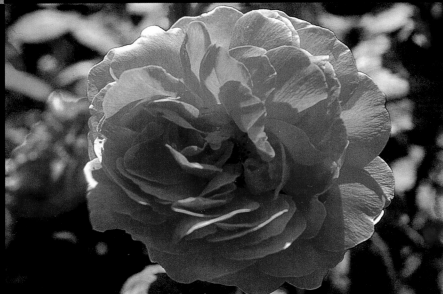

Détail de gauche: 'Astrée'.

Detail left: 'Astrée'.

Detail links: 'Astrée'.

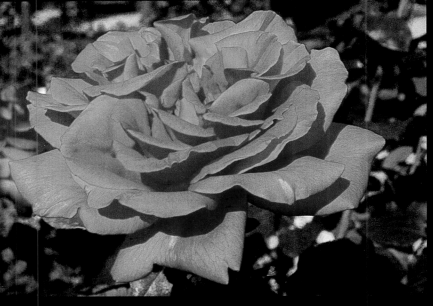

Détail de droite: 'Julethe'.

Detail right: 'Julethe'.

Detail rechts: 'Julethe'.

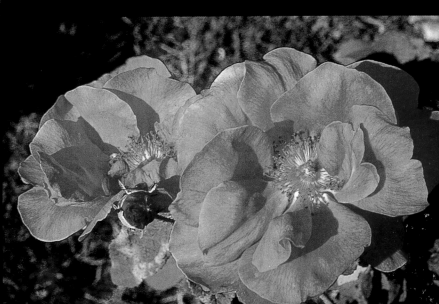

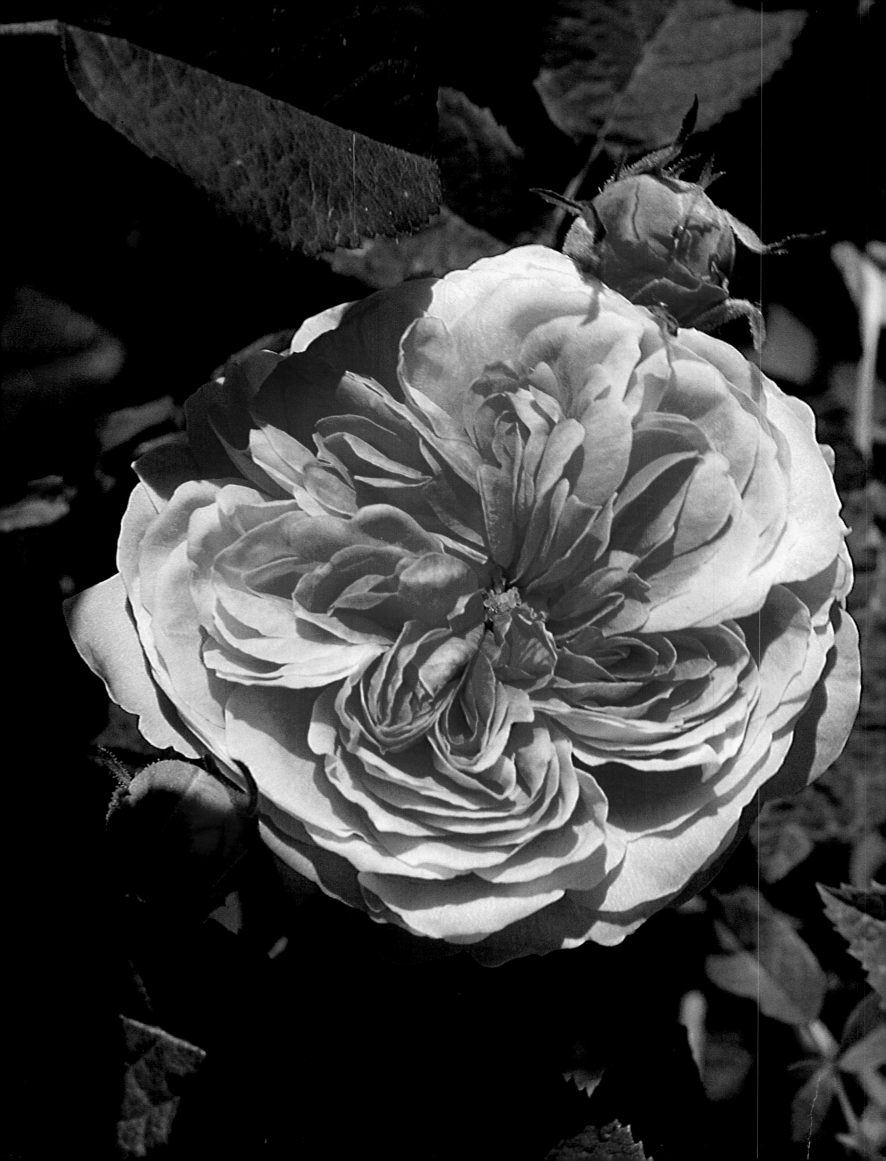

Dans ce parc à la française soumis à l'architecture de son château, il y a plus d'eau que d'herbe, a-t-on souvent dit. L'eau de source s'y déplace spontanément, sans l'aide du moindre artifice, alimentant cascatelles, bassins et canaux. Attribués à Le Nôtre, les jardins abandonnés reprirent vie au siècle dernier grâce à Berthe de Béhague, marquise de Ganay, qui fit appel à l'architecte paysagiste Achille Duchêne, et créa, assistée par une amie anglaise, le jardin anglo-japonais. Le château Louis XIII est amené par une majestueuse avenue de platanes bordée de tapis verts et de canaux. Il est construit sur une île et cerné d'eau. La perspective le traverse, passe par les parterres en broderie de buis, puis par le miroir, le bassin du Dauphin, pour aller s'achever sur le Rond du Moigny. Près du château, une allée part en oblique sur la droite pour rejoindre La Gerbe et le Grand Canal. Perpendiculairement à celui-ci s'étagent les fameuses cascatelles. En revenant vers le château, on croise la nymphe Aréthuse qui domine le bassin du Fer à Cheval. Puis en se dirigeant vers l'église du village, on découvre la pièce d'eau du Presbytère, juste avant le jardin anglo-japonais. Celui-ci est planté de bulbes, d'arbustes rares, de pivoines et d'érables choisis par une dame qui aimait les plantes avec la même passion qui anime aujourd'hui Philippine de Ganay dont les plantations, n'enlevant rien à la noblesse de l'ensemble, humanisent l'architecture formelle du tracé.

Courances

In this French-style park, which unfolds beneath the imposing façade of the castle, there is more water than lawn. The stream flows spontaneously from a spring and no engineering is required to produce the little cascades, ponds and canals. The gardens are attributed to Le Nôtre, but had fallen into disrepair when they were rescued by Berthe de Béhague, the Marquise de Ganay; she brought in the architect and landscape gardener Achille Duchêne and, with the help of an English companion, created the Anglo-Japanese garden. The Louis XIII chateau is approached along a majestic avenue of plane trees bordered by lawns and canals; it is built on an island and surrounded by water. It is placed at the centre of the main axis, which comprises parterres embroidered with box hedges, the "miroir d'eau" formed by the Bassin du Dauphin and finally the Rond du Moigny. Near the chateau, a walk leads off at an oblique angle towards the Gerbe (fountain) and the Grand Canal. The famous series of little cascades is perpendicular to the canal. Returning to the chateau, one comes across the nymph Arethusa who reigns over the Horseshoe pond. Then, as one sets out toward the village church, one comes across the Presbytery lake before reaching the Anglo-Japanese garden, which is planted with bulbs, rare shrubs, peonies and maples selected with admirable flair. Today's owner, Philippine de Ganay, shows the same meticulous attention to detail, and her own additions have tended to soften the formality of the garden while enhancing its overall harmony.

In diesem ganz der Architektur des Schlosses untergeordneten Barockpark gibt es mehr Wasser als Grün. Das Quellwasser speist ohne jegliche künstliche Hydraulik kleine Kaskaden, Becken und Kanäle. Die Le Nôtre zugeschriebenen Gärten drohten zu verfallen, wurden dann aber im letzten Jahrhundert von Berthe de Béhague, der Marquise de Ganay, wiederhergestellt. Sie beauftragte damit den Gartenarchitekten Achille Duchêne und schuf selbst unter Mitwirkung einer englischen Freundin den englisch-japanischen Garten. Zum Schloß aus der Zeit Ludwigs XIII. führt eine majestätische Platanenallee, die rechts und links von Rasenflächen und Kanälen gesäumt wird. Das Gebäude liegt auf einer Insel mitten im Wasser. Die Hauptblickachse verläuft durch das Schloß hindurch über die Broderie-Parterres mit ihren Buchsbaumhecken, das große Wasserbecken und das Bassin du Dauphin bis zum Rond du Moigny. Neben dem Schloß geht schräg rechts ein Weg zur Fontäne und zum Grand Canal ab. Im rechten Winkel dazu liegen die berühmten Kleinen Kaskaden. Auf dem Rückweg zum Schloß kommt man an der Nymphe Arethusa vorbei, die das Hufeisenbecken ziert. Geht man anschließend auf die Kirche des Dorfes zu, entdeckt man den Pfarrhausbrunnen unmittelbar vor dem Eingang zum englisch-japanischen Garten. Dieser Teil des Parks ist mit Zwiebelgewächsen, seltenen Sträuchern, Pfingstrosen und Ahornbäumen bepflanzt. Ausgewählt wurden sie von einer Dame, die für die Flora die gleiche Leidenschaft empfand wie heute Philippine de Ganay, deren Gartengestaltung die strenge Linienführung etwas abgemildert hat, ohne jedoch den Gesamteindruck zu schmälern.

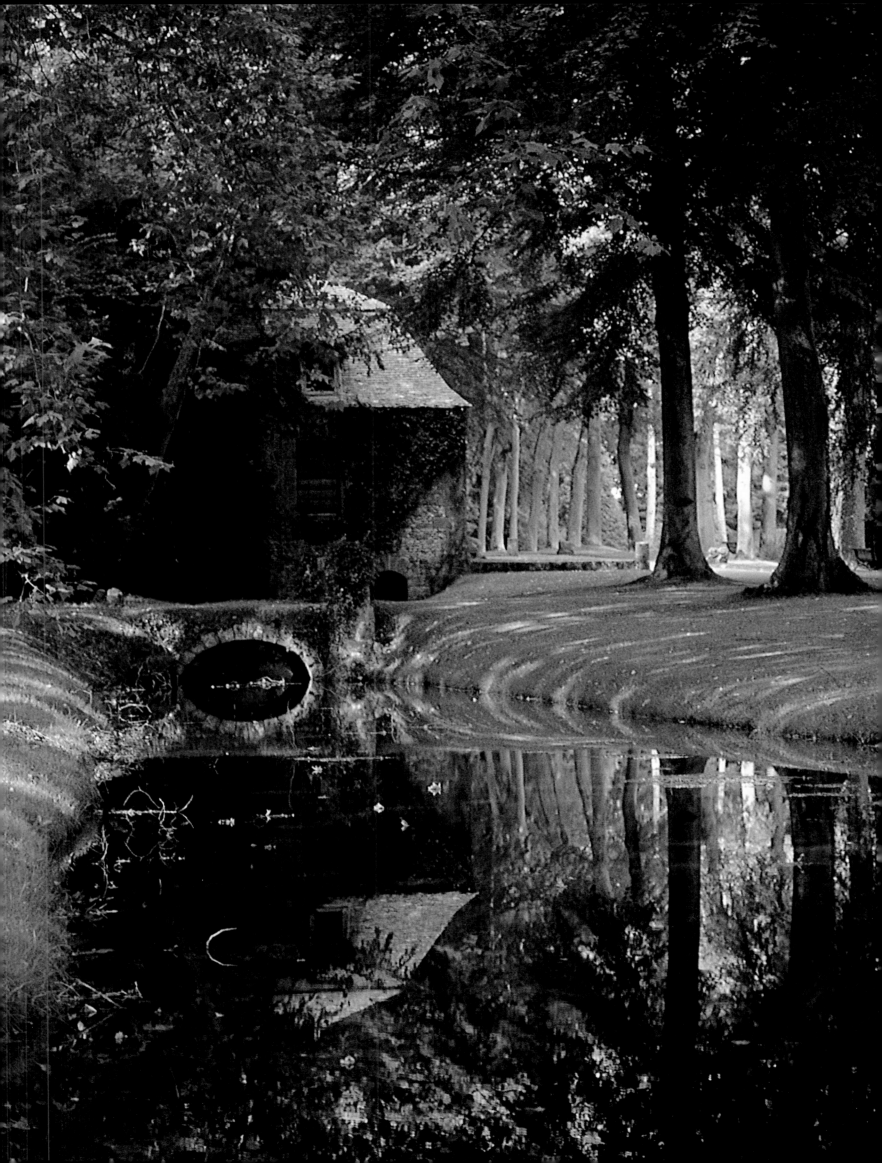

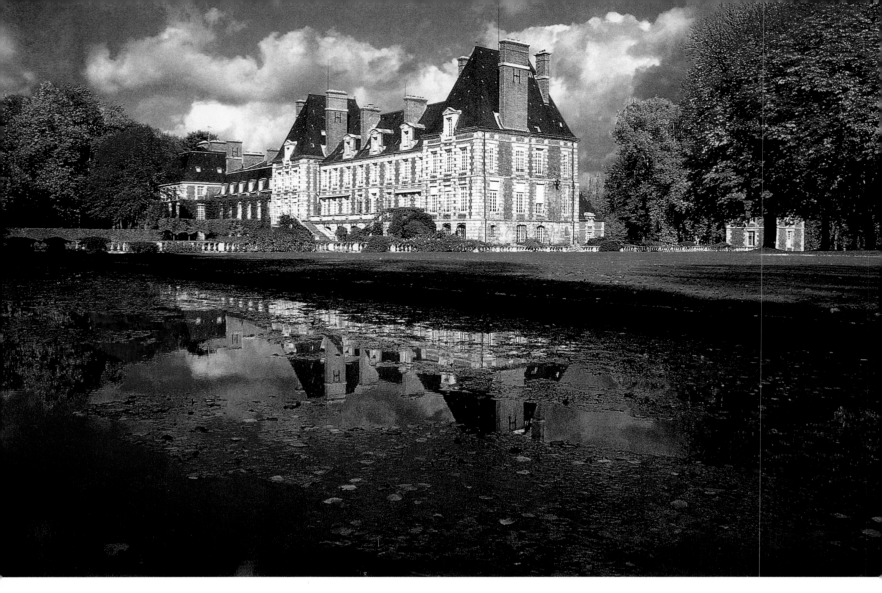

Page précédante: En quittant le château et en se dirigeant vers le jardin anglo-japonais, on découvre la Foulerie, un bâtiment qui se mire dans l'eau, à l'ombre des grands arbres du parc.
Ci-dessus: Le château Louis XIII est cerné d'eau et construit sur une île; il est introduit par des canaux bordés de platanes.
A droite: Les pièces de réception du château donnent sur deux motifs en broderie de buis ornés de savantes arabesques, puis sur le miroir.

Previous page: On the walk between the chateau and the Anglo-Japanese garden stands the fullery (or fulling-mill), which is reflected in the water shaded by the mature trees of the park.
Above: Surrounded by water, the Louis XIII chateau is reached by canals bordered by plane trees.
Right: The reception rooms of the chateau look out over two beds embroidered with box hedges in delicate arabesques, behind which lies the "miroir d'eau".

Vorhergehende Seite: Geht man vom Schloß aus auf den englisch-japanischen Garten zu, erreicht man die Foulerie (Walkerei), die sich im Schatten der großen Parkbäume im Wasser spiegelt.
Oben: Das Schloß aus der Zeit Ludwigs XIII. liegt mitten im Wasser auf einer Insel. Platanengesäumte Kanäle führen darauf zu.
Rechts: Von den Empfangssälen des Schlosses aus blickt man auf zwei Broderie-Parterres mit kunstvollen Arabesken aus Buchsbaum. Dahinter schließt sich das große Wasserbecken an.

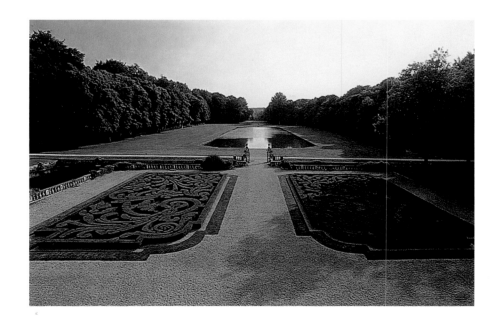

Courances *Ile-de-France*

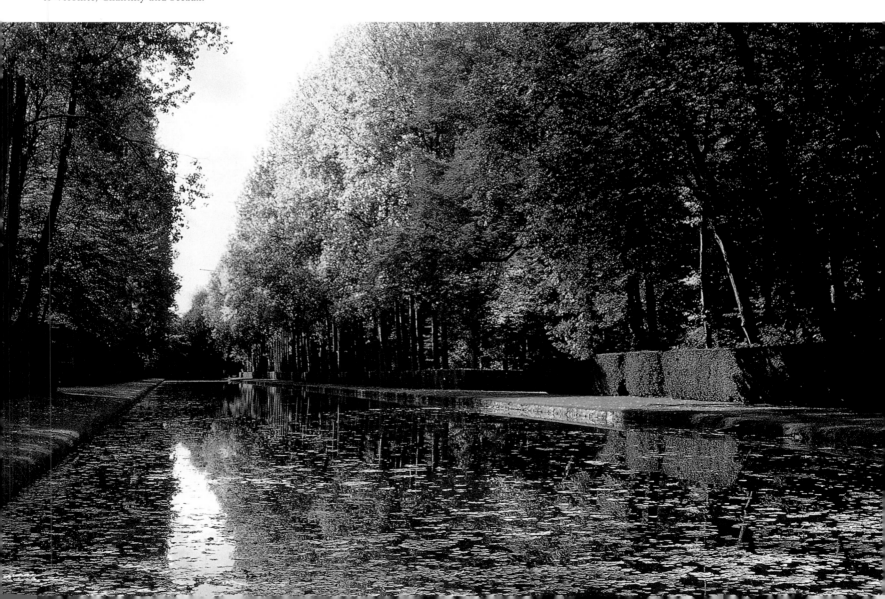

A droite: la «baigneuse» ou nymphe Aréthuse. Cette statue en marbre sculpté vient de Marly-le-Roi et surplombe la pièce d'eau du Fer à Cheval.
Ci-dessous: On retrouve le thème du Grand Canal à Vaux-le-Vicomte, Chantilly ou Sceaux.

Right: The "bather" or the nymph Arethusa. This statue in sculpted marble comes from Marly-le-Roi and reigns over the horseshoe pond.
Below: The feature of the Grand Canal recurs at Vaux-le-Vicomte, Chantilly and Sceaux.

Rechts: die »Badende«, eigentlich die Nymphe Arethusa. Die Marmorskulptur stammt aus Marly-le-Roi und thront über dem Hufeisenbecken.
Unten: Das Motiv des Grand Canal findet sich auch in Vaux-le-Vicomte, Chantilly und Sceaux.

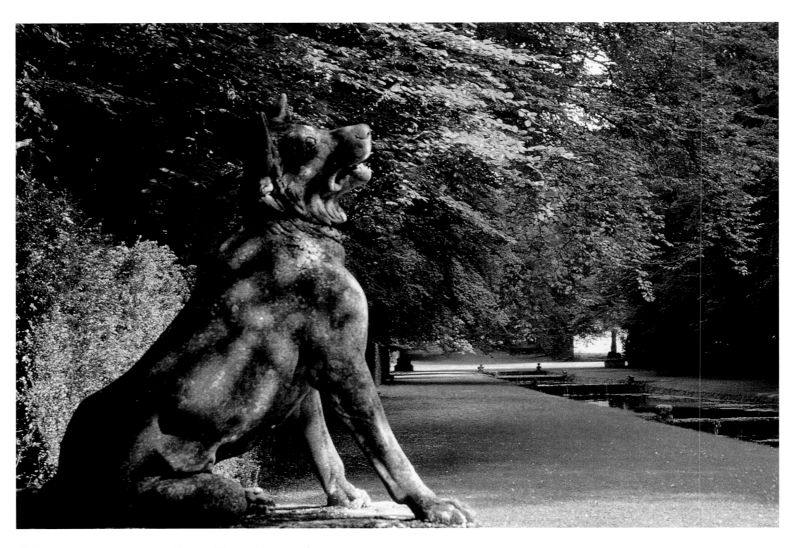

Ci-dessus: un loup près des cascatelles appelées aussi les «Nappes».
A droite: une statue, peut-être Flore, près du miroir.
Page de droite: L'eau des Nappes s'écoule sur les marches, offrant sa luisance, ses miroitements, ses jeux d'ombre et de lumière. A Courances, les allées sont bordées par des haies taillée au-dessus desquelles les branches des grands arbres poussent en liberté.
Double page suivante: le jardin anglo-japonais.

Above: A wolf stands guard over the series of little weirs forming the cascades.
Right: a statue, perhaps Flora, near the "miroir d'eau".
Facing page: The water of the cascades runs over the weirs in a calm procession of reflections under the play of light and shade. At Courances, the "allées" are lined with clipped hedges over the which branches of the mature trees extend their shade.
Following pages: the Anglo-Japanese garden.

Oben: ein Wolf nahe den Kleinen Kaskaden, die man auch als »Nappes« bezeichnet.
Rechts: eine Statue, vielleicht Flora, in der Nähe des großen Wasserbeckens.
Rechte Seite: Das Wasser der »Nappes« läuft die Stufen hinab und bietet dabei mit seinem Glitzern, Schillern und dem Spiel von Licht und Schatten ein eindrucksvolles Schauspiel. In Courances sind die Wege mit beschnittenen Hecken eingefaßt, darüber strecken jedoch mächtige Bäume ungehindert ihre Äste aus.
Folgende Doppelseite: der englisch-japanische Garten.

Courances *Ile-de-France*

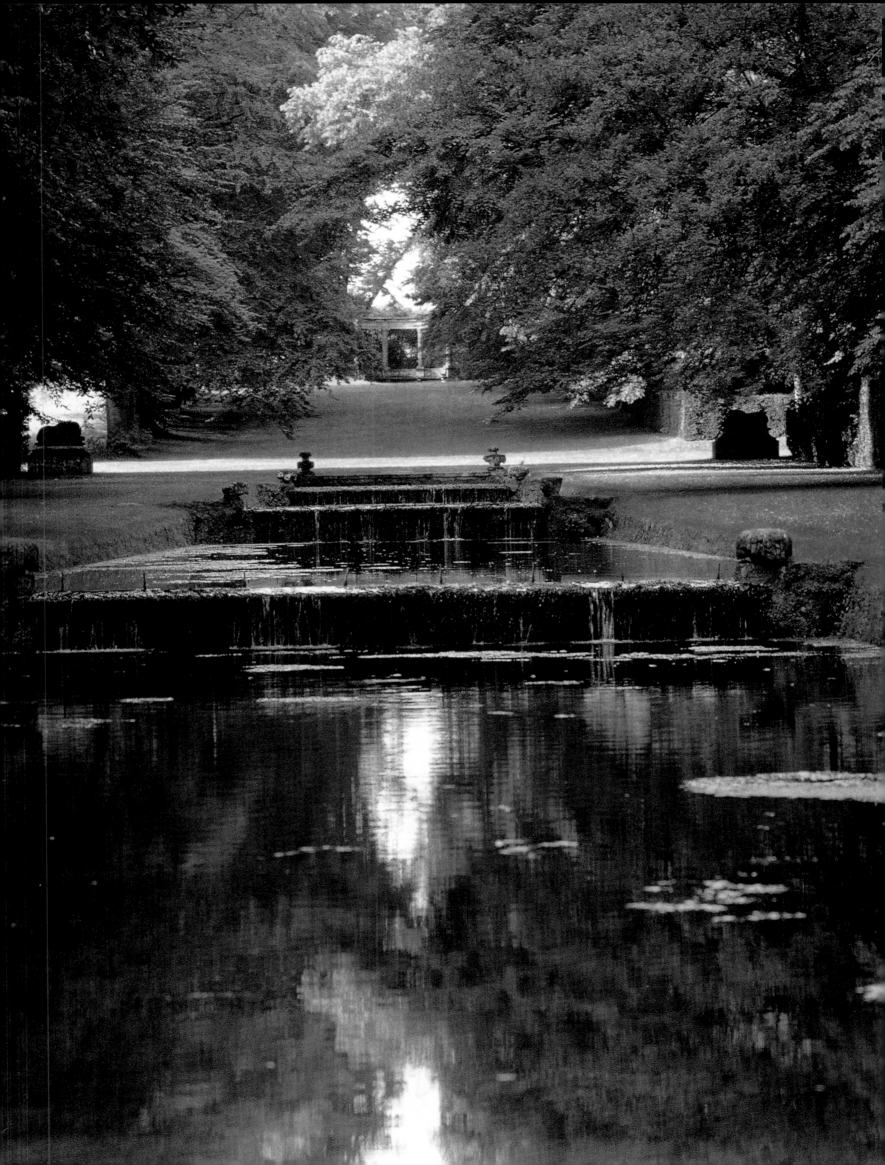

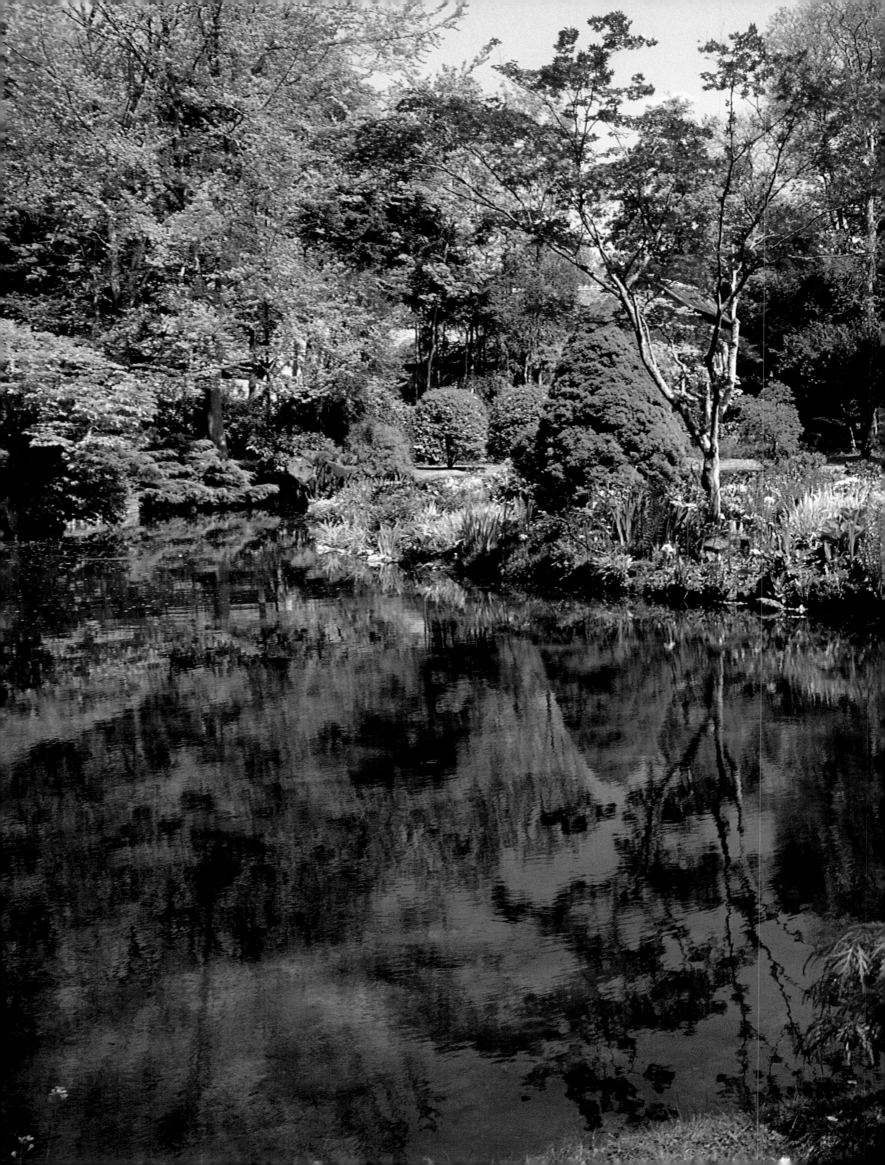

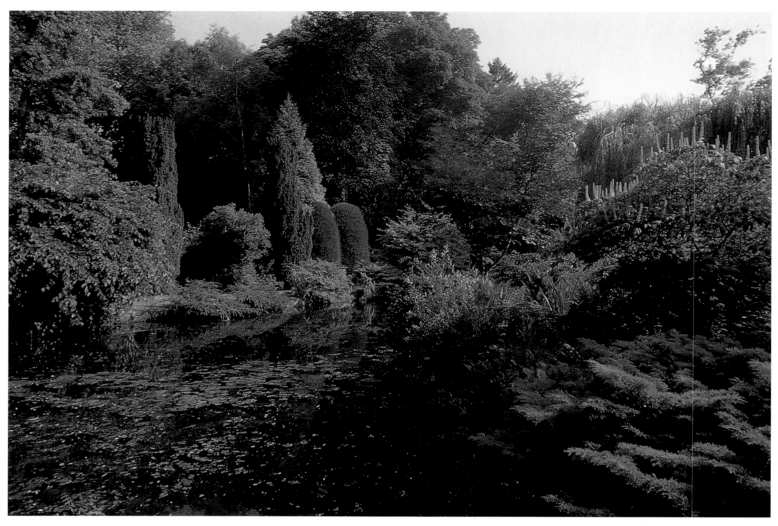

Ci-dessus, à droite et page de droite: Le jardin anglo-japonais fut conçu entre les deux guerres par Berthe de Béhague, marquise de Ganay, qui se fit aider par une amie anglaise. Il est très beau à l'automne quand les feuillages des érables et des liquidambars flamboient. Il est planté autour d'une pièce d'eau en forme d'étang où se mirent les végétaux. Çà et là, des conifères aux silhouettes rampantes ou érigées apportent une note de diversité parmi les autres essences d'arbres et d'arbustes.

Above, right and facing page: The Anglo-Japanese garden was designed between the wars by Berthe de Béhague, Marquise de Ganay, and an English companion. It is especially beautiful when the autumn colours of the maples and the sweetgum leaves are at their most vivid. At its centre is a pond in which the plants are reflected. Here and there, spreading or upright conifers bring their own distinctive note to this harmonious arrangement of trees and shrubs.

Oben, rechts und rechte Seite: Der englisch-japanische Garten wurde zwischen den Weltkriegen von Berthe de Béhague, der Marquise de Ganay, mit Hilfe einer englischen Freundin angelegt. Im Herbst, wenn die Ahorn- und Amberbäume sich flammendrot färben, ist der Garten besonders reizvoll. Den Mittelpunkt bildet ein Teich, in dem sich die Gewächse spiegeln. Hier und dort setzen niedrige oder säulenförmige Koniferen zwischen den übrigen Baum- und Strauchsorten aparte Akzente.

Courances *Ile-de-France*

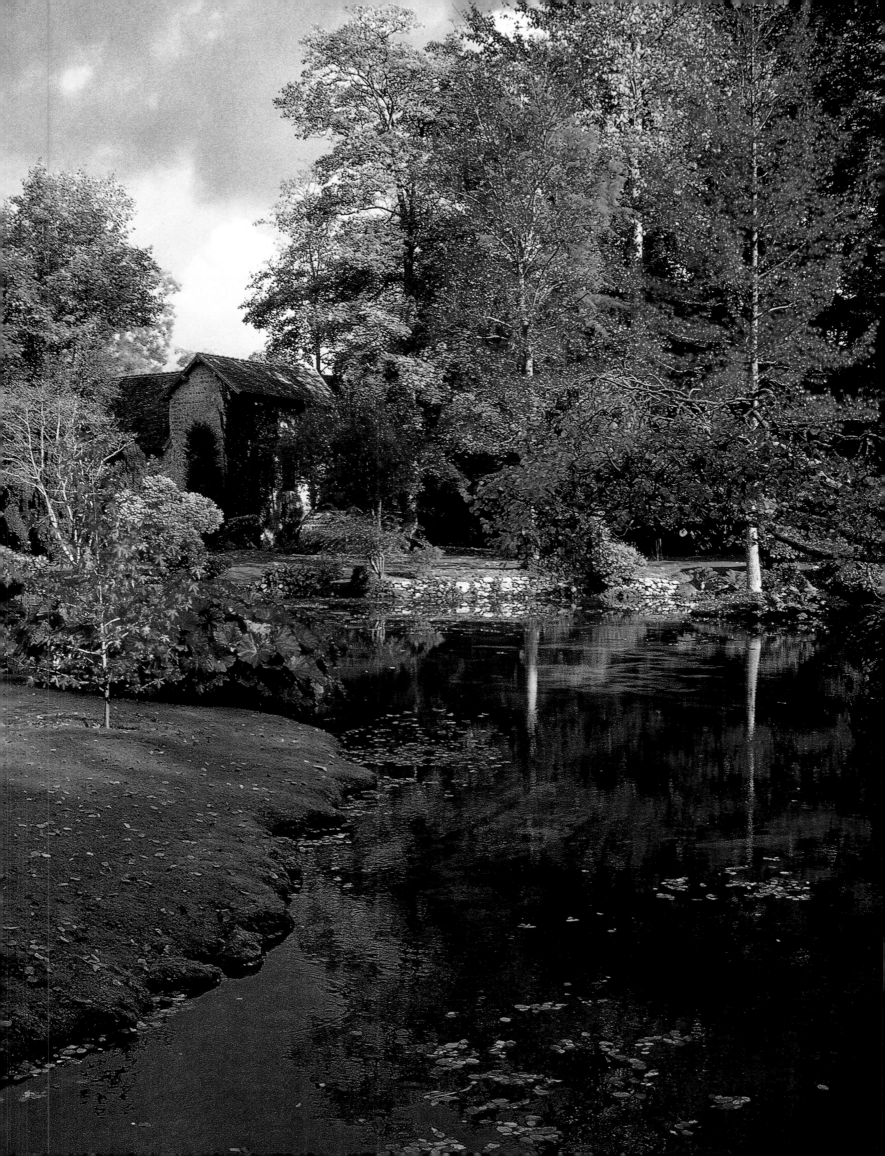

«J'aime les fleurs, mon mari connaît bien les arbres fruitiers et notre jardinier est un ancien maraîcher. Sans eux, je n'y serais jamais arrivée» raconte modestement Muriel de Curel. Quoi qu'il en soit, le potager de Saint-Jean-de-Beauregard a été restauré sous sa houlette jusqu'à devenir un grand modèle du genre. Cette belle aventure commença en 1985. Muriel de Curel se pencha sur l'histoire du parc et du château qui remonte au 17e siècle, conserva les serres, le verger, les murs, le bassin central; elle divisa les quatre carrés existants en seize, en s'inspirant de la structure du Potager du Roi à Versailles, puis fleurit les allées. Les quatre croix mélangent des annuelles, des plantes vivaces et des légumes décoratifs. Deux d'entre elles sont jaunes et orange. Et en diagonale, les deux autres sont bleues ou roses. L'un des grands axes est voué aux iris. L'autre est planté à la gloire des pivoines, se prolonge par une tonnelle de rosiers puis dessert un jardin bouquetier avant de rejoindre les serres et le verger. Sur les murs et à leur pied, selon les expositions, se déploient des collections de clématites, de rosiers, d'arbres fruitiers palissés, de petits fruits, de plantes d'ombre et de soleil. Le spectacle commence avec les bulbes et les fleurs des arbres fruitiers et se prolonge jusqu'à l'automne grâce aux légumes qui peuplent les carrés. L'année est aussi animée par deux grands événements: la fête des Plantes vivaces en avril, celle des Fruits et Légumes d'hier et d'aujourd'hui au mois de novembre.

Saint-Jean-de-Beauregard

"I love flowers, my husband knows fruit trees well, and our gardener is a former market gardener. Without their help, I should never have managed," says Muriel de Curel. Her modesty is emphatic, but under her direction, the kitchen garden of Saint-Jean-de-Beauregard has been restored to become a model of its kind. This enterprise began in 1985. Muriel de Curel studied the history of the 17th-century park and chateau, kept the greenhouses, the orchard, the walls and the central pond, but divided the four square beds to obtain sixteen, drawing on the design of the Potager du Roi at Versailles. Then she bordered the garden walks with flowers. Her four cross-shaped borders mix annuals, perennials and ornamental vegetables. Two are yellow and orange; the others are blue and pink. One of the main axes is given over to irises, the other to peonies. The peony border leads into a rose bower, and continues through the garden for cutting flowers to the greenhouses and orchard. On the walls and at their feet, depending on the aspect, are collections of clematis, roses, palisaded fruit trees, soft fruits and sun- and shade-loving plants. The spectacle begins with bulbs and fruit blossoms and continues right through to autumn, thanks to the vegetables which populate the square beds. There are two major seasonal events: the Perennials Festival in April and the Fruit and Vegetables of Yesterday and Today Festival in November.

»Ich liebe Blumen, mein Mann kennt sich gut mit Obstbäumen aus, und unser Gärtner war früher Gemüsebauer. Ohne die beiden wäre mir all das nie gelungen«, erzählt Muriel de Curel bescheiden. Wie dem auch sei – der Gemüsegarten von Saint-Jean-de-Beauregard ist unter ihrer Federführung so schön restauriert worden, daß er heute als Vorbild für viele Anlagen dieser Art gilt. Das erfolgreiche Vorhaben wurde 1985 begonnen. Muriel de Curel vertiefte sich in die Geschichte von Park und Schloß, die im 17. Jahrhundert begann, und stellte die Gewächshäuser, den Obstgarten, die Mauern sowie das zentral gelegene Wasserbecken wieder her. Die vier vorhandenen Beete unterteilte sie nach dem Vorbild des Potager du Roi in Versailles in sechzehn Einzelbeete und säumte die Wege mit bunten Blumen. Die vier Kreuzungspunkte sind mit einjährigen Pflanzen, Stauden und Ziergemüsen eingefaßt, zwei davon ganz in Gelb und Orange, die zwei anderen jedoch ganz in Blau und Rosa. Eine der Hauptachsen ist einzig den Schwertlilien gewidmet, eine zweite den Pfingstrosen. Hieran schließt sich eine Rosenlaube an, die zu einem Schnittblumengarten führt und von dort weiter zu den Gewächshäusern und dem Obstgarten. An den Mauern und zu ihren Füßen prunken je nach Sonneneinstrahlung verschiedene Sorten Clematis, Rosen, Spalier- und Beerenobst, Schattengewächse und sonnenliebende Pflanzen. Das Schauspiel beginnt im Frühling mit Zwiebelgewächsen und der Obstbaumblüte und währt dank der Gemüse in den Beeten bis weit in den Herbst. Höhepunkte des Jahres sind das Staudenfest im April und das Fest alter und neuer Obst- und Gemüsesorten im November.

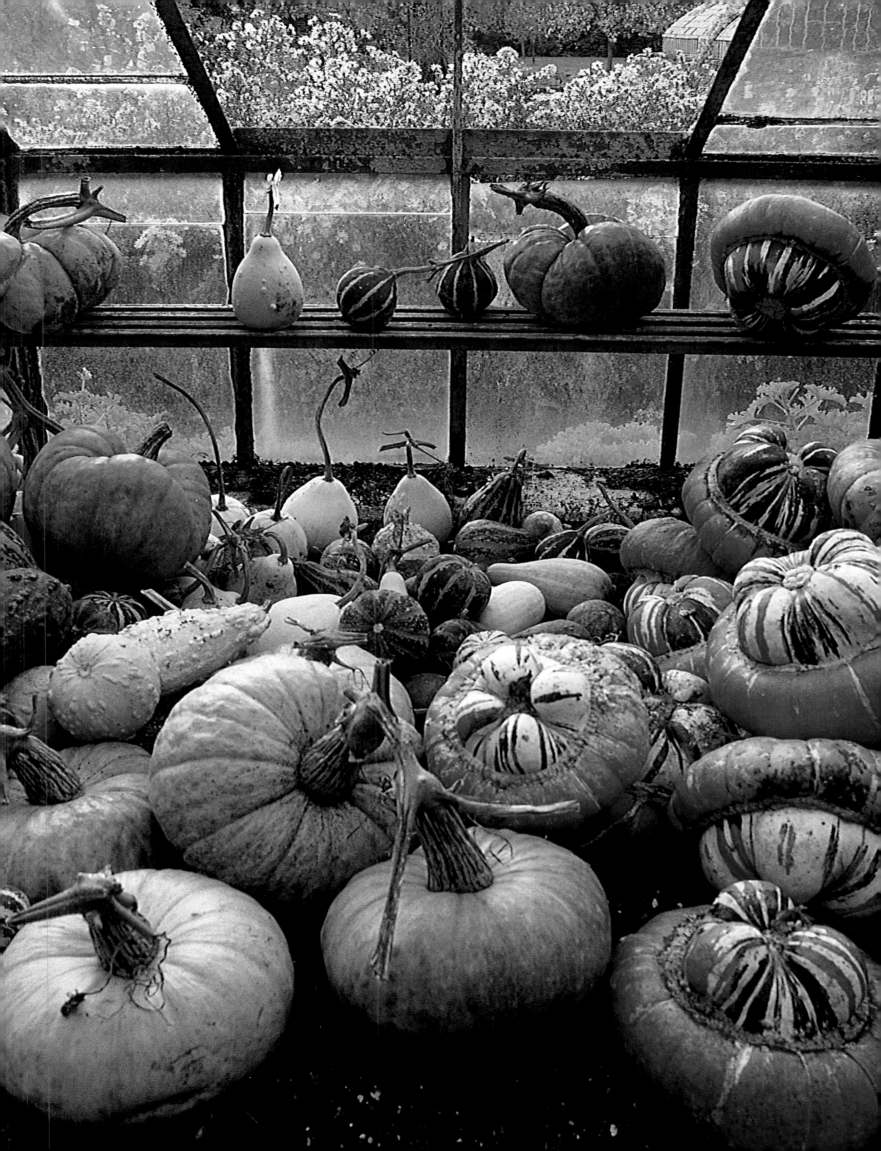

Page précédente: collections de cucurbitacées dans la serre avec des potirons 'Bleu de Hongrie' à gauche, des giraumons 'Turban' à droite et des coloquintes au fond. Derrière, des asters.

A droite: Les cardons *(Cynara cardunculus)* sont des plantes potagères qui ressemblent aux artichauts, mais ce sont leurs côtes que l'on consomme. Pour qu'elles soient tendres, on les blanchit en les enfermant dans des sacs, à la fin de l'été. Elles sont prêtes à l'emploi environ trois semaines plus tard.

Ci-dessous: scène du potager fleuri, prise dans l'une des croix jaune et orange. A gauche, des cardons et au centre, *Leonotis leonurus* rouge-orangé. A droite, des roses d'Inde.

Previous page: collections of cucurbitaceous plants in the greenhouse: 'Bleu de Hongrie' pumpkins to the left, 'Turban' pumpkins to the right and colocynths at the rear. Behind them asters are visible.

Right: Cardoons *(Cynara cardunculus)* are edible plants which resemble artichokes, but it is the leafstalk that is eaten. They are blanched for tenderness by enclosing them in sacks at the end of the summer. They are ready to cook some three weeks later.

Below: the kitchen garden with its flowering borders; this is the yellow and orange border. Left: cardoons. In the centre: red-orange lion's ear *(Leonotis leonurus)*. Right: Indian roses *(Tagetes)*.

Vorhergehende Seite: Diverse Kürbisgewächse lagern im Treibhaus, darunter links im Bild Zentnerkürbisse 'Bleu de Hongrie', rechts Zierkürbisse der Sorte 'Turban' und im Hintergrund Koloquinthen. Ganz hinten sieht man Astern.

Oben: Karden *(Cynara cardunculus)* sind Gemüsepflanzen und ähneln Artischocken, doch ißt man nicht die Köpfe, sondern die Blattstiele. Damit sie zart bleiben, bleicht man sie unter Säcken, die im Spätsommer um die ganze Pflanze gebunden werden. Nach rund drei Wochen kann man die Karden dann ernten.

Unten: Ansicht des blühenden Gemüsegartens an einem der gelb-orangenen Kreuzungspunkte. Links Karden, in der Mitte orangerotes Löwenohr *(Leonotis leonurus)*, rechts Studentenblumen *(Tagetes)*.

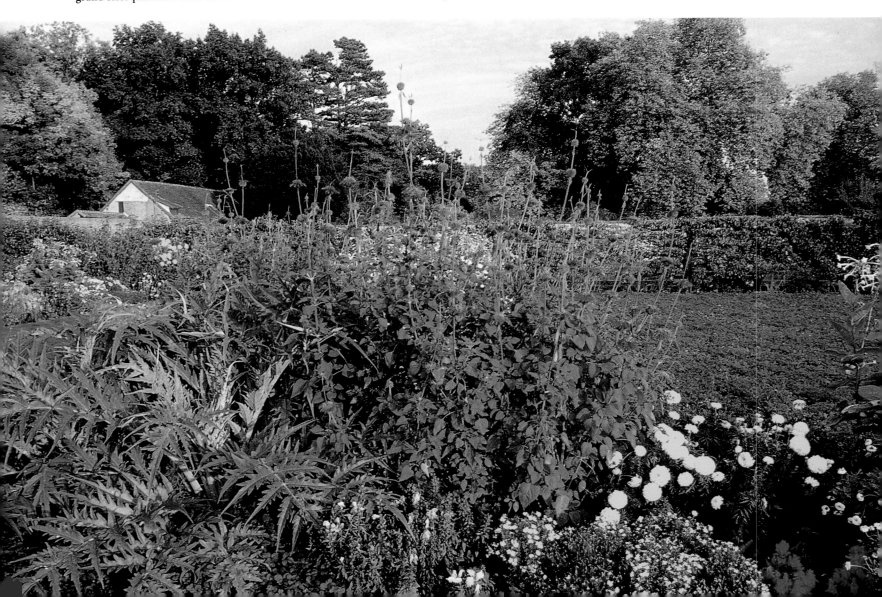

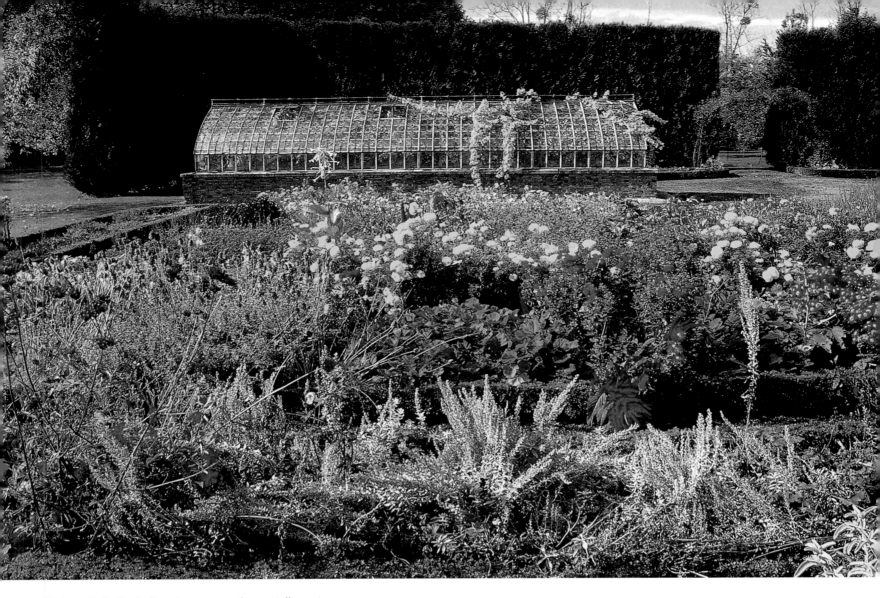

Ci-dessus: Le jardin de fleurs à couper est chamarré d'un mélange d'armoises grises *(Artemisia)*, de verveines *(Verbena bonariensis)*, d'amarantes *(Amaranthus caudatus)*, de chrysanthèmes et de roses d'Inde.
A droite: la serre et ses vignes vues de l'intérieur.
Double page suivante: Les cucurbitacées sont mises à l'abri du gel dans la serre. On distingue des courges de Siam tachetées de vert, délicieuses, et des courges de Provence qui sont vertes au début. Sur le sol, des potirons 'Jaune Gros de Paris'.

Above: The garden of flowers for cutting is embroidered with grey wormwood *(Artemisia)*, verbenas *(Verbena bonariensis)*, amaranth, chrysanthemums and Indian roses.
Right: the greenhouse and its vines seen from the inside.
Following pages: The cucurbitaceous plants are protected from the frost in the greenhouse. Speckled with green, the Siam marrows are delicious. Also visible are Provence marrows, which are green till they ripen. On the ground are 'Jaune Gros de Paris' pumpkins.

Oben: Der Schnittblumengarten ist mit einer Mischung aus grauem Beifuß *(Artemisia)*, Verbenen *(Verbena bonariensis)*, Gartenfuchsschwanz *(Amaranthus caudatus)*, Chrysanthemen und Studentenblumen übersät.
Rechts: das mit Weinreben berankte Gewächshaus von innen gesehen.
Folgende Doppelseite: Die Kürbisse werden im Gewächshaus frostsicher gelagert. Man erkennt die grün gefleckten köstlichen Siam-Zucchini sowie die runden provenzalischen Zucchini, die zunächst grün sind. Auf dem Boden liegen mehrere Riesenkürbisse 'Jaune Gros de Paris'.

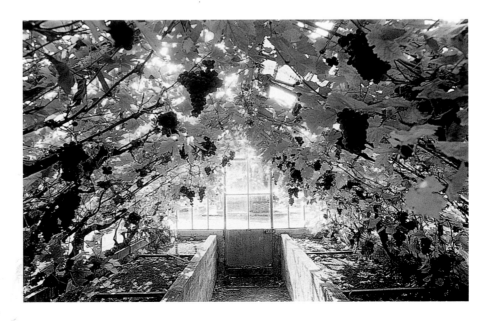

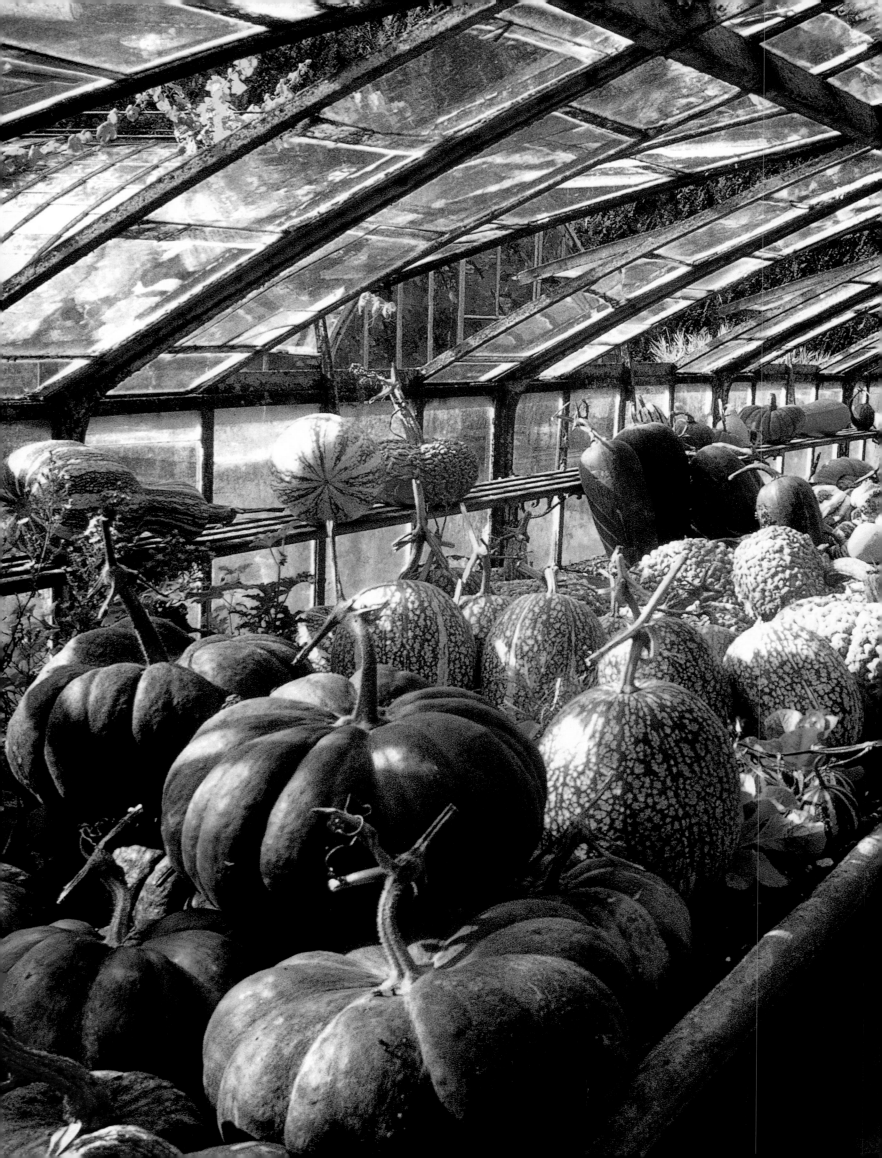

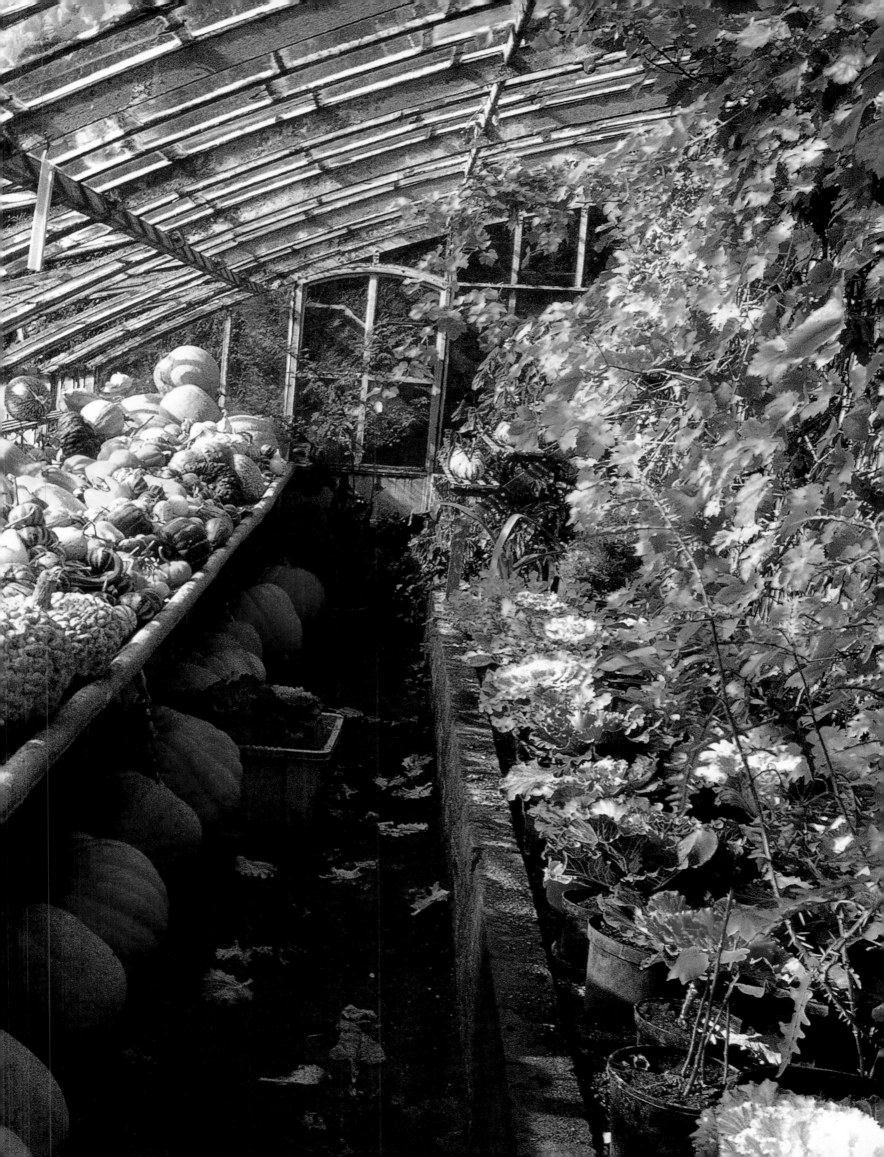

Détail de gauche: pommes
'Primerouge de Delbard'
d'un pommier conduit en
espalier.

Detail left: 'Primerouge de
Delbard' apples from an
espaliered apple tree.

Detail links: Äpfel der Sorte
'Primerouge de Delbard' von
einem Spalierbaum.

Détail de droite: joli bouquet
de poires produites par un
poirier centenaire conduit en
espalier.

Detail right: a fine crop of
pears produced by a one-
hundred-year-old espaliered
pear tree.

Detail rechts: ein hübsches
Birnengebinde von einem
hundertjährigen Spalier-
baum.

Détail de gauche: une vigne palissée sur le mur exposé au sud, plus décorative que comestible, *Vitis vinifera* 'Purpurea'.

Detail left: Grape vine *Vitis vinifera* 'Purpurea', which is here palisaded on a wall of southern aspect, is grown more for its appearance than its grapes.

Detail links: Spalierwein an einer sonnenüberfluteten Südmauer. Die Sorte *Vitis vinifera* 'Purpurea' ist eher dekorativ als schmackhaft.

Détail de droite: raisins conservés selon la méthode de la ville de Thomery pour éviter qu'ils ne se dessèchent.

Detail right: grapes conserved in Thomery fashion to avoid them drying out.

Detail rechts: Weintrauben werden nach der in dem Städtchen Thomery gebräuchlichen Methode so gelagert, daß sie nicht austrocknen.

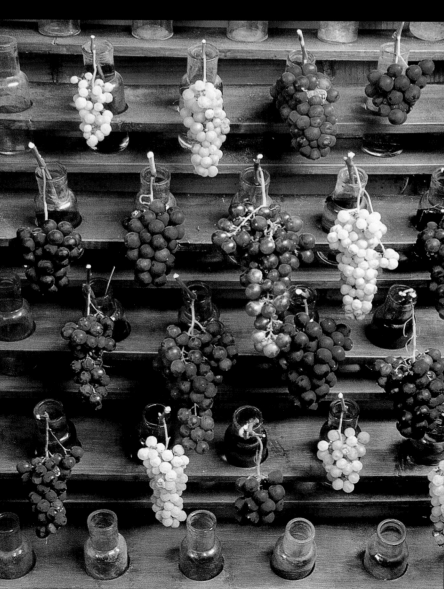

L'histoire veut que les jardins de Versailles soient inspirés de Vaux-le-Vicomte. Ils sont l'œuvre de deux génies: André Le Nôtre et Louis XIV. L'architecte les a empreints d'intelligence. Le Roi-Soleil, de magnificence. Ils sont soumis au palais et descendent en suivant les points cardinaux. Car le grand axe épouse symboliquement la course du soleil: le soir de la Saint-Louis, l'astre se couche sur le Grand Canal en forme de croix qui prolonge le parterre d'Eau, le parterre de Latone et le Tapis vert en s'éloignant du château. Au nord, les jardins se penchent vers le bassin de Neptune. Au sud, ils se prolongent par l'Orangerie, image de prospérité et d'abondance. Cette prodigieuse composition est devenue l'emblème du jardin à la française. Née d'un esprit cartésien et d'un goût certain pour la grandeur et le faste, elle fut commencée en 1661. Louis XIV enrichit son œuvre jusqu'à la fin de sa vie. Entre 1689 et 1705, il écrivit un ouvrage intitulé «Manière de montrer les Jardins de Versailles» où il se pose en maître absolu et en fin connaisseur. Il fallait une journée entière pour les parcourir à pied, pour aller de bosquet en bosquet et savourer l'équilibre des parterres, la majesté des perspectives, la symbolique des statues, la perfection des palissades de charmilles et des boulingrins. Ils étaient et sont toujours transcendés par les jeux d'eau les jours des Grandes Eaux, lorsque les bassins, les fontaines, les cascades, les miroirs, les parterres d'eau et les allées d'eau prennent vie et dévoilent toute leur magie.

Versailles

History has it that the gardens of Versailles were inspired by those of Vaux-le-Vicomte. They are the work of two men of genius: André Le Nôtre and Louis XIV. To Le Nôtre they owe their lucidity, to the Sun King, their magnificence. Sweeping down from the palace that dominates them, they are laid out east-west and north-south. The great central axis is a symbol of the sun's course; on Saint-Louis' name day, the sun sets on the cross-shaped Grand Canal, which itself continues the prospect offered by the Water Parterre, the Parterre de Latone and the Tapis Vert (lawn). To the north, the gardens descend toward the Bassin de Neptune. To the south stands the Orangerie, an image of prosperity and abundance. This majestic composition has come to symbolize the French-style of garden. The product of a Cartesian turn of mind and an undeniable taste for grandeur and luxury, the gardens were begun in 1661. Louis XIV continued to lavish attention on his creation until the end of his life. Between 1689 and 1705, he wrote a work entitled «Instructions for Presenting the Versailles Gardens», in which he figures as absolute master and sensitive connoisseur. An entire day was required to walk the full extent of the gardens: to go from one grove to another, savouring the symmetry of the parterres, the majesty of the vistas, the symbolism of the statues, the perfection of the lawns and the hornbeam palisades. The gardens attain a transcendent state on the days of «Grandes Eaux», when all the fountains are playing, the waterfalls cascading, and the «miroirs d'eaux», water parterres and water courses are brought to life and deploy their full magic.

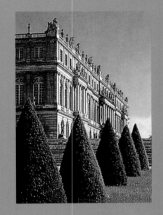

Der Überlieferung zufolge soll der Park von Versailles von demjenigen von Vaux-le-Vicomte inspiriert worden sein. Zwei Genies, André Le Nôtre und Ludwig XIV., prägten ihn – der Architekt mit Klarheit, der Sonnenkönig mit Pracht. Auf dem sanft abfallendem Gelände um das Schloß erstrecken sich die Gärten in allen vier Himmelsrichtungen. Dabei zeichnet die große Achse den Lauf der Sonne nach: Am 25. August, dem Fest des Heiligen Ludwig, geht die Sonne exakt über dem kreuzförmigen Grand Canal unter, der sich an die vom Parterre d'Eau, dem Parterre de Latone und dem Tapis Vert gebildete Achse anschließt. Im Norden senkt sich der Park zum Bassin de Neptune, dem Neptunsbrunnen, nach Süden führt er zur Orangerie, Sinnbild für Wohlstand und Überfluß. Diese prachtvolle Anlage gilt als Inbegriff des französischen Barockparks. Sie entsprang ebensosehr dem rationalen kartesianischen Denken wie auch einem ausgeprägten Hang zu Prunk. Die Arbeiten begannen 1661, und Ludwig XIV. ergänzte und erweiterte die Anlage bis an sein Lebensende. Zwischen 1689 und 1705 schrieb er die Abhandlung »Manière de montrer les Jardins de Versailles«, in der er sich als meisterhafter, hochgebildeter Gartenkenner zeigt. Zu Fuß benötigte man einen ganzen Tag, um den Park und seine Bosketts zu durchstreifen, um die Symmetrie der Parterres zu bewundern, die majestätischen Ausblicke, die allegorischen Skulpturen, die Perfektion der Buchenalleen und der sauber eingefaßten Rasenflächen. An den Tagen der Großen Wasserspiele erwachen die Bassins, die Brunnen, die Kaskaden, die Wasserbecken und die Kanäle wieder zum Leben und entfalten ihre Zauberkraft.

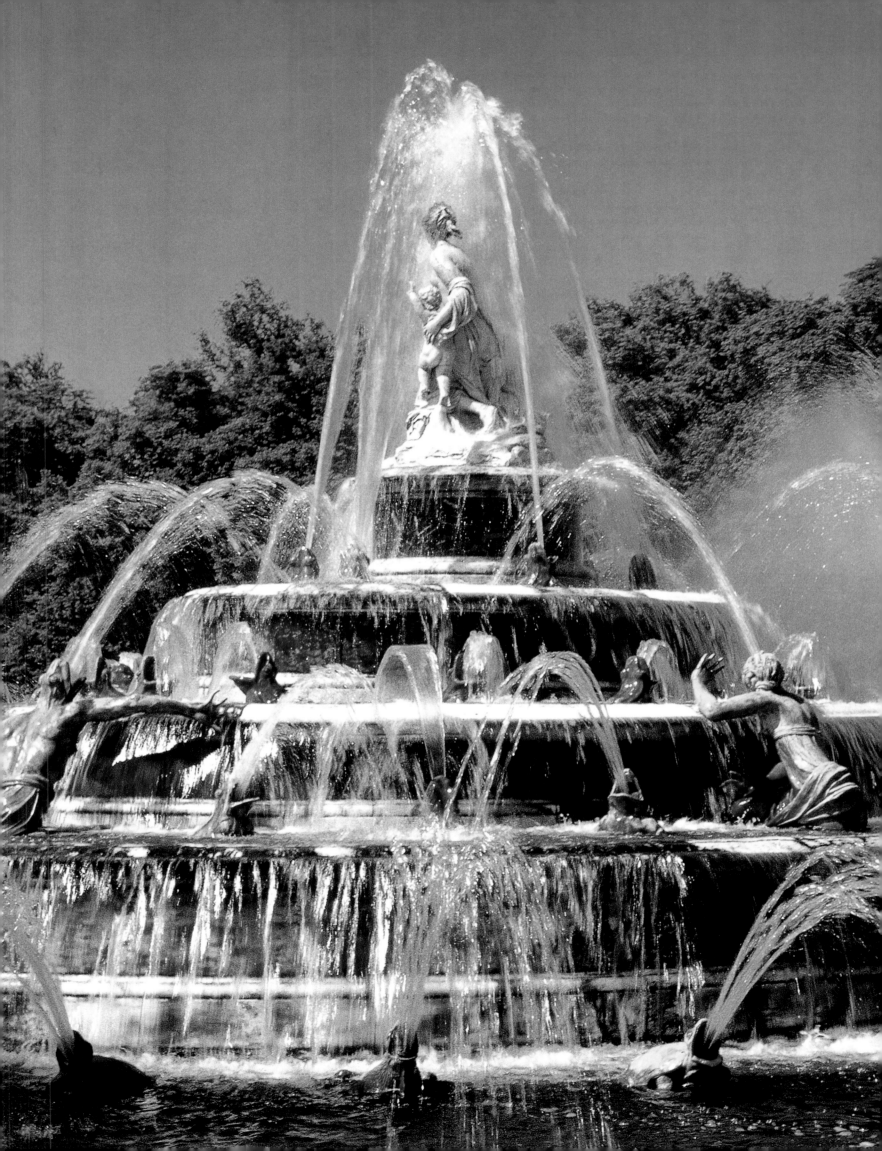

Page précédente: On découvre le bassin de Latone en quittant le parterre d'Eau, avant de longer le Tapis vert. De vasques étagées et animées de jets d'eau jaillissent des grenouilles et des tortues en plomb. La statue de Latone et de ses enfants dominent le bassin.

A droite: la naissance des jardins, au pied du palais à l'est, avec leurs parterres fleuris délimités par des haies de buis et surmontés d'ifs taillés en cônes.

Ci-dessous: Le bassin de Neptune est vraiment grandiose et prodigieux quand il est alimenté en eau. Il fut construit par André Le Nôtre puis modifié par l'architecte Jacques Ange Gabriel (1698-1782). Il est animé de quatre-vingt-dix-neuf jeux d'eau.

Previous page: the Bassin de Latone. It comes into view as one leaves the Water Parterre and before one strolls alongside the Tapis Vert. Basins set one above another, animated by jets of water emerging from frogs and turtles made of lead, climb up to the statue of Leto and her children, wich dominates the pond.

Right: At the foot of the palace, the gardens begin, with their flowering parterres defined by box hedges and overlooked by the cone-shaped topiary yew trees.

Below: The Bassin de Neptune is a prodigious sight when the fountains are playing. It was constructed by André Le Nôtre and modified by the architect Jacques Ange Gabriel (1698-1782). A battery of ninety-nine fountains can be brought into play.

Vorhergehende Seite: Das Bassin de Latone entdeckt man zwischen dem Parterre d'Eau und dem Tapis Vert. Die übereinander angeordneten Becken werden bekrönt von einer Statue der Leto und ihrer Kinder. Aus Mündungen in Form von Frö-

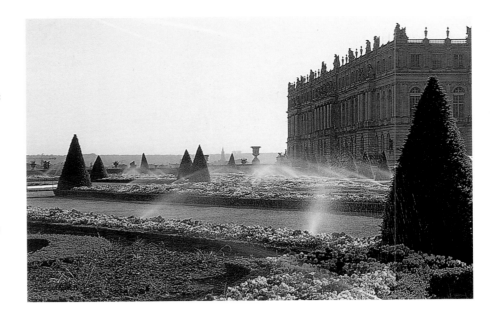

schen und Schildkröten aus Blei schießen kleine Wasserfontänen hervor.

Oben: Östlich des Schloßes erstreckt sich der Park mit seinen von Buchsbaumhecken eingefaßten Blumenparterres, die von kegelförmig beschnittenen Eiben überragt werden.

Unten: Der Neptunbrunnen bietet ein wahrhaft grandioses, prunkvolles Schauspiel, wenn er von Fontänen belebt wird. Er wurde von André Le Nôtre gebaut und später vom Architekten Jacques Ange Gabriel (1698-1782) umgestaltet. Insgesamt neunundneunzig Fontänen erwecken ihn zum Leben.

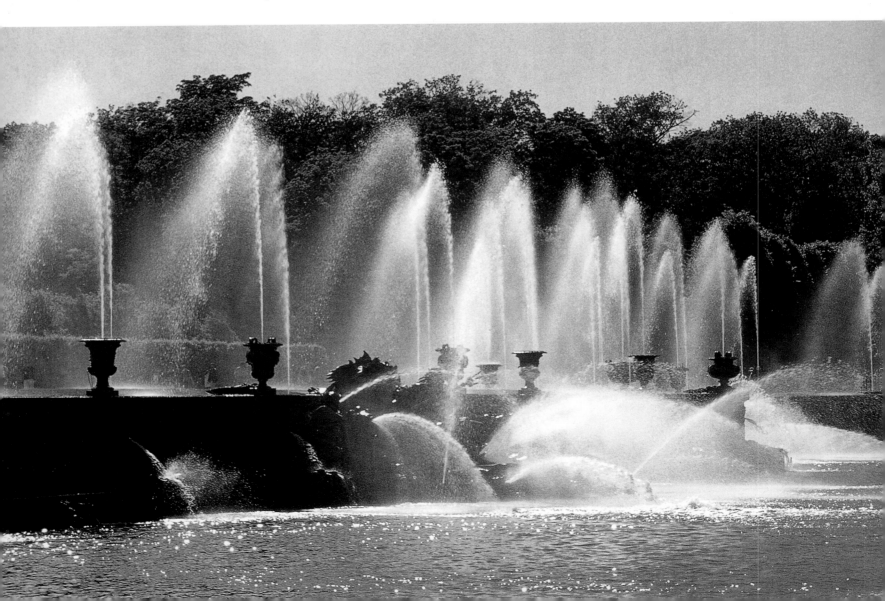

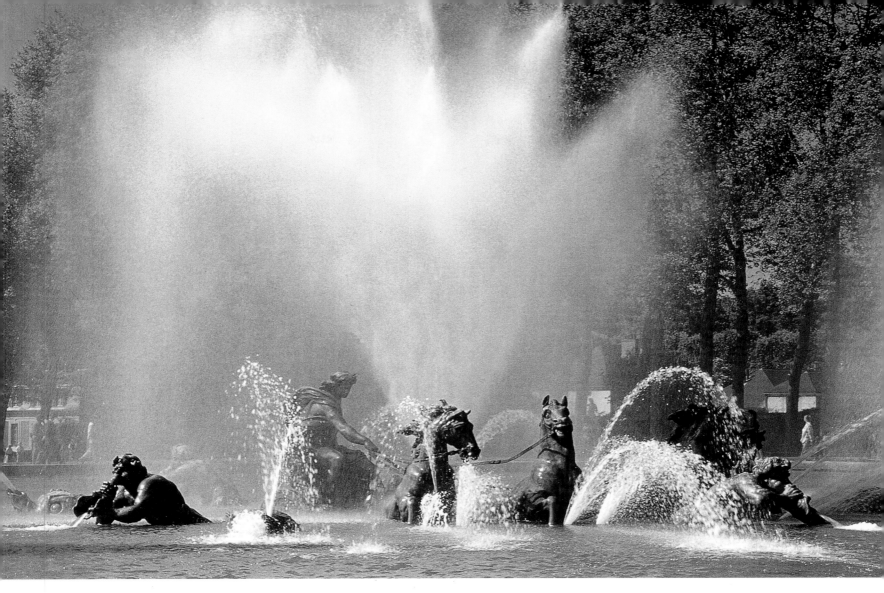

Ci-dessus et à droite: le bassin d'Apollon. Il est situé dans le prolongement du Tapis vert. Là, quatre chevaux fougueux font émerger de l'eau le char d'Apollon. Ces sculptures en plomb sont dues au sculpteur Jean-Baptiste Tubi (1635-1700) et s'animent de gerbes immenses qui ajoutent à la majesté de la scène.

Above and right: the Bassin d'Apollon. It is situated below the Tapis Vert. Four impetuous horses draw the chariot of Apollo out of the water. These sculptures, made in lead, are the work of Jean-Baptiste Tubi (1635-1700). When active, the vast columns of water of the fountains add to the majesty of the scene.

Oben und rechts: Der Apollobrunnen liegt in der Verlängerung des Tapis Vert. Von vier ungestümen Pferde gezogen, steigt der Sonnenwagen Apollos aus dem Wasser empor. Die vom Bildhauer Jean-Baptiste Tubi (1635-1700) in Blei gegossenen Plastiken werden von riesigen Fontänen überragt – ein majestätisches Bild.

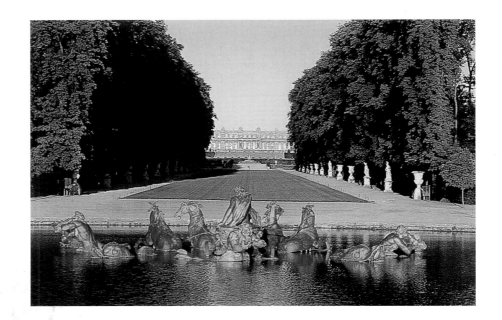

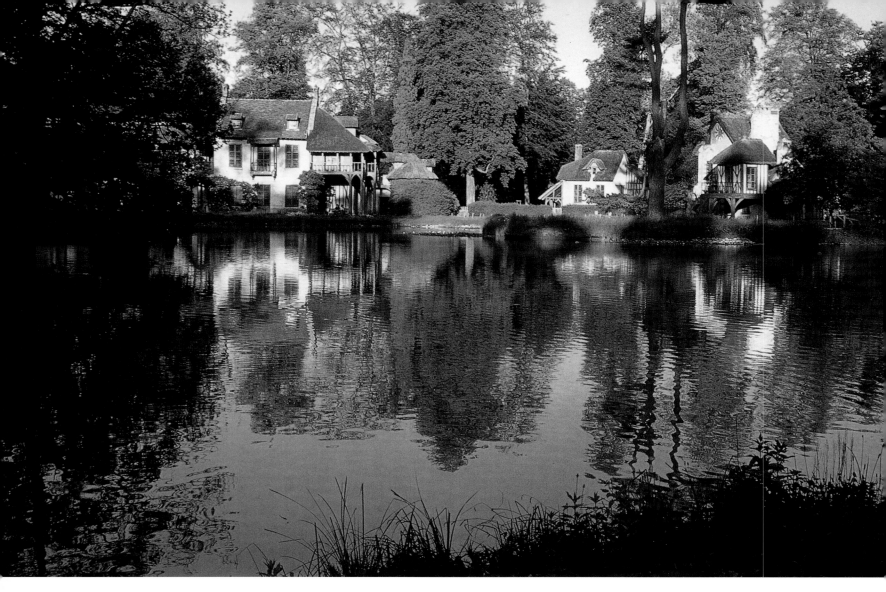

Ci-dessus: Le Hameau de Marie-Antoinette est situé à Trianon, hors des limites du jardin à la française. Il fut édifié pour la reine à une époque où les théories de l'écrivain et philosophe Jean-Jacques Rousseau (1712-1778) étaient à la mode. Là, elle pouvait s'adonner à des plaisirs simples proches des activités d'une ferme. On le doit à l'architecte Richard Mique (1728-1794).
A droite: la Salle des Antiques ou Amphithéâtre, près de Trianon. Au centre, quatre nymphes. Autour, vingt-cinq bustes de personnages légendaires ou historiques de l'Antiquité.

Above: Marie-Antoinette's Hamlet is beside the Trianon, outside the boundaries of the French-style garden. It was built for the queen at a time when the theories of the author and philosopher Jean-Jacques Rousseau (1712-1778) were in vogue. Here, she could give herself up to the pleasures of a «pastoral» life. It was built by the architect Richard Mique (1728-1794).
Right: the Antiques Room or Amphitheatre, near to the Trianon. In the centre, four nymphs. Around them, twenty-five busts of legendary or historical figures from Ancient Greece and Rome.

Oben: Le Hameau de la Reine – Marie Antoinettes künstliches Bauerndorf – liegt außerhalb des Barockparks beim Trianon. Die Königin ließ ihn zu einer Zeit anlegen, als der Schriftsteller und Philosoph Jean-Jacques Rousseau (1712-1778) populär war. Hier konnte sie sich den einfachen Freuden eines – fast – echten Bauernhofs hingeben. Er wurde geschaffen von dem Architekten Richard Mique (1728-1794).

Unten: die Salle des Antiques oder das Amphitheater beim Trianon. Im Zentrum des Beckens befinden sich vier Nymphen, ringsherum stehen die Büsten von fünfundzwanzig legendären und historischen Persönlichkeiten aus der Antike.

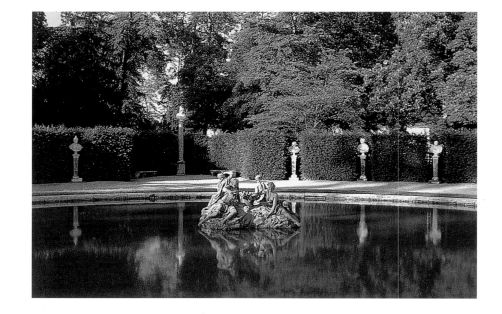

Versailles *Ile-de-France*

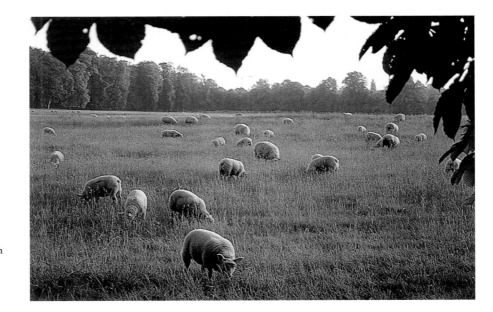

A droite: Dans le parc, non loin du Hameau de la reine, on a laissé la nature reprendre ses droits en abandonnant des herbages aux moutons.

Ci-dessous: Le Belvédère, près du Hameau de la reine, fut construit pour la reine Marie-Antoinette, en 1777. Le pavillon est octogonal et il est orné d'évocations des quatre saisons. C'est également une œuvre de Richard Mique.

Right: In the park, not far from the queen's Hamlet, nature has been allowed to take ist course by leaving the grazing land to sheep.

Below: The Belvedere, close to the queen's Hamlet, was constructed for Marie-Antoinette in 1777. The lodge is octogonal and decorated so as to recall the four seasons. It is also the work of Richard Mique.

Rechts: Unweit des Hameau de la Reine bleibt die Natur sich selbst überlassen. Schafe halten die Wiesen kurz.

Unten: das Belvedere neben dem Hameau de la Reine. Der oktogonale Pavillon wurde 1777 von Richard Mique für die Königin Marie-Antoinette errichtet. Der Bauschmuck verweist auf die vier Jahreszeiten.

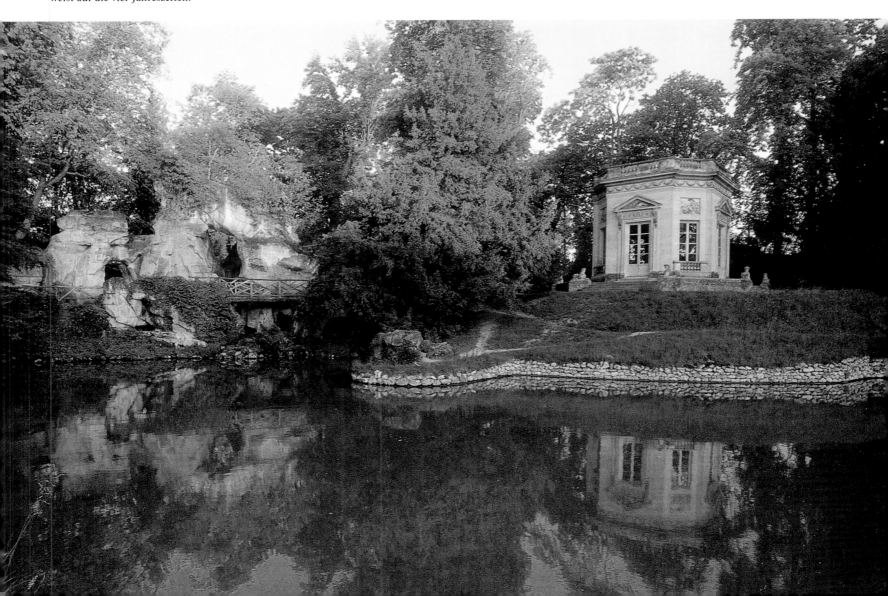

«J'habite la maison du jardinier que j'ai restaurée. J'aime vivre à côté du fantôme de cet hôtel particulier du 19e siècle délabré. Je suis tombé sous le charme de cet endroit qui a de belles proportions. L'axe principal prend naissance dans le bassin, passe par le salon, traverse la maison, la serre et l'orangerie, puis se perd dans le parc dont les limites sont mal définies. J'ai restructuré le jardin. J'aime qu'il soit peu fleuri. J'ai planté des bambous et des fougères et j'ai dessiné un escalier que j'ai scandé de genévriers *(Juniperus)* au port étalé, alternés avec des cyprès au port érigé. J'aime cette sobriété. Mais je ne vais pas en rester là. Ma recherche m'entraîne vers une architecture souterraine où je planterai simplement un palmier. Il sera pour moi un repaire mental car je suis capable d'appréhender le végétal comme une abstraction, sans frustration. J'ai dépassé le côté bucolique de la nature. Mes sculptures sont des évocations de celle-ci. Rien ne pousse à l'intérieur de mes pots, mais ils renvoient à une nature colorée, fleurie et généreuse. Les pots rouges me font penser à des coquelicots qui ne fanent pas, les pots dorés sont précieux comme l'or. Dans la nuit, les pots fluorescents deviennent intemporels. Dans le jaune, il y a du vert qui part à la rencontre de la verdure du végétal. J'ai reçu une formation de jardinier, mais je travaille la nature à ma façon. J'ai le sentiment d'accomplir ma vie d'homme et d'artiste à travers cette horticulture qui est très particulière».

Le jardin de Jean-Pierre Raynaud

"I live in the gardener's house, which I have restored. I like to live alongside the ghost of this dilapidated 19th-century 'hôtel particulier'. I have fallen in love with this place, with its fine proportions. The central axis starts at the pond, passes through the transparent living room, dividing the house, the greenhouse and the orangery and continues on into the park and the distance. I have rearranged the garden. I prefer a modicum of flowers. I have planted bamboos and ferns, and designed a staircase where I have alternated low, spreading juniper with upright cypresses. This sobriety is to my taste. But there is more to do. My quest leads me toward an underground architecture, in which I shall plant a solitary palm tree. For me, it will be a kind of mental refuge; I can perceive plantlife as abstract, without any sense of frustration. I have grown out of the bucolic aspect of nature. My sculptures evoke nature; in my pots, nothing grows, but they allude to a vivid, bountiful, blossoming nature. The red pots make me think of poppies that cannot wither. The golden pots are precious as gold. By night, the fluorescent pots have a timeless air. In yellow, there is a nuance of green that seeks out the green of plants. I was trained as a gardener, but I work nature to my own ends. I feel that, through this very individual kind of horticulture, I perfect my life as a man and as an artist."

»Das Gärtnerhaus, das ich bewohne, habe ich selbst restauriert. Ich mag es, direkt gegenüber von diesem Gespenst von einem Gebäude zu leben, das im 19.Jahrhundert einmal ein Herrenhaus war. Dem Charme dieses Ortes bin ich wegen seiner schönen Proportionen verfallen. Die Hauptachse führt durch den Salon; sie beginnt am Wasserbecken, durchquert Wohngebäude, Gewächshaus und Orangerie, bevor sie sich im Park verliert, dessen Grenzen nicht klar bestimmt sind. Den Garten habe ich neu gestaltet. Ich habe es gern, wenn er nicht allzu viele Blütenpflanzen enthält. Ich habe Bambus und Farn gepflanzt, eine Treppe entworfen und sie abwechselnd mit Kriechwacholder *(Juniperus)* und aufrechten Zypressen bepflanzt. Ich liebe die Schlichtheit. Aber ich habe noch mehr im Sinn. Mich reizt der Gedanke an ein unterirdisches Gebäude, in das ich nur eine einzige Palme setzen werde. Das soll mein geistiger Ruhepunkt werden, denn ich bin in der Lage, Pflanzen ohne jede Enttäuschung als Abstraktion zu erleben. Die bukolische Seite der Natur habe ich überwunden. Meine Skulpturen drücken genau das aus. In meinen Töpfen wächst nichts, aber sie verweisen dennoch auf eine bunte, blühende, üppige Natur. Die roten Töpfe erinnern mich an Klatschmohn, der nie verwelkt. Die vergoldeten Töpfe sind kostbar wie pures Gold. Nachts werden die fluoreszierenden Töpfe zeitlos. Das Gelb enthält einen Hauch von Grün, der an das Grün der Pflanzenwelt anknüpft. Ich bin ausgebildeter Gärtner, aber ich bearbeite die Natur auf meine Art. Ich habe das Gefühl, in diesem eigenwilligen Garten mein Leben als Mensch und als Künstler zur Vollendung zu bringen.«

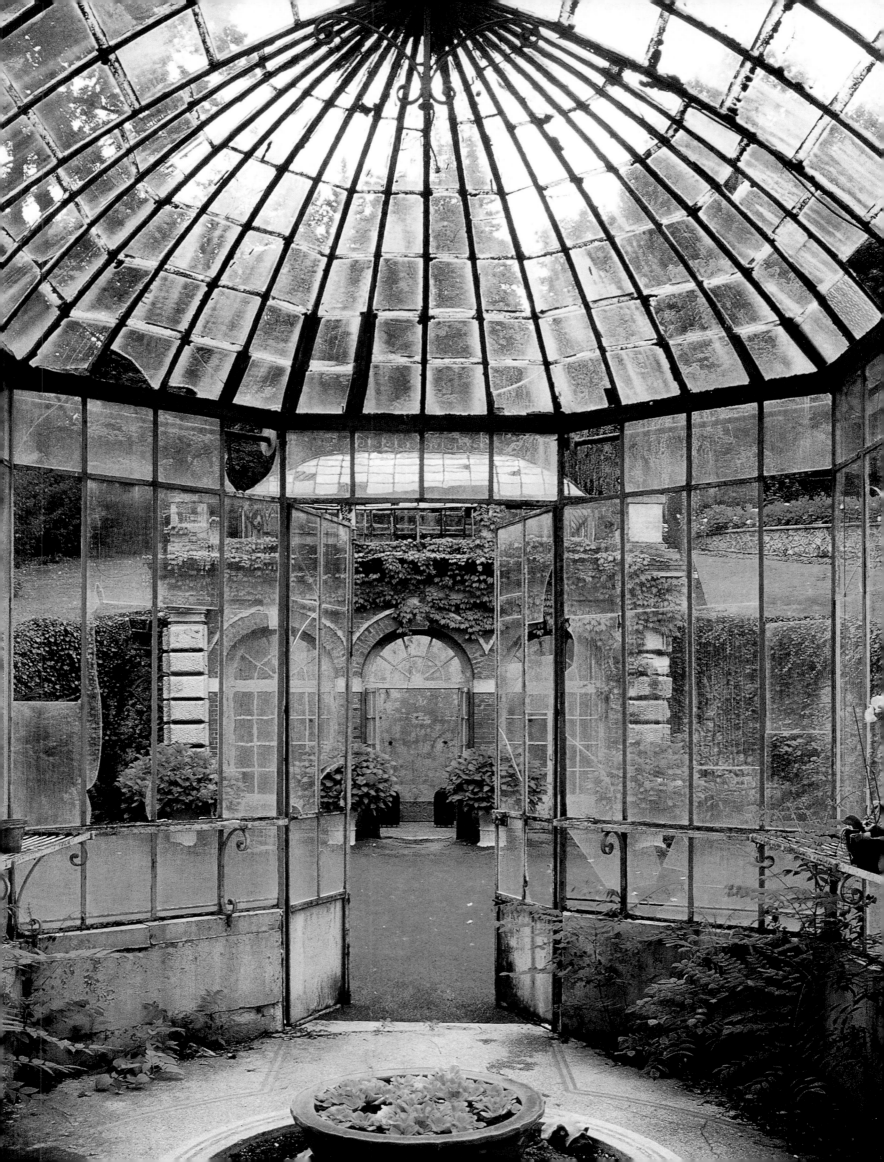

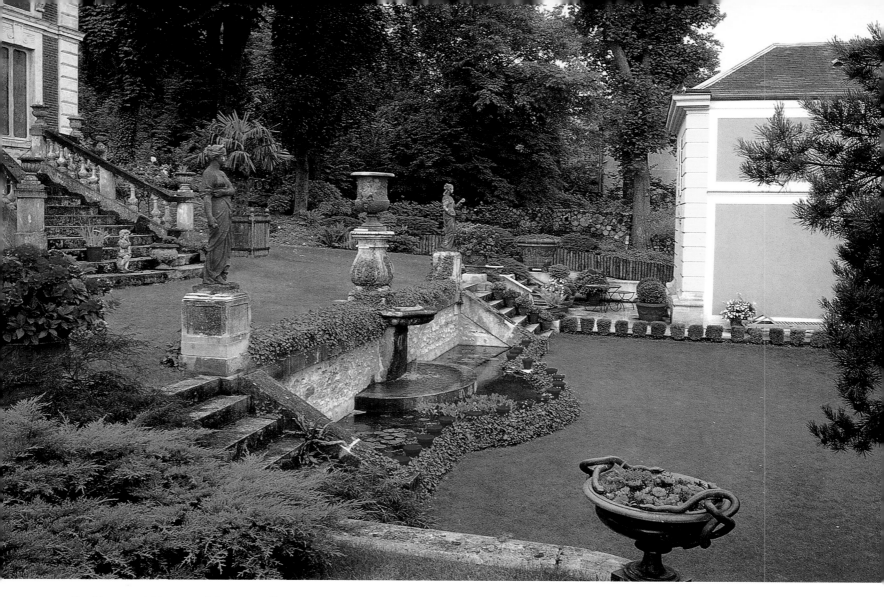

Double page précédente: vue de la serre sur l'orangerie.
Ci-dessus: au centre, le bassin, sa fontaine et une série de pots tels que J.P. Raynaud les réalisait en 1962, expression de la rencontre entre sa nature mentale et la nature réelle. A gauche, l'hôtel particulier. A droite, la maison du jardinier restaurée où habite J.P. Raynaud.

Previous pages: view from the glasshouse to the orangery.
Above: in the centre, the pond and fountain, and a series of pots of the kind that J.P. Raynaud was making in 1962. They are a meeting-place between Nature and temperament. To the left, the "hôtel particulier". To the right, the restored gardener's house, in which J.P. Raynaud lives.

Vorhergehende Doppelseite: Blick aus dem Gewächshaus auf die Orangerie.
Oben: Der Teich mit dem Springbrunnen und einer Reihe von Töpfen, wie sie J.P. Raynaud 1962 herstellte. Hier treffen geistige und reale Natur aufeinander. Links das Palais. Rechts sieht man das restaurierte Gärtnerhaus, das J.P. Raynaud bewohnt.

Le jardin de Jean-Pierre Raynaud *Ile-de-France*

A droite: du haut de l'hôtel particulier du 19e siècle, vue sur l'ancienne serre en verre et sur l'orangerie. A droite, un escalier monte vers le bois et se perd dans le parc.
Ci-dessous: le fameux pot doré de J.P. Raynaud, recouvert de feuilles d'or. Devant, une vasque en bronze posée sur un muret drapé de lierre et entouré de bergénias *(Bergenia cordifolia).*

Right: view from the top of the 19th-century "hôtel particulier" down onto the greenhouse, which still possesses its original glass, and the orangery. To the right, a staircase leads up towards the wood.
Below: J.P. Raynaud's famous gilded pot, covered in gold leaf. In front of it is a bronze bowl perched on a low ivy-draped wall. At its foot grow bergenias *(Bergenia cordifolia).*

Rechts: Blick vom oberen Stockwerk des Palais' aus dem 19. Jahrhundert auf das Gewächshaus mit den alten Glasscheiben und auf die Orangerie. Rechts im Bild führt eine Treppe zum Wald hinauf und verliert sich im Park.
Unten: der berühmte vergoldete Topf von J.P. Raynaud, der mit Blattgold überzogen ist. Davor steht ein Bronzegefäß auf einer efeuüberwucherten Trockenmauer. An ihrem Fuß wachsen Bergenien *(Bergenia cordifolia).*

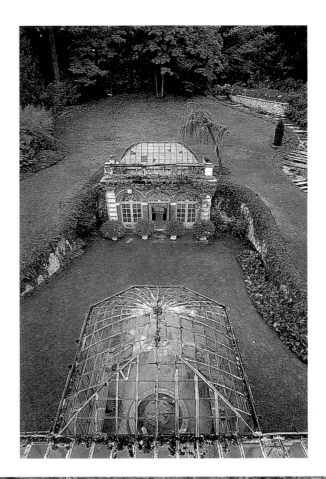

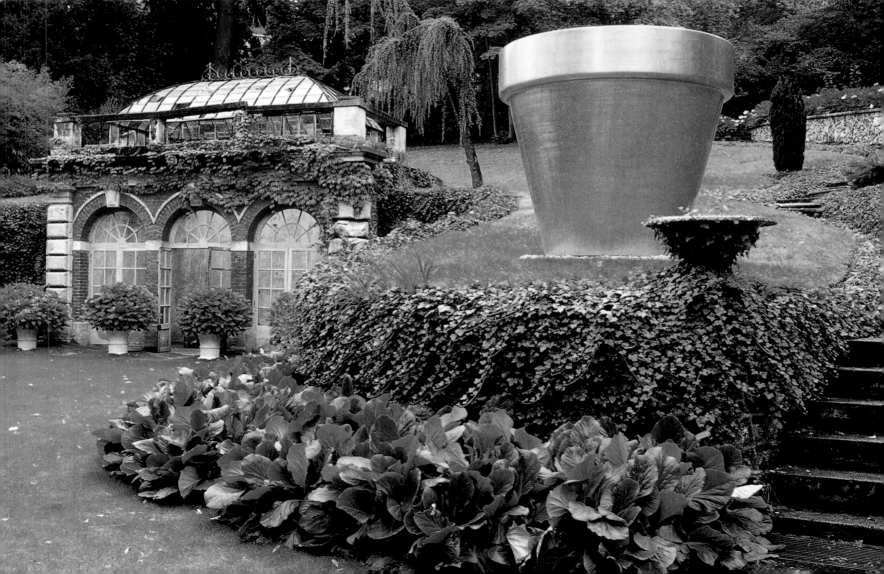

Depuis que le destin de Groussay est entre ses mains, Juan de Beistegui restaure les fabriques et replante le parc. Il a créé un jardin de fleurs près du château qu'il a voulu pastel. Fermé de haies comme une succession de chambres de verdure, il est orné de plantes vivaces et rompt avec l'atmosphère générale de l'endroit où Charles de Beistegui, son oncle, avait essaimé ses souvenirs de voyage. Avec audace, il avait fait édifier des constructions inspirées de l'Angleterre victorienne, des Pays-Bas, de Suède, d'Espagne ou de la France de Louis XVI et il les avaient placées avec talent en jouant avec les futaies et les étangs. Il avait acheté la propriété en 1938 et fait réaliser ses fabriques entre 1958 et 1969. Elles sont toujours là. Les plus fascinantes sont la tente tartare qui rappelle celle du Désert de Retz et fut inspirée de la tente de Gustave III de Suède toujours présente à Drottningholm. Elle est en tôle, peinte de motifs en trompe-l'œil. Le pont palladien évoque celui de Lord Pembroke à Wilton House. La pyramide se reflète dans l'étang. Vue du château la pagode semble être posée sur l'eau, pourtant elle est reliée à la terre ferme par une passerelle. Un obélisque, un temple antique, une colonne surgissent encore au détour des allées dans ce parc vallonné au tracé à l'anglaise. Grandeur nature à ciel ouvert, elles furent préalablement peintes à l'aquarelle en miniature, par Alexandre Serebriakoff.

Groussay

From the moment Groussay became his responsibility, Juan de Beistegui has been restoring the follies and replanting the park. He has created a flower garden in pastel colours near the chateau; enclosed in hedges like a "green room" and planted with perennials, it is at odds with the atmosphere of Groussay, which his uncle Charles de Beistegui scattered with souvenirs of his travels. Audaciously, Charles had decided to build pavilions inspired by Holland, Sweden, Spain, Victorian England and the France of Louis XVI. They are carefully sited among the mature woods and the lakes. He bought the property in 1938 and built the follies between 1958 and 1969. And there they stand today. Among the most fascinating is the Tartar tent, reminiscent of the one at Le Désert de Retz, and inspired by the tent of Gustavus III at Drottningholm. It is made of galvanised steel and painted with "trompe l'œil" motifs. The Palladian bridge was inspired by that of Lord Pembroke at Wilton House. The pyramid is reflected in the waters of a lake. Seen from the chateau, the pagoda seems to float on the lake; in fact, it is connected to dry land by a narrow footbridge. Elsewhere in the walks of the garden, an obelisk, a classical temple and a column rise into view amid the undulating landscape of this English-style garden. Before being realised as life-size buildings, the follies were painted as watercolour miniatures by Alexandre Serebriakoff.

Seit die Geschicke von Groussay in seiner Hand liegen, ist Juan de Beistegui mit der Restaurierung der Gebäude und der Neubepflanzung des Parks beschäftigt. Nahe beim Schloß hat er einen Blumengarten bewußt nur in Pastellfarben angelegt. Er ist von Hecken eingeschlossen und wirkt, als bestünde er aus einer Abfolge mehrerer grüner Kammern. Hier herrscht eine ganz andere Stimmung als auf dem Rest der Anlage, die sein Onkel Charles de Beistegui mit Reiseerinnerungen ausgestattet hat. Er hatte kühn verschiedene Gebäude nach Vorbildern aus dem viktorianischen England, den Niederlanden, Schweden, Spanien und dem Frankreich Ludwigs XVI. errichten lassen und sie geschickt mit Hochwald und Teichen kombiniert. Das Anwesen hatte er 1938 erworben. Die Ziergebäude entstanden zwischen 1958 und 1969 und existieren auch heute noch. Zu den faszinierendsten gehört ein Tartarenzelt, das an dasjenige in Le Désert de Retz erinnert und auf das Zelt des Schwedenkönigs Gustav III. anspielt, das noch heute in Drottningholm steht. Dieses hier besteht aus Blech und ist in Trompe-l'œil-Manier bemalt. Die palladianische Brücke ähnelt der von Lord Pembroke in Wilton House. Weitere Höhepunkte sind die Pyramide, die sich im Teich spiegelt sowie die Pagode, die auf dem Wasser zu treiben scheint, an der Rückseite aber durch einen Steg mit dem festen Land verbunden ist. Durchstreift man den hügeligen englischen Park, entdeckt man außerdem einen Obelisken, einen antiken Tempel und eine Säule. Hier sieht man sie in natürlicher Größe unter freiem Himmel, doch zuvor wurden sie von Alexander Serebriakoff in Miniaturformat aquarelliert.

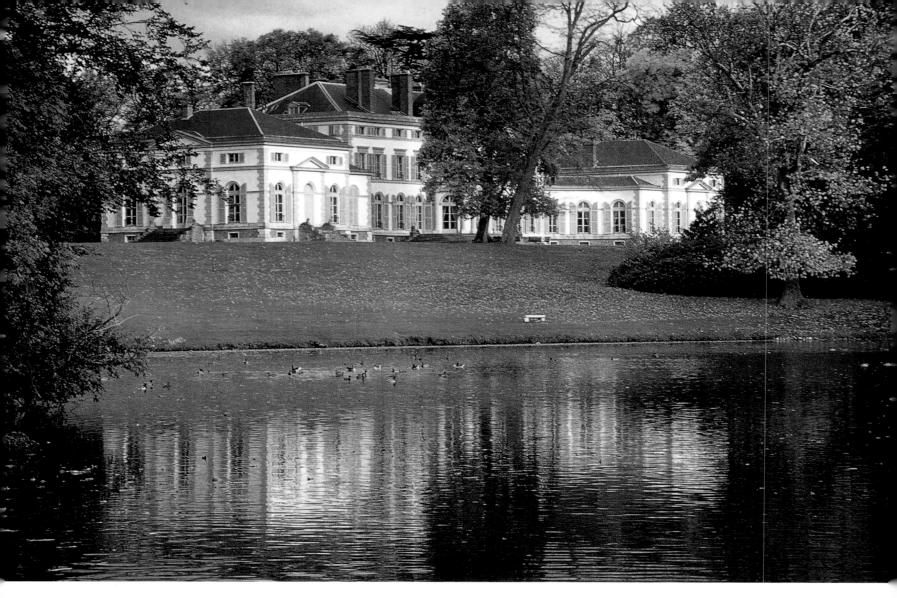

Première page: Le parc fait une trentaine d'hectares. Il est traité à l'anglaise, avec des allées sinueuses, des vallonnements et des étangs.
Ci-dessus: Charles de Beistegui fit ajouter deux ailes au château.
A droite: la pagode octogonale et sa passerelle. Elle semble flotter sur l'eau, vue du château. Son toit est en cuivre, surmonté d'une flèche dorée.

First page: The park occupies some thirty hectares. It is landscaped like an English garden, with sinuous walks, hills and lakes.
Above: Charles de Beistegui added two wings to the chateau.
Right: the pagoda and its footbridge. Seen from the chateau, it seems to float on the water. It is octagonal and has a copper roof, surmounted by a gilt spire.

Eingangsseite: Der Park ist rund dreißig Hektar groß. Er ist mit seinen verschlungenen Wegen, Hügeln, Tälern und Teichen im Stil des englischen Landschaftsgartens angelegt.
Oben: Charles de Beistegui ließ das Schloß um zwei Flügel erweitern.
Rechts: die Pagode mit dem Steg. Vom Schloß aus gesehen scheint sie auf dem Wasser zu treiben. Das Gebäude ist achtseitig und besitzt ein Kupferdach, das von einem vergoldeten Türmchen gekrönt ist.

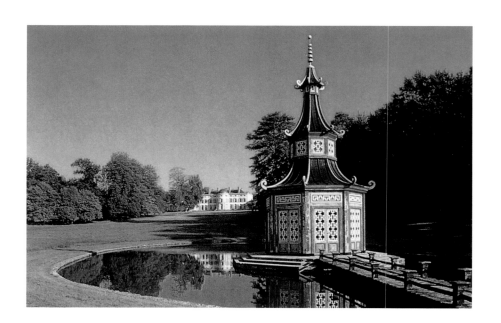

Groussay *Ile-de-France*

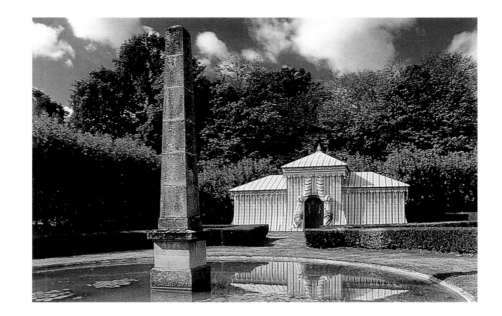

A droite: La tente en tôle est peinte de draperies, glands et lambrequins en trompe-l'œil. Au premier plan: un bassin et au centre: un obélisque.
Ci-dessous: la pyramide se mirant dans l'eau et offrant son image inversée. Un temple lui fait pendant de l'autre côté de l'étang.

Right: The tent of galvanised steel is painted with "trompe l'œil" draperies, tassels and lambrequins. In the foreground, a pond with the obelisk at its centre.
Below: The pyramid stands over its reflected image in the water. On the other side of the lake stands a temple.

Rechts: Das Zelt aus Blech ist in Trompe-l'œil-Manier mit Draperien, Troddeln und Lambrequins bemalt. Davor liegt ein Wasserbecken, in seiner Mitte steht ein Obelisk.
Unten: Die Pyramide spiegelt sich im Wasser. An der gegenüberliegenden Seite des Teiches bildet ein Tempel das Pendant.

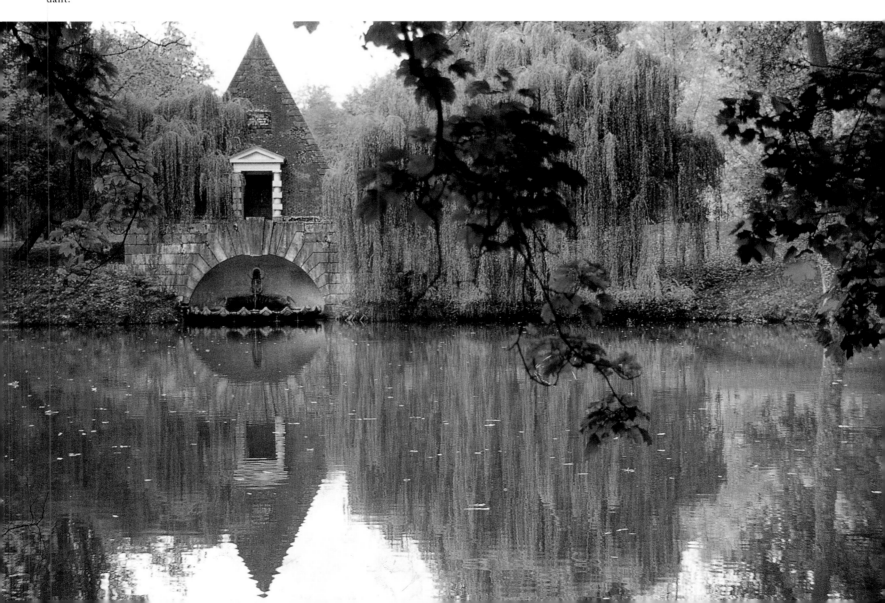

Groussay *Ile-de-France*

Page de gauche: la colonne-belvédère.
Ci-dessus et détails de droite: dans la forêt, un théâtre en plein air orné de statues.

Facing page: the belvedere column.
Above and details rights: In the forest there is an open-air theatre decorated with statues.

Linke Seite: die Aussichtssäule.
Oben und Details rechts: Im Wald steht ein mit Statuen geschmücktes Freilichttheater.

Monsieur de Monville était un galant homme doué d'un bel esprit, fin botaniste, ami des plus grands. Il acheta Retz avant la Révolution, voulut y créer un parc, opta d'abord pour un tracé à la française, puis céda sans doute aux goûts de l'époque et décida d'y composer un jardin anglo-chinois. Quelle promenade y aurait fait Monsieur de Monville? Il serait entré par la porte de la forêt, puis il aurait fait le tour des fabriques: la grotte, le théâtre découvert et la tente tartare, la glacière en forme de pyramide, avec ses emmarchements et sa voûte biaise, le temple du dieu Pan dont l'arrière dépouillé contraste en tout point avec la façade ornée de colonnes pleines de majesté, la maison chinoise construite en teck dont l'intérieur était d'un raffinement extrême, la colonne détruite. Car il faut savoir que Monsieur de Monville habitait une ruine artificielle comme on les aimait aux 18e siècle: pierres volontairement usées, fissure factice de haut en bas, construction délibérément déchiquetée dans sa partie haute. Mais quel contraste avec l'intérieur meublé d'objets précieux! Le parc, quant à lui, était planté d'arbres – pour la plupart des essences rares – groupés en bosquets. Le Désert subit les vicissitudes de l'histoire jusqu'à ce qu'Olivier Choppin de Janvry et Jean-Marc Heftler entreprennent de le sauver. Les perspectives furent remises en état, les arbres soignés et les fabriques restaurées. Aujourd'hui, chacun peut y refaire la promenade de Monsieur de Monville.

Le Désert de Retz

Monsieur de Monville was a gentleman, a wit and an excellent botanist, who moved in the highest circles. He bought Retz before the Revolution, decided to landscape the property, and opted for a "jardin à la française" before changing his mind under the impulse of contemporary fashions and deciding to create an Anglo-Chinese garden. Let us imagine him strolling in his park. He would have entered by the forest gate, then made the rounds of his follies: first, the grotto, the open-air theatre and the Tartar tent; then the pyramid-shaped ice-house, with its symmetrical stairs and skewed arch; the Temple of Pan, whose majestic columnar façade gives through onto a contrasting austerity; the Chinese house, built in teak, with its exquisitely detailed interior; and lastly the Ruined Column. For Monsieur de Monville inhabited an artificial ruin of the kind in vogue in the 18th century: stonework deliberately distressed, artificial cracks from top to bottom, freshly dilapidated work on the upper stories. But what a contrast with the "objets d'art" within. The park itself was planted with trees, mostly rare species gathered in little groves. Le Désert was abandoned to the vicissitudes of time until the 20th century, when Olivier Choppin de Janvry and Jean-Marc Heftler set about saving it. The vistas were restored, the trees attended to and the follies repaired. Today, it is again possible to follow in the footsteps of Monsieur de Monville's stroll through the park.

Monsieur de Monville war nicht nur ein geistvoller Edelmann und in den vornehmsten Kreisen zu Hause, sondern zudem ein ausgezeichneter Botaniker. Er erwarb Retz noch vor der Revolution in der Absicht, dort einen Park anzulegen. Nachdem er zunächst an einen Barockgarten gedacht hatte, entschied er sich dann letztlich für einen englisch-chinesischen Landschaftspark. Welchen Weg durch seinen Park hätte Monsieur de Monville eingeschlagen? Er wäre vom Wald her durch die Pforte eingetreten und an den Ziergebäuden vorbeigeschlendert: vorbei an der Grotte, dem Freilichttheater und dem Tartarenzelt, dem Eiskeller in Form einer Pyramide, verziert mit einem Treppenaufgang und einem schrägen Gewölbe. Auch an dem Pan-Tempel wäre er vorbeispaziert, dessen nüchterne Rückansicht einen scharfen Kontrast zur säulengeschmückten, majestätischen Front bildet, an dem chinesischen Haus aus Teakholz, und schließlich an der verfallenen Säule. Monsieur de Monville bewohnte nämlich eine künstliche Ruine, was im 18. Jahrhundert sehr beliebt war. Sie wurde aus abgenutzten Steinen errichtet, und man ließ von oben bis unten tiefe Risse durch das Mauerwerk verlaufen. Welchen Gegensatz bilden hierzu die Innenräume mit ihrem kostbarstem Mobiliar und Zierrat! Im Park selbst pflanzte man Bäume – meist seltene Arten – zu Bosketts. Retz hatte eine wechselvolle Geschichte, bis Olivier Choppin de Janvry und Jean-Marc Heftler zu seiner Rettung antraten. Sie stellten die Blickachsen wieder her, kümmerten sich um den Baumbestand und setzten die Bauten instand. Heute kann wieder jeder Besucher auf den Spuren des Monsieur de Monville durch den Park schlendern.

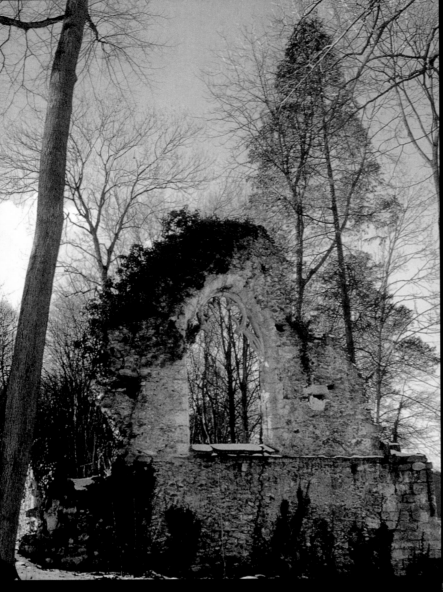

Détail de gauche: l'église gothique ruinée.

Detail left: the (authentic) ruined Gothic church.

Detail links: die Überreste der gotischen Kirche.

Première page: le temple du dieu Pan.

First page: the Temple of Pan.

Eingangsseite: der Pan-Tempel.

Détail de droite: à l'arrière du temple du dieu Pan, une entrée du parc.

Detail right: behind the Temple of Pan, one of the entrances to the park.

Detail rechts: einer der Eingänge zum Park an der Rückseite des Pan-Tempels.

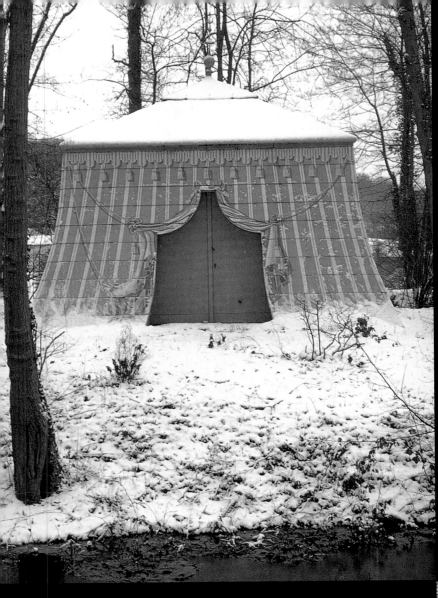

Détail de gauche: La tente tartare évoque des contrées lointaines.

Detail left: The Tartar tent evokes faraway places.

Detail links: Das Tartarenzelt erinnert an ferne Länder.

Détail de droite: la glacière en forme de pyramide.

Detail right: the pyramid-shaped ice-house.

Detail rechts: der Eiskeller in Form einer Pyramide.

Double page précédente: la colonne détruite.

Previous pages: the Ruined Column.

Vorangehende Doppelseite: die verfallene Säule.

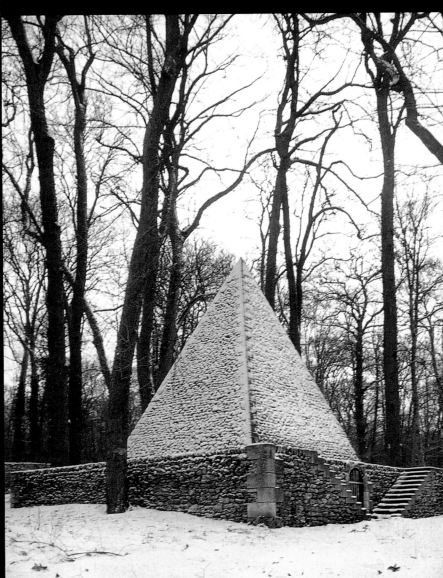

Normandie

Les peintres l'ont aimée pour sa lumière. Les jardiniers l'ont choisie pour sa terre. Cette contrée est riche en jardins. Son climat s'y prête : humide et frais, plutôt doux, il autorise la culture d'une belle gamme de plantes. Le vent du renouveau des jardins des vingt dernières années a probablement soufflé d'Angleterre, faisant une halte heureuse en Normandie. D'éminents jardiniers et jardinières ont émaillé cette province de créations nouvelles qui illustrent leur amour des plantes, des fleurs et des couleurs.

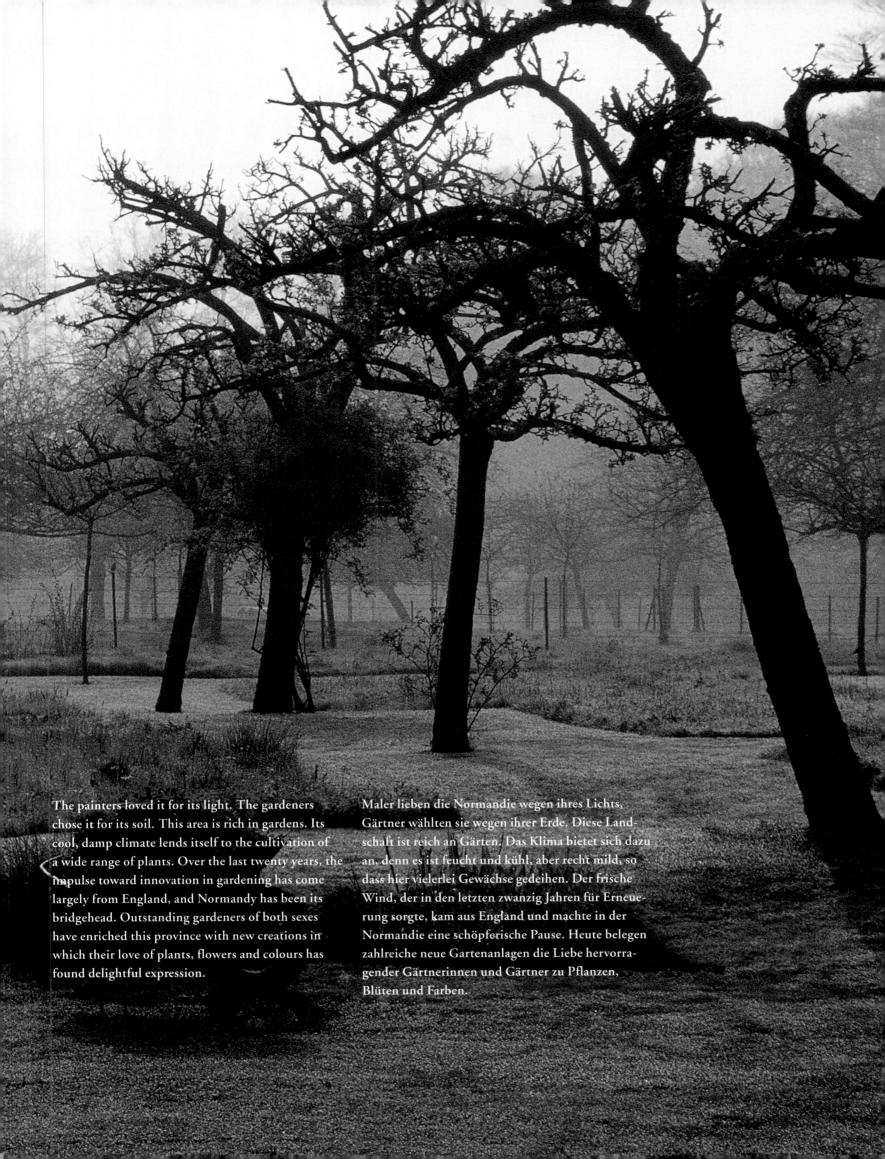

The painters loved it for its light. The gardeners chose it for its soil. This area is rich in gardens. Its cool, damp climate lends itself to the cultivation of a wide range of plants. Over the last twenty years, the impulse toward innovation in gardening has come largely from England, and Normandy has been its bridgehead. Outstanding gardeners of both sexes have enriched this province with new creations in which their love of plants, flowers and colours has found delightful expression.

Maler lieben die Normandie wegen ihres Lichts, Gärtner wählten sie wegen ihrer Erde. Diese Landschaft ist reich an Gärten. Das Klima bietet sich dazu an, denn es ist feucht und kühl, aber recht mild, so dass hier vielerlei Gewächse gedeihen. Der frische Wind, der in den letzten zwanzig Jahren für Erneuerung sorgte, kam aus England und machte in der Normandie eine schöpferische Pause. Heute belegen zahlreiche neue Gartenanlagen die Liebe hervorragender Gärtnerinnen und Gärtner zu Pflanzen, Blüten und Farben.

Tous les jardiniers sont peintres, mais seuls quelques peintres sont jardiniers. Claude Monet, lui, conjuga tous les talents. Il savait construire, planter, jouer avec la lumière. C'est ainsi qu'il créa à Giverny, à partir de 1883, un jardin en deux parties. Celles-ci sont distinctes et s'opposent. L'une, baptisée le «Clos normand», sert de présentoir à la maison. C'est un jardin de curé fleuri et structuré, dont les axes majeurs et mineurs se coupent à angles droits. Les massifs y sont aménagés comme dans un potager et les arbustes scandent les bordures comme dans un verger. Quels sont les grands moments du Clos normand? A la fin du mois de mai, quand les iris bordent les allées ou à la fin de l'été: «C'est un extraordinaire mélange de couleurs, une lutte de teintes pâles, une profusion resplendissante et musicale de blancs, de roses, de jaunes et de mauves, un incroyable roulement de tons de chair blonds, des fanfares rutilantes de cuivre, des rouges saignants et enflammés; des violets s'ébattent, des pourpres noirs sont léchés par les flammes» (Octave Mirbeau, «L'Art dans les deux mondes»), notamment quand les capucines s'enchevêtrent au milieu de la grande allée. L'autre partie forme un jardin libre. C'est le jardin d'eau, avec son étang où flottent les nymphéas inspirateurs des fameux tableaux, avec son pont japonais où court une glycine, ses arceaux fleuris recouverts de rosiers et ses berges festonnées de plantes semi-aquatiques, ses reflets, son eau calme et étale où se joue la lumière dans des variations infinies.

Les jardins de Claude Monet à Giverny

All gardeners are painters, but few painters are gardeners. Claude Monet brought to gardening all the talents required: he was a builder, a plantsman and a master of the play of light. He loved flowers and colours and took pleasure in their combination. At Giverny, he created a garden in two parts, beginning in 1883. The two parts are quite distinct. The first, called "Clos normand", acts as a frame for the house. It is a small mixed garden, whose major and minor axes intersect at right angles; the beds are set out as in a kitchen garden and the shrubs are placed at regular intervals along the walls, as in an orchard. The high points of the year are May, when the garden paths are bordered with irises, and late summer, particularly when the nasturtiums overflow into the main path. Then the garden is "an extraordinary mixture of colours, a fierce contest of pale shades, a resplendent and musical profusion of whites, pinks, yellows and mauves, an incredible alternation of pale flesh tones, lambent brass fanfares and sanguinolent and fiery reds; violets disport and purple-blacks are submerged in the flames"(Octave Mirbeau, "L'Art dans les deux mondes"). The second part is the water garden. It centres around the lily pond that inspired Monet's famous "Nymphéas" and the Japanese bridge draped with wisteria; over its paths are arches covered in roses and along the banks of the pond are planted a profusion of semi-aquatic plants. On the calm surface of the lily pond, all this is reflected amid the ceaselessly changing effects of light.

Alle Gärtner sind zugleich Maler, doch nur wenige Maler sind auch Gärtner. Claude Monet vereinigte alle Talente der Gartenbaukunst in sich. Er verstand es zu bauen, zu pflanzen, mit Licht zu spielen. Er liebte Blumen und Farben und kombinierte sie mit großem Vergnügen. In Giverny schuf er ab 1883 einen aus zwei völlig gegensätzlichen Teilen bestehenden Park. Der eine Teil, »Clos normand« genannt, ist ein am Haus gelegener Ziergarten. Er wirkt wie ein Pfarrgarten, ist reich bepflanzt und trotzdem streng strukturiert mit Haupt- und Nebenachsen. Die Beete sind wie in einem Gemüsegarten unterteilt, und Sträucher säumen ihre Ränder wie in einem Obstgarten. Zu welchen Zeiten ist der »Clos normand« besonders reizvoll? Ende Mai, wenn die Schwertlilien am Wegesrand blühen, und im Spätsommer, wenn die Kapuzinerkresse den Hauptweg regelrecht belagert: »Die Farbenpracht ist außerordentlich, ein Wettkampf heller Schattierungen, eine strahlende, musikalische Fülle von Weiß-, Rosa-, Gelb- und Malventönen, ein unglaubliches Dröhnen heller Fleischfarbe, leuchtende Fanfaren von Kupfer-, Blut- und Flammenrot; man sieht jauchzendes Lila und schwärzliches, rot geflammtes Purpur« (Octave Mirbeau, »L'Art dans les deux mondes«). Den zweiten Teil bildet der Landschaftsgarten, in dem sich alles um das Element Wasser dreht. Der Teich mit den Seerosen diente als Inspiration für die berühmten »Nymphéas«. Die japanische Brücke wird von einer Glyzine überspannt. Am Ufer stehen rosenüberrankte Bögen, während die Böschung mit Uferpflanzen besetzt ist, die sich im Wasser spiegeln. Dort spielt das Licht auf der stillen Oberfläche in unendlichen Variationen.

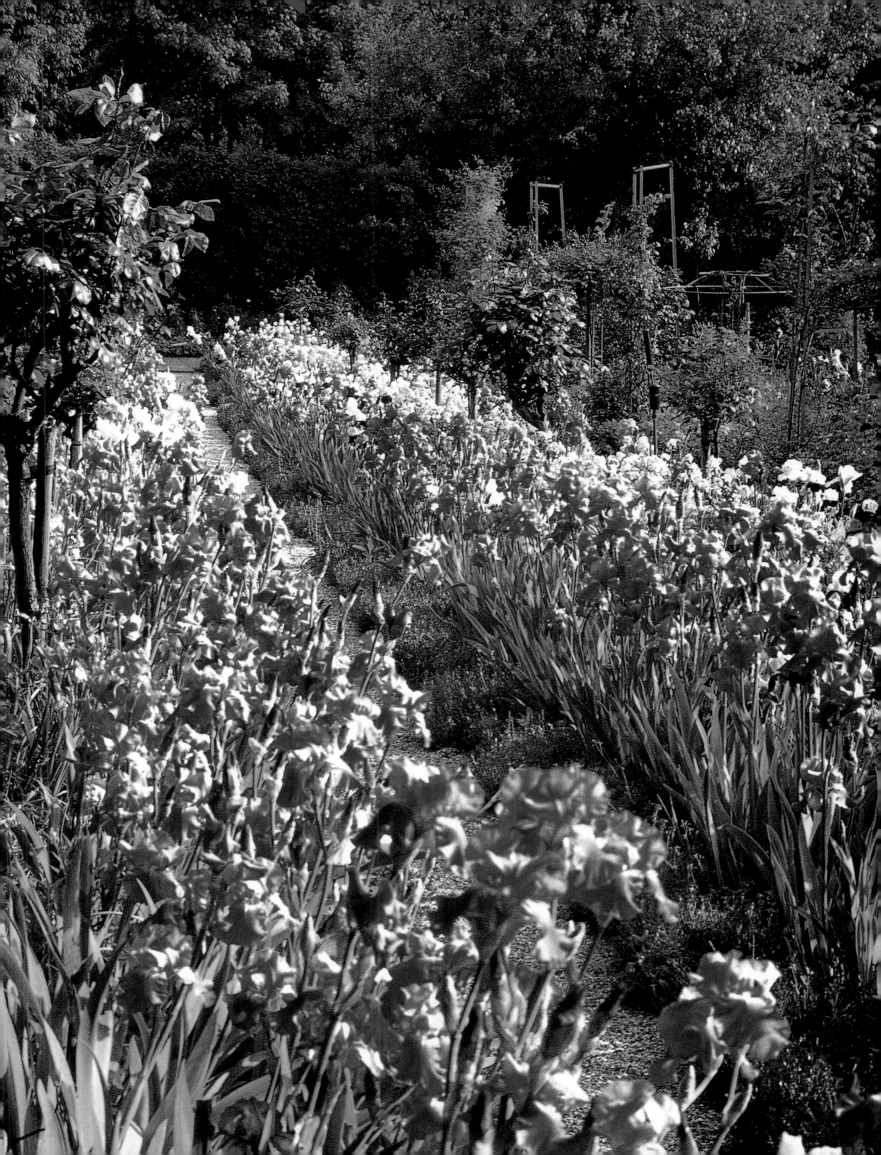

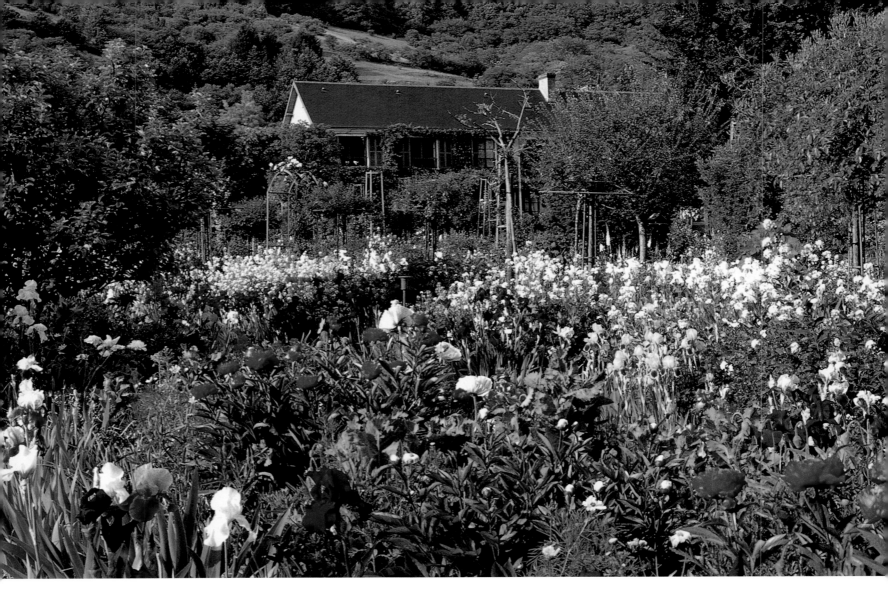

Page précédente: Il faut voir Giverny fin mai quand les iris des jardins *(Iris germanica)* sont en fleurs. A cette saison, leur présence bleue, blanche, mauve, violette ou améthyste embellit encore davantage le Clos normand.
Ci-dessus: Les massifs du Clos normand sont structurés par des allées rectilignes. Ils sont composés d'un mélange de pivoines *(Paeonia)*, d'iris, de monnaies-du-pape *(Lunaria annua)* et de juliennes-des-dames *(Hesperis matronalis)*.
A droite: tulipes et myosotis.

Previous page: Giverny must be visited in late May when the German flag iris *(Iris germanica)* is in flower; then the Clos normand is awash with their blue, white, mauve, violet and amethyst flags.
Above: The beds of the Clos normand are laid out along rectilinear garden paths. They are a mix of peonies *(Paeonia)*, iris, honesty *(Lunaria annua)*, and dame's violet *(Hesperis matronalis)*.
Right: tulips and forget-me-nots *(Myosotis)*.

Vorhergehende Seite: Giverny muß man Ende Mai sehen, wenn die Schwertlilien *(Iris germanica)* in voller Blüte stehen. Zu dieser Jahreszeit wird der Clos normand durch die blauen, weißen, zartlila, violetten und amethystfarbenen Blüten noch reizvoller.
Oben: Die Beete im Clos normand sind durch schnurgerade Wege unterteilt. In ihnen blühen Pfingstrosen *(Paeonia)*, Schwertlilien, Silberlinge *(Lunaria annua)* und Nachtviolen *(Hesperis matronalis)*.
Rechts: Tulpen und Vergißmeinnicht *(Myosotis)*.

Les jardins de Claude Monet à Giverny *Normandie*

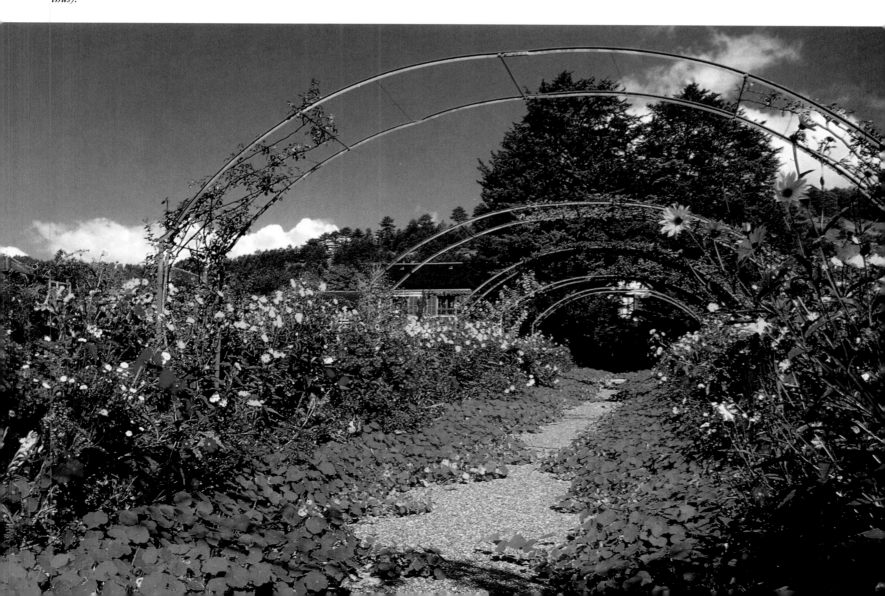

A droite: Le Clos normand jouxte la maison – ici un parterre printanier.
Ci-dessous: scène d'automne dans l'allée principale, avec des tapis de capucines *(Tropaeolum majus)* surmontés de plates-bandes où se mêlent des asters et des soleils *(Helianthus).*

Right: The Clos normand is situated right next to the house – this is a spring border.
Below: autumn in the main path, with the spreading mat of nasturtiums *(Tropaeolum majus)* under beds in which asters and sunflowers *(Helianthus)* jostle for place.

Rechts: Direkt am Haus erstreckt sich der Clos normand – hier ein Frühlingsbeet.
Unten: herbstliche Szene auf dem Hauptweg mit einem Teppich aus Kapuzinerkresse *(Tropaeolum majus).* In den darüber liegenden Beeten stehen Astern und Sonnenblumen *(Helianthus).*

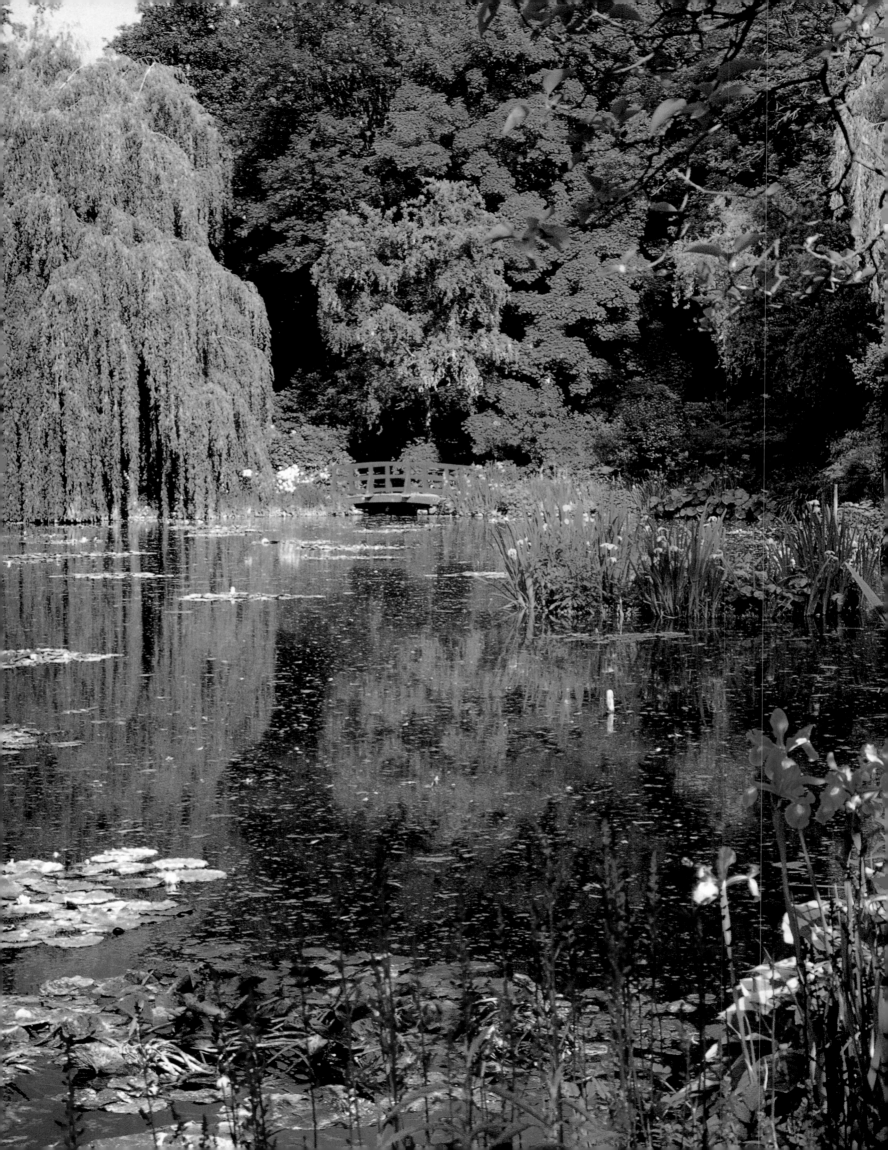

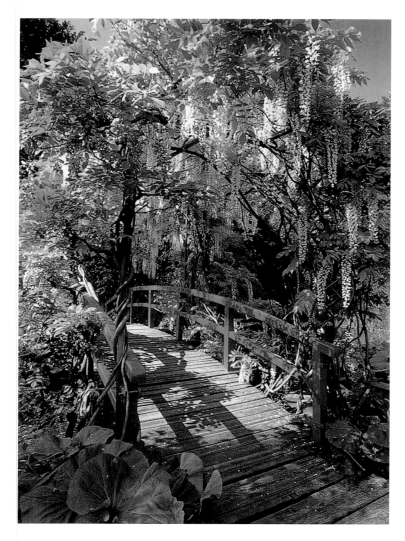

Page de gauche: le jardin d'eau aux berges agrémentées de plantes semi-aquatiques comme des iris des marais *(Iris pseudacorus)* et des salicaires *(Lythrum salicaria).*

Ci-dessus: Le pont japonais est drapé de plusieurs glycines à fleurs blanches *(Wisteria floribunda* 'Alba') ou de glycines à grappes mauves. Les branches d'un saule pleureur plongent dans l'eau.

Double page suivante: le jardin d'eau dans toute sa splendeur, avec ses jeux d'ombre, de lumière et ses miroitements, sources d'inspiration infinie pour Monet.

Facing page: the water garden, whose banks are planted with semi-aquatic plants like yellow flags *(Iris pseudacorus)* and purple loosestrife *(Lythrum salicaria).*

Above: The Japanese bridge is draped with wisterias with white flowers *(Wisteria floribunda* 'Alba') and wisterias with purple flowers. The branches of a weeping willow trail in the water.

Following pages: The water garden in all its splendour, with its play of shadow, light and reflections, was an inexhaustible source of inspiration for Monet.

Linke Seite: der Wassergarten. An den Böschungen des Teiches wuchern Uferpflanzen wie Sumpfiris *(Iris pseudacorus)* und Blutweiderich *(Lythrum salicaria).*

Oben: Die japanische Brücke wird von mehreren Glyzinen mit weißen Blüten *(Wisteria floribunda* 'Alba') und Glyzinen mit malvenfarbenen Blütentrauben überspannt. Die Zweige einer Trauerweide hängen bis ins Wasser hinab.

Folgende Doppelseite: der Wassergarten in seiner ganzen Pracht, mit den Spiegelungen, dem Spiel von Licht und Schatten, von denen Monet sich immer wieder inspirieren ließ.

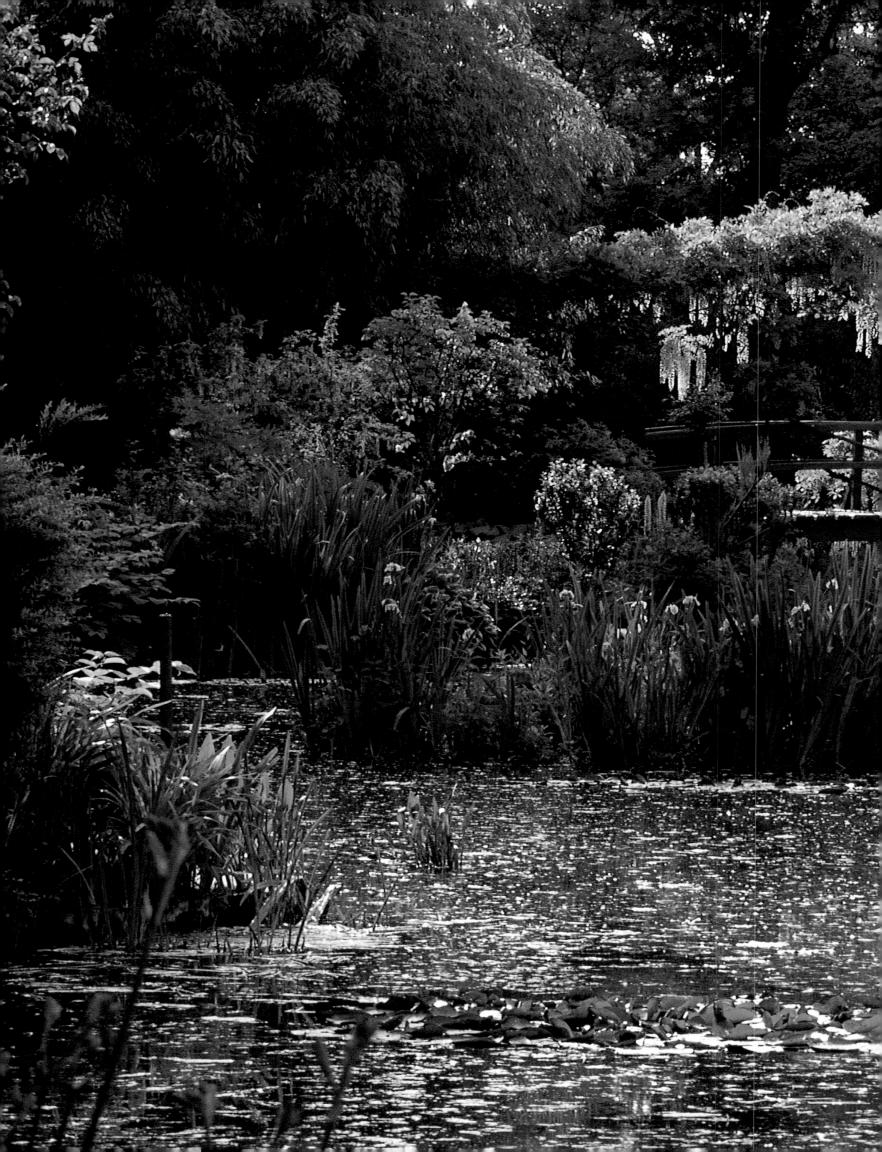

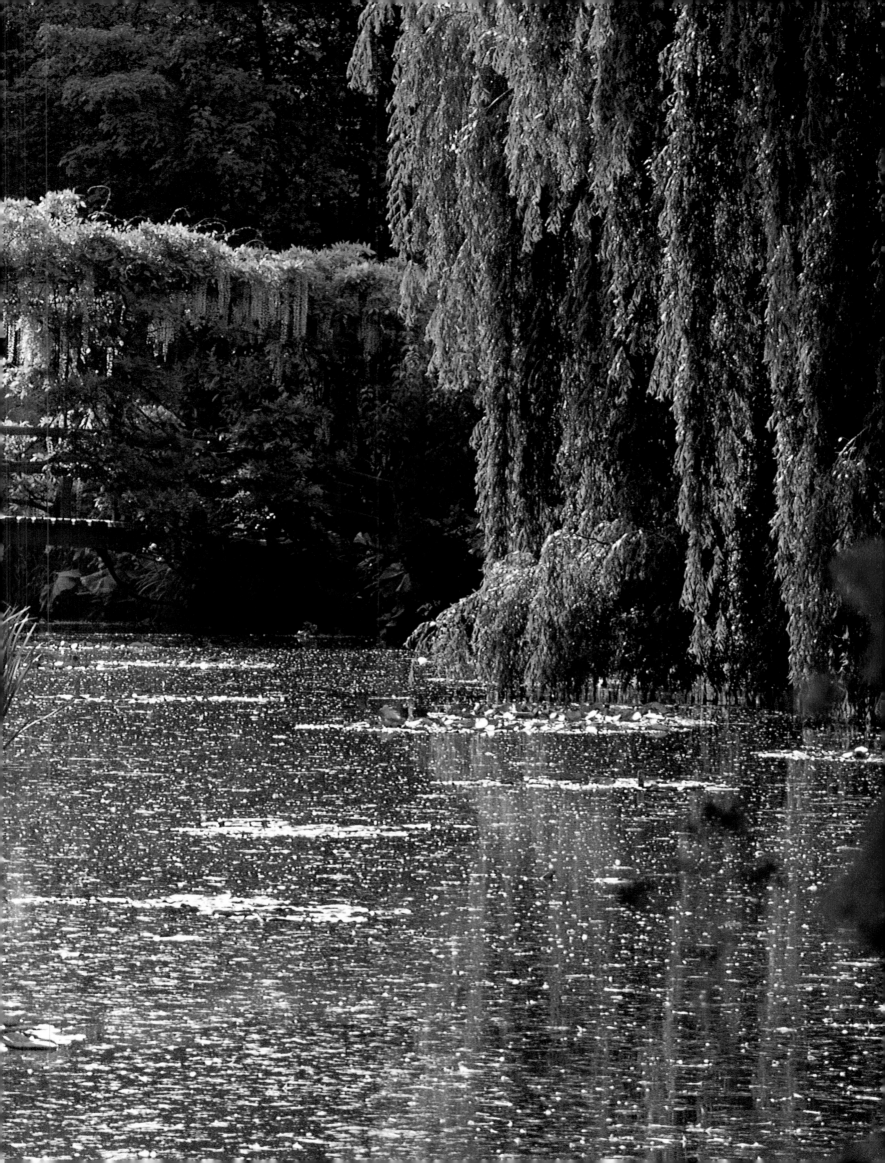

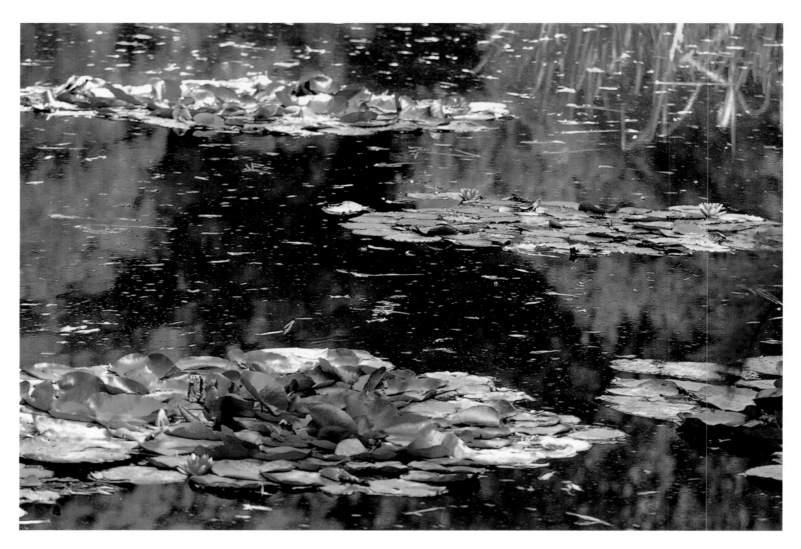

Ci-dessus, à droite et page de droite: A la surface de l'étang flottent toutes sortes de nymphéas à fleurs blanches ou roses qui ont fasciné Monet. Il écrira «ces paysages d'eau et de reflets sont devenus une obsession». On leur doit la superbe série des «Nymphéas» et leurs innombrables variations.

Above, right and facing page: On the surface of the lake float all kinds of red- and white-flowered water lilies. Monet wrote: "These landscapes of water and reflections have begun to obsess me." The result was his incomparable series of "Nymphéas" and their countless variations.

Oben, rechts und rechte Seite: Auf der Oberfläche des Teichs entfalten verschiedenste Sorten von Seerosen ihre weißen oder rosa Blütenkelche, die Monet so faszinierten. Er schrieb: »Diese Wasserlandschaften mit ihren Reflexen sind Obsession geworden.« Dieser Faszination verdanken wir die brillanten »Nymphéas« in ihren zahllosen Variationen.

Les jardins de Claude Monet à Giverny *Normandie*

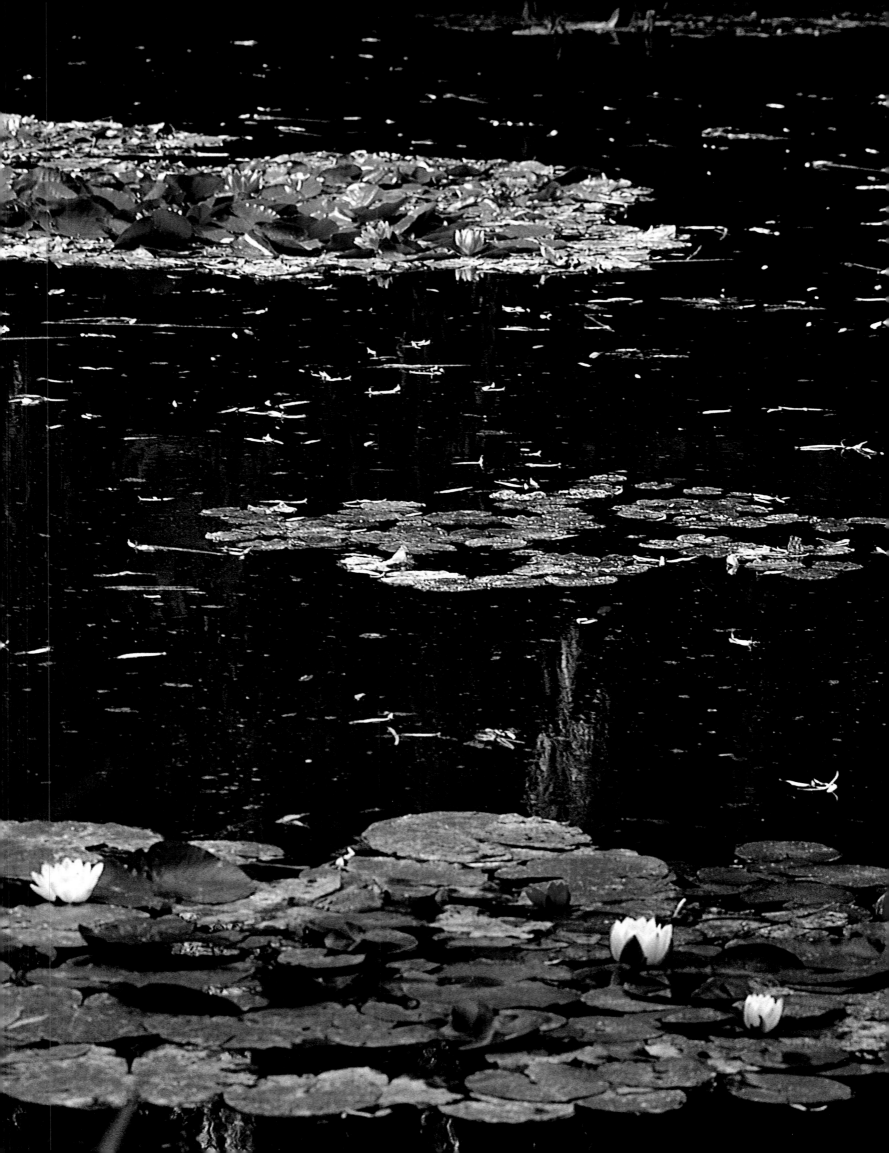

Célèbre entre tous car il lança le style des potagers fleuris et l'érigea en art, ce potager d'autrefois, clos de murs de briques roses, jouxte le château du 17e siècle. Il mélange fleurs, fruits, légumes, petits fruits, herbes aromatiques et il est également réputé pour ses collections de clématites et de rosiers. Le comte et la comtesse de Vogüé firent l'acquisition des lieux en 1938. Simone de Vogüé entreprit de replanter le potager pour nourrir ses enfants et sa famille. Elle mélangea d'emblée fleurs et légumes car elle aimait aussi les bouquets. Puis elle l'ouvrit à la visite dans les années cinquante. Ce fut un succès et un encouragement. Aussi perfectionna-t-elle son œuvre par un travail perpétuel de recherches des meilleures graines et des plus belles associations. En 1995, son fils Thierry de Vogüé prit la relève, enrichissant sans cesse les collections avec la même passion. Palissés contre les murs, les clématites et les rosiers se mêlent aux arbres fruitiers. A l'intérieur, les plantations de légumes alignées en planches s'organisent en quatre carrés. Deux allées fleuries croisent leurs chemins engazonnés. L'une est vouée aux delphiniums, l'autre mélange toutes les couleurs en utilisant des bulbes, des plantes annuelles ou vivaces. C'est l'exubérance. Il en ressort une impression de gaieté, de simplicité et de générosité, avec beaucoup de charme à la clef.

Miromesnil

One of the most famous of all gardens, for here the art of the "potager fleuri" – a decorative kitchen garden interspersed with flowers – was invented and brought to perfection. Brick walls enclose the garden, at the centre of which stands the 17th-century chateau. The garden mixes flowers with fruit, vegetables, soft fruit, aromatic herbs and is famous, too, for its clematis and rose collections. The Comte and Comtesse de Vogüé acquired the estate in 1938. Simone de Vogüé set about replanting the kitchen garden for a very practical reason: to provide food for her husband and family. From the very first she mixed flowers and vegetables out of a simple love of flowers. She opened the gardens to the public in the fifties. The success of this experiment encouraged her to perfect her art and renew her efforts to discover still better seeds and more refined juxtapositions of plants. In 1995, her son Thierry de Vogüé took over the garden, and continued to enrich the collection with similarly scrupulous attention. Clematis and roses are mixed with the fruit trees palisaded along the garden walls. Within this frame, the vegetables are laid out in four square beds of long, narrow rows. Two grassed garden paths bordered by flowers intersect at the centre, one of them lined with delphiniums, the other a riot of colour from bulbs, annuals and perennials. The effect is one of joyous simplicity and generosity.

Dieser Garten ist berühmt, weil er den Stil des kombinierten Blumen- und Gemüsegartens begründete und zur Kunst erhob. Der von hellroten Backsteinmauern umschlossene ehemalige Gemüsegarten grenzt an ein Schloß aus dem 17. Jahrhundert. Man findet hier Blumen, Obst, Gemüse, Beerenobst und Kräuter nebeneinander. Auch die verschiedenen Clematis und Rosen sind weithin bekannt. Graf und Gräfin de Vogüé erwarben das Anwesen 1938. Simone de Vogüé ließ den Gemüsegarten neu bepflanzen, um Kinder und Familie damit zu ernähren. Von Anfang an mischte sie Blütenpflanzen zwischen die Gemüse, weil sie auch Freude an Blumensträußen hatte. In den fünfziger Jahren gab sie den Garten dann zur Besichtigung frei. Der Erfolg ermutigte sie. Sie perfektionierte ihr Werk, stets auf der Suche nach noch besserem Saatgut und noch schöneren Pflanzenkombinationen. Seit 1995 setzt ihr Sohn Thierry de Vogüé ihr Werk fort. Auch er bemüht sich eifrig darum, die Sammlungen zu erweitern. An Mauern ranken Clematis und Rosen zwischen Spalierbäumen. Im Inneren des Gartens sind die Gemüsekulturen auf vier langgestreckte Beete verteilt. Dort kreuzen sich zwei grasbewachsene, mit Blumenrabatten gesäumte Wege. Der eine ist dem Rittersporn vorbehalten, im anderen mischen sich die Farben von Zwiebelgewächsen, einjährigen Pflanzen und Stauden: eine einzige Pracht, die Fröhlichkeit, Schlichtheit, Großzügigkeit und vor allem viel Charme ausstrahlt.

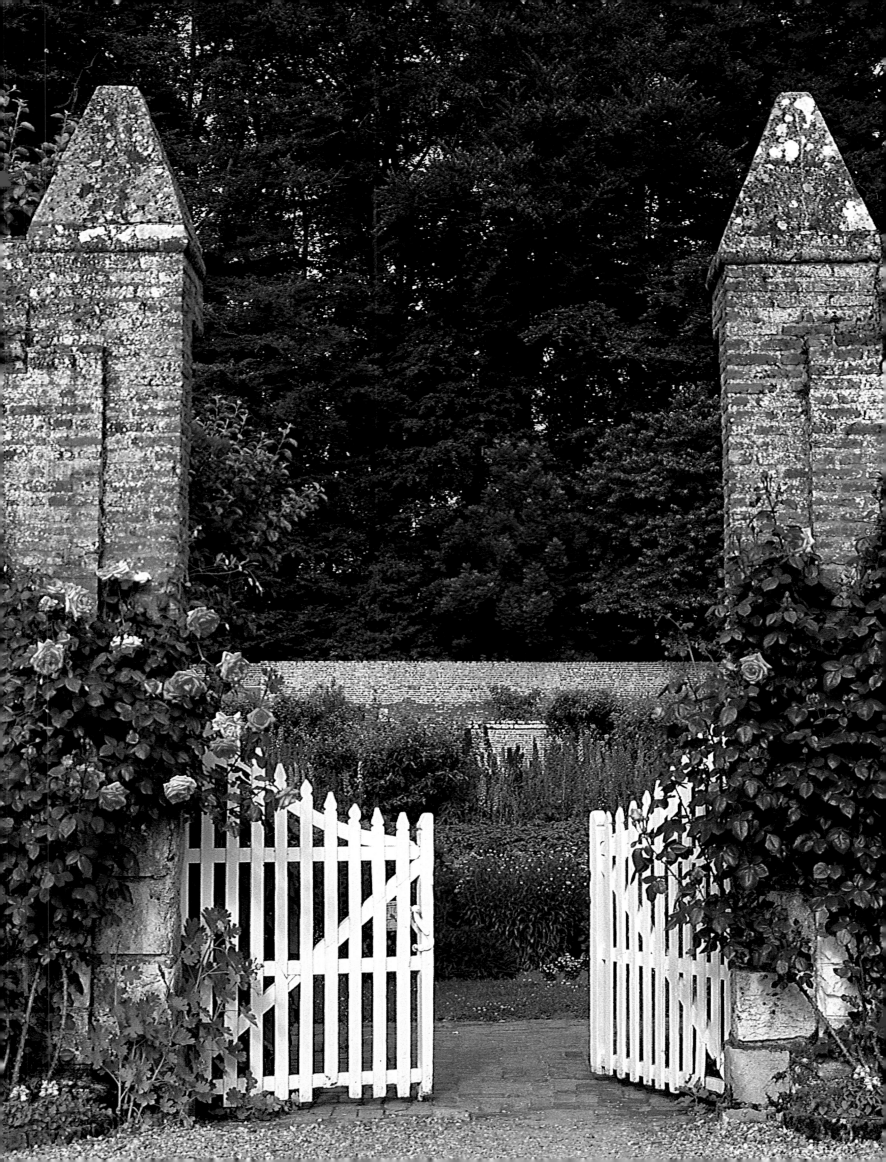

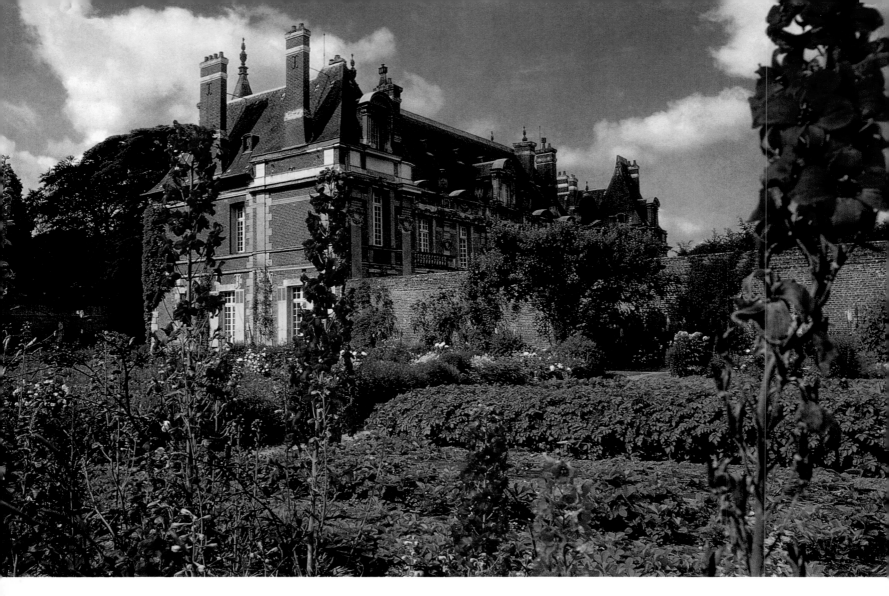

Page précédente: L'entrée du potager est encadrée de rosiers 'Campanile'. Les piliers de briques roses et le portail de bois blanc sont typiquement normands.

Ci-dessus: Le château du 17e siècle, avec ses façades de briques roses surmontées de toits d'ardoise, jouxte le potager entouré de murs. Au premier plan, l'allée de delphiniums.

A droite: Les rosiers grimpants montent à l'assaut des murs de brique rose.

Previous page: The gateway to the kitchen garden is awash with *Rosa* 'Campanile'. The pale pink brick and white wooden gates are typically Norman.

Above: The 17th-century chateau, with its pink brick façade and slate roof, stands next to the kitchen garden. In the foreground, the delphinium walk.

Right: Roses are trained against the light red brick walls.

Vorhergehende Seite: Der Eingang zum Gemüsegarten wird von der Rose 'Campanile' eingerahmt. Die aus blaßroten Backsteinen errichteten Pfeiler und das weiße Holztor sind typisch für die Normandie.

Oben: das Schloß aus dem 17. Jahrhundert mit seiner blaß-roten Backsteinfassade und dem Schieferdach. Unmittelbar daneben befindet sich der von Mauern umgebene Gemüse-garten. Im Vordergrund der mit Rittersporn *(Delphinium)* gesäumte Gartenweg.

Rechts: An den hellroten Backsteinmauern ranken Rosen.

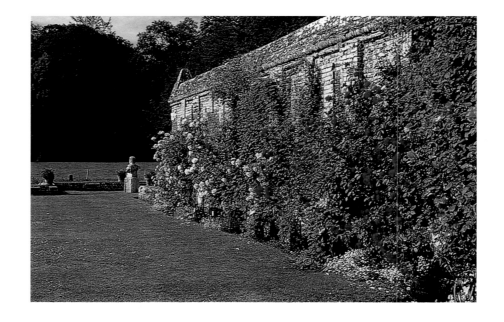

Miromesnil *Normandie*

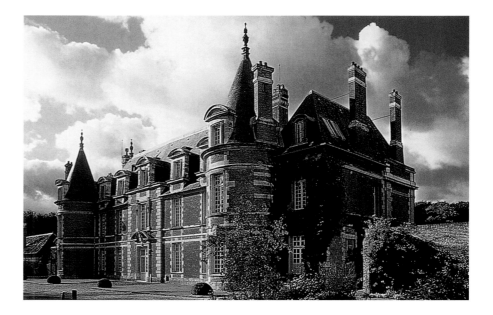

A droite: Le château où naquit l'écrivain Guy de Maupassant (1850–1893).

Ci-dessous: Les légumes sont alignés en planches comme dans tout potager traditionnel. Au centre, une belle variété de choux comestibles et décoratifs aux feuilles bleu-vert veinées de rose accompagnent poireaux, épinards et choux de Bruxelles. Ils se mettent mutuellement en valeur grâce aux contrastes de leurs formes et de leurs couleurs.

Double page suivante: vue d'ensemble du potager avec les carrés de légumes, les deux «mixed-borders» et l'allée des delphiniums.

Right: the chateau. Here the writer Guy de Maupassant (1850–1893) was born.

Below: The vegetables are set out in long, narrow rows in the traditional fashion. In the centre, a handsome variety of edible and ornamental cabbage, its blue-green leaves veined with pink, is seen amid leeks, spinach and Brussels spouts. The overall effect is enhanced by the contrasting forms and colours.

Following pages: overall view of the kitchen garden. The square vegetable beds, the two mixed borders and the delphinium walk.

Oben: In dem Schloß wurde der Schriftsteller Guy de Maupassant (1850–1893) geboren.

Unten: Die Gemüse werden auf langgestreckten Beeten gezogen, wie es früher üblich war. In der Mitte ein ansehnlicher eßbarer Zierkohl mit blaugrünen, rosa geäderten Blättern neben Lauch, Spinat und Rosenkohl. Durch die kontrastierenden Formen und Farben bringen sich die Pflanzen gegenseitig zur Geltung.

Folgende Doppelseite: Gesamtansicht des Gemüsegartens. Die Gemüsebeete, die beiden »mixed-borders« und der Ritterspornweg.

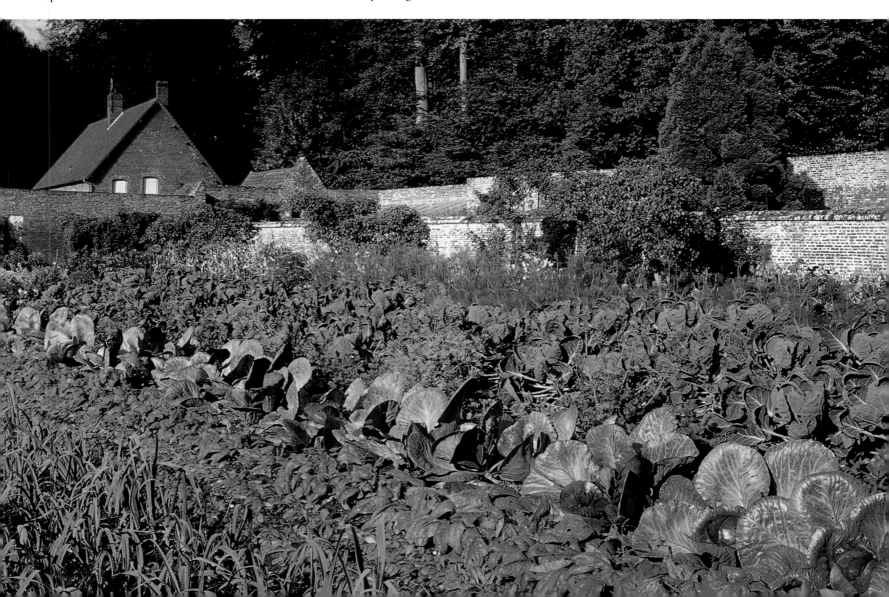

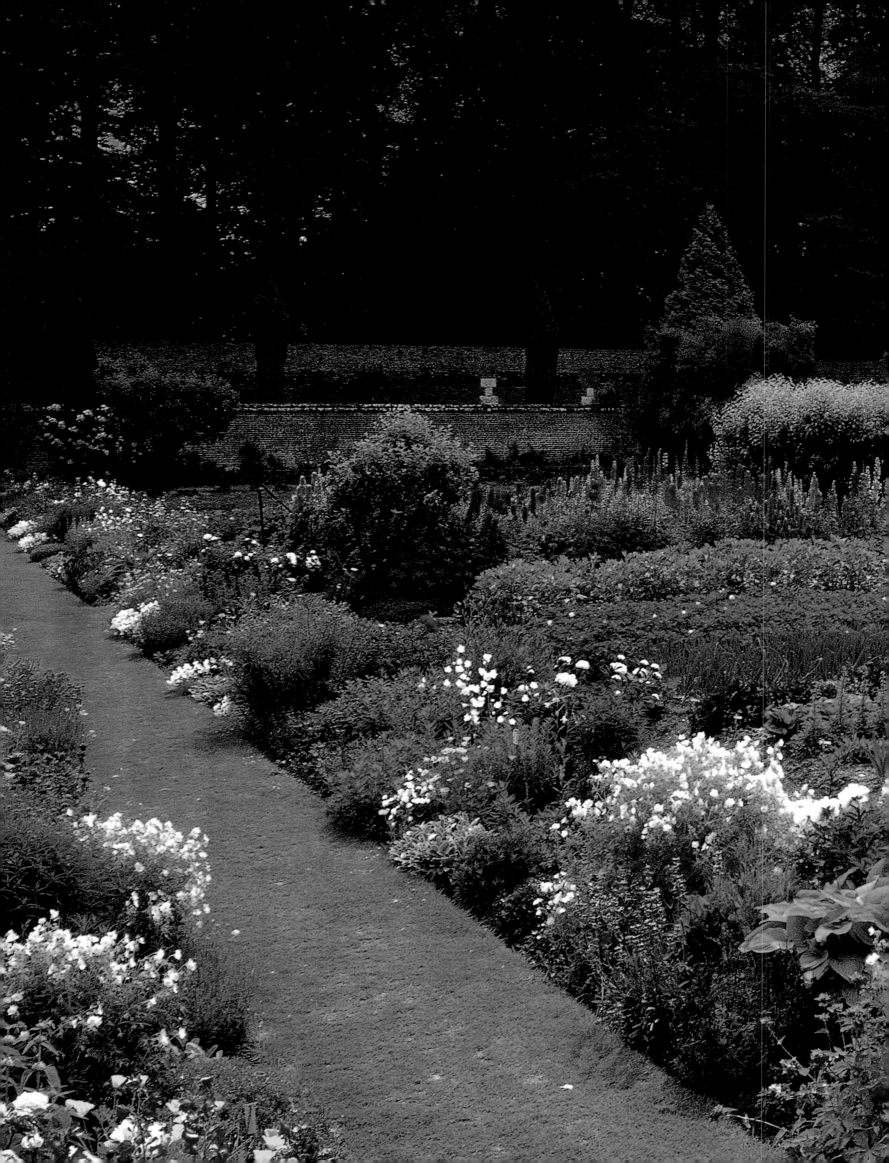

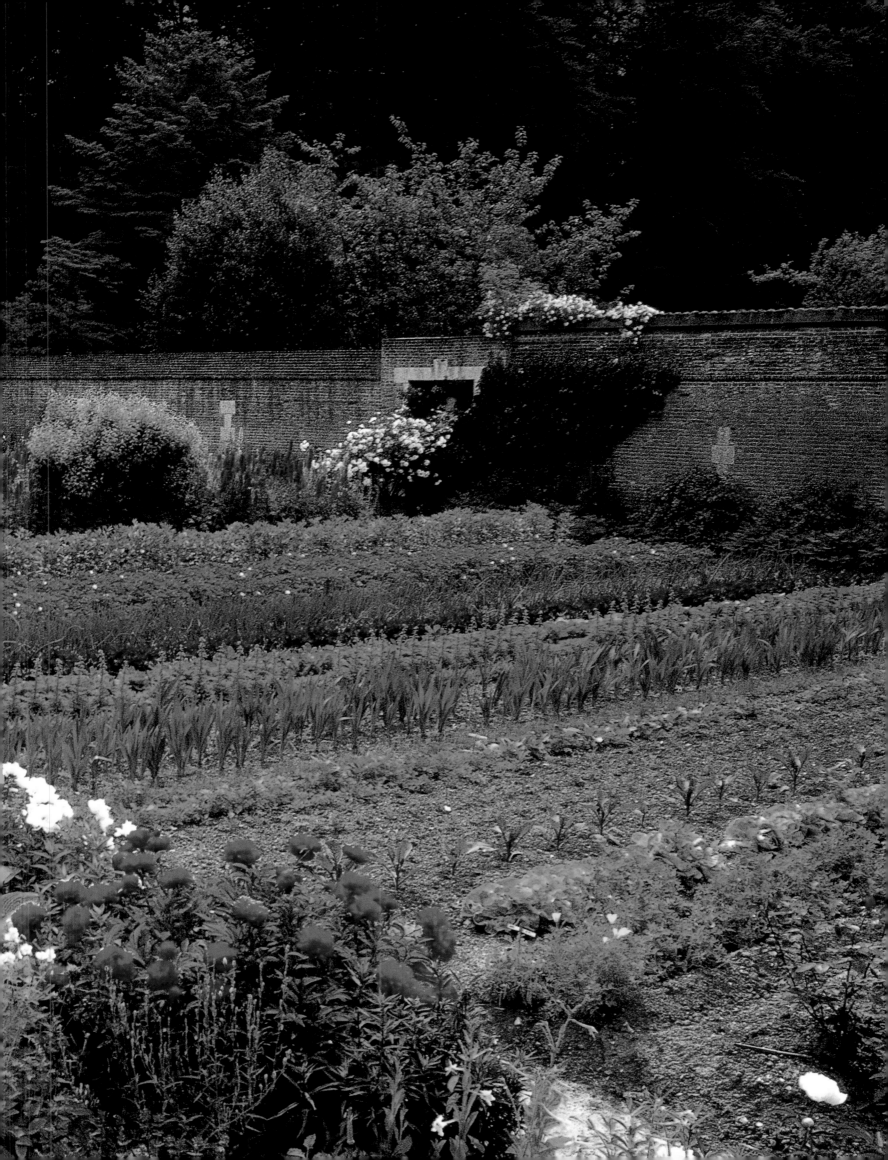

Ci-dessus: Les murs de briques roses sont palissés de rosiers et de clématites. Le rosier 'Campanile' et deux clématites emmêlées, 'The President' et 'Ville de Lyon'.
Page de droite: la clématite 'H.F. Young' et des digitales *(Digitalis purpurea).*

Above: The pink brick walls are palisaded with roses and clematis: the rose 'Campanile' and two mingling clematis, 'The President' and 'Ville de Lyon'.
Facing page: Clematis 'H.F. Young'. At its foot, foxgloves *(Digitalis purpurea).*

Oben: Die blaßroten Backsteinmauern sind mit Rosen und Clematis an Spalieren berankt. Hier die Rose 'Campanile' und zwei ineinander verflochtene Clematis, 'The President' und 'Ville de Lyon'.
Rechte Seite: die Clematis 'H.F. Young', davor Roter Fingerhut *(Digitalis purpurea).*

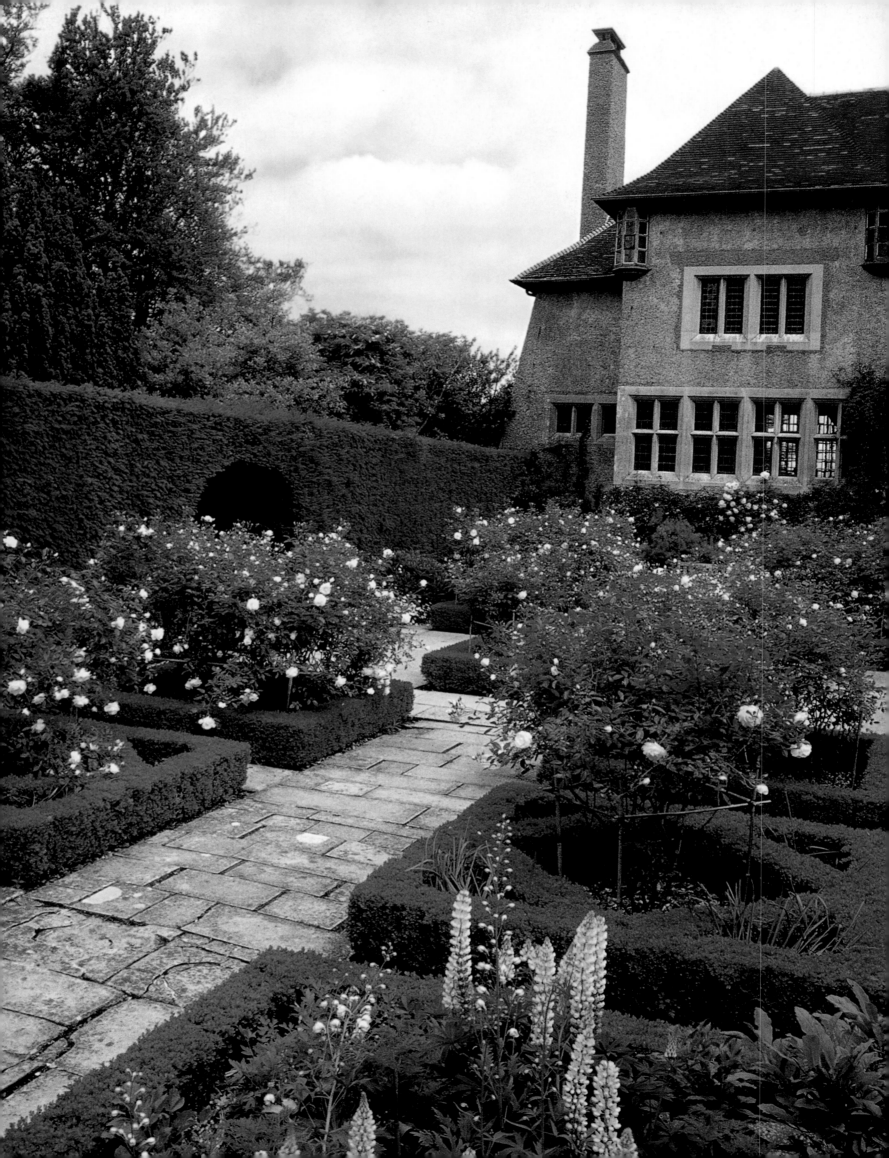

Le parc du Bois des Moutiers est un chef-d'œuvre élégamment composé. Au début du siècle, son créateur Guillaume Mallet s'y consacra avec amour. Aujourd'hui, il est vénéré par ses descendants qui se sont passionnés pour sa restauration et vouent un véritable culte à sa beauté. Il est très anglais dans sa conception et dans ses plantations. Guillaume Mallet choisit Varengeville-sur-Mer car il fut séduit par une atmosphère qui lui rappelait celle de l'Ile de Wight. Il s'attacha les conseils de l'architecte Sir Edwin Lutyens (1869-1944) et de la fameuse paysagiste Gertrude Jekyll (1843-1932), déjà très à la mode à l'époque, outre-Manche. Lutyens construisit le manoir et les jardins. Gertrude Jekyll orienta les plantations. On entre par le jardin blanc, clos et dallé à l'italienne, dont les haies de buis enserrent mille et une plantes joliment associées. Puis on passe devant l'entrée du manoir embelli par deux magnifiques «mixed-borders», plantées dans le plus pur goût anglais. Une pergola habillée de roses anciennes et de clématites laisse sur sa droite le jardin du cadran solaire pour conduire au jardin des magnolias. La promenade traverse ensuite l'ancien potager transformé en roseraie et en verger pour se perdre dans le grand parc paysager où camélias, érables du Japon *(Acer japonicum)*, *Cornus*, *Prunus*, *Viburnum* et *Hydrangea* descendent jusqu'au pied des massifs de gigantesques rhododendrons. Ce chef-d'œuvre est magnifique en toute saison. Et c'est ce qui en fait aussi un jardin d'exception.

Le Bois des Moutiers

The park of Le Bois des Moutiers is a masterpiece. It owes its elegant composition to Guillaume Mallet, who devoted himself to it; his descendants have set about its restoration in a spirit of veneration and worked hard to enhance its beauty. It is very English in its design and planting. Guillaume Mallet chose Varengeville-sur-Mer because its atmosphere reminded him of the Isle of Wight. He obtained the services of the architect Sir Edwin Lutyens (1869-1944) and the garden designer Gertrude Jekyll (1843-1932) – the latter was very sought after in France at the time – who cooperated in the design of the garden. Lutyens built the manor and laid out the gardens, and the planting was overseen by Gertrude Jekyll. The way in is a flagged path leading between the high yew hedges that enclose the white garden. Here little box hedges frame a multitude of carefully selected white blossoms. Then one comes to the entrance to the manor itself, with its two magnificent mixed borders in the purest English style. A pergola awash with old garden roses and clematis leads to the magnolia garden offering a glimpse of the sundial to the right. The promenade then crosses the rose garden and orchard, in what was formerly the kitchen garden, before leading on into the landscaped park. There camellias, Japanese maples *(Acer japonicum)*, dogwood *(Cornus)*, flowering cherries *(Prunus)*, *Viburnum* and *Hydrangea* stand before the huge walls of rhododendron. Le Bois des Moutiers is resplendent all year-round.

Der Park Le Bois des Moutiers ist ein elegant komponiertes Meisterwerk. Sein Schöpfer Guillaume Mallet legte ihn zu Beginn des Jahrhunderts mit viel Liebe an. Heute wird er von Mallets Nachfahren ehrfürchtig gepflegt. Sie setzen sich voller Begeisterung für seine Erhaltung ein und widmen ihm einen regelrechten Schönheitskult. Der Park ist sehr »englisch« in Anlage und Bepflanzung. Guillaume Mallet wählte Varengeville-sur-Mer, weil ihm die Atmosphäre gefiel und ihn an die Isle of Wight erinnerte. Er beauftragte den Architekten Sir Edwin Lutyens (1869-1944) und die Gartengestalterin Gertrude Jekyll (1843-1932), die seinerzeit in England bereits sehr populär waren. Lutyens baute Wohnhaus und Garten, während Gertrude Jekyll die Bepflanzung bestimmte. Man betritt die Anlage durch den weißen Garten, der nach italienischer Art geschlossen angelegt und gepflastert ist. Kleine Buchshecken fassen tausenderlei Blumen in hübschen Kombinationen ein. Vor der Eingangstür des Landhauses liegen dagegen zwei prachtvolle »mixed-borders«. Eine mit alten Rosen und Clematis berankte Pergola führt an der Sonnenuhr zur Rechten vorbei in den Magnoliengarten. Der Weg durchquert nun den ehemaligen Nutz- und heutigen Rosengarten, den Obstgarten und verliert sich schließlich im großen Landschaftspark. Dieser ist mit Kamelien, Japan-Ahorn *(Acer japonicum)*, Hartriegel *(Cornus)*, Zierkirschen *(Prunus)*, Schneeball *(Viburnum)* und Hortensien *(Hydrangea)* bepflanzt und erstreckt sich bis zu Beeten mit riesigen Rhododendronbüschen. Dieses Meisterwerk ist zu jeder Jahreszeit ein Genuß und schon allein deshalb ein ganz außergewöhnlicher Garten.

Première page: le jardin blanc, ses murs d'ifs et sa structure de buis. Au premier plan, des lupins, puis des rosiers 'Fée des neiges', et la demeure de style «Arts and Crafts».
Ci-dessus: le jardin sylvestre planté d'arbres et d'arbustes amateurs de terre acide.
A droite: Les pieds des arbres sont tapissés d'anémones des bois *(Anemone nemorosa).*
Page de droite: Le jardin des magnolias se découvre au sortir de la pergola chère à Gertrude Jekyll.

First page: the white garden with its yew enclosure and little box hedges. In the foreground, white lupins, then 'Iceberg' roses and the "Arts and Crafts" style house.
Above: the woodland garden planted with trees and shrubs that thrive on acid soil.
Right: Wood anemones *(Anemone nemorosa)* cluster at the roots of the trees.
Facing page: The magnolia garden is reached through Gertrude Jekyll's much-loved pergola.

Eingangsseite: der weiße Garten mit seinen Wänden aus Eibe und dem mit Buchsbaum markierten Grundriß. Im Vordergrund Lupinen, dahinter Rosen der Sorte 'Schneewittchen' und das im Stil der »Arts and Crafts Movement« erbaute Landhaus.
Oben: Der Waldgarten ist mit Bäumen und Sträuchern bepflanzt, die sauren Boden bevorzugen.
Rechts: Zu Füßen der Bäume sind Buschwindröschen *(Anemone nemorosa)* gepflanzt.
Rechte Seite: Durch Gertrude Jekylls geliebte Pergola gelangt man zum Magnoliengarten.

Le Bois des Moutiers *Normandie*

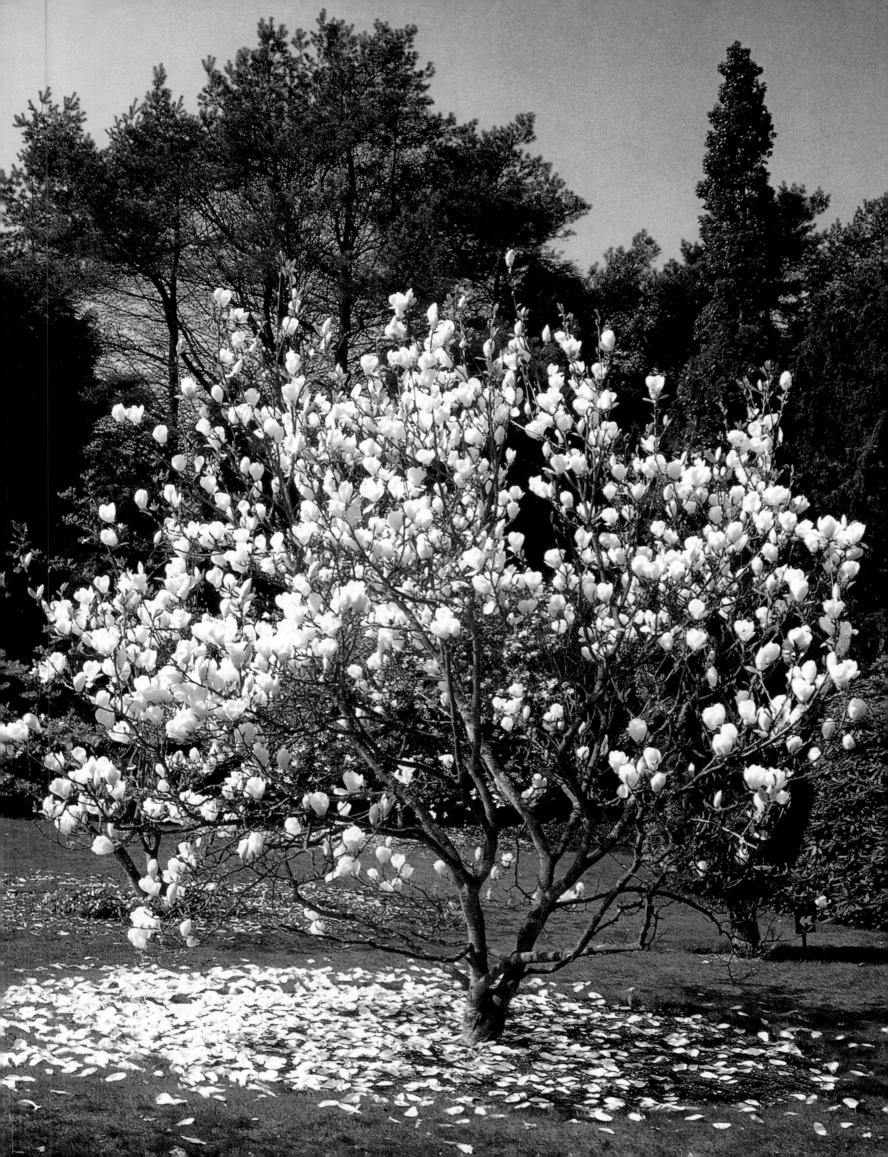

A droite: Le parc du Bois des Moutiers est une source d'inspiration inépuisable pour les peintres qui sont nombreux à venir y dresser leur chevalet.
Ci-dessous: Le jardin sylvestre est composé de groupes d'arbres ou d'arbustes espacés par de belles clairières de pelouse.

Right: The garden and park of Le Bois des Moutiers are an inexhaustible source of inspiration for the many painters who set up their easels there.
Below: The woodland garden is composed of groups of trees or shrubs set out in wide, peaceful expanses of lawn.

Rechts: Der Park Le Bois des Moutiers ist eine unerschöpfliche Quelle der Inspiration für zahlreiche Maler, die hier ihre Staffeleien aufstellen.
Unten: Der Waldgarten besteht aus Gruppen von Bäumen und Sträuchern, die durch schöne rasenbewachsene Lichtungen unterbrochen werden.

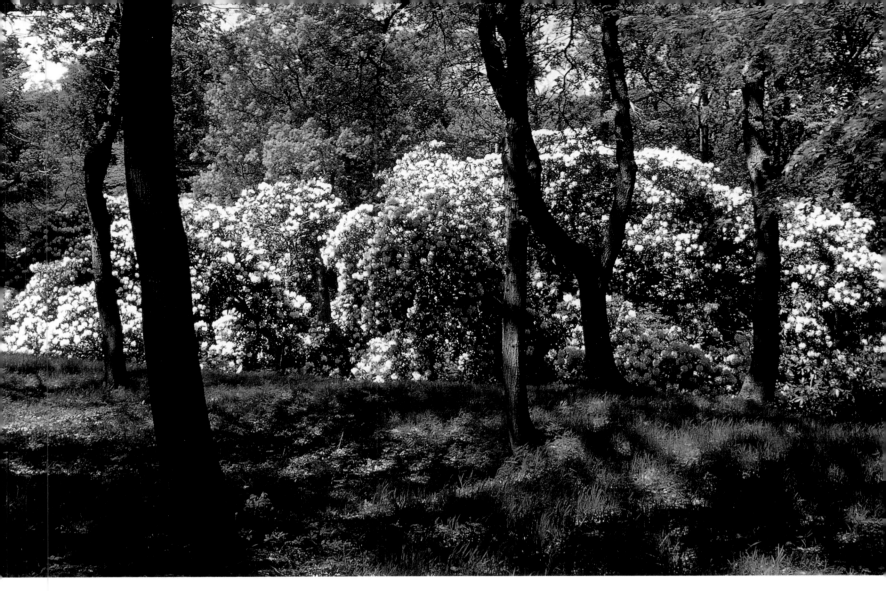

Ci-dessus: Dans le sous-bois, en descendant vers la mer, des vagues gigantesques de rhododendrons déploient au mois de mai leurs glorieuses floraisons.

A droite: Le parc descend une valleuse qui rejoint la mer dont la présence adoucit le climat assez semblable à celui de l'Ile de Wight, si chère à Guillaume Mallet.

Above: In May, the great walls of rhododendron nearer the sea are resplendent with flowers.

Right: The park is set in a narrow valley leading down to the sea, and the maritime climate that results is similar to that of Guillaume Mallet's much-loved Isle of Wight.

Oben: Im Mai wirkt die Blütenpracht der Rhododendren in dem zum Meer hin gelegenen unteren Teil des Waldes wie ein wogendes Meer.

Rechts: Ein trockenes Tal verläuft vom Park bis zur Küste hinunter. Ähnlich wie auf der Isle of Wight sorgt auch hier das Meer für ein mildes Klima, wie es Guillaume Mallet schätzte.

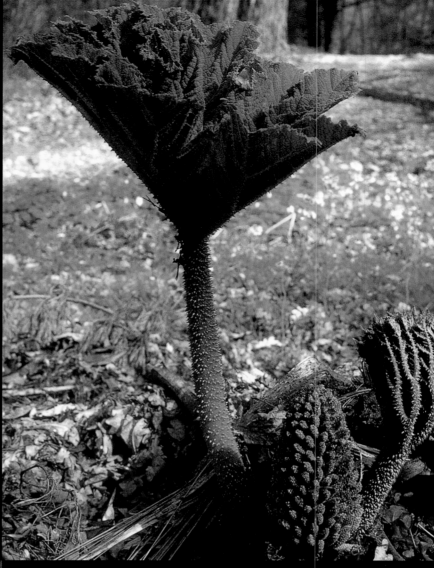

Détail de droite: Au printemps, se déploient les feuilles géantes des *Gunnera manicata.*

Detail right: In spring, the giant leaves of the *Gunnera manicata* unfold.

Detail rechts: Im Frühling entfalten sich die großen Blätter des Mammutblattes *(Gunnera manicata).*

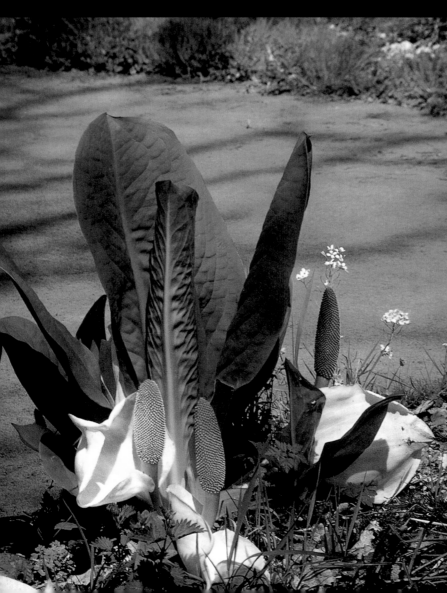

Détail de gauche: Lysichiton camschatcensis est très rare. C'est une plante à fleurs blanches qui apprécie un terrain frais.

Detail left: This white-flowered *Lysichiton camschatcensis* is very rare. It is a plant which likes a shaded site.

Detail links: Diese seltene weiße Scheincalla *(Lysichiton camschatcensis)* liebt kühlen Boden.

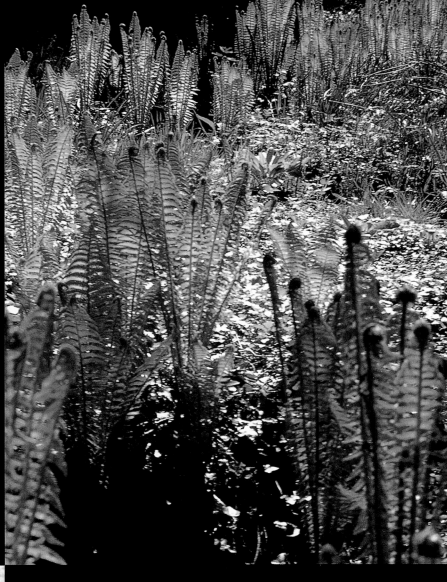

Détail de droite: Des colonies de fougères peuplent le sous-bois. Elles étirent leurs frondes au mois de mai.

Detail right: Colonies of ferns are found in the coppice. They unroll their leaves in May.

Detail rechts: Ganze Farnkolonien bevölkern das Unterholz. Sie entrollen ihre Wedel im Mai.

Détail de gauche: Lysichiton americanus avec ses fleurs jaunes est plus courant. La plante développe ensuite un très beau feuillage.

Detail left: The yellow-flowered *Lysichiton americanus* is more common. The leaves that follow the flower are exceedingly handsome.

Detail links: Die gelbe Scheincalla *(Lysichiton americanus)* mit ihren wunderschönen Blättern ist dagegen weit häufiger anzutreffen.

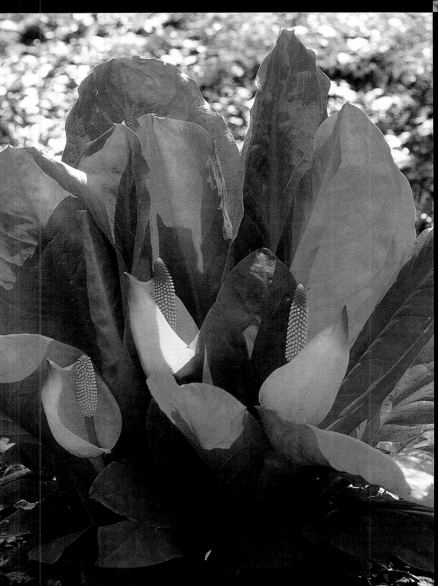

Dans le jardin qu'il a créé à Varengeville-sur-Mer, autour d'une ancienne ferme à colombages aux couleurs délicieusement passées, Mark Brown a poussé le raffinement à l'extrême. Il est anglais et paysagiste de métier. Il est d'abord fin botaniste et connaît parfaitement bien les plantes, leur famille, leur origine, les infinies variétés d'une même espèce, leurs différences exactes, leur nom précis. Son regard est infaillible quand il s'agit de les associer et sa vision est très subtile. Il a un sens inné de l'harmonie des couleurs et sait les juxtaposer dans des dégradés très progressifs. Il discernera un port particulièrement élégant, une forme gracieuse, des textures qui se mettent mutuellement en valeur. Il aime passionnément les plantes mais reste en même temps intransigeant dans ses choix. On entre dans son jardin par une porte secrète qui ouvre sur un univers blanc, flou, japonisant. De l'autre côté, des plantes viennent caresser les colombages de la maison dont les tonalités furent inspirées d'un coucher de soleil sur Newhaven. Puis les couleurs vont crescendo, évoquant celles de l'arc-en-ciel dans des plates-bandes qui bordent la maison, puis s'en écartent pour filer au grand air. Un jardin shakespearien rassemble toutes les plantes citées par le dramaturge dans ses œuvres, créant un tapis fleuri qui contraste avec le tapis vert, tondu en damier, qui entoure les pommiers.

Un jardin à Varengeville-sur-Mer

In the garden that he has created at Varengeville-sur-Mer around an old half-timbered farm in deliciously faded colours, Mark Brown has taken refinement to extremes. He is English and a professional landscape gardener. He is first and foremost an excellent botanist and has an expert's knowledge of plants: their family, origin, varieties within a particular species, differences and common names. He has an infallible sense for the harmonious juxtaposition of different textures and colours, and creates subtle harmonies with very gradually nuanced movement from colour to colour. He can immediately visualise the scale required and compose a particularly elegant outline or eloquent texture to match. He loves plants passionately but his choices are ruthless and dispassionate. A secret door leads into this garden, opening onto a world in which shades of white merge one with another in Japanese style. Beyond it, plants brush against the half-timbering in colours inspired by a Newhaven sunset. There follows a crescendo of colour; all the shades of the spectrum are found in the beds which surround the house and spread out into the distance. A Shakespearian garden brings together all the plants mentioned in his works, creating a carpet of blossom that contrasts with the little squares of meadow grass in the apple orchard.

In dem Garten, den Mark Brown in Varengeville-sur-Mer rings um ein altes, wundervoll verblichenes Fachwerkhaus anlegte, ließ er es an keiner Raffinesse fehlen. Er ist Engländer und von Beruf Gartenarchitekt, vor allem aber ein vorzüglicher Botaniker, der mit den Pflanzen, ihren Familien, ihrer Herkunft sowie den zahllosen Sorten einer Art und den feinen Unterschieden zwischen ihnen ebenso vertraut ist wie mit ihren exakten botanischen Namen. Was die Zusammenstellung der Pflanzen anbelangt, so ist sein Blick unfehlbar und sein Vorstellungsvermögen sehr fein entwickelt. Er besitzt einen angeborenen Sinn für harmonische Farbklänge und weiß sie in höchst dynamischen Abstufungen nebeneinanderzusetzen. Ein eleganter Wuchs, eine grazile Form oder außergewöhnliche Strukturen, die sich gegenseitig aufwerten, fallen ihm sofort auf. Zwar liebt er Pflanzen leidenschaftlich, bleibt jedoch in seinen Entscheidungen stets unbeugsam. Man betritt seinen Garten durch eine Geheimtür, die in ein weißes, fließendes, japanisch geprägtes Universum führt. Auf der gegenüberliegenden Seite streicheln die Pflanzen das Fachwerk in Farben, zu denen Mark Brown von einem Sonnenuntergang in Newhaven inspiriert wurde. Doch dann kommt Bewegung in die Farbgebung, die in den Rabatten am Haus fast alle Stufen des Regenbogens durchläuft, bevor sie sich am Rande des Gartens in der freien Natur verliert. Der Shakespeare-Garten weist alle Blumen auf, die der Dramatiker in seinen Werken nennt. Sie bilden einen Blütenteppich, der sich vor dem schachbrettartig geschnittenen Rasen zwischen den Apfelbäumen leuchtend absetzt.

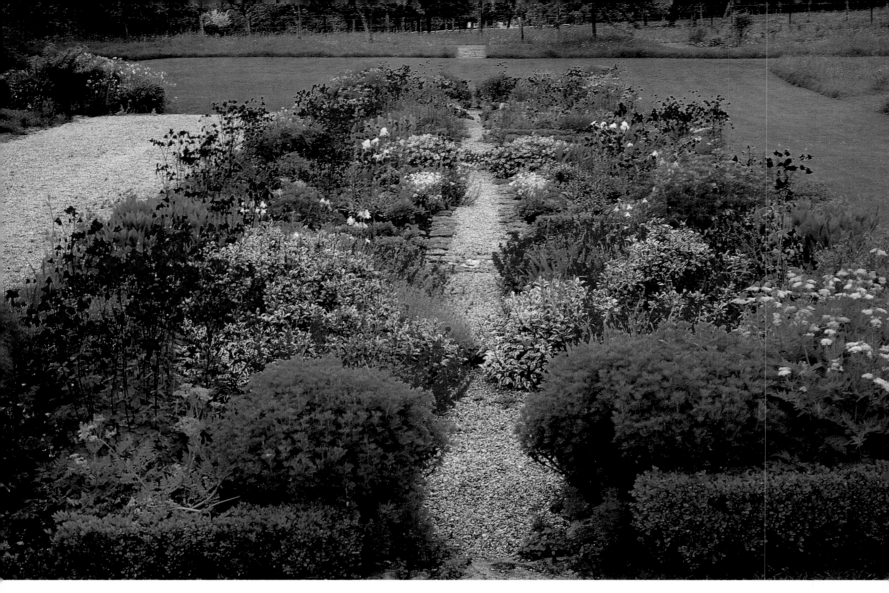

Page précédente: Devant la maison s'étale une prairie où poussent des pommiers. Elle est émaillée de fritillaires *(Fritillaria meleagris)* blanches ou pourpres et tachetées en damier.
Ci-dessus: Le jardin shakespearien rassemble les plantes citées par le dramaturge dans ses œuvres – ancolies *(Aquilegia),* armoises *(Artemisia),* sauges *(Salvia),* cerfeuil musqué *(Myrrhis odorata),* giroflées *(Cheiranthus cheiri).*
A droite: Dans le verger de pommiers, Mark Brown a tondu la pelouse en damier et traité les carrés en prairie sauvage.

Previous page: In front of the house stretches an apple orchard, underplanted with a profusion of white, purple or chequered fritillaries (Fritillaria meleagris).
Above: The Shakespearean garden brings together all the plants mentioned in his works: columbine *(Aquilegia),* wormwood *(Artemisia),* sage *(Salvia),* sweet cicely *(Myrrhis odorata),* and wallflowers *(Cheiranthus cheiri).*
Right: In the apple orchard, Mark Brown has cut paths to allow little squares of wild meadow plants.

Vorhergehende Seite: Vor dem Haus erstreckt sich eine Wiese mit Apfelbäumen. Hier tummeln sich weiße, purpurne und gewürfelte Schachbrettblumen *(Fritillaria meleagris).*
Oben: Der Shakespeare-Garten vereint Gewächse, die in den Werken des englischen Dramatikers erwähnt werden: Akelei *(Aquilegia),* Beifuß *(Artemisia),* Salbei *(Salvia),* Süßdolde *(Myrrhis odorata)* und Goldlack *(Cheiranthus cheiri).*
Rechts: Das Gras der Apfelbaumwiese mäht Mark Brown zu einem Schachbrettmuster, in dem Rasenfläche und Wildblumenwiese miteinander abwechseln.

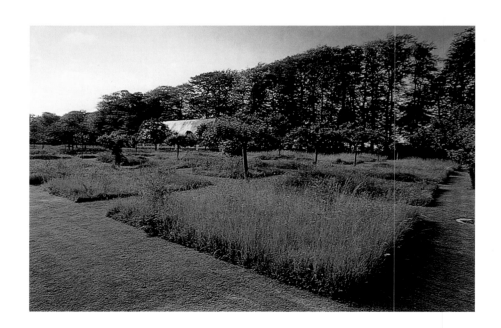

Un jardin de Mark Brown *Normandie*

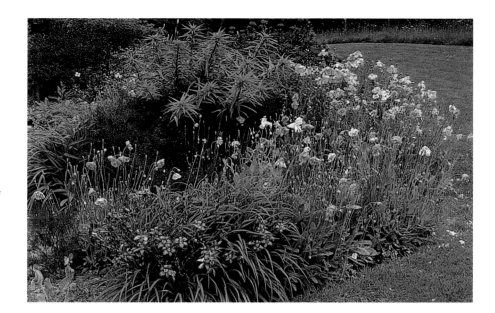

A droite: séquence orange avec des hémérocalles, des pavots, des fenouils bronze et à l'arrière des euphorbes.
Ci-dessous: la nouvelle roseraie devant la maison. Les roses sont saumon, jaunes ou abricot. A gauche, des fenouils bronze *(Foeniculum vulgare* 'Bronze'), puis le rosier 'Golden Celebration' qui est une création du rosiériste anglais David Austin. Sur la pergola grimpe 'Dr. Eckener'.

Right: harmony of orange with day lilies *(Hemerocallis),* poppies, bronze fennels and, behind, euphorbia.
Below: the new rose garden in front of the house. The roses are salmon pink, yellow and apricot. To the left, bronze fennels *(Foeniculum vulgare* 'Bronze'), then a 'Golden Celebration' rose bred by the English rose breeder David Austin. The rose climbing on the pergola is 'Dr. Eckener'.

Rechts: ein Arrangement in Orange aus Taglilien (Hemerocallis), Mohn, bronzefarbenem Fenchel und Wolfsmilch (Euphorbia).
Unten: der neue Rosengarten vor dem Haus. Die Rosen sind lachsfarben, gelb und apricot. Links ein gelblicher Gartenfenchel *(Foeniculum vulgare* 'Bronze'), davor die Rose 'Golden Celebration', eine Züchtung des englischen Rosenzüchters David Austin. Am Laubengang sieht man die Rose 'Dr. Eckener'.

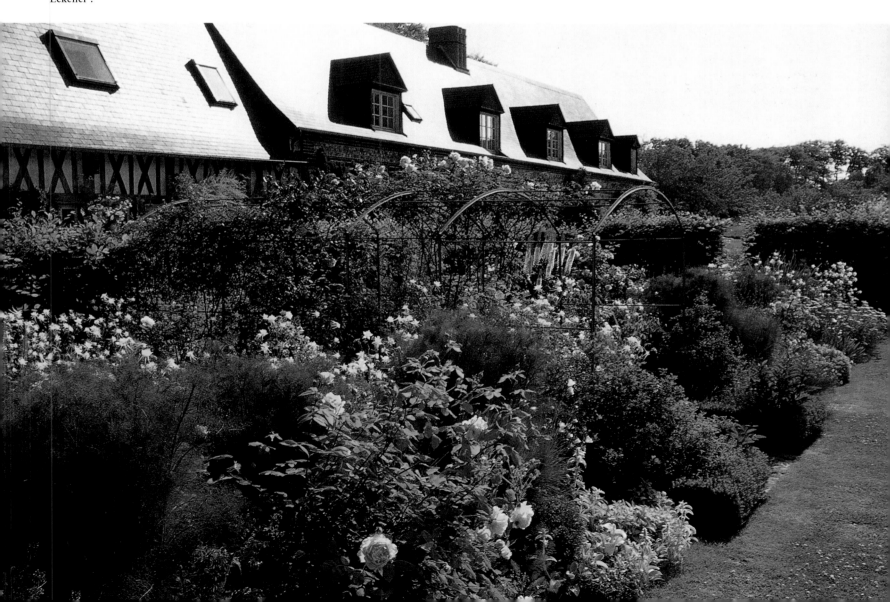

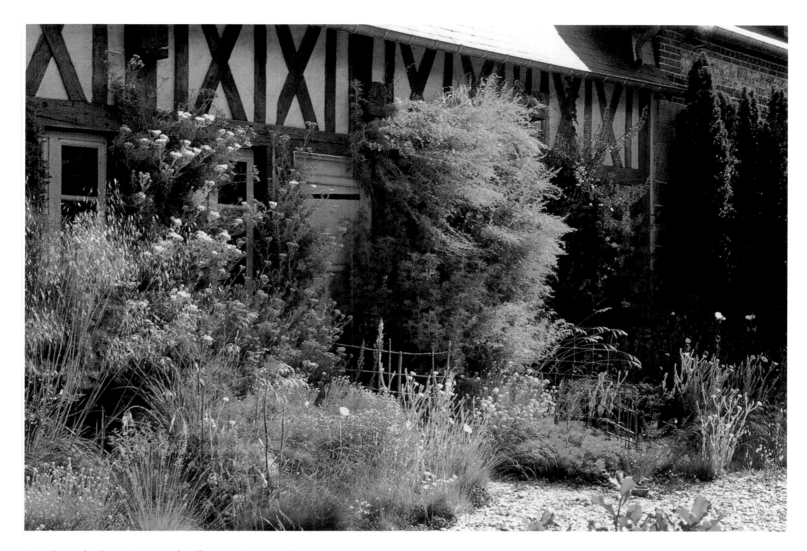

Page de gauche: des anémones pulsatilles, montées en graine, et des fenouils bronze.

Ci-dessus: En bordure de la maison et contre les colombages, on distingue, de gauche à droite, des graminées *(Stipa gigantea),* un séneçon *(Senecio vira-vira);* à droite de la porte, *Artemisia arborescens* et à l'extrême droite, un Phygelius corail. Plus bas, des santolines, des lychnis et des hélichrysums.

A droite: Mark Brown répand du compost qu'il fabrique lui-même: il s'agit d'une sorte de paillis dont il recouvre les plates-bandes.

Facing page: pulsatillas gone to seed and bronze fennels.
Above: Alongside the house, and contrasting with its half-timbering, we see (left to right): golden oats *(Stipa gigantea),* and a senecio *(Senecio vira-vira);* to the right of the door, *Artemisia arborescens* and on the far right, a coral *Phygelius.* Below them are cotton-lavender *(Santolina), Lychnis* and strawflower *(Helichrysum).*
Right: Mark Brown spreading compost, which he makes himself; he uses it as a sort of mulch with which to cover his beds.

Linke Seite: in Samen geschossene Küchenschellen *(Pulsatilla)* und bronzefarbener Fenchel.
Oben: Im Vorgarten und vor dem Fachwerk erkennt man von links nach rechts: Riesenfedergras *(Stipa gigantea),* Greiskraut *(Senecio vira-vira),* rechts neben der Tür einen hohen Beifuß *(Artemisia arborescens)* und ganz rechts eine korallenrote Kaffernfuchsie *(Phygelius).* Davor wachsen Heiligenkraut *(Santolina), Lichtnelken (Lychnis)* und Strohblumen *(Helichrysum).*
Rechts: Mark Brown verwendet Kompost, den er selbst herstellt, wie eine Art Mulch, mit dem er die Beete bedeckt.

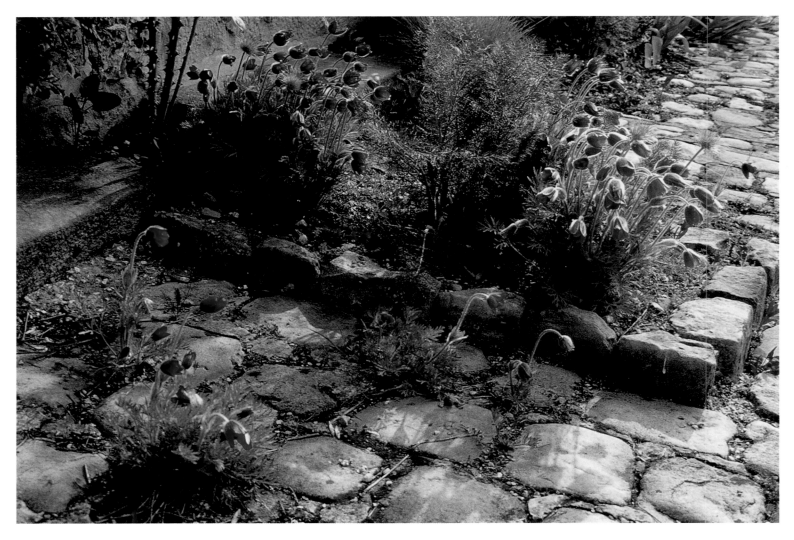

Ci-dessus: Les plantes se ressèment toutes seules devant la maison, entre les pavés, comme ces pulsatilles *(Pulsatilla vulgaris* 'Rubra').
Détails de droite: la tulipe perroquet 'Black Parrot'; un pavot *(Papaver orientale* 'Patty's Plum').
Page de droite: Au premier plan, une graminée, *Festuca glauca,* devant un noisetier pourpre *(Corylus maxima* 'Purpurea'), un lupin rouge et un groseillier d'ornement *(Ribes speciosum),* dont la floraison ressemble à celle du fuchsia, ornent la plate-bande qui court le long de la maison.

Above: In front of the house, among the paving stones, plants reseed themselves spontaneously, like these pasqueflowers *(Pulsatilla vulgaris* 'Rubra').
Details right: a parrot tulip 'Black Parrot'; a poppy *(Papaver orientale* 'Patty's Plum').
Facing page: In the foreground, a fescue *(Festuca glauca)* in front of a filbert *(Corylus maxima* 'Purpurea'), a red lupin, and a fuchsia-flowered currant *(Ribes speciosum)* ornament the bed that runs alongside the house.

Oben: Vor dem Haus säen sich die Pflanzen von selbst zwischen den Pflastersteinen aus, so beispielsweise Küchenschellen *(Pulsatilla vulgaris* 'Rubra').
Details, rechts: eine Papageientulpe 'Black Parrot'; ein Türkenmohn *(Papaver orientale* 'Patty's Plum').
Rechte Seite: In der Rabatte, die am Haus entlang verläuft, findet sich ein Alaunschwingel *(Festuca glauca)* vor einer Bluthasel *(Corylus maxima* 'Purpurea'), einer roten Lupine und einem Zierjohannisstrauch mit fuchsienähnlichen Blüten *(Ribes speciosum).*

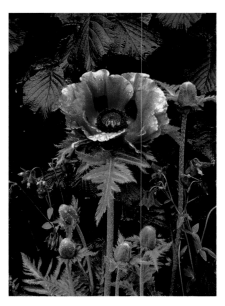

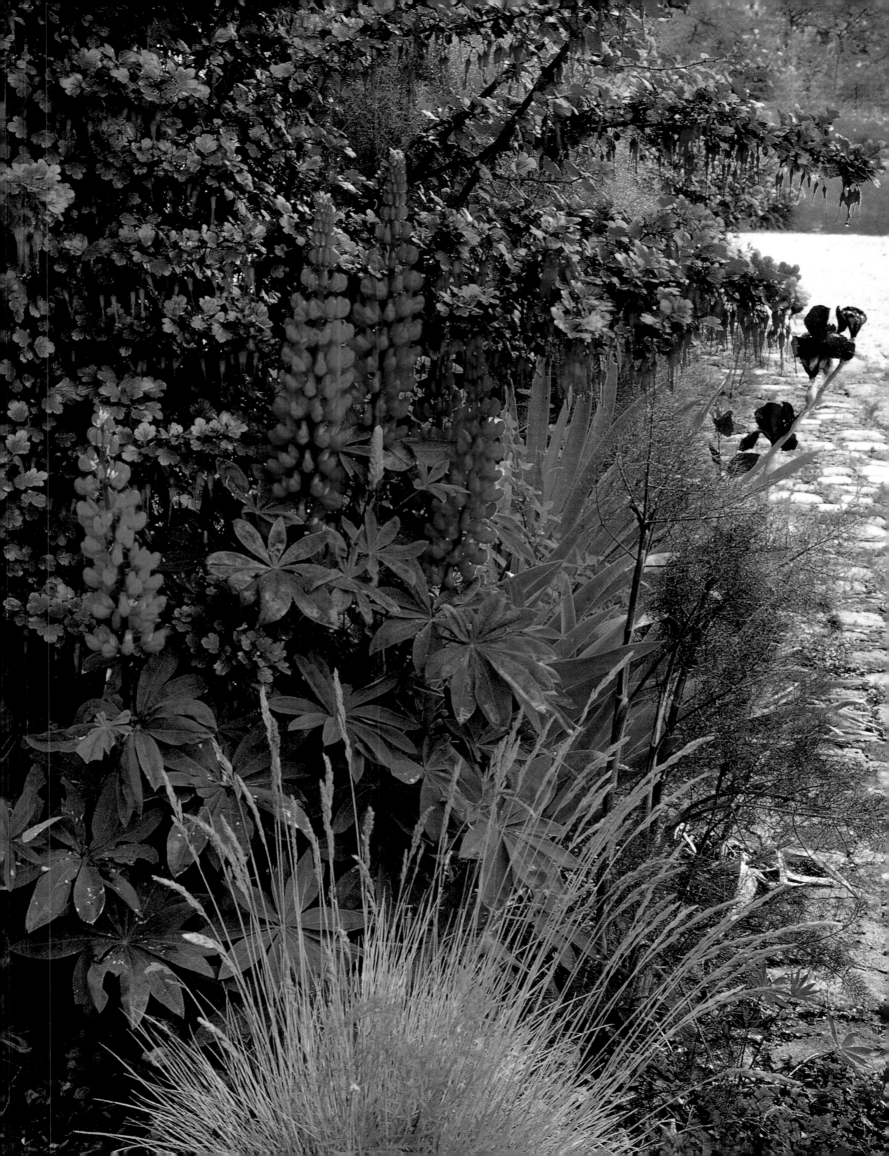

On l'appelle depuis toujours le «jardin des quatre saisons». La princesse Sturdza l'a créé au fil des années en vénérant la beauté. Il reflète sa patience, sa persévérance, son espérance et son goût pour la poésie. L'histoire du Vasterival commence en 1957 lorsque le prince et la princesse Sturdza firent l'acquisition de ces terres qui jouxtent la mer. La lutte contre le vent, les ronces et l'argile fut au début difficile. Mais peu à peu, les plates-bandes se dessinèrent pour former un jardin de sous-bois, libre, sinueux, vallonné où prospèrent aujourd'hui différentes espèces de plantes heureuses en terrain acide. Il n'est pas un jour du calendrier qui soit privé de fleur. Les floraisons sont installées dans un mouvement perpétuel que rien ne semble pouvoir troubler. L'hiver est magnifique, fleuri et parfumé, avec ses demi-teintes subtiles, ses hamamélis, ses hellébores et ses camélias. Le printemps est glorieux avec ses magnolias; un peu plus tard, les rhododendrons offrent un spectacle somptueux. L'été est embelli d'hydrangéas et l'automne chatoie sous les érables. La maison normande ouvre sur une allée moussue qui conduit au jardin de sous-bois où règnent les rhododendrons. Une avenue pentue descend vers la vallée tapissée d'innombrables plates-bandes plantées, sur plusieurs niveaux, de bulbes, de plantes couvre-sol, de plantes vivaces, d'arbustes et d'arbres. Le Vasterival s'est récemment enrichi de nouveaux tableaux d'hiver pour faire triompher la beauté au cœur de la saison la plus déshéritée.

Le Vasterival

It has always been known as "the garden of the four seasons". Its beauty is the product of the many years of devoted attention lavished on it by Princesse Sturdza. It reflects her patience, perseverance, optimism and sense of poetry. The story of Le Vasterival begins in 1957, when the prince and princesse acquired this seaside estate. At first, it was a constant struggle to overcome the depredations of wind and brambles, and the inert clay soil. Little by little, beds were laid out and a wooded garden grew up; a wandering, sinuous, undulating garden in which today there flourish many different species suited to the acid soil. There is a flower for every day of the year; an untroubled succession of blossoms from year's end to year's end. The winter is magnificent, all subtle half-tones, with its fragrant witch hazels *(Hamamelis),* hellebores and *Camellia* all in flower. In spring, the magnolias are resplendent; later, the rhododendrons form a spectacular mass of flowers. The summer is the season of hortensias, and in autumn the maples turn a vivid red. The Norman house opens onto a mossy pathway which leads to a coppice garden in which rhododendrons predominate. An avenue slopes down into the valley in which innumerable beds are planted with several levels of bulbs, ground-cover, perennials, shrubs and trees. Le Vasterival has recently been enriched with new winter compositions so that beauty reigns supreme even during the darkest months.

Seit jeher nennt man ihn den »Garten der vier Jahreszeiten«. Prinzessin Sturdza schuf ihn in vielen Jahren und entspann um seine Schönheit einen wahren Kult. Der Garten spiegelt ihre Geduld, Beharrlichkeit und Zuversicht ebenso wie ihre Liebe zur Poesie. Die Geschichte von Le Vasterival beginnt 1957, als Prinz und Prinzessin Sturdza das Grundstück direkt am Meer kauften. Der Kampf gegen Wind, Brombeergestrüpp und Lehmboden war anfangs ermüdend. Doch nach und nach bildeten die Rabatten einen großzügigen, verschlungenen, hügeligen Gehölzgarten, in dem heute die unterschiedlichsten Gewächse gedeihen, die sich auf sauren Böden wohl fühlen. Es vergeht kein Tag ohne Blüten. Die Blühzeiten folgen einem ewigen Kreislauf, den offenbar nichts zu stören vermag. Besonders schön ist der Winter mit seinen subtilen, gedämpften Farben, den Blüten und Düften von Zaubernuß *(Hamamelis),* Christrosen und Kamelien. Der Frühling kommt strahlend mit Magnolien daher, und etwas später folgt das prachtvolle Schauspiel der Rhododendron- und Azaleenblüte. Der Sommer prunkt mit Hortensien und der Herbst mit roten Ahornbäumen. Von dem normannischen Wohnhaus führt ein moosbewachsener Weg zu dem von Rhododendren beherrschten Gehölzgarten. Ein steiler Weg zieht sich hinab ins Tal, in dem sich unzählige Beete mit Zwiebelgewächsen, Bodendeckern, Stauden, Sträuchern und Bäumen nach Größe gestaffelt aufreihen. Erst kürzlich wurden in Le Vasterival an einigen Stellen neue Winterszenerien geschaffen, in denen die Schönheit der Natur auch in der traurigsten Gartensaison triumphiert.

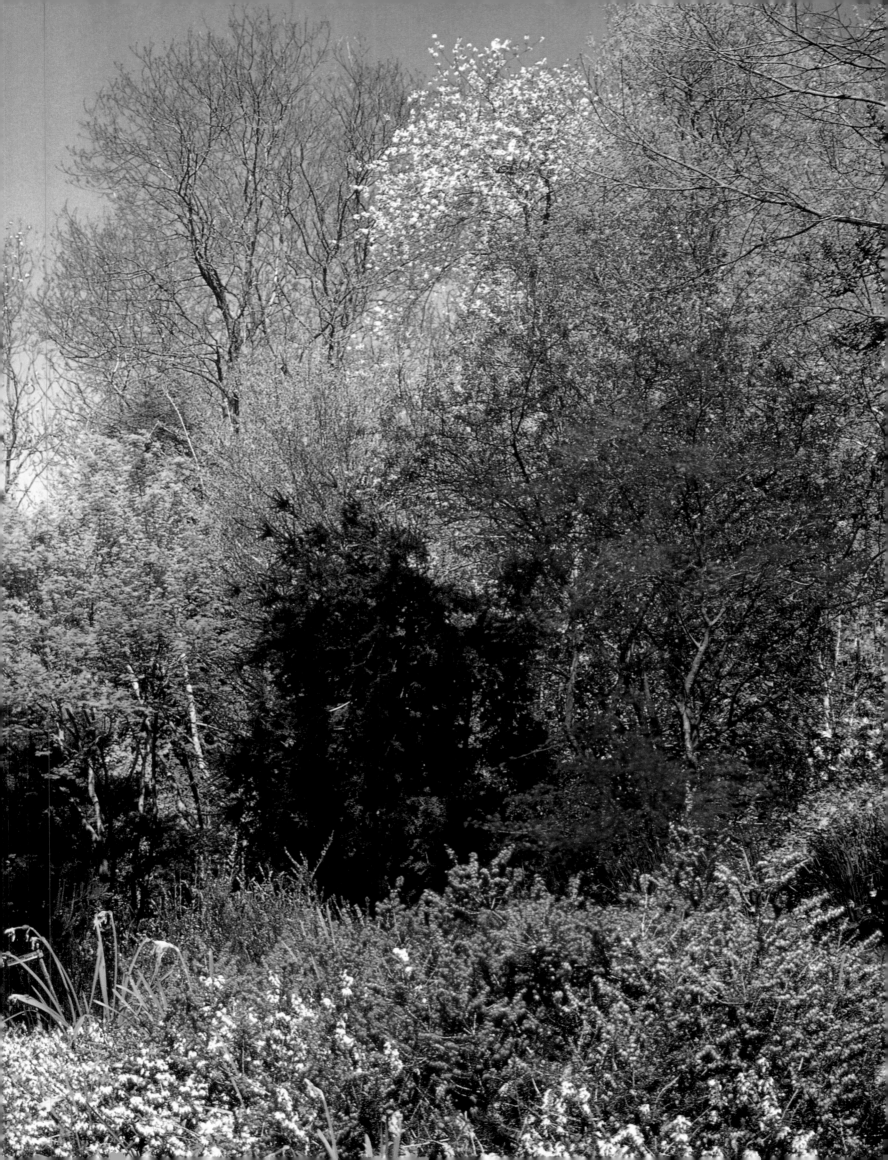

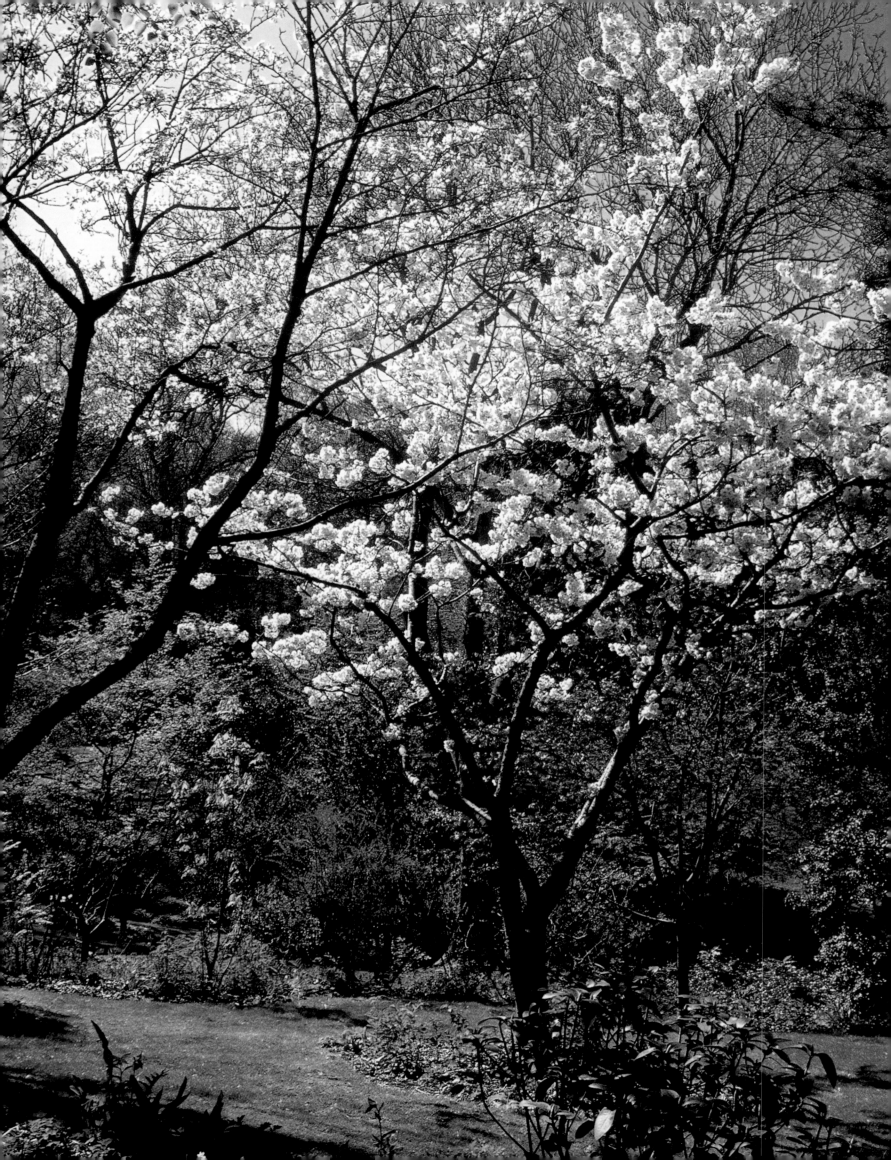

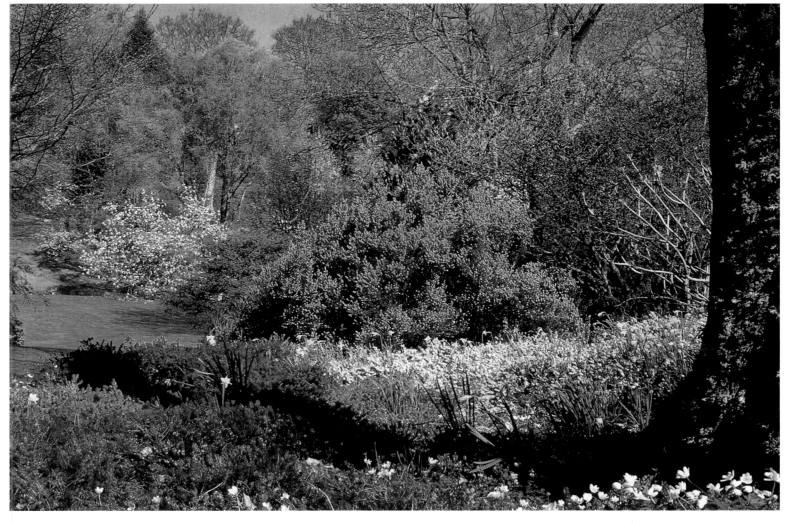

Page précédente: une scène de la fin de l'hiver. Au premier plan, des bruyères *(Erica carnea)*. Au centre, un conifère, *Saxegothaea conspicua.* Derrière, en fleurs, *Malus baccata var. mandshurica,* pommier à floraison hâtive et parfumée.
Page de gauche: Prunus 'Takasago' aux fleurs roses semi-doubles et aux feuilles duveteuses.
Ci-dessus: au centre, une bruyère arborescente *(Erica erigena).* A sa gauche, *Magnolia x loebneri* 'Leonard Messel'.
A droite: au premier plan, *Azalea kurume* 'Hinomayo'. Au fond, rhododendron 'Cynthia'. Entre les deux, *Zenobia pulverulenta.* C'est un arbuste qui émet au début de l'été des fleurs ressemblant à du muguet et à odeur d'anis.

Previous page: late winter. In the foreground, winter heath *(Erica carnea).* In the centre, Prince Albert's yew *(Saxegothaea conspicua).* Flowering behind it, *Malus baccata var. mandshurica,* a flowering crab whose blossom is highly scented and very brief.
Facing page: Prunus 'Takasago' with pink semi-double flowers and downy leaves.
Above: in the centre, a tree heather *(Erica erigena).* To its left, *Magnolia x loebneri* 'Leonard Messel'.
Right: in the foreground, *Azalea kurume* 'Hinomayo'. At the back, rhododendron 'Cynthia'. Between them, *Zenobia pulverulenta,* a shrub which in early summer bears flowers like those of the lily of the valley; they have an aniseed scent.

Vorhergehende Seite: eine Szenerie im späten Winter. Im Vordergrund Schneeheide *(Erica carnea),* in der Mitte eine Konifere *(Saxegothaea conspicua),* dahinter der früh blühende, duftende Zierapfel *Malus baccata var. mandshurica.*

Linke Seite: Die japanische Zierkirsche *Prunus* 'Takasago' hat halbgefüllte rosa Blüten und samtweiche Blätter.
Oben: in der Mitte eine Baumheide *(Erica erigena).* Links davon die Magnolienhybride *Magnolia x loebneri* 'Leonard Messel'.
Unten: im Vordergrund eine *Azalea kurume* 'Hinomayo', im Hintergrund der Rhododendron 'Cynthia'. Dazwischen sieht man eine Zenobie *(Zenobia pulverulenta),* die im Frühsommer voller maiglöckchenähnlicher, nach Anis duftender Blüten hängt.

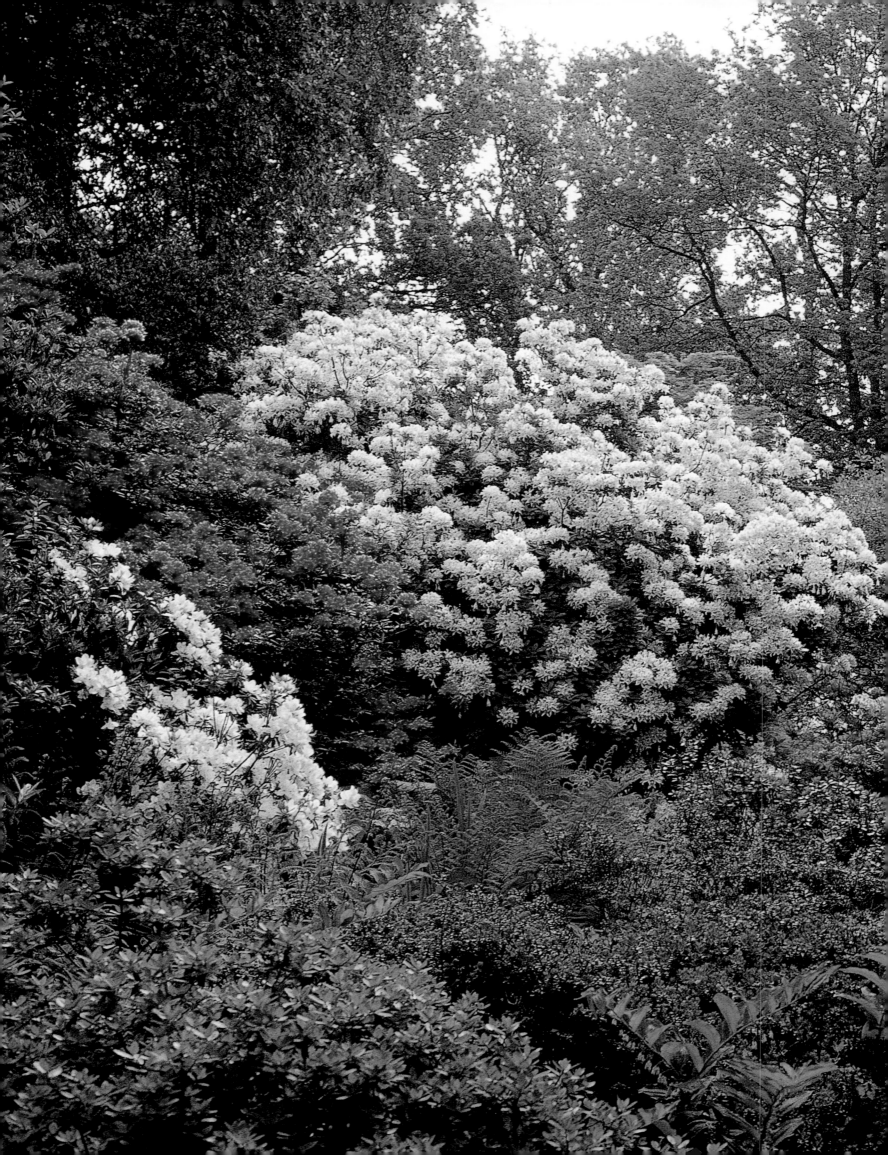

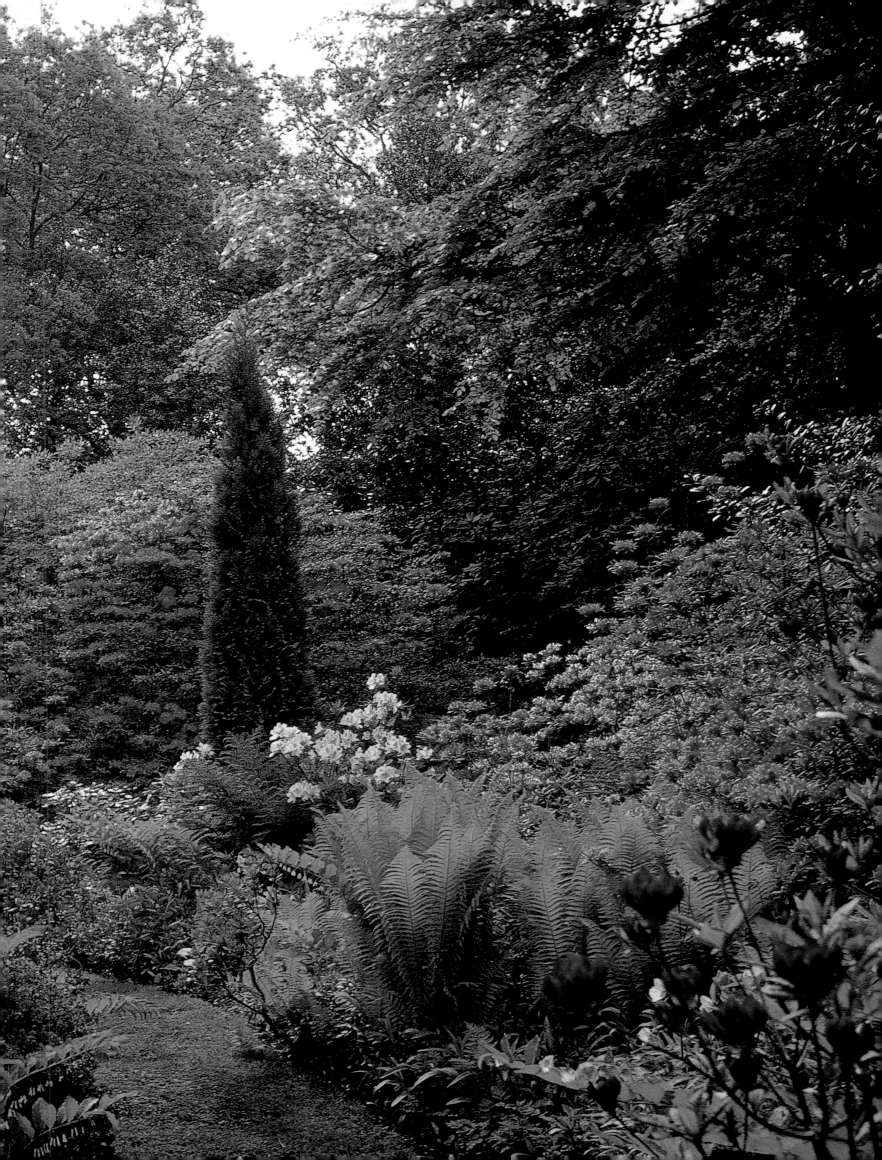

Double page précédente: une scène du sous-bois où azalées et rhododendrons resplendissent au mois de mai. On distingue les azalées 'Wada's Chichiba' (blanche), 'Fanny' (rose soutenu), *Azalea mollis* hybride (jaune-rose), *Azalea delicatissima* (rose clair), parmi des fougères et des sceaux-de-Salomon *(Polygonatum).*

A droite: gros plan sur les fleurs du *Magnolia* hybride 'Iolanthe'.

Ci-dessous: La princesse Sturdza a choisi des arbres remarquables pour leur écorce. Au premier plan, *Betula nigra* dont l'écorce s'exfolie.

Previous pages: azaleas and rhododendrons resplendent in May. The azaleas 'Wada's Chichiba' (white), 'Fanny' (dark pink), hybrid *Azalea mollis* (yellow-pink), *Azalea delicatissima* (pale pink) can be seen among the ferns and Solomon's seal *(Polygonatum).*

Right: a close-up of the flowers of hybrid *Magnolia* 'Iolanthe'.

Below: Princesse Sturdza has chosen trees remarkable for their bark. In the foreground, a *Betula nigra* whose bark is flaking off.

Vorhergehende Doppelseite: ein Blick in den Gehölzgarten, der während der Rhododendron- und Azaleenblüte im Mai seine ganze Pracht entfaltet. Man erkennt die Azaleen 'Wada's Chichiba' (weiß) und 'Fanny' (dunkelrosa), eine *Azalea mollis*-Hybride (gelb-rosa), *Azalea delicatissima* (hellrosa), dazwischen Farne und Salomonssiegel *(Polygonatum).*

Rechts: Nahaufnahme der Blüten der Magnolienhybride 'Iolanthe'.

Unten: Prinzessin Sturdza wählte Bäume mit besonders reizvoller Rinde. Im Vordergrund eine Schwarzbirke *(Betula nigra),* deren Rinde sich schält.

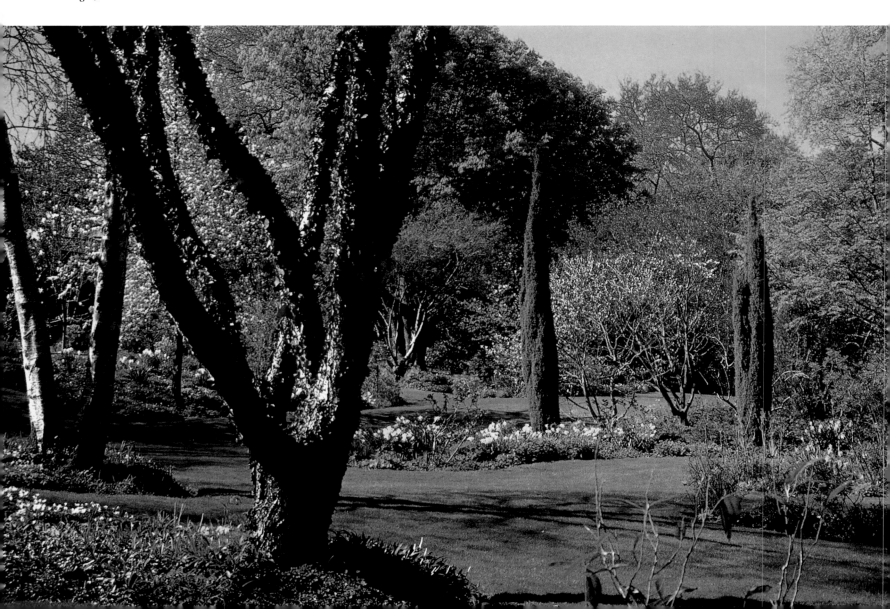

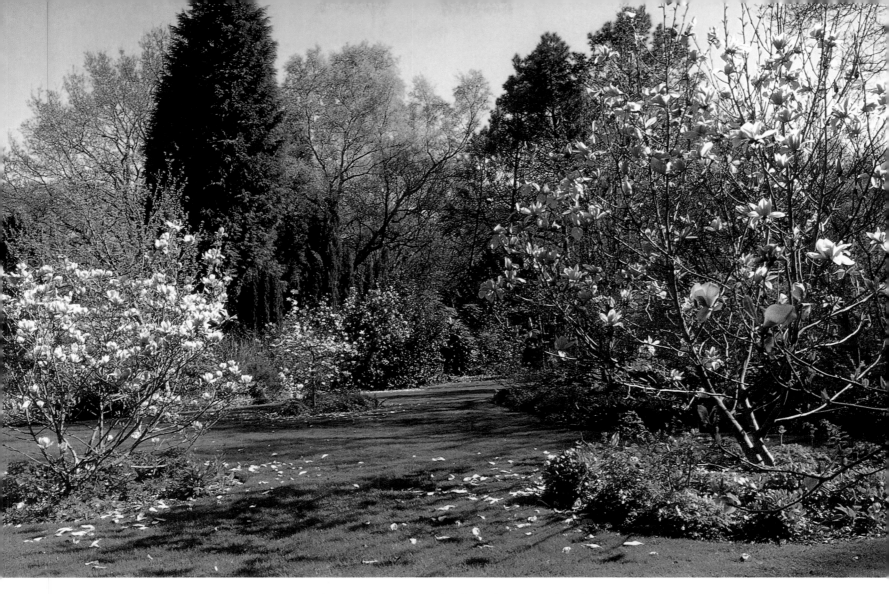

Ci-dessus: La princesse Sturdza crée souvent une plate-bande en plantant d'abord un magnolia, puis en l'entourant d'autres végétaux. Le Vasterival possède ainsi une étonnante collection de magnolias. Il a fallu parfois attendre des années avant de les voir fleurir: *Magnolia sprengeri* 'Star Wars', *M. soulangeana* 'Burgundy', et au fond, *Camellia x williamsii* 'Donation'.

Double page suivante, dans le sens des aiguilles d'une montre: Les plates-bandes sont peuplées de plantes vivaces dont les floraisons se relaient au fil des saisons: *Polygonatum biflorum; Helleborus orientalis* hybride; *Euphorbia dulcis* 'Chameleon', *Cimicifuga simplex* 'Atropurpurea', *Iris foetidissima* 'Variegata', *Hosta* hybride et le fenouil pourpre (*Foeniculum vulgare* 'Atropurpureum'); *Helleborus orientalis* 'Nigristern'.

Above: Princesse Sturdza often starts a bed by planting a magnolia, then surrounding it with other plants. Le Vasterival therefore contains an astonishing array of magnolias. Years have sometimes passed before the magnolia flowered. Here: *Magnolia sprengeri* 'Star Wars', *M. soulangeana* 'Burgundy' and, at the back, *Camellia x williamsii* 'Donation'.

Following pages, clockwise from top left: The flower-beds are dense with perennials, which flower throughout the year: *Polygonatum biflorum;* hybrid *Helleborus orientalis;* spurge *Euphorbia dulcis* 'Chameleon', *Cimicifuga simplex* 'Atropurpurea', *Iris foetidissima* 'Variegata', hybrid *Hosta* and fennel *Foeniculum vulgare* 'Atropurpureum'; hybrid *Helleborus orientalis* 'Nigristern'.

Oben: Prinzessin Sturdzas Rabatten entstehen oft, indem sie zunächst eine Magnolie pflanzt und diese dann mit anderen Pflanzen umgibt. Le Vasterival besitzt deshalb eine erstaunliche Fülle von Magnolien. Manchmal dauerte es Jahre bis zur ersten Blüte: *Magnolia sprengeri* 'Star Wars', *M. soulangeana* 'Burgundy' und im Hintergrund die Kamelie *Camellia x williamsii* 'Donation'.

Folgende Doppelseite, im Uhrzeigersinn von links oben: Die Rabatten sind bevölkert mit Stauden, die gestaffelt im Jahreslauf blühen: Salomonssiegel (*Polygonatum biflorum);* Nieswurz (*Helleborus orientalis*-Hybride); Wolfsmilch *Euphorbia dulcis* 'Chameleon', Silberkerze *Cimicifuga simplex* 'Atropurpurea', Schwertlilie *Iris foetidissima* 'Variegata' und dahinter Funkien (blaulaubige *Hosta*-Hybride) und der rotlaubige Gartenfenchel *Foeniculum vulgare* 'Atropurpureum'; *Helleborus orientalis* 'Nigristern'.

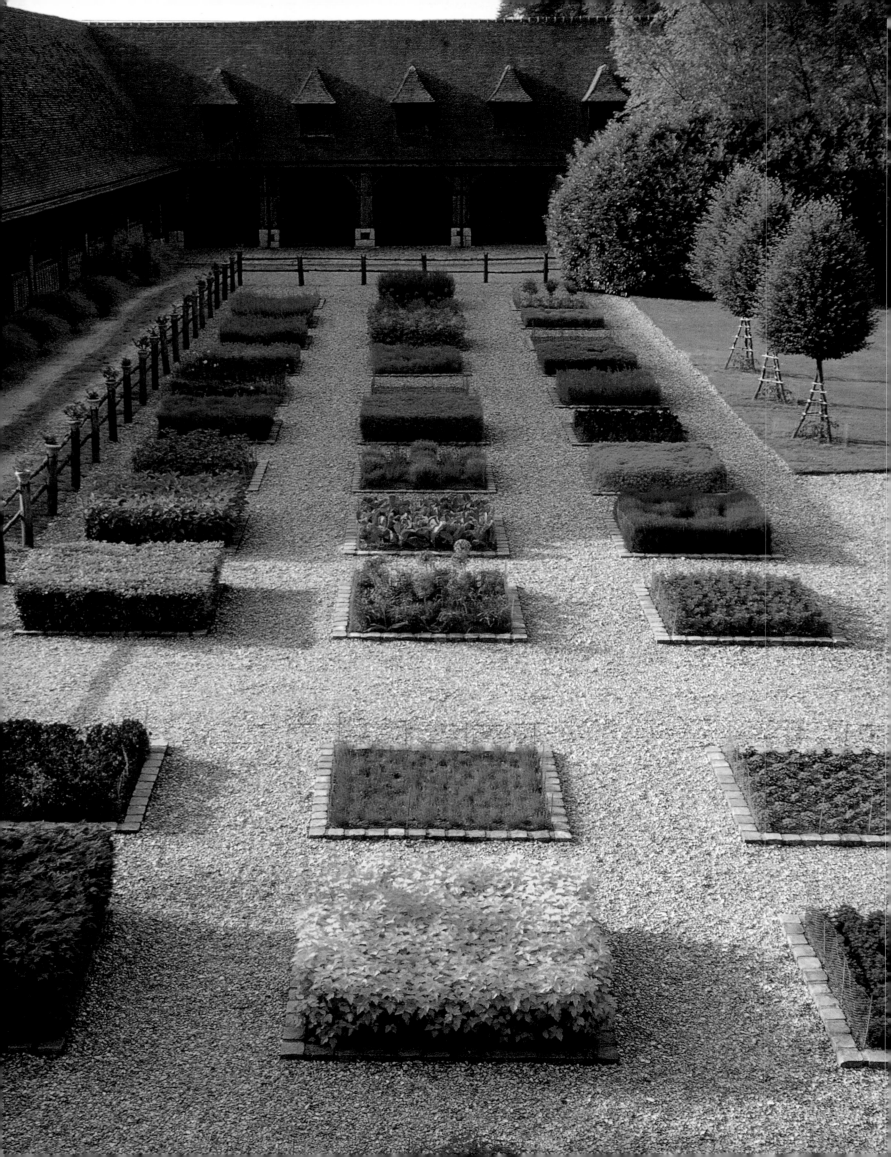

Anne-Marie de Bagneux souhaitait créer un potager près de sa ferme normande et s'adressa pour cela au talentueux paysagiste Pascal Cribier. Il conçut un potager d'avant-garde au tracé géométrique dépouillé, composé de trente-six carrés. Ce damier relie les bâtiments, la maison et les étables et s'entretient très facilement car ses allées sont gravillonnées. En outre, chaque carré est entouré de pavés et consacré à une seule et même variété. Les végétaux sont plantés serré et ne permettent pas aux mauvaises herbes de s'installer. Le potager étant proche de la maison, il fallait qu'il soit beau à regarder toute l'année. C'est pourquoi il fut planté non seulement de plantes potagères ou aromatiques, mais aussi de plantes vivaces, de bulbes ou de plantes annuelles, ou encore d'arbustes à fleurs et de végétaux à feuillage persistant que l'on taille au carré. Les plantations changent d'une année sur l'autre car il faut respecter, comme dans tout potager, le cycle des rotations. Les jardins de Limesy se sont aussi enrichis de buis taillés en boule insérés entre les pavés, d'une «mixed-border» qui connaît son apogée en été, d'un saut-de-loup qui empêche le bétail de passer, de salles vertes et d'une prairie fleurie qui s'inscrivent dans le parc planté depuis 1745 d'arbres majestueux. Car le domaine appartient à la même famille depuis plus de cinq cents ans.

Limesy

Anne-Marie de Bagneux wished to create a kitchen garden near her farm in Normandy and commissioned a design from the landscape gardener Pascal Cribier. He designed for her an avant-garde kitchen garden of austere geometrical form composed of thirty-six square beds. This "chequerboard" acts as a link between buildings, house and stables, and is easy to maintain; the garden paths are gravelled, and each bed is bordered with paving stones and devoted to a single variety. The dense planting inhibits weeds. The kitchen garden is next to the house, and had therefore to be of attractive appearance all year-round. It was therefore planted not only with aromatic and edible plants, but with perennials, bulbs and annuals, and with flowering shrubs and evergreens that could be trimmed to fit their square. The planting varies year by year, as the principle of rotation has, of course, to be observed. Sphere-shaped topiary box trees stand amid the paving stones, and there is also a mixed border, which is at its very best during the summer months. A ha-ha prevents cattle invading. There are "green rooms" and a flowering meadow within the confines of the park, whose earliest trees date from 1745. This estate has belonged to the same family for more than five hundred years.

Als Anne-Marie de Bagneux beabsichtigte, neben ihrem normannischen Haus einen Gemüsegarten anzulegen, wandte sie sich an den begabten Gartenarchitekten Pascal Cribier. Er entwarf einen avantgardistischen Gemüsegarten mit einer nüchternen geometrischen Grundstruktur von sechsunddreißig Beeten. Diese schachbrettartige Anlage liegt zwischen dem Wohnhaus und den Ställen und läßt sich mühelos instand halten, denn die Wege zwischen den Beeten sind mit Kies bestreut. Außerdem ist jedes Beet mit Pflastersteinen eingefaßt und jeweils einer einzigen Sorte vorbehalten. Die Pflanzen sind dicht gesetzt, damit Unkraut dazwischen keinen Platz findet. Da der Nutzgarten direkt ans Haus grenzt, sollte er zu allen Jahreszeiten hübsch anzusehen sein und wurde deshalb nicht nur mit Gemüsepflanzen und Küchenkräutern bestückt, sondern auch mit Stauden, Zwiebelgewächsen und einjährigen Pflanzen, mit blühenden Sträuchern und immergrünen Gewächsen, die zu Quadern geschnitten werden. Wie in jedem Gemüsegarten wechselt die Bepflanzung der Beete jedes Jahr nach den Regeln der Kulturfolge. Im Garten von Limesy finden sich überdies Heckengärten, eine Blumenwiese, eine »mixed-border«-Rabatte, deren Blüte im Sommer ihren Höhepunkt erreicht, kugelförmig geschnittener Buchsbaum, der zwischen den Pflastersteinen wächst, und ein versenkter, nahezu unsichtbarer Zaun, der die Kühe fernhält. Den Park mit seinen riesigen Bäumen gibt es schon seit 1745, denn das Anwesen gehört seit über fünfhundert Jahren derselben Familie.

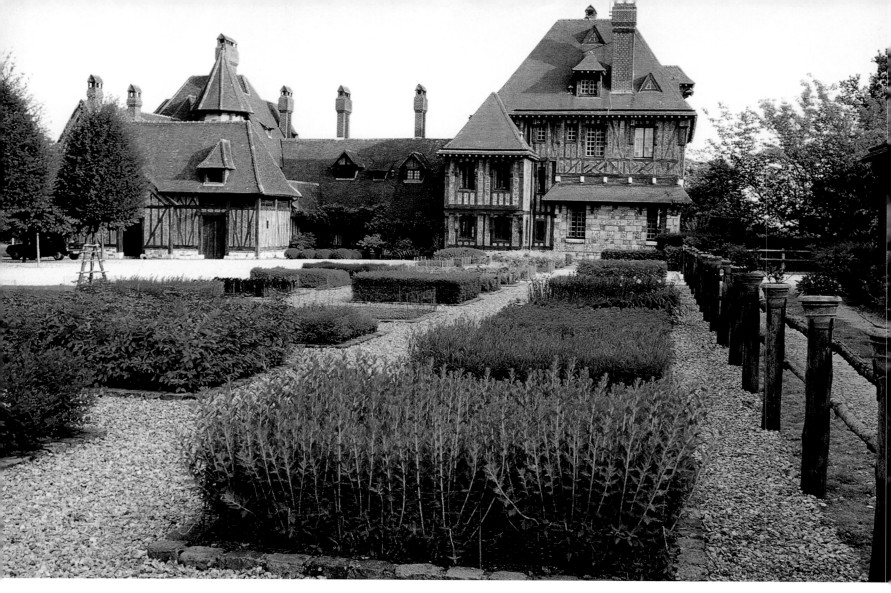

Première page: le potager vu de la maison. Il est composé de trente-six carrés de deux mètres de côté chacun, entourés de pavés. Au fond, les étables, à droite, trois charmes qui servent de tuteur vivant à des pieds de tomates.
Ci-dessus: le potager, et au fond, la maison normande avec ses briques roses et ses colombages. Au premier plan, un carré de *Perovskia atriplicifolia* dont les fleurs bleues s'épanouissent en août et en septembre.

First page: the kitchen garden seen from the house. It comprises thirty-six beds two metres square, each bordered by paving stones. Behind the kitchen garden are the stables; on the right, three hornbeams serve as supports for tomato plants.
Above: the kitchen garden in front of the Norman house with its pale pink bricks and half-timbering. In the foreground, a square of *Perovskia atriplicifolia* whose blue flowers are best seen in August and September.

Eingangsseite: Blick vom Haus in den Gemüsegarten. Er besteht aus sechsunddreißig Beeten von jeweils vier Quadratmetern, die mit Pflastersteinen eingefaßt sind. Im Hintergrund sieht man die Ställe, rechts drei Hainbuchen, die Tomatenpflanzen als lebende Stützen dienen.
Oben: der Gemüsegarten und im Hintergrund das normannische Haus mit seinen blaßroten Backsteinen und dem Fachwerk. Im Vordergrund ein Beet mit Perowskien *(Perovskia atriplicifolia),* die im August und September ihre blauen Blüten entfalten.

Limesy *Normandie*

A droite: De l'autre côté de la maison normande, Pascal Cribier a rassemblé des bouquets d'hortensias *(Hydrangea)* qui prennent de très belles couleurs à la fin de l'été.
Ci-dessous: Près de l'entrée de la maison normande, du côté du potager, il a inséré des buis taillés en boule entre les pavés.

Right: On the other side of the house, Pascal Cribier has planted clumps of hydrangea, whose colours are brightest in late summer.
Below: Near the entrance of the Norman house, on the kitchen garden side of the house, topiary box grows among the paving stones.

Rechts: An der Rückseite des normannischen Hauses hat Pascal Cribier Hortensienbüsche *(Hydrangea)* angepflanzt, die sich im Spätsommer interessant verfärben.
Unten: Am Eingang des normannischen Hauses auf der Seite des Gemüsegartens setzte er kugelige Buchsbäume zwischen die Pflastersteine.

Détail de gauche: Les carrés sont plantés d'ails ornementaux *(Allium christophii).*

Detail left: Some of the squares are planted with ornamental *Allium christophii.*

Detail links: Dieses Beet ist mit Zierlauch *(Allium christophii)* bepflanzt.

Détail de droite: pensées *(Viola).*

Detail right: pansies *(Viola).*

Detail rechts: Stiefmütterchen *(Viola).*

Détail de droite: Sedum 'Autumn Joy'.

Detail right: stonecrop *Sedum* 'Autumn Joy'.

Detail rechts: Fetthenne *Sedum* 'Autumn Joy'.

Détail de gauche: salades associées à *Solanum rantonnetii.*

Detail left: salad plants alongside a blue potato bush *(Solanum rantonnetii).*

Detail links: Salat neben Nachtschatten *(Solanum rantonnetii).*

Détail de gauche: Spiraea japonica 'Goldflame'.

Detail left: Spiraea japonica 'Goldflame'.

Detail links: Der Spierstrauch *Spiraea japonica* 'Goldflame'.

Détail de gauche: Cornus.

Detail left: dogwood *(Cornus).*

Detail links: Hartriegel *(Cornus).*

Détail de droite: persil.

Detail right: parsley.

Detail rechts: Petersilie.

Détail de gauche: Physocarpus opulifolius 'Dart's Gold'.

Detail left: ninebark *Physocarpus opulifolius* 'Dart's Gold'.

Detail links: Gelbe Blasenspiere *Physocarpus opulifolius* 'Dart's Gold'.

Détail de gauche: santoline grise *(Santolina).*

Detail left: grey cotton-lavender *(Santolina).*

Detail links: Graues Heiligenkraut *(Santolina).*

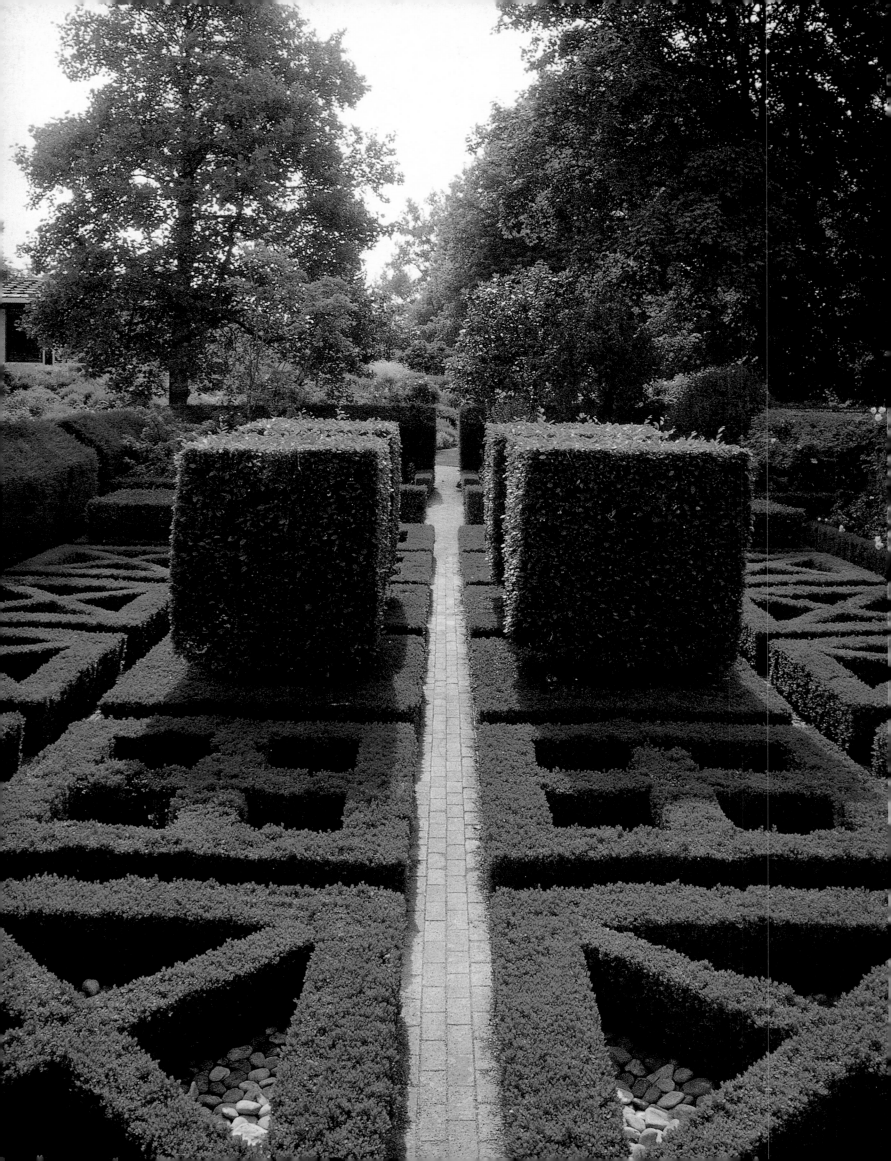

Ce jardin normand, situé près de Deauville, fut dessiné en 1966 par le célèbre paysagiste anglais Russell Page (1906-1985) pour le baron et la baronne van Zuylen. Il a évolué depuis et continue à vivre grâce au talent de Gabrielle van Zuylen, une jardinière éclairée et auteur de plusieurs ouvrages traitant de l'art des jardins. Lorsqu'ils achetèrent le haras de Varaville, en 1964, le baron et la baronne van Zuylen trouvèrent de belles écuries bicentenaires et les ruines d'un château qui avait brûlé en 1937. Ils décidèrent de bâtir une maison de style contemporain et s'attachèrent à cet effet les services de l'architecte américain Peter Harden. La mission du paysagiste Russell Page était ardue, le jardin devant relier des bâtiments qui n'avaient rien en commun. De plus, il devait tenir compte de la présence des chevaux que rien n'arrête s'ils trouvent l'herbe plus verte de l'autre côté de la barrière. Décision fut prise d'inclure deux grandes chambres de verdure à l'intérieur des murs de l'ancien potager et de ménager au milieu une vaste pelouse conduisant à un jardin sauvage. Deux grands rectangles fermés par d'imposantes haies d'ifs sombres signent la composition de Russell Page. Ils sont tous deux divisés en compartiments: un jardin de printemps, un jardin d'été et un jardin de roses y trouvent leur place, architecturés par des formes topiaires imposantes qui permettent, à l'intérieur des parterres, des variations au fil des ans et au gré des passions.

Varaville

This garden, near Deauville in Normandy, was designed in 1966 by the famous English landscape gardener Russell Page (1906-1985) for the Baron and Baronne van Zuylen. It has changed since then and continues to evolve thanks to Gabrielle van Zuylen, an erudite gardener who has written several works on the garden design. When they bought the Varaville stud farm, in 1964, the Baron and Baronne van Zuylen acquired handsome stables two centuries old, and the ruins of a chateau which had burnt down in 1937. They decided to build a house in contemporary style and engaged the American architect Peter Harden. The job of the landscape gardener Russell Page was an awkward one, in that the garden had to link buildings which had nothing in common. It also had to take account of the fact that horses would be present, and that horses have a tendency to find the grass greener on the other side of the fence. The decision was made to plant two large green enclosures within the old kitchen garden and at the centre of these to create a huge lawn leading to a wild garden. Two great rectangles enclosed by impressive yew hedges are the main features of Russell Page's design. Both are divided into compartments: a spring garden, a summer garden and a rose garden are among these, with large-scale topiary used as architectural elements. These allow the beds to be varied as taste and time dictate.

Dieser Garten liegt ganz in der Nähe von Deauville. Der berühmte englische Gartenarchitekt Russell Page (1906-1985) hat ihn 1966 für Baron und Baronin van Zuylen entworfen. Daß die Anlage heute noch existiert und sich sogar weiterentwickelt hat, ist Gabrielle van Zuylen, einer talentierten, aufgeschlossenen Gärtnerin zu verdanken, die bereits mehrere Bücher über die Gartenkunst geschrieben hat. Als Baron und Baronin van Zuylen 1964 das Gestüt Varaville kauften, fanden sie schöne, zweihundert Jahre alte Stallungen und die Ruinen eines Schlosses vor, das 1937 abgebrannt war. Sie beschlossen, ein modernes Wohnhaus zu bauen, und beauftragten den amerikanischen Architekten Peter Harden mit dem Bau. Die Aufgabe, die sich Russell Page bei der Gartengestaltung stellte, war ausgesprochen schwierig, denn der Garten sollte das Bindeglied zwischen Gebäuden werden, die nichts gemeinsam haben. Darüber hinaus mußte er berücksichtigen, daß es auf dem Anwesen Pferde gibt, die nichts und niemand halten kann, wenn sie auf die Idee kommen, das Gras sei jenseits des Zauns saftiger als diesseits. Man beschloß deshalb, zwei geräumige »grüne Kammern« in den Mauern des ehemaligen Gemüsegartens anzulegen und dazwischen eine große Rasenfläche zu belassen, die zu einem verwilderten Park überleitet. Zwei große, mit dunklen Eibenhecken eingefaßte Rechtecke bilden das Kernstück der Komposition von Russell Page. Beide sind nochmals unterteilt in einen Frühlings-, einen Sommer- und einen Rosengarten. Die Beete sind mit beschnittenen Buchshecken eingefaßt, zwischen denen je nach Jahreszeit und Laune unterschiedliche Gewächse gedeihen.

Première page: On reconnaît le style de Russell Page, sa maîtrise de l'architecture végétale, son bon usage des haies et des structures affirmées. Le jardin des carrés servait autrefois d'écrin à des roses et à des dahlias. Aujourd'hui, c'est un espace vert et paisible.
A droite: Les écuries de ce haras normand ont une architecture caractéristique de la région.
Ci-dessous: La maison contemporaine, créée par l'architecte américain Peter Harden, est surélevée par un talus. Au centre, une pelouse est encadrée par les deux jardins clos de Russell Page.

First page: The imprint of Russell Page is clear in the mastery of architectural elements and the authoritative use of hedges. The garden of square box hedges was once the setting for roses and dahlias. Today it is a reposeful precinct of green.
Right: The stables of this Norman stud farm are fine examples of the regional architecture.
Below: The contemporary house designed by the American architect Peter Harden is built on a low embankment. The central lawn is bordered by Russell Page's two enclosed gardens.

Eingangsseite: Man erkennt den Stil von Russell Page an der Beherrschung der »grünen Architektur«, dem gekonnten Einsatz von Hecken und den eigenwilligen Strukturen. Der Viereckgarten diente früher als Hintergrund für Rosen und Dahlien, bietet aber heute ein rein grünes, ruhiges Bild.
Rechts: Die Stallungen des Gestüts weisen die typische Architektur der Normandie auf.
Unten: Das moderne Wohnhaus nach dem Entwurf des amerikanischen Architekten Peter Harden steht erhöht auf einer Böschung. Die Rasenfläche wird von den beiden von Russell Page angelegten Gartenkammern eingeschlossen.

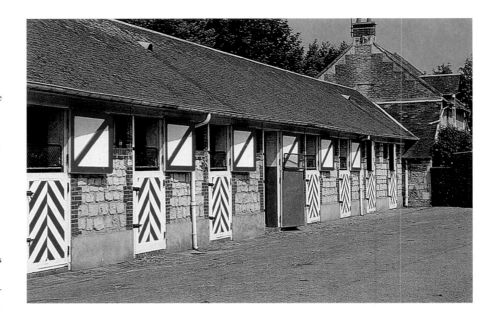

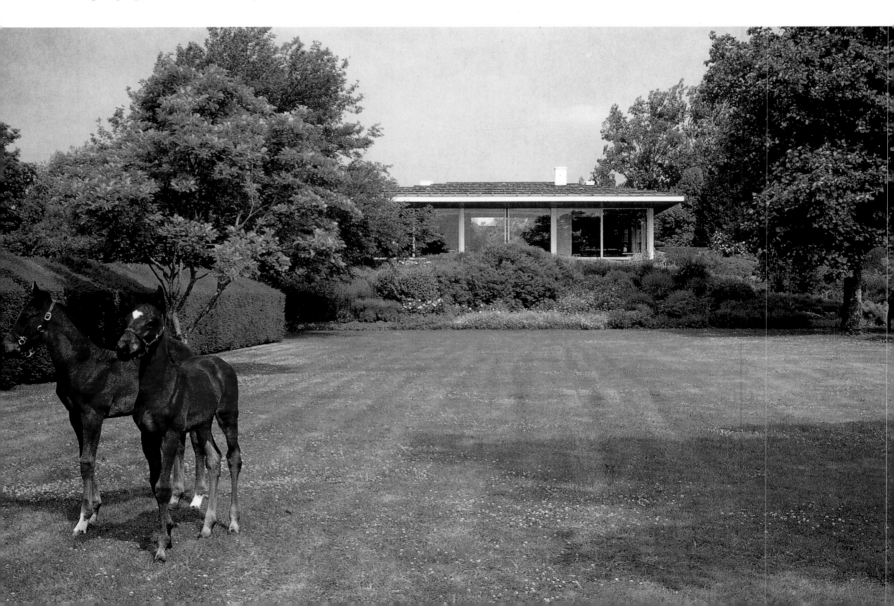

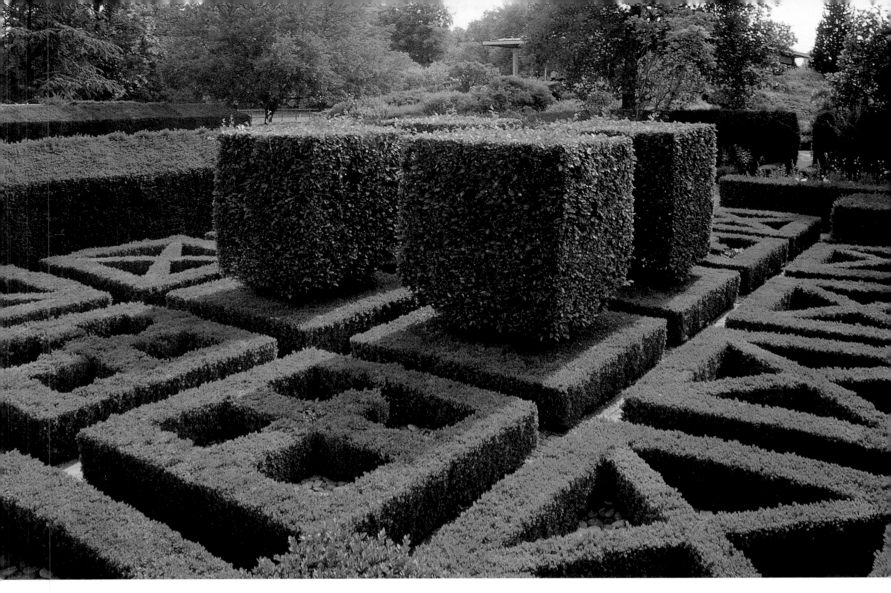

Ci-dessus: le jardin des carrés.
A droite: le jardin des carrés et au fond, la maison. L'œuvre de Russell Page, à Varaville, constitue un lien entre le style contemporain de la demeure et le style normand traditionnel des écuries.

Above: the garden of square box parterres.
Right: the house seen over the box garden. Russell Page's work at Varaville constitutes a link between the contemporary style of the house and the traditional Norman architecture of the stables.

Oben: der Viereckgarten.
Rechts: der Viereckgarten, im Hintergrund das Wohnhaus. Russell Page kombinierte hier in Varaville den modernen Stil des Hauses mit dem traditionell normannischen Stil der Stallungen.

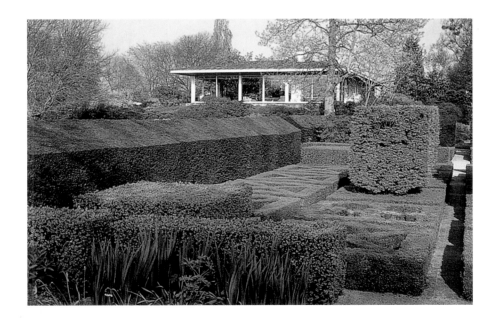

Ci-dessus: Dans la partie non cultivée de l'ancien potager s'est créé un jardin sauvage d'arbres, d'arbustes à fleurs et de plantes vivaces.

Page de droite: Le jardin blanc s'ordonne le long d'un axe. De chaque côté, des ifs taillés en pointe de diamant, sombres et statiques, contrastent joliment avec les rosiers légers où dominent surtout des *Rosa* 'Fée des neiges' blancs.

Above: In the uncultivated part of the former kitchen garden a wild garden has been created with trees, flowering shrubs and perennials.

Facing page: The white garden is organised around a central axis. On each side, the sombre, immobile forms of yews clipped into diamond points act as a foil for the rose bushes, which are for the most part white *Rosa* 'Iceberg'.

Oben: Aus dem brachliegenden Teil des ehemaligen Gemüsegartens ist ein verwilderter Garten mit Bäumen, blühenden Büschen und Stauden geworden.

Rechte Seite: Der weiße Garten gruppiert sich um eine Mittelachse. Zu beiden Seiten bilden die beschnittenen dunkelgrünen Eiben einen hübschen Kontrast zu den locker angelegten Rosenbeeten, die vor allem mit der weiß blühenden Sorte 'Schneewittchen' bestückt sind.

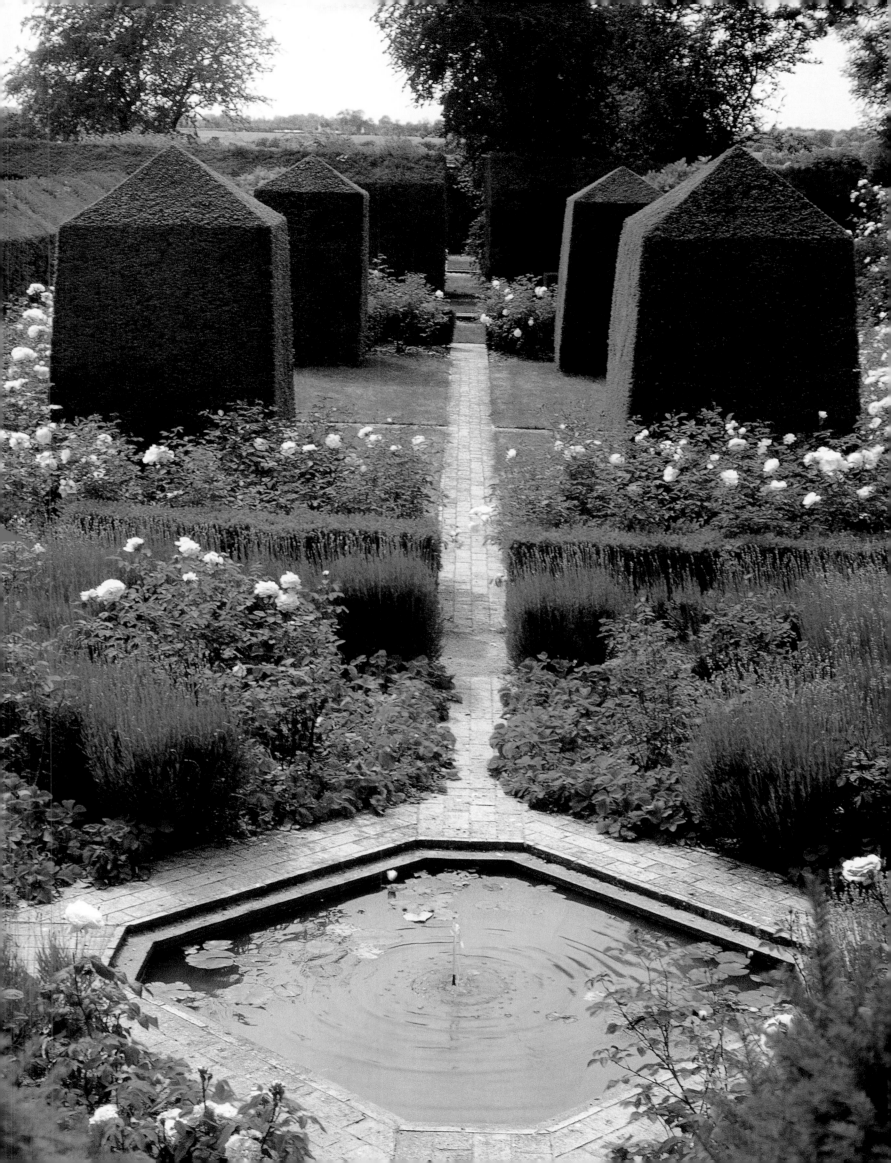

Ce parc normand mêle classicisme et romantisme. Ses axes, ses avenues plantées de grands arbres, son miroir et ses alignements furent conçus dans un esprit français. Ses fabriques signent son appartenance aux jardins du 18e siècle, inspirés des tableaux de Nicolas Poussin, de Claude Lorrain ou d'Hubert Robert, qui représentaient des paysages bucoliques idylliques agrémentés de temples, de turqueries, de kiosques, de chinoiseries, de fausses ruines ou de pagodes. Il fut en effet remanié dans la deuxième partie du 18e siècle par Jean-Baptiste Elie de Beaumont, à la suite d'un voyage en Angleterre où il découvrit, entre autres, les parcs de Stowe et les jardins de Kew. Le parc de Canon lui doit ses statues provenant d'Italie, sa grille à chardons en forme de demi-lune, le temple de la Pleureuse édifié en 1783 en souvenir de Madame de Beaumont, le kiosque chinois magnifiquement placé dans une grande allée ombragée à l'orée des bois et des prés, le pigeonnier du château Béranger, et bien sûr les chartreuses. Jean-Baptiste Elie de Beaumont les appelait ses «fruitiers». Il avait fait construire cette enfilade de jardins pour y obtenir des fruits difficiles à cultiver en Normandie: grâce aux murs protecteurs, pêches, abricots, figues et raisins pouvaient y mûrir. Aujourd'hui, les chartreuses sont fleuries. Les asters, les cosmos ou les lavatères *(Lavatera trimestris)* s'harmonisent avec les vieilles pierres et embellissent la perspective qui s'achève sur la statue de Pomone, déesse des fruits et des jardins.

Canon

This Norman park is a mixture of the romantic and the classical. Its clear, rectilinear layout, avenues planted with mature trees, "miroirs d'eaux" and carefully aligned features are in the French manner. Its follies place it among those 18th-century gardens inspired by the paintings of Nicolas Poussin, Claude Lorrain and Hubert Robert, which portrayed idyllic landscapes featuring temples, Turkish-style buildings, summerhouses, chinoiseries, fake ruins and pagodas. It was in fact revised in the second half of the 18th century by Jean-Baptiste Elie de Beaumont after he had been to England and visited Stowe and Kew Gardens, which are famous for their romantic landscapes and follies. It was he who introduced Italian statues, the gate with a crescent-shaped thistle pattern, and who in 1783 built the Temple of the Mourner in memory of Madame de Beaumont. He also built the Chinese pavilion, beautifully sited in a promenade between the wood and the fields, the dovecote of the Château Béranger, and of course the chartreuses. Jean-Baptiste Elie de Beaumont called them his "fruiterers". He had this row of gardens built in order to cultivate fruit which do not ripen easily in Normandy; thanks to the protecting walls, peaches, apricots, figs and grapes could be grown. Today, the chartreuses are a mass of flowers. Asters, cosmos and tree mallow *(Lavatera trimestris)* form an apt contrast with the old stonework and embellish the vista at the end of which stands Pomona, the goddess of fruits and gardens.

Bei diesem Park in der Normandie vermischen sich Klassizismus und Romantik. Die Blickachsen, die von hohen Bäumen gesäumten Alleen, das große Wasserbecken und die Linienführung folgen den Vorgaben des französischen Barockgartens. Die Ziergebäude allerdings belegen, daß der Park im 18. Jahrhundert entstand. Er orientiert sich an Gemälden von Nicolas Poussin, Claude Lorrain oder Hubert Robert mit ihren bukolischen Idyllen voller Tempel, orientalischen Bauten, Pavillons, Chinoiserien, künstlichen Ruinen und Pagoden. Der Park wurde tatsächlich in der zweiten Hälfte des 18. Jahrhunderts durch Jean-Baptiste Elie de Beaumont neu gestaltet. Er war zuvor nach England gereist und hatte dort unter anderem den Park von Stowe und die Gärten von Kew besichtigt, die seinerzeit als berühmteste Landschaftsgärten der Romantik galten. Der Park von Canon verdankt diesem Vorbild seine italienischen Statuen, den mit halbmondförmigen Eisenspitzen versehenen Zaun, den 1783 zum Andenken an Madame de Beaumont errichteten Tempel der Klagenden, den chinesischen Pavillon, das Taubenhaus von Schloß Béranger und natürlich die Kartausen: Jean-Baptiste Elie de Beaumont nannte sie seine »Fruchtkammern«. Er hatte diese Folge von Gärten anlegen lassen, um Obstsorten zu ziehen, die sonst in der Normandie nicht gedeihen. Dank der schützenden Mauern konnten hier Pfirsiche, Aprikosen, Feigen und Trauben reifen. Heute stehen die Kartausen voller Blumen. Die Astern, Schmuckkörbchen *(Cosmos)* und Bechermalven *(Lavatera trimestris)* harmonieren mit dem alten Mauerwerk und unterstreichen die Blickachse, die zur Statue der Pomona führt – der Göttin der Gärten.

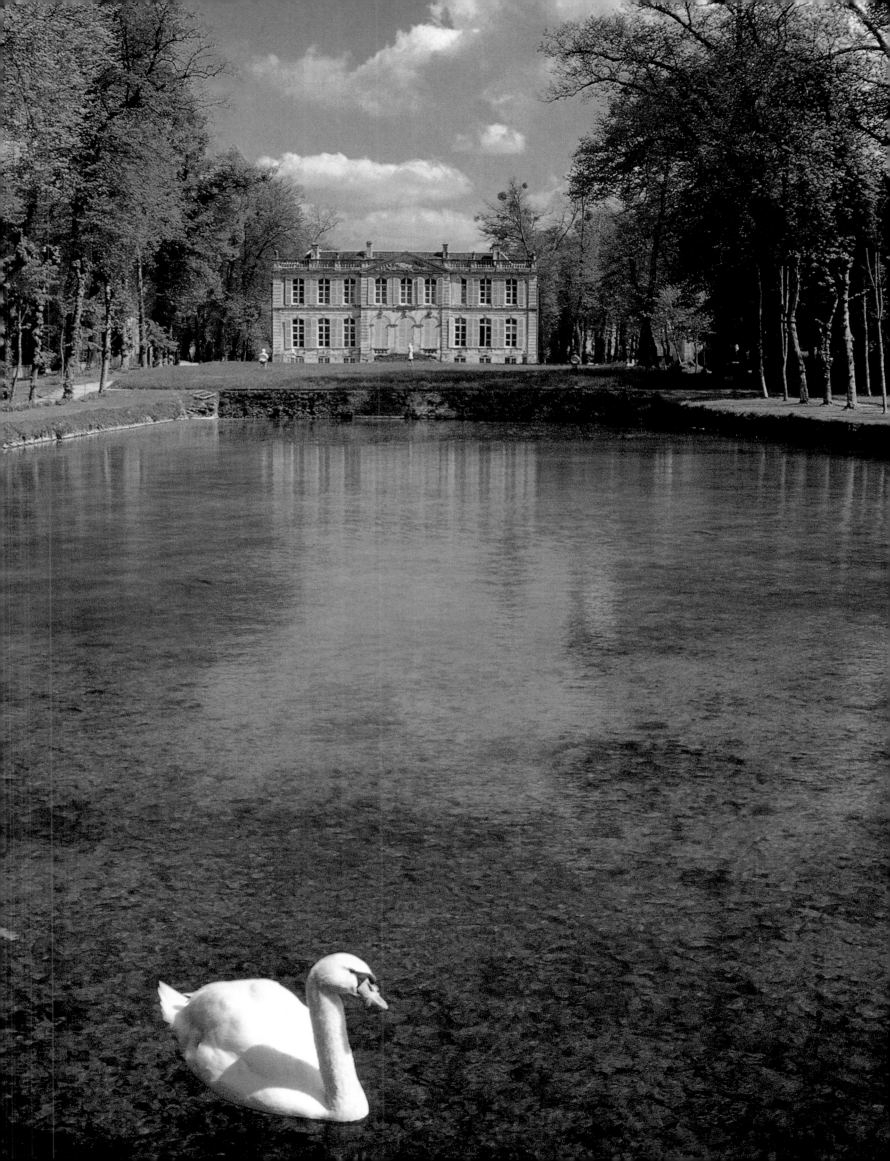

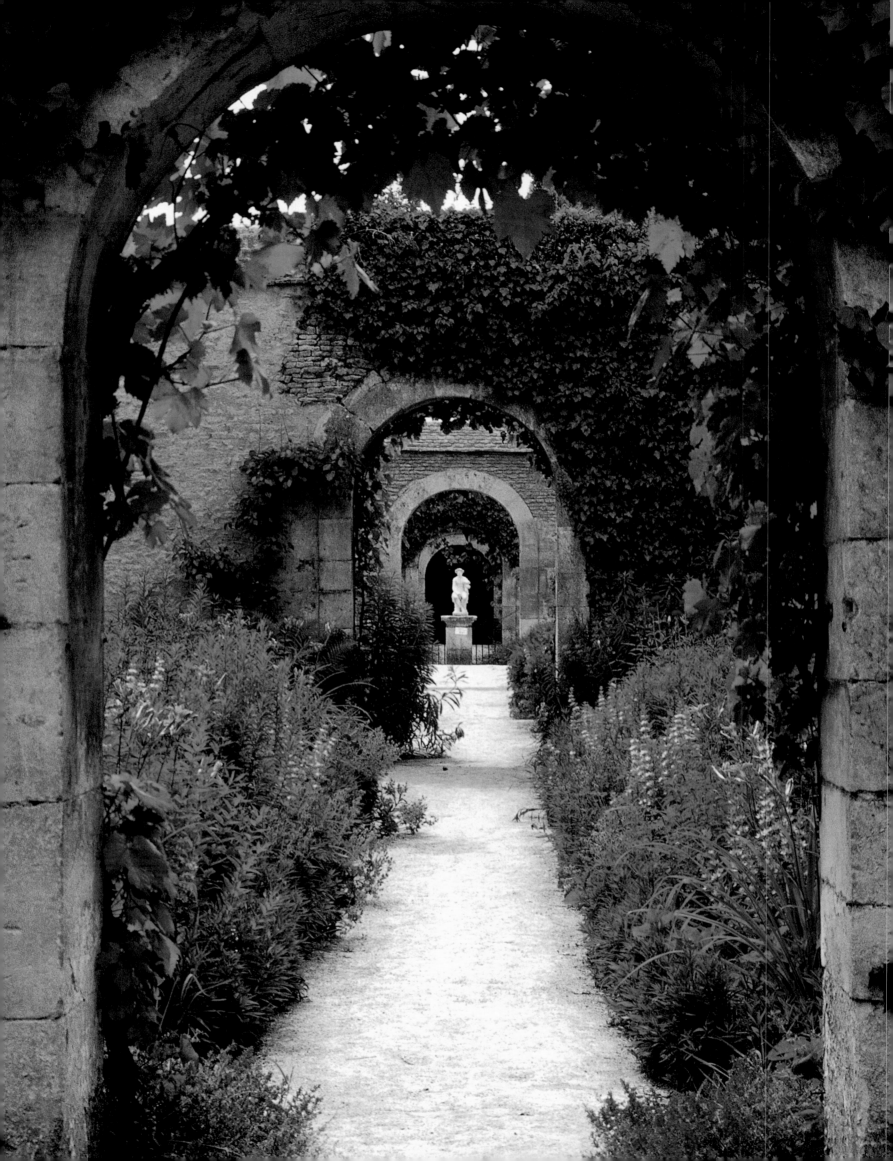

Page précédente: Le château dont la façade ouest fut remaniée par Elie de Beaumont se reflète dans le miroir d'eau.
Page de gauche: L'enfilade des chartreuses où l'on cultivait des arbres fruitiers à l'époque de J.B. Elie de Beaumont, est aujourd'hui fleurie de plantes vivaces. Au fond, la statue de Pomone, déesse des fruits et des jardins.
Ci-dessus: Le parc romantique est orné de statues.

Previous page: The chateau's west façade was revised by Elie de Beaumont and is reflected in the "miroir d'eau".
Facing page: Perennials blossom in the row of chartreuses, which was built by J.B. Elie de Beaumont to protect his fruit trees. At the end of the row stands the statue of Pomona, the goddess of fruits and gardens.
Above: Statues reveal the park in its romantic aspect.

Vorhergehende Seite: Das Schloß, dessen Westfassade von Elie de Beaumont umgestaltet wurde, spiegelt sich in dem großen Wasserbecken.
Linke Seite: Die Enfilade der Kartausen, in denen zur Zeit J.B. Elie de Beaumonts Obstbäume kultiviert wurden, ist heute mit Stauden bepflanzt. Im Hintergrund Pomona, die Göttin der Gärten.
Oben: Der romantische Park ist mit Statuen geschmückt.

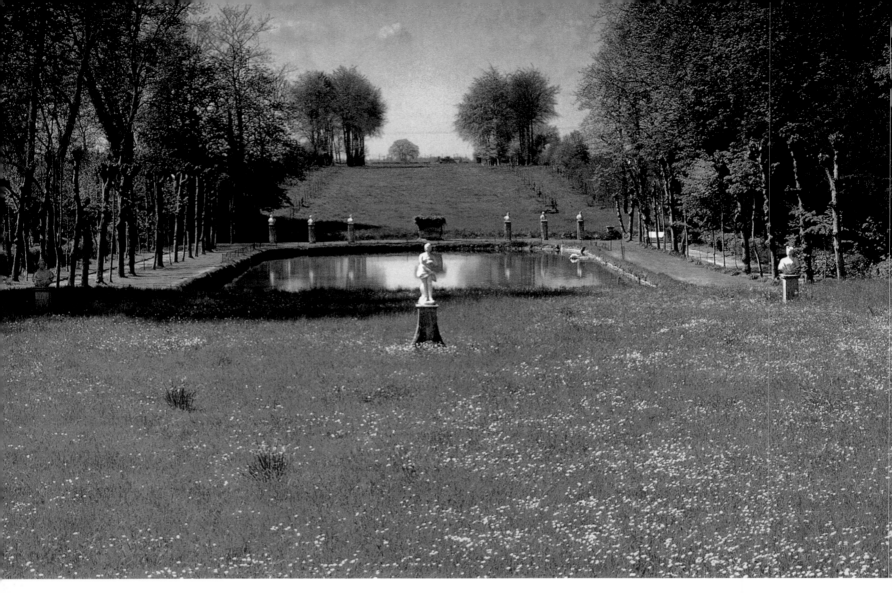

Ci-dessus: Des bustes d'empereurs romains et de divinités antiques bordent le miroir d'eau qui s'inscrit dans le parc. Les arbres ménagent une percée visible de la façade ouest du château.
A droite: le pavillon du château Béranger, une des fabriques du parc.

Above: Busts of emperors and gods line the banks of the "miroir d'eau". The trees are aligned to offer a view of the west façade of the chateau.
Right: the pavilion of the Château Béranger, one of the follies in the park.

Oben: Die Büsten römischer Kaiser und antiker Gottheiten säumen das große Wasserbecken im Park. Die Bäume geben den Blick auf die Westfassade des Schlosses frei.
Rechts: der Pavillon von Schloß Béranger, eines der Ziergebäude im Park.

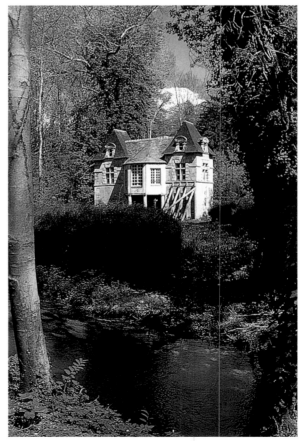

Canon *Normandie*

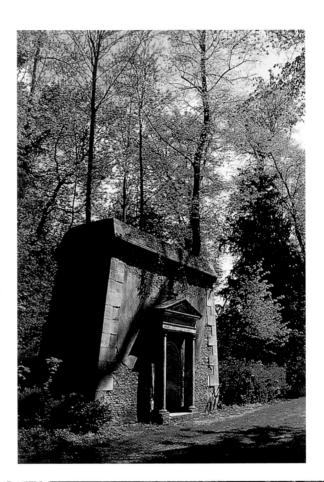

A droite: Le pigeonnier du château Béranger est orné en son milieu d'un décor néoclassique.
Ci-dessous: Le temple de la Pleureuse est une fabrique qui fut construite en 1783 par Elie de Beaumont à la mémoire de son épouse.

Right: The dovecote of the Château Béranger is ornamented with a classical pediment.
Below: The Temple of the Mourner is a folly built by Elie de Beaumont in 1783 in memory of his wife.

Rechts: Der Eingang des Taubenhauses von Schloß Béranger ist mit klassizistischem Dekor verziert.
Unten: Den Tempel der Klagenden ließ Elie de Beaumont 1783 zum Andenken an seine Gattin errichten.

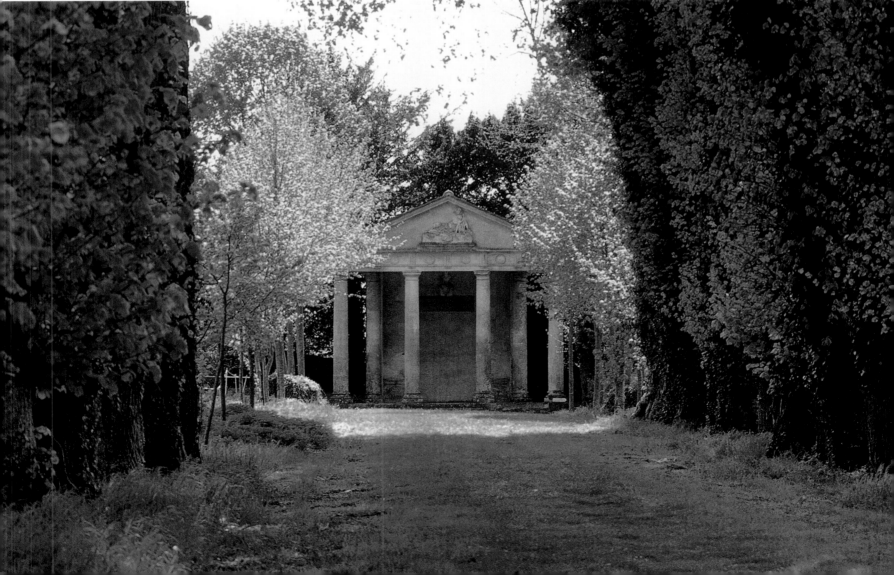

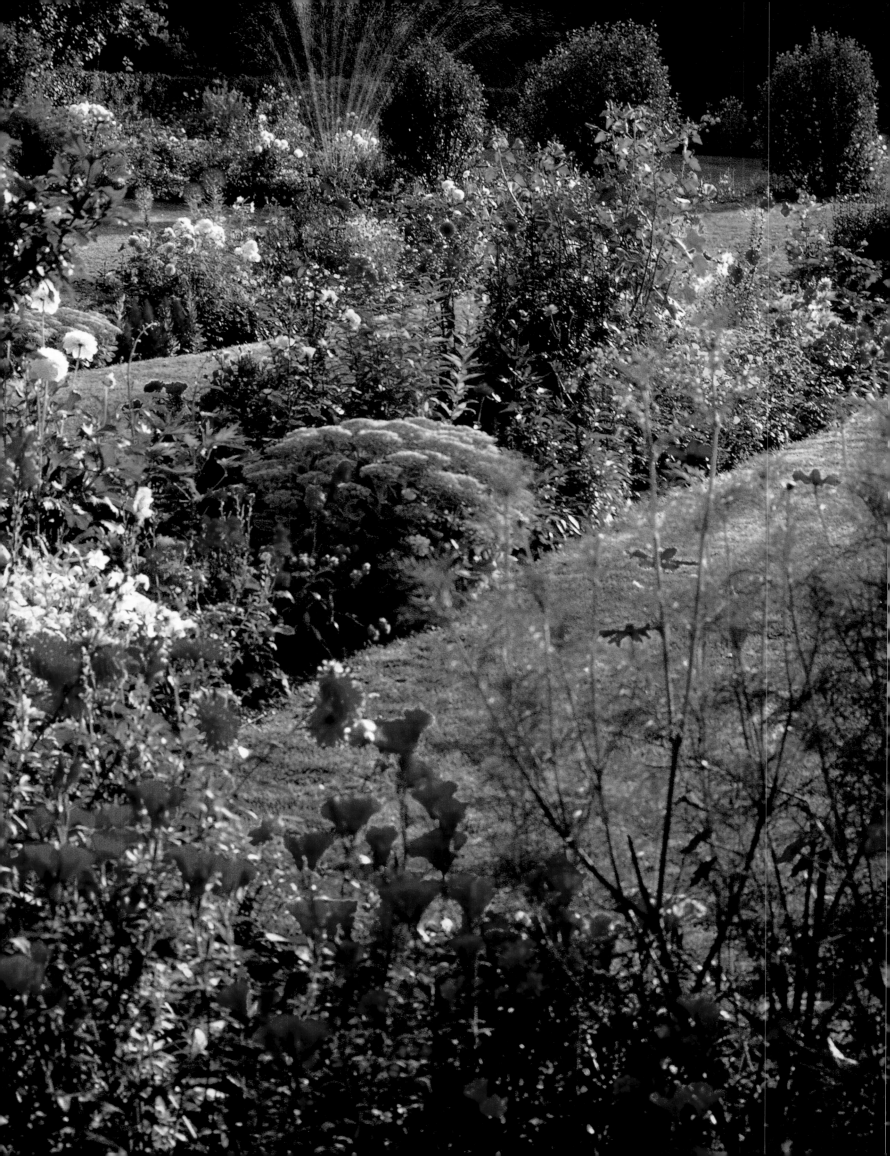

Les tresses de fleurs étaient autrefois un symbole de perfection spirituelle et de vie éternelle. Celle du duc d'Harcourt traduit les mêmes sentiments élevés et dessine un jardin dont on peut admirer la pureté du tracé. C'est un jardin d'été qu'on découvre sans s'y attendre. La guirlande se déroule sur un tapis vert. Elle épouse les formes d'un jardin à la française géométrique, sobre et symétrique. Celui-ci est ordonné selon deux grands axes qui se coupent à angle droit. Le centre de la composition est marqué par un cercle composé d'hibiscus qui précisent le coin des allées. Pour comprendre ce jardin, il faut se le faire raconter car il est chargé de messages. Il s'adresse à nos sens et à notre esprit. La vue est charmée par la couleur des fleurs, l'odorat est éveillé par leur parfum, l'ouïe par la multitude d'insectes qui les butinent, le toucher par la douceur du tapis vert moelleux. L'esprit, quant à lui, est comblé par l'harmonie dont voici les ingrédients: «L'architecture, la peinture, la musique et la philosophie prêtent leur concours à la création d'un beau jardin. Le dessin relève de l'architecture, le choix des couleurs, de la peinture, le rythme observé dans les tonalités, de la musique. Enfin, l'importance donnée aux espaces vides est le propre du philosophe. Le vide n'est-il pas un appel, un centre autour duquel tout s'ordonne? Les fleurs doivent le plus souvent servir de parure aux espaces vides» (Duc d'Harcourt). N'est-ce pas là une belle leçon d'art des jardins?

Thury-Harcourt

In the past, flower garlands were a symbol of spiritual perfection and eternal life. These elevated sentiments are one aspect of the admirable garden created by the Duc d'Harcourt, as its outline is traced by a "garland". It is a summer garden which gives onto the park below it, though the park is invisible from most of the garden. The garland is laid against a background of lawn. It encloses a French garden of geometrical symmetry, whose two main perpendicular axes divide it into four rectangles. At the centre of the composition, a hibiscus circle marks the intersection of the garden paths. This is a garden which requires explanation; it is full of overtones, and has designs on the visitor's mind and senses. The profusion of flowers appeals to the eye, their scents to the nose, the constant hum of insect life to the ear, and the luxuriously soft lawn underfoot to the touch. And the mind is enchanted by the harmony, which the Duc d'Harcourt has described in these terms: "Architecture, painting, music and philosophy are brought together in the creation of a beautiful garden. Outline pertains to architecture, the choice of colours to painting, and the rhythm to be observed among the colours to music. Finally, the importance given to empty space is proper to philosophy. For is not the void a summons in itself, and the centre around which everything revolves? Flowers must generally be used to ornament empty space." Does this not admirably summarise the art of the garden?

Blumengirlanden waren einst Symbol der Vollkommenheit des Geistes und des ewigen Lebens. Auch auf dem Besitz des Grafen von Harcourt wecken sie die gleichen erhabenen Gefühle und zieren zugleich einen Garten, an dem man die Reinheit der Linienführung bewundern kann. Es ist ein etwas tiefer gelegener Sommergarten, der ganz unvermittelt auftaucht. Die Girlande entrollt sich auf einem grünen Teppich und konturiert den geometrisch-symmetrischen, zurückhaltenden Barockpark, dessen zwei senkrecht zueinander verlaufende Hauptachsen vier Rechtecke entstehen lassen. Das Zentrum der Komposition ist durch ein rund angelegtes Hibiskusbeet am Schnittpunkt der Wege markiert. Um den Garten zu verstehen, muß man ihn sich erzählen lassen, denn er steckt voller Botschaften. Er richtet sich an unsere Sinne und unseren Geist. Dem Auge schmeicheln die Farben der Blumen, der Nase ihre Düfte, dem Ohr die Myriaden von Insekten, dem Tastsinn der weich nachgebende Grasteppich. Der Geist wiederum ist von der Harmonie beeindruckt, die der Graf von Harcourt so beschrieben hat: »Architektur, Malerei, Musik und Philosophie wetteifern darum, einen schönen Garten zu schaffen. Der Entwurf wurzelt in der Architektur, die Wahl der Farben in der Malerei, der Rhythmus der Schattierungen in der Musik. Und die Bedeutung, die den Leerräumen zugestanden wird, ist der Philosophie eigen. Ist die Leere nicht eine Mahnung, ein Zentrum, dem sich alles unterordnet? Die Blumen dienen meist nur als Schmuck für die Leerräume«. Was für eine schöne Lektion in Gartenkunst!

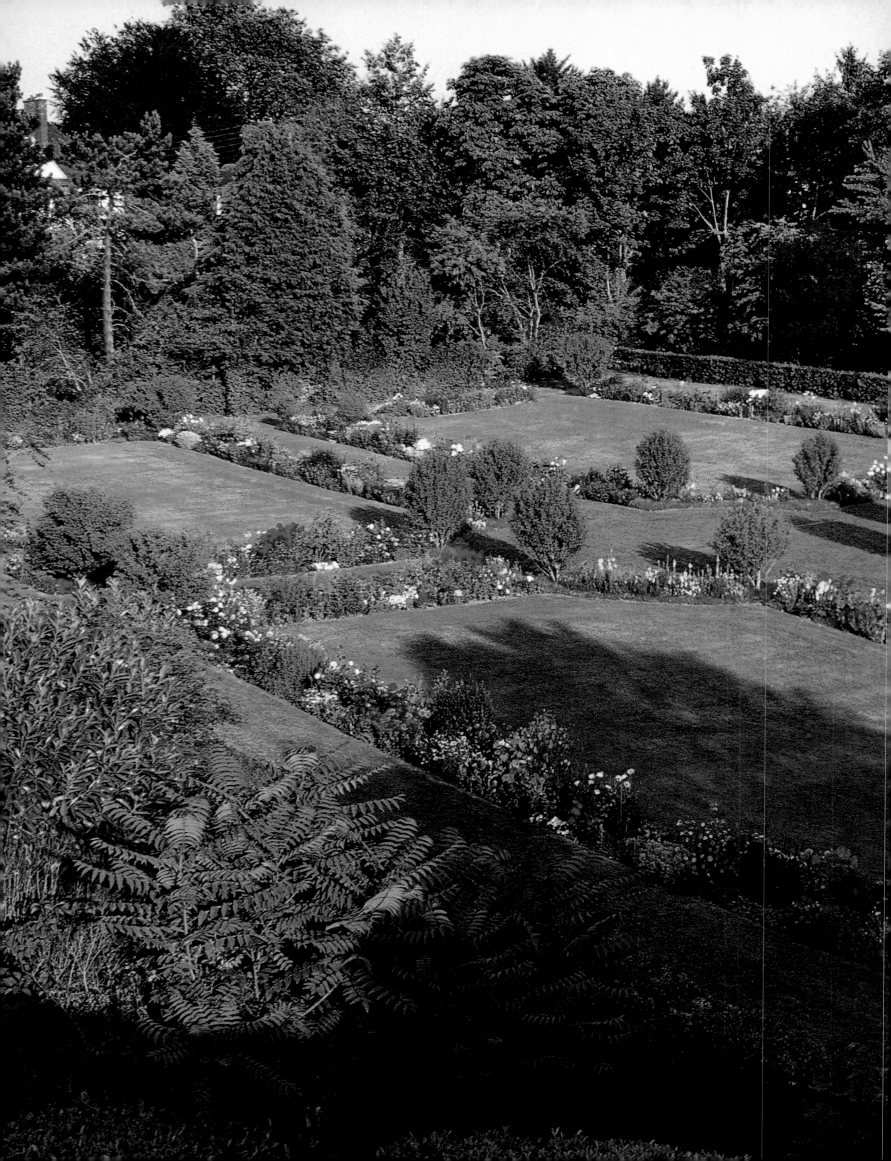

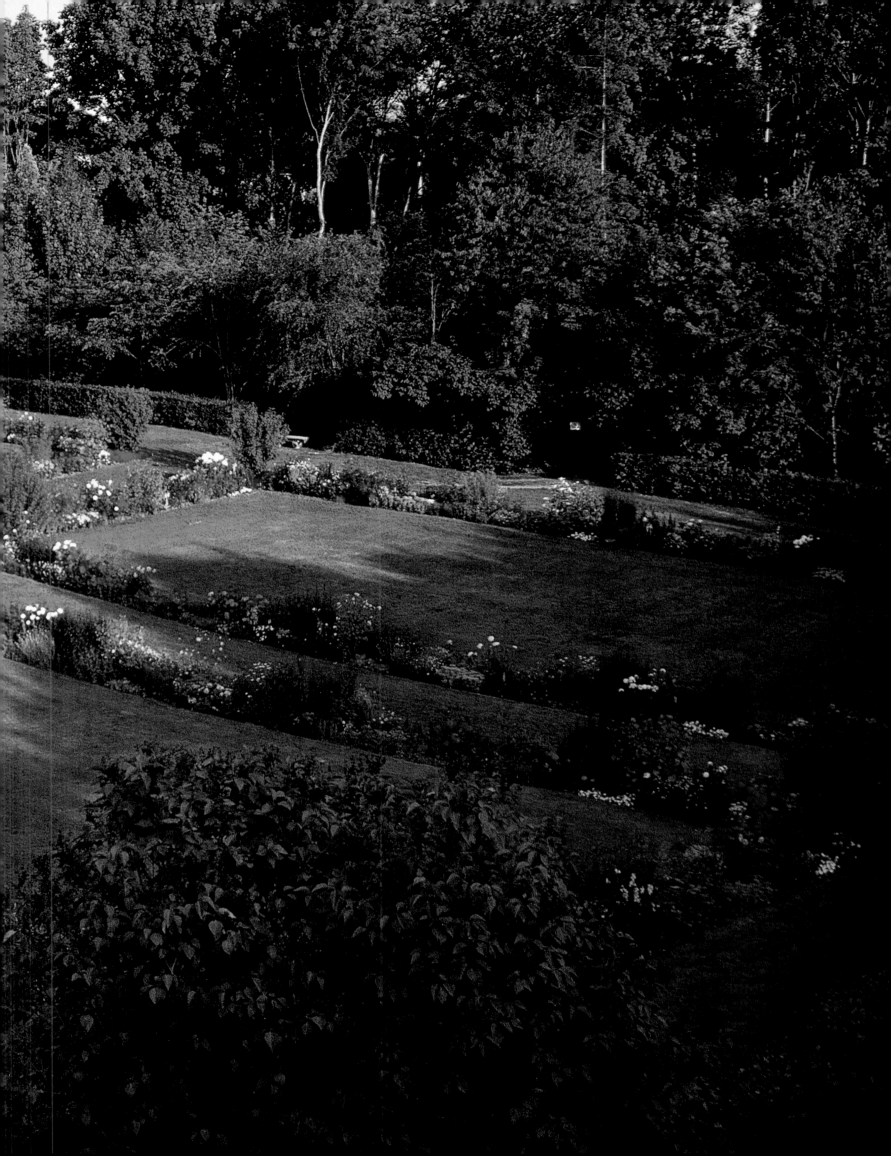

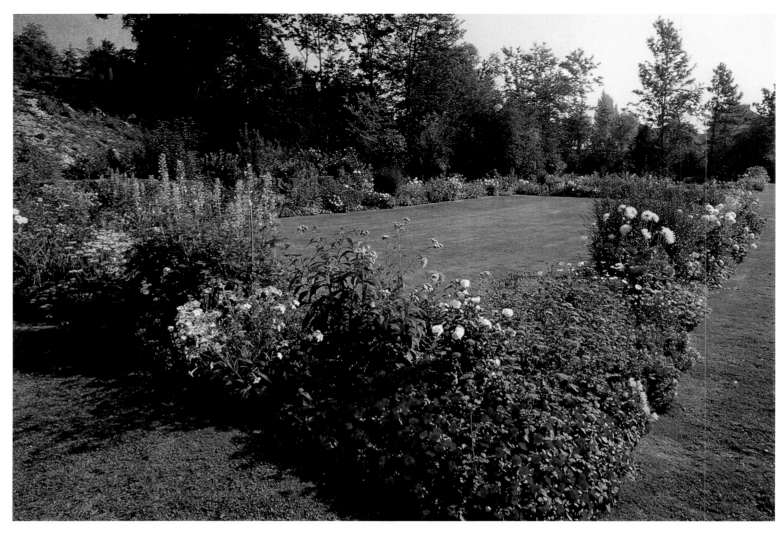

Première page: Les plates-bandes fleuries sont composées d'annuelles, de bisannuelles, de plantes vivaces ou de dahlias. Ici, on distingue des sédums, des fenouils, des lavatères et des zinnias.
Double page précédente: vue générale du jardin d'été où la guirlande de fleurs suit le tracé d'un jardin à la française justement proportionné. Le duc d'Harcourt a en effet suivi la règle du nombre d'or.
Ci-dessus: Le jardin est constitué de quatre grands rectangles fleuris.
A droite: gros plan sur un détail de la guirlande composée, entre autres, de cosmos et de tabacs *(Nicotiana)*.
Page de droite: une allée ombragée du parc.

First page: The flowerbeds are made up of annuals, biennials, perennials and dahlias. Here stonecrops *(Sedum)*, fennel, *Lavatera* and *Zinnia* are visible.
Previous pages: an overall view of the summer garden, in which the flower garland follows the outline of a French garden of admirable proportions. The Duc d'Harcourt has followed the prescriptions of the Golden Section.
Above: The garden is formed by four large rectangles of flower beds.
Right: a detail of the garland, which is woven of cosmos, tobacco plants *(Nicotiana)* and others.
Facing page: a shady walk in the park.

Erste Seite: Die Blumenbeete setzen sich aus ein- und zweijährigen Pflanzen, Stauden und Dahlien zusammen. Auf dem Bild erkennt man Fetthenne *(Sedum)*, Fenchel, Bechermalven *(Lavatera)* und Zinnien *(Zinnia)*.

Vorhergehende Doppelseite: Gesamtansicht des Sommergartens, in dem die blühende Girlande nach den Regeln eines korrekt proportionierten Barockparks angelegt wurde. Der Graf von Harcourt befolgte die Regel des Goldenen Schnitts.
Oben: Der Garten besteht aus vier großen Rechtecken, die von blühenden Rabatten gebildet werden.
Rechts: Detail der Girlande, an dem Schmuckkörbchen *(Cosmos)* und Ziertabak *(Nicotiana)* vorherrschen.
Rechte Seite: ein schattiger Laubengang des Parks.

Thury-Harcourt *Normandie*

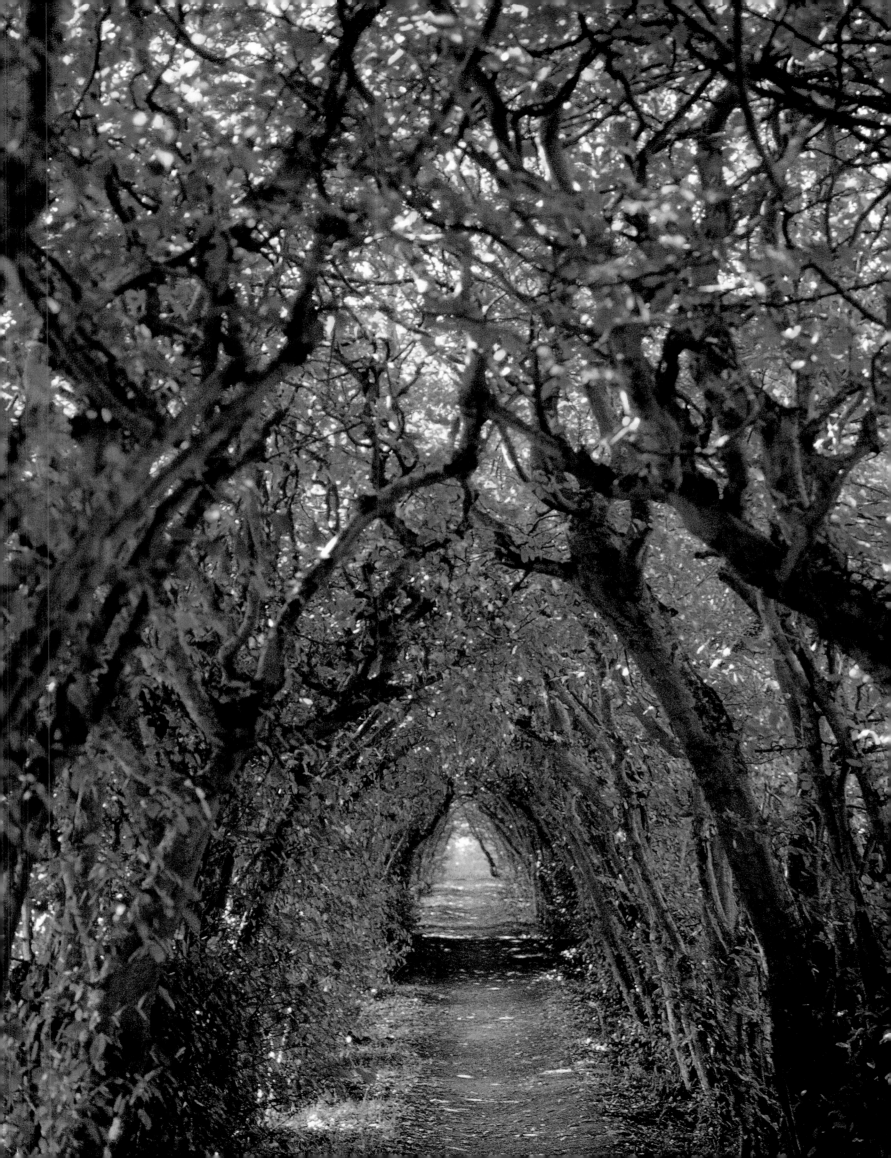

Le climat du Cotentin est très particulier. Il rappelle celui d'Inverewe en Ecosse ou celui des Iles Scilly. Très venteux, il peut gêner les végétaux, les plier et les torturer. Très doux, du fait de la présence du Gulf Stream passant à proximité, il permet de cultiver des plantes qui normalement ne devraient pas prospérer sous cette latitude. Vauville fait donc exception sur la côte normande. C'est un jardin botanique subtropical, planté de végétaux originaires de l'hémisphère austral. Le jardin est né du talent et de la curiosité d'Eric Pellerin à partir de 1947, date à laquelle il prit le destin de la propriété en main. Depuis quelques années, sa fille et son fils Guillaume, aidé de son épouse Cléophée et de ses enfants, l'entretiennent, l'agrandissent et enrichissent ses collections avec passion. Composé de chambres de verdure au tracé informel, il se déploie autour du château. Pour empêcher le vent d'être trop violent, Eric Pellerin planta des haies géantes de phormiums, d'escallonias, d'éryngiums, de gynériums *(Cortaderia selloana)* ou de gunneras qui protègent des plantes délicates ou frileuses comme les agaves, les aloès, les alstroémères ou les dimorphothecas. L'ambiance est très particulière: luxuriante, naturelle, spectaculaire, exotique et normande à la fois. Le jardin est beau en toute saison car les écorces et les feuillages persistants sont légion. Les végétaux plantés en masse créent à la belle saison des taches de couleur bienvenues qui mettent en valeur les toits d'ardoise et les murs de granit du château.

Le jardin du Château de Vauville

The climate of the Cotentin area is rather unusual; it is like that of Inverewe in Scotland or the Scilly Isles. The strength of the wind can deform and flatten plants. The proximity of the Gulf Stream means that plants that would not normally flourish at this latitude can be successfully cultivated. Vauville is therefore a rather exceptional case among the gardens of the Normandy coast. It is a subtropical botanical garden planted with flora from the southern hemisphere. The garden is the product of the talent and curiosity of Eric Pellerin, who took over the property in 1947. Over the last few years, he has been ably assisted by his daughter, his son Guillaume and daughter-in-law Cléophée and their children. The garden is made up of "green rooms" of irregular shape, and stretches from the walls of the chateau down to the sea. Eric Pellerin planted windbreaks: giant hedges of New Zealand flax *(Phormium)*, *Escallonia, Eryngium,* pampas grass *(Cortaderia selloana)* and *Gunnera* protect plants that are delicate or vulnerable to the cold, such as agaves, aloes, *Alstroemeria* and Cape marigold *(Dimorphotheca)*. Vauville has a very special atmosphere: luxuriant, spectacular, exotic and Norman. The garden is beautiful throughout the year, thanks to the extraordinary variety of evergreens and coloured barks. Great clumps of a single blossom form masses of colour in the summer, admirably setting off the slate roof and granite walls of the chateau.

Das Klima auf der Halbinsel Cotentin ist außergewöhnlich. Es ähnelt dem von Inverewe in Schottland oder der Scilly Islands. Es ist sehr windig, was den Pflanzen schaden kann. Gleichzeitig ist es sehr mild, weil der Golfstrom ganz in der Nähe verläuft, so daß man hier Gewächse ziehen kann, die normalerweise in diesen Breiten niemals gedeihen. Vauville nimmt deshalb in der Normandie eine Sonderstellung ein. Es handelt sich um einen subtropischen botanischen Garten, der mit Gewächsen der südlichen Halbkugel bestückt ist. Der Garten verdankt seine Entstehung dem Können und der Neugier von Eric Pellerin, der seit 1947 die Geschicke des Anwesens leitet. Seit einigen Jahren unterstützen ihn seine Tochter, sein Sohn Guillaume, dessen Frau Cléophée und ihre Kinder. Die Anlage setzt sich aus unregelmäßig geformten Heckengärten zusammen und erstreckt sich rings ums Schloß bis ans Meer. Damit der Wind nicht zuviel Angriffsfläche findet, pflanzte Eric Pellerin riesige Hecken aus Neuseeländer Flachs *(Phormium)*, Escallonien, Edeldisteln *(Eryngium)*, Pampasgras *(Cortaderia selloana)* oder Mammutblatt *(Gunnera)* als Schutz für wind- und kälteempfindliche Gewächse wie Agaven, Aloe, Inkalilien *(Alstroemeria)* oder Kapkörbchen *(Dimorphotheca)*. Die Atmosphäre hat etwas ganz Besonderes, sie ist üppig, natürlich, spektakulär, exotisch und gleichzeitig normannisch. Der Garten bietet zu allen Jahreszeiten einen schönen Anblick, denn auch im Winter gibt es interessante Rinden und immergrünes Laub zu bestaunen. Im Sommer sorgen die in großen Gruppen komponierten Blumen für willkommene Farbtupfer, die sich von den schönen Schieferdächer und Granitmauern des Schlosses abheben.

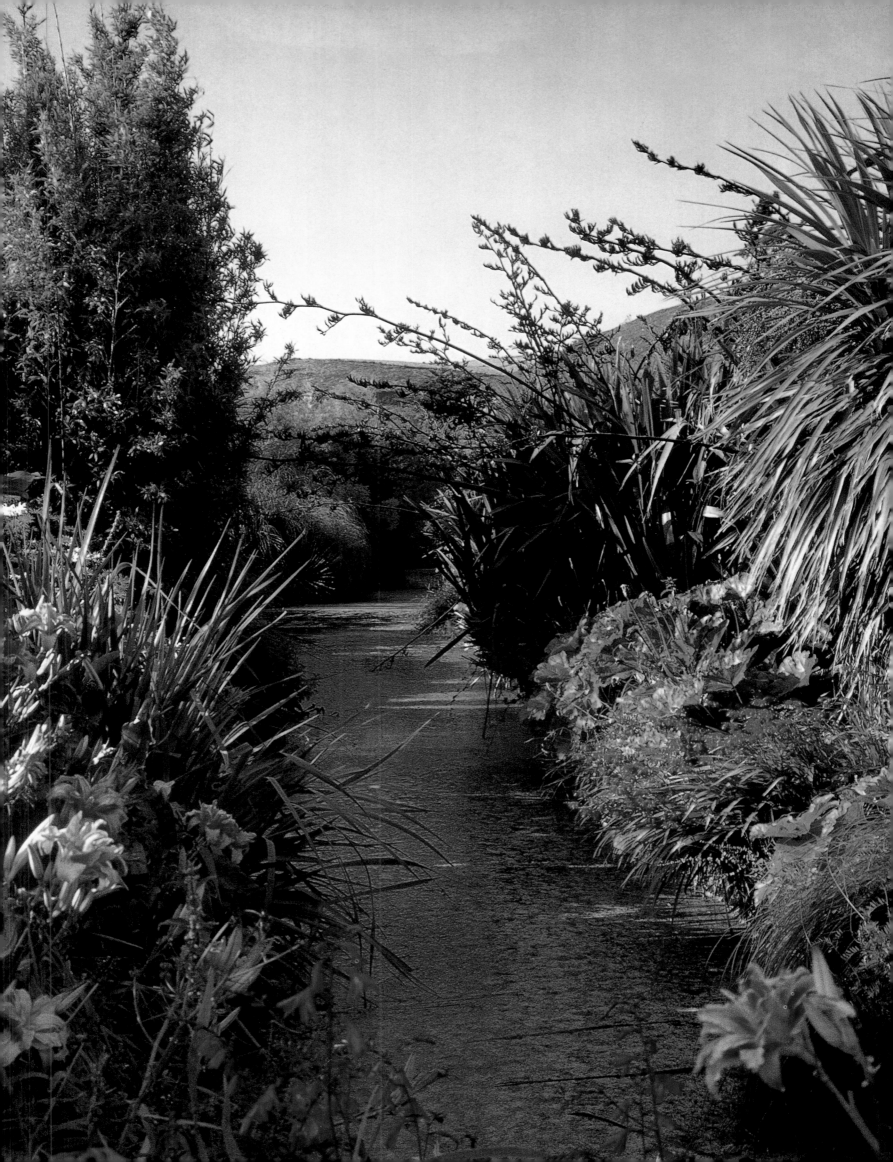

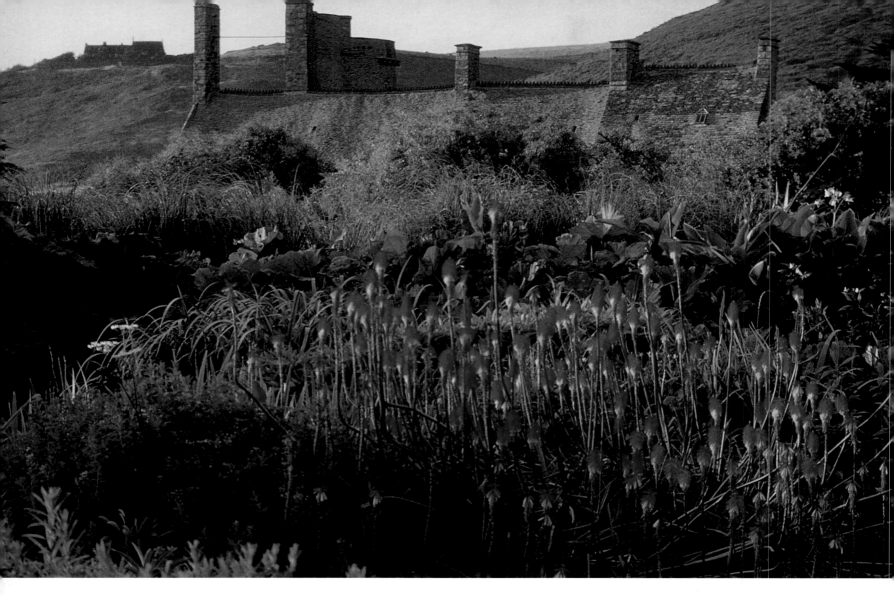

Page précédente: Sur les bords d'un ruisseau qui se jette dans la mer, des hémérocalles, des phormiums et des crocosmias se mêlent à une végétation subtropicale.
Ci-dessus et à droite: Pour que les plantes se défendent mieux contre le vent, le créateur de ce jardin a choisi de les planter en masse, comme ces kniphofias qui lancent leurs goupillons orange ou jaunes vers le ciel. Le jardin étant situé très près de la mer, les plantes doivent aussi être capables de résister aux embruns.

Previous page: On the banks of a stream that flows into the sea, day lilies *(Hemerocallis),* New Zealand flax *(Phormium)* and *Crocosmia* mingle with the subtropical plants.
Above and right: Eric Pellerin planted flowers in clumps to protect them from the wind, as we can see with these orange- and yellow-wattled red hot pokers *(Kniphofia)* waving in the breeze. Since the garden is so close to the sea, the plants must also be capable of surviving spindrift.

Vorhergehende Seite: Am Rand eines Baches, der ins Meer fließt, stehen inmitten der subtropischen Flora Taglilien *(Hemerocallis),* Neuseeländer Flachs *(Phormium)* und Montbretien *(Crocosmia).*
Oben und rechts: Um die Pflanzen vor dem Wind zu schützen, stellte der Gartenarchitekt sie zu großen Gruppen zusammen, etwa diese Fackellilien *(Kniphofia),* die ihre orangeroten und gelben Wedel emporrecken. Da der Garten nah am Meer liegt, müssen die Pflanzen auch die salzige Gischt vertragen.

Le jardin du Château de Vauville *Normandie*

A droite et ci-dessous: Le jardin botanique se déploie au pied du château, dans les douves, à l'abri du vent, et dans les chambres de verdure qui rejoignent la mer.
Double page suivante: Abélias, agapanthes bleues, monardes roses, échiums, cordylines et pavots en arbre *(Romneya coulteri)* blancs plantés en masse créent une atmosphère d'abondance et de luxuriance.

Right and below: The botanical garden is situated at the foot of the chateau walls, in the shelter of the moat, and in the "green rooms" which lead down to the sea.
Following pages: Abelia, blue *Agapanthus*, pink bergamot *(Monarda),* viper's-bugloss *(Echium), Cordyline* and white Californian poppies *(Romneya coulteri)* planted in clumps create an atmosphere of luxuriant abundance.

Rechts und unten: Der botanische Garten erstreckt sich im Windschutz der ehemaligen Burggräben am Fuße des Schlosses und in den Heckengärten, die bis ans Meer heranreichen.
Folgende Doppelseite: Abelie, blaue Schmucklilie *(Agapanthus),* rosa Indianernessel *(Monarda),* Natternkopf *(Echium),* Keulenlilie *(Cordyline)* und weißer Baummohn *(Romneya coulteri)* sind in großen Gruppen zusammengepflanzt und schaffen eine Atmosphäre großzügiger Fülle.

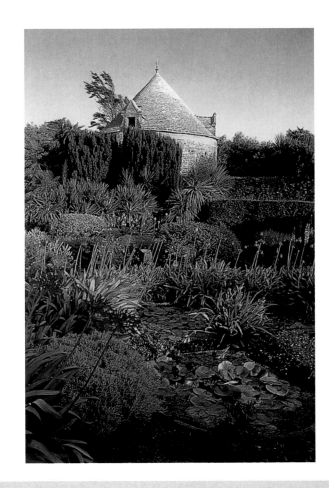

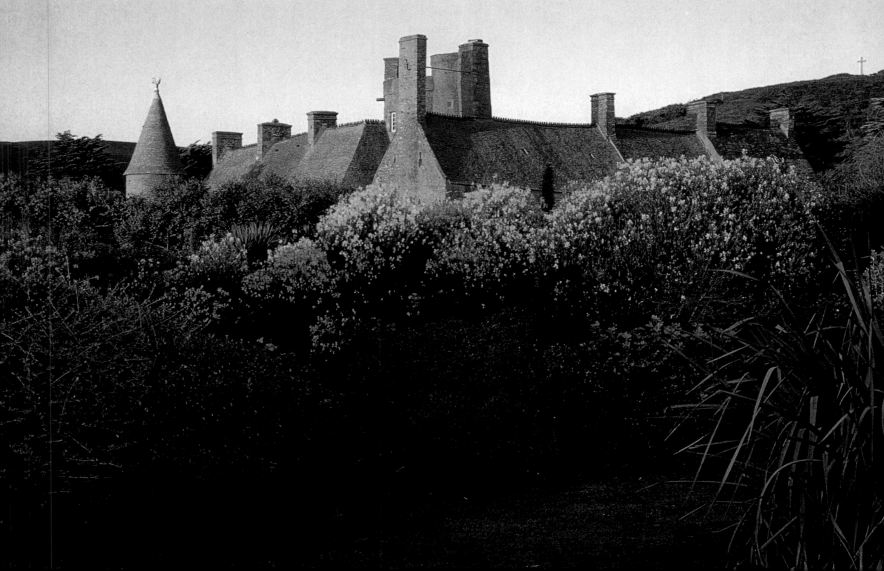

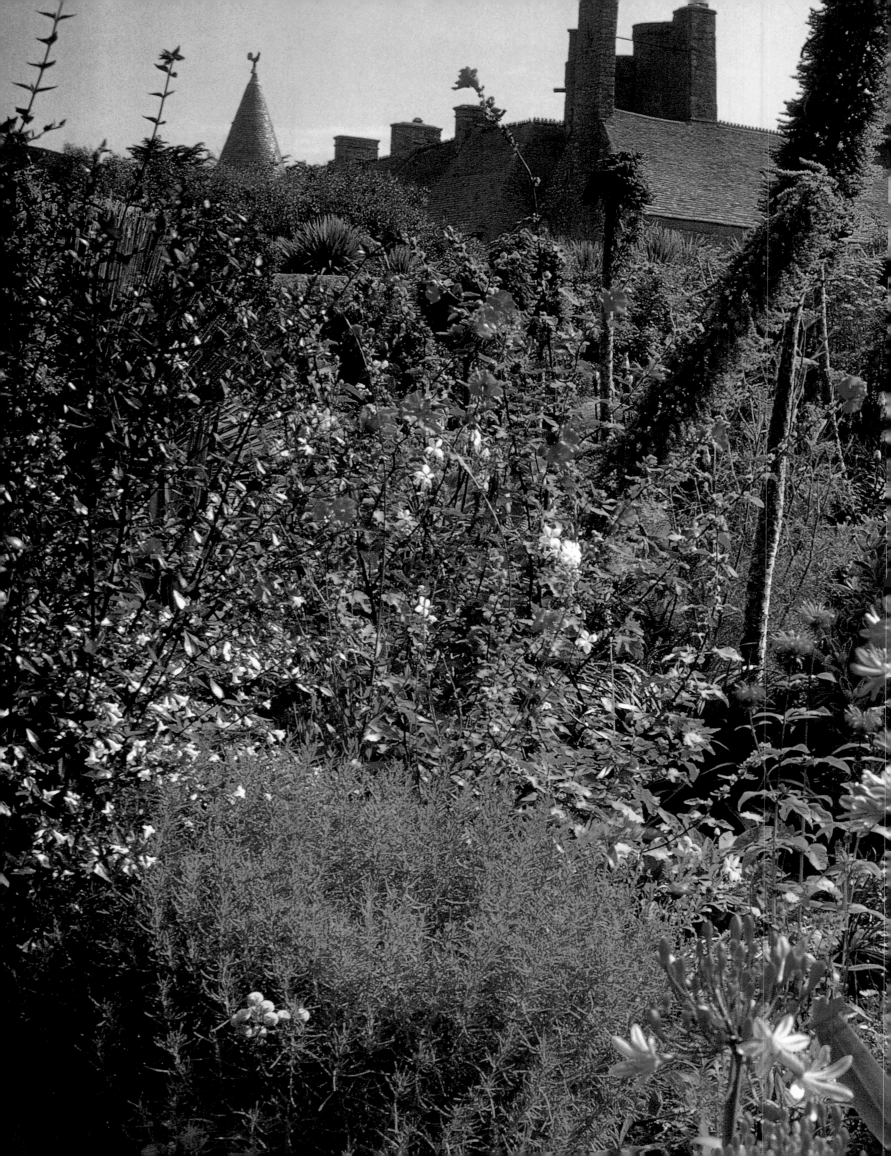

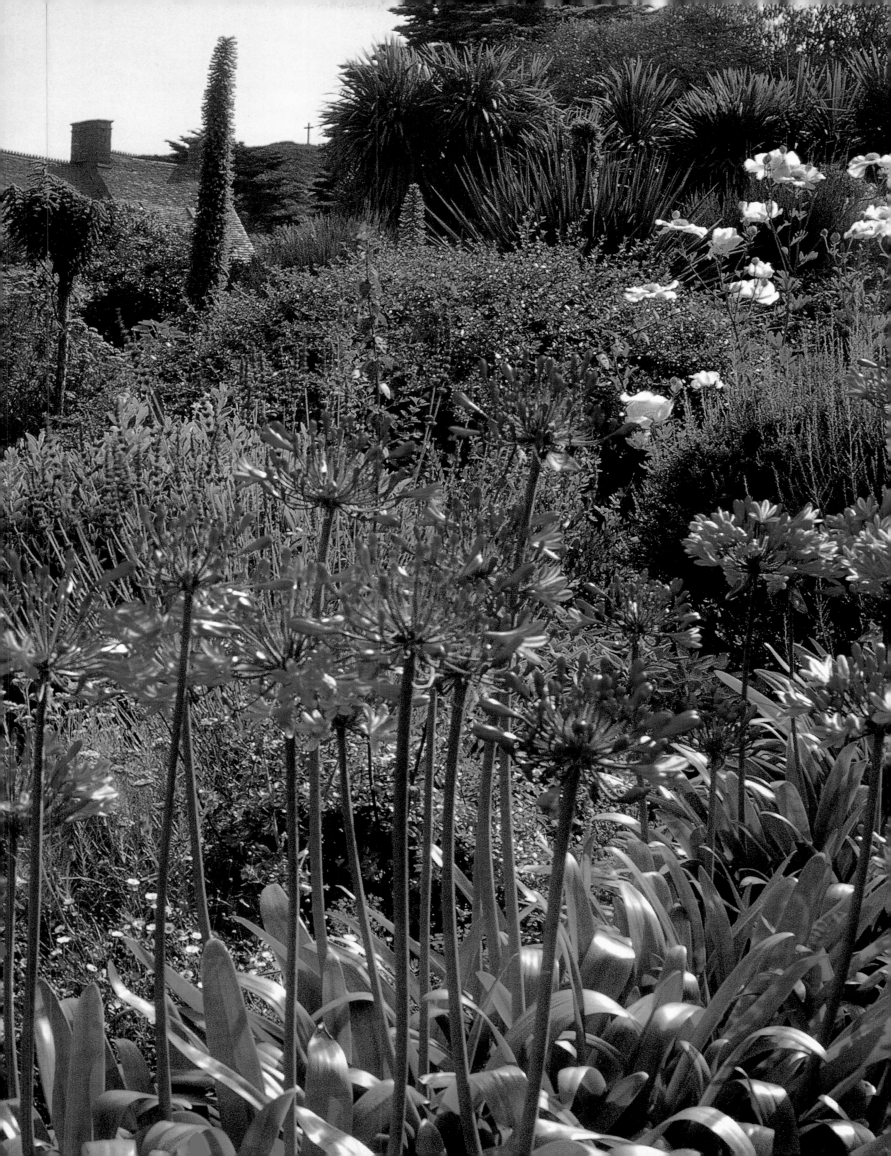

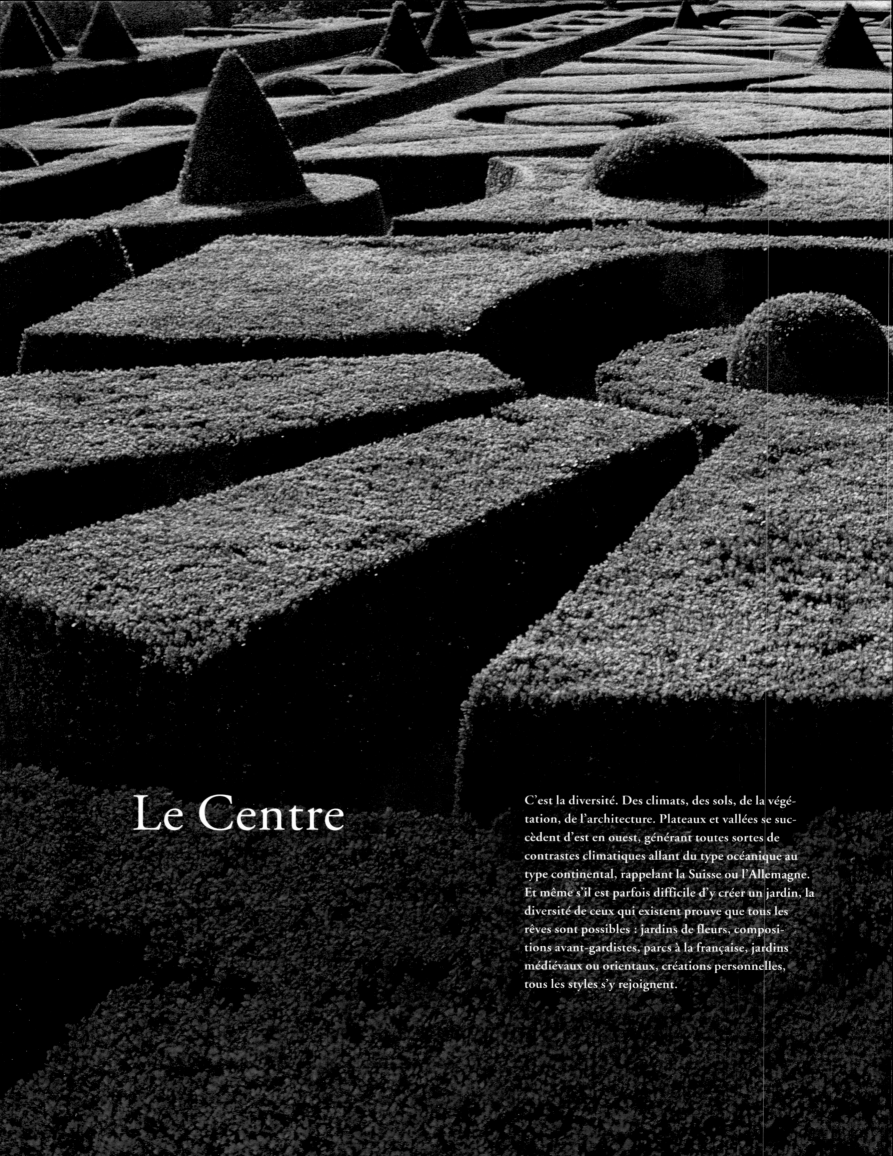

Le Centre

C'est la diversité. Des climats, des sols, de la végétation, de l'architecture. Plateaux et vallées se succèdent d'est en ouest, générant toutes sortes de contrastes climatiques allant du type océanique au type continental, rappelant la Suisse ou l'Allemagne. Et même s'il est parfois difficile d'y créer un jardin, la diversité de ceux qui existent prouve que tous les rêves sont possibles : jardins de fleurs, compositions avant-gardistes, parcs à la française, jardins médiévaux ou orientaux, créations personnelles, tous les styles s'y rejoignent.

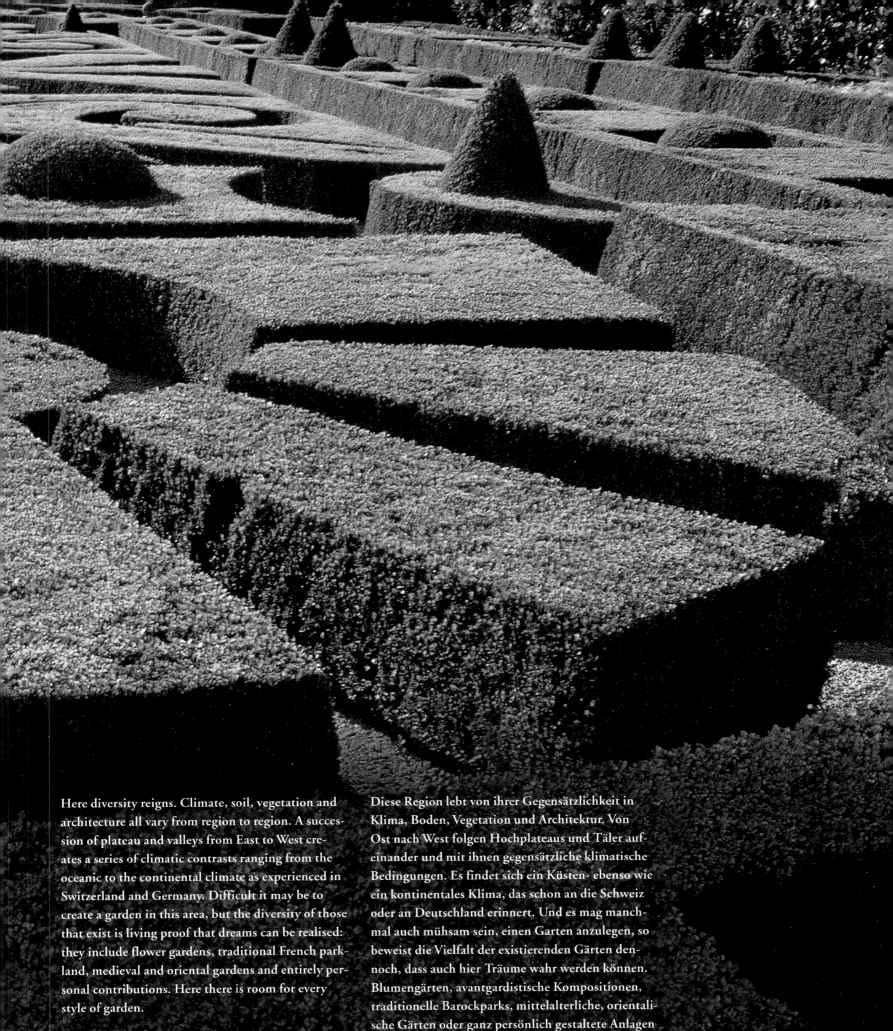

Here diversity reigns. Climate, soil, vegetation and architecture all vary from region to region. A succession of plateau and valleys from East to West creates a series of climatic contrasts ranging from the oceanic to the continental climate as experienced in Switzerland and Germany. Difficult it may be to create a garden in this area, but the diversity of those that exist is living proof that dreams can be realised: they include flower gardens, traditional French parkland, medieval and oriental gardens and entirely personal contributions. Here there is room for every style of garden.

Diese Region lebt von ihrer Gegensätzlichkeit in Klima, Boden, Vegetation und Architektur. Von Ost nach West folgen Hochplateaus und Täler aufeinander und mit ihnen gegensätzliche klimatische Bedingungen. Es findet sich ein Küsten- ebenso wie ein kontinentales Klima, das schon an die Schweiz oder an Deutschland erinnert. Und es mag manchmal auch mühsam sein, einen Garten anzulegen, so beweist die Vielfalt der existierenden Gärten dennoch, dass auch hier Träume wahr werden können. Blumengärten, avantgardistische Kompositionen, traditionelle Barockparks, mittelalterliche, orientalische Gärten oder ganz persönlich gestaltete Anlagen – hier ist Raum für jeden Gartenstil.

Le site est exceptionnel. Le château Renaissance avec ses toits d'ardoise domine le village et le fleuve, et s'accorde à merveille avec le beau ruban cendré de la Loire. Le parc fut redessiné au siècle dernier par le paysagiste et restaurateur Achille Duchêne (1866-1947), grâce à la princesse de Broglie qui devint propriétaire du domaine en 1874. Puis il sombra dans l'abandon jusqu'à l'installation du Festival international des Jardins qui s'y déroule tous les ans depuis l'automne 1992. Il se tient dans une clairière du parc où le paysagiste belge Jacques Wirtz a conçu trente petits jardins fermés par une haie de hêtres. Chaque année, des paysagistes prestigieux venus du monde entier exercent leurs talents sur une parcelle pour traiter le thème de l'année. En 1992, ils s'appliquèrent à illustrer «Le plaisir», en 1993 «L'imagination de la crise», en 1994 «L'acclimatation», en 1995 ils durent créer des «Jardins de curiosité», en 1996, on leur demanda de répondre à la question suivante: «La technique est-elle poétiquement correcte?». Le thème choisi pour 1997 s'intitule: «Que d'eau, que d'eau!». On entre par une passerelle puis on gravit une allée: là, sur un plateau, sont disposés les jardins clos. Chacun est un site exceptionnel où s'expriment conceptions d'avant-garde, talents artistiques exubérants et associations botaniques audacieuses. Ce festival est la vitrine du Conservatoire international des Parcs et Jardins et du Paysage, qui regroupe une filière complète de formation aux métiers du paysage.

Chaumont

The setting is superlative. The Renaissance chateau, with its slate-grey roof, dominates the village and harmonises with the dove-grey waters of the Loire. The park was redesigned in the 19th century by the garden designer and restorer Achille Duchêne (1866-1947) under the patronage of the Princesse de Broglie who acquired the estate in 1874. Then it lay abandoned until becoming the venue for the Festival International des Jardins, which has taken place in its grounds annually since 1992. The festival site is a clearing in the park where the Belgian landscape artist Jacques Wirtz has designed thirty little gardens enclosed within a beech hedge. Each year, celebrated landscape gardeners from all over the world take over one of these little plots and create a garden in accord with the theme of that year. In 1992, their challenge was to illustrate "Pleasure", in 1993 the theme was "Imagination in time of crisis", in 1994 "Acclimatisation", and in 1995 they were asked to create "Gardens of curiosity". In 1996, they were asked to respond to the question: "Is technique poetically correct?" and in 1997 the theme chosen is "Water, water everywhere". The park is entered by a footbridge which leads into an "allée"; there, on a plateau, stand the enclosed gardens. Each is an exceptional site; in each, avant-garde gardening notions are tested, exuberant artistic talents displayed and daring collocations of plants attempted. The festival is the shop window of the Conservatoire International des Parcs et Jardins et du Paysage, which includes a school devoted to landscaping.

Die Lage ist einmalig. Das Renaissanceschloß mit seinen Schieferdächern überragt Ort und Fluß und harmoniert perfekt mit dem aschgrauen Band der Loire. Der Park wurde im letzten Jahrhundert von dem Gartenarchitekten und Restaurator Achille Duchêne (1866-1947) im Auftrag der Prinzessin de Broglie angelegt, die das Anwesen 1874 erworben hatte. Später blieb der Park sich selbst und damit dem Verfall überlassen, bis er zum Schauplatz des Festival International des Jardins wurde, das seit dem Herbst 1992 jedes Jahr hier stattfindet. Das Festival findet auf einer Lichtung im Park statt, die der Landschaftsarchitekt Jacques Wirtz in dreißig von Buchenhecken eingefaßte Einzelgärtchen unterteilt hat. Jahr für Jahr führen hier ehrgeizige Gartenarchitekten aus aller Herren Länder ihr Können auf einer der Parzellen vor und lassen im Rahmen eines vorgegebenen Themas ihrer Phantasie freien Lauf. 1992 ging es darum, »Freude« darzustellen, 1993 die »Phantasie der Krise«, 1994 um »Akklimatisation«; 1995 sollte ein »Garten der Neugier« geschaffen und 1996 eine Antwort auf die Frage »Ist die Technik poetisch korrekt?« gefunden werden. Das Thema für 1997 lautet: »Nur Wasser, nur Wasser!«. Man betritt den Park über einen Steg und gelangt über eine Allee zu der Fläche mit den Heckengärten. Jeder von ihnen ist ein einzigartiges Experimentierfeld für avantgardistische Konzepte und gewagte Pflanzenzusammenstellungen. Das Festival ist die Visitenkarte des Conservatoire International des Parcs et Jardins et du Paysage, das auch verschiedenste Ausbildungsgänge in den Bereichen Gartenbau und Gartenarchitektur anbietet.

Page précédente: Cet espace situé au sortir d'un jardin gris fut aménagé par les jardiniers du Festival. Il s'agit d'une prairie fleurie semée de chardons *(Onopordum arabicum).*
A droite: un jardin intitulé «Saules tressés», créé par deux paysagistes anglais Judy et David Drew. Les saules ont été plantés dans le sol, puis ont été tressés. Ils se sont enracinés et couverts de feuilles.
Ci-dessous: «La serre du *Victoria regia»* de l'Atelier de l'Entrepôt Edouard François et Duncan Lewis (France et Angleterre). Cette serre souple est soutenue par des cannes de bambou et protège une plante rare et délicate, le *Victoria regia,* qui ressemble à un grand nénuphar.

Previous page: This area, a flowering meadow planted with the thistle *Onopordum arabicum,* was created by the festival gardeners as the exit from a grey garden.
Right: a garden entitled "Woven willow" created by two English landscape gardeners, Judy and David Drew. The willows were planted directly in the ground, and then woven. They have taken root and put out leaves.
Below: "The *Victoria regia* glasshouse" by the Atelier de l'Entrepôt Edouard François and Duncan Lewis (France and England). This delicate glasshouse is held up by bamboo and protects a rare and delicate plant, the *Victoria regia,* which resembles a large water lily.

Vorhergehende Seite: Die Gärtner des Festivals gestalteten diese Fläche am Ausgang eines grauen Gartens als eine Blumenwiese, die mit Eselsdisteln *(Onopordum arabicum)* übersät ist.

Oben: ein Garten der beiden englischen Gartenarchitekten Judy und David Drew mit dem Titel »Verflochtene Weiden«. Die Weiden wurden zunächst in den Boden gepflanzt und dann miteinander verflochten. Mittlerweile haben sie Wurzeln geschlagen und treiben aus.
Unten: »Das Gewächshaus der *Victoria regia«,* gestaltet von Edouard François und Duncan Lewis vom Atelier de l'Entrepôt (Frankreich und England). Das biegsame Gewächshaus wird von Bambusstöcken getragen und schützt die seltene, hochempfindliche Pflanze *Victoria regia,* die einer Seerose ähnelt.

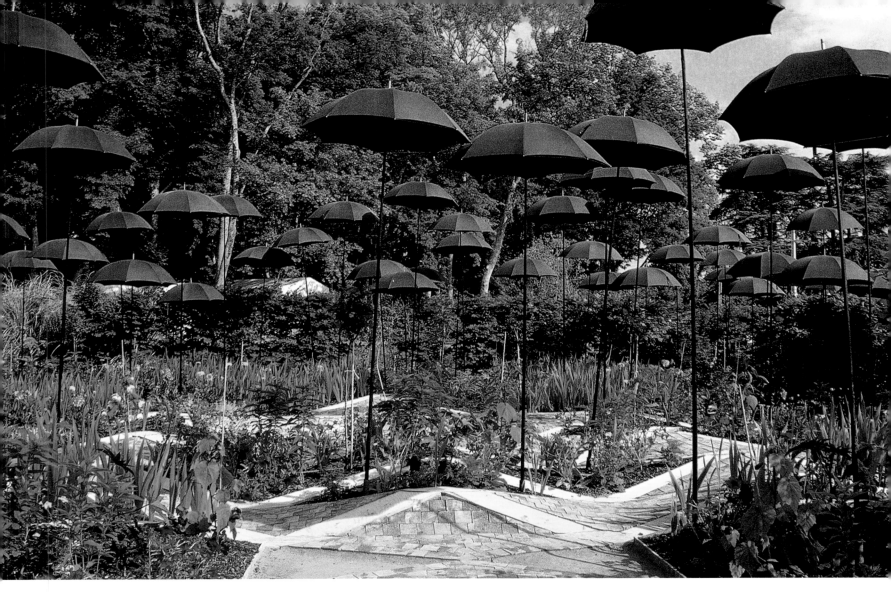

Ci-dessus: «Jardin d'ombres et d'ombrelles» d'Agnès Daval,
Tanguy Gwenaël et Marc Schoellen (France), où plusieurs di-
zaines de parapluies composent avec le vent, l'ombre et la lu-
mière.
A droite: «La Volière blanche» de l'Atelier de l'Entrepôt
Edouard François et Duncan Lewis (France et Angleterre), fut
réalisée pour «Madame Figaro» («L'Art du Jardin») et trans-
portée à Chaumont. Dans cette cage, des pigeons simulent
des feuilles.

Above: "Garden of shade and sunshades" by Agnès Daval,
Tanguy Gwenaël and Marc Schoellen (France), in which sev-
eral dozen umbrellas interact with wind, sun and shadow.
Right: "The white aviary" by the Atelier de l'Entrepôt
Edouard François and Duncan Lewis (France and England),
was created for "Madame Figaro" ("L'Art du Jardin") and
transported to Chaumont. The pigeons in the aviary are like
leaves on the tree.

Oben: »Garten der Schatten und Sonnenschirme« von Agnès
Daval, Tanguy Gwenaël und Marc Schoellen (Frankreich), in
dem mehrere Dutzend aufgespannte Schirme mit Wind,
Schatten und Licht spielen.
Rechts: »Die weiße Voliere« des Atelier de l'Entrepôt Edouard
François und Duncan Lewis (Frankreich und England) wurde
für die Zeitschrift »Madame Figaro« (»L'Art du Jardin«) ge-
schaffen und nach Chaumont gebracht. In diesem Käfig neh-
men Tauben die Stelle von Blättern ein.

Chaumont *Centre*

Double page précédente, à gauche: «Babylones» de Béatrice Fauny et Benoît Séjourné (France) évoque les jardins suspendus de Babylone.

Double page précédente, à droite: «Le Sillon romand» de Daniel Örtli et les Jardins de la Ville de Lausanne (Suisse) où des miroirs renvoient des images de sillons.

Ci-dessus: «L'Archipel» de Shodo Suzuki (Japon). Ce jardin d'inspiration zen symbolise l'état de crise du Japon contemporain et l'espoir du futur.

Previous pages, left: "Babylons" by Béatrice Fauny and Benoît Séjourné (France) evokes the Hanging Gardens of Babylon.

Previous pages, right: "The Swiss-French Furrow" by Daniel Örtli and the Jardins de la Ville de Lausanne (Switzerland). Mirrors offer the spectator an image of the furrows.

Above: "Archipelago" by Shodo Suzuki (Japan). This Zen garden symbolises the crisis of contemporary Japan and hope for the future.

Vorhergehende Doppelseite, links: Die Installation »Babylons« von Béatrice Fauny und Benoît Séjourné (Frankreich) erinnert an die hängenden Gärten von Babylon.

Vorhergehende Doppelseite, rechts: »Die römische Furche« von Daniel Örtli und der Gärtnerei der Stadt Lausanne (Schweiz). Spiegel werfen das Bild der angelegten Furchen zurück.

Oben: »Der Archipel« von Shodo Suzuku (Japan). Dieser vom Zen-Buddhismus beeinflußte Garten thematisiert die Krise des modernen Japan und die Hoffnung auf eine bessere Zukunft.

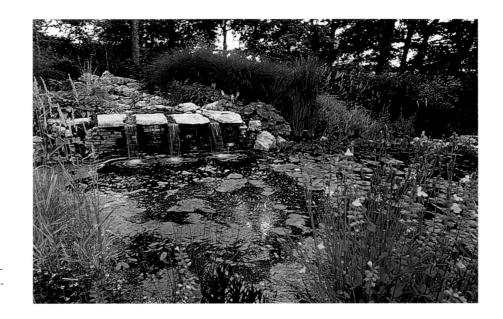

A droite: «Le Naturel exotique», d'Aquiculture et Paysage, Aquatic' Bezançon (France), met en scène des plantes aquatiques.
Ci-dessous: «Le Bassin des nymphéas», de l'établissement botanique Latour-Marliac (France). Cette pépinière est spécialisée dans la production de plantes aquatiques et surtout de nénuphars qui sont associés ici aux sculptures de Pierre Culot.

Right: "Exotic nature", by Aquiculture et Paysage, Aquatic' Bezançon (France) is a display of aquatic plants.
Below: "The lily pond" by the botanic firm Latour-Marliac (France). This nursery specialises in the production of aquatic plants and especially water lilies, which are set off here by Pierre Culot's sculptures.

Rechts: »Exotische Natur« von Aquiculture et Paysage, Aquatic' Bezançon (Frankreich) setzt Wasserpflanzen ein.
Unten: »Der Seerosenteich« der Gärtnerei Latour-Marliac (Frankreich). Dieser Betrieb hat sich auf die Zucht von Wasserpflanzen spezialisiert, insbesondere von Seerosen, die hier neben Skulpturen von Pierre Culot zu sehen sind.

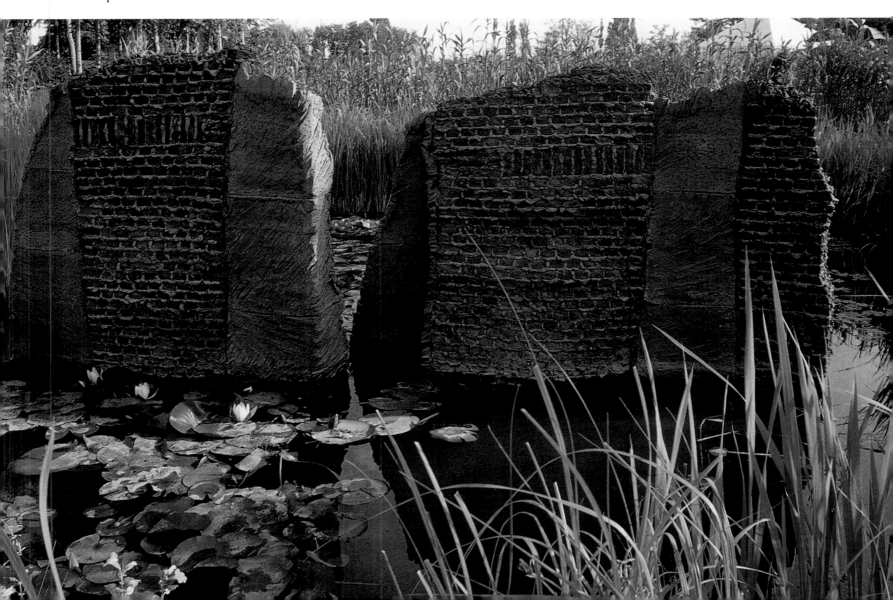

Françoise de Dreuzy fait partie de ces héroïnes discrètes qui en France, aux Etats-Unis, en Italie ou en Angleterre, contribuent à faire vivre l'art des jardins. Le sien est une œuvre très personnelle. Romantique et très féminin, conçu dans un esprit anglais avec une profusion de fleurs associées en toute liberté, il n'en possède pas moins une belle structure. Deux promenoirs de vigne mettent les plates-bandes dans un écrin, contribuant à donner un caractère intime à ce jardin. A l'intérieur, se croisent deux axes majeurs et des axes mineurs. Des gloriettes et des arceaux offrent un prétexte à la culture de rosiers grimpants, de clématites et de chèvrefeuilles qui agrémentent l'air berrichon de leurs tiges fleuries volubiles et de leurs parfums. Arbustes, bulbes, plantes annuelles et vivaces se relaient du printemps à l'automne, dans des couleurs pastel qui célèbrent la douceur de vivre. Car Françoise de Dreuzy s'est en effet attachée à faire régner une atmosphère de vie paisible à Villiers. Et cette impression ne quitte pas celui qui franchit le porche surmonté d'un pigeonnier. Il foule une allée pavée, traverse la cour des communs, passe devant le château du 17e siècle, entre dans le jardin de fleurs féminin, s'y repère grâce au cadran solaire, le découvre et s'en délecte. Il en ressort, est attiré par un étang, le longe à l'ombre des marronniers, se dirige vers une collection de lilas et de deutzias, puis vers la roseraie. En revenant vers le château, il traverse un quinconce de néfliers et achève la promenade en prenant le thé.

Villiers

Françoise de Dreuzy is one of those discreet heroines who in France, the United States, Italy and England has been instrumental in breathing new life into gardens. Her own garden is an intensely personal creation. It is a romantic garden, feminine in character, and though its style is that of the English country garden, with a profusion of flowers growing apparently at liberty, it is carefully structured. Two vine-covered pergolas form a screen for the beds and impart an intimate character to the garden. Within this screen, two major and two minor axes intersect. Arbours and arches support climbing roses, clematis and honeysuckle; their intertwined flowers scent the country air of the Berry. Shrubs, bulbs, annuals and perennials ensure that the garden's pastel colours prevail throughout the year. A peaceful atmosphere was one of Françoise de Dreuzy's goals in creating Villiers. And she has succeeded; once through the entrance porch, which is surmounted by a dovecote, one is immediately aware of this. A paved avenue crosses the lesser of the two courtyards, passes in front of the 17th-century chateau, and leads into the exquisite flower garden. The centre of this delightful garden is a sundial. Beyond lies a pond, its banks shaded by horse chestnuts, on the far side of which is a collection of lilies and deutzias; then comes the rose garden. The way back to the chateau leads through a quincunx of medlars. There, one's tour is rounded off with a cup of tea.

Françoise de Dreuzy gehört zu den stillen Heldinnen, die sich in Frankreich, den USA, Italien und England für den Fortbestand der Gartenkunst einsetzen. Ihr Garten ist ein ganz persönliches Werk. Er ist romantisch und sehr weiblich, im englischen Geist entworfen und mit einer Fülle von Blumen bestückt, die völlig frei miteinander kombiniert werden. Dennoch entbehrte er keineswegs einer schönen Struktur. Zwei mit Wein bewachsene Wandelgänge umfangen die Blumenbeete wie einen kostbaren Schatz und betonen den intimen Charakter dieses Gartens. Im Innern kreuzen sich zwei Haupt- und Nebenachsen. Glorietten und Rankbögen bieten sich für die Kultur von Kletterrosen, Clematis und Geißblatt an, deren verschlungene, blühende Ranken die Luft des Berry mit ihrem Duft erfüllen. Sträucher, Zwiebelgewächse, einjährige Pflanzen und Stauden blühen gestaffelt vom Frühling bis in den Herbst hinein. Dabei dominieren Pastellfarben als Ausdruck einer sanften Lebensfreude. Françoise de Dreuzy hat dem Garten von Villiers ganz bewußt eine friedvolle Atmosphäre verliehen, die den Besucher schon am Eingang bei dem Taubenhaus umfängt. Auf einem gepflasterten Weg gelangt man zum Wirtschaftshof, passiert das Schloß aus dem 17. Jahrhundert und entdeckt den sehr femininen Blumengarten mit der Sonnenuhr. Anschließend wird man magisch angezogen von einem Teich, der im Schatten von Kastanien liegt, geht auf eine Gruppe von Flieder- und Deutzienbüschen und dann auf den Rosengarten zu, bevor man zwischen versetzt stehenden Mispelsträuchern hindurch wieder zum Schloß gelangt. Und dort kann man den Spaziergang bei einer Tasse Tee beschließen.

Page précédente: Le jardin de fleurs est situé non loin du château. Les allées **sont** engazonnées et les axes marqués par des arches de *Lonicera fragrantissima.* Au premier plan, la tonnelle; au bord **des** allées, des iris.
A droite: l'étang **de** Villiers et son moulin récemment restauré.
Ci-dessous: Le jardin de fleurs est romantique et féminin. Devant les arches de *Lonicera fragrantissima,* des touffes de *Geranium endressii* et des valérianes blanches *(Centranthus ruber* 'Albus'). A droite, un poirier *(Pyrus calleryana).*

Previous page: The flower garden is not far from the chateau. The walks are grassed over and the axes are marked by arches covered in honeysuckle *(Lonicera fragrantissima).* In the foreground, **a** bower. Irises grow along the paths.
Right: the Villiers lake and its recently-restored windmill.
Below: The flower garden is delicate and feminine. Arches of honeysuckle *(Lonicera fragrantissima)* stand behind clumps of *Geranium endressii* and white valerian *(Centranthus ruber* 'Albus'). To the **right** is a pear tree *(Pyrus calleryana).*

Vorhergehende Seite: Der Blumengarten liegt unweit vom Schloß. Die Wege sind mit Gras bewachsen und die Seitenwege von duftendem Geißblatt *(Lonicera fragrantissima)* überwölbt. Im **Vordergrund** die Laube, am Wegesrand Schwertlilien.
Rechts: der Teich **von** Villiers mit der kürzlich restaurierten Mühle.
Unten: Der Blumengarten wirkt romantisch und feminin. Vor den Rankbögen mit Geißblatt *(Lonicera fragrantissima)* stehen mächtige **Tuffs** von Storchschnabel *(Geranium endressii)* und weißen **Spornblumen** *(Centranthus ruber* 'Albus'). Rechts ein Birnbaum *(Pyrus calleryana).*

Ci-dessus: sous la tonnelle où grimpent les rosiers 'Souvenir de la Malmaison' et 'Wedding Day', un cadran solaire. Les plates-bandes sont garnies de delphiniums et d'euphorbes.
A droite: le rosier 'Wedding Day' en fleurs. Ses petites fleurs blanches sont groupées en bouquets.
Double page suivante, à gauche: une pivoine issue d'une vieille souche provenant d'une propriété de famille.
Double page suivante, à droite: une mauve musquée blanche *(Malva moschata 'Alba').*

Above: The roses 'Souvenir de la Malmaison' and 'Wedding Day' climb the bower, under which is a sundial. The beds are planted with delphiniums and spurges *(Euphorbia).*
Right: the rose 'Wedding Day' in bloom. Its little white flowers form clusters.
Following pages, left: a peony *(Paeonia)* grown from root stock brought from another family property.
Following pages, right: a white musk mallow *(Malva moschata 'Alba').*

Oben: Unter der Laube, die mit Rosen der Sorten 'Souvenir de la Malmaison' und 'Wedding Day' überrankt ist, steht eine Sonnenuhr. Die Beete sind mit Rittersporn *(Delphinium)* und Wolfsmilch *(Euphorbia)* bepflanzt.
Rechts: die Rose 'Wedding Day' in Blüte. Die kleinen weißen Blüten bilden üppige Dolden.
Folgende Doppelseite, links: eine Pfingstrose aus einem alten Wurzelstock, der auf einem Familienbesitz gezogen wurde.
Folgende Doppelseite, rechts: eine weiße Moschusmalve *(Malva moschata 'Alba').*

Des contreforts en ifs taillés marquent l'entrée du village. Un village plein de charme, qui égrène ses maisons de tuiles brunes et de pierres chaudes le long de l'Allier, et qui recèle d'autres formes topiaires, aussi magnifiquement conduites … Maisons et sculptures végétales franchissent les grilles du parc car le village et le jardin ne font qu'un. Ils furent tous deux restaurés et créés par Gilles de Brissac. Son style, en tant que paysagiste, l'apparente aux grands jardiniers amateurs qu'étaient Charles de Noailles et Jacqueline de Chimay, esthètes qui, au début de notre siècle, ont marqué l'art des jardins français et l'ont empreint d'élégance. Les premiers travaux du parc débutèrent en 1973. Gilles de Brissac avait en mémoire les jardins anglais qu'il avait visités, notamment Sheffield Park «avec ses étangs qui se déversent les uns dans les autres». Il avoue quelques erreurs dans les plantations car il connaissait mal le climat continental d'Apremont, qui ressemble à celui de la Suisse ou de l'Allemagne. Il voulut enfin introduire dans le parc des fabriques dans l'esprit des jardins pittoresques en vogue avant la Révolution et créa le pont chinois, le pavillon turc et le belvédère d'après les plans du peintre Alexandre Serebriakoff. Ces constructions pleines de fantaisie ajoutent au charme de la promenade qui traverse le jardin blanc, la pergola, la cascade et les étangs, puis fait une boucle dans l'arboretum avant de rejoindre les maisons du village.

Apremont

Buttresses of clipped yew mark the entry into the village, whose charming houses, with their brown-tiled roofs and warm stone walls, are dotted along the banks of the Allier. Behind the houses, further prodigies of the topiarist's art come into view. Since the village and the garden are continuous, sculpted trees and village houses are found on both sides of the park gates. The village was restored and the garden recreated by Gilles de Brissac. He is a landscape gardener in the style of those great aesthete-gardeners of the turn of the century, Charles de Noailles and Jacqueline de Chimay, who imparted a new elegance to the classical French tradition. Work on the park began in 1973. The English gardens that Brissac had visited, notably Sheffield Park, with its "chain of lakes flowing one into another" were in his mind's eye when he began the design. Some of his initial choices of plant were mistaken, he confesses; he was ill acquainted with the continental climate of Apremont, which is akin to that of Switzerland or Germany. He wanted to build follies in the park, in accordance with the pre-Revolutionary tradition of picturesque gardens; the result was the Chinese bridge, the Turkish pavilion, and the belvedere, which were built to designs by the painter Alexandre Serebriakoff. These fantastical constructions are a charming addition to the promenade that leads through the white garden, the pergola, the cascade, and the lakes, and makes a loop around the arboretum before reaching the houses of the village.

Beschnittene Eiben bilden den Zugang zum Dorf, in dem es weitere kunstvoll gestaltete Formbäume gibt. Ein Dorf voller Charme, dessen Häuser mit den braunen Dachziegeln und warmen Steinfarben sich wie Perlen an einer Schnur an dem Flüßchen Allier aneinanderreihen. Auch im Park finden sich Häuser und pflanzliche Skulpturen, denn es gibt keine klare Grenze zwischen Dorf und Park. Beide wurden von Gilles de Brissac restauriert und geplant. Sein Stil als Landschaftsgärtner stellt ihn neben die großen Amateurgärtner und Ästheten Charles de Noailles und Jacqueline de Chimay, die der französischen Gartenkunst zu Beginn unseres Jahrhunderts Eleganz verliehen. Die Arbeiten am Park wurden 1973 aufgenommen. Gilles de Brissac hatte dabei vor seinem geistigen Auge die englischen Landschaftsgärten, die er vorher besichtigt hatte — vor allem Sheffield Park »mit seinen Teichen, deren Wasser von einem in den anderen überfloß«. Er gesteht ein, bei der Bepflanzung einige Fehler gemacht zu haben, weil er das kontinentale Klima von Apremont nicht berücksichtigte, das bereits dem der Schweiz oder Deutschlands ähnelt. Schließlich wollte er in den Park auch Ziergebäude stellen, ganz im Sinne der Landschaftsgärten, wie sie vor der Französischen Revolution in Mode waren. So entstanden die Chinesische Brücke, der Türkische Pavillon und das Belvedere nach Entwürfen des Malers Alexander Serebriakoff. Diese phantasievollen Bauten machen den Reiz des Rundwegs aus, der durch den weißen Garten, an der Pergola, der Kaskade, den Teichen entlangführt, im Arboretum eine Schleife vollführt und schließlich wieder den Dorfrand erreicht.

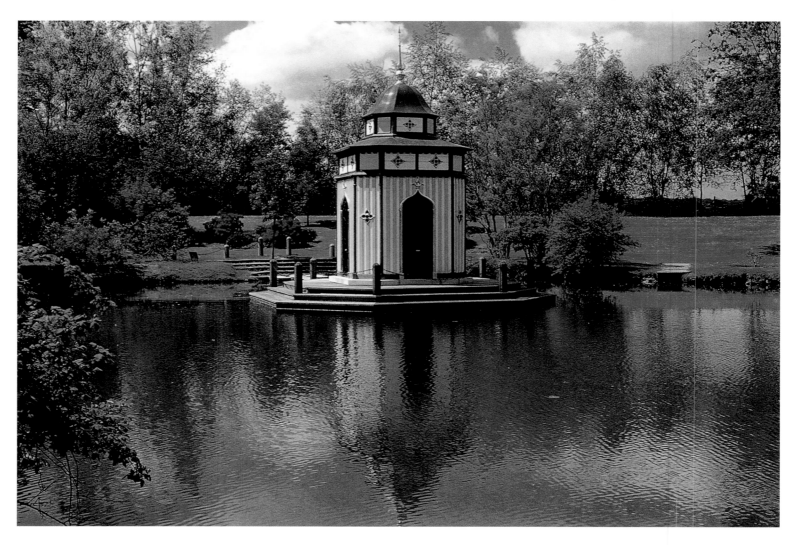

Première page: Le château d'Apremont, avec ses tours et ses remparts, domine le parc floral d'Apremont. Au premier plan, les créneaux de charmes du jardin blanc.
Ci-dessus: Gilles de Brissac a toujours été fasciné par les fabriques, d'où la création du pavillon turc qui flotte sur un étang. Il est en bois exotique et son toit, en cuivre.
A droite: L'intérieur du pavillon est très raffiné. Les fenêtres sont fermées par des grilles forgées d'après des documents turcs.

First page: The Château d'Apremont with its towers and ramparts stands guard over the garden of Apremont. In the foreground, the hornbeam crenellations of the white garden.
Above: Gilles de Brissac has always been fascinated by follies, whence this Turkish pavilion floating on the waters of a lake. It is made in exotic hardwood, with a copper roof.
Right: The interior of the pavilion is exquisitely detailed. The windows are protected by wrought iron grilles copied from Turkish documents.

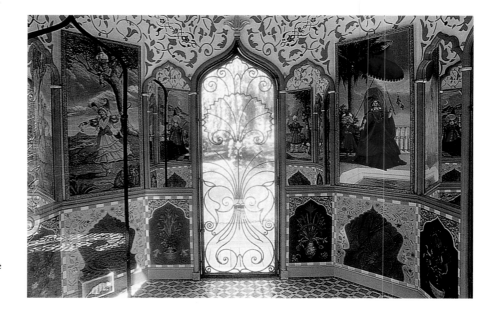

Eingangsseite: Schloß Apremont mit seinen Türmen und Festungswällen überragt den gleichnamigen Blumenpark. Im Vordergrund die zinnenartig zugeschnittenen Hainbuchen des weißen Gartens.
Oben: Gilles de Brissac war seit jeher fasziniert von Ziergebäuden und schuf deshalb den Türkischen Pavillon, der auf dem Teich zu treiben scheint. Er wurde aus Tropenholz erbaut und ist mit einem Kupferdach versehen.
Rechts: Der Innenraum des Pavillons ist exquisit gestaltet. Die schmiedeeisernen Fenstergitter sind nach alten türkischen Originalentwürfen angefertigt.

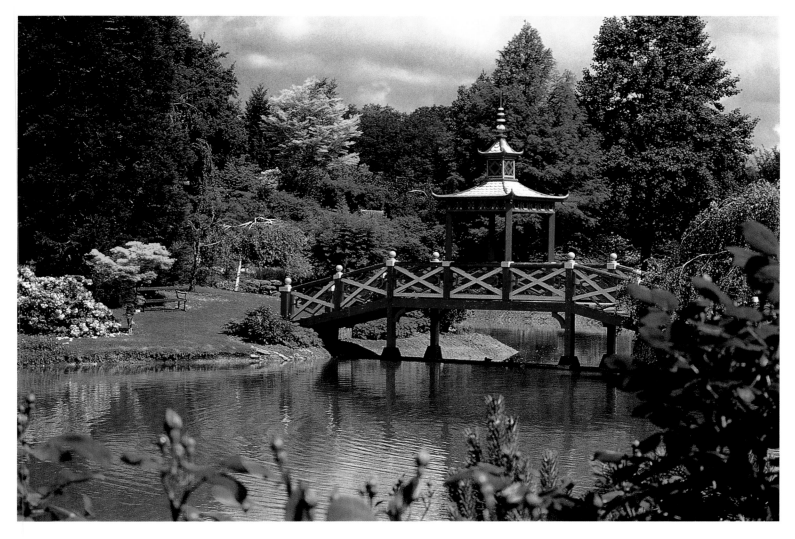

Ci-dessus: Le pont chinois enjambe un étang au sortir du jardin blanc. Cette fantaisie conçue dans l'esprit des jardins pittoresques de la deuxième moitié du 18e siècle s'intègre très bien dans le parc.
A droite: détail de l'intérieur du pavillon turc.

Above: The Chinese bridge crosses a lake at one end of the white garden. This fantastical construction, designed in the tradition of the picturesque gardens of the second half of the 18th century, fits beautifully into the scenery of the park.
Right: a detail of the interior of the Turkish pavilion.

Oben: Die Chinesische Brücke führt am Ausgang des weißen Gartens über einen Teich. Dieses phantasievolle, ganz dem Geist der zweiten Hälfte des 18. Jahrhunderts verpflichtete Element fügt sich harmonisch in den Park ein.
Rechts: der Innenraum des türkischen Pavillons.

A droite: Des arums *(Zantedeschia aethiopica* 'Crowborough'), utilisés en abondance, s'appuient contre le mur d'une maison, palissé d'un *Hydrangea petiolaris.*
Ci-dessous: Le jardin blanc, inspiré de celui de Sissinghurst, en Angleterre, est bordé d'une haie de charmes crénelée. Au fond à gauche, les maisons du village pénètrent dans le parc.

Right: Arums (*Zantedeschia aethiopica* 'Crowborough') are used in abundance; here they stand against the wall of a house palisaded with *Hydrangea petiolaris.*
Below: The white garden draws on the example of Sissinghurst. It is bordered with a hedge of crenellated hornbeams. In the far left hand corner can be seen one of the village houses that form part of the park.

Rechts: Die Zimmerkalla (*Zantedeschia aethiopica* 'Crowborough') ist im ganzen Park häufig anzutreffen. Hier steht sie vor einer mit Kletterhortensien *(Hydrangea petiolaris)* bewachsenen Hauswand.
Unten: Vorbild für den weißen Garten war der Park im englischen Sissinghurst. Seine Einfassung bildet eine Hainbuchenhecke, die wie mit Zinnen bewehrt erscheint. Links im Hintergrund die Häuser des Dorfes, das sich bis in den Park hinein erstreckt.

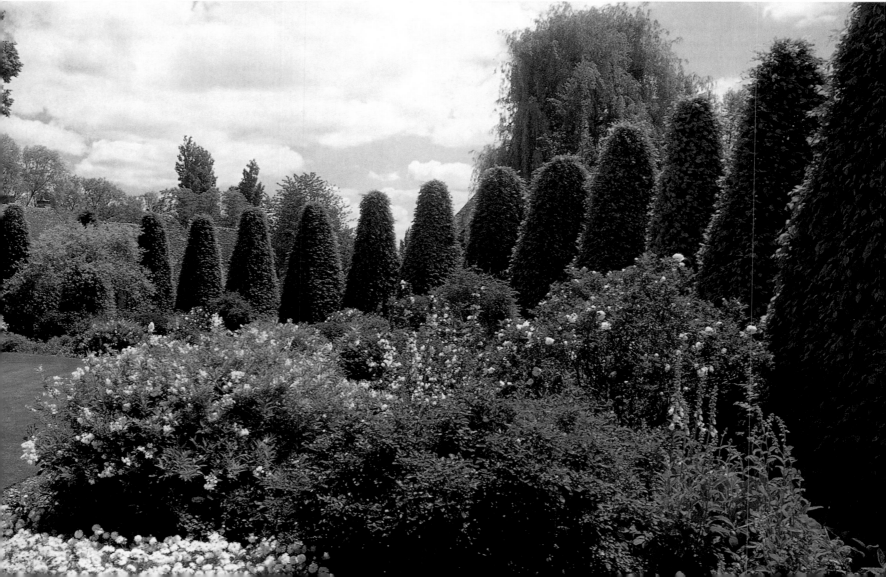

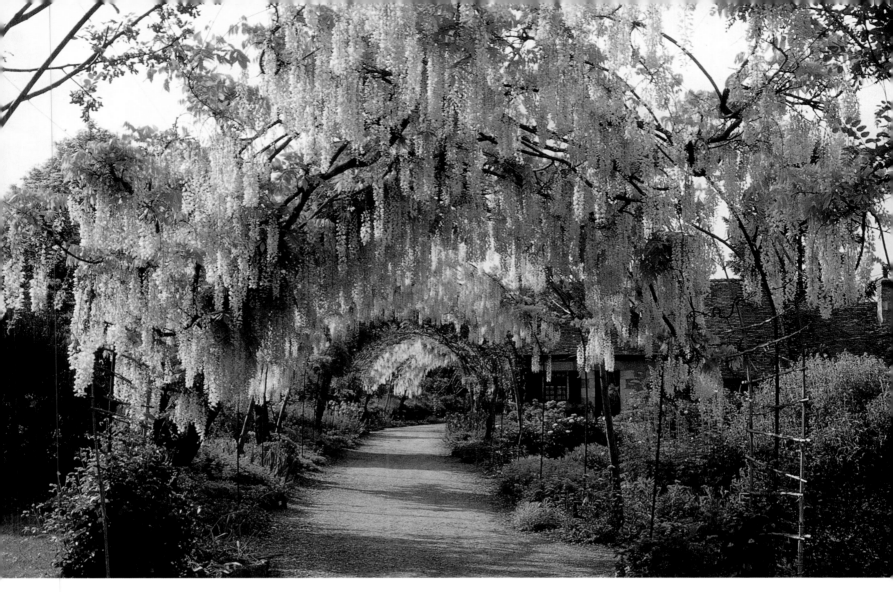

Ci-dessus: la pergola. En sortant du jardin blanc, on passe sous la pergola drapée de glycine *(Wisteria floribunda* 'Alba'), qui est longée par une bordure de printemps, une d'été et une d'automne, et mène à la troisième fabrique nommée le «belvédère».
A droite: un cytise *(Laburnum)* près du puits de la pergola.

Above: the pergola. On the way out of the white garden, one walks under the pergola and its *Wisteria floribunda* 'Alba'. It is flanked by spring, summer and autumn ornamental borders, and leads to the third folly, the belvedere.
Right: A laburnum stands by a well near the pergola.

Oben: die Pergola. Beim Verlassen des weißen Gartens geht man unter der Pergola her, die mit der weißen Glyzine *Wisteria floribunda* 'Alba' überrankt ist. An ihr entlang verläuft je eine Frühlings-, Sommer- und Herbstrabatte, die zum Belvedere überleiten.
Rechts: Bei der Pergola wächst ein Goldregen *(Laburnum)* neben einem Ziehbrunnen.

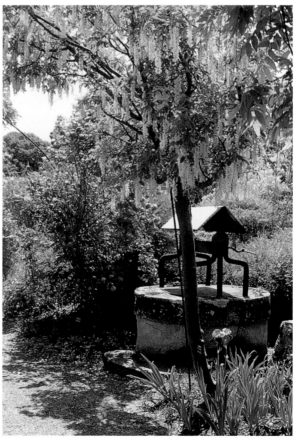

Détail de gauche: Campa-
nula persicifolia 'Alba'.

Detail left: bellflower *Cam-*
panula persicifolia 'Alba'.

Detail links: eine pfirsich-
blättrige weiße Glocken-
blume *Campanula persicifo-*
lia 'Alba'.

Détail de droite: Astrantia
major 'Alba'.

Detail right: masterwort
Astrantia major 'Alba'.

Detail rechts: Sterndolde
Astrantia major 'Alba'.

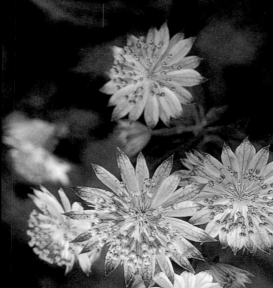

Détail de droite: Dianthus
plumarius 'Diamant'.

Detail right: carnation
Dianthus plumarius
'Diamant'.

Detail rechts: Federnelke
Dianthus plumarius
'Diamant'.

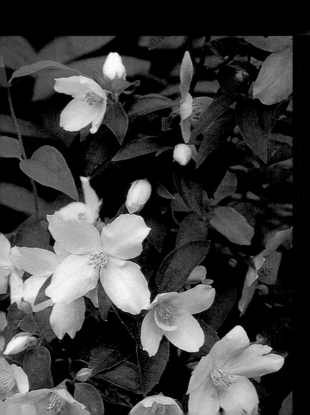

Détail de gauche: Philadel-
phus microphyllus.

Detail left: mock orange
(Philadelphus microphyllus).

Detail links: Pfeifenstrauch
(Philadelphus microphyllus).

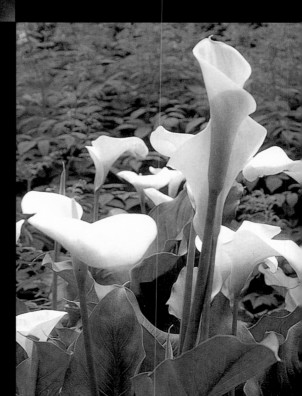

Détail de gauche: Gillenia trifoliata.

Detail left: Bownan's root (*Gillenia trifoliata*).

Detail links: Dreiblattspiere (*Gillenia trifoliata*).

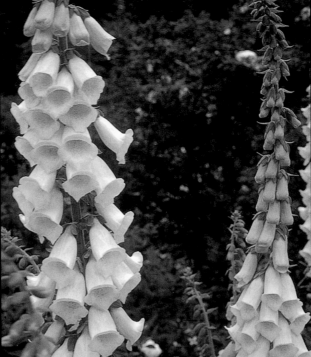

Détail de gauche: Digitalis purpurea 'Alba'.

Detail left: foxglove *Digitalis purpurea* 'Alba'.

Detail links: Fingerhut *Digitalis purpurea* 'Alba'.

Détail de droite: Lupin de Russell 'La Demoiselle'.

Detail right: Russell lupin 'La Demoiselle'.

Detail rechts: Russell-Lupine 'La Demoiselle'.

Détail de gauche: Zantedeschia aethiopica 'Crowborough'.

Detail left: arum *Zantedeschia aethiopica* 'Crowborough'.

Detail links: Zimmerkalla *Zantedeschia aethiopica* 'Crowborough'.

Détail de gauche: Geranium clarkei 'Kashmir White'.

Detail left: Geranium clarkei 'Kashmir White'.

Detail links: Storchschnabel *Geranium clarkei* 'Kashmir White'.

Les jardins du Prieuré Notre-Dame d'Orsan, dans le Berry, sont une œuvre d'art à la fois traditionnelle et très actuelle, originale et personnelle, composée par Sonia Lesot et Patrice Taravella. Ils cherchaient depuis longtemps un endroit pour y créer un jardin et furent séduits par ce prieuré bâti au creux d'une vallée. Ils remontèrent le fil de son histoire jusqu'au début du 12e siècle et se penchèrent avec ferveur sur les miniatures, les enluminures et les textes médiévaux qui seuls témoignent des jardins de cette époque. On est d'emblée subjugué par le paysage campagnard. Sa simplicité est rompue par le portail monumental et ouvragé du prieuré, par la douceur des couleurs de la pierre chaude, des boiseries vert-de-gris et des végétaux dont les feuillages tirent vers le bleu et l'argent, par l'architecture de grande envergure agrémentée de charmes, par le «plessage» de bois vivant utilisé, comme au Moyen Age, pour construire des clôtures inextricables, enfin par les treillis et les «plessis» (treillis en châtaigner) qui signent le style du jardin. Le tracé est régulier. Serti dans les bâtiments, le cloître de verdure reste l'élément majeur de la composition. Il dessert des jardins à thème adjacents: le jardin de simples, le verger, le jardin des petits fruits, le potager, la roseraie, le potager aromatique, la pergola et les jardins d'oliviers, le parterre et les jardins secrets. Orsan est une œuvre en mouvement. Sonia Lesot et Patrice Taravella, assistés de leur jardinier Gilles Guillot, ne cessent d'enrichir cette magnifique enluminure.

Les jardins du Prieuré Notre-Dame d'Orsan

The gardens of the Prieuré Notre-Dame d'Orsan, in the Berry, exhibit an art at once highly traditional and right up to the minute, and as original as personal. They are the work of Sonia Lesot and Patrice Taravella, who, having long sought somewhere to create a garden, fell under the spell of this priory and its sheltered setting deep in the fold of a valley. They studied its history from its origins in the 12th century, and eagerly set out to discover from miniatures, illuminations and medieval manuscripts how the gardens had looked in earlier times. The setting is an agricultural landscape of great charm, whose simplicity contrasts strongly with the monumental wrought-iron gates of the priory. Behind these gates lie the warm stone and grey-green woodwork of the priory, which harmonises with predominantly blue and grey shades of the flora. The large-scale architecture of the garden is enhanced by its hornbeam hedges, while throughout the garden, the living wood has been woven (as it was in the Middle Ages) to create densely pleached hedges. Also typical of the garden are the trellises and "plessis", a trellis of chestnut. The layout of the garden is symmetrical. Enclosed by the buildings, the green cloister is the main feature of the design. Onto it open gardens with related themes: the herb garden, the orchard, the soft fruit garden, the kitchen garden, the rose garden, the aromatic kitchen garden, the pergola and the olive gardens, the "parterre" and the secret gardens. Orsan is a work in progress. Sonia Lesot and Patrice Taravella, assisted by their gardener Gilles Guillot, never cease enriching this splendid and original garden.

Die Gärten des Priorats Notre-Dame d'Orsan im Berry sind ein originelles, traditionelles und zugleich sehr persönliches Kunstwerk. Sonia Lesot und Patrice Taravella suchten seit langem einen Ort für einen Garten und waren von dem tief im Tal gelegenen Prieuré auf Anhieb begeistert. Sie verfolgten seine Geschichte bis ins 12. Jahrhundert zurück und studierten mit glühendem Eifer mittelalterliche Handschriften und Buchmalereien, die die letzte Zeugen der damaligen Gärten waren. Auf Anhieb ist man begeistert von der bäuerlichen Landschaft. Ihre Schlichtheit wird aufgelockert durch das monumentale Portal des Prieuré mit seinem gemeißelten Schmuck, durch die sanften, warmen Farben des Steins, die grünen und grauen Hölzer und die ins Bläulich-Graue spielende Vegetation. Die weitläufige Anlage ist mit Einfriedungen aus lebendem Holz, die nach mittelalterlichen Vorbildern geflochten wurden, mit Gittern und »Plessis« verziert, geflochtenen Einfassungen aus Kastanienästen, die eine stilistische Besonderheit dieses Gartens bilden. Der Grundriß ist regelmäßig und wird nach wie vor von dem grünen Kreuzgang bestimmt, der von den Gebäuden gerahmt wird. Er führt zu den angrenzenden Gärten: dem Heilkräutergarten, dem Obstgarten, dem Beerengarten, dem Gemüselabyrinth, dem Rosengarten, dem Küchengarten, der Pergola und den Olivenhainen, dem Parterre und den Geheimgärten. Orsan ist ständig im Wandel begriffen. Unermüdlich bereichern Sonia Lesot und Patrice Taravella dieses prächtige Gartenbild und werden dabei von ihrem Gärtner Gilles Guillot unterstützt.

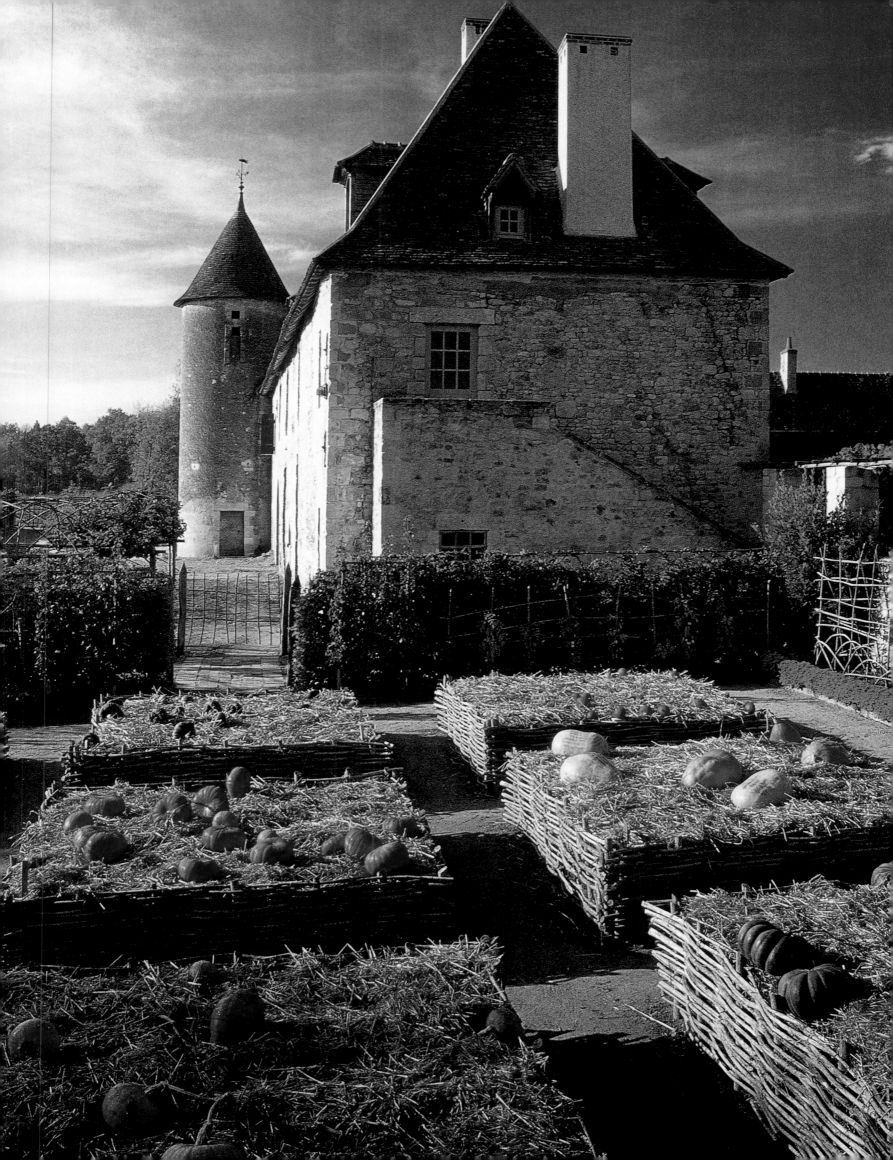

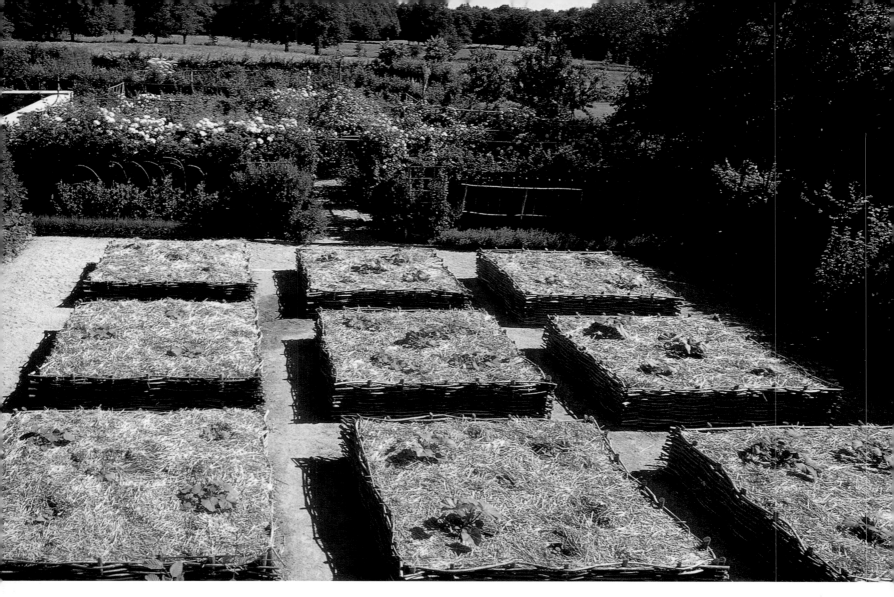

Première page: Le potager aromatique est composé de neuf carrés surélevés dont les bords sont fermés par des «plessis» en châtaigner. En automne, on y voit mûrir quantité de courges.
Double page précédente: Le potager-labyrinthe est matérialisé par des haies de pruniers palissés. Il illustre la difficulté pour tout chrétien d'accéder au salut et le devoir de cultiver soi-même son jardin pour obtenir des moyens de subsistance. Il est également fleuri de capucines *(Tropaeolum majus)* et de cosmos.
Ci-dessus: le potager aromatique. Au fond, la roseraie aux roses blanches et roses à la gloire de Marie.
A droite: Le puits dans le cloître de verdure.

First page: The aromatic kitchen garden comprises nine square raised beds, whose edges are supported by "plessis" of woven chestnut withies. In autumn, quantities of marrows can be seen ripening there.
Previous pages: The labyrinthine kitchen garden is organised by hedges of palisaded plum trees. It symbolises the arduous course of the Christian in quest of salvation and the need to cultivate one's own garden to ensure one's own subsistence. Nasturtiums and cosmos protect the crop.
Above: the aromatic kitchen garden. Behind it, the rose garden. Its roses are pink and white, to the glory of the Virgin.
Right: The well in the green cloister.

Eingangsseite: Der Küchengarten besteht aus neun Hochbeeten, die mit »Plessis« aus geflochtenen Kastanienästen eingefaßt sind. Im Herbst reifen zahlreiche Kürbisse und Zucchini.

Vorhergehende Doppelseite: Das Gemüselabyrinth wird von Pflaumenspalieren eingefaßt. Der Garten symbolisiert den schweren Weg jedes Christen zum Heil und seine Pflicht, selbst sein Gärtchen zu bestellen, um den Lebensunterhalt zu sichern. Aber es gibt auch Blumen, so etwa Kapuzinerkresse *(Tropaeolum majus)* und Schmuckkörbchen *(Cosmos).*
Oben: der Küchengarten, dahinter der Rosengarten. Zu Ehren der Jungfrau Maria sind die Rosen alle weiß oder rosa.
Unten: Der Brunnen im grünen Kreuzgang.

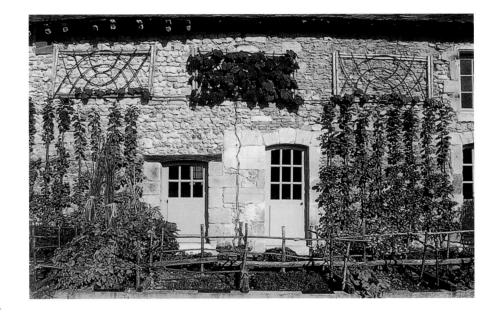

A droite: Le jardin des simples est situé devant les dépendances dont les murs sont palissés d'arbres fruitiers.
Ci-dessous: Le parterre est situé devant les communs, dans le prolongement du cloître de verdure. Ses plantations varient car elles respectent le cycle des rotations. En principe, le parterre est planté de blé et de fèves.
Double page suivante: la récolte des courges.

Right: The herb garden is situated in front of the outhouses whose walls are palisaded with fruit trees.
Below: The parterre faces the farm courtyard and is a continuation of the green cloister. The planting here follows the principle of rotation. The parterre is generally planted with wheat and broad beans.
Following pages: the marrow crop.

Rechts: Der Heilkräutergarten liegt vor den Nebengebäuden, deren Wände mit Obstspalieren bedeckt sind.
Unten: Das Parterre grenzt an die Wirtschaftsgebäude in der Verlängerung des grünen Kreuzgangs. Hier werden nach den Regeln der Kulturfolge immer wieder andere Gewächse gezogen. Normalerweise werden hier Weizen und Puffbohnen gesät.
Folgende Doppelseite: die Kürbisernte.

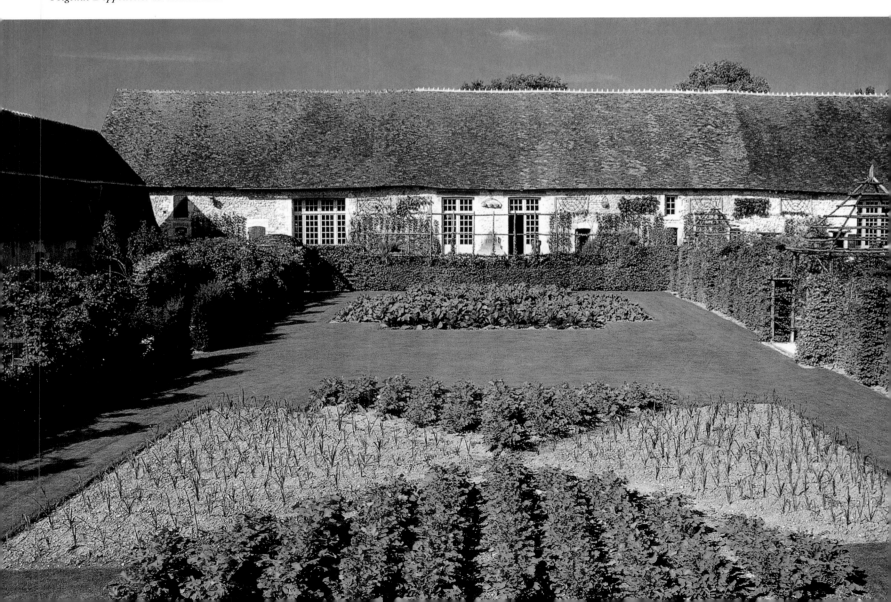

Ci-dessus: Sonia Lesot récoltant le raisin; un jardinier devant un berceau de charme tressé.
Page de droite: un fauteuil installé au pied d'un poirier dans le verger. Au printemps, la prairie est constellée de bulbes.

Above: Sonia Lesot harvests the grapes; a gardener in front of a cradle of woven hornbeam.
Facing page: a garden chair at the foot of a pear tree in the orchard. In spring, the meadow is studded with bulbs.

Oben: Sonia Lesot bei der Weinlese; ein Gärtner steht vor einer Laube aus geflochtenen Hainbuchen.
Rechte Seite: Ein Gartenstuhl steht am Fuße eines Birnbaums im Obstgarten. Im Frühling ist die Wiese mit Zwiebelgewächsen übersät.

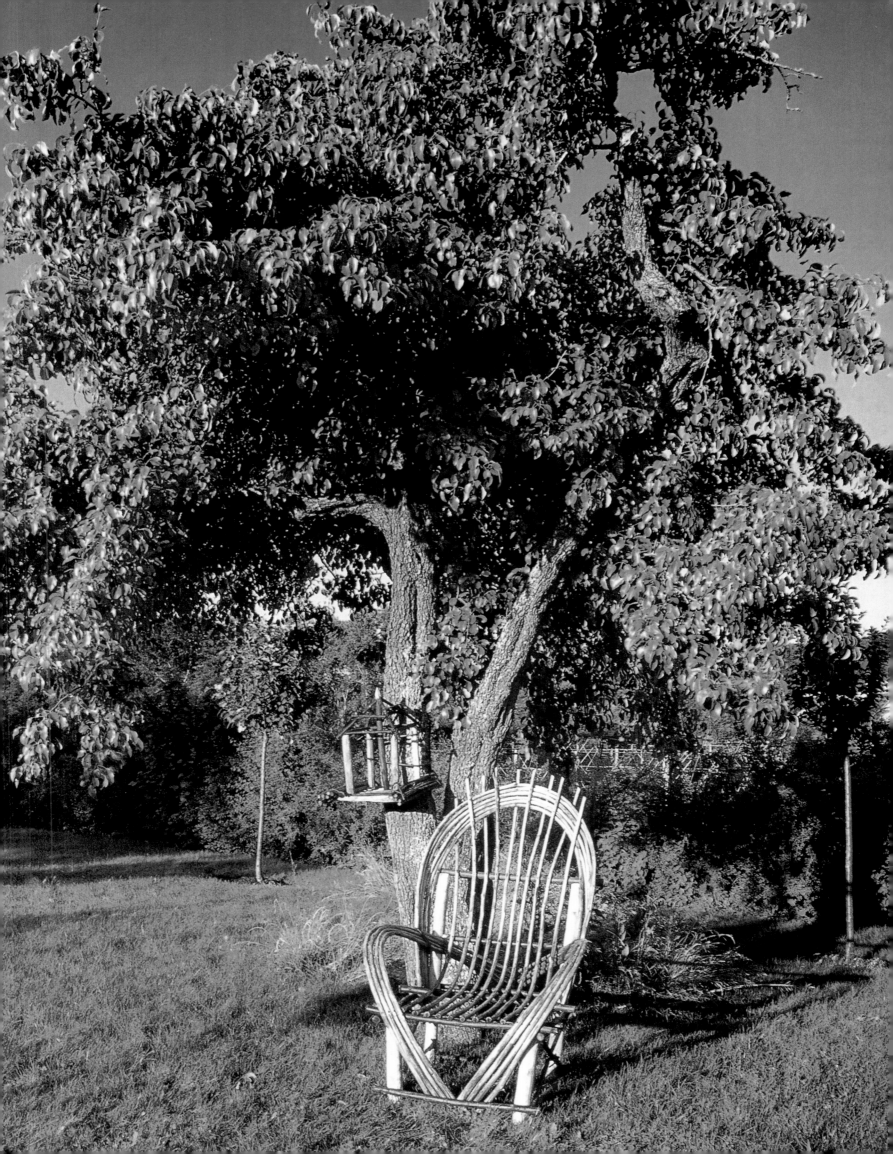

Détail de gauche: sous un buis, mangeoire pour mésanges charbonnières et rouges-gorges.

Detail left: Under a box tree hangs a bird-table for great tits and robins.

Detail links: Unter einem Buchsbaum hängt eine Futterstelle für Kohlmeisen und Rotkehlchen.

Détail de droite: nichoir pour étourneaux fabriqué à partir d'un morceau de tronc d'arbre évidé par ces oiseaux et récupéré par le jardinier. Il a été installé dans un prunier Saint-Julien.

Detail right: a nest box for starlings made from a piece of tree trunk hollowed out by thrushes; the gardener rescued it and hung it up in a Saint Julien plum tree.

Detail rechts: Dieser Starenkasten ist aus einem Stück Baumstamm geschnitten, das von den Vögeln ausgehöhlt und vom Gärtner gefunden worden war. Der Kasten wurde in einem Pflaumenbaum angebracht.

Détail de gauche: dans un poirier, mangeoire pour les merles friands de fruits.

Detail left: in a pear tree, a feeder for blackbirds, who love fruit.

Detail links: In einem Birnbaum gibt es ein Futterhäuschen für Amseln, die gern an Früchten naschen.

Détail de droite: capuchon de paille pour protéger des rayons du soleil une poire mise en bouteille, destinée à recevoir un alcool que le fruit parfumera.

Detail right: a cowl of straw protects a pear in a bottle from the sun; eventually the bottle will be filled with alcohol, to which the pear will add flavour.

Detail rechts: Die Strohabdeckung schützt eine Flaschenbirne vor den Sonnenstrahlen. Die Flasche wird später mit Alkohol aufgefüllt, dem die Birne ihr Aroma vermittelt.

Les jardins de Villandry ont le goût de l'excellence: ils sont bien construits, bien dessinés, bien plantés, remarquablement entretenus. Ils s'accordent avec le château du 16e siècle qui fut conçu par Jean Le Breton, ministre de François Iᵉʳ. Succédant à plusieurs propriétaires qui avaient dénaturé l'endroit, Joachim Carvallo entre en scène en 1906. Il s'intéresse à la restauration des jardins, les réhabilite et leur redonne leur esprit de jadis. Les jardins sont construits sur trois niveaux. Une pièce d'eau occupe le plan supérieur. Viennent ensuite les jardins d'ornement. Le premier est voué à l'amour avec ses fleurs aux couleurs vives et ses buis dessinant des glaives, des poignards, des éventails, des masques ou des croix, le second, avec des représentations d'instruments stylisés, est dédié à la musique. Ses motifs de buis sont adoucis par les harmonies pastel des iris, des santolines et des lavandes. Le potager s'étend sur le niveau le plus bas. Il s'inspire des jardins médiévaux et des jardins de la Renaissance italienne. Il est divisé en neuf carrés qui décrivent des croix, des grecques ou des lignes brisées. L'intersection des allées est ponctuée par un bassin et les carrefours sont arrondis par quatre berceaux de treillage. A l'intérieur, les légumes déploient leurs gammes de couleurs. Le potager de Villandry est un modèle. On s'en inspire, on s'y réfère, on s'en souvient. Et l'on y revient.

Villandry

Villandry exemplifies the highest standards in garden design, plantsmanship and upkeep. In this, the gardens are at one with the chateau, which was commissioned in the 16th century by Jean Le Breton, a minister of François I. Joachim Carvallo acquired the estate in 1906. Until then, the gardens had been neglected and even disfigured. Joachim Carvallo set about their restoration with a passion, and has returned to them the luminous clarity of design that is their birthright. The gardens are on three levels. A pond occupies the upper level. Then come the ornamental gardens, of which the first is a love garden, awash with bright colours, in which the box hedges form swords, daggers, fans, masks and crosses. The second, its box motifs laid out in the shape of stylised instruments, is a music garden; here the sombre box contrasts with the pastel shades of the irises, cotton-lavender *(Santolina)* and lavenders. The lowest level is given over to the kitchen garden. It is based on medieval and Italian Renaissance plans, and divided into nine square areas within which are crosses, Greek key patterns or broken lines. There is a pond at the central intersection of the garden paths and four trellis bowers at minor intersections. The colours of the vegetables within this formal layout offer further pleasures to the eye. The Villandry kitchen garden is a model to which one returns again and again for pleasure and inspiration.

Die Gärten von Villandry zeichnen sich in jeder Hinsicht durch Perfektion aus. Sie sind sorgfältig angelegt, gekonnt entworfen, perfekt bepflanzt und hervorragend gepflegt. Sie harmonieren wunderbar mit dem Schloß aus dem 16. Jahrhundert, das von Jean Le Breton, einem Minister Franz' I., erbaut wurde. Nachdem mehrere Eigentümer die Anlage völlig entstellt hatten, kaufte Joachim Carvallo das Anwesen im Jahre 1906. Er begann voller Begeisterung mit der Restaurierung der alten Gärten und stellte die durchdachte Gestaltung wiederher. Die Gärten liegen auf drei Ebenen. Die oberste nimmt ein geometrisches Wasserbecken ein; es folgen die thematisch orientierten Ziergärten. Der erste behandelt die verschiedenen Arten der Liebe in Form von Schwertern, Dolchen, Fächern, Masken und Kreuzen, die von Buchsbaum gebildet werden. Dazwischen leuchten bunte Blüten. Der zweite Ziergarten ist mit Nachbildungen stilisierter Instrumente dem Thema Musik gewidmet. Die Buchsbaummotive erhalten durch die Pastellfarben von Schwertlilien, Heiligenkraut und Lavendel eine harmonische Note. Auf der untersten Ebene schließlich liegt der Gemüsegarten. Er orientiert sich an mittelalterlichen Vorbildern sowie an den Gärten der italienischen Renaissance und ist in Form von Kreuzen, Mäandern und durchbrochenen Linien in neun großen Quadraten angeordnet. Der Schnittpunkt der Wege ist mit einem Wasserbecken geschmückt, die Kreuzungen sind durch vier Ranklauben abgerundet. In den Beeten selbst entfalten Gemüse ihre kräftigen Farben. Der Gemüsegarten von Villandry diente oft als Vorbild: Viele Besucher ließen sich von ihm inspirieren, berufen sich auf ihn, erinnern sich an ihn. Und kommen wieder.

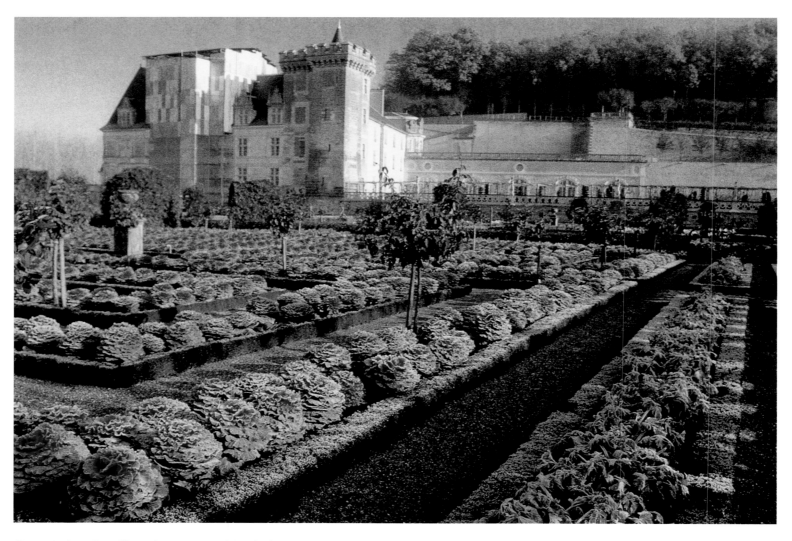

Page précédente: Pour l'hiver, le potager est planté de choux d'ornement 'Red Pigeon' qui prennent de jolies couleurs givrées.

Ci-dessus et page de droite: Les carrés du potager sont au nombre de neuf et ont tous la même dimension. A l'intérieur de chacun, des motifs différents sont replantés deux fois par an, au printemps et en été. Les couleurs des légumes ont été très étudiées. Chaque carré est entouré d'un treillis en chêne et comporte au centre une fontaine. Ici, associées dans les mêmes tonalités de gris-vert, les formes rondes des choux contrastent avec le feuillage des poireaux.

Double page suivante, dans le sens des aiguilles d'une montre: La poirée 'Rhubarb Chard' a des cardes pourpres et des feuilles vertes; chou rouge 'Tête de Nègre'; chou d'ornement 'Red Pigeon'; chou d'ornement 'White Pigeon'.

Previous page: In winter, the kitchen garden is planted with ornamental 'Red Pigeon' cabbages which take on vivid colours under the frost.

Above and facing page: The kitchen garden consists of nine squares, each of the same dimensions. Within each one, different motifs are planted twice a year, in spring and summer. The vegetables have been carefully chosen for their colours. Each square is fenced with oak trelliswork and has a fountain at its centre. Here the round leaves of the cabbages contrast with the foliage of the leeks in a tonality of grey-green.

Following pages, clockwise from top left: the white beet 'Rhubarb Chard' with its purple chards and green leaves; the red cabbage 'Tête de Nègre'; the ornamental cabbage 'Red Pigeon'; the ornamental cabbage 'White Pigeon'.

Vorhergehende Seite: Im Winter ist der Gemüsegarten mit dem Zierkohl 'Red Pigeon' bepflanzt, der sanfte, wie mit Reif überzogene Farben aufweist.

Oben und rechte Seite: Der Gemüsegarten besteht aus Beeten, die zu neun gleich großen Quadraten angeordnet sind. In jedem Beet werden zweimal im Jahr, im Frühling und im Sommer, jeweils andere Motive gepflanzt. Dabei werden die verschiedenen Farben der Gemüse gekonnt eingesetzt. Jedes Quadrat ist von einem Eichengitter umgeben, in der Mitte steht jeweils ein Brunnen. Das rechts gezeigte Beet ist in Graugrün gehalten, die runden Kohlköpfe bilden einen schönen Kontrast zu den Lauchstangen.

Folgende Doppelseite, im Uhrzeigersinn von oben links: Mangold der Sorte 'Rhubarb Chard' mit purpurroten Blattstielen und grünen Blättern; Rotkohl 'Tête de Nègre'; Zierkohl 'Red Pigeon'; Zierkohl 'White Pigeon'.

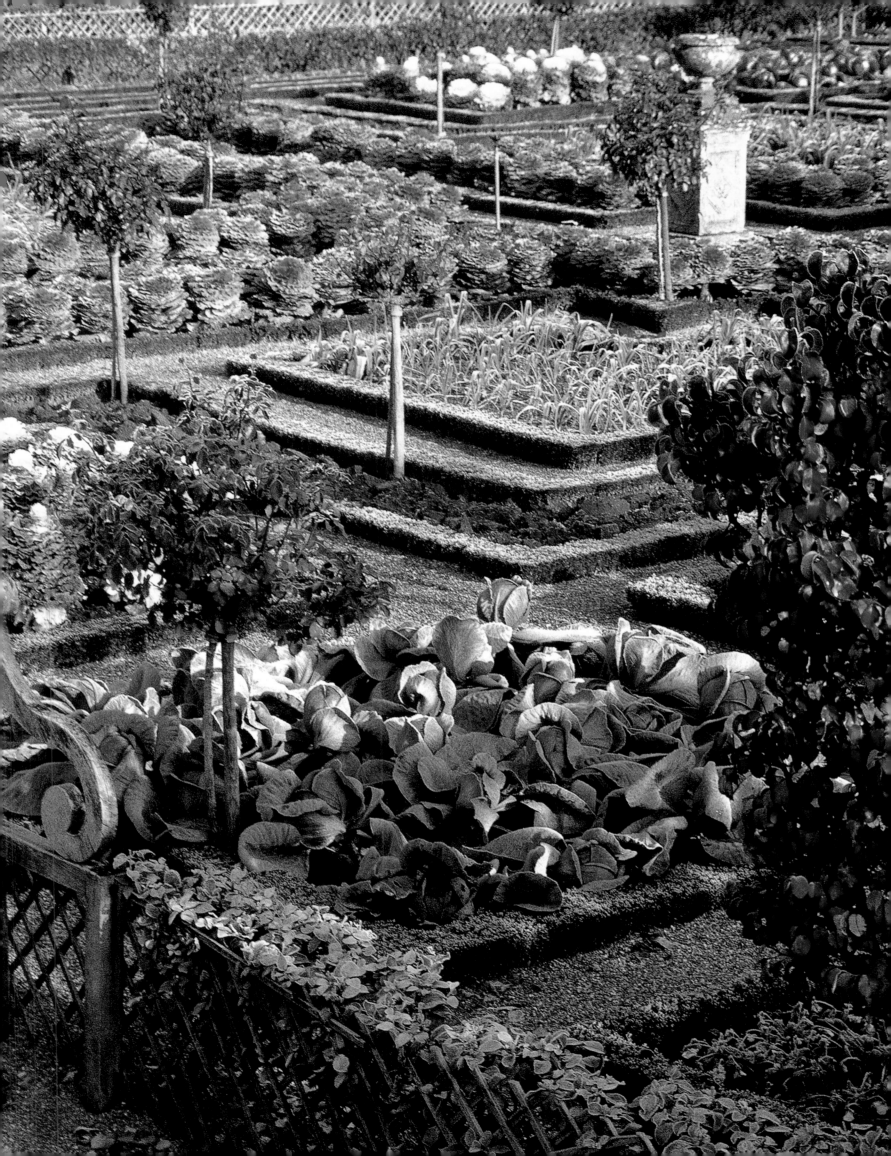

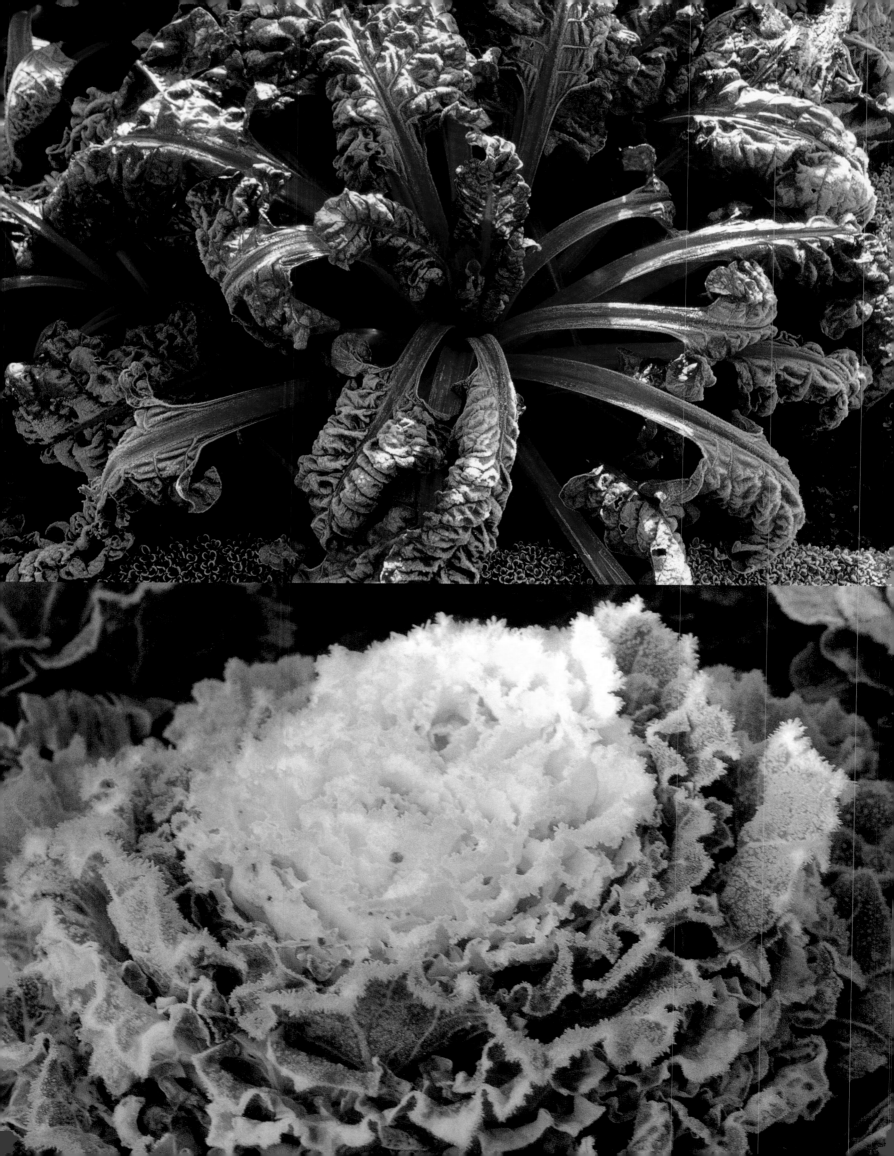

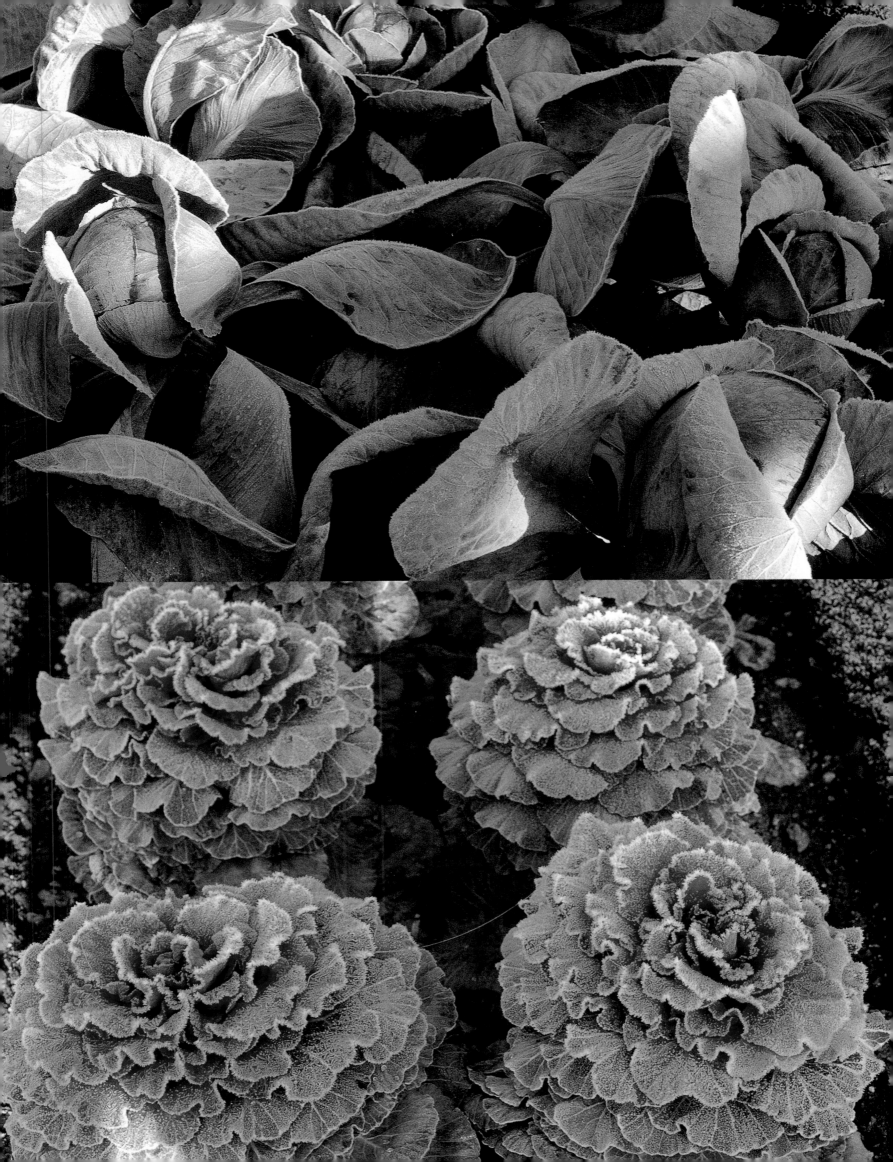

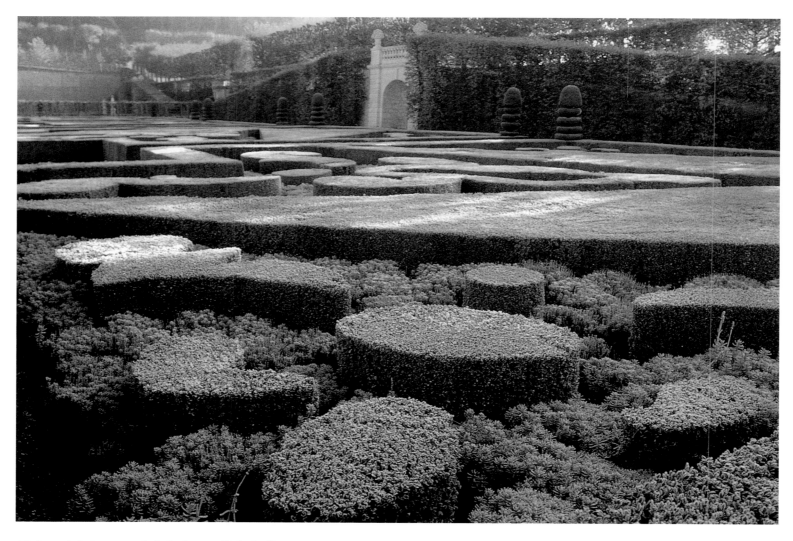

Ci-dessus, à droite et page de droite: Les motifs des jardins d'ornement sont en buis. En hiver, le givre sublime leurs dessins. Ces jardins, de plain-pied avec les pièces de réception du château, ont une valeur symbolique: ce sont les «jardins d'amour». Ils représentent l'Amour tragique, l'Amour adultère, l'Amour tendre et l'Amour passionné.

Above, right and facing page: The ornamental gardens have motifs laid out in box. The designs are particularly spectacular during the winter frosts. These gardens are level with the reception rooms of the chateau and have a symbolic import: they represent Tragic Love, Adulterous Love, Tender Love and Passionate Love.

Oben, rechts und rechte Seite: Die Motive in den Ziergärten werden von Buchsbaumhecken gebildet. Im Winter verleiht der Rauhreif den Ornamenten eine ätherische Note. Dieser Bereich, der auf gleicher Höhe mit den Empfangssälen des Schlosses liegt, behandelt symbolisch verschiedene Themen. In den »Liebesgärten« sind die tragische Liebe, die ehebrecherische Liebe, die zärtliche Liebe und die leidenschaftliche Liebe dargestellt.

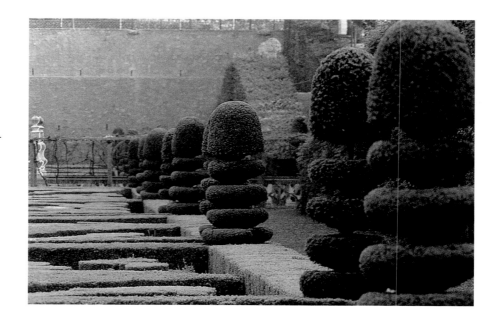

Villandry *Centre*

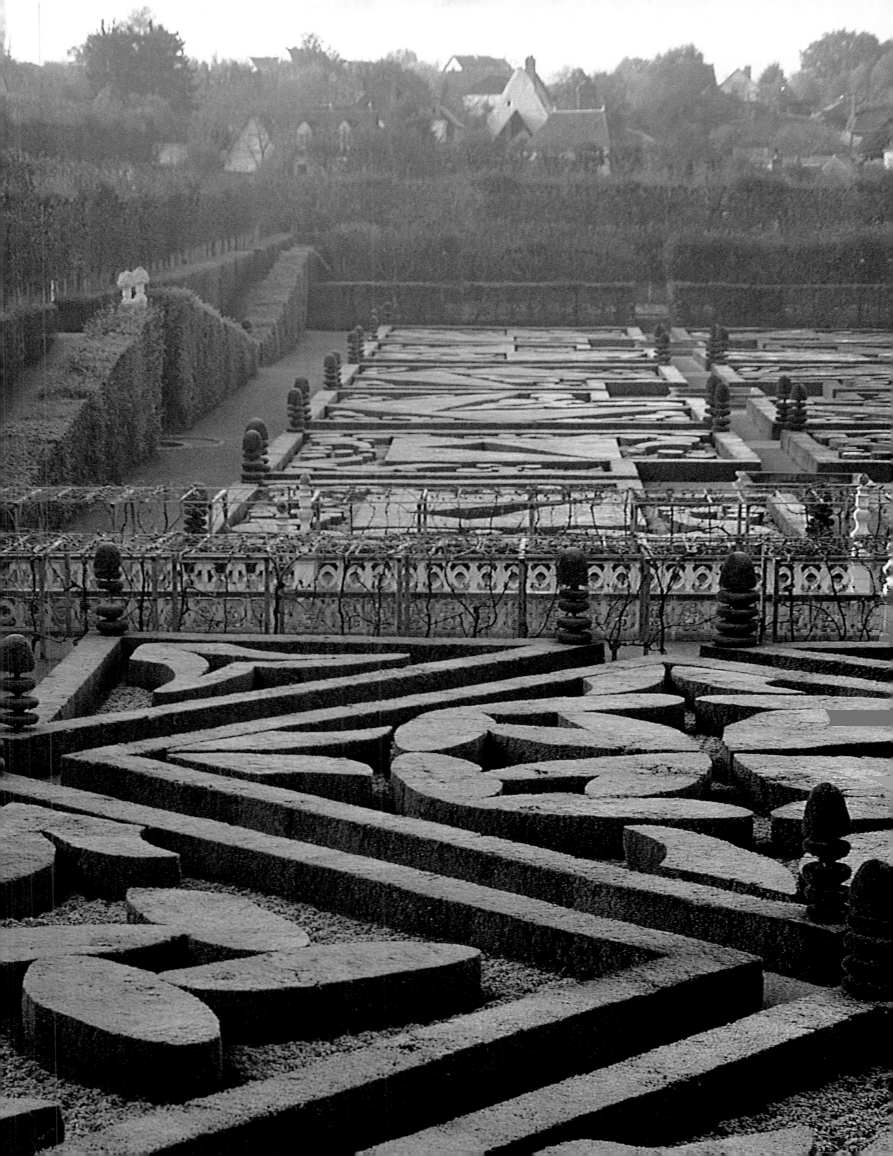

Les ifs taillés sont l'emblème des jardins du Château du Pin. Que représentent-ils? «On peut imaginer un jeu d'échecs, un roi et son armée, une ronde de danseurs ou encore une collection de flacons de parfum» raconte Jane de la Celle qui a repris l'œuvre de son grand-père et la restaure en respectant la structure établie, tout en laissant parler son goût personnel. Si le château évoque la Renaissance, les jardins ne furent créés qu'en 1921 par Gérard Christmas Gignoux, un Américain. C'était un grand esthète qui possédait un jugement sûr en matière d'art des jardins. Il étagea ceux-ci sur trois niveaux. La promenade s'est aujourd'hui enrichie de onze nouveaux thèmes grâce aux efforts passionnés de Jane de la Celle. Devant l'orangerie, la terrasse dallée d'ardoises sert de présentoir à une collection d'agrumes opulents. Ils contrastent joliment avec les ifs qui dans un sens, sont plantés autour d'un bassin et ouvrent une perspective allant vers la chapelle, dans l'autre, ménagent une percée embrassant les coteaux de la Loire. Plus bas, la pelouse est inondée à l'automne d'un tapis de cyclamens innombrables et naturalisés. Puis des marches conduisent aux jardins de fleurs très architecturés reliés par des escaliers et ornés chacun d'un bassin: le jardin d'iris, le jardin d'odeurs, le jardin des roses jaunes de création récente, le jardin des delphiniums qui fait chanter les bleus. Plus loin, le jardin des douves évoque un amphithéâtre habillé de plantes vivaces.

Le Château du Pin

The yews in the topiary garden are the emblem of the Château du Pin. What do they represent? "They might be a game of chess, a king and his army, a circle of dancers or even a collection of perfume flasks," says Jane de la Celle, who has taken over her grandfather's creation and is restoring it within the existing structure but according to her own personal taste. The chateau dates from the Renaissance, but the gardens date only from 1921. They were created by Gérard Christmas Gignoux, an American aesthete with a very sure taste in gardens. He organised those of the Château du Pin on three levels. Since his time the promenade has acquired eleven new themes, thanks to the dedication and inventiveness of Jane de la Celle. In front of the orangery, the slate-paved terrace provides a background for a collection of mature citrus trees. They form a delightful contrast with the yews, which in one direction border the pond and open up a vista toward the chapel, and in the other create an opening through which the low hills of the Loire can be seen. Below this, the lawns are invaded in autumn by a mass of self-seeding cyclamens. From there, steps lead down to the very formal flower gardens, which are linked by staircases, each with its own pond. There is an iris garden, a scent garden, a garden of modern yellow roses and a delphinium garden offering every nuance of blue. Beyond this is the moat garden, which is like an amphitheatre clothed in perennials.

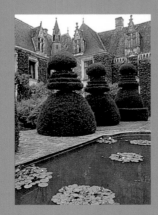

Die beschnittenen Eiben sind das Wahrzeichen des Château du Pin. Was stellen sie dar? »Man kann sich vorstellen, es seien Schachfiguren, ein König mit seiner Armee, ein Ballett oder eine Sammlung von Parfümflacons«, erzählt Jane de la Celle, die das Werk ihres Großvaters weiterführt, den Park instand setzt und dabei die bestehende Struktur beibehält, ohne jedoch ihren persönlichen Geschmack zu verleugnen. Während das Schloß aus der Renaissance stammt, wurden die Gärten erst 1921 von dem Amerikaner Gérard Christmas Gignoux angelegt, der über einen untrüglichen ästhetischen Geschmack in der Gartenbaukunst verfügte. Die von ihm auf drei Ebenen angelegten Gärten wurden mittlerweile dank der begeisterten Arbeit von Jane de la Celle durch elf weitere Anlagen bereichert. Vor der Orangerie ist eine umfangreiche Sammlung von Zitrusbäumen auf einer mit Schieferplatten gefliesten Terrasse aufgestellt. Sie bilden einen hübschen Kontrast zu den Eiben, die ein Wasserbassin säumen. Von dort aus führt eine von Eiben gerahmte Blickachse zur Kapelle, während man in der anderen Richtung einen überwältigenden Blick auf die Hänge der Loire hat. Weiter unten verwandelt sich die Wiese im Herbst in einen Teppich aus unzähligen wilden Alpenveilchen. Anschließend führen ein paar Stufen zu den streng geometrisch angelegten Blumengärten, die durch Treppen verbunden und jeweils mit einem Wasserbecken geschmückt sind. Der Schwertliliengarten, der Duftgarten, der Garten der gelben Rosen und der überwiegend in Blau gehaltene Rittersporngarten sind einige davon. Darunter schließt sich im früheren Burggraben ein Staudengarten an, der wie ein farbenprächtiges Amphitheater wirkt.

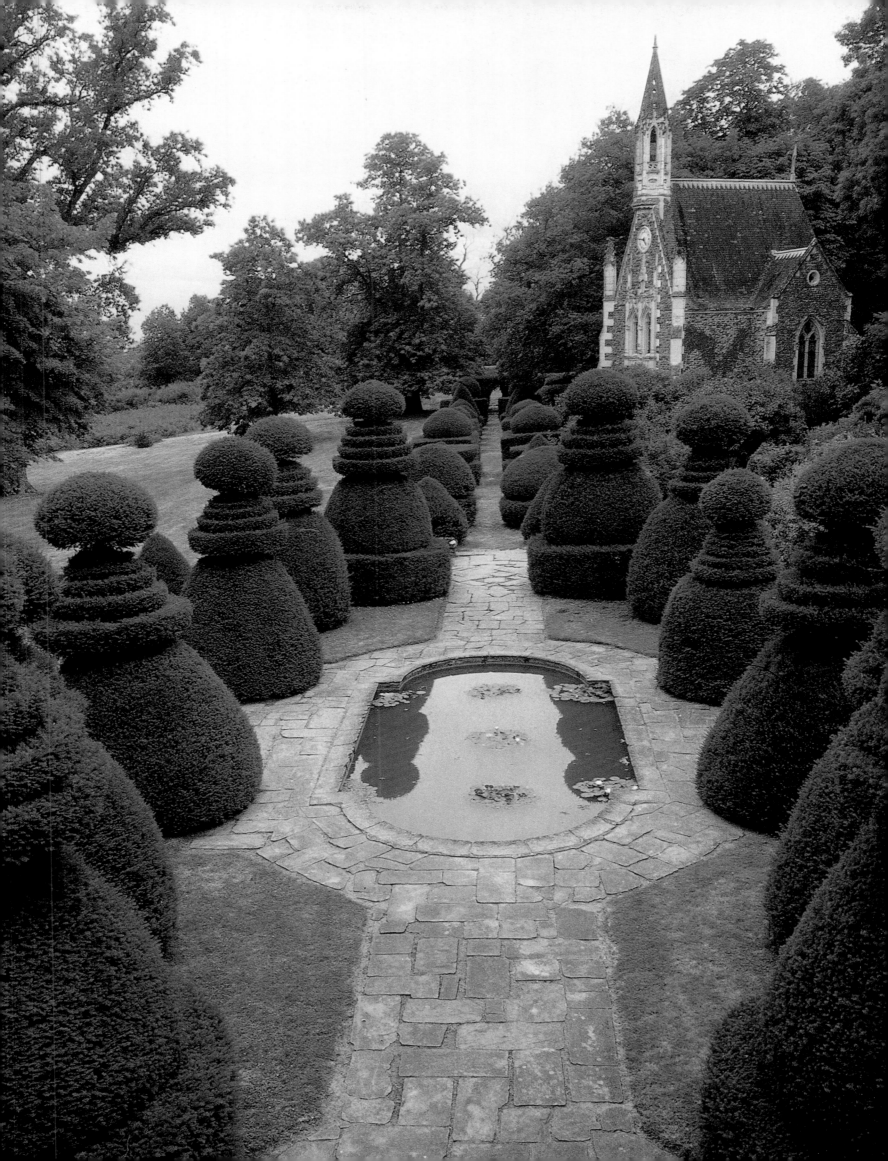

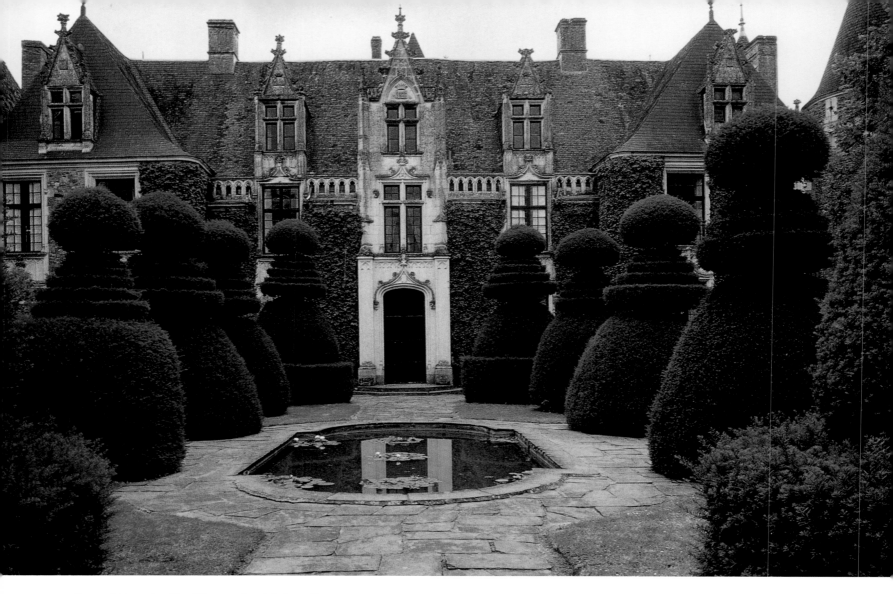

Page précédente: Les ifs taillés sont plantés le long d'une perspective dallée qui ouvre vers la chapelle.
Ci-dessus: Un autre axe coupe le précédent à angle droit, perpendiculairement au château. Ils se croisent dans le bassin. Du château, la vue descend vers les nouveaux jardins et plus loin, vers la campagne angevine.
A droite: La chapelle s'appuie sur les frondaisons du parc.

Previous page: The topiary yews are planted along a flagstone vista leading to the chapel.
Above: A second axis is perpendicular to the first and to the castle; the pond is the point of intersection. From the chateau, one looks out over the new gardens and the countryside of Anjou.
Right: The chapel seems to lean upon the foliage of the park.

Vorhergehende Seite: Beschnittene Eiben säumen den gepflasterten Weg zur Kapelle.
Oben: Eine zweite Achse kreuzt die zuvor genannte im rechten Winkel, senkrecht zum Schloß. Im Schnittpunkt der Achsen liegt ein Wasserbassin. Vom Schloß aus hat man über die neuen Gärten hinweg den Blick auf die Landschaft des Anjou.
Rechts: Die Kapelle schmiegt sich in die Baumkronen des Parks.

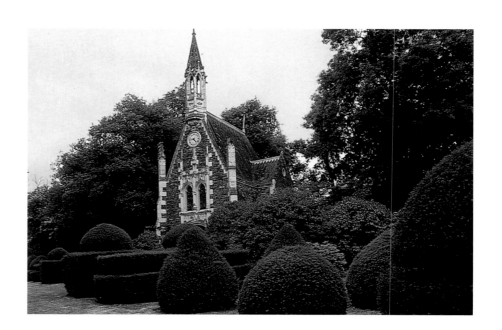

Le Château du Pin *Pays de la Loire*

A droite: La terrasse située devant le château est orientée plein sud. C'est un endroit idéal pour cultiver des plantes exotiques ou méditerranéennes en bacs: daturas, bananiers *(Musa)*, hibiscus, lauriers-roses *(Nerium oleander)*, avocatiers et toutes sortes d'agrumes.

Ci-dessous: Jane de la Celle taille elle-même ses cinquante-huit ifs dont quarante-huit sont alignés devant le château. Elle utilise une cisaille à main et il lui faut une journée par arbre.

Right: The terrace in front of the castle faces due south, and is an ideal place in which to cultivate exotic and Mediterranean plants in containers. There are thorn-apples *(Datura)*, banana trees *(Musa)*, hibiscus, oleanders *(Nerium oleander)*, avocado trees and all kinds of citruses.

Below: Jane de la Celle herself sculpts her fifty-eight yews, of which forty-eight are aligned in front of the castle. She uses hand-shears and each tree takes her a whole day.

Rechts: Die Terrasse vor dem Schloß liegt nach Süden und eignet sich deshalb besonders für die Kultur tropischer oder mediterraner Kübelpflanzen, etwa Trompetenblumen *(Datura)*, Bananenstauden *(Musa)*, Hibiskus, Oleander *(Nerium oleander)*, Avocadobüsche und verschiedene Zitrusfrüchte.

Unten: Ihre achtundfünfzig Eiben, von denen achtundvierzig vor dem Schloß aufgereiht stehen, schneidet Jane de la Celle selbst. Sie verwendet dazu eine mechanische Heckenschere und benötigt pro Baum einen ganzen Tag.

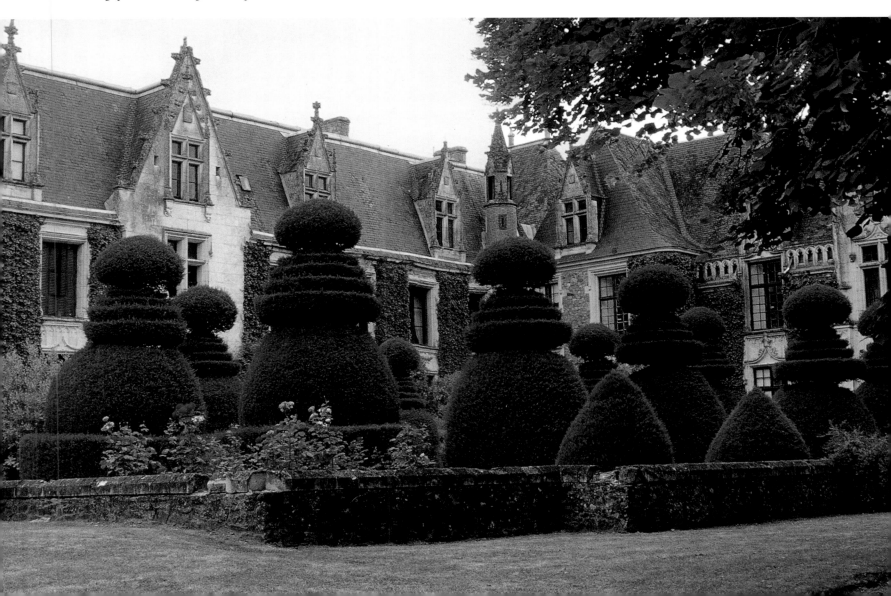

La porte rouge à l'entrée du parc donne le ton et l'envie d'aller quérir plus loin les images d'un rêve oriental totalement étranger au village paisible de Maulévrier. Un chemin longe le vallon en imitant le cours de la rivière. Ils se rencontrent au pied de la pièce d'eau autour de laquelle s'enchaînent de très beaux tableaux. Le parc a été créé en 1900 par Alexandre Marcel qui l'a travaillé comme une succession d'aquarelles. Sa restauration a débuté en 1980 sous la direction de Jean-Pierre Chavassieux qui la mène avec passion. Alexandre Marcel était architecte, spécialisé dans l'architecture de style asiatique. Sa carrière fut jalonnée de commandes prestigieuses inspirées des pays orientaux, d'où son goût pour les jardins japonais qui étaient aussi très à la mode à l'époque. Le spectacle de la pièce d'eau est très prenant. Sans doute à cause de la présence de l'eau, de ses reflets, de ses différents mouvements. Les feuilles des érables tremblent au-dessus d'elle tandis que les lanternes de pierre et les rochers restent immobiles. La pergola de glycines, l'embarcadère, le pont Khmer, la pagode, le temple et le pont rouge qui rejoint des îles nous transportent sous des cieux orientaux. Cette atmosphère est accentuée par la silhouette de végétaux travaillés dans le goût japonais: des buis taillés en nuage ou en plateau, des ifs conduits qui s'étirent et se penchent à la surface de l'eau. Ici, le dépaysement est total, tout concourt à l'évasion.

Maulévrier

The red gate that gives entrance to the park is a statement in itself, one that inspires the visitor to go further in his search for an oriental atmosphere wholly at odds with that of the peaceful village of Maulévrier. A path runs a sinuous course alongside the river in the hollow of the valley. They meet at the lake around which are a series of superlative compositions. The park was created in 1900 by Alexandre Marcel who endlessly retouched it as one might a succession of watercolours. Its restoration began in 1980 under the accomplished direction of Jean-Pierre Chavassieux. Alexandre Michel was an architect who specialised in buildings of Asiatic style. His career was a series of prestigious commissions for buildings of oriental inspiration, which he combined with a taste for the Japanese gardens then so fashionable. The lake is an enchanting sight, all reflections and shifting light. The maple leaves tremble above their own reflections while the lanterns and boulders form an unmoving framework. The wisteria pergola, the jetty, the Khmer bridge, the pagoda, the temple and the red bridge between the islands transport us to an eastern world. This atmosphere is enhanced by the silhouettes of the trees and shrubs, which have been moulded in Japanese style so that the boxes are clipped into cloud or tray shapes and the yews trained to stretch out over the surface of the water. This is an escapist's paradise.

Das rote Tor zum Park stimmt die Melodie an und fordert den Besucher auf, weiterzugehen und den Bildern eines orientalischen Traums nachzuforschen, der in dem verschlafenen Dörfchen Maulévrier so völlig fremd wirkt. Im Tal folgt ein Weg dem Bachufer. Beide führen an einen großen Teich mit wunderschöner Aussicht auf den Park. Er wurde 1900 von Alexandre Marcel wie eine Folge von Aquarellbildern gestaltet und unter der Leitung von Jean-Pierre Chavassieux restauriert, der die Anlage seit 1980 mit großem Enthusiasmus führt. Alexandre Marcel war Architekt, der sich auf asiatische Stilrichtungen spezialisiert hatte. Das erklärt auch seine Vorliebe für japanische Gärten, die zu seiner Zeit gleichfalls sehr beliebt waren. Der Teich bietet ein eindrucksvolles Schauspiel. Der Blick wird magisch angezogen von den Wirbeln und Reflexen auf der Wasserfläche. Darüber bewegen sich leicht die Blätter der Ahornbäume, während steinerne Laternen und Felsen unbeweglich verharren. Die Glyzinenpergola, der Landungssteg, die Khmer-Brücke, die Pagode, der Tempel und die rote Brücke zu den Inseln entführen uns in eine fernöstliche Welt. Diese Atmosphäre wird noch betont durch die Silhouetten der nach japanischem Geschmack beschnittenen Sträucher: Buchsbaum in Form von Wolken oder flachen Quadern, hochragende Eiben, die sich über die Wasserfläche beugen. Alles strebt in die Ferne, man glaubt sich in fremden Welten.

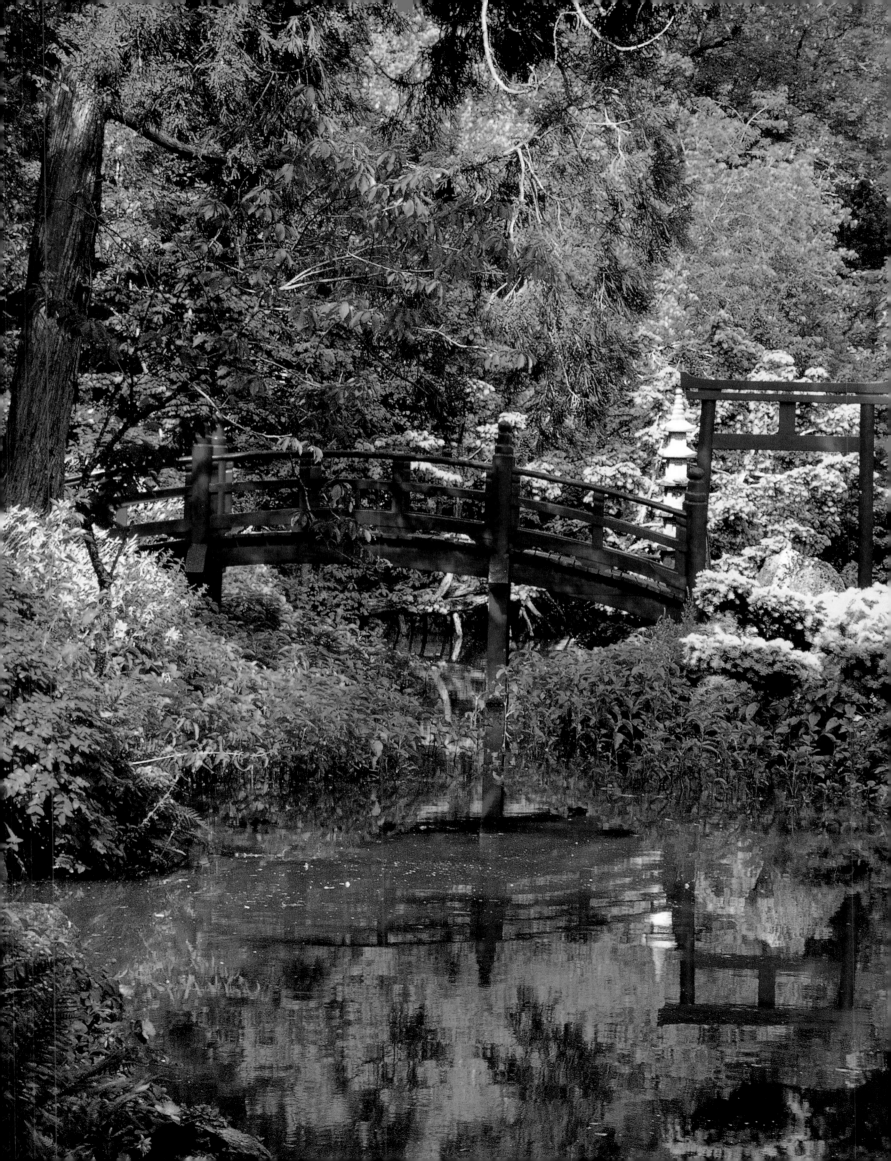

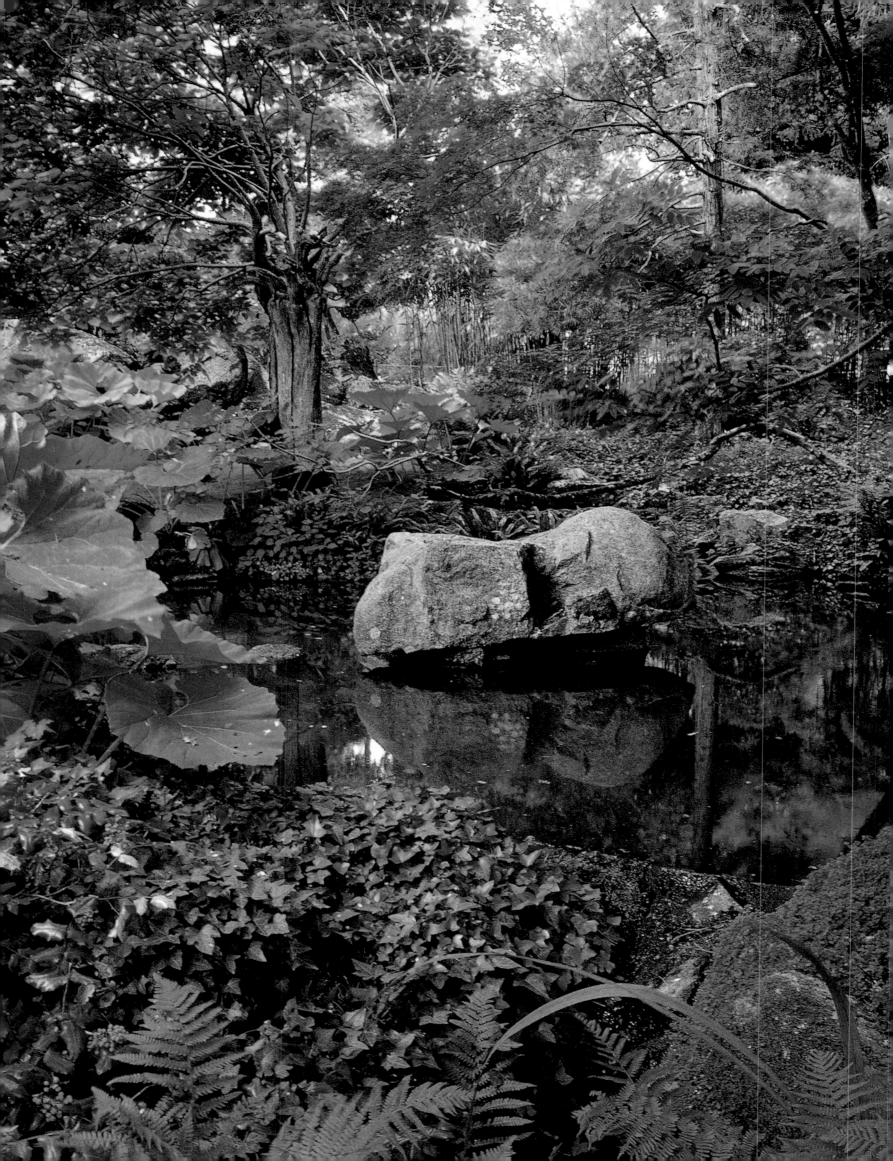

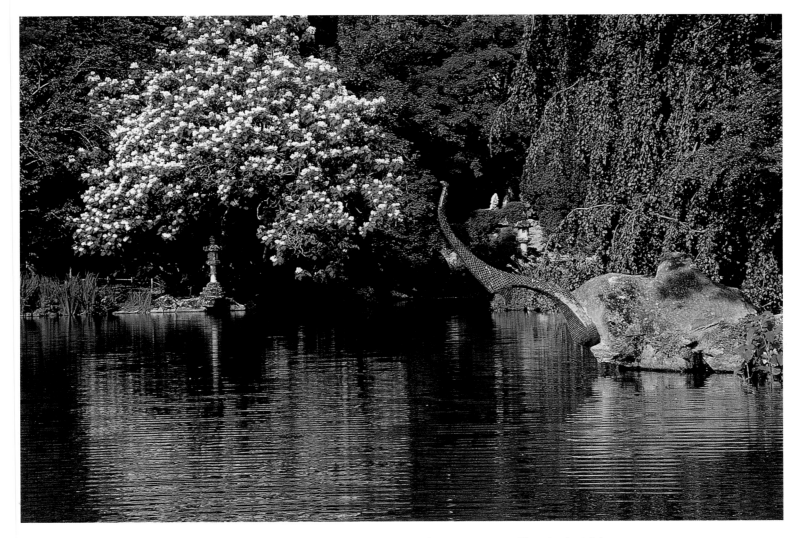

Page précédente: La note japonaise est d'emblée donnée par le pont rouge qui permet symboliquement l'accès au paradis, la couleur rouge évoquant le sacré.

Page de gauche: la pièce d'eau et ses reflets. Elle est bordée de grands arbres et ses berges sont peuplées de plantes appréciant un terrain frais: lierre *(Hedera),* fougères, *Helxine,* pétasites aux feuilles géantes.

Ci-dessus: la pièce d'eau, ses îles et un *Catalpa bignonioides* en fleurs.

A droite: le temple khmer. Ce temple avait été présenté au public à Paris en 1900, dans le cadre du pavillon du Cambodge aménagé par Alexandre Marcel lors de l'Exposition universelle.

Previous page: A Japanese note is immediately sounded by the red bridge, which symbolises entry into paradise; red is the colour of things sacred.

Facing page: the lake and its reflections. It is surrounded by mature trees and its banks sown with plants that prefer shady soil: ivy *(Hedera),* ferns, *Helxine,* and the giant leaves of butterburs *(Petasites).*

Above: the lake, its islands, and an Indian bean tree *(Catalpa bignonioides)* in flower.

Right: the Khmer temple. This temple was exhibited in Paris in 1900, in the Cambodian Pavilion designed by Alexandre Marcel for the Universal Exhibition of that year.

Vorhergehende Seite: Die fernöstliche Atmosphäre umfängt den Besucher schon am Eingang mit der roten Brücke. Die heilige Farbe Rot betont den symbolischen Charakter der Brücke als Zugang zum Paradies.

Linke Seite: Die mächtigen Bäume am Ufer spiegeln sich im Teich. Außerdem wachsen hier Pflanzen, die ein kühleres Klima bevorzugen: Efeu *(Hedera),* Farn, Bubiköpfchen *(Helxine)* und die Pestwurz *(Petasites)* mit ihren riesigen Blättern.

Oben: der Teich mit seinen Inseln. Am Ufer blüht ein Trompetenbaum *(Catalpa bignonioides).*

Rechts: der Khmer-Tempel. Er war in dem Kambodschanischen Pavillon ausgestellt worden, den Alexandre Marcel für die Weltausstellung 1900 in Paris gestaltet hatte.

«Cette maison vendéenne était une ruine mal aimée. J'ai voulu la sauver et remettre l'endroit en valeur comme il m'est arrivé de le faire pour un compositeur délaissé depuis trois cents ans» raconte le chef d'orchestre William Christie, spécialiste de musique baroque. «Ce jardin représente un aboutissement pour moi, une incantation et en même temps un défi. Je l'ai créé de toute pièce comme l'extension de l'architecture de cette ferme noble du 17ᵉ siècle. D'où ce tracé structuré et toutes ces formes taillées. J'ai respecté la sobriété du logis en choisissant des végétaux très simples: des buis, des ifs, des charmes ou des tilleuls. J'ai commencé cette création il y a une dizaine d'années. Je suis un visiteur de jardins invétéré. Celui-ci est très éclectique car les jardins s'apparentent à la musique: on improvise, on s'inspire, on interprète». Le grand portail ouvre sur un parterre symétrique de buis à l'italienne, encadré d'un côté par un jardin de simples en broderie, de l'autre par une pergola surmontée d'une chinoiserie rustique en châtaigner drapée de rosiers. Voici pour la cour d'honneur qui met en valeur la façade principale du manoir. Plusieurs jardins le prolongent sur la droite: un jardin circulaire, une tonnelle, un cloître et un potager. A l'arrière, la vue s'étend sur un mail de tilleuls qui fait le tour d'une grande pelouse rectangulaire ornée de formes topiaires, et se prolonge sur un plan d'eau. Tout est pensé, voulu, extrêmement raffiné.

Le jardin de William Christie

"This Vendée house was an uncared-for ruin. I wanted to save it and restore its former glory as I might have done the works of a composer similarly neglected for three hundred years". The speaker is William Christie, conductor and specialist in Baroque music. "For me, the garden is at once a fulfilment, a challenge and an enchantment. I built it up from scratch as an extension of the architecture of this noble 17th-century farm. Whence the very formal outline and the many clipped forms. I chose very simple plants to respect the sober lines of the house: box, yew, hornbeam and lime. I began about ten years ago. I am an inveterate visitor of gardens. This one is very eclectic. Gardens are like music; I have improvised, interpreted and followed my own inspiration." The main gate opens onto a symmetrical Italianate box parterre; it is flanked on the one hand by an embroidered parterre of "simples" and on the other by a pergola over which rises a rustic chinoiserie in chestnut wood, submerged in climbing roses. This is the main courtyard, which sets off the main façade of the manor house. To the right, it extends into several further gardens: a circular garden, a bower, a cloister and a kitchen garden. Behind the house, a palisade of limes surrounds a large rectangular lawn on which the planting has been chosen for topiary; behind this lies a stretch of water. Everything is meticulously planned and precisely executed.

»Dieses Haus in der Vendée war eine heruntergekommene Ruine. Ich wollte sie retten und den Ort wieder aufwerten, so wie mir das schon einmal bei einem dreihundert Jahre lang vergessenen Komponisten gelungen ist«, erzählt William Christie, Dirigent und Spezialist für Barockmusik. »Dieser Garten ist ein Ziel, das ich mir gesetzt habe und das mich gleichzeitig verzaubert und herausfordert. Ich habe ihn gestaltet als Verlängerung des Herrengutes aus dem 17. Jahrhunderts, deshalb auch der geometrische Grundriß und die vielen Formbäume. Der Schlichtheit des Gebäudes habe ich mit der zurückhaltenden Bepflanzung aus Buchsbaum, Eiben, Hainbuchen und Linden Tribut gezollt. Begonnen habe ich dieses Werk vor rund zehn Jahren. Ich besuche leidenschaftlich gerne Gärten. Dieser Garten ist ausgesprochen eklektisch, denn Gärten ähneln der Musik: Man improvisiert, läßt sich inspirieren, interpretiert.« Das große Portal führt zu einem symmetrischen Parterre in italienischem Stil mit Buchsbaumhecken, das an der einen Seite durch den als Broderie-Parterre gestalteten Heilkräutergarten und auf der anderen durch eine Pergola abgeschlossen wird. Deren Mitte bildet eine mit Rosen überrankte rustikale Pagode aus Kastanienzweigen. Von hier aus gelangt man zum Ehrenhof, in dem die Hauptfassade des Herrenhauses zur Geltung kommt. Rechter Hand schließen sich mehrere Gärten an, so etwa ein runder Garten, eine Laube, ein Kreuzgang und ein Gemüsegarten. Hinter dem Haus wandert der Blick an einer langgestreckten Lindenallee entlang über ein großes, mit Formbäumen bepflanztes Rasenviereck und weiter bis zum Wasserbecken. Alles ist durchdacht und unendlich raffiniert gestaltet.

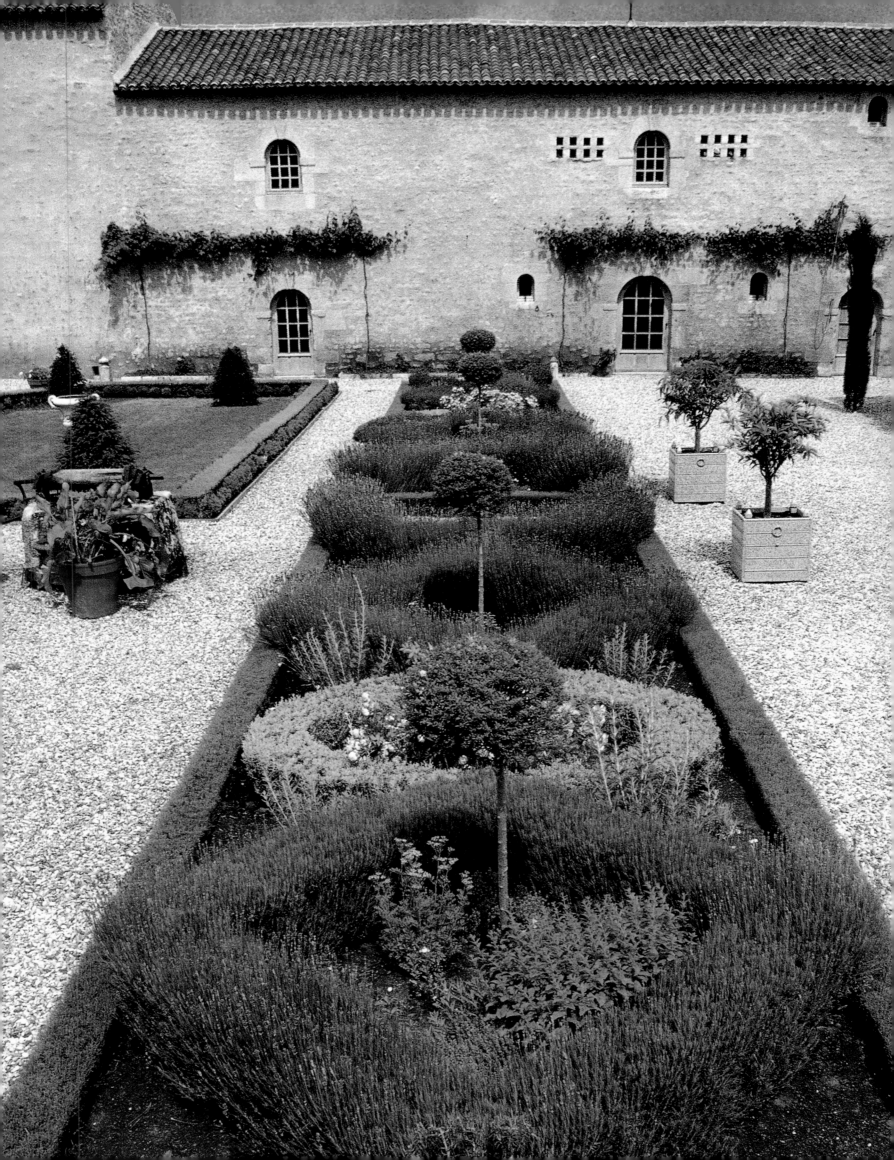

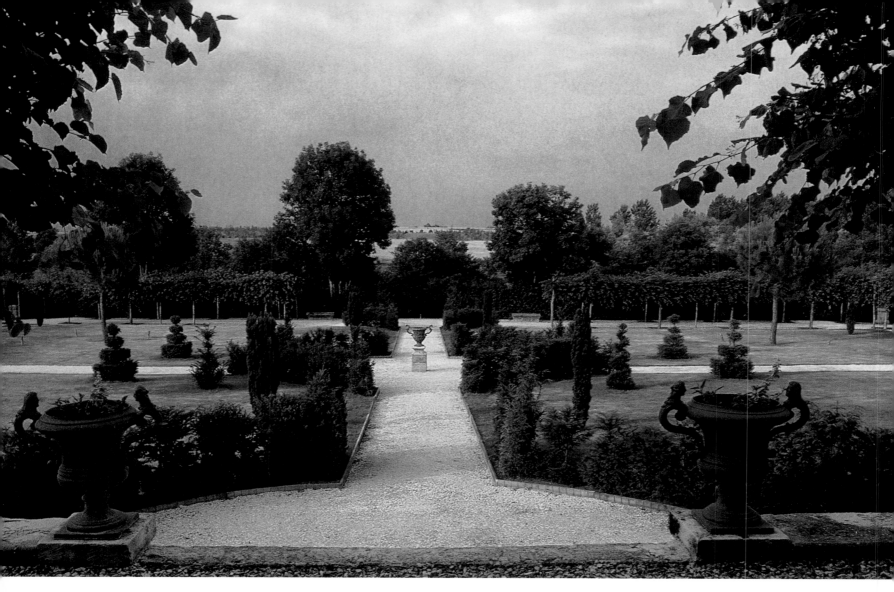

Page précédente: Le jardin de simples devant le logis, orné de lavandes et de santolines vertes ou grises, est planté de rue *(Ruta graveolus),* de romarin et de menthes. Il est rythmé de *Lonicera* montés sur tige et de rosiers roses 'Raubritter'.
Ci-dessus: La perspective qui part de l'arrière du logis traverse le jardin topiaire et ouvre sur le bocage vendéen. Ce jardin est entouré d'un mail de tilleuls palissés à l'italienne.
A droite: vue sur la maison.

Previous page: The herb garden in front of the house is decorated with lavender and grey and green cotton-lavender *(Santolina)* and planted with rue *(Ruta graveolus),* rosemary and mints. A rhythm is produced by the bare-stemmed honeysuckle *(Lonicera)* and pink 'Raubritter' roses.
Above: the vista from behind the house over the topiary garden onto the "bocage" of the Vendée. The garden is surrounded by an Italian-style palisade of lime.
Right: view on the house.

Vorhergehende Seite: Der Heilkräutergarten vor dem Wohnhaus ist mit Lavendel, grauem und grünem Heiligenkraut *(Santolina)* verziert und mit Raute *(Ruta graveolus),* Rosmarin und Minze bepflanzt. Heckenkirschenhochstämmchen *(Lonicera)* und Rosen der Sorte 'Raubritter' gliedern den niedrigen Bewuchs.
Oben: Diese Perspektive verläuft von der Rückseite des Haupthauses quer durch den Formschnittgarten bis zur Küste der Vendée. Der Garten ist von einer Lindenallee umgeben, an der die Bäume nach italienischer Manier an Spalieren gezogen werden.
Rechts: Blick auf das Haus.

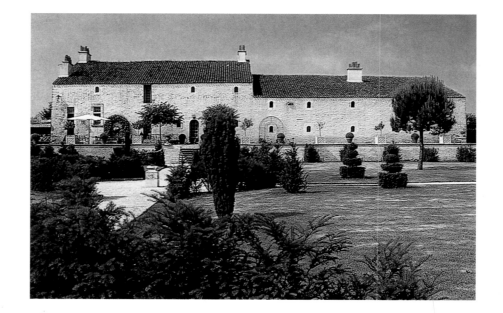

Le jardin de William Christie *Pays de la Loire*

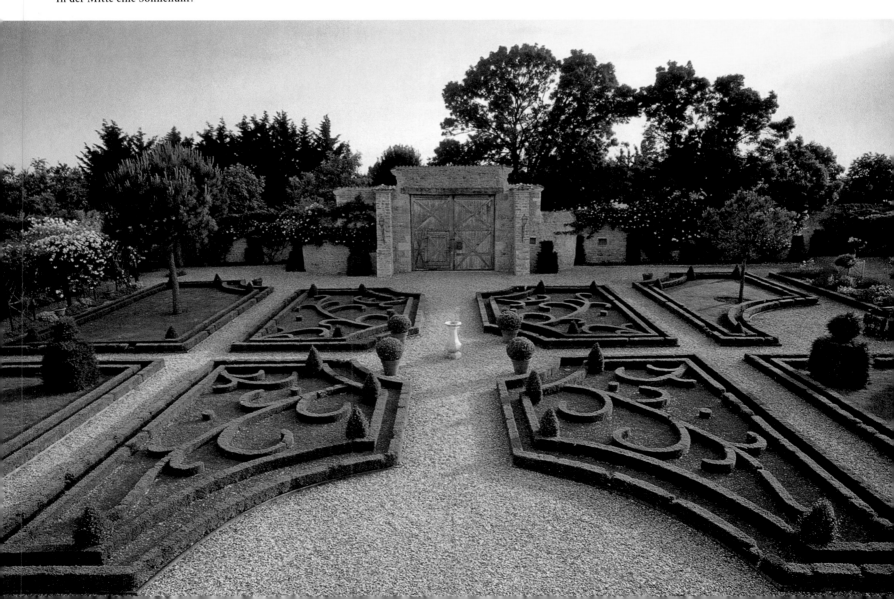

A droite et ci-dessous: la cour d'honneur et ses parterres de broderies. Les buis ressortent sur de la brique pilée dont la couleur ocre rappelle le toit de la maison. Les motifs sont symétriques et représentent des épis, des plumes ou des accolades. Au centre, un cadran solaire.

Right and below: The main courtyard and its embroidered parterres. The box stands out against the ochre of the crushed brick, which echoes the roof of the house. The motifs are symmetrical and represent finials, plumes and accolades. In the centre, a sundial.

Rechts und unten: der Ehrenhof mit seinen Broderie-Parterres. Die Flächen zwischen den Buchsbaumhecken sind mit Ziegelmehl bestreut, dessen Ockerton die Farbe des Hausdaches aufnimmt. Die Motive sind symmetrisch angeordnet und stellen Ähren, Federn und geschweifte Klammern dar. In der Mitte eine Sonnenuhr.

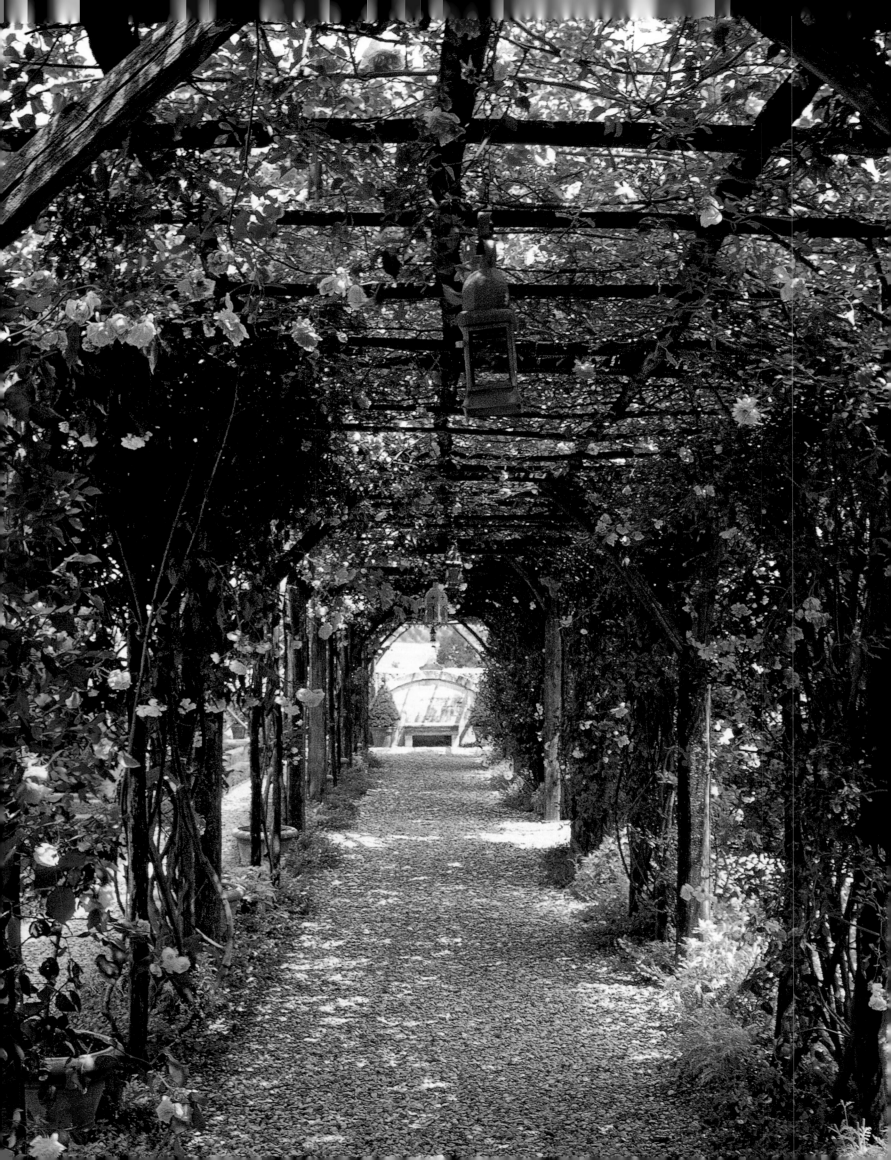

Page de gauche: la pergola, recouverte de vignes et des rosiers
'Ley's Perpetual Yellow', 'François Juranville' et 'Gardénia'.
Cette pergola est surmontée d'un kiosque central sur lequel
courent 'New Dawn', 'Thalia' et 'Madame Caroline Testout'.
Ci-dessus: L'été, on prend les repas sous la tonnelle où sont
palissés les rosiers 'Reine des Violettes' et 'Phyllis Bide'. Sur
son toit s'entremêlent des vignes et des clématites botaniques.
Détails de droite: Cette auge ancienne placée sur la terrasse en
guise de fontaine est recouverte de lierre *(Hedera);* une petite
niche abrite des fragments de vieilles pierres sculptées.

Facing page: The pergola is covered in vines and roses: 'Ley's
Perpetual Yellow', 'François Juranville' and 'Gardénia'. It is
surmounted by a central kiosk on which 'New Dawn',
'Thalia' and 'Madame Caroline Testout' ramble.
Above: In summer, meals are taken in the bower, which is pal-
isaded with the roses 'Reine des Violettes' and 'Phyllis Bide'.
On its roof, vines and clematis mingle.
Details right: This old trough which catches the water of the
terrace fountain is covered by ivy *(Hedera);* a little niche dis-
plays fragments of carved stone.

Linke Seite: Die Pergola ist mit Wein und Rosen der Sorten
'Ley's Perpetual Yellow', 'François Juranville' und 'Gardenia'
bewachsen. In ihrer Mitte erhebt sich eine Pagode, an der Ro-
sen der Sorten 'New Dawn', 'Thalia' und 'Madame Caroline
Testout' emporklettern.
Oben: Im Sommer speist man unter der Laube, die mit den
Rosen 'Reine des Violettes' und 'Phyllis Bide' berankt ist. Auf
dem Dach sieht man ineinander verschlungen Weinranken
und Waldreben *(Clematis).*

Details unten: Efeu *(Hedera)* rankt sich um einen alten
Futtertrog, der auf der Terrasse als Brunnen genutzt wird; in
einer kleinen Nische sind Bruchstücke alter Werksteine mit
eingemeißeltem Dekor aufgestellt.

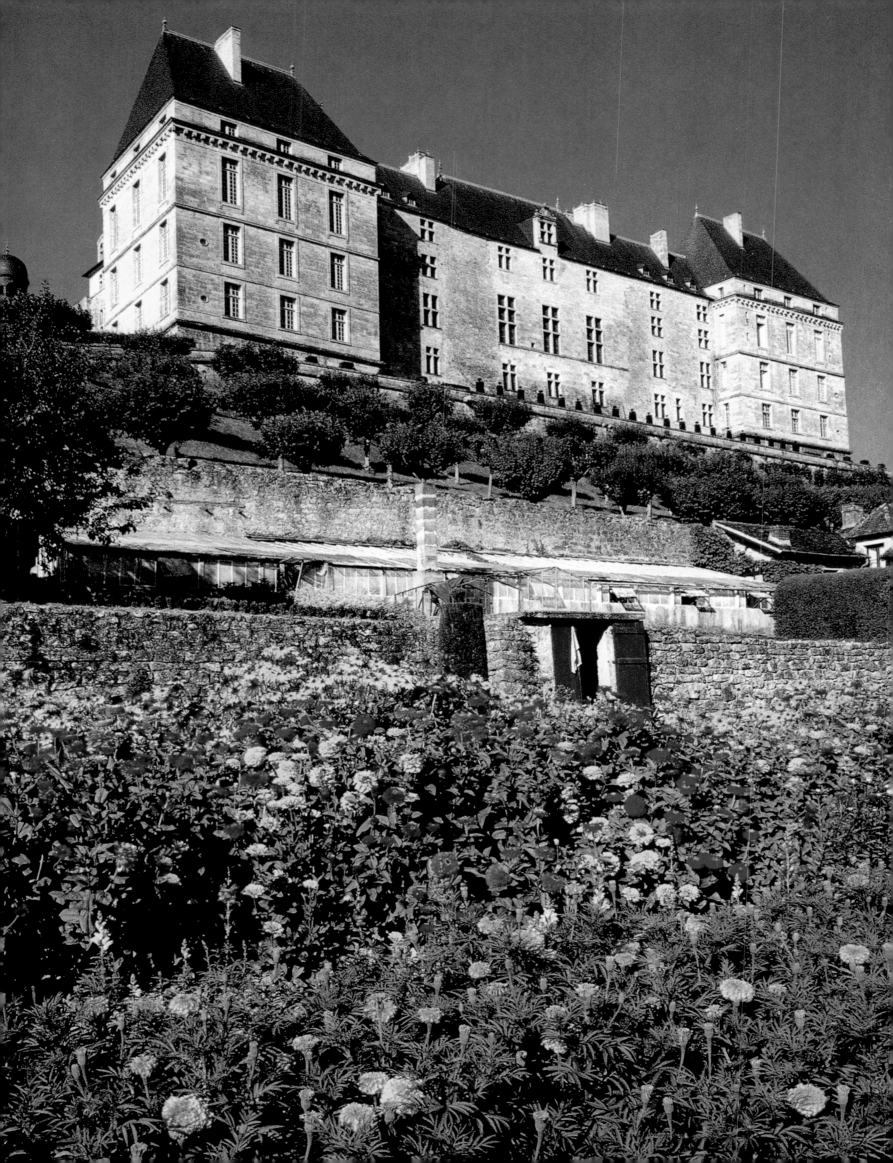

Le château est imposant et majestueux. Les jardins sont à son image. Tous deux dominent le village, site imprenable. La forteresse médiévale repose sur une plate-forme surélevée qui l'a obligée à étager ses jardins en terrasses. Pour retracer l'histoire récente de Hautefort, il faut préciser quelques dates. 1929: le baron et la baronne de Bastard achètent la demeure et la restaurent, réalisant à l'intérieur comme à l'extérieur des travaux considérables. 1957: Henri de Bastard disparaît. Son épouse poursuit son œuvre. 1968: un incendie ravage le château. La baronne entreprend sa reconstruction avec détermination. Depuis, les jardins ne cessent d'être embellis, notamment par leur responsable Jean Bernard Desmaison qui les fleurit et les entretient avec passion. Ces jardins à la française sont traditionnels et élégants. On y rencontre des buis et des ifs taillés en boule, en cône ou en forme de champignon – rappelant les dômes à lanternon du château, des motifs de buis géométriques et symétriques dessinant des arabesques, des rosaces ou des frises, une longue pergola de thuyas *(Thuja)* pour arrêter le vent et se protéger du soleil s'il est trop brûlant, un jardin d'herbes dans les douves sèches où s'entrelacent les lettres H et S, initiales d'Henri et Simone de Bastard. Les jardins connaissent deux fleurissements par an. Les fleurs très colorées des plantes annuelles utilisées sont mises en valeur par les buis sombres qui soulignent leur beauté. Le dessin est très affirmé, dans des couleurs contrastées.

Hautefort

The huge bulk of the chateau dominates the site; the gardens are no less imposing. Set on an impregnable elevation, chateau and gardens stand guard over the village. As the medieval fortress was built on an artificial embankment, the gardens are steeply terraced. The recent history of Hautefort begins in 1929, when the Baron and Baronne de Bastard bought the castle and restored it; this involved substantial work inside and out. Henri de Bastard died in 1957, and his wife continued with the restoration. In 1968, the chateau was devastated by fire, but the baronne immediately set about repairing the damage. The gardens have become ever more beautiful in the hands of the devoted chief gardener, Jean Bernard Desmaison. These "jardins à la française" are highly traditional and extremely elegant. Topiary gardens feature spheres, cones and mushrooms, the latter of which echo the chateau's turret lanterns; geometrical and symmetrical box motifs form arabesques, friezes and rosettes. A long pergola of thujas serves to protect the gardens from wind and sun. In the dry moat, a herb garden traces out the interlaced letters H and S, the initials of Henri and Simone de Bastard. The gardens can be seen in flower twice a year; the impact of the brightly coloured annuals is enhanced by the sombre box hedges. The result is a carefully orchestrated display of colour.

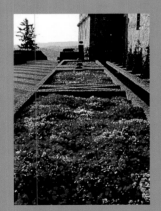

Schloß und Park sind eindrucksvoll und majestätisch. Die mittelalterliche Burg steht auf einem erhöhten Plateau und wirkt wie eine uneinnehmbare Festung. Darunter erstrecken sich die terrassenförmigen Gärten. Zur neueren Geschichte von Hautefort hier nur einige wenige Daten: 1929 kauften Baron und Baronin de Bastard das Anwesen und restaurierten es innen und außen mit beträchtlichem baulichem Aufwand. 1957 starb Henri de Bastard, und seine Frau führte sein Werk fort. Nach einem Brand, der das Schloß 1968 verwüstete, begann die Baronin entschlossen mit dem Wiederaufbau. Seit dieser Zeit wurde die Gartenanlage immer wieder verschönert, nicht zuletzt durch den Verwalter Jean Bernard Desmaison, der mit Hingabe für die Bepflanzung und Instandhaltung sorgt. Die französischen Gärten sind stilistisch der Tradition verpflichtet und sehr elegant. Eiben und Buchs sind in Anspielung auf die mit Laternen versehenen Turmhauben der Burg zu Kugeln, Kegeln oder Pilzen geschnitten. Buchsbaum ist zu symmetrisch angeordneten, geometrischen Arabesken, Rosetten und Friesen geformt. Als Windschutz dient eine langgestreckte Pergola aus Lebensbaum *(Thuja)*, die zugleich auch die allzu grelle Sonne abhält, und im trockengelegten Burggraben, wo man die ineinander verschlungenen Initialen H und S für Henri und Simone de Bastard sieht, wuchern alle möglichen Kräuter. Zweimal im Jahr erblühen die Gärten. Dabei kommen die vielfarbigen einjährigen Blumen vor dem dunklen Buchsbaum in voller Pracht zur Geltung. Die kontrastreichen Farbklänge sind ein Grundprinzip dieser selbstbewußten Gartengestaltung.

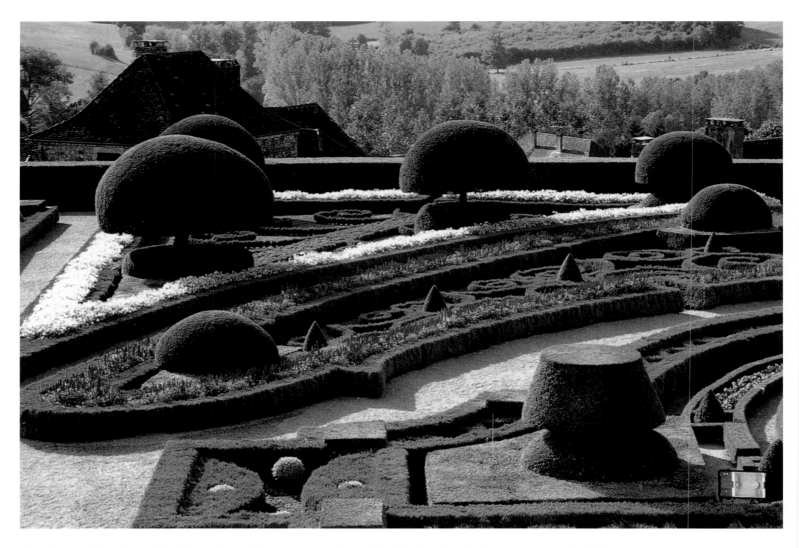

Première page: la façade nord du château. A ses pieds, une plantation de tilleuls. Plus bas, les serres, et au premier plan, le jardin de fleurs à couper inclus dans le potager.
Ci-dessus: détail des jardins de l'est.
A droite: la façade ouest du château.
Page de droite: le parterre à la française situé sur la façade sud.
Double page suivante: Les jardins de l'est sont posés sur une terrasse qui domine le village et le paysage périgourdin. Ils dessinent des motifs savants de buis enserrant des fleurs et sont ornés d'arbustes topiaires qui donnent du relief à la composition.

First page: the north façade of the chateau. At its foot are rows of lime trees; lower down, we see the greenhouses, and, in the foreground, the flowers for cutting, which are grown alongside the edible plants in the kitchen garden.
Above: a part of the east garden.
Right: the west façade of the chateau.
Facing page: the embroidered parterre of the south façade.
Following pages: The east gardens are on a terrace with a panoramic view of the village and the Périgord countryside. The intricate box motifs frame the beds and are ornamented by the topiary, which imparts relief to the parterres.

Eingangsseite: die Nordseite des Schlosses, davor eine Gruppe von Linden. Weiter unten sind die Gewächshäuser zu sehen, im Vordergrund liegt der in den Gemüsegarten eingebettete Schnittblumengarten.
Oben: Detail des östlichen Gartens.
Rechts: die Westfassade des Schlosses.

Rechte Seite: Das französische Parterre grenzt an die Südfassade.
Folgende Doppelseite: Der östliche Gartenteil liegt auf einer Terrasse hoch über dem Dorf und der Landschaft des Périgord. Der Garten ist hier geprägt von kunstvoll gestalteten Buchsbaumhecken, die Blumenbeete einfassen und durch gemoetrisch geschnittene Bäume zu einer reliefreichen Komposition ergänzt werden.

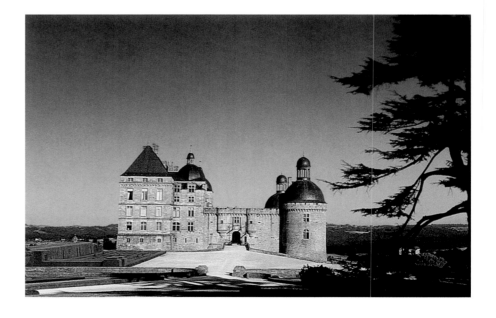

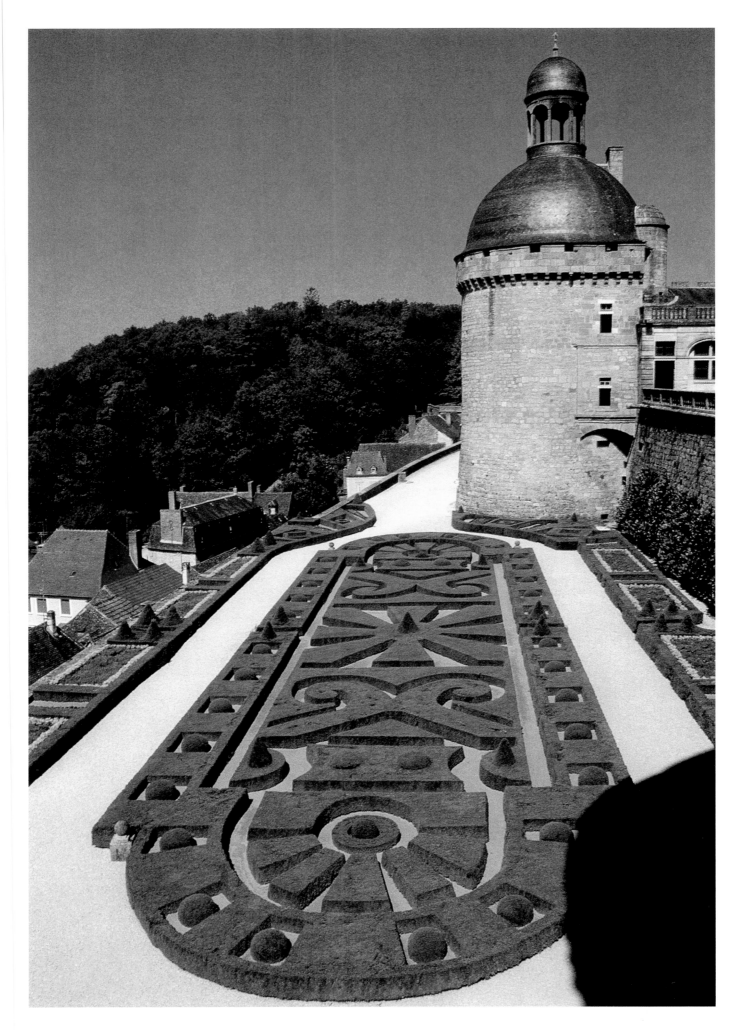

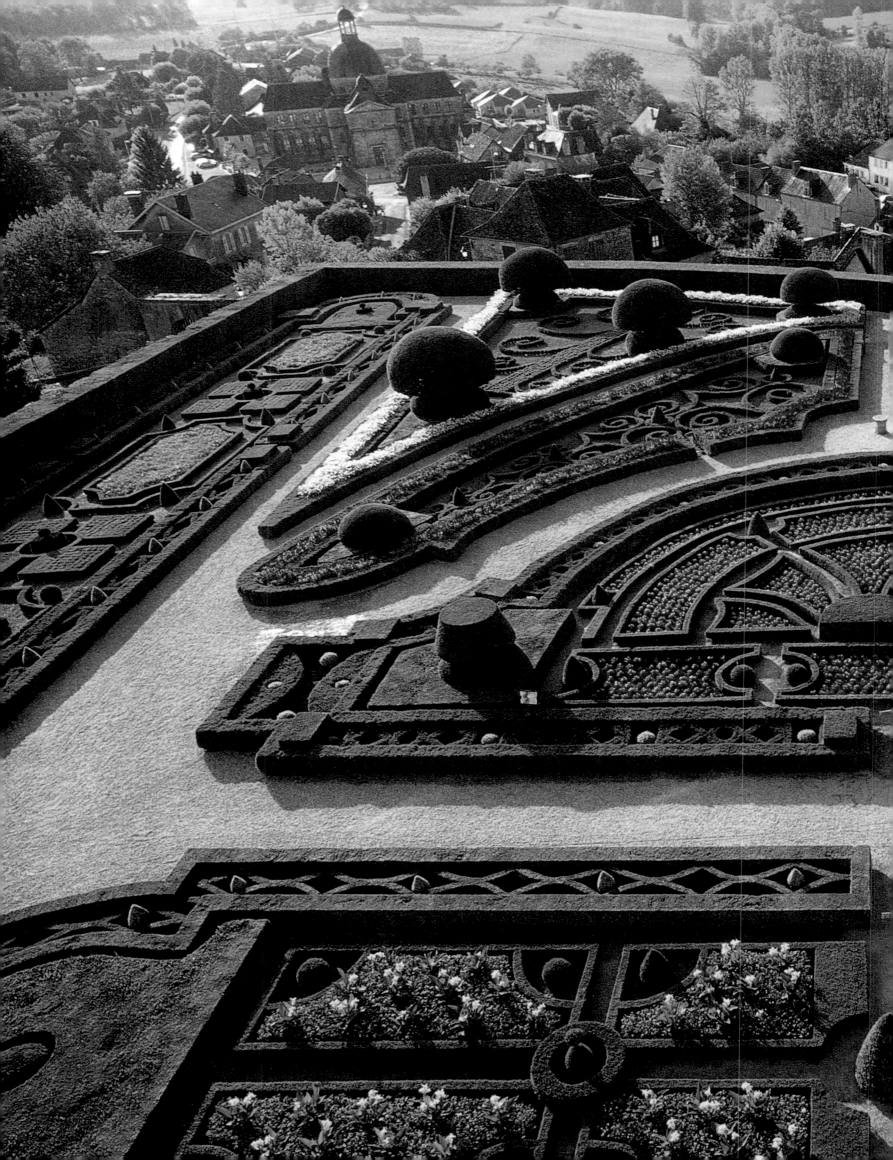

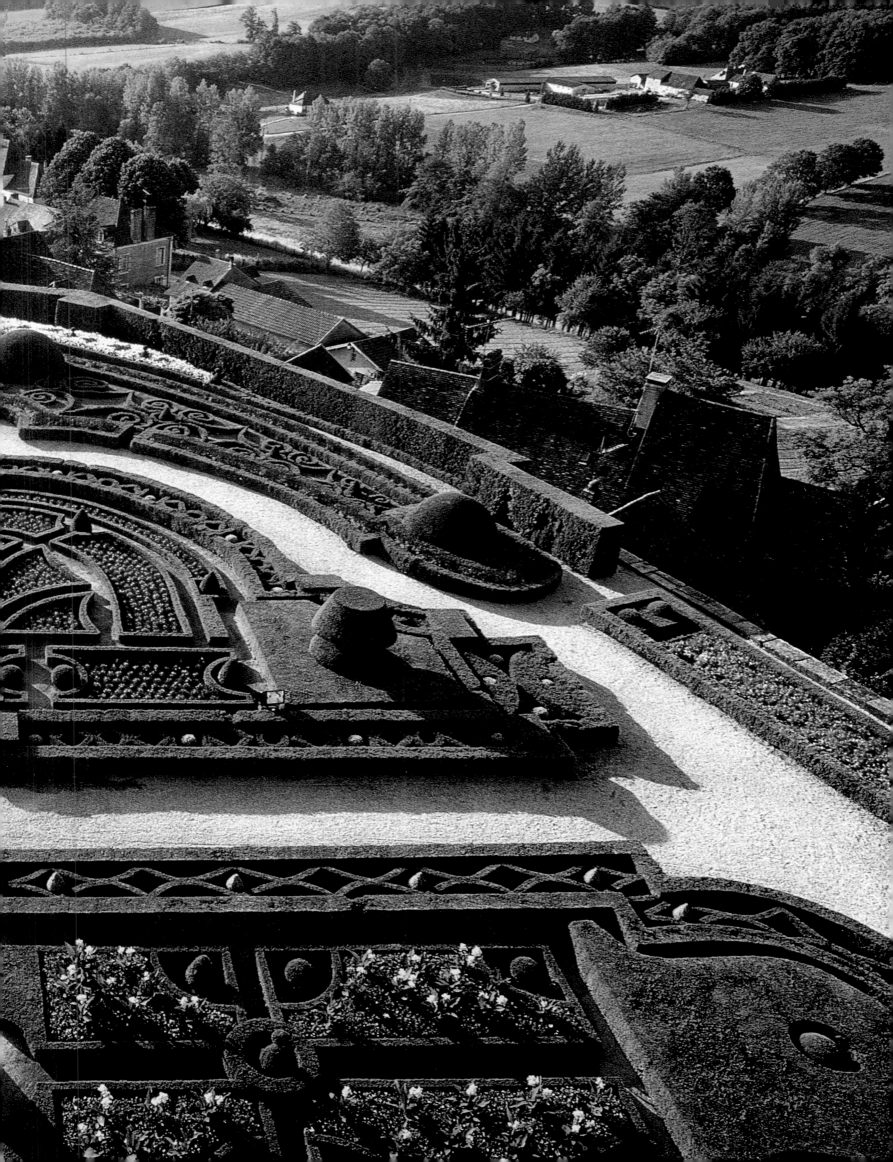

Détail de droite: Les ailes du moulin à vent rappellent que le château se dresse sur une butte venteuse.

Detail right: The sails of a windmill remind one of the chateau's exposed position.

Detail rechts: Die Windmühlenflügel spielen auf die Lage des Schlosses auf einer windumbrausten Anhöhe an.

Détail de gauche: motif du parterre à la française représentant le soleil et rappelant que le Périgord est une région ensoleillée.

Detail left: motif of the embroidered parterre representing the sun, a reminder of the sunny climate of Périgord.

Detail links: Die dargestellte Sonne im französischen Parterre erinnert daran, daß das Périgord eine ausgesprochen sonnenreiche Gegend ist.

Détail de droite: motifs qui s'imbriquent les uns dans les autres du jardin de buis situé à l'est .

Detail right: part of the east box garden and its intricate interlocking motifs.

Detail rechts: ineinander verschlungene Motive im Buchsbaumgarten des östlichen Teils.

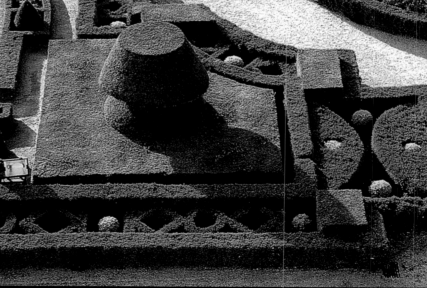

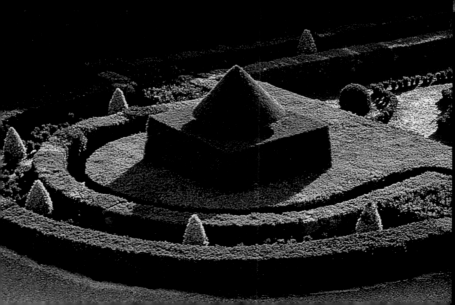

Détail de gauche: Les cônes simples ou posés sur un socle de buis donnent du relief à l'ensemble.

Detail left: Topiary imparts relief to the parterres.

Detail links: Die Formbäume verleihen dem Bild prägnante Konturen.

Détail de droite: motifs de buis de l'esplanade devant le château.

Detail right: box motifs from the esplanade in front of the chateau.

Detail rechts: Buchsbaum-motive auf der Esplanade vor dem Schloß.

Détail de gauche: double arabesque.

Detail left: a double arabesque.

Detail links: doppelte Arabeske.

Détail de droite: colimaçon de buis sous le pont-levis.

Detail right: a spiral drawn in box below the drawbridge.

Detail rechts: Buchsbaumspirale unter der Zugbrücke.

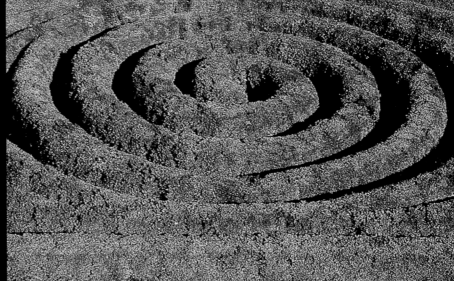

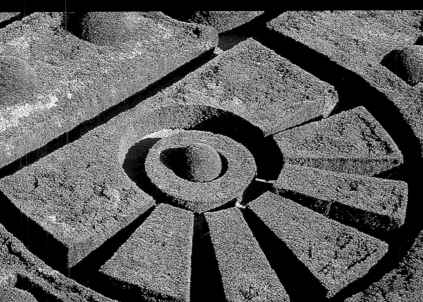

Détail de gauche: motif représentant les rayons du soleil périgourdin.

Detail left: motif representing rays of Périgord sunshine.

Detail links: eine Darstellung der strahlenden Sonne des Périgord.

Terrasson-Lavilledieu, avec ses toits d'ardoise, borde la Vézère. A deux pas du site préhistorique de Lascaux, il fallait un jardin qui raconte l'histoire de l'humanité à travers celle des jardins. L'architecte paysagiste Kathryn Gustafson fut choisie pour créer cet espace résolument contemporain. Elle y suggère des éléments que l'on retrouve dans tous les jardins du monde: les jeux d'eau, les mouvements du vent, les terrasses ou les perspectives. Les ornements sont en fer, en verre ou en béton. Avant de s'enfoncer dans le bois sacré, on est interloqué par cinq dalles de pierre sur lesquelles les parcours des cinq grands fleuves du monde ont été gravés. Ces dalles sont irriguées par une source rejoignant une cascade. Puis on passe dans un tunnel drapé de lianes avant de découvrir les jardins élémentaires plantés d'un mélange éclectique de végétaux. Plus loin, un théâtre de verdure situé près de la serre en verre signée Ian Ritchie étage ses bancs de fer. De là, part l'axe des vents orienté vers la ville grâce à ses longues girouettes alignées. Puis des terrasses bleues, grises et blanches descendent vers la vallée, plantées de népétas, de graminées et de rosiers. On pénètre alors dans les jardins d'eau où un canal, un bassin, une forêt de jets d'eau, une grande cascade et un chemin de fontaines interprètent cet élément de multiples façons. Suit une gigantesque structure métallique habillée de rosiers qui précède le dernier jardin où des arbustes taillés prouvent que l'homme, par son aptitude à sculpter le végétal, maîtrise la nature.

Les Jardins de l'Imaginaire

Terrasson-Lavilledieu is a slate-roofed town on the banks of the Vézère. It lies just a few miles from Lascaux, and this suggested the notion of a garden that recounted the history of humanity. The landscape gardener Kathryn Gustafson was chosen to create this resolutely modern narrative space. She has contrived to suggest the elements encountered in all gardens: fountains, wind movement, terraces and vistas. The ornaments are in iron, glass or concrete. Before entering the sacred wood, one is confronted with five great slabs of stone engraved with the courses of the five great rivers of the world and watered by a spring that flows into a cascade. Then one passes through a tunnel hung with creepers and reaches elemental gardens planted with an eclectic mix of flora. Beyond this lie the iron benches of a green theatre, which is flanked by a greenhouse designed by Ian Ritchie. This leads to the wind axis, which is oriented toward the town by its rows of tall, slender weather vanes that respond to a breath of wind like mobiles. Then come blue, grey and white terraces, which lead down into a valley planted with catmint *(Nepeta),* grasses and roses. Here one enters the water gardens: a canal, a pond, a forest of water jets, a large-scale cascade and a fountain walk offer diverse interpretations of a single element. The last garden is guarded by a huge metallic structure overgrown with roses; it is a topiary garden, and symbolises, in its sculpted plant life, man's mastery over nature.

Terrasson-Lavilledieu mit seinen Schieferdächern liegt am Ufer der Vézère. So nah an den prähistorischen Höhlen von Lascaux bedurfte es eines Parks, der mit der Geschichte der Gärten zugleich die der Menschheit erzählt. Die Gartenarchitektin Kathryn Gustafson wurde beauftragt, diesen streng zeitgenössischen Raum zu schaffen. Sie verwendete dazu Elemente, die in den Gärten der ganzen Welt heimisch sind: Wasser, Wind, Terrassen und Ausblicke, dazu Materialien wie Eisen, Glas und Beton. Bevor man den heiligen Hain betritt, verharrt man verblüfft vor fünf Steinplatten, auf denen der Verlauf der größten Ströme der Erde eingraviert ist. Von einer nahe gelegenen Quelle aus fließt Wasser darüber hinweg und ergießt sich in eine Kaskade. Durch einen Lianentunnel erreicht man die »elementaren« Gärten mit ihrer bunten eklektischen Pflanzenvielfalt. Daran schließt sich das grüne Theater mit seinen eisernen Sitzreihen an, daneben liegt das von Ian Ritchie entworfene Gewächshaus. Hier beginnt die »Windachse« mit langen, in einer Reihe aufgestellten Wetterfahnen, die wie Mobiles auf jeden Hauch reagieren. Mit Katzenminze *(Nepeta),* Gräsern und Rosen bepflanzte blaue, graue und weiße Terrassen erstrecken sich bis hinunter zum Tal. Nun betritt man die Wassergärten: Ein Kanal, ein Wasserbecken, ein Fontänenwald, ein großer Wasserfall und ein Springbrunnenweg variieren das Element in seinen vielfältigen Formen. Daran schließt sich eine von Rosen überwucherte riesige Metallkonstruktion an, die zum letzten Teil des Parks hinüberleitet, wo kunstvoll beschnittene Bäume die Herrschaft des Menschen über die Natur bestätigen.

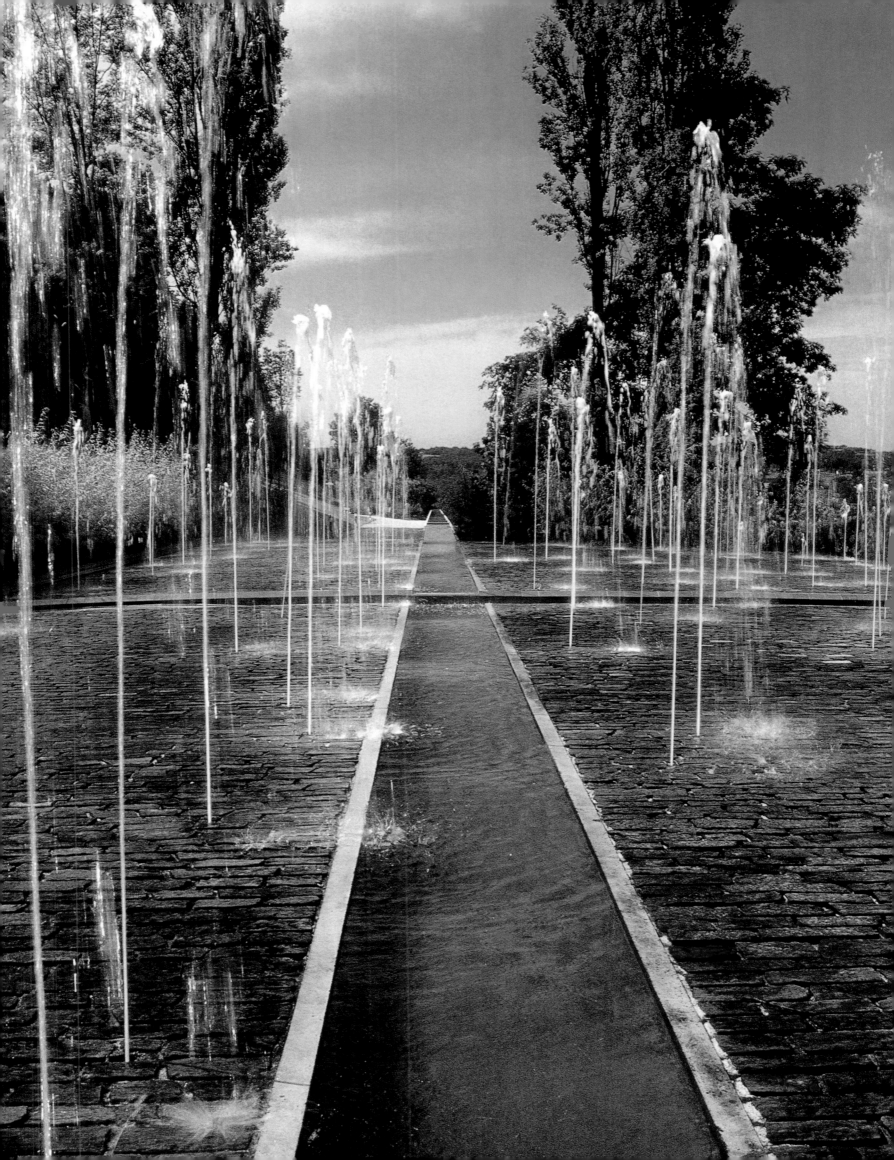

Les Jardins de l'Imaginaire *Aquitaine*

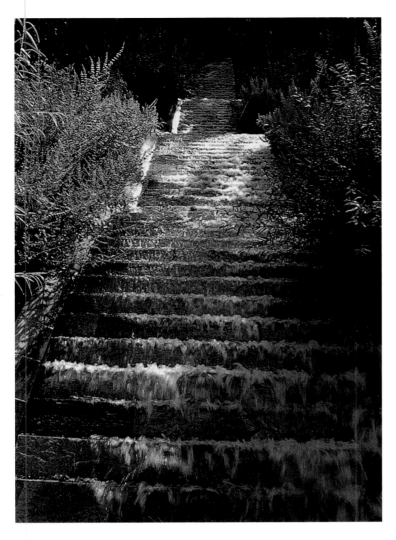

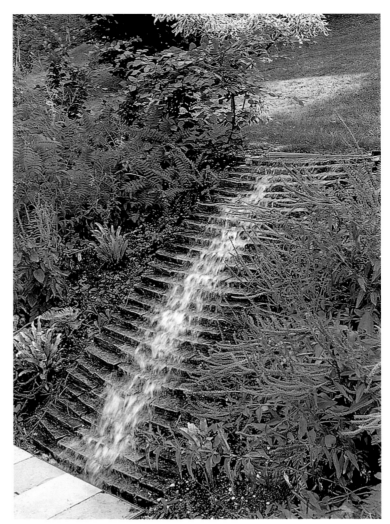

Double page précédente: les jardins d'eau. L'eau jaillit de la pierre pour créer une forêt de jets parmi lesquels les promeneurs peuvent se faufiler. Le canal et l'axe des vents dessiné par de grandes girouettes qui s'approchent de la ville de Terrasson forment d'autres angles de vue (détails).
Page de gauche: Le cours de l'Amazone est gravé dans la pierre. Dans chaque coin, l'eau d'une source alimente le fleuve et rejoint une cascade.
Ci-dessus: le chemin des fontaines, dont les bords sont plantés de *Perovskia atriplicifolia,* de véroniques *(Veronicastrum virginicum)* à hampes bleues et de sorbarias *(Sorbaria sorbifolia)* à fleurs blanches.
A droite: la forêt de jets d'eau.

Previous pages: the water gardens, where water spurts out of the paving: a forest of water for the visitor to enjoy. The canal and the wind axis with a grove of weather vanes pointing to the town of Terrasson form other axes (details).
Facing page: The course of the Amazon is engraved in the stone. At each corner, a spring supplies the river with water and feeds into the cascade.
Above: the fountain walk, which is bordered by *Perovskia atriplicifolia,* blue-spiked veronicas *(Veronicastrum virginicum)* and white-flowered false Ural spirea *(Sorbaria sorbifolia).*
Right: the forest of water jets.

Vorhergehende Doppelseite: der Wassergarten. Das Wasser schießt direkt aus dem Stein und bildet einen Fontänenwald, durch den sich der Besucher schlängeln kann. Weitere Blickachsen bilden der Kanal und die »Windachse« mit ihren großen Wetterfahnen, die bis an den Ort Terrasson heranreichen (Details).
Linke Seite: Der Verlauf des Amazonas ist in die Platte eingemeißelt. Von den Ecken her strömt Quellwasser durch das Flußbett und fließt dann über eine Kaskade ab.
Oben: der Springbrunnenweg, dessen Ränder mit Perowskien *(Perovskia atriplicifolia),* den blauen Schäften des Ehrenpreises *(Veronicastrum virginicum)* und weißblühenden Fiederspieren *(Sorbaria sorbifolia)* besetzt sind.
Unten: der Fontänenwald.

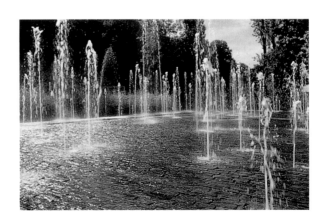

Arabesques de buis sur tapis vert, ifs taillés en cylindre, en pointe de diamant ou en plateau, charmes dessinant des demi-lunes, voici Eyrignac. C'est un jardin émeraude, magnifiquement taillé, très architecturé. Ses perspectives sont rythmées d'accords parfaits étudiés avec la précision d'un métronome, tout en harmonies de verts. La beauté d'Eyrignac fut forgée dans le secret par le père de Patrick Sermadiras de Pouzols de Lile. Il restaura ces jardins fidèlement aux plans du 18e siècle, que le décorateur italien Ricci exécuta. Depuis une dizaine d'années, Patrick Sermadiras ne cesse de les embellir dans un souci de perfection. Il projette de créer bientôt un labyrinthe et une roseraie. Le tracé de cette composition rappelle celui d'un jardin à la française mais par ses ornements, il évoque un jardin italianisant. Car nous sommes en Périgord noir où le Midi se fait déjà sentir. Le manoir du 17e siècle ouvre sur la cour d'honneur et sur des motifs de buis qui se prolongent par une perspective d'ifs disposés en trompe-l'œil. A gauche, l'allée des charmes est jalonnée de contreforts végétaux où viennent s'intercaler des ifs taillés en cylindre. Un bassin et son pavillon, un verger et une salle de verdure créent un changement de ton avant l'allée des vases. Scandée de cyprès, celle-ci rejoint une chambre à ciel ouvert jouxtant le manoir. Au fil des heures, l'ombre et la lumière jouent avec les volumes, faisant ressortir et varier par contraste la beauté des sculptures végétales.

Eyrignac

Box embroidery on a cloth of green, yews sculpted into cylinders, diamond points and flat surfaces, hornbeams clipped into crescents; these are among the attractions of Eyrignac. It is a garden of bright and sombre greens, magisterial in its layout, superlative in its topiary and of the utmost precision of design. Its vistas are harmonious sequences of green, impeccably ordered and executed. The garden at Eyrignac was created by the father of Patrick Sermadiras de Pouzols de Lile. He secretly set about restoring these gardens, using the 18th-century plans made by the Italian decorator Ricci. Patrick Sermadiras has spent the last ten years embellishing the gardens still further in his quest for perfection; he plans to create a labyrinth and a rose garden. Though the layout of the garden is that of a "jardin à la française", it is somewhat Italianate in effect; this is partly a matter of its situation in the "Périgord noir", where the climate is meridional. The 17th-century manor opens onto the main courtyard and box motifs which lead the eye into a vista of yews arranged in "trompe l'œil" perspective. To the left, the hornbeam walk, which consists of clipped hornbeam buttresses interspersed with cylindrical yews. A pond with its own pavilion, an orchard and a green enclosure come next; they lead to the "allée" of vases, with its measured succession of cypresses. This in turn leads to a further "green room" next to the manor house. The changing light gradually shifts the shadows, displacing the accents on the topiary and altering and enhancing the beauty of the gardens.

Arabesken aus Buchs auf grünen Rasenflächen, Eiben in Form von Zylindern, Brillanten oder flachen Quadern, zu Halbmonden geschnittene Hainbuchen – das ist Eyrignac, ein smaragdgrüner, meisterhaft beschnittener, durch und durch architektonisch gestalteter Garten. Die Ausblicke werden durch perfekte, wie mit dem Metronom abgemessene Akkorde aus harmonierenden Grüntönen akzentuiert. All diese Pracht entwarf der Vater von Patrick Sermadiras de Pouzols de Lile. Er stellte die Anlage nach Plänen des italienischen Malers Sebastiano Ricci aus dem 18. Jahrhundert wieder her. Seit rund zehn Jahren ist es nun der Perfektionist Patrick Sermadiras selbst, der den Garten immer wieder bereichert. Derzeit plant er ein Labyrinth und ein Rosarium. Der Grundriß der Anlage läßt einen klassisch französischen Garten erkennen, der jedoch durch seine Ornamentik auch italienische Anklänge aufweist. Schließlich befinden wir uns im tiefsten Périgord, wo bereits ein mediterraner Hauch spürbar ist. Vor dem Herrenhaus aus dem 17. Jahrhundert liegt der Ehrenhof mit seinen Figuren aus Buchsbaum, an die sich in Trompe-l'œil-Manier eine Reihe von Eiben anschließt. Links davon befindet sich eine Buchenallee, ergänzt durch grüne Bögen und unterbrochen von zylindrisch beschnittenen Eiben. Ein Schwimmbecken vor einem Gartenhäuschen, ein Obst- und ein Heckengarten sorgen für Abwechslung, bevor man in eine von Zypressen gesäumte Allee mit Buchsbaumkübeln einbiegt. Sie führt zu einem an das Herrenhaus angrenzenden »grünen Salon«. Mit vorrückender Stunde umspielen Licht und Schatten die Formen und bringen so die Schönheit der pflanzlichen Skulpturen immer neu zur Geltung.

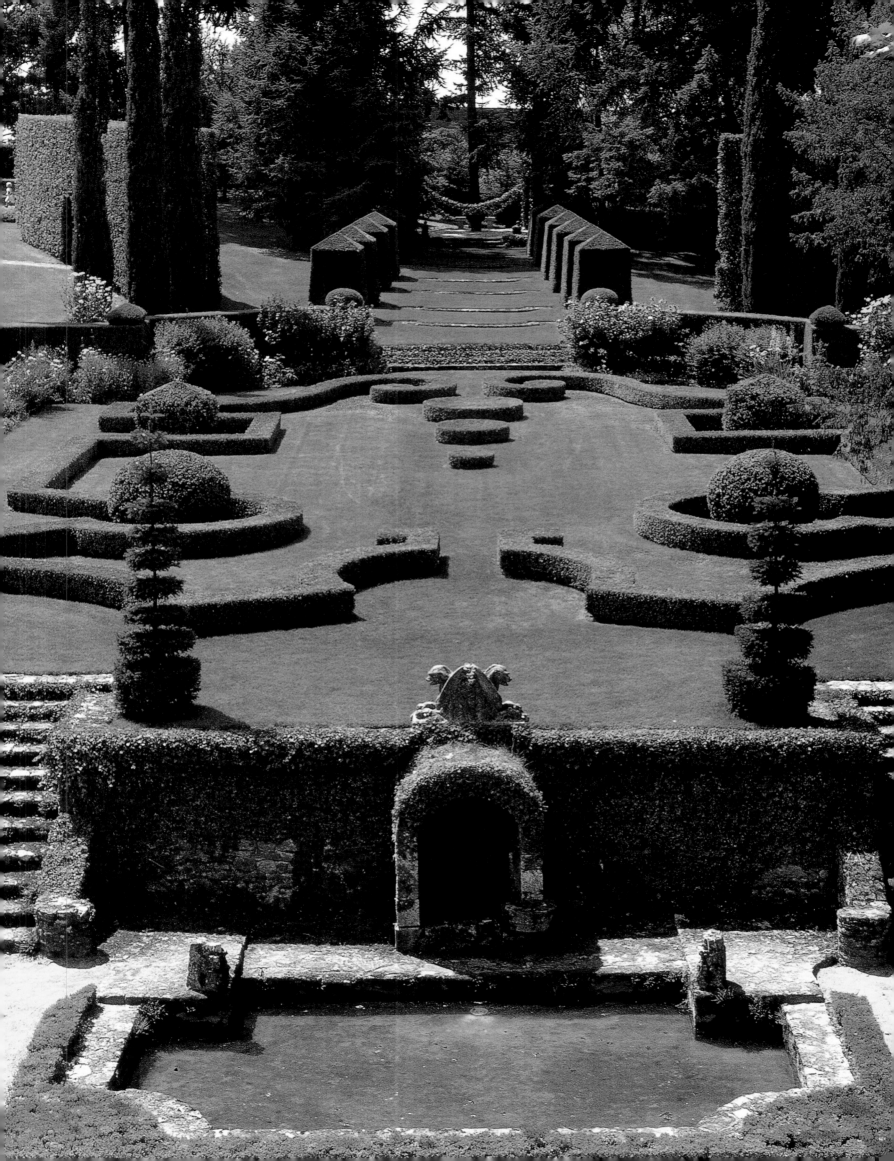

Page précédente: les jardins à la française vus du manoir, avec leurs arabesques de buis sur fond de tapis vert. A leur pied, un bassin; au loin, les ifs se resserrent pour allonger la perspective.
Page de gauche: vue générale de l'allée des charmes et du jardin à la française. A droite, le pavillon de repos.
Ci-dessus: Une cascade de buis nains et de millepertuis *(Hypericum)* crée une ouverture vers le pavillon de repos.
A droite: un jardinier en train de couper les buis.

Previous page: the "jardins à la française" seen from the manor, with their box embroideries on a background of lawn. At their foot, a pond; in the background, the angle of the lines of yews accentuates the perspective effect.
Facing page: overall view of the "jardin à la française" and the hornbeam walk. The rest house is on the right.
Above: A cascade of dwarf box and St John's wort *(Hypericum)* creates a vista toward the rest house.
Right: A gardener is cutting yews.

Vorhergehende Seite: der Blick vom Herrenhaus in den französischen Garten mit seinen Buchsbaumarabesken auf grünen Rasenflächen. Davor liegt ein Wasserbecken. Der Abstand zwischen den weiter hinten stehenden Eiben verjüngt sich, um mehr Tiefe vorzutäuschen.
Linke Seite: Gesamtansicht des französischen Gartens und der Buchenallee. Rechts das Gartenhaus.
Oben: Wellen aus niedrigem Buchsbaum und Johanniskraut *(Hypericum)* leiten den Blick zum Gartenhaus.
Rechts: Ein Gärtner beschneidet die Buchsbaumhecken.

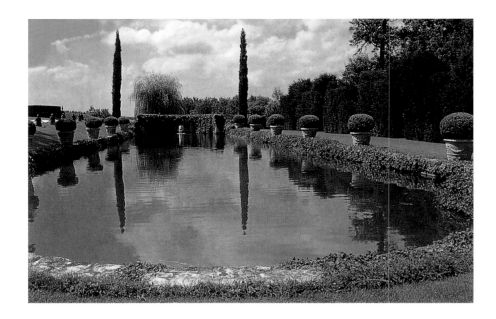

A droite: Le vivier est situé non loin des communs.
Ci-dessous: Les communs du 18e siècle se reflètent dans l'eau du vivier dont le pourtour est orné de vases italiens plantés de buis taillés en boule.

Right: The fish pond is not far from the outhouses.
Below: The 18th-century outhouses are reflected in the fish pond, whose longer sides are lined with sphere-shaped box trees.

Rechts: Der Fischteich liegt in der Nähe der Wirtschaftsgebäude.
Unten: Die Wirtschaftsgebäude aus dem 18. Jahrhundert spiegeln sich im Fischteich, der mit italienischen Terrakottatöpfen und kugelig beschnittenen Buchsbäumen umstellt ist.

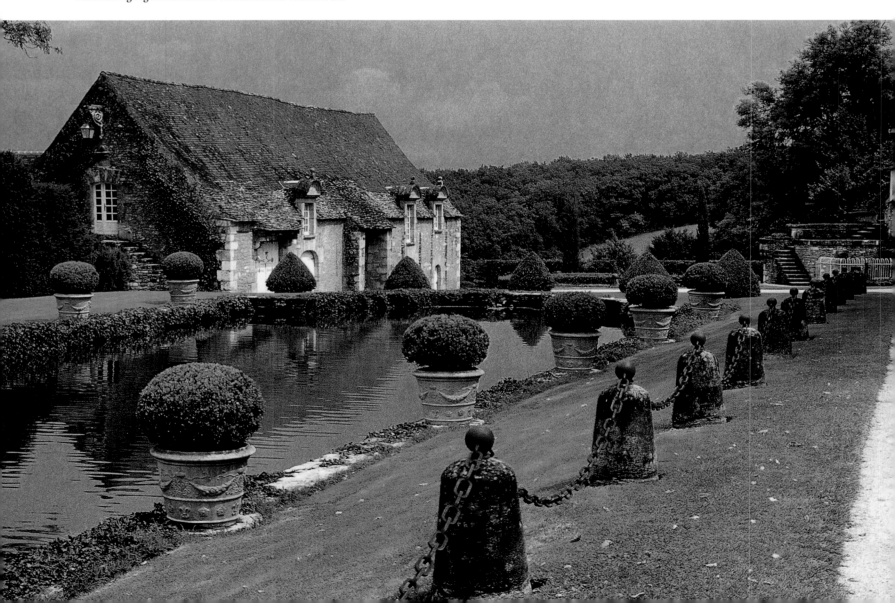

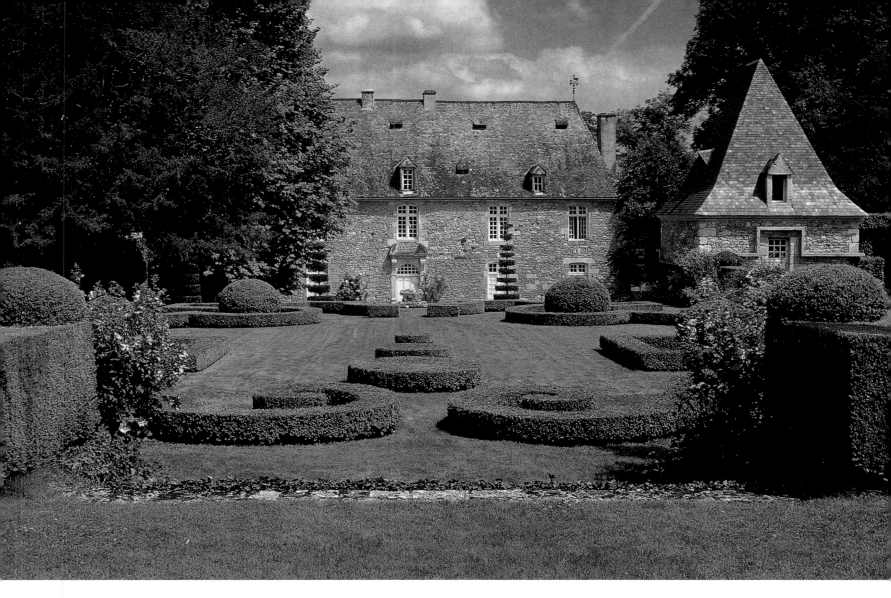

Ci-dessus: La façade principale du manoir du 17e siècle donne sur le parterre à la française légèrement surélevé par rapport à la cour d'honneur. A droite, le pigeonnier.
A droite: détail du jardin à la française.
Double page suivante: Cette perspective est la scène la plus spectaculaire des jardins d'Eyrignac. Il s'agit en effet de l'allée des charmes *(Carpinus),* entre lesquels viennent s'intercaler des ifs taillés en cylindre, unique au monde par l'originalité de son ordonnance. A l'extrémité, une pagode chinoise en laque rouge.

Above: The main façade of the 17th-century manor house faces onto the parterre "à la française", which is slightly raised relative to the main courtyard. To the right, the dovecote.
Right: detail of the "jardin à la française".
Following pages: This vista is the most spectacular in the Eyrignac garden. It is the hornbeam walk, in which hornbeam buttresses *(Carpinus)* alternate with cylindrical yews, an arrangement unique in the world. At the far end stands a red-lacquered Chinese pavilion.

Oben: Blick auf die Hauptfassade des Herrenhauses aus dem 17. Jahrhundert. Das französische Parterre liegt etwas höher als der Ehrenhof. Rechts befindet sich das Taubenhaus.
Rechts: Detail aus dem französischen Garten.
Folgende Doppelseite: Dies ist die wohl spektakulärste Ansicht im Park von Eyrignac. Die Hainbuchenallee *(Carpinus)* wird von zylindrisch beschnittenen Eiben akzentuiert, die in ihrer originellen Anordnung weltweit einzigartig sein dürften. Im Hintergrund sieht man die rot lackierte chinesische Pagode.

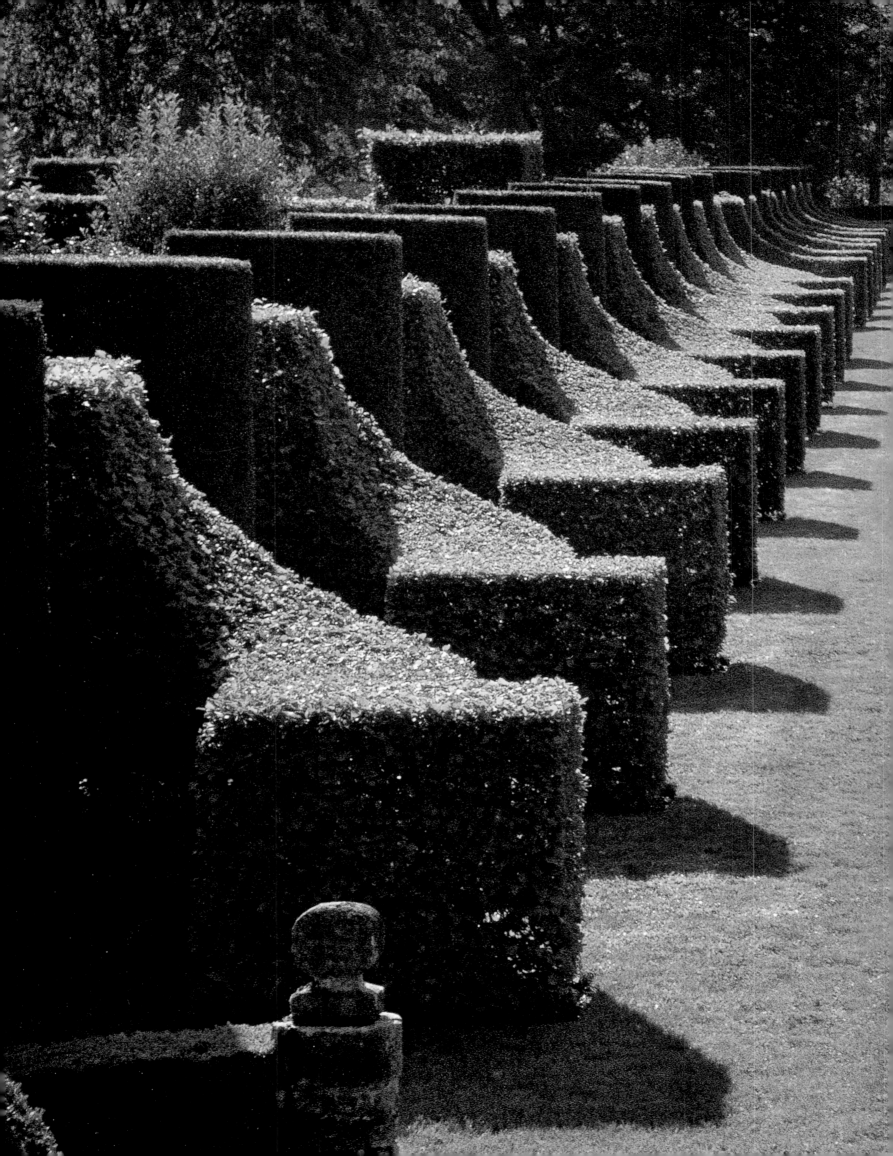

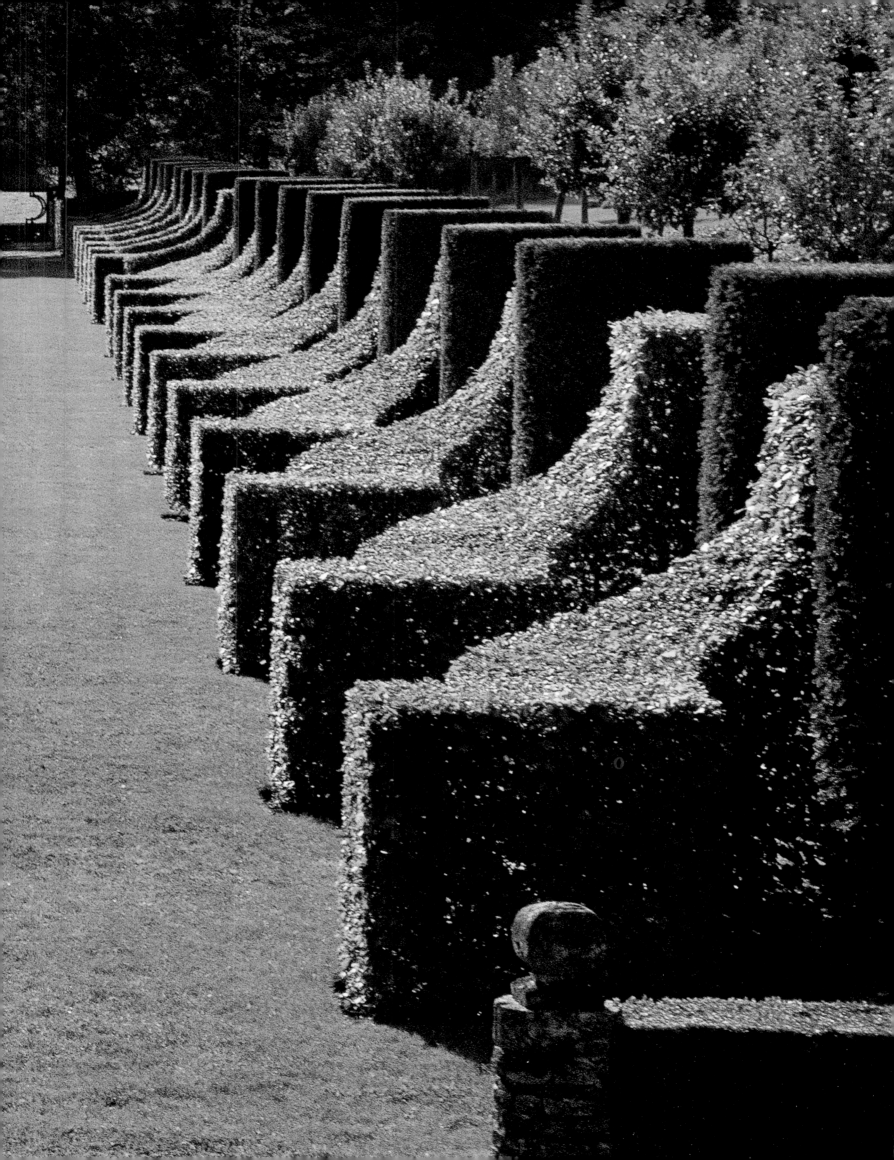

Yvoire est un village fleuri, pittoresque et charmant, situé au bord du lac Léman. L'histoire du château remonte au 14e siècle. En 1986, les descendants actuels Yves et Anne-Monique d'Yvoire voulurent le mettre en valeur en l'ornant d'un jardin. Ils firent appel au talent du paysagiste Alain Richert qui métamorphosa l'ancien potager clos de murs en un jardin initiatique composé de plusieurs chambres. A l'entrée, la prairie alpine regroupe des plantes qui sont heureuses sous le climat de montagne de cette région. Puis un magnifique parterre dessine un tissage planté de rosiers 'Blanc Double de Coubert' et d'avoine bleue *(Helictotrichon sempervirens)*. Situé en hauteur, il ouvre une belle perspective sur le château. Le cloître médiéval est symbolisé par une pergola de charmilles. Il enferme un jardin de simples divisé en quatre carrés ordonnés autour d'une vasque d'eau. Plus bas, le labyrinthe centré sur une volière se divise en quatre jardins clos de haies de charmilles, chacun étant voué à l'un des cinq sens. Le jardin du goût se déguste avec les yeux. Le jardin des senteurs se parfume des fragrances des lis, des violettes, des lilas et des jasmins. Le jardin du toucher joue avec les textures des feuillages. Le jardin de la vue fait vibrer les couleurs et chanter les bleus. Le chant des oiseaux sert d'accompagnement à cette promenade didactique. Dans ces jardins, tout porte au recueillement, à la connaissance, à la méditation. On en ressort enrichi, réconforté et embelli.

Le Labyrinthe – jardin des cinq sens

Yvoire is a charming, picturesque village, full of flowers, on the shores of Lake Geneva. The chateau dates from the 14th century. In 1986, the descendants of the Yvoire line, Yves and Anne-Monique d'Yvoire, decided to enhance its beauty by the creation of a garden. They called in the landscape designer Alain Richert, who transformed the old walled kitchen garden into an initiatory garden divided into several different "rooms". Near the entrance, the alpine meadow brings together flora happy with the mountain climate of the region. Then a superb parterre traces an embroidery of 'Blanc Double de Coubert' roses and blue oat grass *(Helictotrichon sempervirens)*. The parterre offers a magnificent view down to the chateau. The medieval cloister is symbolised by a pergola of hornbeams. It encloses a herb garden divided into four squares with a bird-bath at its centre. Lower again is the labyrinth, centred around an aviary; it comprises four gardens enclosed by hornbeam hedges, each devoted to one of the five senses. The taste garden is to be savoured with the eyes. The scent garden is full of the fragrance of lilacs, violets, lilies and jasmines. The tactile garden plays with leaf textures. The visual garden is full of bright colours and in particular a chorus of blues. Bird-song completes this didactic ensemble. The relaxing effect of these gardens favours a feeling of composure and meditation. One leaves them restored, refreshed and enlightened.

Yvoire ist ein reich mit Blumen geschmücktes, charmant malerisches Städtchen am Ufer des Genfer Sees. Die Geschichte des Schlosses reicht bis ins 14. Jahrhundert zurück. 1986 beschlossen die heutigen Nachkommen des Hauses, Yves und Anne-Monique d'Yvoire, das Anwesen durch einen Garten zu erweitern. Sie wandten sich an den talentierten Gartenarchitekten Alain Richert, der den eingefriedeten früheren Gemüsegarten in einen »Lehrpfad« der menschlichen Sinne verwandelte. Den Auftakt bildet eine Alpenwiese mit Gewächsen, die sich im Bergklima der Gegend wohlfühlen. Es folgt ein prächtiges Parterre aus dicht verwobenen weißen Rosen der Sorte 'Blanc Double de Coubert' und Blaustrahlhafer *(Helictotrichon sempervirens)*. Durch seine erhöhte Lage gibt dieser Teil einen schönen Blick auf das Schloß frei. Die aus Hainbuchen gebildete Pergola wirkt wie ein mittelalterlicher Kreuzgang, zumal sie einen in vier Beete unterteilten Heilkräutergarten umschließt, in dessen Mitte ein Vogelbad steht. Weiter unten teilt sich rings um eine Voliere das Labyrinth in vier von Hainbuchen umgebene Heckengärten, die jeweils einem unserer Sinne gewidmet sind. Der Garten des Geschmackssinns gibt den Augen Gelegenheit zu genußvollem Umherstreifen. Im Garten des Geruchssinns wehen die Düfte von Lilien, Veilchen, Flieder und Jasmin. Der dem Tastsinn gewidmete Garten spielt mit den Strukturen der Blätter, und der Garten des Gesichtssinns läßt die Farben, insbesondere Blautöne, in allen Nuancen schillern. Der lehrreiche Rundgang wird von Vogelgezwitscher begleitet. Die Gärten sind auf Sammlung, Erkenntnis, Meditation angelegt, und man kehrt daraus bereichert und gestärkt zurück.

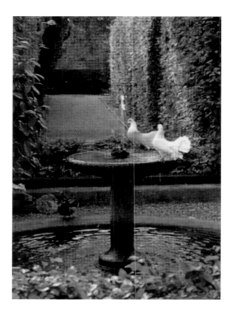

Première page: le jardin de simples.
A droite: Le jardin de simples s'articule autour d'une vasque d'eau ou bain d'oiseau.
Ci-dessous: Les plantes médicinales ont été classées par carrés. On y trouve des plantes médicinales universelles, des toxiques, celles qui entrent dans la composition des liqueurs, celles qui sont utilisées en cosmétologie.

First page: the herb garden.
Right: The herb garden is centred around a bird-bath.
Below: The medicinal plants have been classified into squares according to category: medicinal, toxic, those used in the making of liqueurs, and those used in cosmetology.

Eingangsseite: der Heilkräutergarten.
Rechts: Der Heilkräutergarten erstreckt sich rings um eine Wasserschale, die als Vogelbad dient.
Unten: Die Heilkräuter sind auf quadratische Beete aufgeteilt. Man findet Heilpflanzen, Giftpflanzen, Kräuter für die Herstellung von Likören sowie Pflanzen, die für Kosmetika verwendet werden.

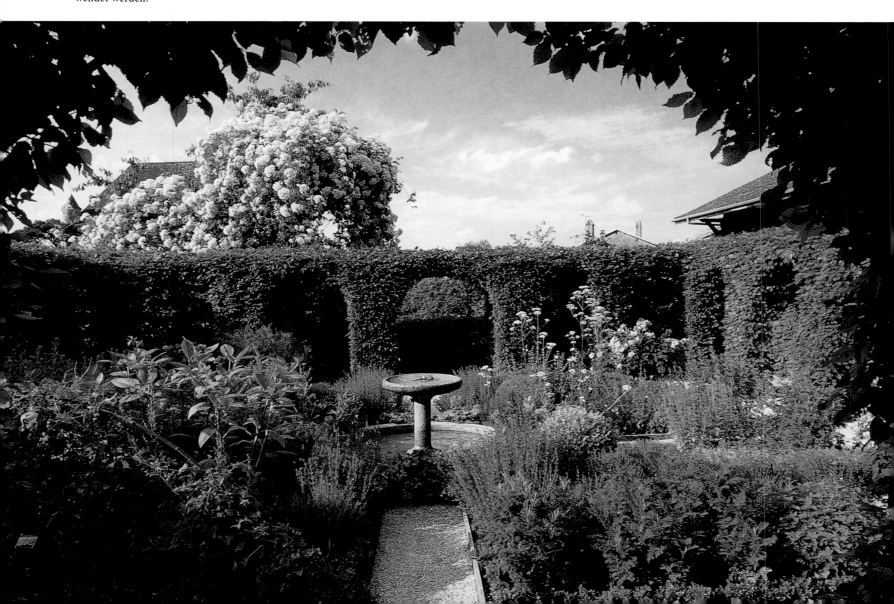

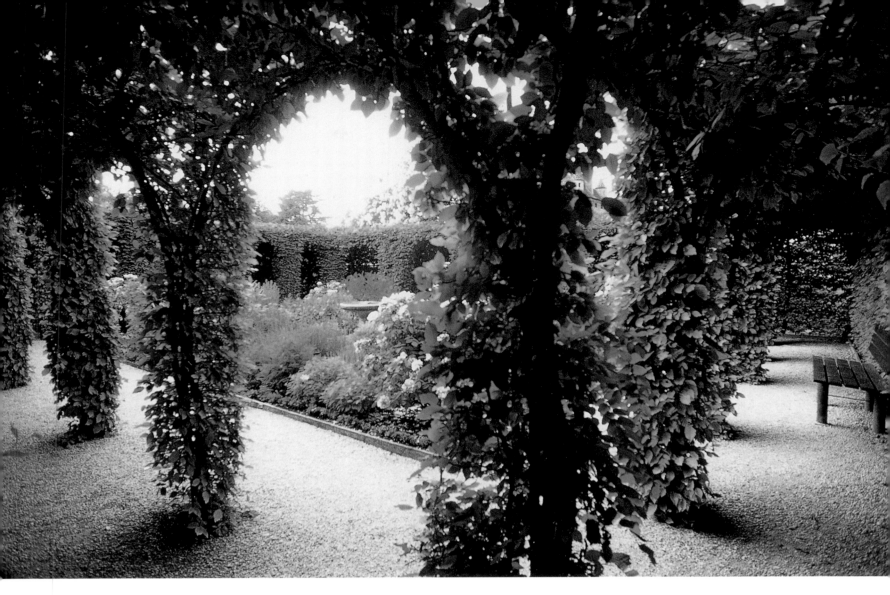

Ci-dessus: Le jardin de simples occupe le centre du cloître végétal planté de charmilles *(Carpinus).* C'est un lieu de recueillement.
A droite: Dans chaque coin, on distingue la *Rosa gallica* 'Versicolor' aux fleurs panachées et aux propriétés médicinales, qui est une forme de la 'Rose de Provins'.
Double page suivante: vue d'ensemble des jardins. Au premier plan, le parterre et son tissage de plantes. A droite, l'entrée du cloître. Au second plan, le labyrinthe surmonté de sa volière.

Above: The herb garden is at the centre of a live hornbeam *(Carpinus)* "cloister". It is a place of meditation.
Right: In each corner, one can see the feathery blooms of *Rosa gallica* 'Versicolor', a type of 'Rose de Provins', which possesses medicinal properties.
Following pages: overall view of the gardens. In the foreground, the parterre and its embroidery of plants. To the right, the entrance to the cloister. In the middle ground, the labyrinth and the aviary prominent above it.

Oben: Der Heilkräutergarten liegt inmitten des aus Hainbuchen *(Carpinus)* bestehenden »Kreuzgangs« – ein Ort der Ruhe.
Rechts: In jedem Winkel entdeckt man die Essigrose *(Rosa gallica* 'Versicolor') mit ihren karminrot gestreiften Blüten, die wegen ihrer Heilkraft geschätzt wird und eine Art der 'Rose de Provins' ist.
Folgende Doppelseite: Gesamtansicht des Gartens. Im Vordergrund das Parterre mit der ineinander verwobenen Bepflanzung. Rechts befindet sich der Eingang zum Kreuzgang, in der Mitte das Labyrinth, darüber lugt die Voliere hervor.

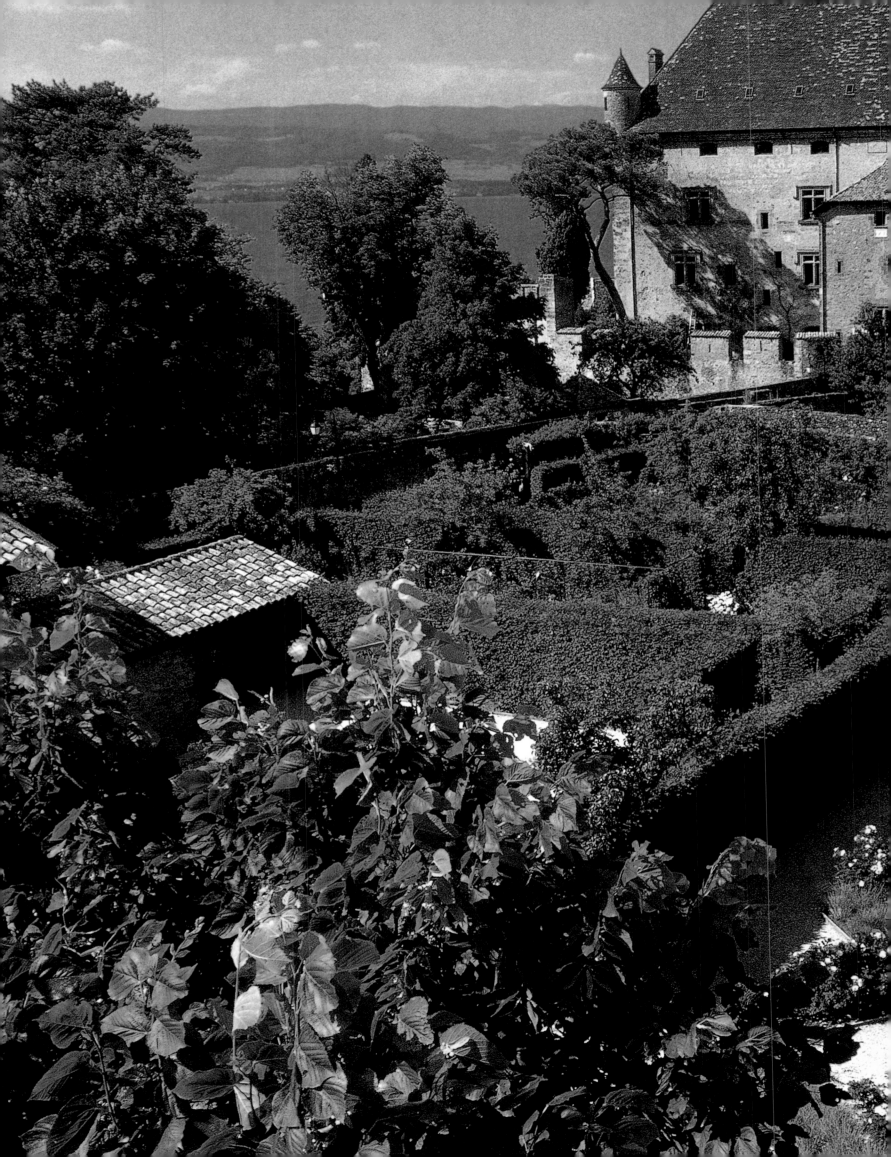

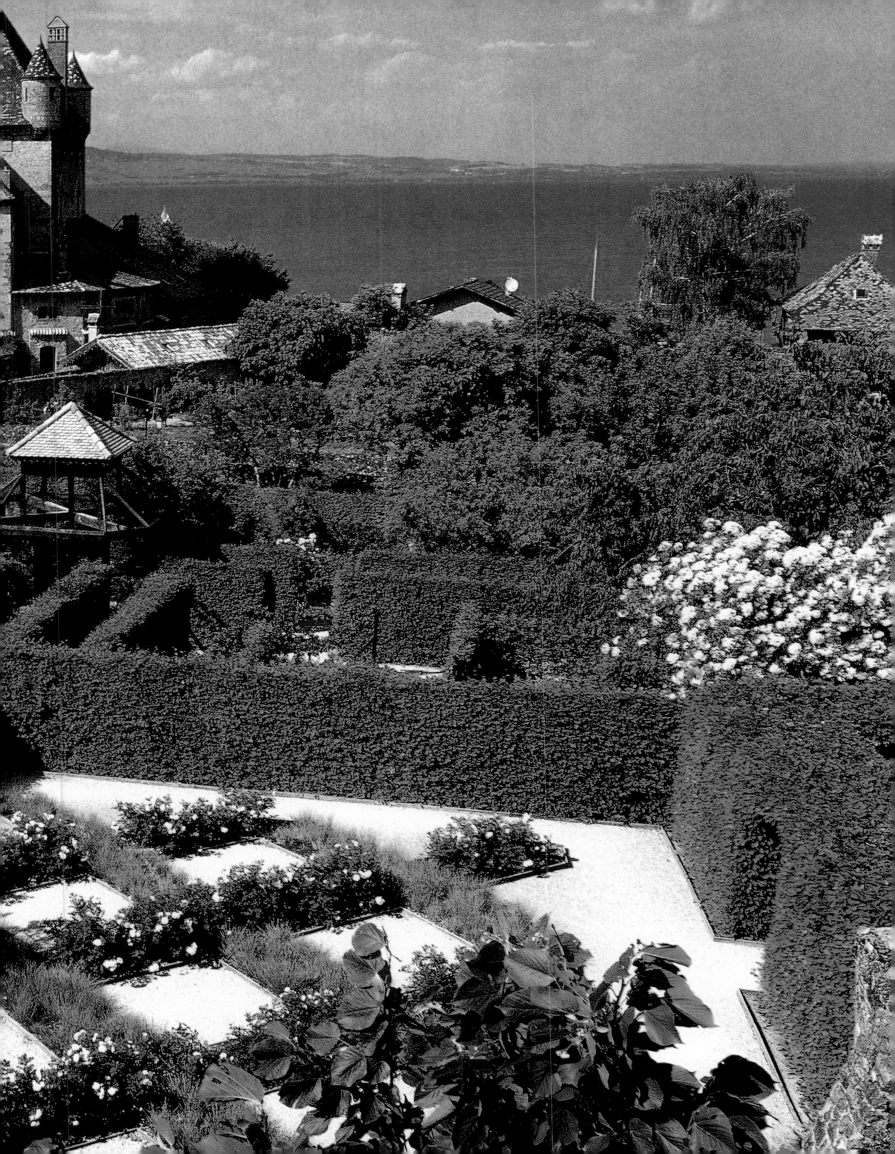

Le Sud

Le climat fait son unité. Chaud, sec et aride, très
ensoleillé, il oblige le jardinier à s'adapter : à la végé-
tation indigène qu'il fait entrer dans ses composi-
tions en s'inspirant de la garrigue, au relief qu'il
apprivoise, à un style préétabli qui fait penser à
l'Italie. Grands ou petits, les jardins sont souvent
très architecturés. Quand ils sont fleuris, ils sont
délicieusement parfumés. La présence de l'eau y
est indispensable. Tout y est gai. On s'y promène
comme dans un décor de théâtre.

Here, the unity is that of climate. The hot, dry weather and long hours of sun mean the gardener has to adapt. The local vegetation enters into compositions that take their inspiration from the "garrigue" – the Provençal shrubby vegetation, local relief enters into design, and there is a well-established local style reminiscent of Italian gardens. However small, Southern gardens are generally very formal in layout. When they are full of flowers, they are wonderfully balmy. There is a practical and psychological need for the presence of water. Everything here breathes contentment. Each garden has the artifice and elegance of a theatre set.

Das einheitliche Bild dieser Region ist durch das Klima bedingt. Die Gärtner müssen sich an das heiße trockene Wetter und die intensive Sonneneinstrahlung anpassen. Sie greifen zurück auf die heimische Flora mit den typischen Pflanzen der „garrigue", der provenzalischen immergrünen Buschlandschaft, und orientieren sich an dem lokalen Stil mit seinen italienischen Anklängen. Ob groß oder klein – die Gärten sind oft streng durchkomponiert. Wenn sie in Blüte stehen, steigt ein verführerischer Duft aus ihnen auf. In diesen heiteren Gärten ist Wasser unverzichtbar. Man wandelt dort wie in den Kulissen einer Theaterbühne.

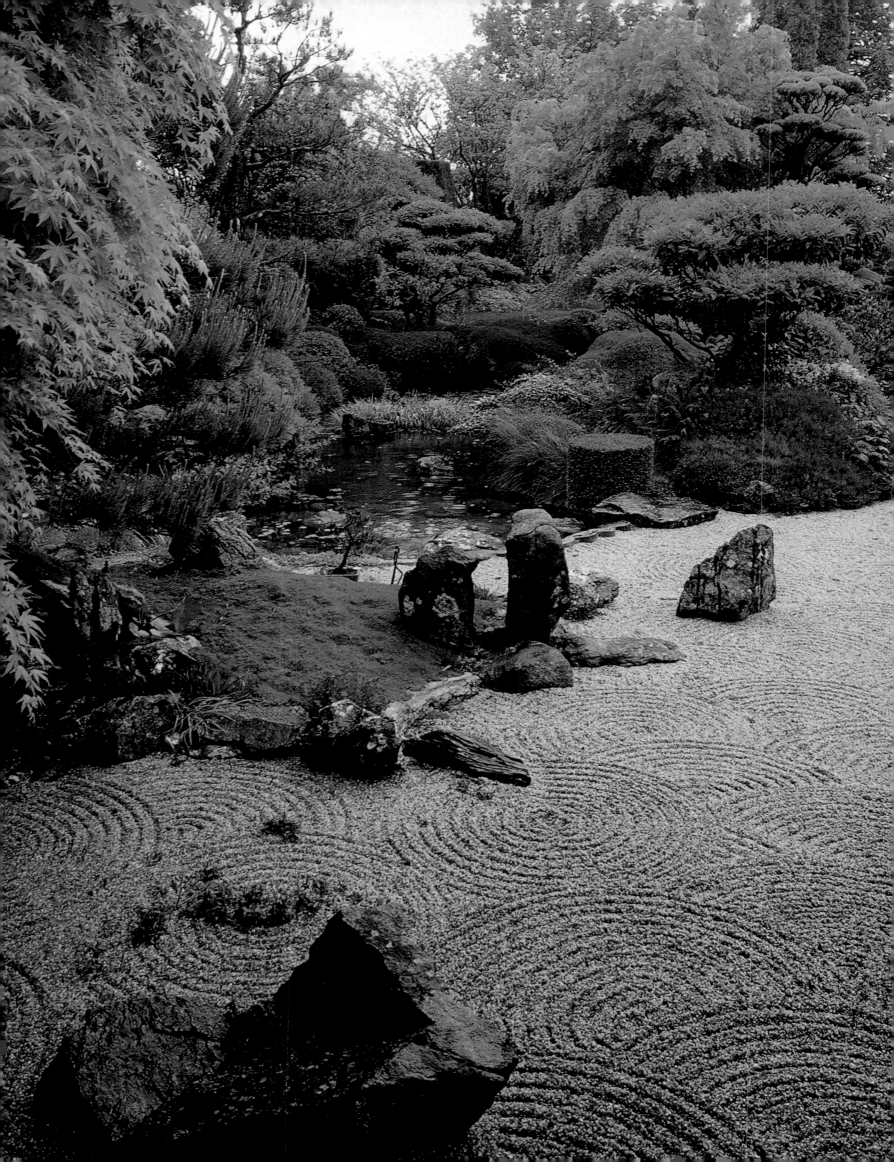

Un *Podocarpus* taillé en forme de nuage marque l'entrée du jardin et rompt avec le paysage de la Drôme sobrement planté de vignes et de pêchers. On entre dans un univers japonisant sophistiqué, sous-tendu par une pensée. Ce jardin, Erik Borja l'a façonné comme une sculpture. Car il est sculpteur et peu, à peu son jardin est devenu son atelier. A partir de 1973, il se met à travailler les végétaux, conformément à la pensée zen dont il s'est fait l'adepte au cours de deux voyages au Japon. Cette démarche s'applique à la première partie du jardin, celle qui jouxte l'ancienne maison de vigneron et qui se déploie, comme tout jardin zen, devant la pièce principale, pour être appréhendée à partir d'un point fixe, comme un tableau: un paysage naturel miniaturisé avec un étang, des îles, une montagne, des vallées, des rochers et des végétaux étagés par ordre croissant jusqu'à retrouver progressivement leur taille naturelle. En contrebas du jardin japonais se déploie le jardin méditerranéen. Tourné vers le sud, architecturé en terrasses, il permet à Erik Borja de renouer avec ses racines. C'est un jardin ouvert au soleil, à la différence du premier où l'ombre et la fraîcheur prédominent. Assisté de Christian Coureau, Erik Borja approche toujours ses jardins comme un sculpteur. Ses créations sont en perpétuelle évolution, sans cesse en quête de perfection.

Les jardins d'Erik Borja

A Yacca tree *(Podocarpus)* clipped into the shape of a cloud marks the entrance to the garden and forms an abrupt contrast with the Drôme landscape and its sober cladding of vines and peach trees. This is a sophisticated, Japanese-style garden of outstanding unity. Erik Borja has moulded the landscape as if sculpting it; he is sculptor, and his garden has slowly become his studio. After 1973, he also began to shape the flora of his garden, in conformity with the precepts of Zen, into which he was initiated during two trips to Japan. The Zen style is confined to the first part of the garden, that which stands next to the old wine-grower's house, in front of the main room, like all Zen gardens which are designed to be visible from a fixed point, like a picture. It is a miniaturised natural landscape with a pond, islands, a mountain, valleys, and rocks; the plants are ranked in order of growth, with the hindmost allowed to attain their natural size. Below the Japanese garden is a Mediterranean garden. South-facing and terraced, for Erik Borja it means a return to his childhood places. It is an open, sunny garden contrasting with the shade and cool of the Japanese garden. With Christian Coureau's help, Erik Borja always takes a sculptural approach to garden design. His creations are in a state of perpetual transformation as he strives toward the impossible goal of perfection.

Eine wolkenförmig beschnittene Steineibe *(Podocarpus)* überragt den Eingang zum Garten und bildet einen starken Kontrast zur typischen Drôme-Landschaft mit ihren säuberlich aufgereihten Weinstöcken und Pfirsichbäumen. Hier betritt man ein exquisites, vom reinen Gedanken getragenes, japanisch geprägtes Universum. Erik Borja gestaltete diesen Garten wie eine Skulptur, denn er ist Bildhauer, und so ist sein Garten allmählich zu seinem Atelier geworden. Seit 1973 bearbeitet er die Pflanzen inspiriert vom Zen-Buddhismus, in dem er während seiner beiden Japanaufenthalte seine Berufung fand. Das betrifft vor allem den Teil des Gartens, der an das alte Winzerhaus angrenzt und sich wie jeder Zen-Garten vor dem Wohnraum ausbreitet, um von dort aus wie ein Gemälde betrachtet zu werden: eine natürlich wirkende Landschaft im Miniaturformat, komplett mit Teich, Inseln, einem Berg, Tälern, Felsen und Gewächsen mit zunehmender Höhe, die schließlich wieder ihre natürliche Größe erreichen. Unterhalb des japanischen Gartens erstreckt sich der Mittelmeergarten mit seinen nach Süden ausgerichteten Terrassen. Hier hat Erik Borja zu seinen Wurzeln zurückgefunden. Dieser Garten öffnet sich ganz der Sonne, während der japanische Teil Schatten und kühle Frische ausströmt. Bei der Arbeit mit seinem Assistenten Christian Coureau erlebt Erik Borja seinen Garten stets mit den Augen des Bildhauers. Seine Werke entwickeln sich ständig weiter und spiegeln sein nicht nachlassendes Streben nach Perfektion.

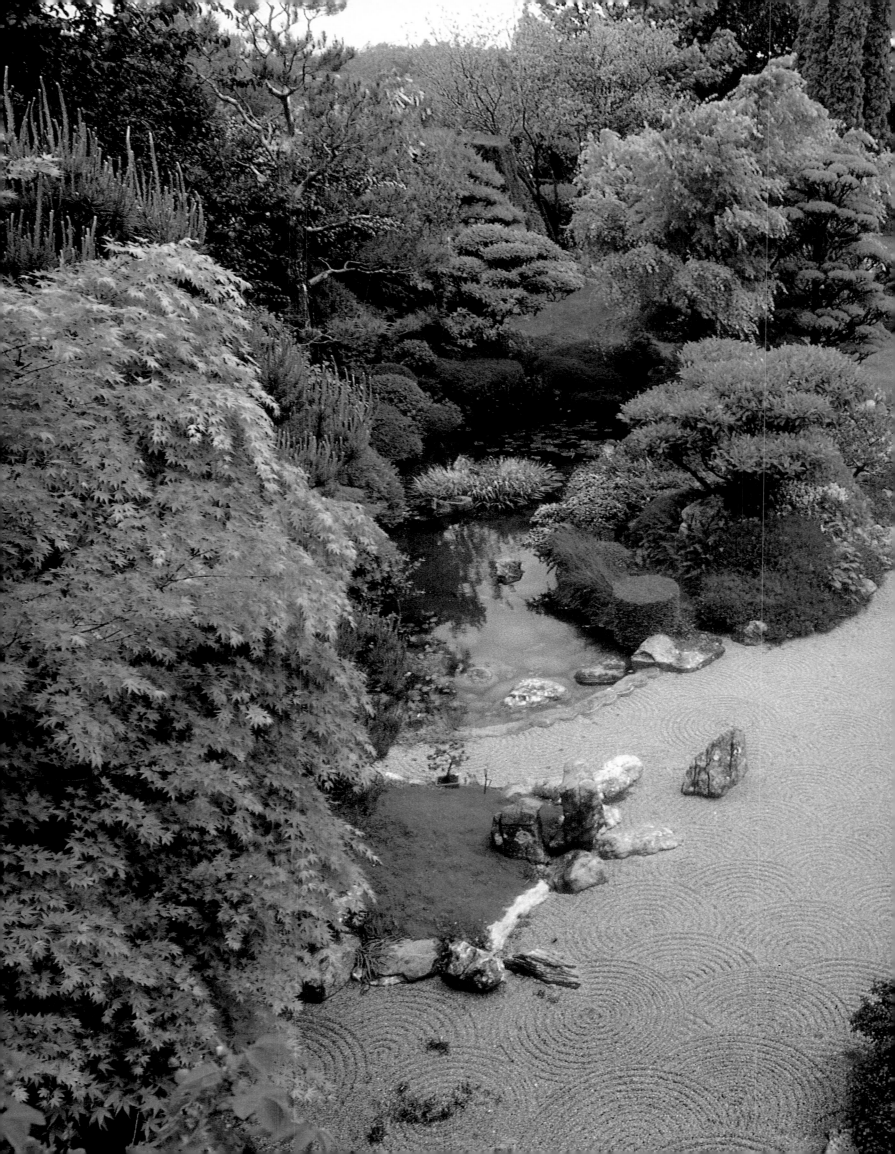

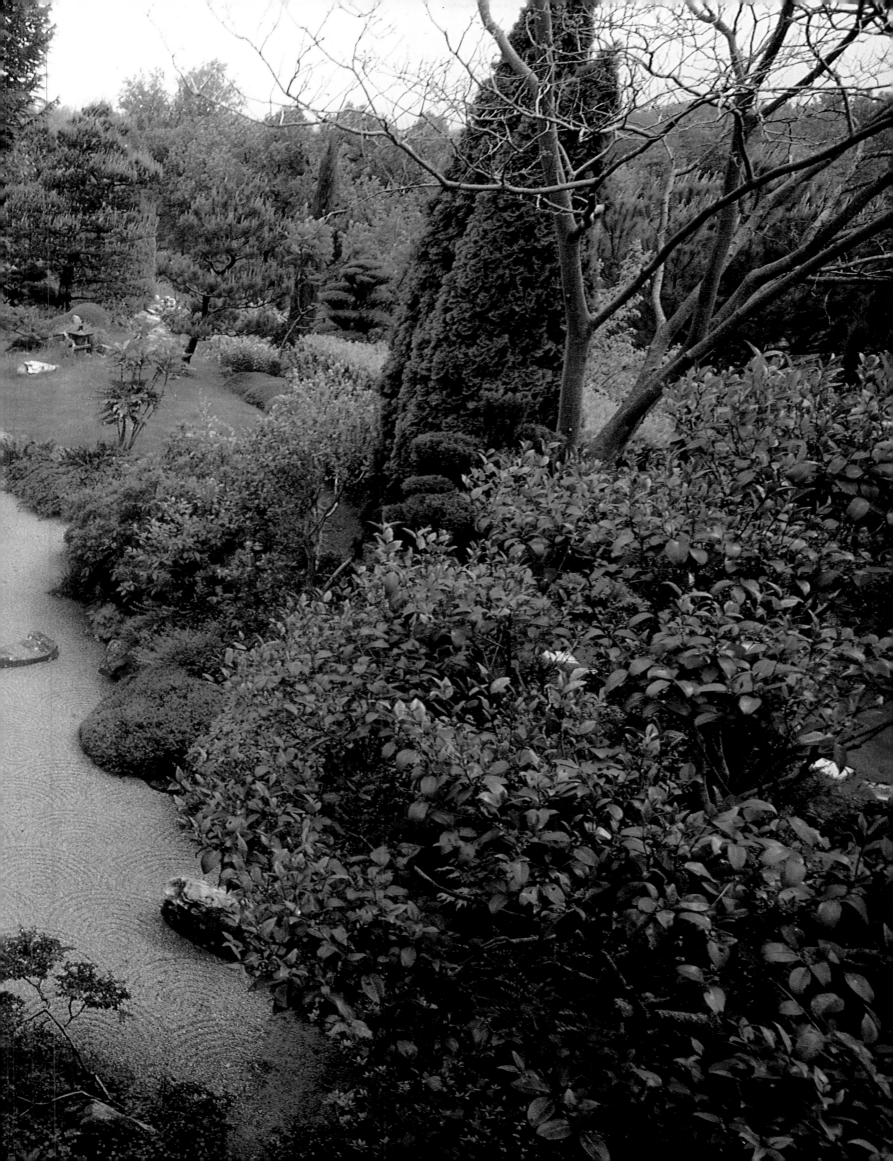

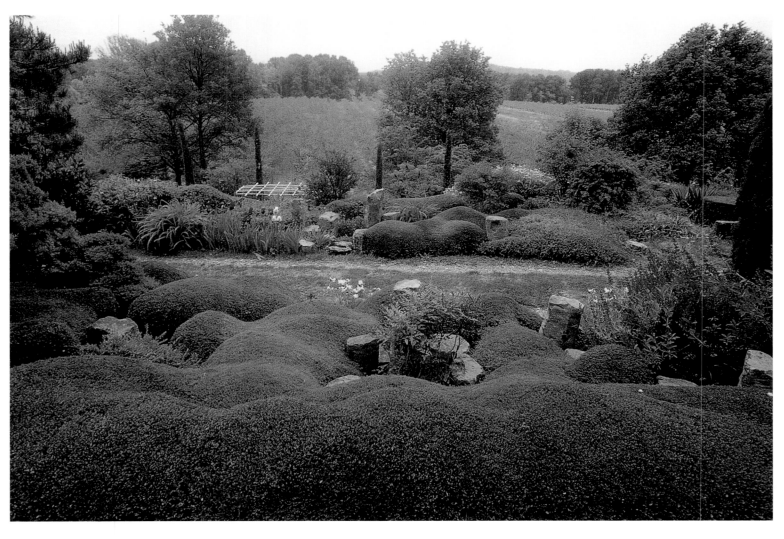

Première page: Le sable du jardin japonais représente une masse aquatique. Le ratissage en écailles de carpe symbolise des éventails ou les ondes de l'eau autour des pierres.
Double page précédente: vue d'ensemble du jardin japonais.
Ci-dessus: Le jardin japonais très sophistiqué contraste avec le paysage environnant planté d'arbres fruitiers alignés.
A gauche: sculptures végétales dans le jardin japonais.

First page: The sand of the Zen garden represents water. The carp-scale pattern into which it is raked symbolises fans or waves of water around the rocks.
Previous pages: overall view of the Zen garden.
Above: The very sophisticated Zen garden contrasts with the surrounding landscape and its rows of fruit trees.
Left: sculpted plant shapes in the Japanese garden.

Eingangsseite: Im japanischen Garten symbolisiert der Sand eine Wasserfläche. Die mit der Harke gezogenen Muster versinnbildlichen Fächer oder Wellen, die sich rings um Steine ausbreiten.
Vorhergehende Doppelseite: Gesamtansicht des japanischen Gartens.
Oben: Der raffinierte japanische Garten hebt sich von der Umgebung mit ihren geradlinigen Obstplantagen ab.
Links: Pflanzenskulpturen im japanischen Garten.

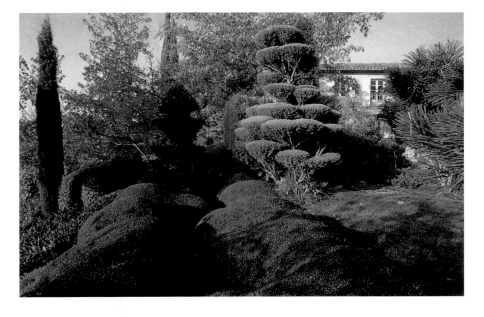

Les jardins d'Erik Borja *Provence*

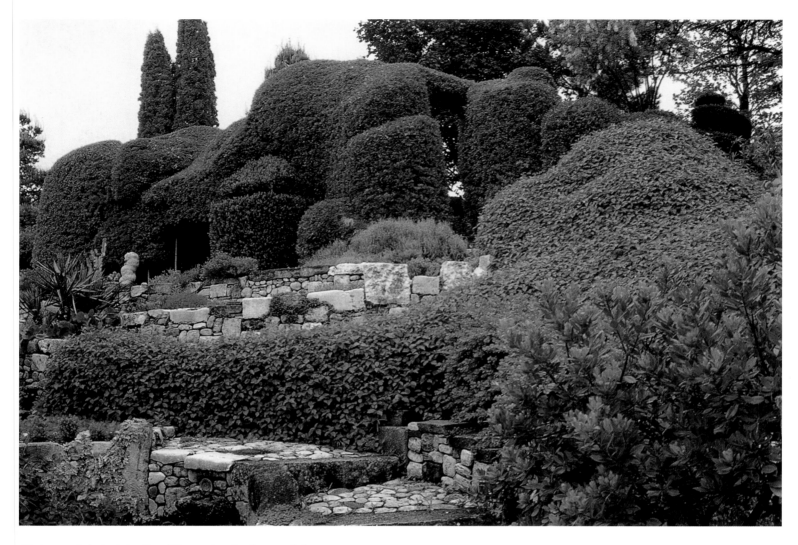

Ci-dessus et à droite: le jardin méditerranéen. Les formes végétales sont sculptées dans trois variétés de buissons-ardents *(Pyracantha)* qui donnent trois couleurs de fruits différentes.

Above and right: the Mediterranean garden. The three varieties of firethorn *(Pyracantha),* with their three different colours of berry, are used to form a wall of topiary.

Oben und rechts: der Mittelmeergarten. Die Pflanzenfiguren sind aus drei Sorten Feuerdorn *(Pyracantha)* geschnitten, die jeweils unterschiedlich gefärbte Beeren ausbilden.

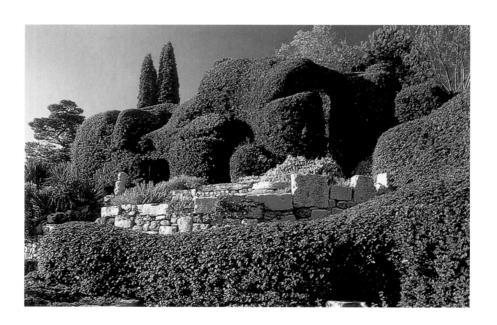

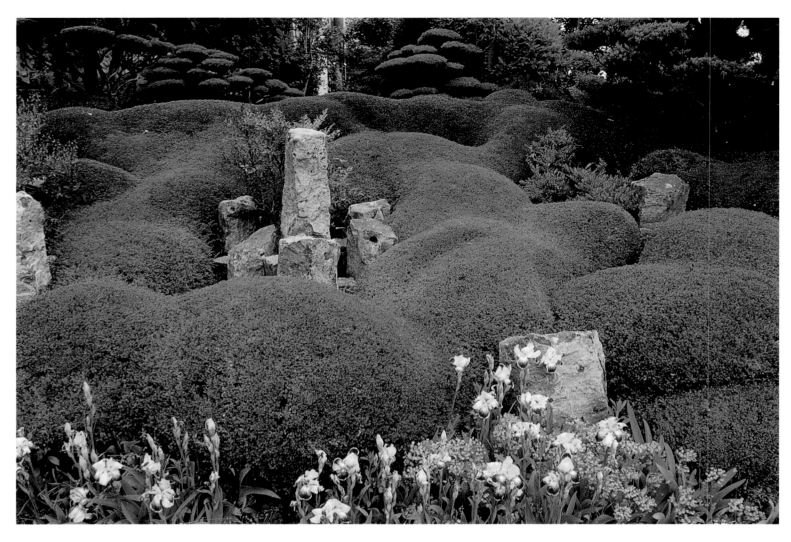

Ci-dessus: dans le jardin japonais: mariage de pierres et de buis, le minéral rejoignant le végétal. Les buis forment un moutonnement et sont surmontés d'arbres taillés en nuage. Au premier plan, des iris en pleine floraison, et des euphorbes.
A droite: Erik Borja et Christian Coureau en train de tailler les végétaux.
Page de droite: gros plan sur les sculptures végétales. Surplombant un moutonnement sculpté dans une masse de chèvrefeuille *(Lonicera nitida):* à gauche un cyprès de Florence, au centre un if en forme de lanterne, à droite un *Chamaecyparis lawsoniana* 'Ellwoodii' taillé en forme de nuage.

Above: in the Japanese garden: a combination of stone and box – mineral meeting vegetable. The box takes on a wave-like form and is overlooked by trees sculpted into the shape of clouds. In the foreground, irises in full bloom, and spurges.
Right: Erik Borja and Christian Coureau at work on the topiary.
Facing page: a close-up of the topiary. Overlooking the swelling waves of the honey suckle *(Lonicera nitida),* on the right, an Italian cypress. In the centre, a lantern-shaped yew, and to the left a cloud-shaped *Chamaecyparis lawsoniana* 'Ellwoodii'.

Oben: Im japanischen Garten verbinden sich Stein und Buchsbaum zu einem harmonischen Ganzen. Den wellenförmig beschnittenen Buchsbaum überragen Bäumen, die ihrerseits in Wolkenform geschnitten sind. Im Vordergrund sieht man in voller Blüte stehende Schwertlilien und Wolfsmilch *(Euphorbia).*

Rechts: Erik Borja und Christian Coureau beim Beschneiden von Büschen.
Rechte Seite: Nahaufnahme der Pflanzenskulpturen; über der wie ein aufschäumendes Meer geschnittenen Heckenkirsche *(Lonicera nitida)* erhebt sich links eine toskanische Zypresse, in der Mitte eine laternenförmige Eibe und rechts eine Scheinzypresse *(Chamaecyparis lawsoniana* 'Ellwoodii'), die wie eine Wolke geformt ist.

Les jardins d'Erik Borja *Provence*

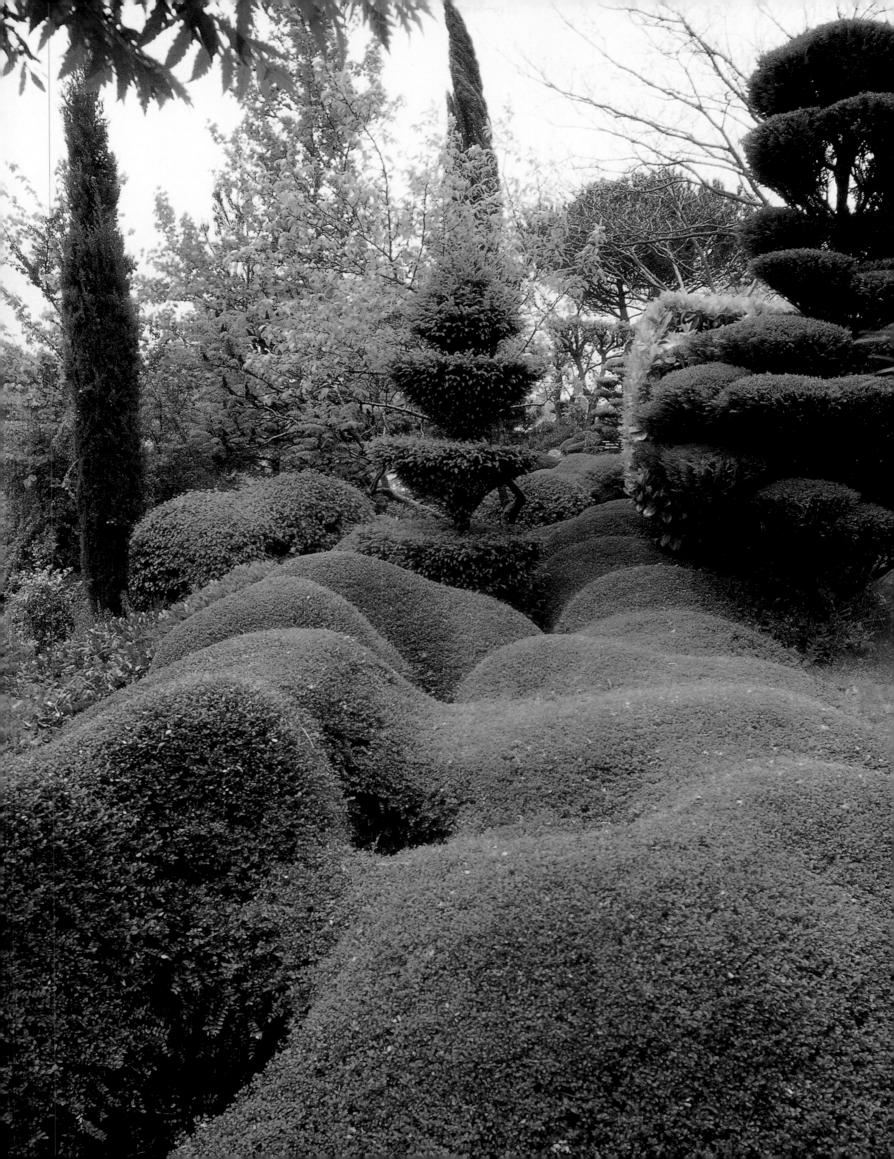

Détail de gauche: un bassin
situé sous les terrasses du
jardin méditerranéen.

Detail left: a pond under the
terraces of the Mediter-
ranean garden.

Detail links: Wasserbecken
unterhalb der Terrassen des
Mittelmeergartens.

Détail de droite: le bassin du
jardin méditerranéen.

Détail right: the pond in the
Mediterranean garden.

Detail rechts: das Wasser-
becken des Mittelmeergar-
tens.

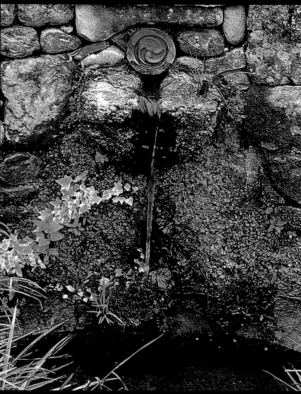

Détail de droite: une allée en
pierres, en briques et en
galets située à l'entrée du
jardin japonais.

Detail right: a pathway
paved with stone, brick and
pebbles leading to the Japa-
nese garden.

Detail rechts: Der Pfad am
Eingang des japanischen
Gartens ist mit Steinplatten,
Ziegeln und Kieseln gepfla-
stert.

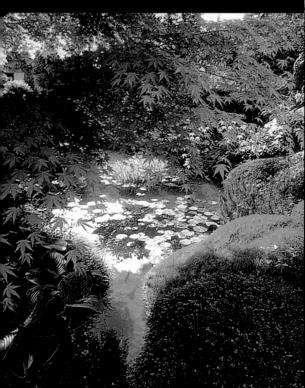

Détail de gauche: le plan
d'eau du jardin japonais.

Detail left: the lake in the
Japanese garden.

Detail links: der Teich im
japanischen Garten.

Détail de gauche: l'étang du jardin japonais. Entre les pierres, on remarque de l'*Helxine* et de l'*Acorus calamus* 'Variegatus' au feuillage panaché.

Detail left: the lake in the Japanese garden. Among the stones can be *Helxine* and *Acorus calamus* 'Variegatus' with its feathery leaves.

Detail links: der Teich im japanischen Garten. Zwischen den Steinen sieht man Bubiköpfchen *(Helxine)* und grün-weiß gemusterten Kalmus *(Acorus calamus* 'Variegatus').

Détail de gauche: passage du jardin zen au jardin de thé.

Detail left: the passage from the Zen to the tea garden.

Detail links: Übergang vom Zen-Garten zum Teegarten.

Détail de droite: pavement menant au jardin japonais.

Detail right: paving on the path to the Japanese garden.

Detail rechts: Pflasterung auf dem Weg zum japanischen Garten.

Détail de gauche: un banc, du sable ratissé en écailles de carpe et des sculptures végétales.

Detail left: a bench, the sand raked in carp-scale patterns, and plant sculptures.

Detail links: eine Bank, zu Halbkreisen geharkter Sand und Pflanzenskulpturen.

Détail de gauche: gros plan sur un *Pinus strobus.*

Detail left: a close-up of a *Pinus strobus.*

Detail links: Nahaufnahme einer Weymouthskiefer *(Pinus strobus).*

L'histoire de cette collection commence en 1855, quand Eugène Mazel fait l'acquisition du domaine. Fin bota-
niste, passionné de plantes, cet importateur d'épices fortuné transfère ses espèces rares d'origine asiatique
rassemblées à Saint-Jean-Cap-Ferrat, dans ce vallon cévenol où un micro-climat méditerranéen lui permet de
les acclimater. Il crée à cet endroit l'un des plus beaux jardins botaniques de l'époque. Il plante en particulier
des bambous. En 1882, il est ruiné. Le parc est repris par le Crédit Foncier de France, puis vendu en 1902 à
Gaston Nègre qui sauve les collections. Son fils Maurice les enrichira, secondé ensuite par son épouse qui
poursuivra sa tâche, puis par sa fille Muriel et son gendre Yves Crouzet. Ces derniers assurent la gestion du
domaine depuis 1977. L'œuvre d'Eugène Mazel, qui rassemble plus de cent variétés différentes de bambous,
est ordonnée par deux grandes allées. La première voûte prend naissance à la grille d'entrée. Elle est bordée
d'immenses bambous, *Phyllostachys viridis,* coiffés par des séquoias *(Sequoiadendron giganteum).* La seconde
allée part de la ferme. Elle est plantée de bambous géants, *Phyllostachys bambusoides,* ainsi que de palmiers. A
l'instigation d'Yves Crouzet, le parc s'est enrichi d'un village laotien, d'un jardin japonais, d'un labyrinthe,
d'un jardin aquatique et d'un «bambusarium» qui montre comment on peut utiliser toutes sortes de variétés
de bambous. Cette bambouseraie nous ouvre les portes d'un univers étonnant et très dépaysant.

La Bambouseraie de Prafrance

The history of this collection begins in 1855, when the wealthy spice merchant Eugène Mazel acquired the
estate. An excellent botanist with a passionate interest in plants, he transferred his collection of rare Asiatic
species from Saint-Jean-Cap-Ferrat to this little valley in the Cévennes, where a Mediterranean microclimate
allowed them to flourish. Here he created one of the finest botanical gardens of the time, with forty full-time
gardeners. His collection was centred on bamboos. In 1882, his fortune collapsed. The park fell into the hands
of the Crédit Foncier de France, which sold it in 1902 to Gaston Nègre, who saved the collections. They were
then further enriched by Gaston's son Maurice, ably seconded by his wife, and subsequently by Maurice's
daughter Muriel and her husband Yves Crouzet, who have managed the estate since 1977. Eugène Mazel's col-
lection, which comprises more than a hundred varieties of bamboo, is laid out around two broad avenues. The
first of these starts directly from the entrance gate, and is flanked by huge bamboos, *Phyllostachys viridis,* be-
hind which stand giant sequoias *(Sequoiadendron giganteum).* The second starts at the farm and is planted
with giant *Phyllostachys bambusoides* and palm trees. On Yves Crouzet's initiative, the park now possesses a
Laotian village, a Japanese garden, a labyrinth, an aquatic garden and a "bambusarium" which shows how the
many varieties of bamboo are used. To enter the Prafrance Bamboo Garden is to enter an astonishing and dis-
orienting new world.

Die Geschichte der Bambouseraie geht zurück auf das Jahr 1855, als Eugène Mazel den Besitz kaufte. Der
begeisterte Botaniker und wohlhabende Gewürzhändler brachte die zunächst in Saint-Jean-Cap-Ferrat zu-
sammengetragenen seltenen Gewächse aus Asien in dieses Cevennental, dessen mediterranes Mikroklima sich
zur Akklimatisation anbot. Er schuf damit einen der schönsten botanischen Gärten seiner Zeit, in dem rund
vierzig Gärtner tätig sind. Wichtigstes Gewächs war der Bambus. 1882 machte Mazel bankrott, der Park
wurde von der französischen Bodenkreditanstalt übernommen und 1902 an Gaston Nègre weiterverkauft, der
die Anlage rettete. Sein Sohn Maurice baute den Park weiter aus, später zusammen mit seiner Frau, die sein
Werk anschließend fortführte. Seit 1977 leiten seine Tochter Muriel und sein Schwiegersohn Yves Crouzet
den Bambuspark. Die Anlage Eugène Mazels mit ihren über hundert verschiedenen Bambussorten ist durch
zwei große Alleen gegliedert. Die erste spannt ihr grünes Dach bereits am Eingangstor aus. Sie ist gesäumt
von Exemplaren des Riesenbambus *Phyllostachys viridis,* darüber erheben sich die Wipfel von Mammutbäu-
men *(Sequoiadendron giganteum)* zu sehen. Die zweite Allee geht vom Bauernhaus ab und besteht aus riesigen
Phyllostachys bambusoides und Palmen. Auf Betreiben von Yves Crouzet wurde der Park um ein laotisches
Dorf, einen japanischen Garten, ein Labyrinth, einen Wassergarten und ein »Bambusarium« erweitert, in
dem man erfährt, wie die einzelnen Bambussorten verwertet werden können. Die Bambouseraie öffnet uns
das Tor zu einem erstaunlichen, überaus exotischen Universum.

Double page précédente: gros plan sur des *Phyllostachys aurea,* originaires de l'est de la Chine. Au soleil, ses chaumes vert pâle tournent au jaune. L'allée est plantée de bambous et de palmiers *Trachycarpus excelsa* (détails).
Ci-dessus: Phyllostachys sulphurea var. viridis originaire de Chine. Ses chaumes sont d'abord vert clair striés de vert foncé, puis ils se colorent en jaune d'or.

Previous pages: close-up of *Phyllostachys aurea,* golden bamboo from eastern China. In the sun, its pale green stems turn yellow. The avenue is planted with bamboo and the palm tree *Trachycarpus excelsa* (details).
Above: Phyllostachys sulphurea var. viridis from China. At first, its stems are pale green striped with darker green, then golden yellow.

Vorhergehende Doppelseite: Nahaufnahme von *Phyllostachys aurea,* einem aus Ostchina stammenden Bambus. Im Sonnenlicht verfärben sich die hellgrünen Rohre gelb. Die Allee ist mit Bambus und Hanfpalmen der Art *Trachycarpus excelsa* bepflanzt (Details).
Oben: Phyllostachys sulphurea var. viridis stammt aus China. Seine Rohre sind zunächst hellgrün mit dunkelgrünen Streifen, verfärben sich dann jedoch goldgelb.

A droite: le village laotien construit en bambous et planté de bananiers *(Musa).* Les toits sont faits de bambous ou de feuilles de palmiers.
Ci-dessous: Phyllostachys viridiglaucescens, originaire de Chine. Ses chaumes bleu-vert sont particulièrement rectilignes.

Right: the Laotian village built of bamboo and planted with banana trees *(Musa).* The roofs are made of bamboo and palm leaves.
Below: Phyllostachys viridiglaucescens from China. Its blue-green stems are particularly rectilinear.

Rechts: Das laotische Dorf ist ganz aus Bambus errichtet und mit Bananen *(Musa)* eingegrünt. Die Dächer bestehen aus Bambus oder Palmblättern.
Unten: der aus China stammende *Phyllostachys viridiglaucescens.* Seine blaugrünen Rohre sind besonders gerade.

Détail de gauche: Phyllostachys pubescens.

Detail left: Phyllostachys pubescens.

Detail links: Phyllostachys pubescens.

Détail de droite: Phyllostachys viridis.

Detail right: Phyllostachys viridis.

Detail rechts: Phyllostachys viridis.

Détail de droite: Phyllostachys viridis.

Detail right: Phyllostachys viridis.

Detail rechts: Phyllostachys viridis.

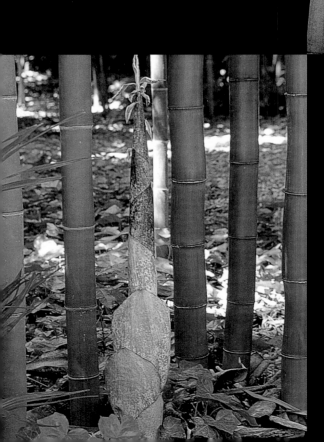

Détail de gauche: Phyllostachys bambusoides.

Detail left: Phyllostachys bambusoides.

Detail links: Phyllostachys bambusoides.

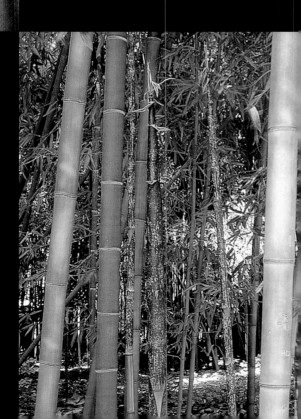

Détail de gauche: Phyllostachys sulphurea var. viridis.

Detail left: Phyllostachys sulphurea var. viridis.

Detail links: Phyllostachys sulphurea var. viridis.

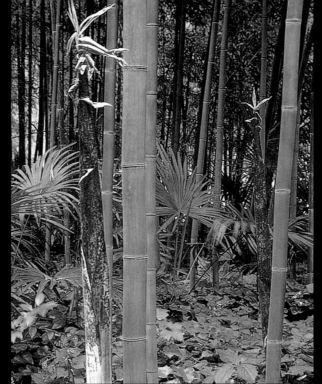

Détail de gauche: Phyllostachys bambusoides.

Detail left: Phyllostachys bambusoides.

Detail links: Phyllostachys bambusoides.

Détail de droite: Phyllostachys aurea.

Detail right: Phyllostachys aurea.

Detail rechts: Phyllostachys aurea.

Détail de gauche: Phyllostachys bambusoides.

Detail left: Phyllostachys bambusoides.

Detail links: Phyllostachys bambusoides.

Détail de gauche: Phyllostachys nigra 'Boryana'.

Detail left: Phyllostachys nigra 'Boryana'.

Detail links: Phyllostachys nigra 'Boryana'.

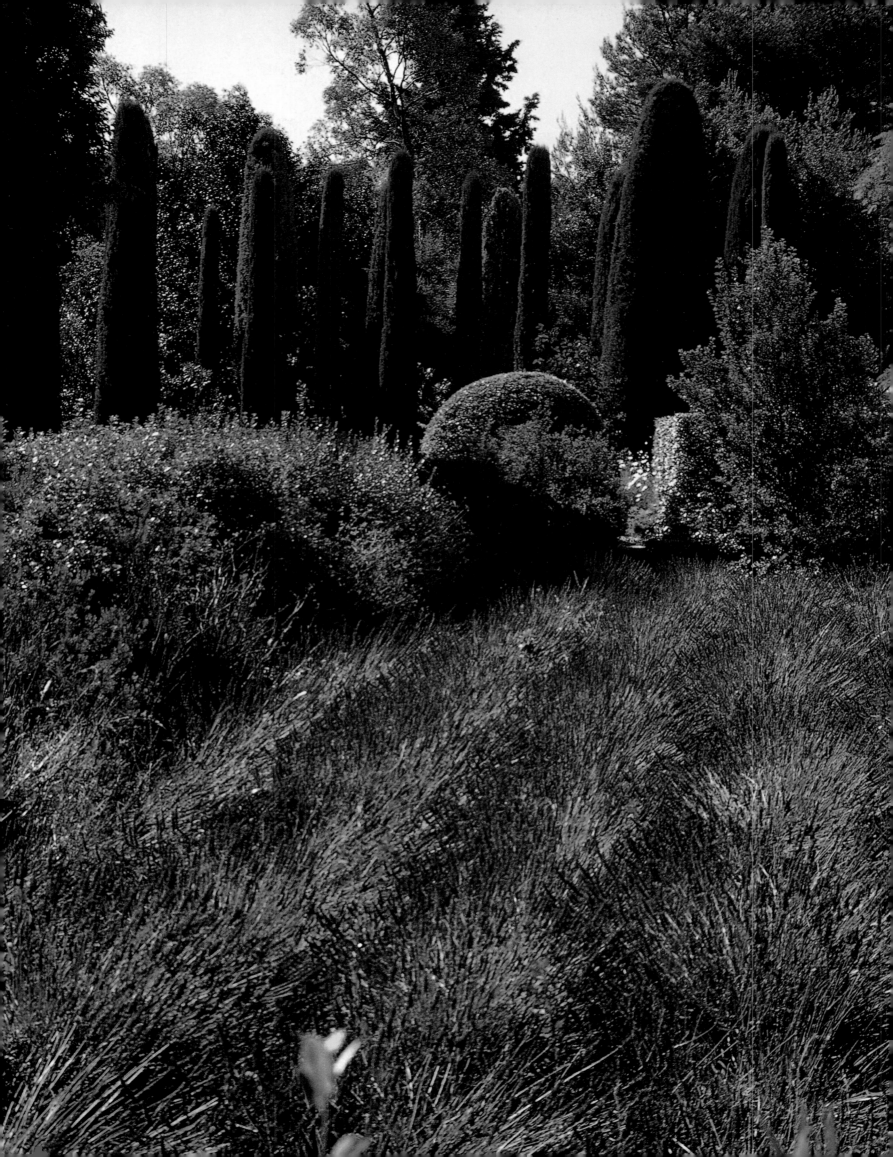

Neuf jardins dans un jardin très féminin: Anne Cox-Chambers l'aime, le fleurit et lui apporte tous ses soins. Elle fait appel à des spécialistes renommés pour le structurer, le confie à ses jardiniers, y travaille elle-même et en savoure les délices depuis de nombreuses années. L'histoire de l'endroit remonte au 14e siècle. Le domaine fut partagé au 19e siècle et de cette division naquirent le Grand et le Petit Fontanille. Anne Cox-Chambers tomba sous le charme de ce dernier et l'acheta en 1979. Elle conserva les micocouliers *(Celtis australis)*, l'allée de cyprès et le champ de lavande et fit successivement appel aux talents de Peter Coates, Rory Cameron, Rosemary Verey, Ryan Gainey et Tim Rees pour composer les différents jardins. Devant le mas s'étend une belle perspective qui passe par un jardin de buis géométrique et symétrique et s'achève sur une grotte ombrée d'une tonnelle. A gauche, une allée de cyprès conduit au jardin de la piscine. Une prairie fleurie descend vers un jardin de fleurs à couper, laissant sur sa droite un champ de lavande qu'une allée traverse. Il faut l'emprunter pour se diriger vers la roseraie, disposée dans un tracé régulier, puis vers le jardin d'herbes également très formel qui diffuse des senteurs délicieuses. En revenant vers le mas, une chambre verte met en scène des jets d'eau qui se déclenchent par surprise, tout près de l'orangerie parfumée à longueur d'année par les jasmins ou les fleurs d'orangers.

Le Petit Fontanille

Nine gardens within a single, very feminine garden, that of Anne Cox-Chambers, who brings great love and attention to her creation. She calls in famous landscape gardeners to structure it, employs gardeners to maintain it, works in it herself, and has long savoured the pleasures it bestows. The history of the site goes back to the 14th century. In the 19th century, the estate was split up, thus giving rise to le Grand and le Petit Fontanille. Anne Cox-Chambers fell in love with the latter and acquired it in 1979. She kept the nettle trees *(Celtis australis)*, the cypress promenade and the lavender field, and called in high-powered support: Peter Coates, Rory Cameron, Rosemary Verey, Ryan Gainey and Tim Rees have all designed gardens here. In front of the "mas", the Provençal farmhouse, stretches a fine vista which leads through a geometrical box garden to a grotto shaded by a bower. To the right, a cypress promenade leads to the swimming-pool garden. A flowering meadow is the prelude to a flower garden; on its right is a lavender field across which there is an "allée", which in turn leads to the symmetrically laid-out rose garden and then to a very formal herb garden full of balmy scents. As one comes back towards the "mas", a green enclosure forms the backdrop for a play of water jets apparently triggered at random. Next to it is the orangery, which jasmine and orange blossoms infuse with scents throughout the year.

Neun Gärten mit einem sehr femininen Ambiente bilden zusammen einen Park: Anne Cox-Chambers liebt ihn, bringt ihn zum Blühen, hegt und pflegt ihn. Sie läßt den Park von renommierten Fachleuten instand halten, vertraut, wenn sie nicht selbst darin arbeitet, die Pflege eigenen Gärtnern an und genießt seit vielen Jahren die Schönheit ihres Gartens. Die Geschichte des Besitzes läßt sich bis ins 14. Jahrhundert zurückverfolgen. Im 19. Jahrhundert wurde er in ein größeres und ein kleineres Anwesen geteilt: Le Grand und Le Petit Fontanille. Anne Cox-Chambers verliebte sich in das kleinere und kaufte es 1979. Die Zürgelbäume *(Celtis australis)*, die Zypressenallee und das Lavendelfeld ließ sie stehen, die übrigen Gartenteile wurden jedoch nach und nach von Peter Coates, Rory Cameron, Rosemary Verey, Ryan Gainey und Tim Rees neu gestaltet. Vom Landhaus aus wandert der Blick über einen symmetrisch angelegten Buchsbaumgarten bis zu einer Grotte im Schatten einer Laube. Linker Hand führt die Zypressenallee zum Schwimmbecken. Eine blühende Wiese erstreckt sich bis hinab zum Schnittblumengarten, vorbei an einem rechter Hand liegenden Lavendelfeld, durch das ein Pfad hindurchführt. Folgt man ihm, gelangt man in den Rosengarten mit seiner regelmäßigen Aufteilung und den im französischen Stil angelegten Gemüse- und Kräutergarten, der köstliche Düfte verströmt. Auf dem Rückweg zum Landhaus passiert man einen Heckengarten, in dem nach dem Zufallsprinzip Wasserfontänen aufsteigen, und eine das ganze Jahr über nach Orangenblüten oder Jasmin duftende Orangerie.

Première page: le champ de lavandins dont on récolte les fleurs pour la fabrication de l'essence de lavande et pour parfumer le linge. A gauche, l'allée de lauriers-tins *(Viburnum tinus)* et de romarins.

Ci-dessus: Certaines parties du jardin sont structurées, d'autres sont libres et sauvages. Ici, on a tondu un chemin sinueux parmi les graminées.

A droite: Les cyprès confèrent au jardin un aspect théâtral très italien près du jardin de buis.

Page de droite: En allant vers la roseraie, un talus ample et pentu est planté de pérovskias aux hampes bleues et de rosiers botaniques.

First page: the field of hybrid lavender, whose flowers are harvested for essential oils and for perfuming linen. To the left, the promenade of laurustinus *(Viburnum tinus)* and rosemary.

Above: Some parts of the garden are formal, others are allowed to grow free and wild. Here a sinuous path has been cut through the grasses.

Right: The theatrical effect of the cypresses is very Italianate. They stand next to the box garden.

Facing page: On the path toward the rose garden, a wide sloping embankment is planted with blue-spiked *Perovskia* and species roses.

Eingangsseite: Das Feld ist mit Lavandin bestellt, der für die Herstellung von Lavendelextrakt und Wäscheparfüm verwendeten Lavendelsorte. Links wachsen immergrüne Schneeballsträucher *(Viburnum tinus)* und Rosmarin.

Oben: Einige Bereiche des Gartens sind durchstrukturiert, andere verwildert. Hier wurde mit dem Rasenmäher ein gewundener Pfad durch eine Wildblumenwiese gezogen.

Rechts: Die Zypressen verleihen dem Garten an dieser Stelle eine ausgesprochen italienisch anmutende, dramatische Wirkung. Ganz in der Nähe liegt der Buchsbaumgarten.

Rechte Seite: An dem weiten, steil zum Rosengarten abfallenden Hang sieht man die zartblauen Rispen der Perowskien und Wildrosen.

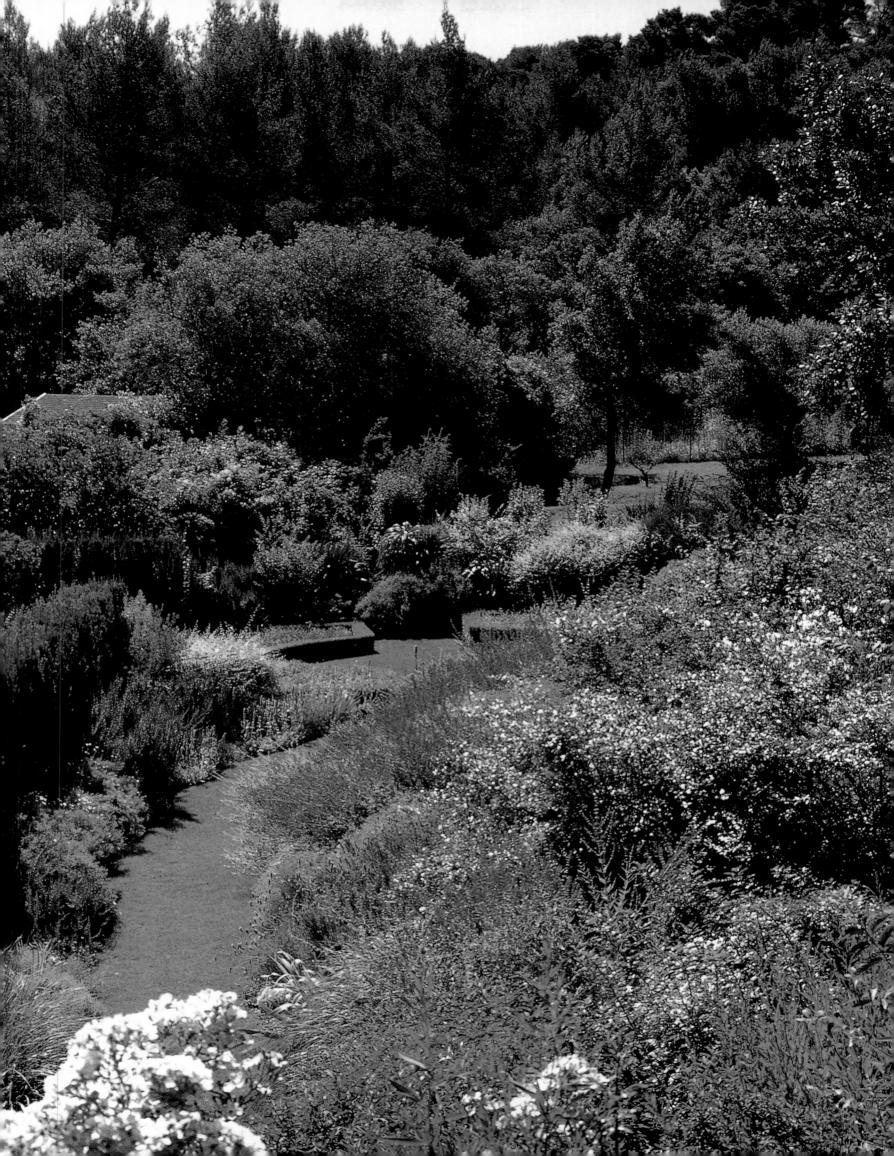

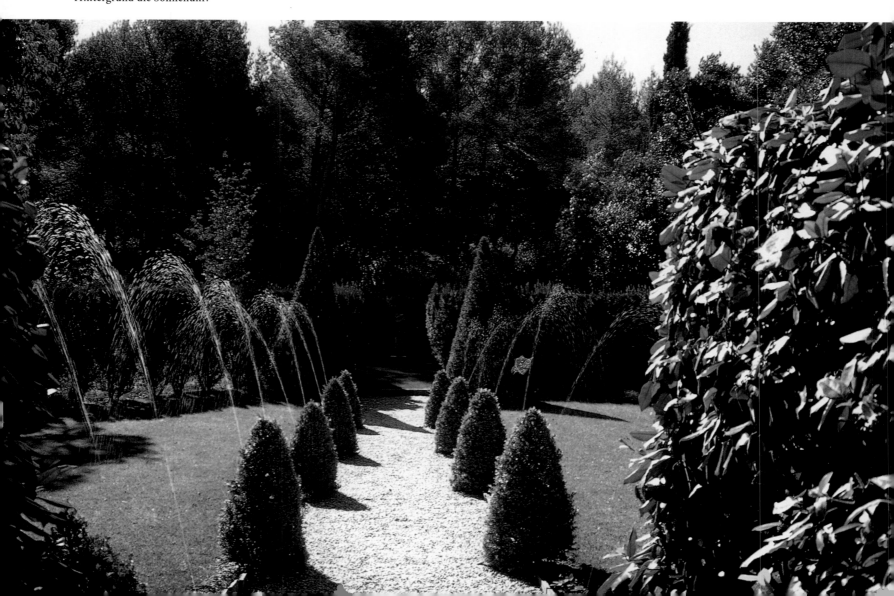

A droite: la roseraie dans un tracé de jardin à la française. Au premier plan, un talus planté de *Perovskia* et de lavandes.
Ci-dessous: la chambre verte avec ses jeux d'eau qui se déclenchent par surprise. A droite, une haie d'*Elaeagnus*. Au fond, le cadran solaire.

Right: The rose garden is laid out "à la française". In the foreground, an embankment planted with *Perovskia* and lavender.
Below: The "green room", with its water jets that surprise the visitor. To the right, an *Elaeagnus* hedge. At the end of the path stands a sundial.

Rechts: der Rosengarten mit seiner klassischen französischen Aufteilung; im Vordergrund eine mit Perowskien *(Perovskia)* und Lavendel überwucherte Böschung.
Unten: der Heckengarten, in dem überraschend Fontänen aufsteigen; rechts eine Hecke aus Ölweiden *(Elaeagnus)*, im Hintergrund die Sonnenuhr.

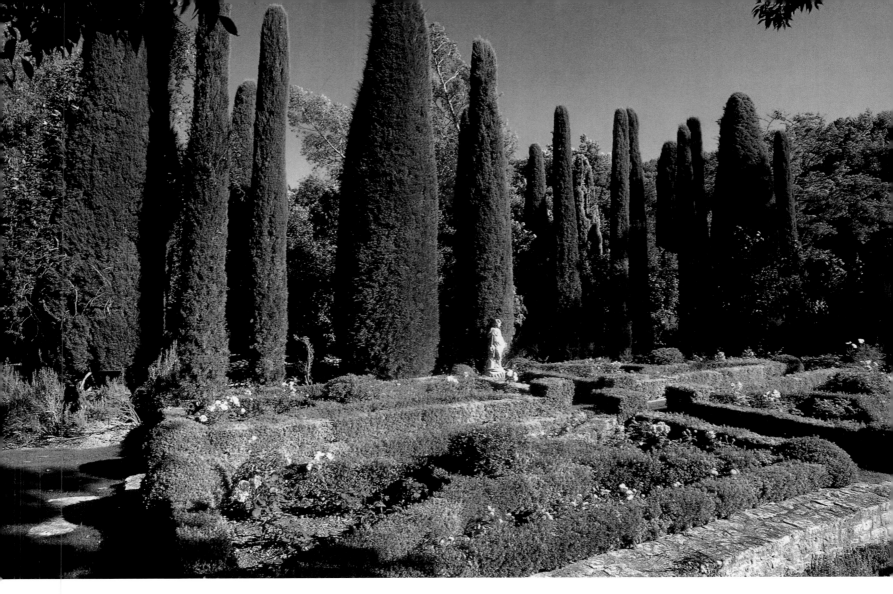

Ci-dessus: Ce jardin de buis est situé devant la maison. Il est planté de bulbes au printemps et de rosiers. Des boules de *Pittosporum* arrondissent les angles. Au fond, l'allée de cyprès relie la maison et le jardin de la piscine.
A droite: le potager ornemental dessiné par Rosemary Verey. Au centre, des herbes aromatiques et au fond, le champ de lavande.

Above: The box garden is in front of the house. It is planted with spring bulbs and roses. *Pittosporum* spheres soften the angles. In the background, one can see the cypress-lined promenade between the house and the swimming pool.
Right: the ornamental kitchen garden designed by Rosemary Verey. At its centre are the aromatic herbs; behind it stretches the lavender field.

Oben: Das Buchsbaumparterre grenzt direkt ans Haus und schmückt sich im Frühling mit Zwiebelgewächsen, im Sommer mit Rosen. Die Ecken rundet kugelig geschnittener Klebsame *(Pittosporum)* ab. Im Hintergrund sieht man die Zypressenallee zwischen dem Haus und dem Schwimmbecken.
Rechts: der von Rosemary Verey entworfene dekorative Gemüsegarten. In der Mitte ein Beet mit Küchenkräutern, im Hintergrund das Lavendelfeld.

L'effet de surprise est magistralement réussi. En arrivant devant le mas, on ne soupçonne pas qu'il existe derrière un jardin extraordinaire. De la terrasse ornée de buis, le regard est charmé par toutes sortes de délices: des platanes majestueux et ombreux, un bassin miroitant et rafraîchissant, un chemin d'eau ouvrant une longue perspective bordée d'oliviers. On y trouve toutes les tonalités de verts et de bleus. Des formes taillées structurent l'espace et servent de cadre à la composition. Cette œuvre est celle de Dominique Lafourcade, créatrice de jardins, dont l'époux, Bruno Lafourcade, est restaurateur de propriétés anciennes dans l'esprit 18e siècle. Ils ont acquis Les Confines en 1990. Le jardin n'existait pas. Dominique Lafourcade l'a voulu italianisant car elle sentait que ce style s'accorderait avec le ciel de Saint-Rémy. Les paysages de Provence n'évoquent-ils pas souvent ceux de l'Italie? Elle a décrit une promenade qui commence dans le jardin rond cerné d'un mur de verdure semi-circulaire en cyprès, traverse le jardin de roses, s'enfonce sous une longue pergola, rejoint une maison de verdure, emprunte une «calade» (sentier de galets) qui longe des champs de lavande, dessine de l'autre côté du chemin d'eau un itinéraire symétrique pour aboutir au jardin d'herbes. La découverte se poursuit dans les potagers, le verger, le jardin portugais et le jardin de boules. Dominique Lafourcade ne peut s'empêcher de créer: elle a toujours un projet en tête et le désir ardent de le réaliser.

Les Confines

The surprise is masterfully prepared. As one approaches the "mas", there is no sign of the magnificent garden behind it. From the box-ornamented terrace, the eye is greeted with a series of delicious sights: majestic, shady plane trees, a resplendent pool, and a watercourse leading down a fine vista bordered with olive trees. Here blue and green predominate. Topiary structures the space and constitutes a kind of framework for the composition of the garden. It is the work of Dominique Lafourcade, landscape designer, whose husband, Bruno, restores old houses in the spirit of the 18th century. They acquired Les Confines in 1990. At that time there was no garden, and Dominique Lafourcade felt that an Italianate garden was required for the sunlight of Saint-Rémy; the landscape of Provence is often reminiscent of Italy. She created a promenade starting in the round garden, which is so named for its semicircular wall of cypresses, which crosses the rose garden, enters a long pergola, traverses a further "green room", then follows a "calade", a pebbled pathway, alongside fields of lavender, returning along a symmetrical path on the other side of the watercourse to reach the herb garden. This is followed by a kitchen garden, an orchard, the Portuguese garden and the sculpted garden, which form the left-hand side of the composition. Dominique Lafourcade, incessantly creative, is full of ideas for further transformations and the energy required to realise them.

Die Überraschung gelingt hervorragend: Wer vor dem »mas«, dem typisch provenzalischen Landhaus, steht, käme nicht auf die Idee, daß sich dahinter ein prachtvoller Garten verbirgt. Doch von der mit Buchsbaum verzierten Terrasse aus bietet sich dem Auge eine Vielfalt von Farben und Formen dar: majestätische, schattenspendende Platanen, ein schillernder, kühlender Wasserspiegel und ein Wasserlauf, der sich schnurgerade durch einen Olivenhain zieht. Farblich dominieren Blau und Grün in allen Nuancen. Beschnittene Büsche gliedern den Raum und rahmen die Komposition ein. Dieser Park wurde geschaffen von der begeisterten Gartenarchitektin Dominique Lafourcade, deren Ehemann Bruno Gebäude im Stil des 18. Jahrhunderts restauriert. 1990 kauften sie Les Confines, damals noch ohne Gartenanlage. Dominique Lafourcade schuf einen Garten im italienischen Stil, denn sie spürte genau, daß dieser gut mit dem azurblauen Himmel über Saint-Rémy harmoniert. Und erinnert die provenzalische Landschaft nicht tatsächlich oft an Italien? Sie legte einen Weg an, der im runden Garten mit seiner grünen, halbkreisförmigen Zypressenwand beginnt und sich durch den Rosengarten, unter der langen Pergola her bis zu einem Heckengarten zieht; hier mündet er in eine »calade«, einen Kiesweg, der am Lavendelfeld entlang und auf der anderen Seite des Kanals symmetrisch zurück bis zum Kräutergarten führt. Dahinter entdeckt man den Gemüse- und Obstgarten sowie links von der Hauptanlage den portugiesischen Garten und den Kugelgarten. Die Gartenanlage verändert sich ständig, da Dominique Lafourcade stets neue Ideen hat und darauf brennt, sie umzusetzen.

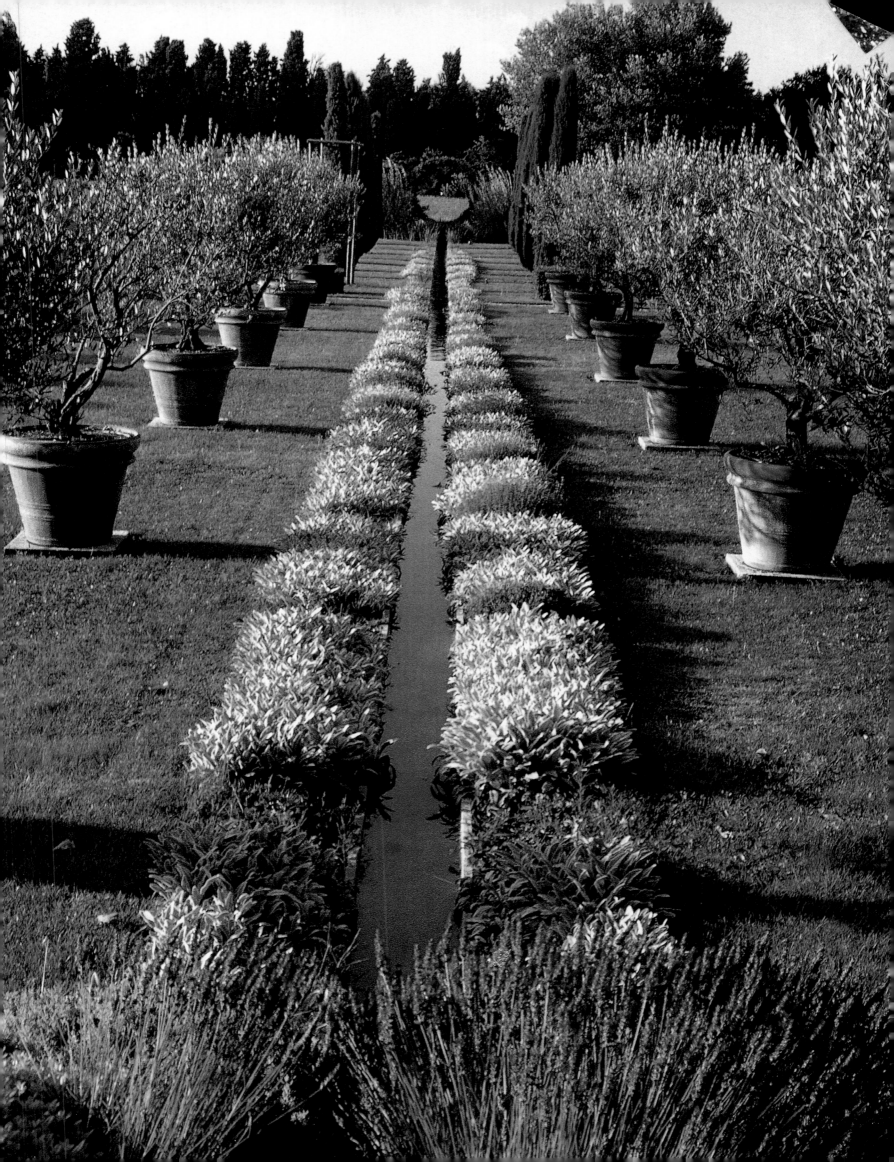

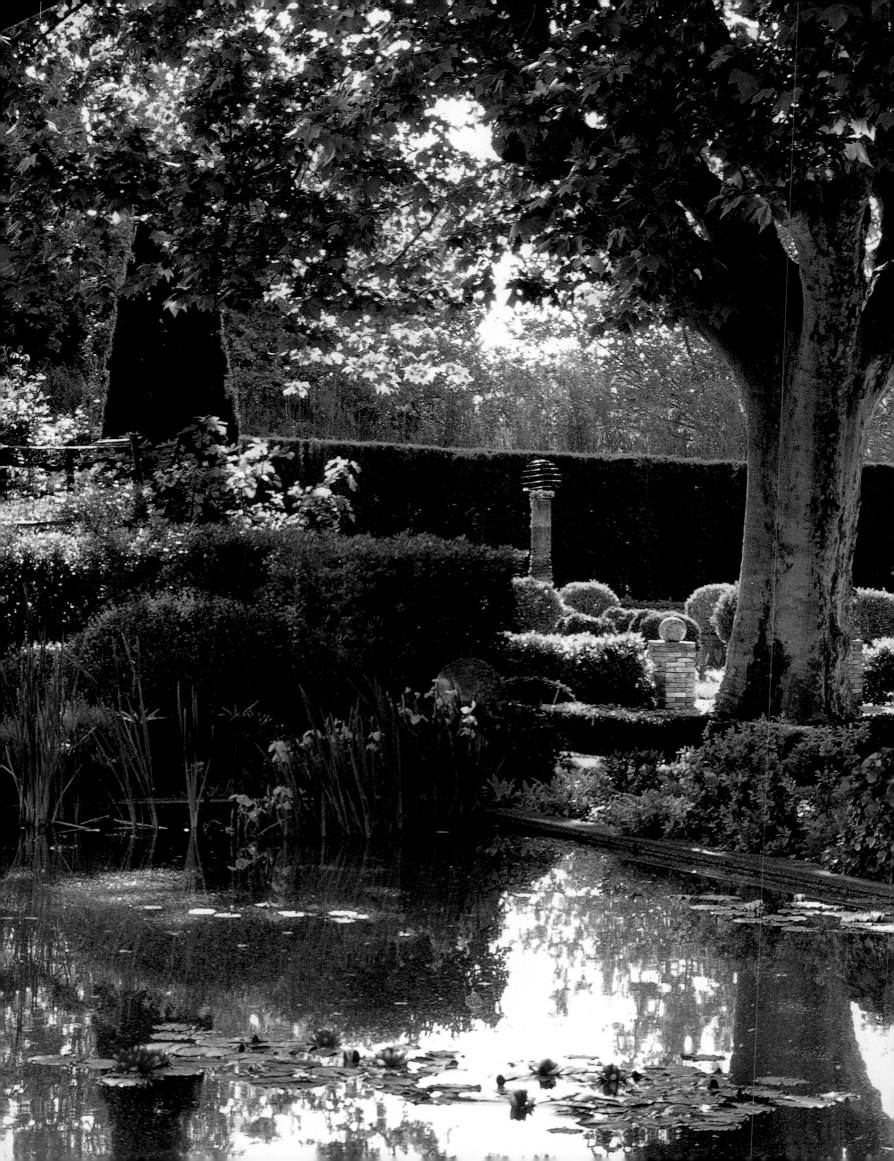

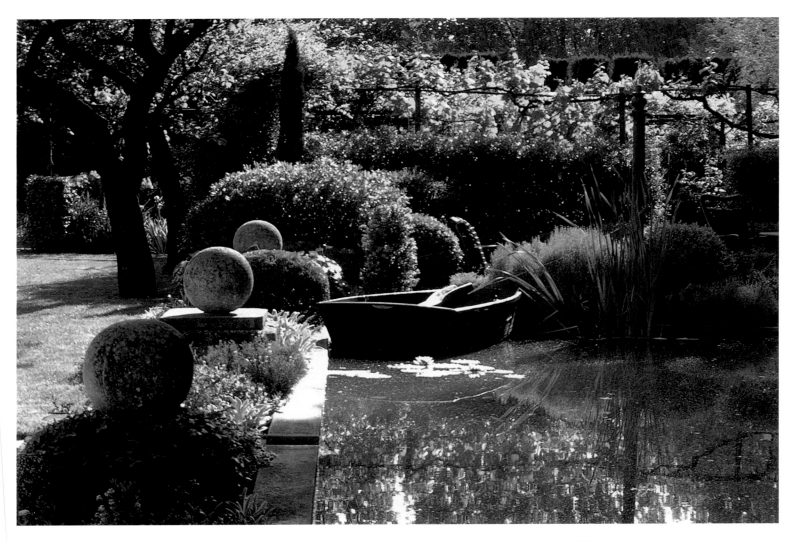

Double page précédente: vue de la maison sur l'axe principal du jardin. Dans les jardins qu'elle crée, Dominique Lafourcade imagine souvent un chemin d'eau car la présence de celle-ci est indispensable en Provence. Il est bordé d'oliviers cultivés en pots qui sont protégés de Noël à la fin du mois de février et il s'achève sur un cercle de lierre (détail en haut). Des plantes cultivées en pots habillent les terrasses devant la maison (détail en bas).
Page de gauche: Les terrasses sont ombrées de cinq platanes géants. Le bassin est situé au premier plan de la composition.
Ci-dessus: le bassin et la treille à l'arrière-plan.
A droite: vue sur le bassin, de l'autre côté.

Previous pages: view from the house on the main axis of the garden. A watercourse is commonly found in the gardens designed by Dominique Lafourcade, and in Provence it is indispensable. It is flanked by olive trees in pots, which are protected from the cold between Christmas and February. It ends in a circle of ivy (detail top). On the terraces in front of the house are cultivated plants in pots (detail bottom).
Facing page: The terraces receive the shade of five enormous plane trees. In the foreground, a view of the pool.
Above: the pool, and behind it, the trellis.
Right: the pool seen from the other side.

Vorhergehende Doppelseite: Blick vom Haus auf die Hauptachse des Gartens. In den Anlagen von Dominique Lafourcade gibt es häufig einen Kanal, denn solche Wasserläufe sind typisch für die Provence. Hier verläuft er zwischen Olivenbäumen in Kübeln, die von Weihnachten bis Ende Februar gegen Kälte geschützt werden, und endet mit einem Efeuring

(Detail oben). Die Terrasse zieren verschiedene Topfpflanzen (Detail unten).
Linke Seite: Die Terrassen werden von fünf riesigen Platanen beschattet. Der Teich im Vordergrund ist mit Wasserpflanzen besetzt.
Oben: der Teich, im Hintergrund die Weinlaube.
Unten: Blick von der anderen Seite her auf den Teich.

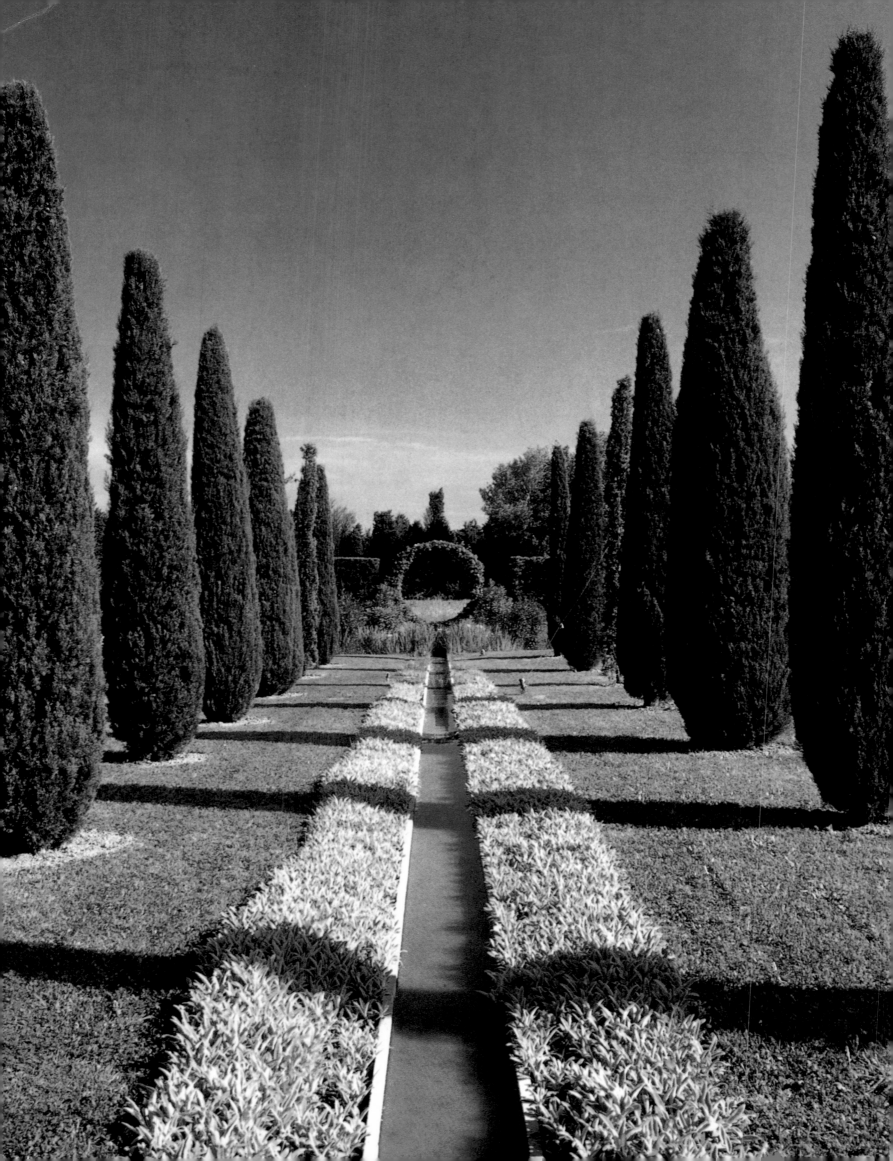

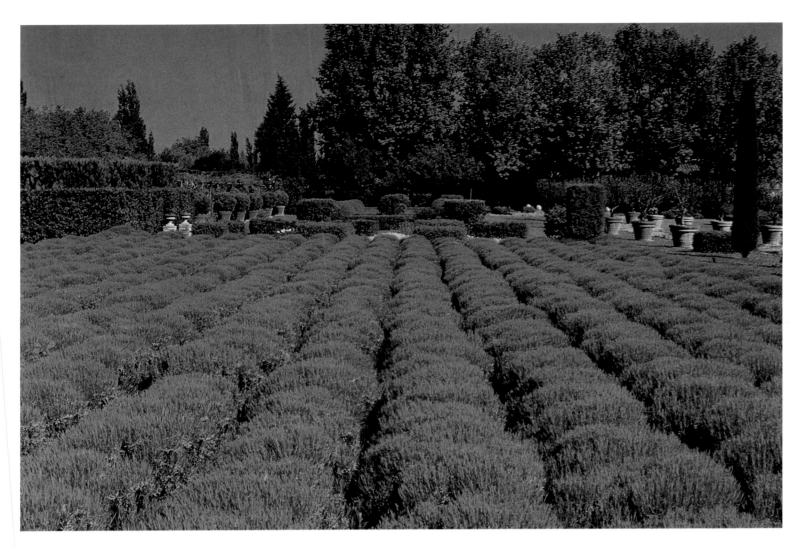

Page de gauche: Cette partie du grand axe est matérialisée par un chemin d'eau bordé de *Stachys byzantina* au feuillage gris et de cyprès. La perspective s'achève sur un cercle de fer garni de lierre *(Hedera),* tout en ouvrant sur un champ de luzerne.
Ci-dessus: l'un des champs de lavande. Leurs fleurs séchées embaument ensuite le linge de la maison.
A droite: Le chemin d'eau se jette dans une mare bordée d'osiers et d'iris des marais.

Facing page: This part of the main vista takes the form of a watercourse flanked by the grey leaves of lamb's ears *(Stachys byzantina)* and by cypresses. The vista ends at an iron hoop carrying a ring of ivy *(Hedera),* through which a field of lucerne is visible.
Above: one of the lavender fields. Their dried flowers are used to perfume the linen.
Right: The watercourse flows into a pond surrounded by willows and water flags.

Linke Seite: Diesen Teil der Hauptachse bildet eine Wasserrinne, deren Ränder von graublättrigem Wollziest *(Stachys byzantina)* und Zypressen gesäumt sind. Der Blick wird zu einem efeuüberwucherten Eisenring geleitet, hinter dem sich ein Luzernefeld erstreckt.
Oben: eines der Lavendelfelder. Die getrockneten Blüten verströmen ihren Duft in den Wäscheschränken des Hauses.
Rechts: Der Kanal mündet in einen Teich, dessen Ufer von Korbweiden und Sumpfschwertlilien gesäumt sind.

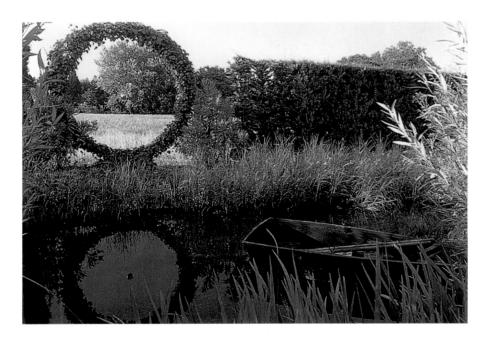

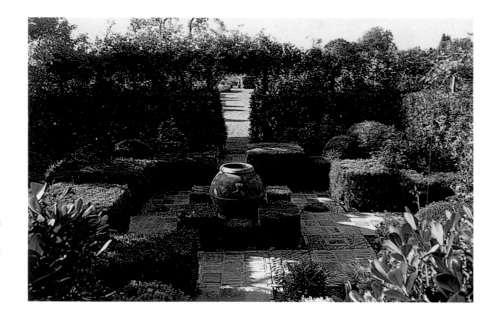

A droite: Le jardin de roses est structuré par des romarins taillés en cube et par quatre allées qui se coupent à angle droit en mettant en valeur, au centre, une vasque en terre cuite.
Ci-dessous: Cette treille crée une longue promenade ombreuse et gourmande où l'on peut grapiller des raisins. Elle dessert les chambres de verdure.

Right: The rose garden is structured by topiary – cube-shaped rosemary bushes – and by four avenues which meet at right angles, emphasising the centrality of the elegant terracotta jar.
Below: This trellis offers a deliciously shady walk with grapes within easy reach. It runs between the "green rooms".

Rechts: Der Rosengarten wird von viereckig beschnittenen Rosmarinbüschen begrenzt. Im rechten Winkel laufen hier vier Wege zusammen, im Kreuzungspunkt steht eine Terrakottavase.
Unten: Die Weinlaube ist wie eine langgestreckte, schattige Promenade gestaltet, die den Spaziergänger zudem mit saftigen Trauben lockt. Sie führt zu den Heckengärten.

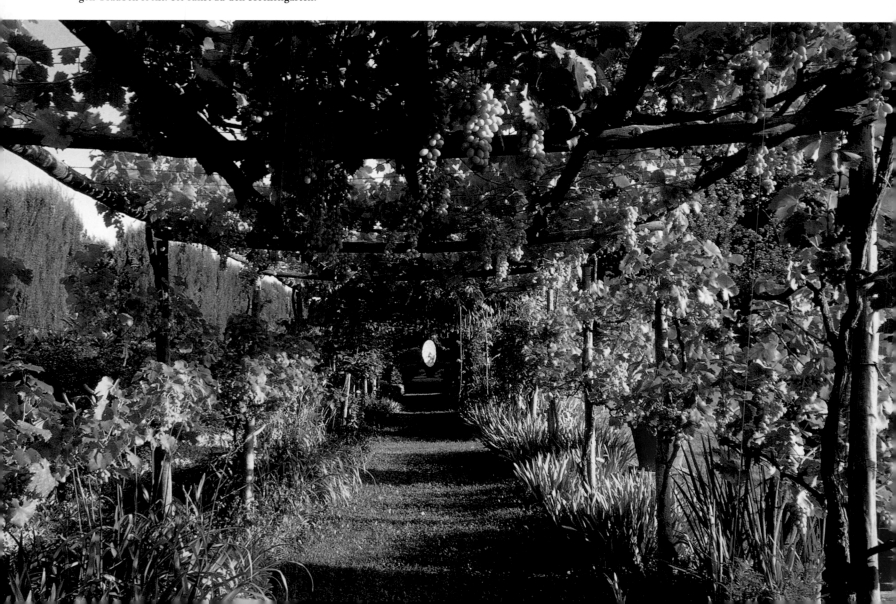

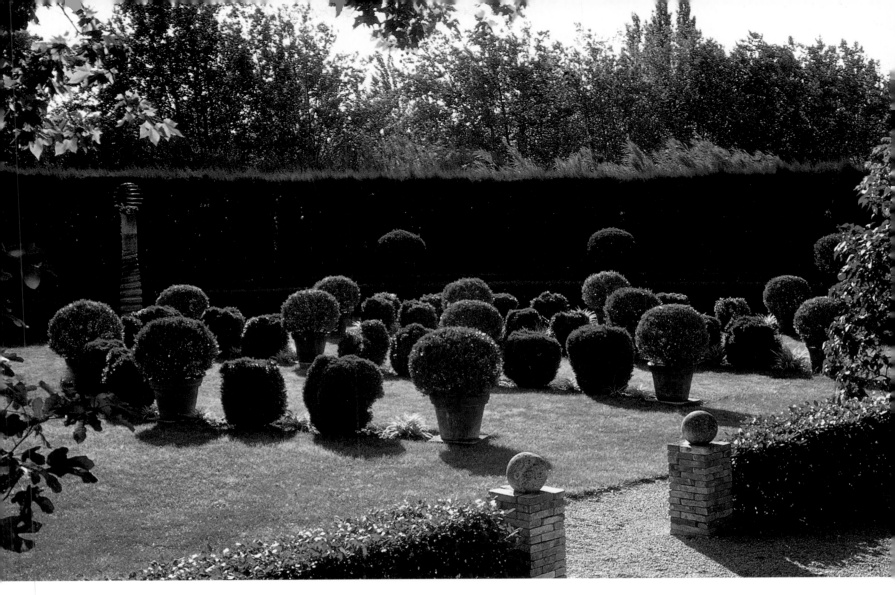

Ci-dessus: Le jardin rond, baptisé aussi le «jardin italien», est apprécié depuis les pièces de réception de la maison. Il est fermé par un mur de cyprès dessinant un demi-cercle et est planté de buis taillés en boule.

A droite: Les pièces de réception se prolongent par une pergola portée par des colonnades. Elles ouvrent sur le jardin italien.

Double page suivante: Deux champs de lavande se déploient de part et d'autre de l'axe des cyprès. Ils sont plantés de 1 700 pieds.

Above: The round topiary garden, also known as the "Italian garden", can be seen from the reception rooms of the house. It is enclosed by a wall of cypress forming a semicircle and planted with box clipped into spheres.

Right: The pergola carried by a colonnade forms an extension of the reception rooms; it looks out onto the Italian garden.

Following pages: Two lavender fields spread out on either side of the cypress promenade; there are 1,700 lavender plants.

Oben: Der runde oder italienische Garten ist von den Empfangsräumen des Hauses aus gesehen am schönsten. Er wird von einer halbkreisförmigen Zypressenwand begrenzt und ist mit kugelig beschnittenem Buchsbaum geschmückt.

Rechts: An die Empfangsräume schließt sich eine Pergola auf mächtigen Säulen an, durch die man in den italienischen Garten blickt.

Folgende Doppelseite: Zu beiden Seiten der Zypressenreihe breiten sich Lavendelfelder mit insgesamt etwa 1.700 Einzelpflanzen aus.

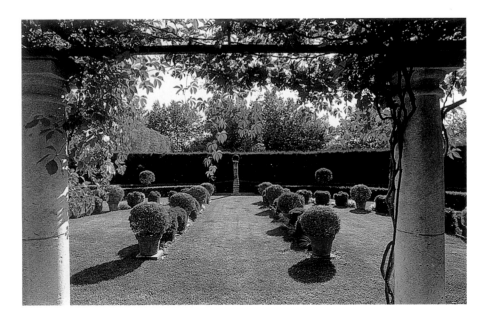

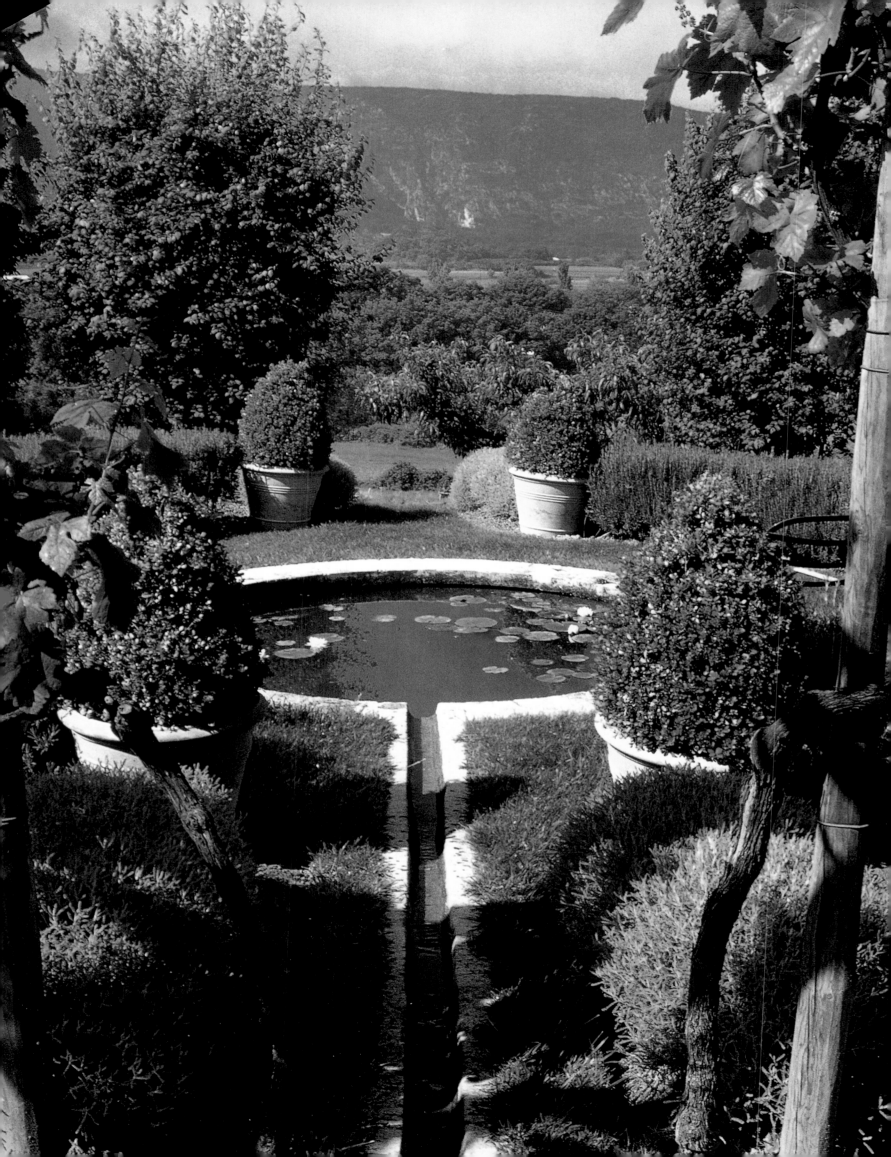

«Longo Maï» signifie en provençal «pourvu que cela dure». L'arrivée est très belle. Une route étroite bordée de murets de pierres gravit la colline. Le mas apparaît tout en haut, précédé d'un champ d'oliviers argentés qui semblent flotter dans l'air, mettant le décor en état d'apesanteur. Les couleurs sont douces, avec des dominantes de vert, de bleu et de gris. Le tracé du jardin fut dessiné par Dominique Lafourcade. L'éxécution des travaux fut menée à bien par Charly Imbert qui assure aussi le suivi de l'entretien. Tous deux savent répondre aux exigences des montagnes du Lubéron. Aussi le jardin s'intègre-t-il parfaitement bien au paysage environnant. Il a été aménagé sur les «restanques» (plantations en terrasses) qui existaient déjà et qu'il a fallu restaurer et relier par des escaliers. Elles étaient autrefois destinées à la culture des oliviers et des cerisiers. Aujourd'hui, elles forment trois jardins différents. La première est bleue. Une allée la parcourt avec souplesse et se faufile au milieu de plantes méditerranéennes aux feuillages verts ou gris donnant des fleurs bleues: romarins, *Caryopteris*, lavandes, céanothes. La seconde «restanque» est ornée d'une pergola où grimpent des treilles, d'un bassin circulaire et d'un jardin d'herbes agrémenté de buis. La troisième est plantée d'arbres fruitiers et de fleurs à couper. Ces jardins ont été conçus pour décrire une promenade qui passe dans un bosquet puis rejoint un champ d'oliviers avant de fermer sa boucle dans la cour du mas où trône un gigantesque figuier.

Longo Maï

In Provençal, "Longo Maï" means "may it last". The approach is magnificent. The garden is reached via a long narrow uphill road bordered with low stone walls. The "mas" appears at the top of the hill, preceded by a field of silvery olive trees whose drifting foliage imparts a certain weightlessness. The colours are subdued, with green, blue and grey prevailing. The design of the garden was the work of Dominique Lafourcade. It was implemented by Charly Imbert, who ensures that the garden is maintained as it was planned. Both of them have taken care to adapt their requirements to the conditions of the Lubéron mountains, and the garden is consequently at one with the landscape around it. It was built on the existing "restanques", Provençal terraced gardens, which had to be restored and linked with staircases; they had previously been used for olive and cherry plantations. Today, they form three different gardens. The first is blue. A path leads through it, sinuously moving through the Mediterranean flora of grey or green foliage and blue flowers: rosemary, bluebeard *(Caryopteris)*, lavenders, and *Ceanothus*. The second "restanque" is ornamented with a pergola on which vines clamber; there is a circular pool and a herb garden framed with box. The third terrace is planted with fruit trees and flowers for cutting. These gardens were designed to create a promenade that passes through a grove, then enters a field of olive trees before returning to the courtyard in which a huge fig tree reigns supreme.

Der provenzalische Begriff »Longo Maï« bedeutet »vorausgesetzt, es dauert an«. Schon die Anfahrt ist wunderschön: Eine schmale Straße führt zwischen Steinmäuerchen den Hang hinauf. Das »mas« erscheint ganz oben hinter einem silbrig schimmernden Olivenhain, der in der Luft zu schweben scheint, so daß die ganze Szenerie Schwerelosigkeit ausstrahlt. Die Farben sind sanft, es überwiegen Grün, Blau und Grau. Die Gartenanlage entwarf Dominique Lafourcade, die Arbeiten selbst wurden von Charly Imbert ausgeführt, der sich auch um die Pflege kümmert. Beide kennen die Vegetation des Lubéron-Gebirges sehr genau, deshalb fügt sich der Garten perfekt in die umliegende Landschaft ein. Die einzelnen Teile des Gartens sind auf den »restanques« angelegt, den typisch provenzalischen Terrassenfeldern, die schon vorhanden waren, jedoch instand gesetzt und mit Treppen verbunden werden mußten. Früher baute man darauf Oliven und Kirschen an, heute bilden sie drei eigenständige Gärten. Der erste ist der blaue Garten. Ein schmaler Pfad schlängelt sich zwischen grün oder grau belaubten, blau blühenden, mediterranen Gewächsen hindurch: Rosmarin, Bartblumen *(Caryopteris)*, Lavendel und Säckelblumen *(Ceanothus)*. Die zweite »restanque« ist mit einer weinüberrankten Pergola, einem runden Wasserbecken und einem von Buchsbaumhecken eingefaßten Kräutergarten versehen. Der dritte Garten ist mit Obstbäumen und Schnittblumen bepflanzt. Die drei Gartenteile wurden bewußt als Promenade angelegt, die durch ein Boskett hindurch zu einem Olivenhain führt, bis sich schließlich im Hof des Landhauses an einem riesigen Feigenbaum der Kreis schließt.

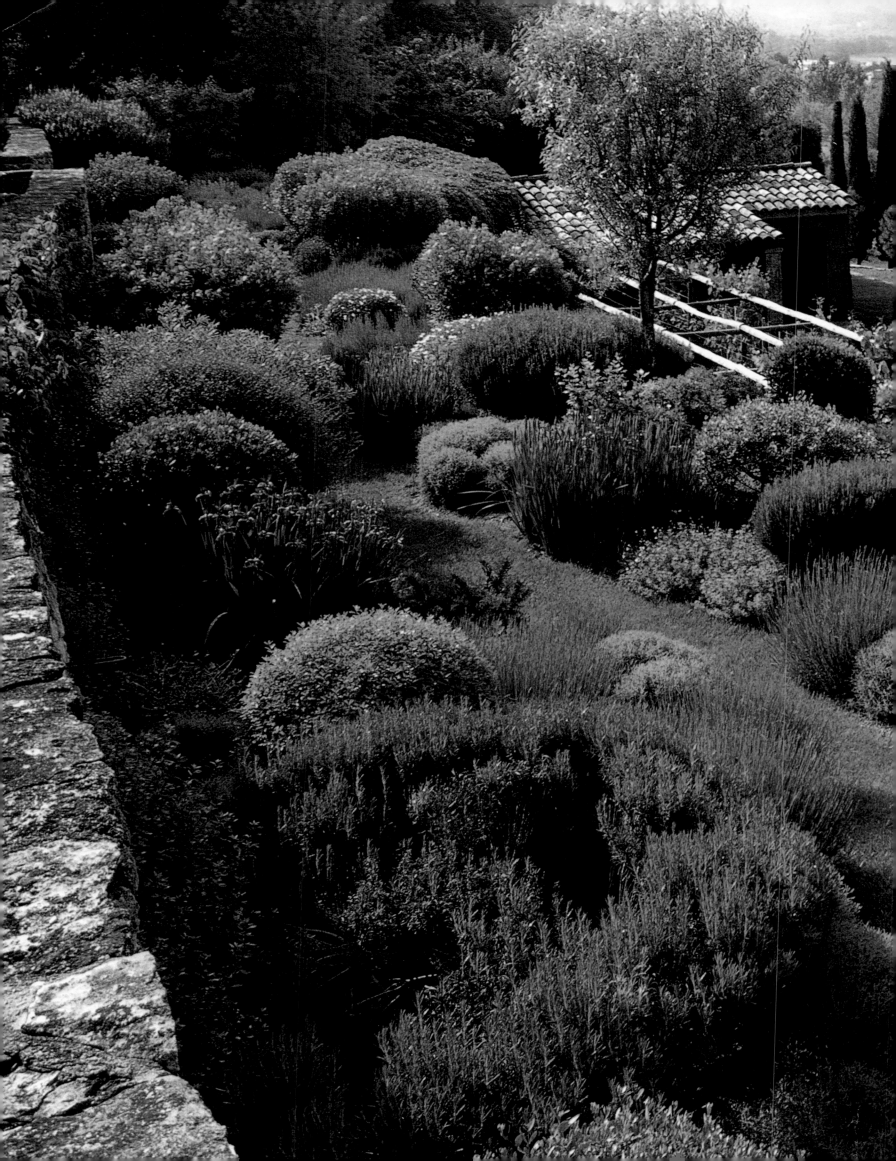

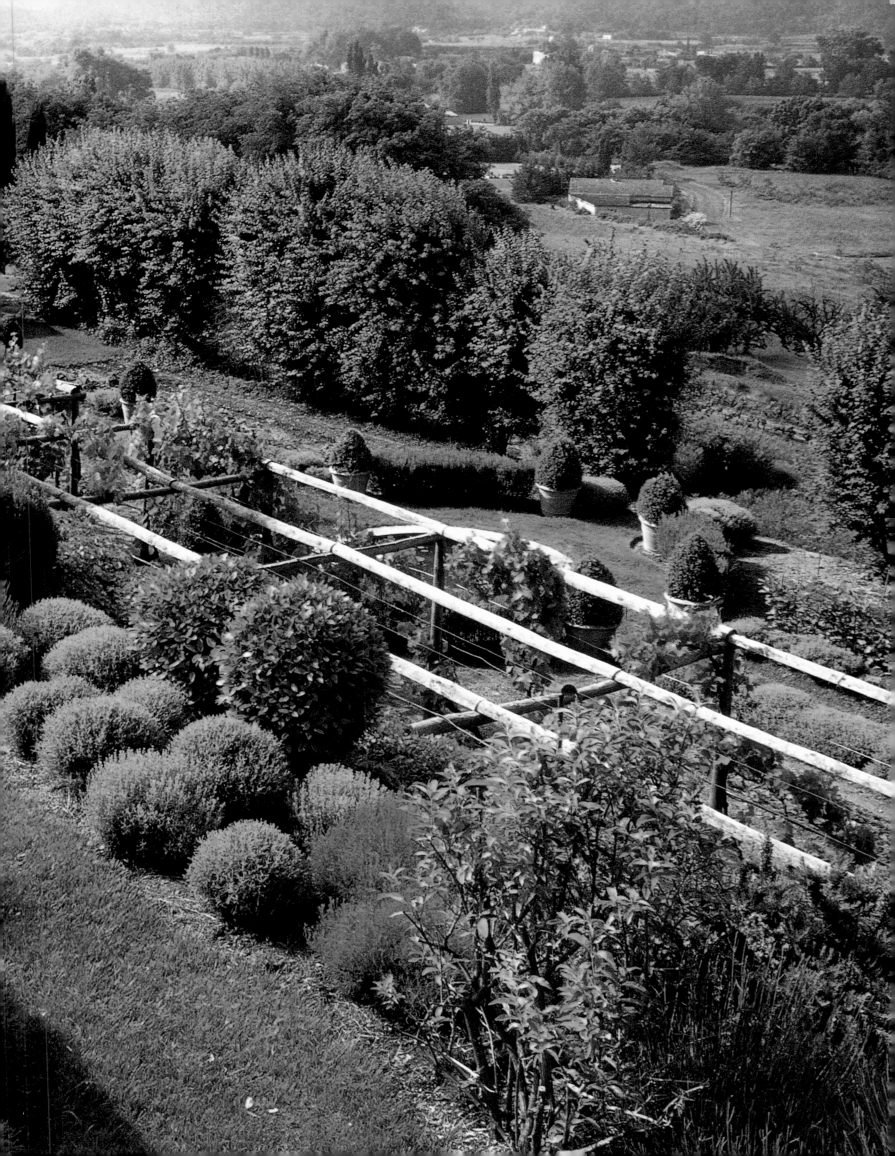

Première page: le bassin de la deuxième «restanque». Une rigole le relie à la pergola. Les buis sont encapuchonnés en hiver car le climat du Lubéron a des saisons bien marquées.
Double page précédente: le jardin bleu de la première «restanque» avec ses plantes à feuillages gris. En dessous, on devine la pergola et le bassin de la deuxième «restanque».
Ci-dessus et page de droite: un champ d'oliviers est tapissé d'une prairie fleurie de *Coreopsis,* d'*Eschscholzia,* de *Rudbeckia hirta,* de coquelicots ou de gaillardes.
A droite: une cage à poussins ancienne.
Double page suivante: Un escalier monte le long de la maison et domine un champ d'oliviers récemment transplantés.

First page: the circular pond of the second "restanque". A little channel links it to the pergola. The boxes have to be covered during the sharp Lubéron winter.
Previous pages: the blue garden of the first "restanque" with its grey foliage. Below we can make out the pergola and the pond of the second "restanque".
Above and facing page: a field of olive trees. The long grass is full of flowers: tickseed *(Coreopsis),* California poppy *(Eschscholzia),* black-eyed susan *(Rudbeckia hirta),* corn poppy *(Papaver rhoeas)* and *Gaillardia.*
Right: an old cage for chickens.
Following pages: The staircaise alongside the house stands over a field of recently transplanted olive trees.

Eingangsseite: das Wasserbecken der zweiten »restanque«. Eine schmale Wasserrinne verläuft von hier bis zur Pergola. Die Buchsbäume werden im Winter warm eingepackt, denn im Lubéron sind die Jahreszeiten recht ausgeprägt.

Vorhergehende Doppelseite: der blaue Garten und die erste »restanque«. Etwas tiefer liegt die zweite Terrasse mit der Pergola und dem Wasserbecken.
Oben und rechte Seite: Die Olivenbäume stehen auf einer Wiese aus Mädchenauge *(Coreopsis),* Goldmohn *(Eschscholzia),* Sonnenhut *(Rudbeckia hirta),* Klatschmohn *(Papaver rhoeas)* und Kokardenblumen *(Gaillardia).*
Unten: ein alter Kükenkäfig.
Folgende Doppelseite: Am Haus entlang steigt eine Treppe hinauf zu einem Hain aus kürzlich versetzten Olivenbäumen.

Longo Maï *Provence*

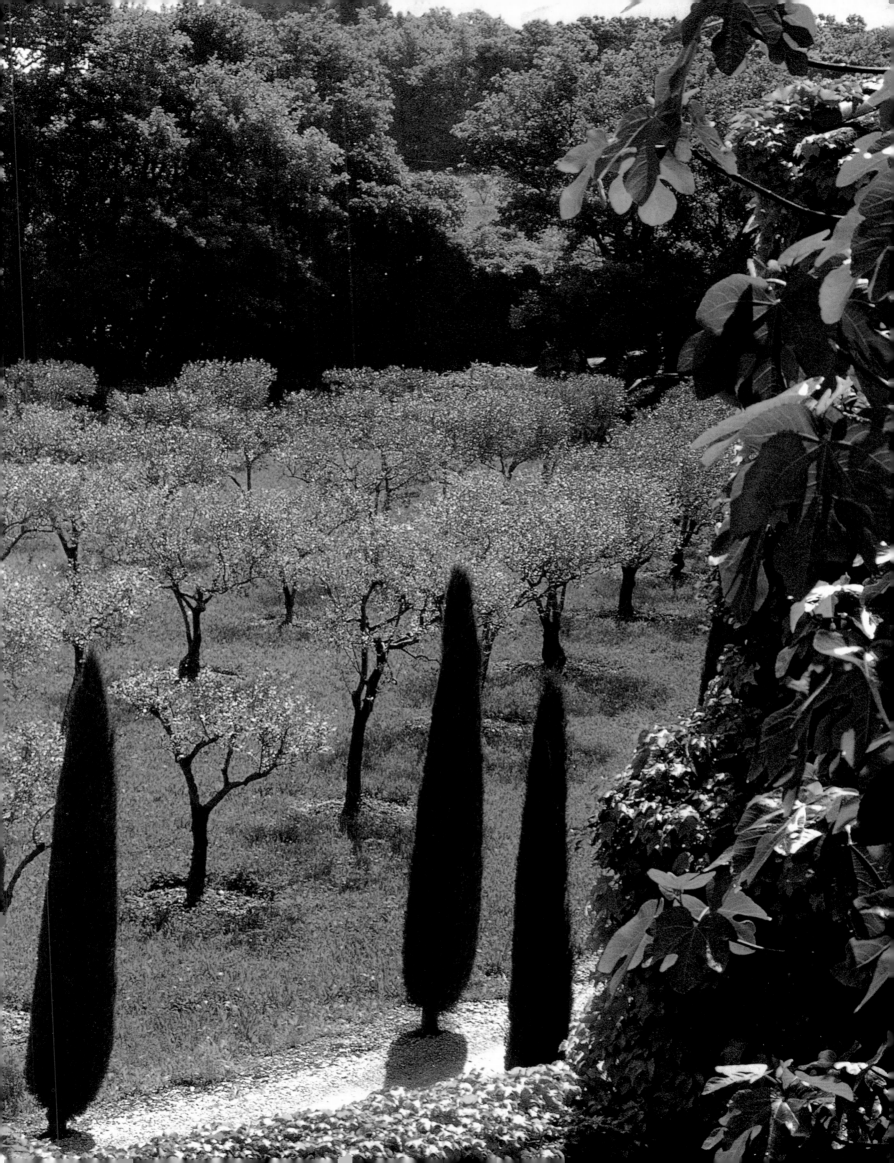

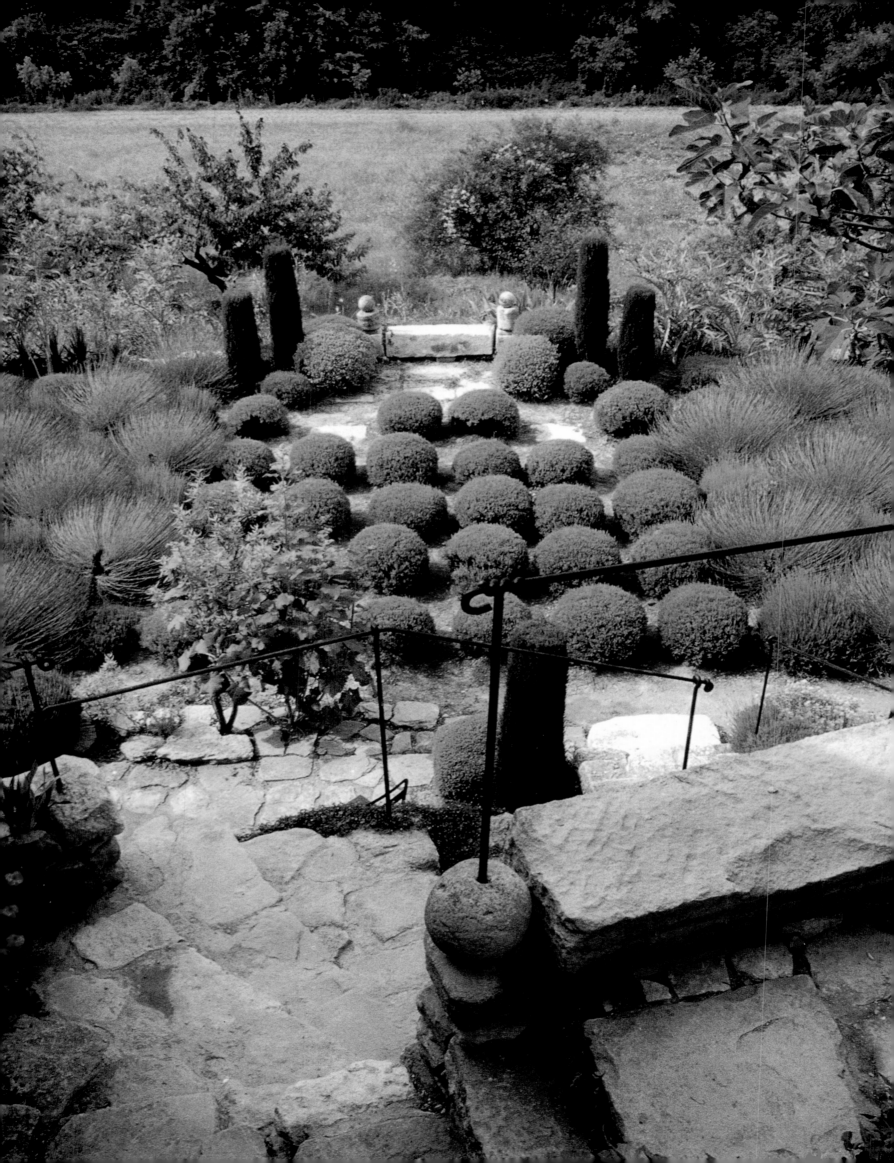

Bonnieux est un village provençal très pittoresque. Ses maisons ocre doux, presque sable, s'empilent les unes sur les autres à flanc de colline comme si la flèche de l'église allait toucher le ciel. Nicole de Vesian construisit son jardin tout en bas, là où les dernières «restanques» rejoignent la vallée. Malheureusement, elle nous quitta l'an passé. Elle avait un sens inné des plantes, de leur mode de vie, de la façon de les tailler ou de les associer, et elle avait un goût sûr pour jouer avec les couleurs qu'elle aimait douces. Puisant son inspiration dans les essences végétales qui poussent dans la garrigue alentour, elle avait fondu son jardin dans le paysage provençal comme si elle avait voulu faire entrer la colline d'en face dans le décor imaginé avec un goût très personnel. Les «restanques» s'étagent en bandes étroites et longues devant la maison. Elles mélangent plantes et pierres, les formes végétales se confondant presque avec les formes minérales. Nicole de Vesian pratiquait l'art de la taille avec maestria jusqu'à former des coussins denses et statiques qu'elle juxtaposait comme de gros galets. Quelles étaient ses couleurs préférées? Les gris et les verts. Ses plantes favorites? Les lavandes et les thyms, les sauges, les santolines et les romarins. Ses fleurs? Son jardin n'est pas un jardin de fleurs. Des plantes à feuillage persistant tapissent le décor toute l'année durant. Seules quelques floraisons discrètes suggèrent le passage des saisons.

Le jardin de Nicole de Vesian

Bonnieux is a very picturesque village in Provence. The houses, made of an ochre stone as pale as sand, are tumbled one on top of another along the flank of a hill, stretching up to the culminating point of the village, the church spire. Nicole de Vesian, who is sadly no longer with us, has made her garden at the base of the hill, where the last "restanques" give way to the valley. She had an innate feeling for plants; she knew what they needed, how they should be pruned, and had a sure touch with colour, which she preferred to be soft and unobtrusive. She had taken her inspiration from the "garrigue" that surrounds Bonnieux, and had merged her garden with the Provençal landscape as if she had sought to bring the facing hillside into the ambit of her own very personal creation. The "restanques" form long narrow terraces sweeping down from the house. Nicole de Vesian mixed plant and stone so that plant outlines meld with the mineral. She was a master of the art of clipping and created dense, spreading shapes which she juxtaposed like large round pebbles. Her favourite colours were greys and greens, and her favourite plants were varieties of lavender, thyme, sage, cotton-lavender (*Santolina*) and rosemary. Hers is not a flower garden. Evergreen and succulent, her plants constitute a year-round decor amid which the occasional blossom indicates the passing of the seasons.

Bonnieux ist ein ausgesprochen malerisches Städtchen in der Provence. Die hell ocker, fast strohgelben Häuser türmen sich an der Flanke eines Hügels übereinander, so daß es scheint, als ob der schlanke Kirchturm den Himmel berühre. Nicole de Vesian legte ihren Garten am Fuße der Erhebung an, dort, wo die letzten »restanques«, die langgestreckten provenzalischen Terrassenfelder, bis ans Dorf reichen. Leider ist Nicole de Vesian inzwischen verstorben. Sie besaß einen angeborenen Sinn für Pflanzen, ihre Lebensweise und die Art, wie man sie schneidet oder kombiniert. Überdies hatte sie einen treffsicheren Geschmack, so daß sie mühelos mit Farben spielen konnte, vorzugsweise mit Pastelltönen. Sie verwob ihren Garten nahtlos mit der umliegenden provenzalischen Landschaft und der trockenen »garrigue«, als wollte sie den Hügel in ihre phantasievolle, sehr persönliche Gestaltung mit einbeziehen. Die »restanques« bilden schmale, lange Terrassenbeete vor dem Haus. Hier gesellen sich Pflanzen zu Steinen, und die Grenzen zwischen vegetativen und mineralischen Strukturen scheinen zu verschwimmen. Nicole de Vesian beherrschte meisterhaft die Kunst des Formschnitts. Es gelang ihr, dichte, unbewegliche Kissen zu bilden, die wie dicke Kieselsteine nebeneinanderliegen. Ihre Lieblingsfarben? Grau und Grün. Ihre Lieblingsgewächse? Lavendel und Thymian, Salbei, Heiligenkraut und Rosmarin. Und Blumen? Ihr Garten ist kein Blumenbeet. Die immergrünen Blattpflanzen breiten das ganze Jahr über ihren dekorativen Teppich aus. Nur wenige, kaum ins Auge fallende Blüten deutet den Wechsel der Jahreszeiten an.

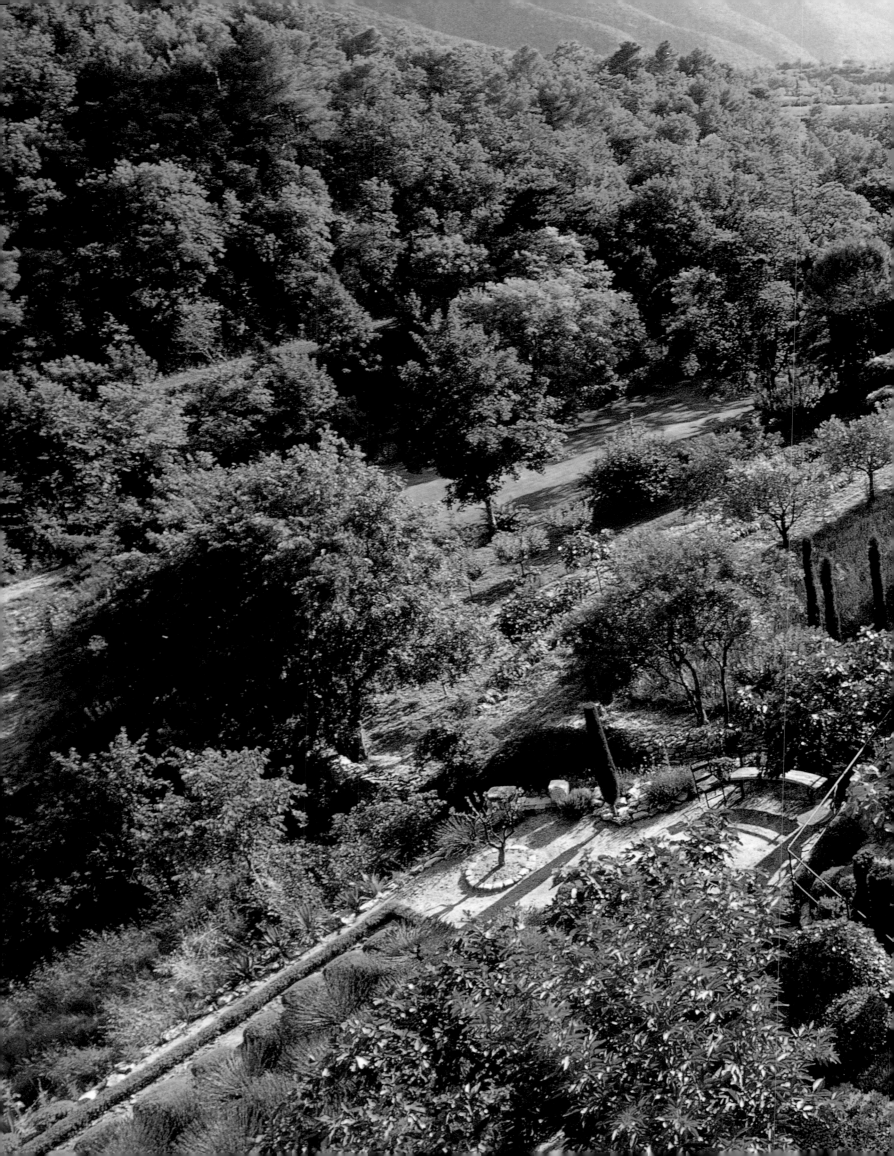

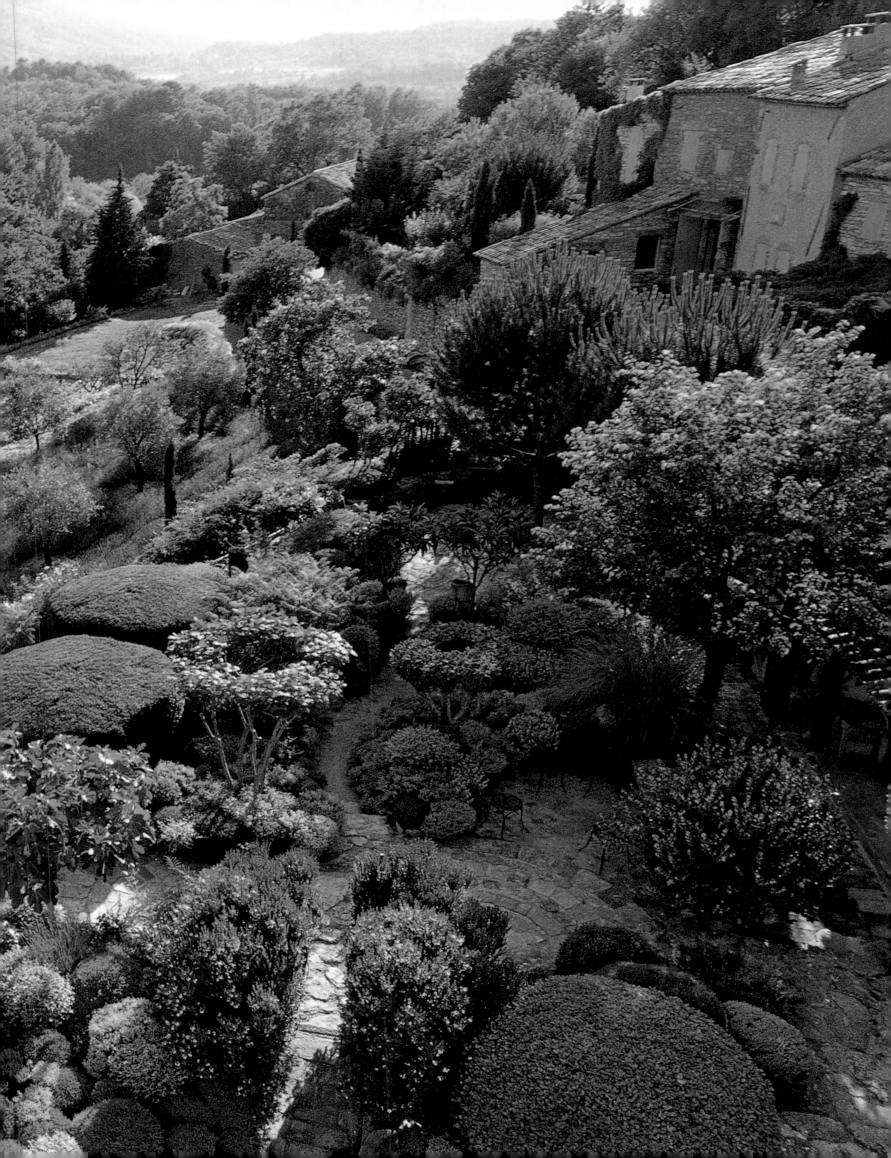

Premières pages: Sur l'une des terrasses rejoignant la vallée, Nicole de Vesian a joué avec les pierres, les formes taillées arrondies ou élevées. Des ornements en pierre s'intègrent parfaitement dans le décor végétal (détails).
Double page précédente: Le jardin de Nicole de Vesian se fond dans le paysage de collines du Lubéron grâce à ses formes arrondies, ses plantes de garrigue et ses harmonies de couleurs.
A droite: De vieilles auges ont été transformées en fontaine ou en bassin.
Ci-dessous: La présence minérale de la maison se prolonge dans le jardin par des pierres, des escaliers, des murets, des dallages, des assemblages de galets ou du gravier.

First pages: On one of the terraces adjoining the valley, Nicole de Vesian had juxtaposed upright and spreading plants, the topiary contrasting with the carved stone. Stone ornaments are integral to this garden (details).
Previous pages: Nicole de Vesian's garden, with its predominantly round shapes, native plants and harmonious colours, merges easily into the landscape of the Lubéron hills.
Right: Old stone troughs have become fountains or water tanks.
Below: The sculptured stone profile of the house is echoed in the garden by stone staircases, low walls, paving, and compositions of pebbles or gravel.

Eingangsseiten: Auf einer der Terrassen, die sich bis ins Tal hinab erstrecken, kombinierte Nicole de Vesian phantasievoll Steine mit runden oder säulenartigen Schnittformen. Steingruppen ergänzen harmonisch die aus Pflanzen gebildeten Schmuckformen (Details).
Vorhergehende Doppelseite: Der Garten von Nicole de Vesian verschmilzt mit der Landschaft auf den Hügeln des Lubéron dank seiner abgerundeten Formen, der heimischen Gewächse und harmonischen Farben.
Rechts: Alte Futtertröge wurden zu Springbrunnen oder kleinen Teichen.
Unten: Nicht nur das Hauses ist aus Stein, auch im Garten ist Stein gegenwärtig, sei es bei den Treppen, Mäuerchen, der Pflasterung oder den Mustern aus Kieseln oder Kies.

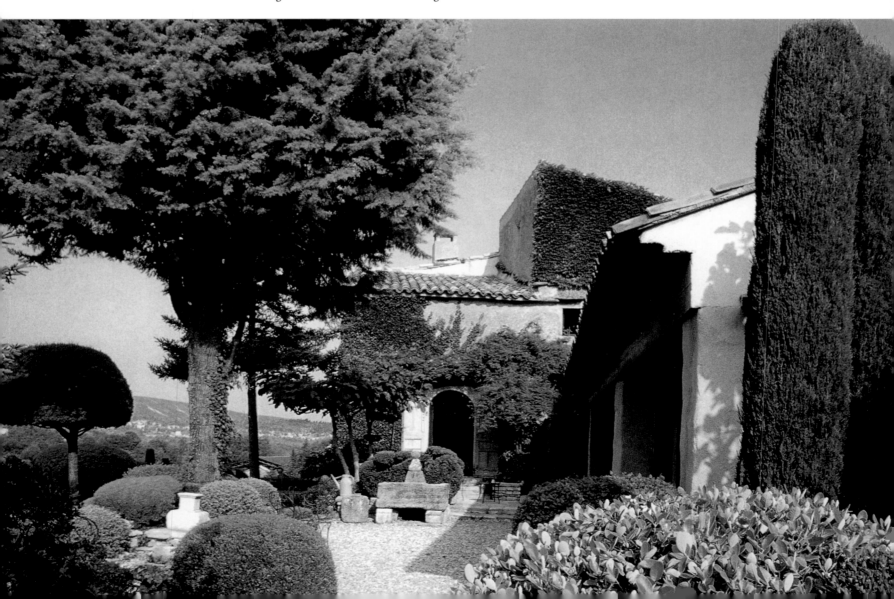

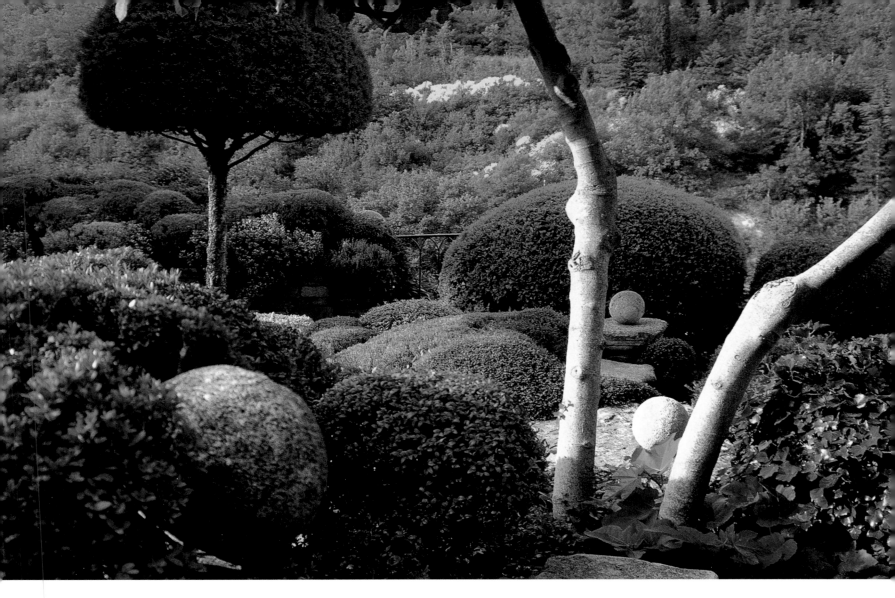

Ci-dessus: Le jardin dans son ensemble témoigne d'exercices de taille raffinés. Les troncs des arbres et des arbustes sont également très travaillés.
A droite: Un salon de verdure permet de profiter des parfums du jardin.
Double page suivante: Le jardin est un lieu de repos où l'on peut savourer l'ombre bienfaisante des arbres. Les végétaux taillés supportent très bien la sécheresse du Lubéron et peuvent vivre longtemps sur leurs réserves.

Above: Throughout the garden, plants have been clipped into harmonious compositions; the trunks of trees and shrubs naturally bear their part in this.
Right: A "green room" receives the balmy air rising from the garden.
Following pages: The garden is a place of repose in which to savour the luxury of shade. The clipped shrubs are ideally suited to the dry Lubéron climate and can survive for long periods without rain.

Oben: Überall im Garten sind meisterhaft geschnittene Pflanzen zu finden. Auch die Stämme von Bäumen und Sträuchern sind kunstvoll bearbeitet.
Rechts: Ein Freisitz bietet Gelegenheit, sich am duftenden Garten zu erfreuen.
Folgende Doppelseite: Der Garten ist ein Ort der Beschaulichkeit, an dem man den wohltuenden Schatten der Bäume genießen kann. Die beschnittenen Gewächse ertragen die Trockenheit des Lubéron ausgezeichnet und kommen lange Zeit ohne Wasser aus.

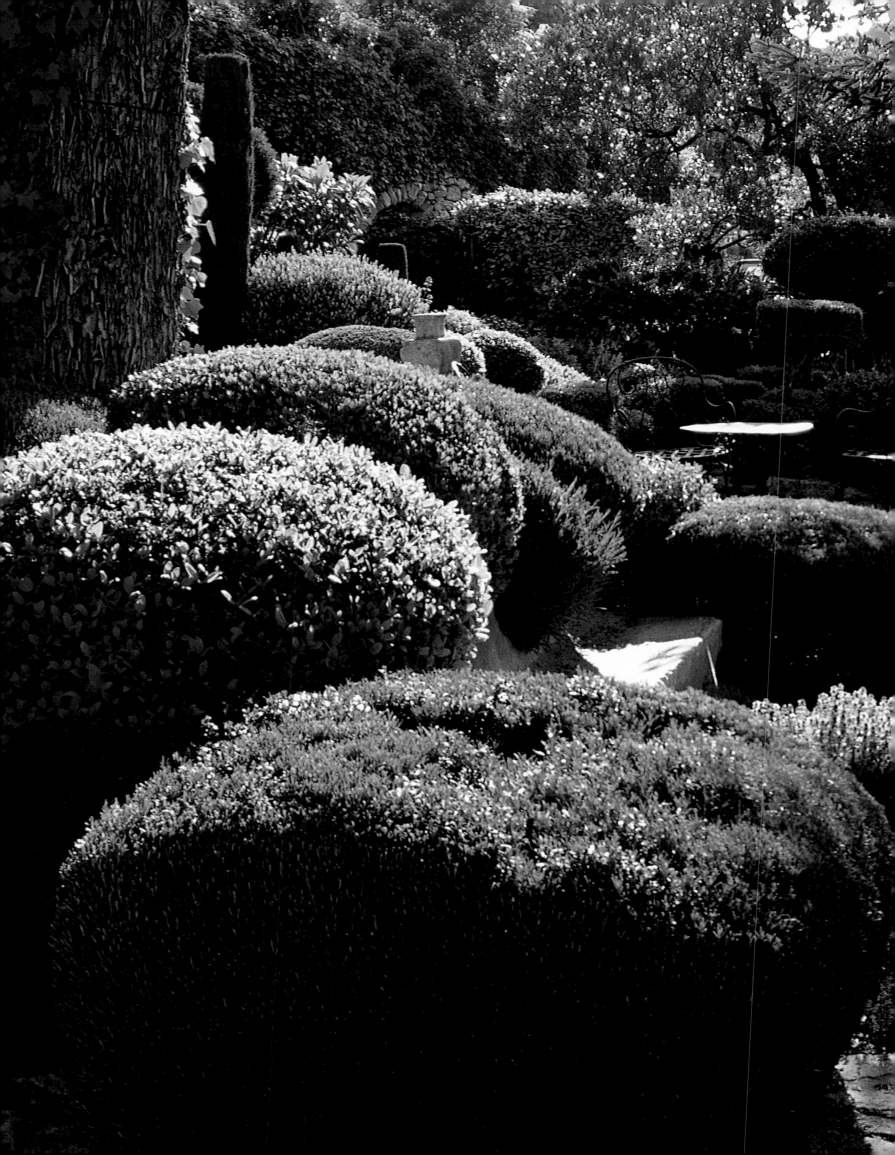

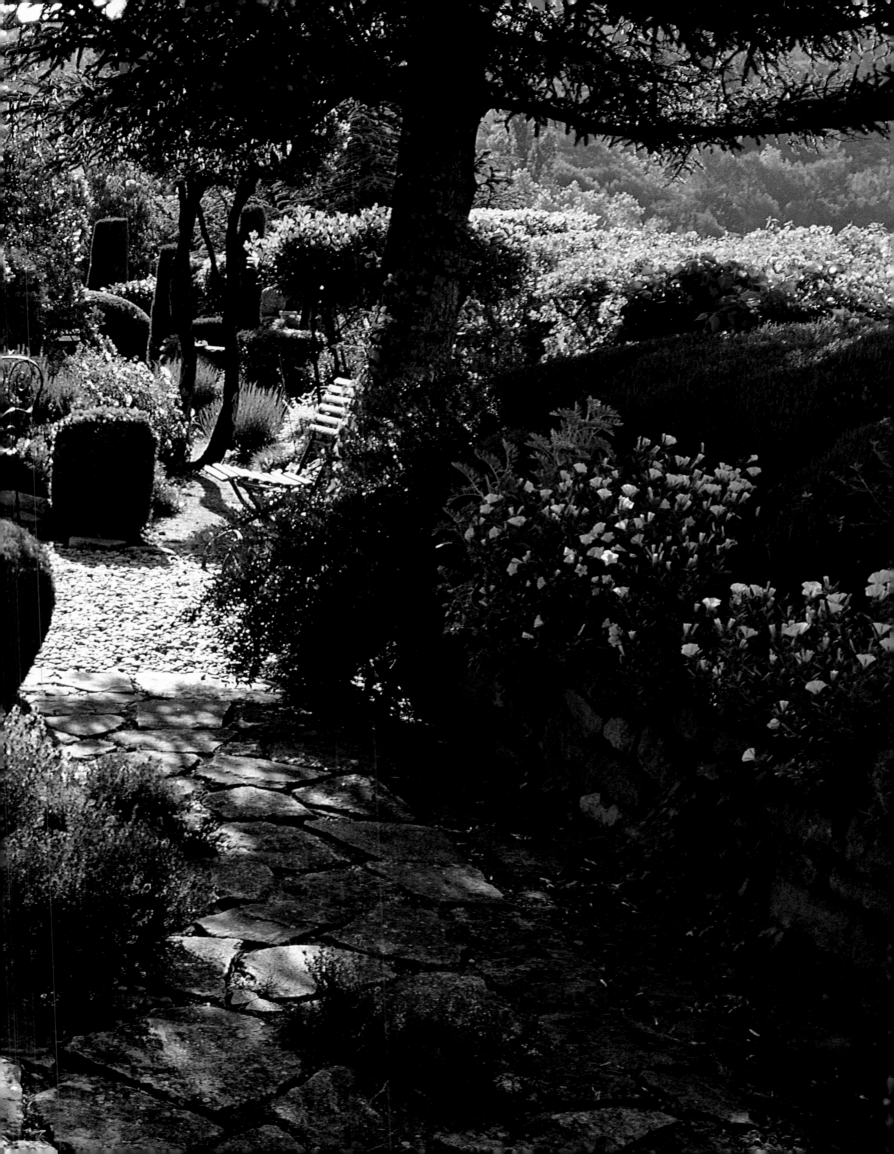

Lorsqu'elle s'est installée sur le domaine en 1978, Cécile Chancel s'est interrogée: quel jardin aurait conçu la châtelaine au 17e siècle? Peut-être un potager. Mais comment aurait-elle tiré parti du dénivelé? Sans doute aurait-elle choisi de construire des terrasses pour donner à la composition une architecture belle en toute saison. Avec un enthousiasme débordant, Cécile Chancel s'attela à la tâche, fit des mouvements de terrain, construisit des murets, visita des jardins, suivit des cours de jardinage, étudia le cycle des rotations, découvrit la botanique, les roses, les plantes vivaces, les plantes potagères, aromatiques et tinctoriales, apprit à composer avec le climat du Lubéron puis un jour, à court d'idée, fit appel au paysagiste Tobie Loup de Viane. Il en résulte un jardin gai: fleuri, gourmand, prolixe. La première terrasse mêle fleurs et légumes comme dans un potager à l'ancienne ordonné en planches. La deuxième terrasse est entièrement consacrée aux fleurs, notamment aux roses. La troisième est plantée d'arbustes d'ornements et d'arbres fruitiers. Une longue pergola habillée de bignones *(Campsis)* et de rosiers longe ces trois jardins, et plus loin, une belle allée dessinée par Louis Benech associe cyprès et oliviers. Si Val Joanis est aujourd'hui un jardin de tradition, il se pourrait qu'il change de direction car Cécile Chancel est sans cesse à l'affût d'idées nouvelles.

Val Joanis

When she moved to the estate in 1978, Cécile Chancel asked herself what kind of garden the mistress of the chateau had designed in the 17th century. Probably a kitchen garden; but then how would she have dealt with the steep incline of the land? Answer: she would have constructed terraces to ensure that the outline of the garden was a handsome one, whatever the season. Full of enthusiasm, Cécile Chancel set about realising this dream; she undertook earthworks, built low walls, visited other gardens, took gardening courses, studied the cycle of rotations, took to botany, discovered roses and perennials, taught herself the different uses of the food, aromatic and dye plants, learnt to accommodate the Lubéron climate, and finally, when she ran short of ideas, called in the landscape gardener Tobie Loup de Viane. The result is a delightful garden, full of flowers, comfort and ease. The first terrace mixes flowers and vegetables like an old-fashioned kitchen garden set out in straight beds. The second terrace is entirely given over to flowers, in particular roses. The third is planted with ornamental shrubs and fruit trees. A long pergola submerged in trumpet creeper *(Campsis)* and roses runs the length of these three gardens, and further on there is a fine avenue of cypresses and olives designed by Louis Benech. For the time being Val Joanis is a traditional garden, but this may not last: Cécile Chancel is always on the look out for new ideas.

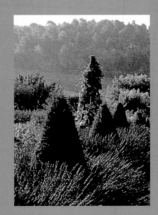

Als sich Cécile Chancel 1978 auf dem Anwesen niederließ, fragte sie sich: Was für einen Garten hätte eine Schloßherrin im 17. Jahrhundert wohl angelegt? Vielleicht einen Gemüsegarten. Aber wie hätte sie die Hanglage genutzt? Zweifellos hätte sie sich für Terrassen entschieden, um der Anlage eine zu allen Jahreszeiten gefällige architektonische Grundlage zu geben. Mit glühender Begeisterung machte sich Cécile Chancel ans Werk, ließ hier Erde anschütten, dort abtragen, Mäuerchen errichten und Terrassen anlegen. Sie besichtigte andere Gärten, besuchte Gärtnerlehrgänge, studierte Fragen der Kulturfolge, beschäftigte sich mit Botanik, Rosen, Stauden, Gemüsepflanzen, Duft- und Färbepflanzen, sie lernte das Klima des Lubéron-Gebirges kennen und wandte sich schließlich wegen der Gestaltung kurz entschlossen an den Gartenarchitekten Tobie Loup de Viane. Das Ergebnis ist ein fröhlicher Garten mit vielen Blumen, ein köstlicher, üppiger Garten. Die erste Terrasse weist ein Gemisch von Blumen und Gemüsen auf, die wie früher in langgestreckten Beeten angeordnet sind. Die zweite Terrasse ist vollkommen den Blumen, vor allem den Rosen gewidmet, die dritte dagegen mit Ziersträuchern und Obstbäumen bepflanzt. Eine lange, von Trompetenblumen *(Campsis)* und Kletterrosen überwucherte Pergola zieht sich an den drei Gärten entlang, an die sich eine von Louis Benech entworfene Allee aus Zypressen und Olivenbäumen anschließt. Val Joanis ist heute ein traditioneller Garten, doch das könnte sich rasch ändern, denn Cécile Chancel sind noch lange nicht die Ideen ausgegangen.

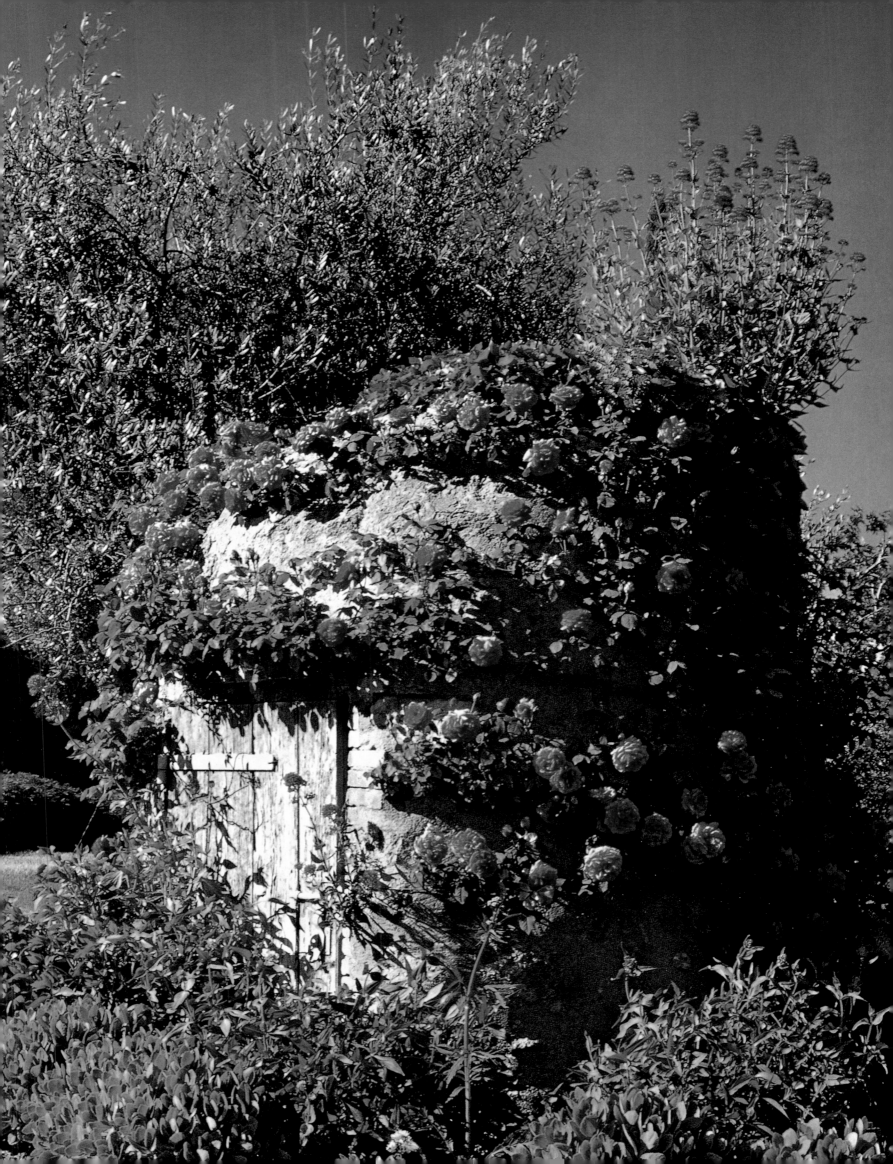

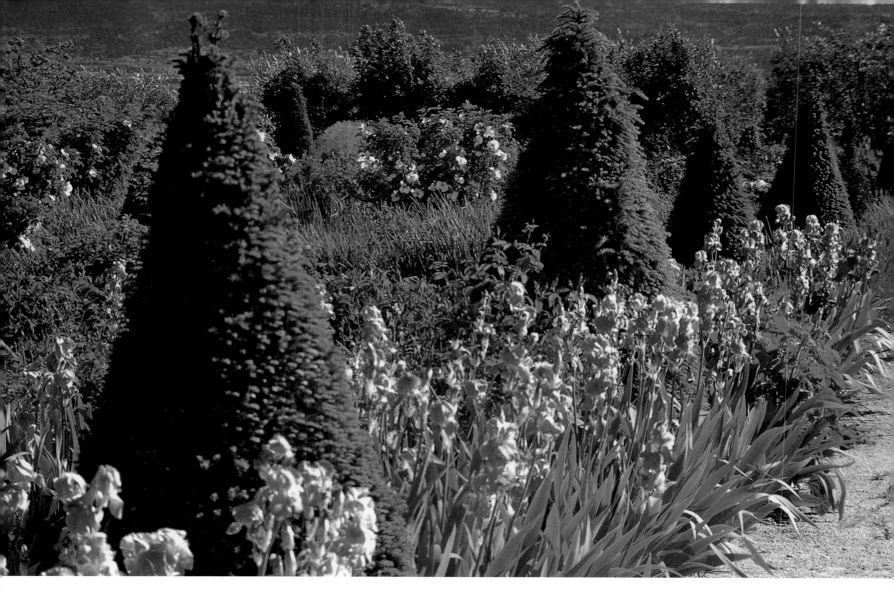

Page précédente: Sur le vieux puits grimpe un rosier 'Madame Isaac Pereire'. A ses pieds, des valérianes *(Centranthus ruber)* et des sédums *(Sedum spectabile)*. Derrière, des oliviers.
Ci-dessus: Sur la deuxième terrasse, les allées sont bordées d'*Iris germanica* et rythmées d'ifs taillés en cône.
A droite: Sur la première terrasse vouée aux plantes potagères et aux fleurs, on trouve des lavandes, des ifs, des pyramides de lierre et de houblon *(Humulus lupulus)*, puis des rosiers.

Previous page: a 'Madame Isaac Pereire' rose clambers over the old well. At its foot are red valerian *(Centranthus ruber)* and stonecrops *(Sedum spectabile)*; in the background are olive trees.
Above: On the second terrace, the walks are bordered with *Iris germanica* and a row of yews clipped into cones.
Right: On the first terrace, which is given over to food plants and flowers, we see lavender, yew, pyramids of ivy and hop *(Humulus lupulus)*, and roses.

Vorhergehende Seite: Der alte Brunnen ist mit der Kletterrose 'Madame Isaac Pereire' überwuchert. Darunter wachsen Spornblumen *(Centranthus ruber)* und Fetthennen *(Sedum spectabile)*. Im Hintergrund sieht man Olivenbäume.
Oben: Auf der zweiten Terrasse sind die Wege von Schwert-lilien *(Iris germanica)* gesäumt, den Rhythmus geben kegel-förmig beschnittene Eiben vor.
Rechts: Die erste Terrasse ist Gemüsen und Blumen gewid-met. Dort wachsen Lavendel, Eiben, Pyramiden aus Efeu und Hopfen *(Humulus lupulus)* sowie Rosen.

Val Joanis *Provence*

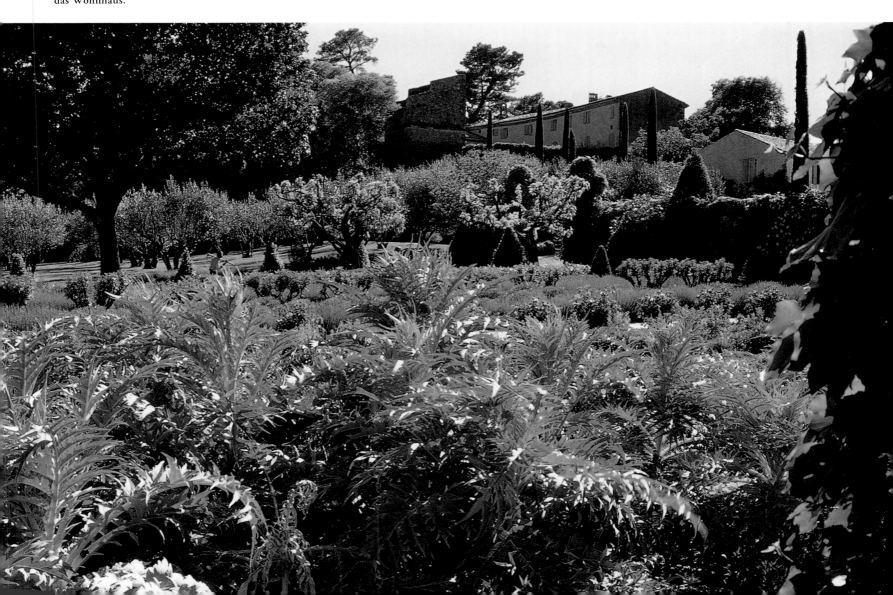

A droite: choux d'ornement plantés en masse sur la première terrasse. Au fond, un petit pavillon.
Ci-dessous: sur la première terrasse, des cardons *(Cynara cardunculus)* aux feuillages argentés, des haricots verts, des salades et des herbes aromatiques. Au fond, la maison.

Right: ornamental cabbages planted "en masse" on the first terrace. Behind them a small garden house is visible.
Below: On the first terrace, the silvery foliage of cardoons *(Cynara cardunculus)* appears in front of green beans, salad plants, and aromatic herbs. The house is visible at the back of the garden.

Rechts: Auf der ersten Terrasse findet sich massenhaft Zierkohl. Im Hintergrund ein kleines Gartenhaus.
Unten: Auf der ersten Terrasse glänzen die silbrigen Blätter der Karden *(Cynara cardunculus)* sowie Bohnen, diverse Salatpflanzen und Küchenkräuter. Im Hintergrund erkennt man das Wohnhaus.

A droite: des lavandes taillées en boules sur la première terrasse.
Ci-dessous: Lavandes, courgettes, salades, fenouils et quantité de plantes aromatiques poussent sur la première terrasse qui mêle plantes potagères et plantes à fleurs.

Right: the topiary of the first terrace: lavender clipped into spheres.
Below: Lavender, courgettes, salad plants, fennel and quantities of aromatic plants are grown on the first terrace, which mixes kitchen produce and flowers.

Rechts: Die kugeligen Lavendelkissen stehen auf der ersten Terrasse.
Unten: Lavendel, Zucchini, Salat, Fenchel und Küchenkräuter aller Art wachsen auf der ersten Terrasse, wo Gemüse und Blumen einträchtig nebeneinander gedeihen.

Ci-dessus: Sur ces tuteurs en bambous, Cécile Chancel cultive toutes sortes de tomates comme les tomates-cerises, les tomates-poires et autres variétés naines.

Above: On these bamboo frames, Cécile Chancel grows many varieties of tomato: cherry tomatoes, pear-shaped tomatoes and other dwarf varieties.

Oben: An Bambusstäben zieht Cécile Chancel ihre Tomaten: Kirschtomaten, Eiertomaten und andere kleine Sorten.

C'est sur ces hauteurs dominant les Iles du Levant que le vicomte de Noailles exerça pour la première fois ses talents d'architecte jardinier en climat méditerranéen. La seconde fois, ce fut à la villa Noailles à Grasse. Son épouse Marie-Laure ayant un goût certain pour les arts d'avant-garde sut le convaincre de faire construire à Hyères une maison dessinée par le fameux architecte Robert Mallet-Stevens. Cela se passait au début des années vingt. Cette immense demeure s'inspire de l'organisation d'un paquebot dont les pièces seraient des cabines et les ouvertures sur le paysage, des hublots. Le jardin attenant, commandé en 1926 à l'artiste arménien Gabriel Guévrekian, fait penser à la proue d'un navire. C'est un jardin cubiste qui s'inscrit dans un triangle. Il est composé de carrés et de rectangles — aujourd'hui en céramique — rouges, bleus, violets, noirs, gris et jaunes où s'intercalent comme dans un damier des carrés ou des rectangles plantés de *Dichondra repens*. Sur les côtés, les formes géométriques sont étagées en «restanques» et sont garnies d'*Erigeron karvinskianus*. Un bassin rectangulaire s'avance vers la pointe où trônait autrefois une statue tournante du sculpteur Jacques Lipchitz. Tout autour, le parc fut planté par le vicomte de Noailles. Aujourd'hui, il est géré par la Ville d'Hyères. Le responsable Pierre Quillier en prend soin et restaure les «restanques» dans l'esprit du vicomte. Avec la même passion pour les plantes.

Villa Noailles

On these heights with their view over the Levant islands, the Vicomte de Noailles for the first time put to work his talents as a Mediterranean landscape gardener. He was to do so a second time at the Villa Noailles in Grasse. His wife Marie-Laure, who had a confirmed taste for the artistic avant-garde, convinced him to have a house built at Hyères by the famous architect Robert Mallet-Stevens. This took place in the early twenties. The huge residence was designed on the model of a ferryboat, with rooms like cabins and openings onto the landscape like portholes. Set against its walls is the garden commissioned in 1926 from the Armenian artist Gabriel Guévrekian, which in its turn resembles the prow of a ship. It is a Cubist garden set in a triangle. Composed of squares and rectangles – which have since been tiled – in blue, violet, black, grey and yellow, it is interspersed with further squares and rectangles planted with *Dichondra repens*. At the sides of the garden, the rectangles are tiered upwards like "restanques" and carpeted with *Erigeron karvinskianus*. A rectangular pool stands at the point of the prow, replacing a revolving statue by Jacques Lipchitz. The planting in the rest of the park was the work of the Vicomte de Noailles. Today it is managed by the Hyères municipality. Pierre Quillier, the head gardener, is currently restoring the "restanques" to the state in which the vicomte left them.

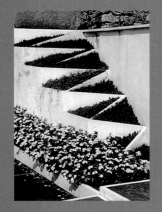

Auf dieser Anhöhe über den Iles du Levant bewies der Vicomte de Noailles zum ersten Mal im mediterranen Klima sein Talent als Gartenarchitekt; sein zweites Projekt war die Villa Noailles in Grasse. Seine Ehefrau Marie-Laure mit ihrer Vorliebe für die Kunst der Avantgarde hatte ihn dazu überredet, in Hyères ein Haus nach Entwürfen des berühmten Architekten Robert Mallet-Stevens errichten zu lassen. Das war zu Beginn der zwanziger Jahre. Das riesige Gebäude ist einem Passagierdampfer nachempfunden, die einzelnen Räume sind als Kabinen und die Fenster als Bullaugen konzipiert. Die Gestaltung des Gartens, der sozusagen den Bug des Schiffes bildet, wurde 1926 bei dem armenischen Künstler Gabriel Guévrekian in Auftrag gegeben. Es handelt sich um einen kubistischen Garten in Form eines Dreiecks, das sich aus Quadraten und Rechtecken zusammensetzt, die heute aus roten, blauen, violetten, schwarzen, grauen und gelben Keramikplatten bestehen. Sie wechseln mit Quadraten und Rechtecken ab, die mit der tropischen Winde *Dichondra repens* bepflanzt sind. An den Seiten sind die geometrischen Formen terrassenförmig übereinander angeordnet, »en restanques«, wie man hier sagt, und mit Berufkraut *(Erigeron karvinskianus)* bepflanzt. Ein rechteckiges Wasserbecken erstreckt sich bis zur Spitze, wo früher eine sich drehende Skulptur von Jacques Lipchitz stand. Den umliegenden Park legte der Vicomte de Noailles selbst an. Er wird heute von der Stadt Hyères verwaltet. Verantwortlich für den Park ist Pierre Quillier, der auch darauf achtet, daß die »restanques« im Sinne des Vicomte erhalten bleiben — mit derselben Begeisterung wie dieser für die Pflanzen.

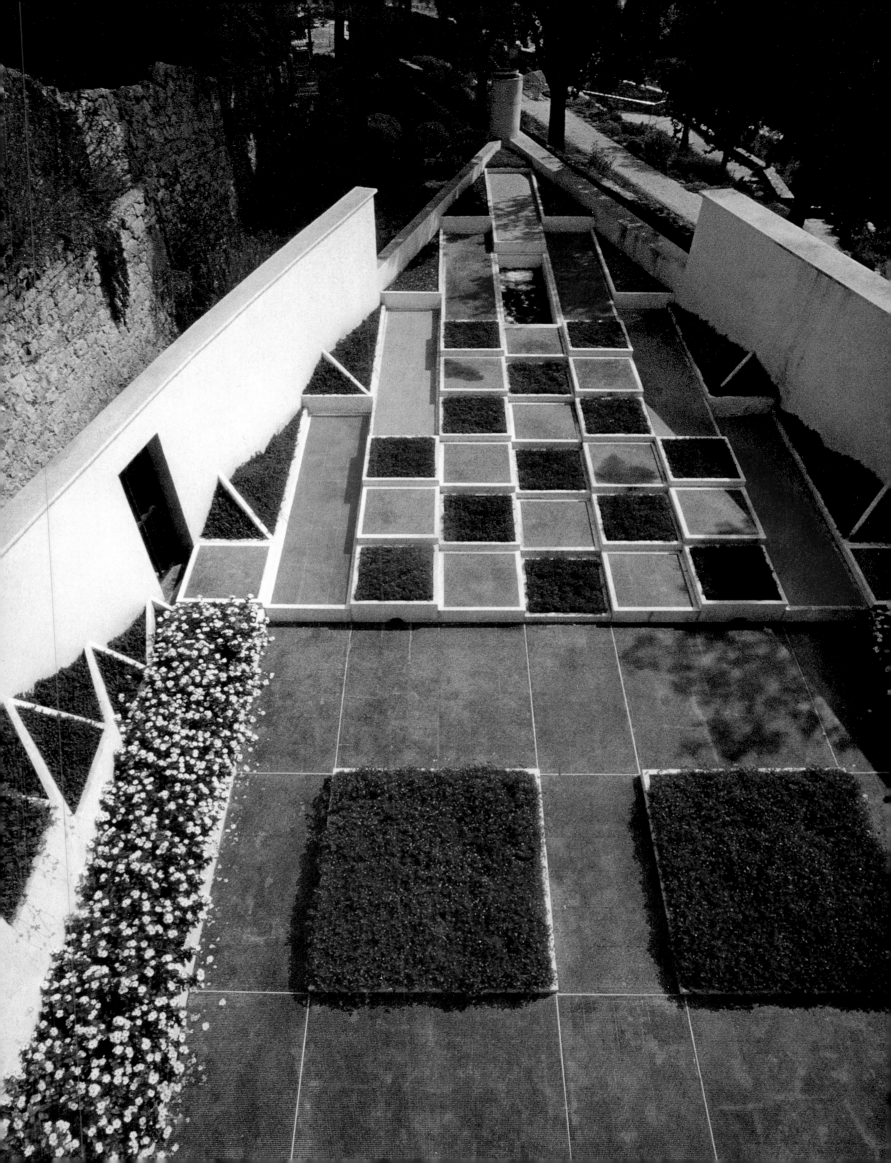

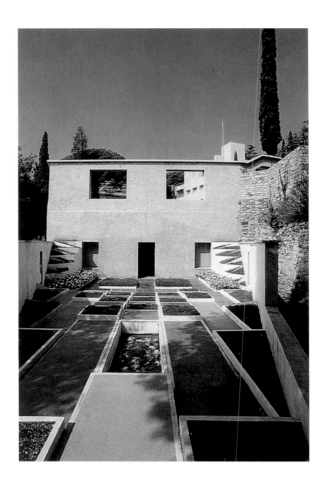

Double page précédente: Le jardin créé par Gabriel Guévrekian dessine un triangle qui rappelle la proue d'un navire. Des triangles étagés en «restanques» sont bordés d'*Erigeron karvinskianus* (détails).
A droite: le jardin cubiste et au fond, la villa Noailles dessinée par Mallet-Stevens.
Ci-dessous: les carrés du jardin cubiste. Au fond, le bassin rectangulaire, puis le socle sur lequel tournait autrefois une statue de Jacques Lipchitz.

Previous pages: The garden created by Gabriel Guévrekian forms a triangle like the prow of a ship. Triangular beds tiered like "restanques" are bordered with *Erigeron karvinskianus* (details).
Right: the cubist garden and, behind it, the villa designed for the Vicomte de Noailles by Mallet-Stevens.
Below: the squares of the cubist garden. At the prow of the garden is the pedestal on which a revolving statue by Jacques Lipchitz once stood.

Vorhergehende Doppelseite: Der von Gabriel Guévrekian geschaffene Garten bildet ein Dreieck, das an den Bug eines großen Schiffes erinnert. Terrassenförmig aufsteigende Dreiecke werden von Berufkraut *(Erigeron karvinskianus)* begrenzt (Details).
Rechts: der kubistische Garten, im Hintergrund die von Mallet-Stevens entworfene Villa Noailles.
Unten: die drei- und viereckigen Beete des kubistischen Gartens. Im Hintergrund das rechteckige Wasserbecken und dahinter der Sockel, auf dem sich früher eine Skulptur von Jacques Lipchitz drehte.

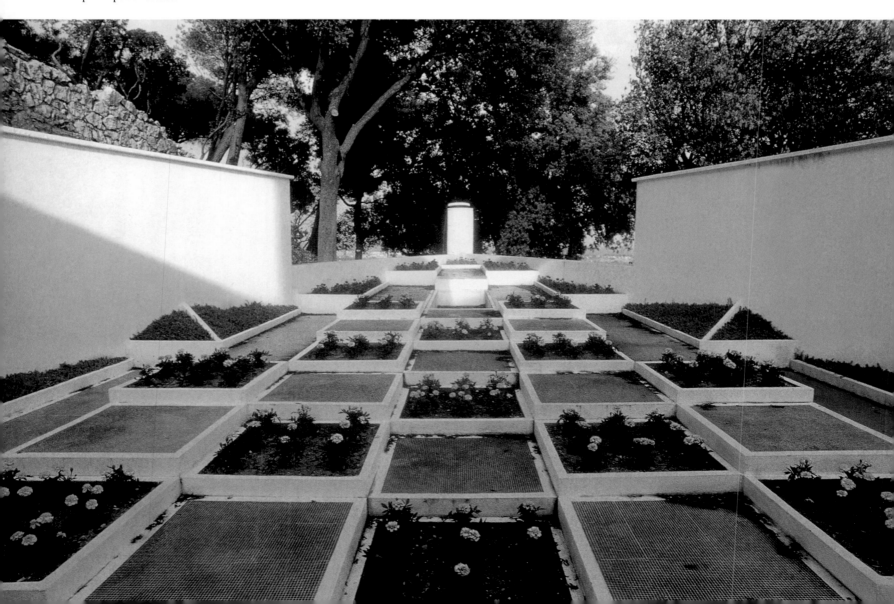

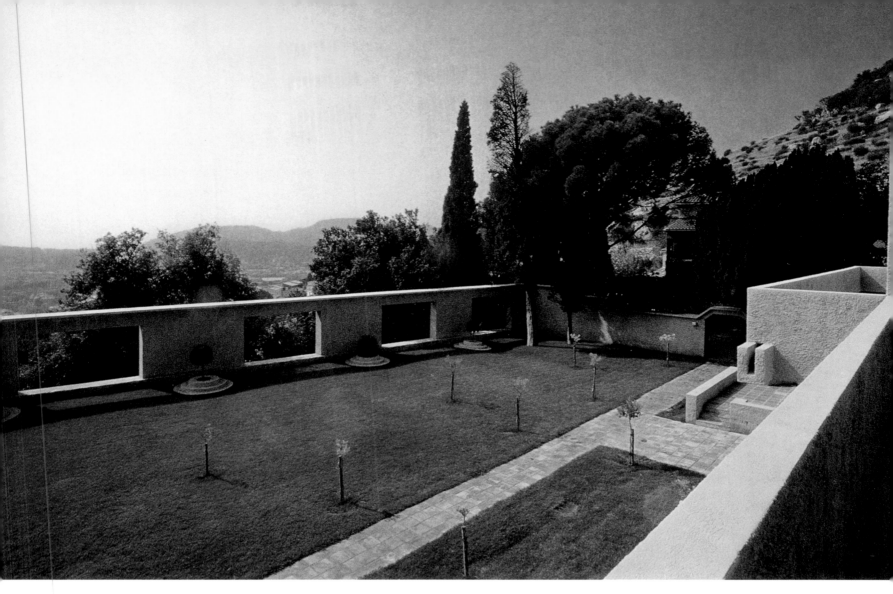

Ci-dessus: le parvis engazonné devant la maison, avec ses troènes sur socles et un mur percé de hublots ouvrant sur le parc et sur la ville.
A droite: La villa Noailles comprenait 1 800 mètres carrés habitables. On la comparait à un navire dont le vicomte de Noailles était le commandant.

Above: the lawn in front of the house, with its privets on pedestals and a wall with porthole-like openings offering a view of the park and the town.
Right: The Villa Noailles comprised 1,800 square metres of living space. It was often compared to a ship captained by the Vicomte de Noailles.

Oben: der Rasenplatz vor dem Haus mit den Ligusterhochstämmen, die aus runden Sockeln wachsen. Die durchbrochene Mauer gibt den Blick auf Park und Stadt frei.
Rechts: Die Villa Noailles hatte eine Wohnfläche von 1.800 Quadratmetern. Man verglich sie mit einem Schiff, das der Vicomte de Noailles befehligte.

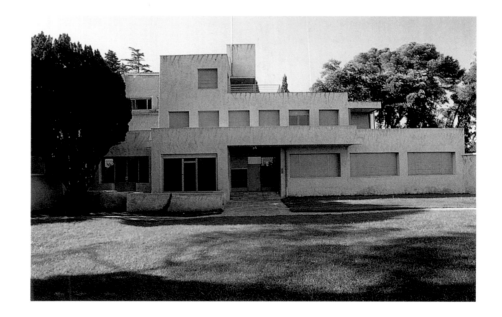

La côte des Maures est rocheuse et découpée. Dans une végétation méditerranéenne naturalisée, le paysagiste Gilles Clément a enchâssé des scènes composées de plantes caractéristiques des différents climats méditerranéens de la planète. La restauration du Domaine de Rayol fut entreprise à l'initiative du Conservatoire du Littoral qui fit l'acquisition des lieux en 1989. Auparavant, ce magnifique parc avait connu des heures de gloire. Un homme d'affaires fortuné, Alfred Théodore Courmes, y avait construit sa résidence en 1910 et il avait entouré d'un jardin d'ornement une pergola d'inspiration antique qui dominait la mer. Puis le domaine avait été vendu en 1940 au grand constructeur aéronautique Henri Potez qui y fit tracer une majestueuse perspective bordée de cyprès et scandée d'escaliers partant de la pergola. On peut l'admirer aujourd'hui encore. Même si elle reste le principal axe rectiligne du parc, la promenade est cependant sinueuse et relie entre eux la demeure d'origine, la ferme, la villa, un pavillon surplombant la plage et un puits, au milieu d'associations végétales naturelles, originaires de pays lointains soumis au climat méditerranéen. Les callistemons et les eucalyptus évoquent l'Australie, les aloès et les strelitzias, l'Afrique australe, les fougères arborescentes *(Dicksonia)* et les cordylines, la Nouvelle-Zélande, les alstroémères et les araucarias, le Chili, les yuccas et les agaves, la Californie, enfin les bambous et les cycas, l'Asie.

Le Domaine du Rayol

The Côte des Maures is rocky and indented. The landscape architect Gilles Clément has interspersed the native Mediterranean flora with scenes composed of plants drawn from other parts of the world where similar climatic conditions prevail. The restoration of the Domaine du Rayol was undertaken at the initiative of the Conservatoire du Littoral, which bought the site in 1989. This magnificent park had fallen on hard times. A rich businessman, Alfred Théodore Courmes, had built a house there in 1910 and surrounded its pergola in the classical style giving onto the sea view with an ornamental garden. In 1940, the domaine was sold to the great aeroplane engineer, Henri Potez, who laid out a majestic vista flanked with cypresses and featuring a series of staircases leading down from the pergola. It can still be seen today. The central axis of the park that twists and turns on its way between the original residence, the farm, the villa, a pavilion that looks out over the beach, and a well. It leads through an imaginative series of settings that juxtapose plants from a variety of "Mediterranean" climates. The *Callistemon* and eucalyptus are evocative of Australia, the aloes and strelitzias of Southern Africa, the tree ferns *(Dicksonia)* and *Cordylines* of New Zealand, the *Alstroemeria* and monkey puzzles *(Araucaria)* of Chile, the yuccas and agaves of California, and the bamboos and *Cycas* of Asia.

Die Côte des Maures ist schroff und felsig. Inmitten der heimischen Mittelmeervegetation schuf Gartenarchitekt Gilles Clément Szenerien aus typischen Gewächsen verschiedener ähnlicher Klimazonen der Erde. Die Domaine du Rayol wurde dank der Intervention des Conservatoire du Littoral, das dieses Anwesen 1989 kaufte, restauriert. Der wundervolle Park hat schon bessere Zeiten gesehen. Alfred Théodore Courmes, ein wohlhabender Geschäftsmann, hatte hier 1910 seine Residenz errichten lassen und sie mit einem Ziergarten und einer nach antiken Vorbildern erbauten Pergola hoch über dem Meer umgeben. 1940 wurde das Grundstück an den Flugzeugbauer Henri Potez veräußert. Er ließ von der Pergola aus ein majestätisches Panorama mit Zypressenallee und verzweigten Treppen anlegen, das noch heute existiert. Die Hauptachse des Parks bildet eine verschlungene Verbindung zwischen dem alten Wohnhaus, dem Wirtschaftshof, der Villa, dem Pavillon über dem Strand und einem Brunnen. Der Weg durchquert dabei natürlich wirkende Gruppen von Gewächsen, die aus fernen Ländern stammen. Zylinderputzersträuche *(Callistemon)* und Eukalyptus erinnern an Australien, Aloe und Strelitzien an das südliche Afrika, Baumfarn *(Dicksonia)* und Keulenlilien *(Cordyline)* an Neuseeland, Inkalilien *(Alstroemeria)* und Andentannen *(Araucaria)* an Chile, Yuccapalmen und Agaven an Kalifornien, Bambus und Palmfarn *(Cycas)* an Asien.

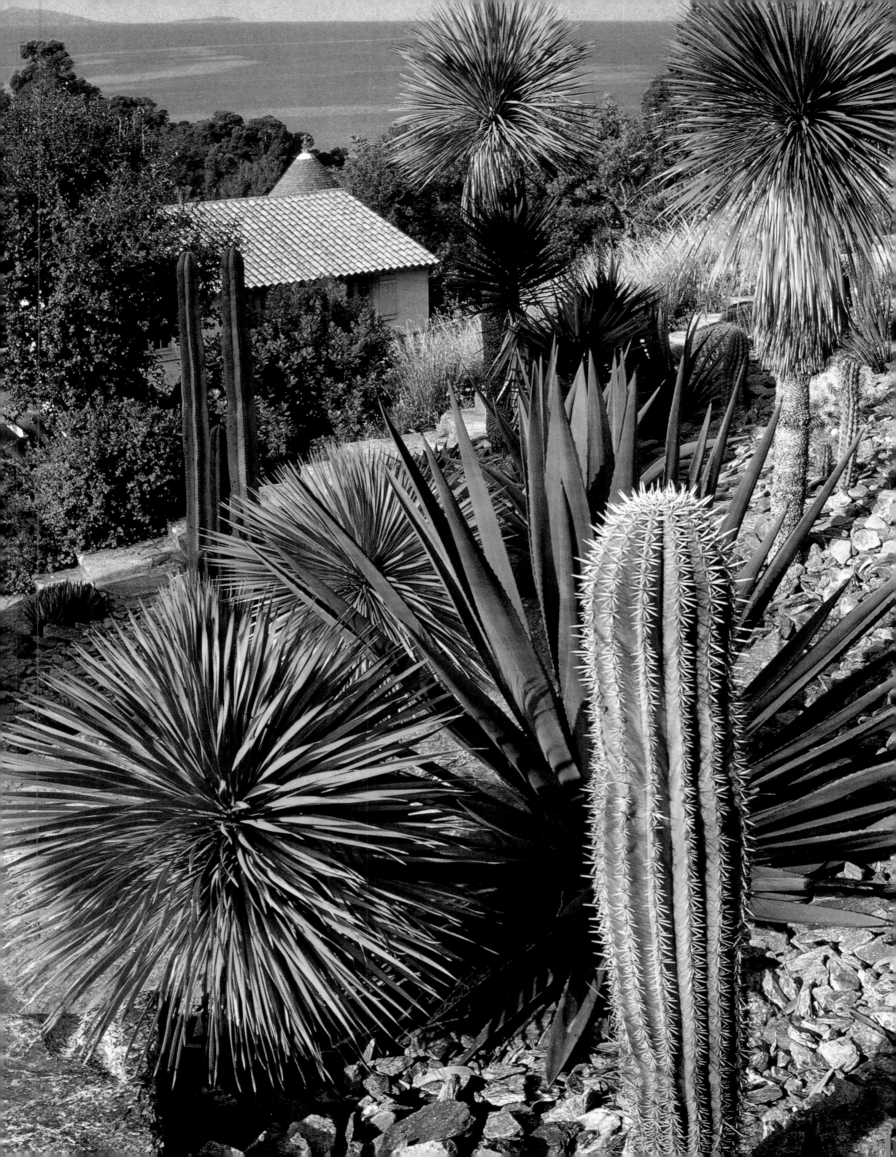

Page précédente: Ce jardin de rocaille est peuplé de plantes originaires des terres arides d'Amérique centrale: on distingue des cactées en forme de cierges *Pachycereus pringlei* et des *Yucca rostrata.*
A droite: Le Domaine du Rayol domine la mer à un endroit où la côte est rocheuse et découpée. On y protège les plantes du littoral des Maures.
Ci-dessous: la prairie neo-zélandaise et sa mer de graminées, *Carex flagellifera* et *Stipa tenuifolia.*

Previous page: This rocky garden is full of flora from the arid soils of Central America, like these tall columnar cacti *Pachycereus pringlei* and *Yucca rostrata.*
Right: The Domaine du Rayol looks out over the rocky, indented coastline. The garden is a nature reserve for the plants of the Côte des Maures.
Below: plants of the New Zealand grasslands: *Carex flagellifera* and *Stipa tenuifolia.*

Vorhergehende Seite: Der Steingarten ist mit Gewächsen bestückt, die aus den trockenen Gebieten Mittelamerikas stammen, etwa dem Säulenkaktus *Pachycereus pringlei* und der Palmlilie *Yucca rostrata.*
Rechts: Die Domaine du Rayol liegt hoch über dem Meer an einer steil abfallenden, zerklüfteten Felsküste, wo man geschützt vor den Einflüssen der Côte des Maures exotische Gewächse pflanzen konnte.
Unten: Die neuseeländische Graslandschaft wirkt wie ein Meer aus Segge *(Carex flagellifera)* und Federgras *(Stipa tenuifolia).*

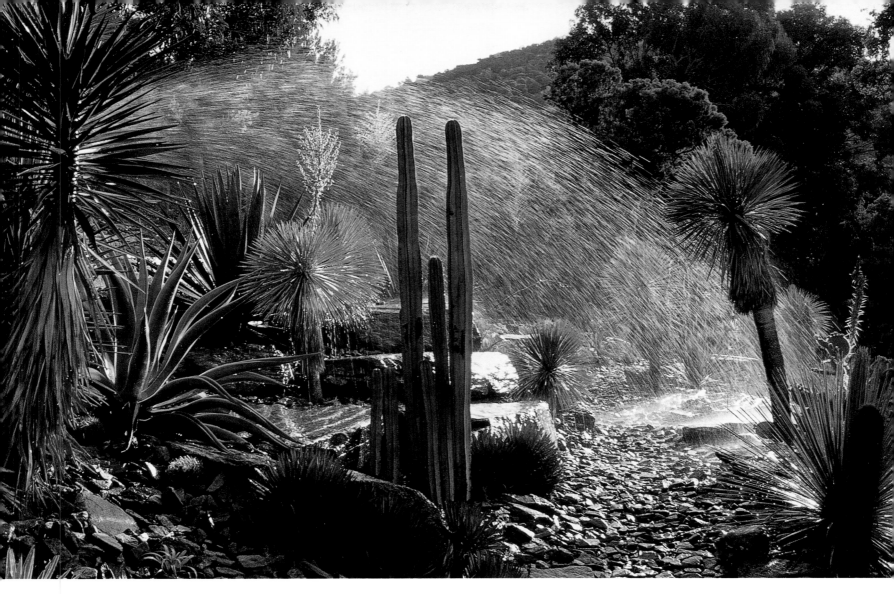

Ci-dessus: le jardin d'Amérique centrale planté de *Yucca rostrata* et de plusieurs espèces d'agaves.
A droite: Cette perspective bordée de cyprès fut tracée dans les années quarante par Henri Potez, le second propriétaire du domaine.

Above: the Central American garden planted with *Yucca rostrata* and several other species of agave.
Right: This cypress-lined vista was laid out in the forties by Henri Potez, the second owner of the domaine.

Oben: Im mittelamerikanischen Garten finden sich die Palmlilien *Yucca rostrata* und verschiedene Agaven.
Rechts: Dieser von Zypressen gesäumte Weg wurde in den vierziger Jahren von Henri Potez, dem zweiten Besitzer des Anwesens, angelegt.

Ce jardin provençal vert et frais fut dessiné par l'architecte Jacques Couëlle dans la première moitié de notre siècle, pour le Docteur Brès et son épouse qui recevaient en ces lieux la belle société de l'époque. Il est toujours vert car il est planté d'une dominante de cyprès, de tapis engazonnés et de buis; il est toujours frais, car l'eau de source y circule et alimente des bassins qui, de terrasse en terrasse, se déversent les uns dans les autres. Jacques Couëlle respecta les «restanques» plantées de vignes qui descendaient jusqu'au pied de la bastide. Il y traça des jardins dont les motifs varient d'un niveau à l'autre. Ils sont pourtant tous liés par une unité de style que l'on pourrait qualifier d'italien: les cyprès plantés en groupes encadrent la vue sur l'arrière-pays cannois et créent un effet théâtral, les buis sont taillés en boules opulentes ou en cônes, la pierre et l'eau servent d'ornements, les escaliers relient les terrasses, les balustrades soulignent les «restanques». Même les ouvertures sur le paysage concourent à rappeler l'Italie. Devant la bastide aux volets bleus trônent deux tilleuls majestueux dont les branches sont ciselées comme de la dentelle. De là, des terrasses très architecturées descendent sur trois niveaux avant de rejoindre la campagne. Un jardin de buis conçu dans le même esprit prolonge sur la gauche l'architecture de la demeure pour former quatre chambres vertes à ciel ouvert. Suspendues au-dessus du panorama, elles sont reliées au firmament par la silhouette filiforme des cyprès.

Fontviel

This fresh, green, Provençal garden was designed by the architect Jacques Couëlle early in the 20th century for Dr Brès and his wife; here they hosted the high society of that era. It is still green, for much of the garden is planted with cypresses, lawns and box; and still fresh, since the water from the spring feeds the water tanks, flowing down from one terrace to another. Jacques Couëlle respected the "restanques" planted with vines which rise almost from the walls of the "bastide", the Provençal farmhouse; on them he created a series of themed gardens. The unifying factor is a somewhat Italianate style: the cypresses planted in groups frame the view of the Cannois hinterland with theatrical effect, box is clipped into fat spheres or cones, water and stone are used for ornamental effect, and on the staircases that lead from one terrace to another, the balustrades enhance the profile of the "restanques". Even the way the garden opens out onto the landscape is reminiscent of Italy. In front of the farmhouse with its blue shutters stand two majestic lime trees, their foliage delicate as lace. From there, three levels of dramatic terraces descend to the valley. A box garden constitutes an extension of the farmhouse and forms four "green rooms" open to the sky to the left of the house. They offer a magnificent view beneath the slender silhouettes of the cyprus trees.

Dieser grüne und erfrischende provenzalische Garten wurde in der ersten Hälfte dieses Jahrhunderts von dem Architekten Jacques Couëlle für Dr. Brès und seine Frau entworfen, die hier die Crème der damaligen Gesellschaft zu Gast hatten. Der Garten ist noch heute grün, denn er besteht überwiegend aus Zypressen, Rasenflächen und Buchsbaum, und er ist noch immer erfrischend, weil überall Quellwasser fließt und Wasserbecken das kühle Naß von einer Terrasse zur nächsten plätschern lassen. Jacques Couëlle beließ die mit Weinstöcken bepflanzten »restanques«, die bis an die »bastide«, das typisch provenzalische Landhaus, heranreichten. Er legte einen Park an, dessen Motive von einer Ebene zur nächsten variieren und der durch den durchgängig italienisch geprägten Stil zusammengehalten wird: In Gruppen zusammenstehende Zypressen bilden einen fast schon dramatischen Rahmen für den Ausblick auf das Hinterland von Cannes. Buchsbäume sind zu dicken Kugeln und Kegeln geschnitten, Steine und Wasser dienen als Zierat, Treppen verbinden die Terrassen miteinander, und die Balustraden geben den »restanques« Kontur. Selbst die Ausblicke auf die Umgebung rufen Erinnerungen an Italien wach. Vor der »bastide« mit ihren blauen Fensterläden stehen zwei majestätische Linden, die Äste wie zarte Spitze verwoben. Von hier aus steigen drei architektonisch gestaltete Terrassen zum freien Feld hinab. Der ähnlich angelegte Boskettgarten setzt die Architektur des Hauses auf der linken Seite mit vier »grünen Salons« fort. Aus diesen hoch über der Landschaft schwebenden Heckengärten scheinen die schlanken Säulen der Zypressen sich zum Firmament emporzurecken.

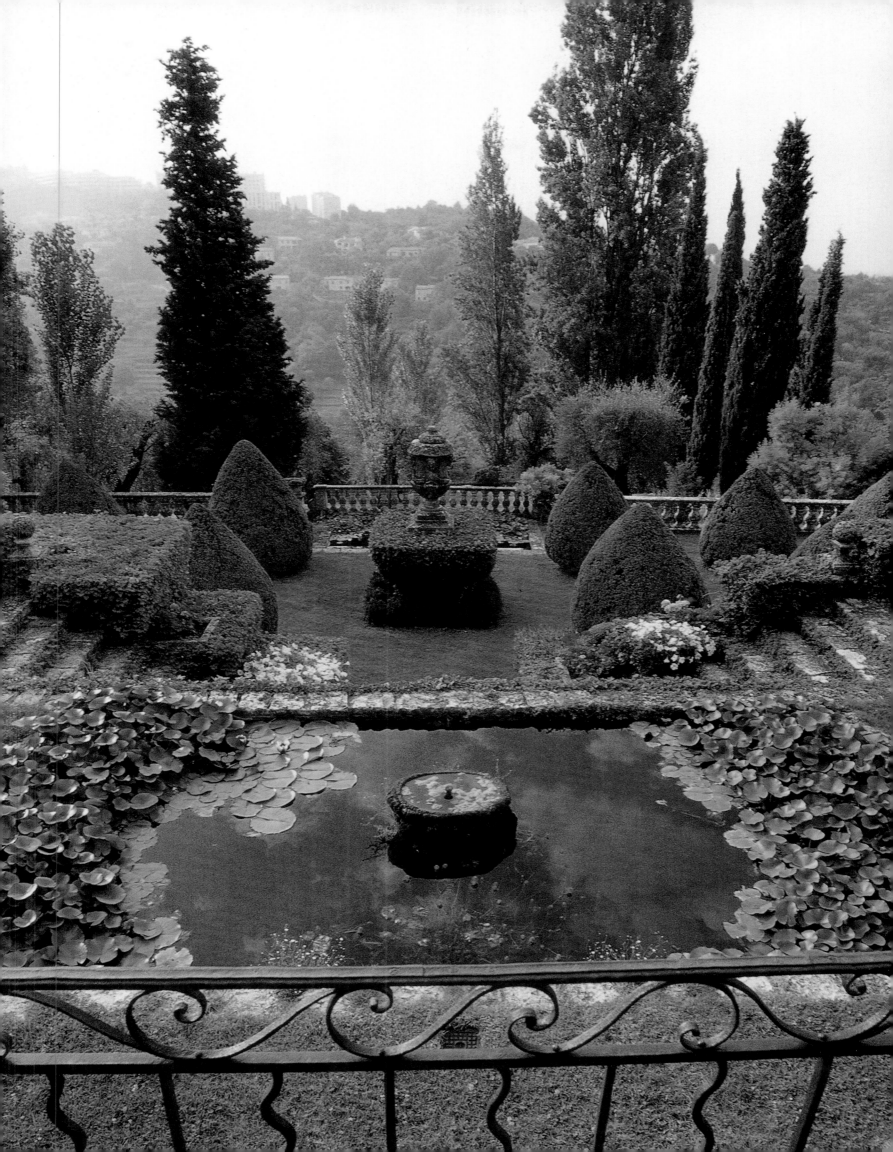

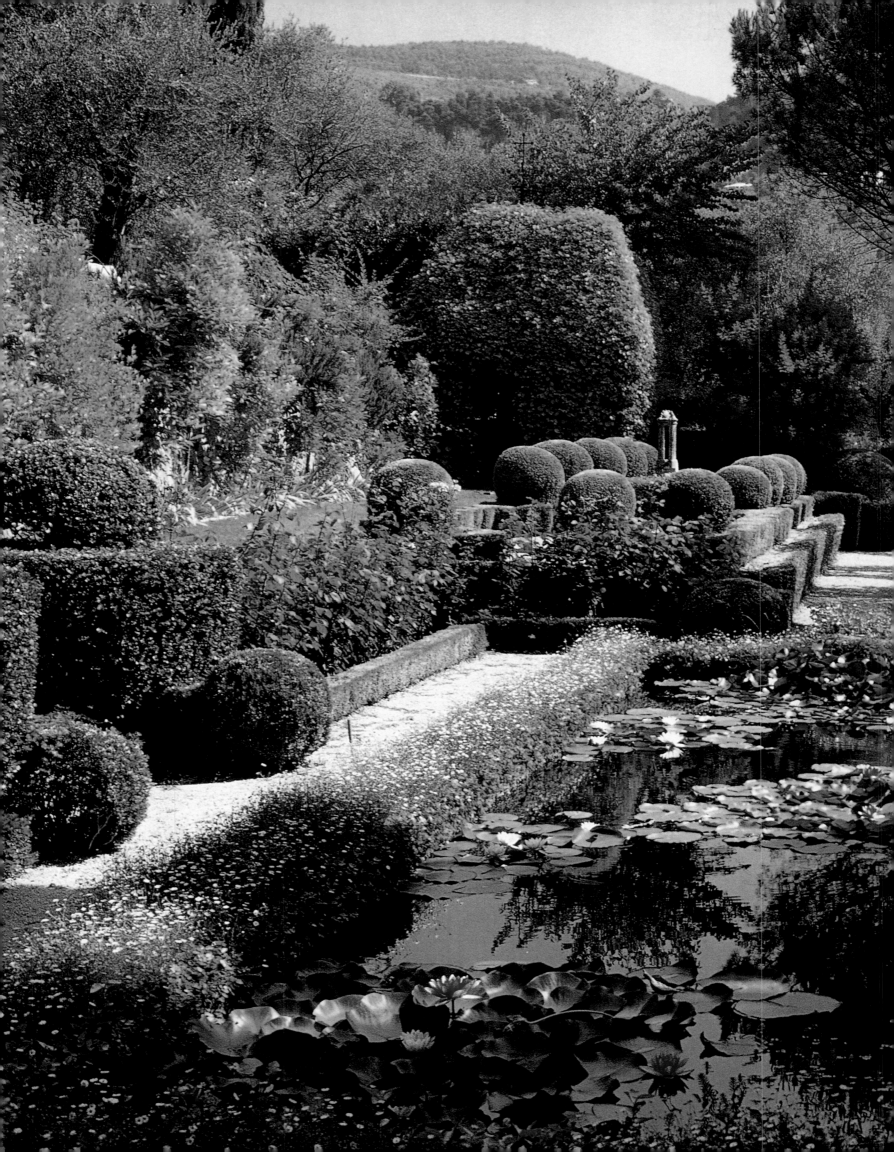

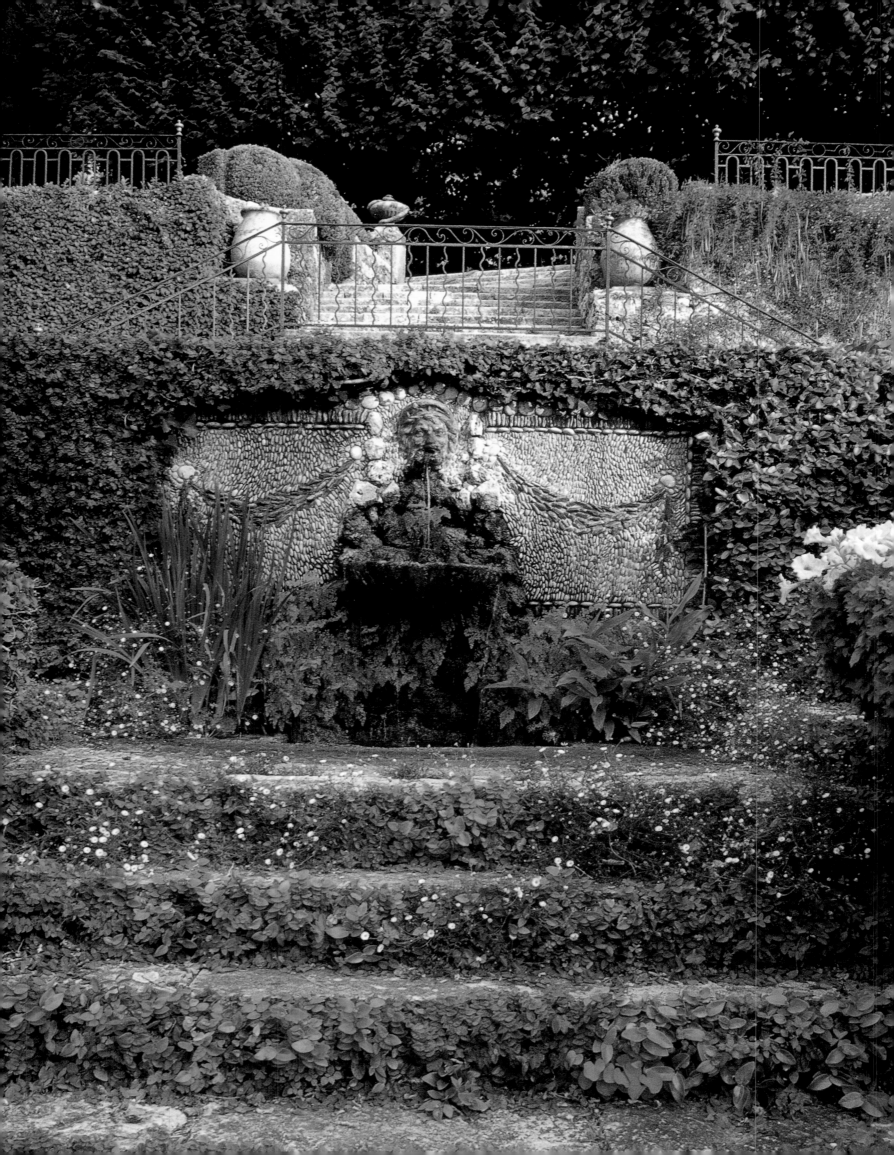

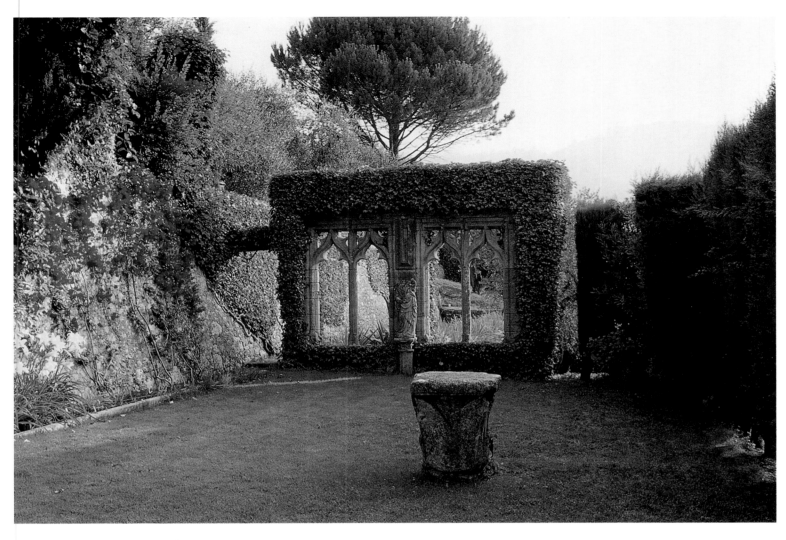

Première page et double page précédente: Les «restanques» ont
été aménagées en terrasses reliées les unes aux autres par des
escaliers magnifiquement architecturés. Sur chaque palier,
une fontaine ou un bassin agrémente les jardins.
Page de gauche: Les marches sont plantées de *Ficus repens* et
d'*Erigeron karvinskianus* qui se resèment librement. Tout en
haut, on aperçoit les tilleuls majestueux dont l'ombre apporte
de la fraîcheur à la bastide.
Ci-dessus: la fenêtre gothique de la première terrasse.
A droite: Les marches des escaliers sont garnies de *Ficus repens.*

First page and previous pages: The "restanques" serve as ter-
races linked to one another by staircases elegantly designed
and leading to a fountain or pool at each level.
Facing page: The stairs are planted with *Ficus repens* and
Erigeron karvinskianus which reseed themselves sponta-
neously. Above them are visible the majestic lime trees
whose branches shade the house.
Above: the ogee window onto the first terrace.
Right: The stairs are carpeted with *Ficus repens.*

Eingangsseite und vorhergehende Doppelseite: Die »restanques«
wurden in Terrassen umgewandelt und durch prachtvoll ge-
staltete Treppen miteinander verbunden. Jeder Absatz ist mit
einem Brunnen oder Wasserbecken verziert.
Linke Seite: Auf den Stufen breiten sich Kletterfeigen *(Ficus
repens)* und Berufkraut *(Erigeron karvinskianus)* aus. Ganz
oben sieht man die mächtigen Linden, die der »bastide« im
Sommer kühlen Schatten spenden.
Oben: das gotische Maßwerk auf der ersten Terrasse.
Rechts: Auf den Stufen wachsen Kletterfeigen *(Ficus repens).*

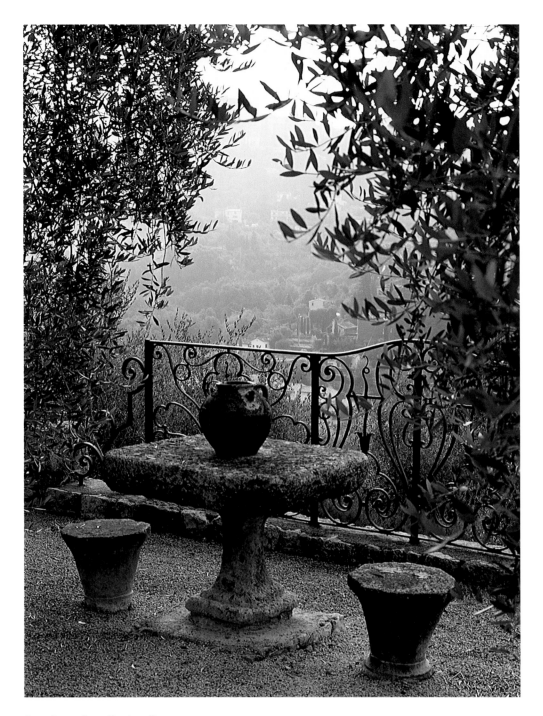

Page de gauche: collection d'agrumes.
Ci-dessus: vue d'une terrasse. Au loin, on devine les collines de
l'arrière-pays cannois.

Facing page: citrus fruits.
Above: view from a terrace. In the distance, one can make out
the hills of the Cannois hinterland.

Linke Seite: Zitrusfrüchte.
Oben: Blick von einer der Terrassen. In der Ferne ahnt man
die Hügel des Hinterlandes von Cannes.

La route monte en lacets à travers la garrigue rocailleuse, noueuse, brûlante, desséchée et parfumée, et Gourdon surgit agrippé à un piton rocheux. Le château construit au 12e siècle par les Comtes de Provence domine la vallée du Loup. Ses jardins défient l'aridité de l'arrière-pays niçois: ils sont verts, rafraîchissants, désaltérants. Ils furent réalisés au 17e siècle par Louis de Lombard, qui les fit soutenir par des voûtes et des arcades pour aménager des terrasses et les suspendre au-dessus de l'abîme. Il en résulte plusieurs jardins que l'on découvre après avoir traversé la cour intérieure. Le premier est ombré de tilleuls. Ses buis dessinent des motifs en fer à cheval sur un tapis de gazon vert. Un peu plus bas, le jardin italien surplombe le précipice et s'orne de buis taillés en forme de poire ou de champignon. Entre les pierres se nichent des plantes alpines qui colorent le décor: des aubriètes bleues, violettes ou mauves, de l'alysse jaune d'or, des sedums et des sempervivums. Le paysagiste Tobie Loup de Viane travailla à Gourdon au début des années soixante-dix. Disciple de Russell Page, originaire des Cévennes, il savait saisir l'humeur des lieux et marier les plantes méditerranéennes. Il imagina le jardin de l'apothicaire d'inspiration médiévale, planté d'herbes médicinales et aromatiques entouré de buis et dessinant une grecque autour d'un cadran solaire, ainsi qu'une promenade longue comme un chemin de ronde, jalonnée de buis taillés en cône et de cyprès sombres reliant l'ensemble au ciel.

Gourdon

The road winds up through the balmy air and sunbaked rockscape of the "garrigue" toward the high stone terraces of Gourdon. The castle, built in the 12th century by the Comtes de Provence, dominates the valley of the Loup. In the midst of the arid Niçois hinterland, its gardens are a luxuriant green. They were laid out in the 17th century by Louis de Lombard, the architect of the vaulted, arcaded terraces that run along the edge of the cliff. Beyond the courtyard, several gardens await the visitor. In the first, lime trees shade a lawn laid out with box hedges in horseshoe motifs. Lower down, an Italian topiary garden forms a terrace in the cliffside, with box in pear or mushroom shapes. Alpine plants lodge in the stones: blue, violet and mauve aubrietias *(Aubrieta)*, golden alyssum, stonecrops *(Sedum)* and houseleeks *(Sempervivum)*. The landscape designer Tobie Loup de Viane worked at Gourdon in the early seventies. Born in the Cévennes, this disciple of Russell Page had a gift for enhancing the spirit of places and for the harmonious arrangement of Mediterranean plants. It was he who conceived the apothecary's garden planted with medicinal and aromatic herbs surrounded by box forming a Greek key-pattern around a sundial; he also designed a long avenue like a rampart-walk studded with cone-shaped box trees and dark cypresses pointing skyward.

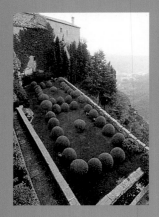

Die Straße windet sich durch die ausgedörrte, duftende Buschwelt der »garrigue«, bis mit einem Mal das an die felsige Bergspitze geklammerte Gourdon auftaucht. Das im 12. Jahrhundert von den Grafen der Provence erbaute Schloß beherrscht das Loup-Tal. Die Gärten sind trotz der Trockenheit des Hinterlandes von Nizza erfrischend grün. Louis de Lombard entwarf sie im 17. Jahrhundert und legte über dem Abgrund schwebende Terrassen an, die durch Gewölbe und Arkaden abgestützt sind. So entstanden mehrere Gärten, die sich nach Durchqueren des Innenhofs eröffnen. Der erste liegt im Schatten von Linden. Auf dem Rasen ist Buchsbaum zu hufeisenförmigen Motiven angeordnet. Ein Stück tiefer liegt der italienische Garten direkt über dem Abgrund; hier ist der Buchs in Birnen- und Pilzform geschnitten. Zwischen den Steinen haben sich Alpenpflanzen angesiedelt und sorgen für Farbe: blaue, lila und malvenfarbene Blaukissen *(Aubrieta)*, goldgelbes Gebirgssteinkraut *(Alyssum)*, Fetthenne und Hauswurz *(Sempervivum)*. Anfang der siebziger Jahre widmete sich der Landschaftsgärtner Tobie Loup de Viane den Gärten von Gourdon. Dem aus den Cevennen stammenden Schüler von Russell Page gelang es, die Stimmung des Ortes einzufangen und die Mittelmeerpflanzen geschickt zu kombinieren. Nach dem Vorbild mittelalterlicher Apothekengärtchen mit ihren von Buchs eingefaßten, rings um eine Sonnenuhr gruppierten Beeten voller Heil- und Gewürzkräuter legte er einen langen, wie ein Wehrgang wirkenden Weg an, der rhythmisch begleitet wird von kegelförmig beschnittenem Buchs und dunklen Zypressen, die in den Himmel ragen.

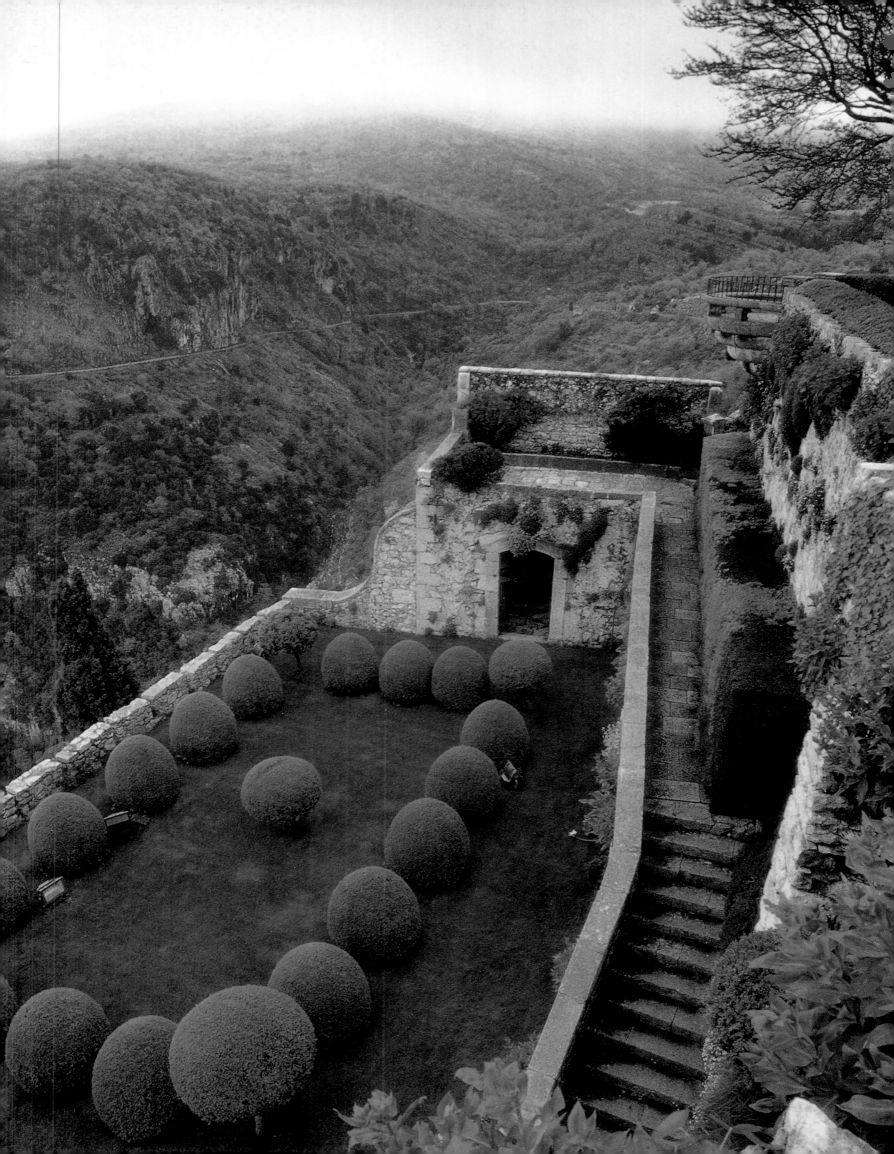

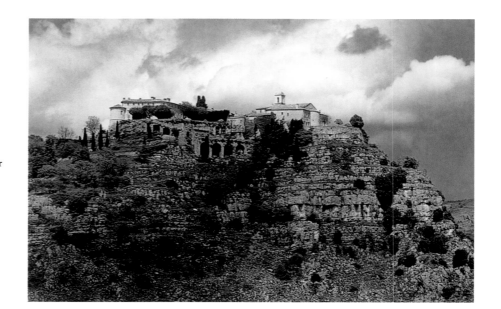

Page précédente: Le jardin italien, planté de buis ressortant sur un tapis vert, domine les gorges du Loup.
A droite: Le village de Gourdon est perché sur un nid d'aigle. Le château est situé tout en haut, près de l'église.
Ci-dessous: Les buis du jardin à la française dessinent des motifs en fer à cheval surmontés par des tilleuls centenaires taillés en boule.

Previous page: The Italian garden, a luxuriant lawn-terrace planted with box, offers a panorama over the valley of the Loup.
Right: the village of Gourdon is perched on a turret of rock. The castle is next to the church, at the summit.
Below: The box hedges of the French garden form horseshoe motifs beneath the pollarded limes.

Vorhergehende Seite: Der italienische Garten ist ein mit Buchsbaum bestandener grüner Teppich hoch über den Gorges du Loup.
Rechts: Das Dorf Gourdon klebt wie ein Adlerhorst auf der Bergkuppe. Das Schloß liegt ganz oben, nahe der Kirche.
Unten: Der Buchsbaum im französischen Garten bildet hufeisenförmige Muster im Schatten kugelig beschnittener hundertjähriger Linden.

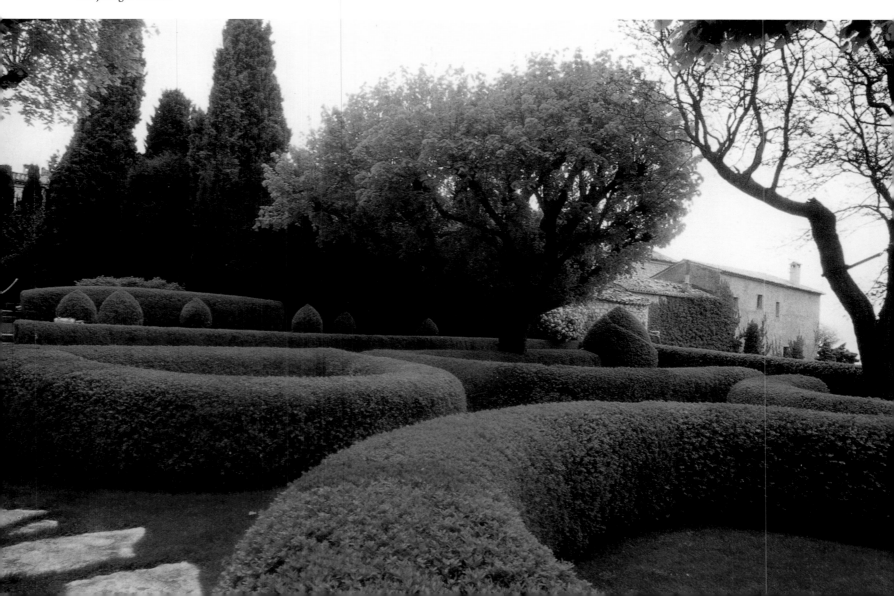

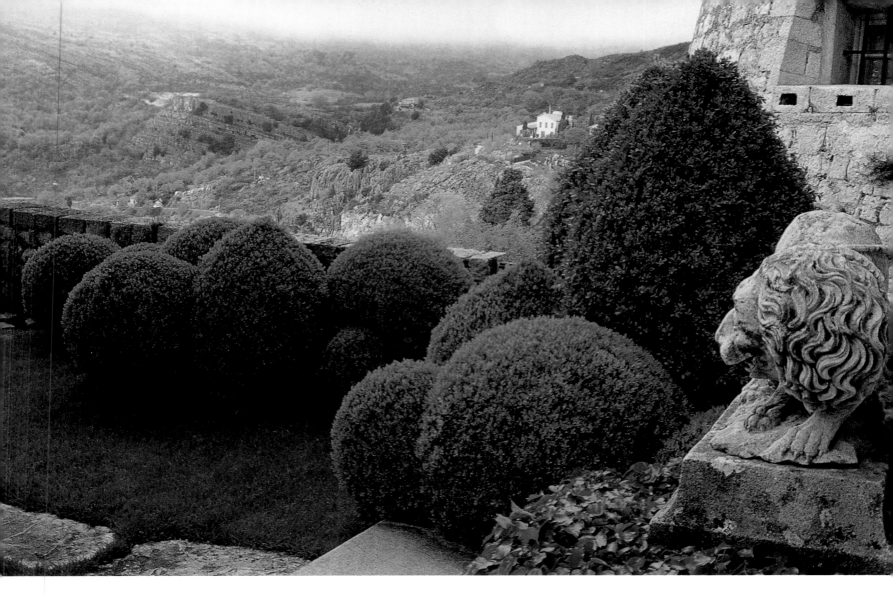

Ci-dessus: gros plan sur les buis du jardin italien surplombant la garrigue.
A droite: Tobie Loup de Viane conçut le jardin de l'apothicaire d'inspiration médiévale. Des carrés d'herbes médicinales et aromatiques sont bordés de buis.

Above: a close-up of the box trees of the Italian garden with its view of the "garrigue".
Right: Tobie Loup de Viane's design for the apothecary's garden reflects medieval practices. Square beds of medicinal and aromatic herbs are edged with box.

Oben: Großaufnahme der Buchsbäume im italienischen Garten, darunter die »garrigue«.
Rechts: der von Tobie Loup de Viane gestaltete Apothekengarten in mittelalterlichem Stil. Beete mit Heil- und Gewürzkräutern werden von Buchs eingefaßt.

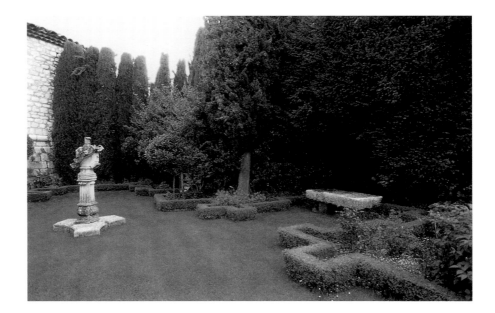

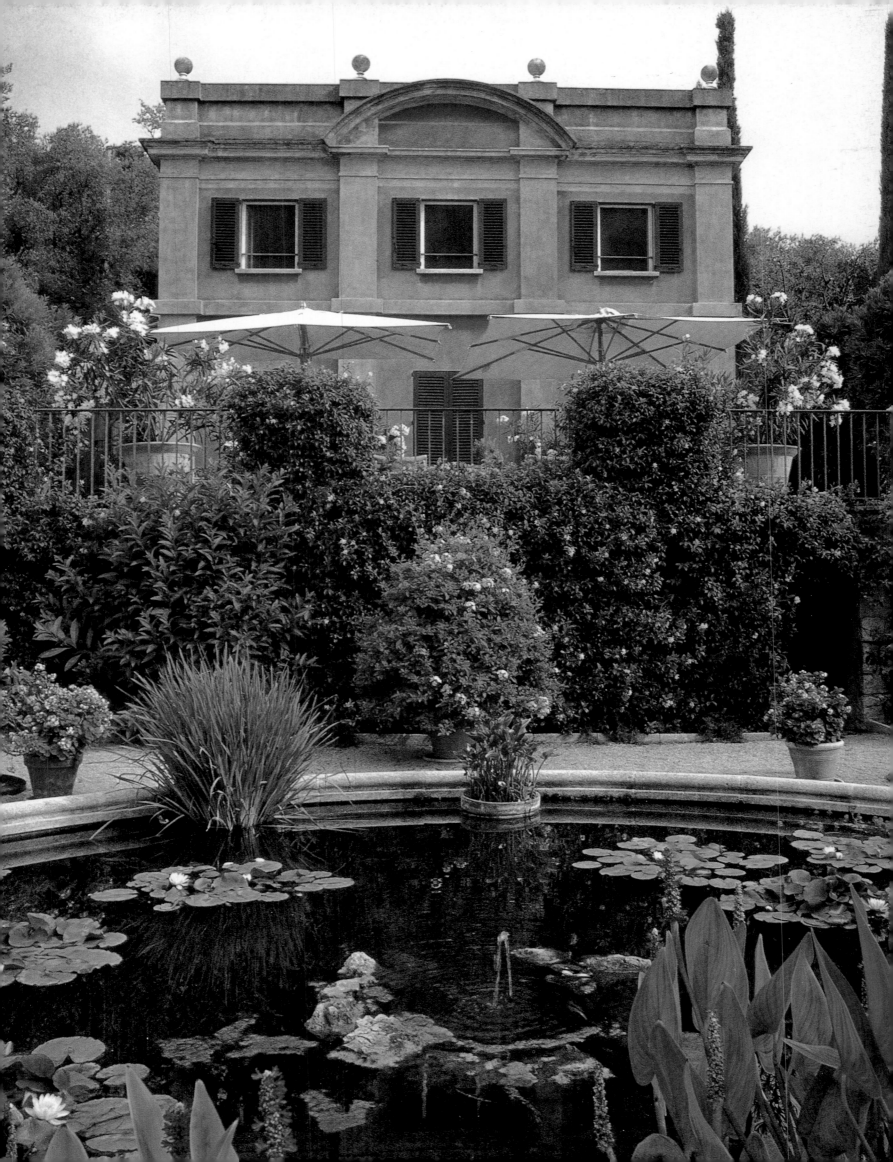

Amateur de plantes et de jardins depuis une dizaine d'années seulement, le propriétaire a su assimiler très vite au fil de lectures, de rencontres et de visites, les connaissances nécessaires à la création d'un beau jardin. Architecte et peintre depuis longtemps sans le savoir, il s'est lancé avec talent dans l'aménagement de ces «restanques» de l'arrière-pays cannois qui servent aujourd'hui d'écrin à une très jolie demeure baptisée «La Casella». Tout y est extrêmement raffiné. Les plantes comptent parmi les plus rares. Les textures des feuillages, la beauté des formes et des volumes, le choix des ornements, le goût des matières nobles: tout concourt à créer un univers où règne l'harmonie. La maison fut construite en 1960 par l'architecte Robert Streitz, élève d'Emilio Terry. Elle est amenée par une cour d'honneur ornée d'arbustes cultivés en pots, disposés autour d'un bassin. La façade orientée au sud regarde une terrasse. La façade tournée vers l'ouest ouvre sur une belle perspective qui s'arrête sur une statue après avoir parcouru un long chemin jalonné de myrtes puis de cyprès. Une pergola drapée de glycines et de *Solanum jasminoides* la domine. Plusieurs «restanques» lui sont soumises: l'une est bordée d'un chemin d'eau, une autre est plantée d'arbres fruitiers, la suivante est ombrée d'arceaux où courent des rosiers, la prochaine dessine un tracé de buis en zigzag, la dernière est un jardin d'agrumes. Les escaliers conduisent de surprise en surprise, de fontaine en bassin, de fleur en parfum.

La Casella

The owner's interest in plants and gardens only goes back some ten years. But through reading, contacts and visits he quickly acquired the knowledge needed to create a beautiful garden. His latent talents as an architect and painter emerged when he set himself to landscaping these "restanques" in the Cannois hinterland; they now form an attractive setting for his house, La Casella. The utmost refinement prevails here. Many of the plants are extremely rare. The textures of the foliage, the beauty of the forms and volumes, the choice ornaments and taste for aristocratic materials all combine to create a harmonious whole. The house was built in 1960 by the architect Robert Streitz, a pupil of Emilio Terry. It is reached through a cobbled courtyard decorated with potted shrubs laid out around a pond. The south façade looks out over a terrace, beneath which stands a further pond. The vista from the west façade is of a narrow lawn leading to a statue, the lawn is initially bordered by myrtle, then cypress. A pergola laden with wisteria and *Solanum jasminoides* overlooks it. The garden incorporates several "restanques"; one is bordered by a narrow canal, another planted with fruit trees, another lies beneath the shade of rose bowers, in the next grows a zig-zag hedge of box, and the last is a citrus garden. Steps lead from one surprise to the next, from fountain and pond to scented shrub and flower.

Der Besitzer des Anwesens ist zwar erst seit rund zehn Jahren Hobbygärtner, eignete sich jedoch durch Lektüre, Gespräche und Reisen rasch ausreichende Kenntnisse an, um einen wunderschönen Garten gestalten zu können. Mit dem Geschick eines Architekten und dem Blick eines Malers machte er sich voll Elan an die Erneuerung der für das Hinterland von Cannes typischen terrassenförmigen »restanques«, die heute sein hübsches Haus La Casella zieren. Die ganze Anlage ist ausnehmend raffiniert und mit seltenen Gewächsen bepflanzt. Von den Blattstrukturen über die Schönheit der zwei- und dreidimensionalen Formen und die Ornamente bis hin zu den edlen Werkstoffen trägt alles zur harmonischen Wirkung dieses kleinen Universums bei. An das 1960 von dem Architekten Robert Streitz, einem Schüler Emilio Terrys, gebaute Haus grenzt ein kiesbestreuter Ehrenhof, der mit Kübelpflanzen rings um ein Wasserbecken geschmückt ist. Die Südfassade blickt auf eine Terrasse und einen darunterliegenden Teich. Von der Westfassade aus wandert der Blick über einen erst von Myrten, dann Zypressen gesäumten, langgestreckten Weg bis zu einer Statue, dann an einer von Glyzinen und Nachtschatten *(Solanum jasminoides)* überrankten Pergola entlang, an die sich eine Reihe von »restanques« anschließt: Die erste folgt dem Lauf eines kleinen Baches, die zweite ist mit Obstbäumen bepflanzt, die dritte liegt im Schatten rosenüberwucherter Rankbögen, die nächste ist mit einer Zickzacklinie aus Buchsbaum und die letzte mit Zitrusbäumen bepflanzt. Die Treppen führen von einer Überraschung zur nächsten, von Brunnen zu Teich, von Blüte zu Duft.

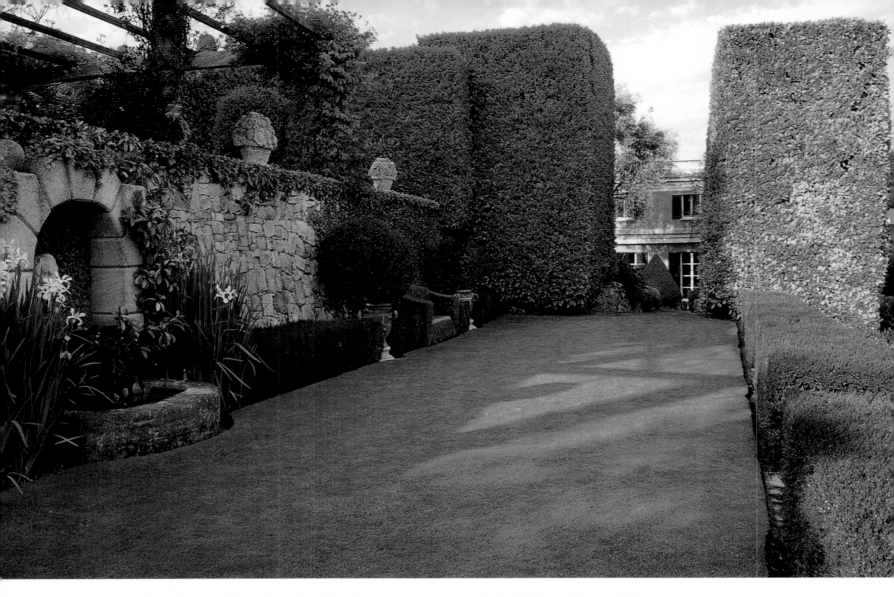

Première page: La maison ocre fut inspirée par le pavillon de Pompadour construit par l'architecte Jacques Ange Gabriel (1698–1782) à Fontainebleau. Les murs de la terrasse sont habillés de *Trachelospermum.* Un bassin circulaire s'étend en contrebas.
Ci-dessus: La façade ouest de la maison ouvre sur la grande perspective scandée de bancs insérés dans des buis, entre des haies de myrtes *(Myrtus communis ssp. tarentina).* Sous la pergola, une fontaine encadrée d'*Iris orientalis* blancs.
Détails à droite: gros plan sur un banc; le bassin de la fontaine est orné de *Pontederia.*

First page: The house's ochre façade was inspired by the Pompadour Pavilion built by the architect Jacques Ange Gabriel (1698–1782) at Fontainebleau. Jasmin star *(Trachelospermum)* curtains the terrace walls; below them is a round pond.
Above: The west façade of the house opens onto a deep vista with stone benches set in box along the myrtle hedges *(Myrtus communis ssp. tarentina).* Under a pergola, the fountain is framed by white *Iris orientalis.*
Details right: close-up of a bench; a fountain planted with pickerelweed *(Pontederia).*

Eingangsseite: Als Vorbild für das ockerfarbene Gebäude diente der von dem Architekten Jacques Ange Gabriel (1698–1782) in Fontainebleau errichtete Pavillon der Madame de Pompadour. Die Terrassenmauern sind mit Sternjasmin *(Trachelospermum)* bewachsen. Etwas unterhalb liegt ein rundes Wasserbecken.
Oben: Von der Westfassade des Hauses eröffnet sich eine prächtige Aussicht in den Garten. Die Myrtenhecke *(Myrtus communis ssp. tarentina)* wird hier und dort von Bänken unterbrochen, die in Buchsbaum hineingeschnitten sind. Unter der Pergola befindet sich ein von weißen Schwertlilien *(Iris orientalis)* eingefaßter Brunnen.
Details unten: Großaufnahme einer Bank; ein mit Hechtkraut *(Pontederia)* bepflanztes Brunnenbecken.

La Casella *Côte d'Azur*

Ci-dessous: L'une des «restanques» est bordée de lavandes, de cyprès *(Cupressus sempervirens)* et de chênes verts *(Quercus ilex),* taillés en boule. Au fond, un banc en teck s'appuie sur des *Pittosporum tenuifolium.*
A droite: gros plan depuis le jardin bleu: *Scilla peruvianus;* Echium.

Below: One of the "restanques" is bordered with lavender, cypress *(Cupressus sempervirens)* and pollarded holm oaks *(Quercus ilex).* A teak bench at the end of the vista.
Right: close-ups in the blue garden: *Scilla peruvianus;* viper's-bugloss *(Echium).*

Unten: Eine der »restanques« ist von Lavendel, Zypressen *(Cupressus sempervirens)* und kugelig geschnittenen Stein-eichen *(Quercus ilex)* gesäumt. Im Hintergrund steht eine Teakholzbank zwischen dünnblättrigen Klebsamen *(Pittosporum tenuifolium).*
Rechts: Detailaufnahmen aus dem blauen Garten: *Scilla peruvianus;* Natternkopf *(Echium).*

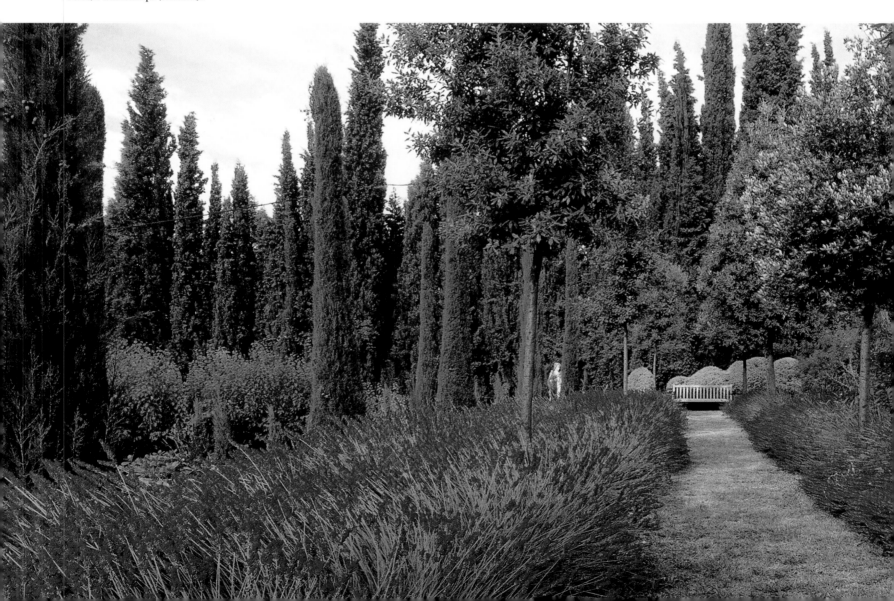

A droite: Le jardin d'agrumes s'étend sur la dernière «restanque». Chaque oranger est cultivé en pleine terre, comme posé sur un socle en buis. Devant une rangée de rosiers 'Feé des neiges', des pots d'agapanthes.

Ci-dessous: De la pergola, on domine le verger et ses pruniers en fleurs. Plus loin, des céanothes *(Ceanothus cyaneus)* déploient leurs somptueuses floraisons bleues. A gauche, des haies de cyprès séparent les jardins en «restanques» des chambres de verdure disposées autour de la maison.

Right: The last "restanque" contains the citrus garden. The orange trees are cultivated directly in the ground, within a little "pedestal" of box. In front of the bed of 'Iceberg' roses, a row of potted agapanthus.

Below: From the pergola, one looks down on the orchard and its flowering plums. Beyond, the sumptuous blue flowers of the ceanothus *(Ceanothus cyaneus)*. To the left, the cypress hedges separate the "restanque" gardens from the green enclosures around the house.

Rechts: Der Zitrusgarten erstreckt sich auf der letzten »restanque«. Jeder Orangenbaum ist direkt in die Erde gepflanzt und ringsum von einer kleinen Buchsbaumhecke wie von einem Sockel eingefaßt. Vor einer Reihe Rosen der Sorte 'Schneewittchen' stehen Schmucklilien *(Agapanthus)* in Kübeln.

Unten: Von der Pergola aus schaut man auf den Obstgarten mit seinen blühenden Pflaumenbäumen. Weiter hinten prunken blau blühende Säckelblumen *(Ceanothus cyaneus)*. Links sieht man die Zypressenhecken, welche die Gärten der »restanques« vom Grün um das Haus herum abtrennen.

Ci-dessus: une «restanque» où dominent les bleus. A gauche, des céanothes à petit développement *(Ceanothus griseus var. horizontalis* 'Yankee Point') surmontées d'un arbuste, *Alyogyne huegelii.* Au centre, *Ceanothus cyaneus.* En bas à droite, des giroflées.
Double page suivante, dans le sens des aiguilles d'une montre: Le jardin d'agrumes est orné d'un bassin circulaire cerné de buis et planté d'helxine; un escalier part du jardin d'agrumes et monte vers les «restanques»; à côte de la maison d'amis, au niveau du jardin d'agrumes, un *Fremontodendron* avec ses fleurs jaunes; un bassin sur les «restanques», planté de *Pontederia* et de lotus et entouré d'*Iris orientalis* blancs.

Above: a "restanque" all in shades of blue. To the left, small ceanothus bushes *(Ceanothus griseus var. horizontalis* 'Yankee Point') under the shrubby *Alyogyne huegelii.* In the centre, *Ceanothus cyaneus.* In the bottom right-hand corner, gilly-flowers.
Following pages, clockwise from top left: the ornamental round pond of the citrus garden, bordered by box and planted with helxin; the steps lead from the citrus garden to the "restanques"; near the guesthouse, seen from the citrus garden, a poppy tree *(Fremontodendron)* with its yellow flowers; a pond planted with pickerelweed *(Pontederia)* and lotus, and surrounded by white *Iris orientalis.*

Oben: eine überwiegend in Blautönen gehaltene »restanque«. Links die schwachwüchsige Säckelblume *Ceanothus griseus var. horizontalis* 'Yankee Point', darüber ein Hibiskusstrauch der Art *Alyogyne huegelii.*
Folgende Doppelseite, im Uhrzeigersinn von links oben: Das runde Bassin des Springbrunnens im Zitrusgarten ist mit Buchsbaum eingefaßt und von Bubiköpfchen *(Helxine)* überwuchert; über die Treppe steigt man vom Zitrusgarten hinauf zu den übrigen »restanques«; neben dem Gästehaus auf Höhe des Zitrusgartens ein gelbblühender *Fremontodendron;* der Teich ist mit Hechtkraut *(Pontederia)* und Lotus besetzt und von weißen *Iris orientalis* umgeben.

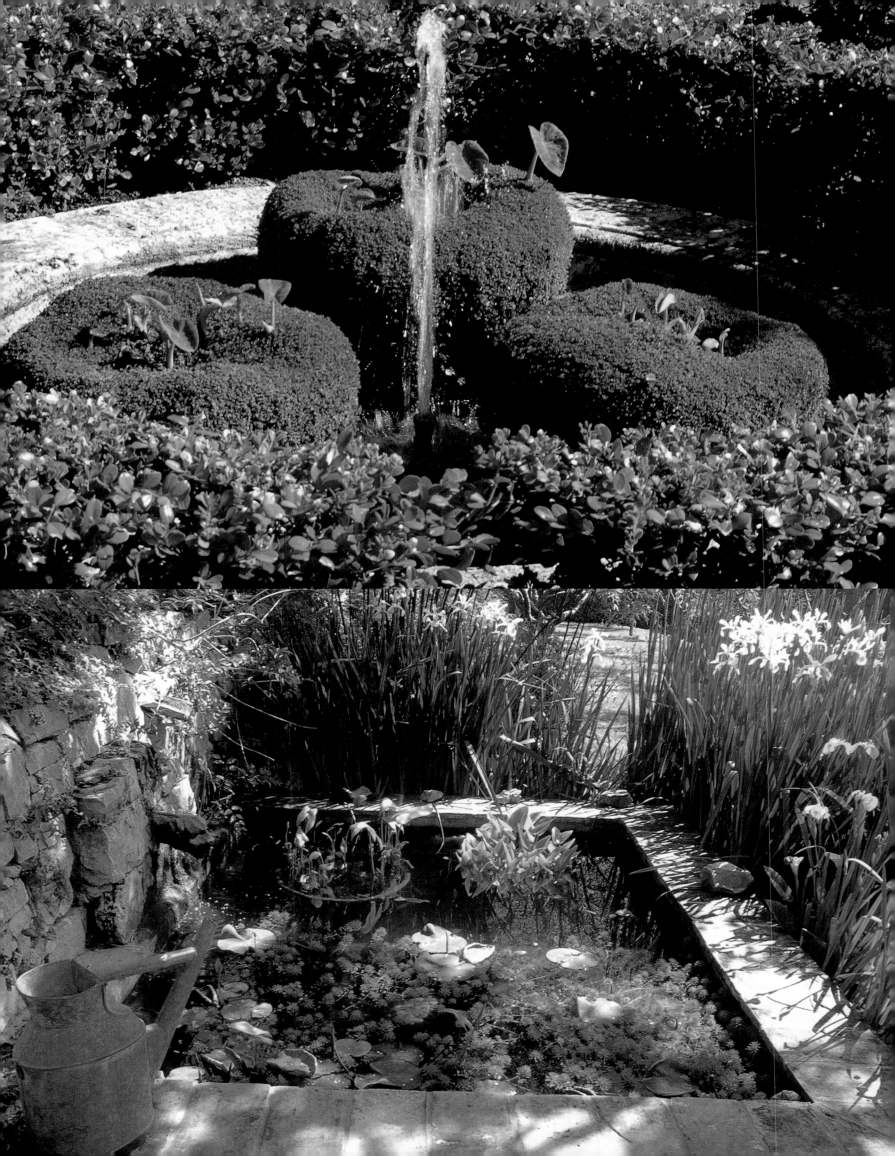

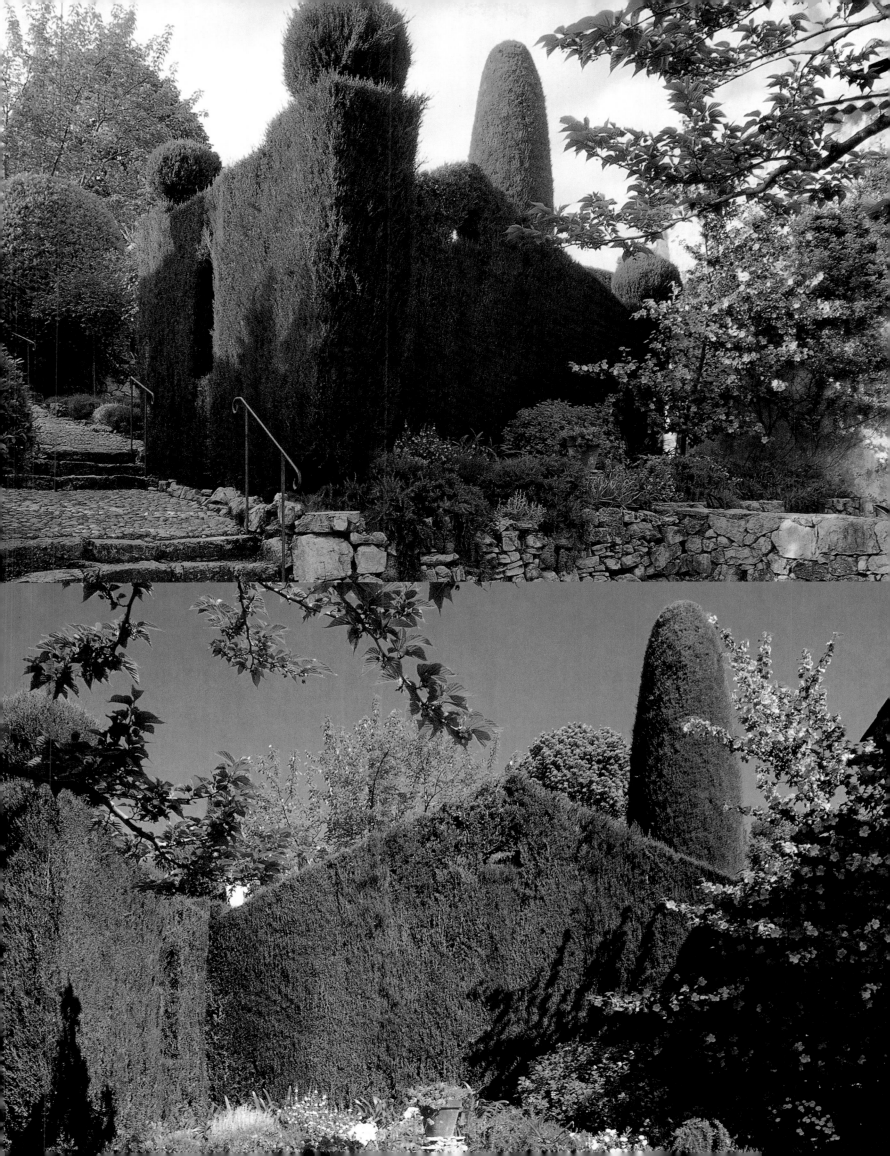

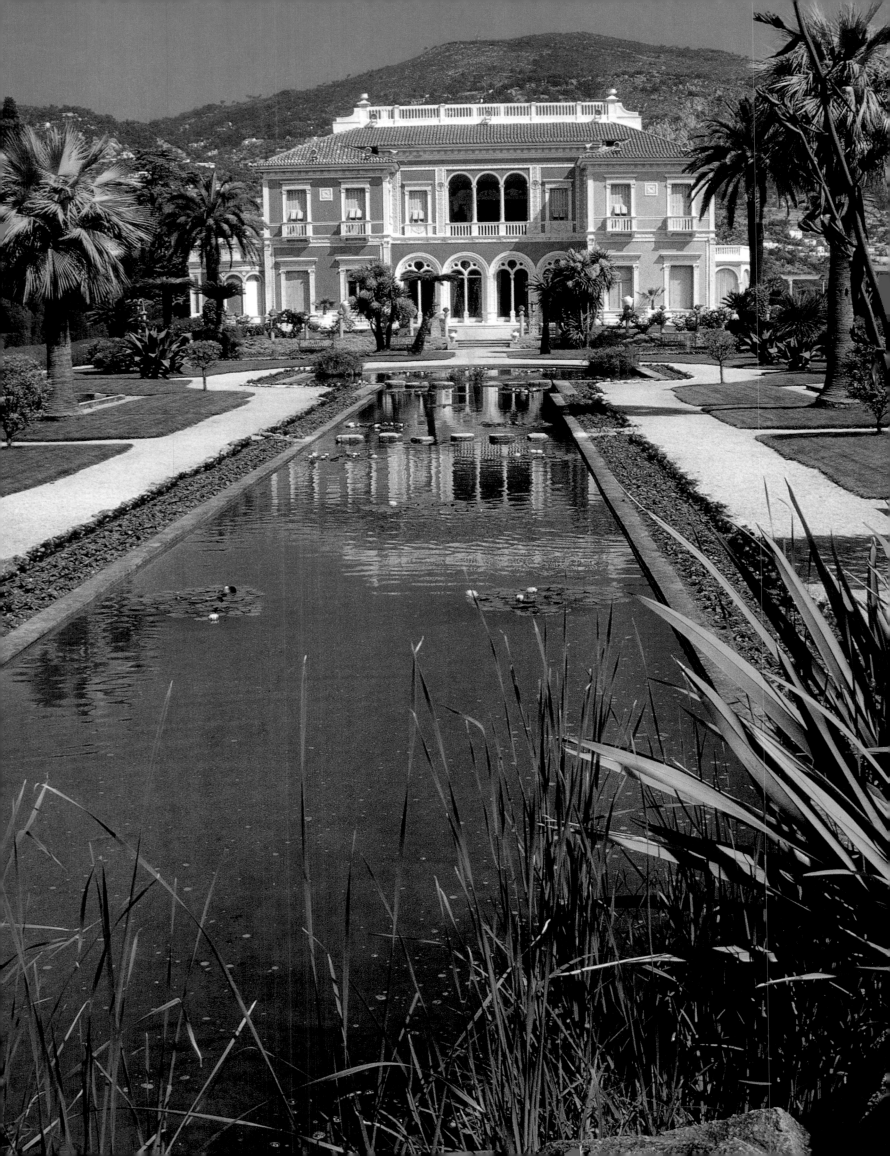

La baronne Béatrice Ephrussi de Rothschild avait le goût des jardins. En 1905, elle fit l'acquisition de plusieurs hectares situés sur la presqu'île de Saint-Jean-Cap-Ferrat où elle fit construire une villa rose d'inspiration vénitienne. Elle y rassembla ses collections de meubles et d'objets d'arts rapportés de ses nombreux périples à travers le monde. Puis elle habilla ses jardins de ses souvenirs de voyage. L'Asie, l'Italie et l'Espagne furent ses sources d'inspiration. Elle dépêcha architectes et jardiniers pour mettre ses désirs à exécution et donna naissance à sept jardins. Un jardin ordonné à la française sert de présentation à la villa et dispose des végétaux exotiques et méditerranéens autour d'un long bassin. Là, des palmiers, des agaves et des dracaenas bordent un miroir d'eau vert et rejoignent un promontoire surmonté d'un temple circulaire à colonnades, inspiré de celui du Trianon. En contrebas, plusieurs jardins secrets se font suite, que l'on découvre après avoir descendu l'escalier en fer à cheval de la cour d'honneur. Le jardin espagnol est luxuriant et rafraîchissant grâce à une fontaine qui dispense de l'eau sous une pergola. Le jardin florentin planté de cyprès jouxte le jardin lapidaire qui rassemble toutes sortes de colonnades, bas-reliefs et chapiteaux sculptés. Viennent ensuite le jardin japonais avec ses pins et ses bambous, le jardin exotique avec sa rocaille et enfin la roseraie. Sept jardins, sept décors imaginaires pour un voyage autour de la terre.

Villa Ephrussi de Rothschild

The Baronne Béatrice Ephrussi de Rothschild was a great garden-lover. In 1905, she purchased several hectares on the Saint-Jean-Cap-Ferrat peninsula, where she built a pink villa in Venetian style. Here she brought together the collection of furniture and "objets d'art" that she had brought back from her many trips around the world. She designed the gardens to remind her of her travels; Asia, Italy and Spain were her sources of inspiration. She commissioned architects and gardeners to realise her vision and seven gardens resulted. A French-style garden surrounds the villa. Mediterranean and exotic plants are arranged around a central canal. There, palms, agaves, and dragon trees *(Dracaena)* border the reflective green water, which leads to a circular peristyle temple inspired by that of the Trianon. Below it, several secret gardens follow one after another; they are revealed only as one reaches the foot of the horseshoe-shaped staircase from the main courtyard. The cool luxuriance of the Spanish garden is maintained by a fountain beneath a pergola. The Florentine garden is planted with cypresses. Next to it is the "jardin lapidaire" which features a variety of colonnades, low-reliefs and sculpted capitals. Then comes the Japanese garden with its pines and bamboos, the exotic garden with its rockery, and finally a rose garden. To walk through the seven gardens is to make a voyage around the world.

Baronin Béatrice Ephrussi de Rothschild liebte Gärten. 1905 erwarb sie mehrere Hektar auf der Halbinsel Saint-Jean-Cap-Ferrat und ließ sich dort eine rosa Villa nach venezianischen Vorbildern erbauen. Hier sammelte sie die von ihren vielen ausgedehnten Reisen mitgebrachten Möbel und Kunstwerke aus aller Welt. Die auf Reisen in Asien, Italien und Spanien gewonnenen Eindrücke ließ sie zu guter Letzt in die Gärten einfliessen, die nach ihren Vorstellungen von Landschaftsarchitekten und Gärtnern angelegt wurden. So entstanden sieben Gärten. Der erste, im strengen französischen Stil gehaltene Garten bildet den Rahmen für die Villa; rings um das langgestreckte Wasserbecken finden sich tropische und mediterrane Gewächse. Palmen, Agaven und Drachenbäume *(Dracaena)* umrahmen den grünen Wasserspiegel bis zu einem Felsvorsprung mit einem säulengeschmückten Rundtempelchen, dem dasjenige beim Trianon als Modell diente. Steigt man vom Ehrenhof über die hufeisenförmig geschwungene Treppe hinab, entdeckt man weiter unten weitere Gärten. Der spanische Garten ist üppig grün und dank des unter einer Pergola plätschernden Springbrunnens sehr erfrischend. An den Florentiner Garten mit seinen Zypressen grenzt der Steingarten, in dem Kolonnaden, Flachreliefs und reich verzierten Kapitelle gesammelt sind. Hieran schließen sich der japanische Garten mit Kiefern und Bambus, der Tropengarten mit Grotten und zuletzt der Rosengarten an: sieben Gärten, sieben phantasievolle Szenerien, die den Betrachter auf eine Reise rund um die Welt einladen.

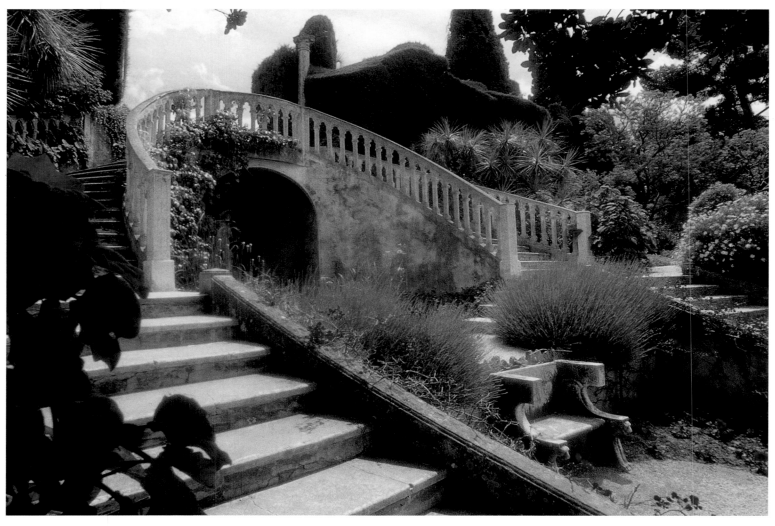

Première page: Le jardin à la française se déploie autour d'un long bassin rectangulaire, devant la villa rose d'inspiration vénitienne.

Ci-dessus et à droite: Cet escalier en fer à cheval part de la cour d'honneur et descend vers les jardins situés en contrebas, qui ouvrent sur la baie de Villefranche.

Page de droite: La perspective du jardin à la française se ferme sur un temple circulaire à colonnades inspiré de celui du Trianon à Versailles et perché sur un promontoire.

First page: The French garden is laid out around a long rectangular pool in front of the pine Venetian-style villa.

Above and right: This horseshoe-shaped staircase leads down from the main courtyard to the gardens beneath, which open onto the bay of Villefranche.

Facing page: the vista down the French garden to the circular peristyle temple inspired by that of the Trianon at Versailles and perched on a promontory.

Eingangsseite: Das langgestreckte rechteckige Becken vor der rosafarbenen Villa im venezianischen Stil ist der Mittelpunkt des französischen Gartens.

Oben und rechts: Die hufeisenförmige Treppenanlage führt vom Ehrenhof zu den verschiedenen Gärten hinab, von denen man auf die Bucht von Villefranche blickt.

Rechte Seite: Über den französischen Garten sieht man zu einem von Säulen getragenen Rundtempel auf einem Felsvorsprung. Als Vorbild diente der Tempel des Trianon in Versailles.

Villa Ephrussi de Rothschild *Côte d'Azur*

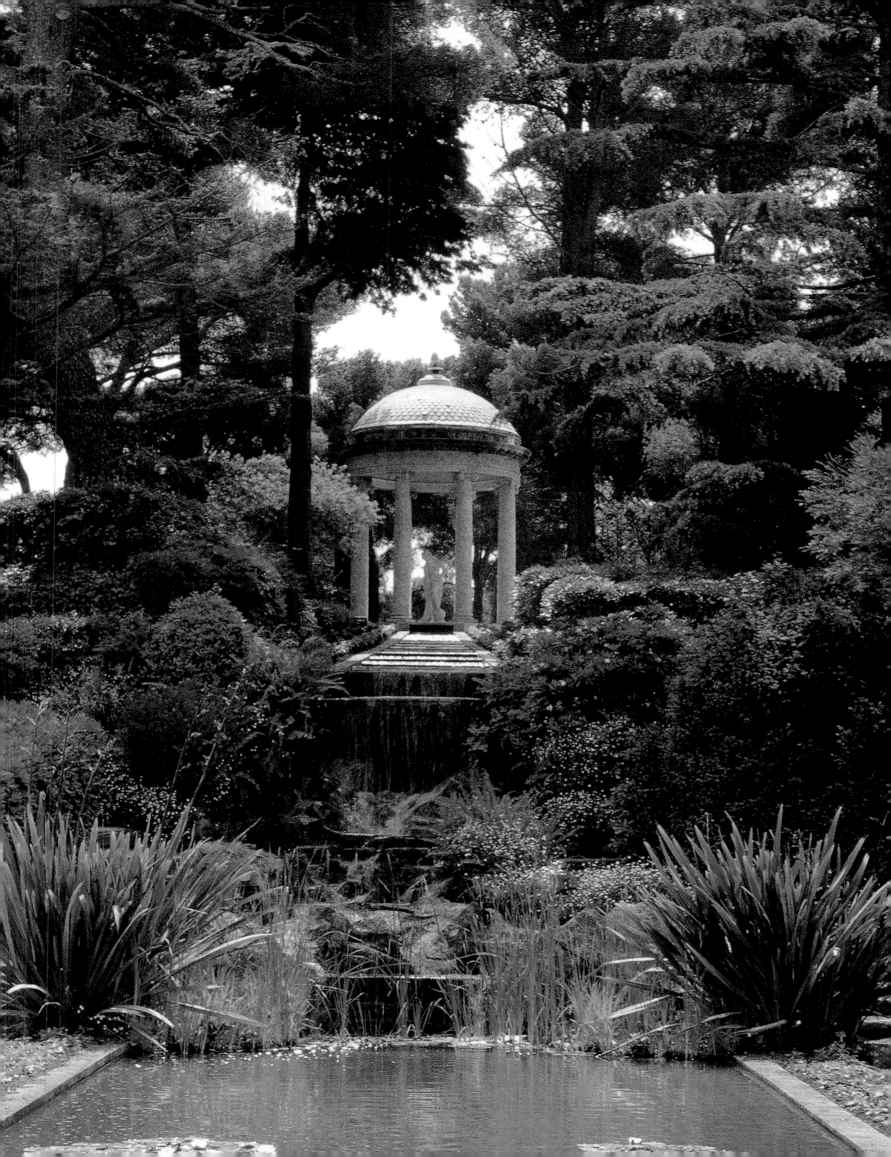

A droite et ci-dessous: On découvre le jardin lapidaire après avoir parcouru l'allée florentine rythmée de colonnades et de cyprès.

Right and below: The "jardin lapidaire" is reached through the Florentine path bordered by colonnades and cypresses.

Rechts und unten: Der Steingarten liegt jenseits der von Säulen und Zypressen gesäumten Florentiner Allee.

Ci-dessus et à droite: Le jardin lapidaire est ombré de camphriers *(Cinnamomum camphora)* et d'arbres de Judée *(Cercis siliquastrum)*. Il regroupe des souvenirs de voyages rapportés par la baronne Béatrice Ephrussi de Rothschild: chapiteaux, bas-reliefs et colonnades.

Above and right: Camphor trees *(Cinnamomum camphora)* and Judas trees *(Cercis siliquastrum)* give shade to the "jardin lapidaire", which is home to the Baronne Béatrice Ephrussi de Rothschild's collection of capitals, low reliefs and colonnades – the spoils of her travels.

Oben und rechts: Im Schatten von Kampferbäume *(Cinnamomum camphora)* und Judasbäumen *(Cercis siliquastrum)* liegt der Steingarten. Die Kapitelle, Reliefs und Kolonnaden brachte Baronin Ephrussi de Rothschild von ihren Reisen mit.

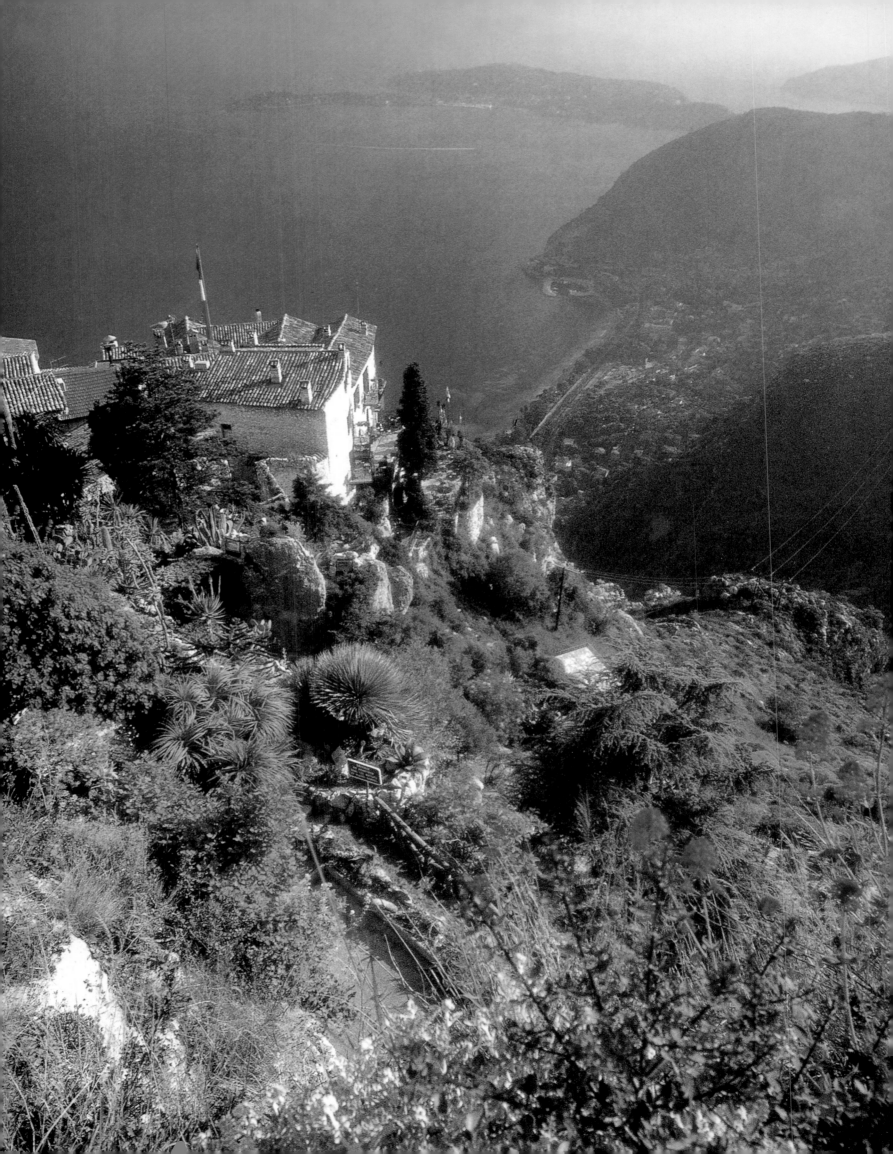

Le site est l'un des plus beaux du monde. Le jardin est accroché sur un piton rocheux dominant la mer. Tout en bas, la côte se découpe sur un fond bleu, et au loin, quand l'air est clarifié par le mistral, on aperçoit les îles du Levant, les îles de Lerins et parfois même, la Corse. Ce jardin exotique fut créé en 1949 grâce à la Commune d'Eze qui suivit les conseils du spécialiste Jean Gastaud également attaché au Jardin exotique de Monaco. On y parvient après avoir gravi la colline et traversé les rues du village semées de maisons pittoresques. Là, sur les ruines de l'ancien château, fut installée une étonnante collection de plantes originaires d'Amérique centrale, des Antilles, d'Amérique du Sud ou d'Afrique australe et appartenant aux familles des cactacées, agavacées, liliacées et euphorbiacées. Les sentiers sinuent au milieu de coussins épineux, de cierges de plusieurs mètres de haut, de feuilles coriaces et géantes et de fleurs aux couleurs éclatantes. Les amateurs de botanique y rencontreront des «coussins de belle-mère» *(Echinocactus grusonii)*, des «têtes de vieillards» *(Cephalocereus senilis)* avec leurs longs poils blancs, des candélabres monstrueux *(Cereus peruvianus monstruosus)*, des agaves communs ou rares, des «figuiers de barbarie», des oponces et toutes sortes d'aloès. Il faut saisir les fleurs au bon moment car certaines succulentes ne fleurissent qu'une fois dans leur vie et d'autres n'émettent des inflorescences que la nuit.

Le Jardin exotique d'Eze

The site is one of the most beautiful in the world. The garden is perched on an outcrop that stands high above the ocean. Immediately below, the coast is delineated by the deep blue sea. When the air is clear after the mistral, one can see the Levant and Lerin islands and sometimes even Corsica. This exotic garden was created in 1949 thanks to the village council of Eze, which was advised by Jean Gastaud, a consultant to the Jardin exotique in Monaco. The garden is reached by a road that leads up the hill and through the picturesque streets of the village. There, the ruins of the castle have been planted with an astonishing collection of Cactaceae, Agavaceae, Liliaceae and Euphorbiaceae from Central and South America, the West Indies, and Southern Africa. The paths meander through thorny cushions, candelabra several metres tall, gigantic leathery leaves and flowers in startling colours. Here we find the Mother-in-law's-seat *(Echinocactus grusonii)*, old-man cactus *(Cephalocereus senilis)* with its profusion of long white hairs, huge columnar cacti such as *Cereus peruvianus monstruosus*, common and rare agaves, barbary figs, prickly pears and all kinds of aloes. One must time one's visits carefully; some of the succulents flower once in their lifetime, while others blossom only at night.

Der Garten liegt an einem der schönsten Orte der Welt auf einem felsigen Berghang hoch über dem Meer. Tief darunter zeichnet sich die Küstenlinie vor dem blauen Hintergrund ab, und wenn der Mistral, der kühle Wind in der Provence, die Luft klärt, sieht man in der Ferne die Iles du Levant und die Ile de Lerins, manchmal sogar Korsika. Dieser Tropengarten entstand 1949 auf Initiative der Gemeinde Eze nach Empfehlungen des Experten Jean Gastaud, der auch den Tropengarten von Monaco betreute. Zur Gartenanlage steigt man den Hügel hinauf und durchquert das Dorf mit seinen malerischen Häusern. Hier oben, auf den Ruinen des alten Schlosses, befindet sich eine eindrucksvolle Sammlung von Kakteen, Agaven, Lilien und Euphorbien, deren Heimat Mittelamerika, die Antillen, Südamerika und Südafrika sind. Die Pfade winden sich zwischen stacheligen Kugeln, meterhohen Säulen, zähen Riesenblättern und Blüten in leuchtenden Farben hindurch. Wer sich für Botanik interessiert, findet hier den »Schwiegermuttersessel« *Echinocactus grusonii* ebenso wie das »Greisenhaupt« *(Cephalocereus senilis)* mit seinem langen weißen Flaum, den wie ein bizarrer Kerzenleuchter anmutenden Säulenkaktus *(Cereus peruvianus monstruosus)*, gängige und seltene Agaven, Feigenkakteen, Opuntien und alle möglichen Sorte Aloe. Entscheidend ist der richtige Zeitpunkt des Besuchs, denn manche Sukkulenten blühen nur ein einziges Mal in ihrem Leben, andere nur nachts.

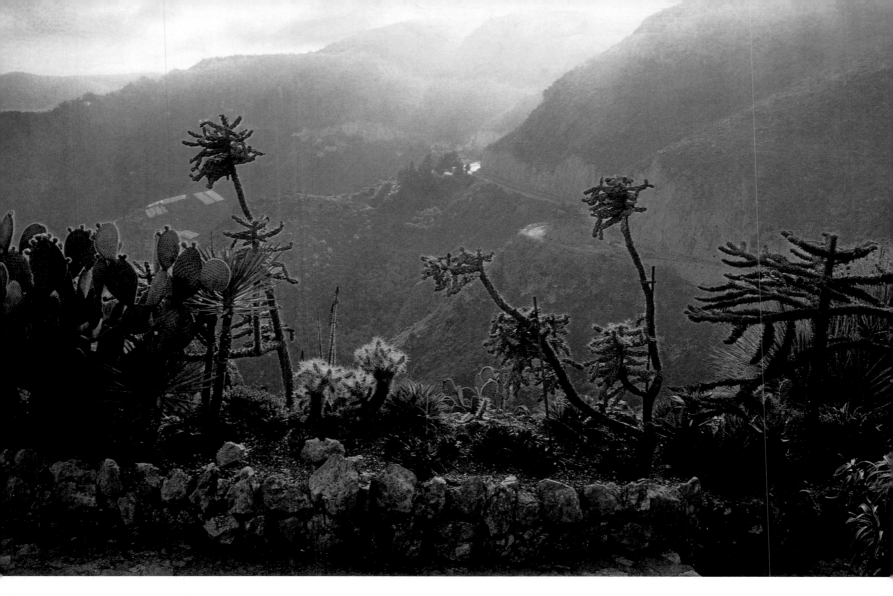

Première page: Le village est perché sur un promontoire rocheux qui domine la côte, non loin de la presqu'île de Saint-Jean-Cap-Ferrat.
Ci-dessus: Le jardin surplombe un à-pic planté de garrigue et ouvre sur un paysage méditerranéen desservi par une corniche.
A droite: Le paysage environnant est sec et aride. Le jardin est orienté au sud et cette exposition convient aux plantes désertiques.

First page: The village is perched on a rocky promontory with extensive views over the coast and the nearby peninsula of Saint-Jean-Cap-Ferrat.
Above: The garden is on the edge of a cliff face planted with scrub and opens onto a Mediterranean landscape through which runs a road cut into the mountain side.
Right: The surrounding countryside is arid and stony. The garden's south-facing situation suits the desert plants.

Eingangsseite: Das Dorf ist auf einem steilen Felsvorsprung erbaut, der die Küste nach der Halbinsel Saint-Jean-Cap-Ferrat beherrscht.
Oben: Der Garten liegt oberhalb einer mit »garrigue« bewachsenen Steilwand und überblickt eine Mittelmeerlandschaft, die von einer der kurvenreichen Küstenstraßen durchzogen wird.
Rechts: Die Umgebung ist trocken und karg. Der Garten ist nach Süden ausgerichtet und bietet deshalb die richtigen Bedingungen für die Sukkulenten.

Le Jardin exotique d'Eze *Côte d'Azur*

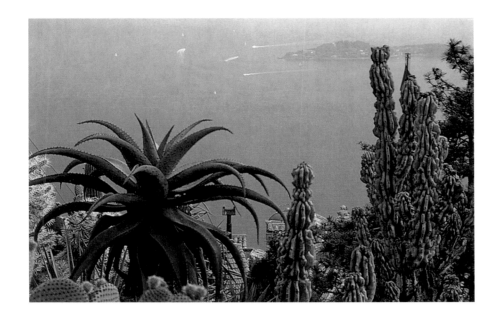

A droite et ci-dessous: Les silhouettes spectaculaires des succulentes s'harmonisent parfaitement avec le décor grandiose de ce bord de Méditerranée.

Right and below: The magnificent silhouettes of the succulents are a wonderfully apt addition to the spectacular Mediterranean coastline.

Rechts und unten: Die bizarren Silhouetten der Sukkulenten fügen sich nahtlos in die grandiose Szenerie der Mittelmeerküste ein.

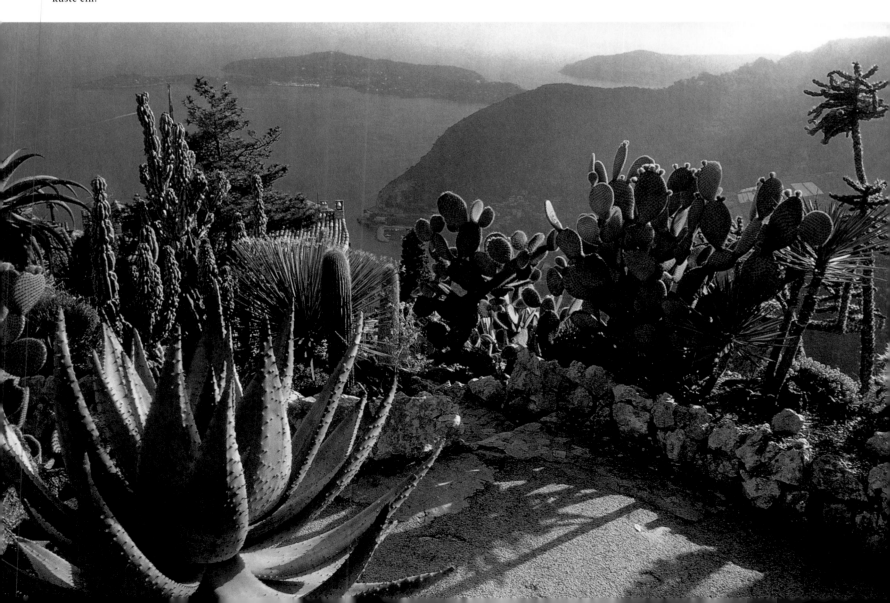

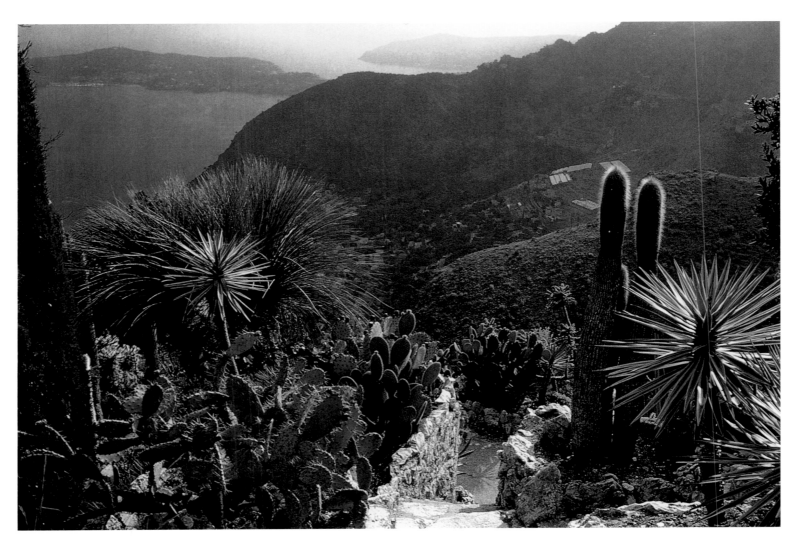

Ci-dessus et page de droite: Les succulentes peuvent prendre la forme de coussins, de longs cierges ou de raquettes épineuses aux couleurs discrètes ou chatoyantes.
Double page suivante: Elles peuvent émettre des fleurs d'une grande beauté ou prendre des formes éléphantesques et torturées.

Above and facing page: The succulents are of various shapes, some like cushions, others like long candles or thorny racquets; some bear muted colours, others are dazzling.
Following pages: Some of the plants beautifully, others exhibit gnarled, elephantine forms.

Oben und rechte Seite: Hier gibt es Sukkulenten in Form von Kissen, hohen Säulen oder stacheligen Scheiben, in dezenten oder grellen Farben.
Folgende Doppelseite: Manche Pflanzen haben wunderschöne Blüten, andere weisen überdimensionale verschlungene Formen auf.

Le Jardin exotique d'Eze *Côte d'Azur*

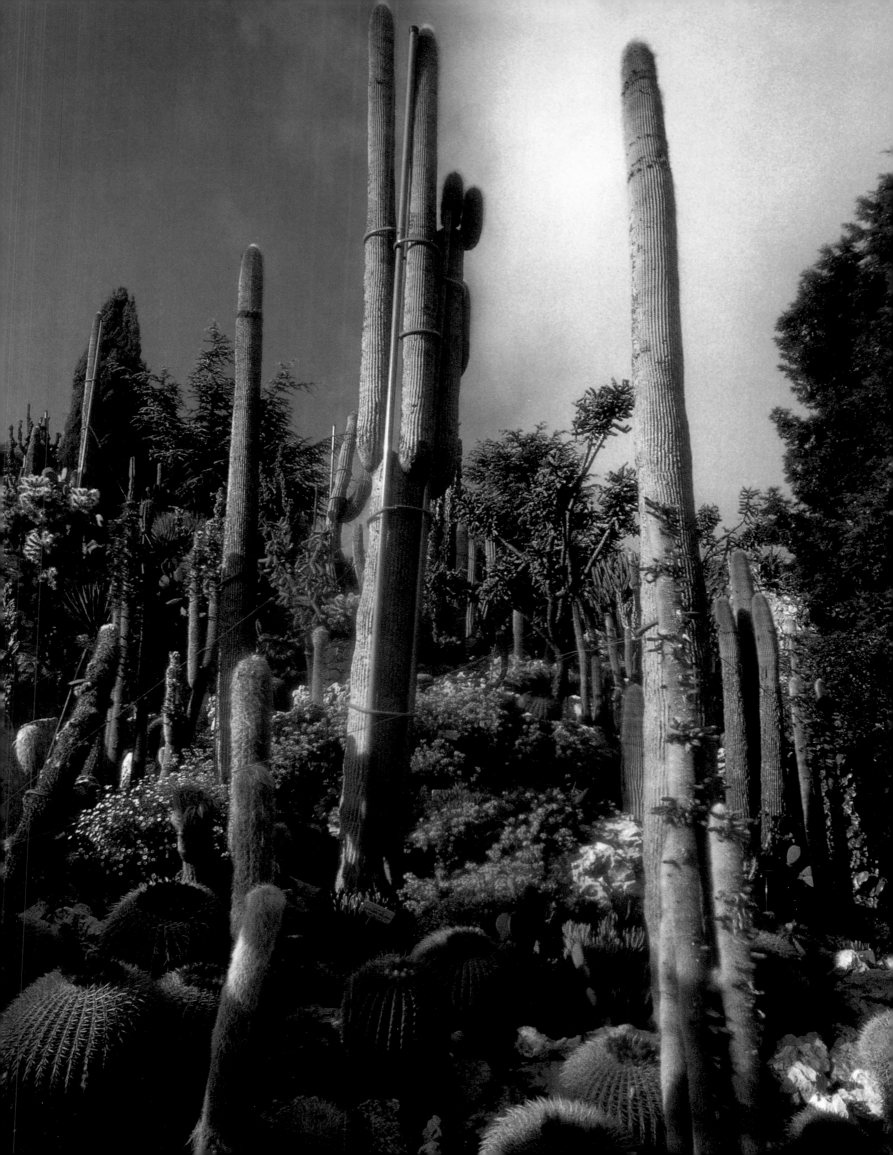

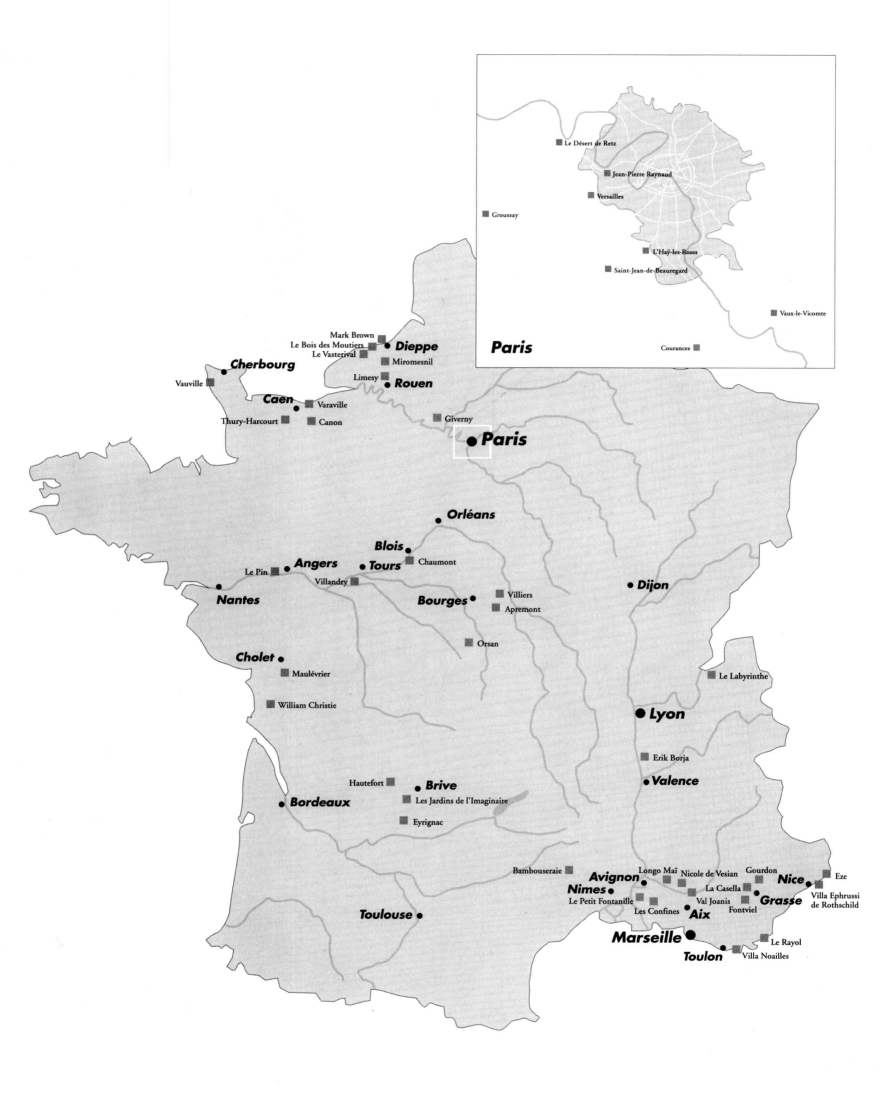

Paris

Le Désert de Retz

Jean-Pierre Raynaud

Versailles

Groussay

L'Haÿ-les-Roses

Saint-Jean-de-Beauregard

Vaux-le-Vicomte

Courances

Mark Brown
Le Bois des Moutiers
Le Vasterival
Dieppe
Miromesnil
Cherbourg
Limesy
Rouen
Vauville
Caen
Varaville
Thury-Harcourt
Canon
Giverny
Paris

Orléans

Blois
Tours
Chaumont
Le Pin
Angers
Villandry
Nantes
Bourges
Villiers
Apremont
Dijon

Orsan

Cholet
Maulévrier

Le Labyrinthe

William Christie

Lyon

Erik Borja

Hautefort
Brive
Valence
Les Jardins de l'Imaginaire
Bordeaux
Eyrignac

Bambouseraie
Longo Maï
Nicole de Vesian
Gourdon
Avignon
Nice
Eze
Nîmes
La Casella
Le Petit Fontanille
Val Joanis
Grasse
Les Confines
Fontviel
Villa Ephrussi
de Rothschild
Aix

Toulouse

Marseille
Le Rayol
Toulon
Villa Noailles

Un aperçu des jardins | The Gardens at a Glance | Alle Gärten im Überblick

Le Domaine de Vaux-le-Vicomte

77950 Maincy
Tel. 01 64 14 41 90 | www.vaux-le-vicomte.com

Page/Seite 10–19

Accès: 55 km de Paris par l'autoroute A 6 ou par les autoroutes A 4 et A 5; gare SNCF: Melun
Heures de visite: tous les jours de 10 h à 18 h d'avril à octobre, sur rendez-vous de novembre à mars; jeux d'eau: d'avril à octobre, le deuxième et le dernier samedi du mois, de 15 h à 18 h, soirées aux chandelles: de mai à début octobre, chaque samedi; de mi-juillet à fin août, également le vendredi de 20 h à 23 h
Chef-d'œuvre d'équilibre et de proportions, cette composition soumise au château fait triompher le jardin à la française grâce à ses perspectives et ses jeux d'eau.

How to get there: 55 km from Paris, via the A 6 or the A 4 and A 5; station: Melun
Opening times: April to October: daily 10am–6pm, November to March: by arrangement; "Jeux d'eaux" (fountain displays): April to October on the second and last Saturdays of every month, 3–6pm, "Soirées aux chandelles" (candlelight evenings): May to early October every Saturday, mid-July to August every Friday and Saturday 8–11pm
A masterpiece of balance and proportion, the park is an outstanding example of the French style of garden thanks to its vistas and fountains.

Anfahrt: 55 km von Paris über die A 6 oder die A 4 und A 5; Bahnhof: Melun
Öffnungszeiten: April bis Oktober: täglich 10–18 Uhr, November bis März: nach Vereinbarung; »Jeux d'eaux« (Wasserspiele): April bis Oktober am zweiten und letzten Samstag im Monat 15–18 Uhr, »Soirées aux chandelles« (Lichterabende): Mai bis Anfang Oktober: samstags, Mitte Juli bis August: auch freitags 20–23 Uhr
Der Schloßpark mit seinen meisterhaft ausgewogenen Proportionen stellt dank seiner Blickachsen und Wasserspiele einen Höhepunkt der klassischen französischen Gartenkunst dar.

La Roseraie du Val-de-Marne à l'Haÿ-les-Roses (Roseraie du Val-de-Marne)

Rue Albert Watel
94240 L'Haÿ-les-Roses
Tel. 01 43 99 82 80 | www.roseraieduvaldemarne.fr

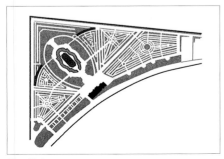

Page/Seite 20–29

Accès: 5 km de Paris par la N 7 et la N 20, ou par la A 86 et la D 126; RER ligne B, station Bourg-la-Reine puis autobus 172 ou 192; métro: station Porte d'Italie et autobus 186 ou 184
Heures de visite: du 15 mai au 15 septembre: de 10 h à 20 h; visites en groupe sur rendez-vous
Restaurant
La Roseraie du Val-de-Marne a été la première du genre en Eu-

rope. Les treize jardins abritent 3 300 espèces (en l'occurrence 16 000 plants) de rosiers dont 85 pour cent ont été cultivés avant 1950.

How to get there: 5 km from Paris, via the N 7 and N 20 or the A 86 and D 126; RER Ligne B: Station Bourg-la-Reine and bus 172 or 192; Metro: Station Porte d'Italie and bus 186 or 184
Opening times: mid-May to mid-September: 10am–8pm; groups by arrangement
Restaurant
The Val-de-Marne rose garden was the first of its kind in Europe. The thirteen gardens contain 3,300 species of rose (16,000 plants) of which 85 per cent date from before 1950.

Anfahrt: 5 km von Paris über die N 7 und N 20 oder die A 86 und D 126; RER Ligne B: Station Bourg-la-Reine und Bus 172 oder 192; Metro: Station Porte d'Italie und Bus 186 oder 184
Öffnungszeiten: Mitte Mai bis Mitte September: 10–20 Uhr; Gruppen nach Vereinbarung
Restaurant
Die Roseraie du Val-de-Marne war das erste Rosarium Europas. Die 13 Einzelgärten beherbergen 3.300 Rosensorten (insgesamt 16.000 Pflanzen), die zu 85 % bereits vor 1950 gezüchtet wurden.

Le parc du Château de Courances

91490 Courances
Tel. 01 64 98 07 36 ou 01 40 62 07 71 | www.courances.net

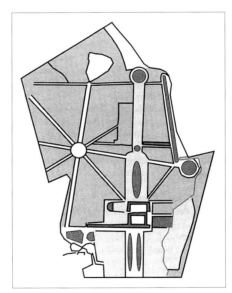

Page/Seite 30–39

Accès: 50 km de Paris par l'autoroute A 6 en direction de Lyon
Heures de visite: du 31 mars au 1er novembre: tous les samedis et les dimanches de 14 h 30 à 18 h 30 ou sur rendez-vous
À la fois romantique et classique, ce jardin à la française est rigoureux tout en laissant la nature s'exprimer, on le voit aussi notamment dans le jardin japonais où les jeux de feuillages culminent à l'automne.

How to get there: 50 km from Paris, via the A 6 towards Lyon
Opening times: 31 March to 1 November: Saturdays and Sundays 2.30–6.30pm or by arrangement
This French-style garden is both romantic and classical. Nature is allowed full expression in its austere architecture; this is especially true of its Japanese garden, in which the play of contrasting foliage is seen at its best in autumn.

Anfahrt: 50 km von Paris über die A 6 in Richtung Lyon
Öffnungszeiten: 31. März bis 1. November: samstags und sonntags 14.30–18.30 (letzter Einlaß) Uhr oder nach Vereinbarung
Dieser romantische und doch klassische Barockgarten zeugt von Strenge, läßt jedoch der Natur ausreichend Spielraum, vor allem in dem japanischen Garten, dessen Glanzzeit der Herbst mit seinem farbenprächtigen Laub ist.

Le Domaine de Saint-Jean de Beauregard

91940 Saint-Jean de Beauregard
Tel. 01 60 12 00 01 | www.domsaintjeanbeauregard.com

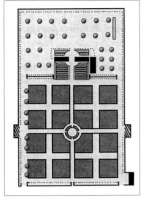

Page/Seite 40–47

Accès: 28 km de Paris par les autoroutes A 6 et A 10, ou par la N 118 et à la sortie de Les Ulis, prendre la D 35 en direction de Chartres
Heures de visite: du 15 mars au 15 novembre: dimanches et jours fériés de 14 h à 18 h; Fête des plantes vivaces en avril, Fête des fruits et des légumes oubliés en novembre
Possibilités d'accueil pour réceptions et séminaires
Son potager fleuri est un modèle du genre. Sur un espace de deux hectares clos de murs, les arbres fruitiers, les fleurs et les légumes se mêlent harmonieusement. Les fêtes d'avril et de novembre sont un lieu de rencontre privilégié pour les pépiniéristes français ou étrangers qui proposent une riche gamme de plantes.

How to get there: 28 km from Paris, via the A 6 and A 10 or the N 118, exit Les Ulis and take the D 35 towards Chartres
Opening times: 15 March to 15 November: Sundays and public holidays 2–6pm; "Fête des Plantes Vivaces" (Perennials Festival) in April, "Fête des Fruits et Légumes oubliés" (Festival of Forgotten Fruits and Vegetables) in November
Facilities for receptions and seminars
Its mixed kitchen and flower garden is a model of its kind. The walled garden of some two hectares offers a harmonious mix of fruit trees, flowers and vegetables. The April and November festivals are important dates in the lives of foreign and French nursery gardeners who bring to it a huge range of plants.

Anfahrt: 28 km von Paris über die A 6 und A 10 oder die N 118, an der Ausfahrt Les Ulis die D 35 in Richtung Chartres
Öffnungszeiten: 15. März bis 15. November: sonn- und feiertags 14–18 Uhr; »Fête des Plantes Vivaces« (Staudenfest) im April, »Fête des Fruits et Légumes oubliés« (Fest vergessener Obst- und Gemüsesorten) im November
Möglichkeiten für Empfänge und Seminare
Der blumenübersäte Küchengarten diente als Vorbild für andere Anlagen. Auf den von Mauern eingeschlossenen zwei Hektar Land stehen Obstbäume, Blumen und Gemüse einträchtig beieinander. Bei den Festen im April und November treffen sich französische und ausländische Züchter, um Gewächse auszutauschen.

Le parc et les jardins du Château de Versailles

78000 Versailles
Tel. 01 30 83 78 00 | www.chateauversailles.fr

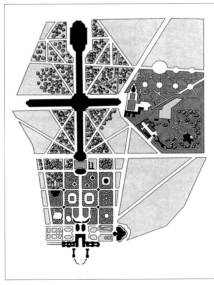

Page/Seite 48–53

Accès: 22 km de Paris par l'autoroute A 13; gare SNCF: Versailles-Chantiers ou Versailles-Rive Droite; RER ligne C, station Versailles-Rive Gauche; métro Pont de Sèvres et autobus 171
Heures de visite: tous les jours de 8 h (7h d'avril à octobre) au coucher du soleil; fermé à l'occasion des cérémonies officielles (renseignements sur demande); jeux d'eau «les Grandes Eaux Musicales»: d'avril à septembre: tous les samedis, dimanches et jours fériés de 11 h à 12 h et de 15 h 30 à 17 h 30; «Les Grandes Eaux Nocturnes», en juillet et août de 21 h 30 à 23 h 30
Les jardins à la française se déploient autour du château. Ils furent imaginés par Louis XIV et André Le Nôtre. Le Parc connut ensuite les différentes modes de l'histoire de l'art des jardins. Au Potager du Roi tout proche, des fruits et des légumes de saison sont vendus aux visiteurs le mardi et le vendredi.

How to get there: 22 km from Paris, via the A 13; station: Versailles-Chantiers or Versailles-Rive Droite; RER Ligne C: Station Versailles-Rive Gauche; Metro: Pont de Sèvres and bus 171
Opening times: daily 8am (April to October: 7am) to sunset; closed for official functions (please check beforehand); "Les Grandes Eaux Musicales" (fountain displays): April to September: Saturdays, Sundays and public holidays 11am–12pm and 3.30–5.30pm, "Les Grandes Eaux Nocturnes" July and August 9.30–11.30pm
The French-style gardens radiate out from the chateau. They were conceived by Louis XIV and André Le Nôtre. Since then, the grounds have been subject to the changing styles in garden design. In the nearby Potager du Roi, seasonal fruits and vegetables are sold to visitors on Tuesdays and Fridays.

Anfahrt: 22 km von Paris über die A 13; Bahnhof: Versailles-Chantiers oder Versailles-Rive Droite; RER Ligne C: Station Versailles-Rive Gauche; Metro: Pont de Sèvres und Bus 171
Öffnungszeiten: täglich 8 Uhr (April bis Oktober ab 7 Uhr) bis Sonnenuntergang; geschlossen bei offiziellen Anlässen (bitte vorher erfragen); »Les Grandes Eaux Musicales« (Wasserspiele) von April bis September: samstags, sonn- und feiertags 11–12 Uhr und 15.30–17.30 Uhr; »Les Grandes Eaux Nocturnes« im Juli und August: 21.30–23.30 Uhr
Der an das Schloß grenzende Barockpark ist das gemeinsame Werk von Ludwig XIV. und André Le Nôtre. Mit den wechselnden Stilrichtungen in der Gartenkunst wurden auch die Gärten von Versailles mehrmals verändert. Im nahegelegenen Potager du Roi, dem ehemaligen Gemüsegarten des Königs, werden noch heute jeweils dienstags und freitags Obst und Gemüse der Saison zum Kauf angeboten.

Le jardin de Jean-Pierre Raynaud

Page/Seite 54–57

Jardin privé
Le jardin accompagne le fantôme d'un hôtel particulier délabré, et s'égaie de ses fameux pots intemporels, créations de l'artiste.

Private garden
The garden is in stark contrast to the ghost-like, dilapidated "hôtel particulier" it surrounds and nicely sets off the famous, timeless pots created by the artist.

Privatgarten
Der Garten umrahmt ein verfallenes Herrenhaus. Blickpunkte bilden die berühmten Töpfe, die der Künstler selbst gestaltete.

Groussay

Page/Seite 58–63

Jardin privé
Ce parc est célèbre pour ses fabriques qui furent créées par Charles de Beistegui entre 1958 et 1969.

Private garden
These grounds were made famous by the follies created by Charles de Beistegui between 1958 and 1969.

Privatgarten
Der Park ist berühmt für die Ziergebäude, die Charles de Beistegui zwischen 1958 und 1969 errichten ließ.

Le Désert de Retz

Page/Seite 64–69

Jardin privé
C'est un jardin de fabriques qui fut créé à la fin du XVIIIe siècle dans le goût anglo-chinois très à la mode à l'époque.

Private garden
This is a garden of follies which was laid out in the late 18th century in the then fashionable Anglo-Chinese manner.

Privatgarten
Der Garten und die Ziergebäude wurden Ende des 18. Jahrhunderts im anglo-chinesischen Stil angelegt, der damals als äußerst chic galt.

Les jardins de Claude Monet à Giverny

Fondation Claude Monet
27620 Giverny
Tel. 02 32 51 28 21 | www.fondation-monet.com

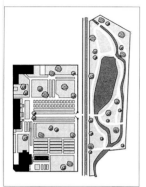

Accès: 3 km au sud-est de Vernon par la D 5
Heures de visite: d'avril à octobre: tous les jours sauf le lundi, de 9 h 30 à 18 h
Restaurant, librairie
Le jardin d'un peintre par excellence, également jardin de fleurs et de couleurs, Giverny est composé de deux parties: le Clos Normand, ordonné comme un jardin de curé, et le jardin d'eau agencé autour d'un étang.

How to get there: 3 km south-east of Vernon, via the D 5
Opening times: April to October: daily except Mondays 9.30am–6pm
Restaurant, bookshop
A painter's garden if ever there was one. A garden of flowers and colours, Giverny is divided into two parts: the Clos Normand, a small, mixed garden, and the water garden laid out around the famous lily pond.

Page/Seite 72–81
d'après le plan de/after the map of/ nach dem Plan von Jamshid Kooros

Anfahrt: 3 km südöstlich von Vernon über die D 5
Öffnungszeiten: April bis Oktober: täglich außer montags 9.30–18 Uhr
Restaurant, Buchhandlung
Giverny ist eindeutig der Garten eines Malers, doch auch ein Garten der Blumen und der Farben. Die Anlage besteht aus zwei Teilen: dem wie ein Pfarrgarten aufgebauten Clos Normand und dem Wassergarten, der sich rings um einen Teich erstreckt.

Le parc et le jardin du Château de Miromesnil

76550 Tourville-sur-Arques
Tel. 02 35 85 02 80 | www.chateaumiromesnil.com

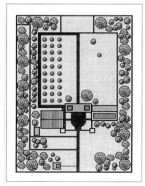

Accès: 8 km au sud de Dieppe par la N27 en direction de Rouen
Heures de visite: du 1er avril au 1er novembre: tous les jours de 14 h à 18 h; groupes toute l'année sur inscription
Un potager ornemental clos de murs de briques roses jouxte le château. Utile et beau, il est devenu LA référence des jardins potagers. La comtesse de Vogüé a mis toute sa passion dans cette création.

How to get there: 8 km south of Dieppe, via the N 27 towards Rouen
Opening times: 1 April to 1 November: daily 2–6pm; groups all year by appointment
An ornamental kitchen garden enclosed within pale pink brick walls lies close to the chateau. It is a byword for the combination of beauty and utility. The comtesse de Vogüé lavished love and attention on this, her creation.

Page/Seite 82–89

Anfahrt: 8 km südlich von Dieppe über N 27 in Richtung Rouen
Öffnungszeiten: 1. April bis 1. November: täglich 14–18 Uhr; Gruppen nach Vereinbarung ganzjährig
Der von einer hellroten Ziegelmauer umschlossene dekorative Gemüsegarten grenzt an das Schloß. Er ist ebenso zweckmäßig wie schön. Zahlreiche Gemüsegärten wurden nach seinem Vorbild angelegt. Diesen Garten hat die Gräfin de Vogüé mit viel Liebe gestaltet.

Le Bois des Moutiers

Route de l'église
76119 Varengeville-sur-Mer
Tel. 02 35 85 10 02

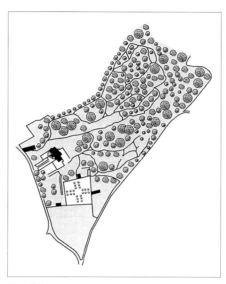

Accès: 10 km à l'ouest de Dieppe par la D 75 en direction de Saint-Valéry-en-Caux
Heures de visite: du 15 mars au 15 novembre: tous les jours de 10 h à 12 h et de 14 h à 18 h
Le manoir et le jardin furent commandés à l'architecte anglais Sir Edwin Lutyens par Guillaume Mallet qui était un grand esthète. Les plates-bandes et les sous-bois sont inspirés de la grande jardinière-paysagiste anglaise Gertrude Jekyll.

How to get there: 10 km west of Dieppe, via the D 75 towards Saint-Valéry-en-Caux
Opening times: 15 March to 15 November: daily 10–12 and 2–6pm
Guillaume Mallet, a great aesthete, commissioned the manor and garden from the English architect Sir Edwin Lutyens. The flower beds and woodlands were inspired by the great English landscape gardener Gertrude Jekyll.

Page/Seite 90–97
d'après le plan de/after the map of/ nach dem Plan von Jacques de Givry

Anfahrt: 10 km westlich von Dieppe über die D 75 in Richtung Saint-Valéry-en-Caux
Öffnungszeiten: 15. März bis 15. November: täglich 10–12 Uhr und 14–18 Uhr
Herrenhaus und Garten wurden von Guillaume Mallet, einem großen Ästheten, bei dem englischen Architekten Sir Edwin Lutyens in Auftrag gegeben. Die Gestaltung der Beete und Gehölze wurde nach den Ideen der großen englischen Gartenarchitektin Gertrude Jekyll angelegt.

Un jardin à Varengeville-sur-Mer

Page/Seite 98–105

Jardin privé
Dans ce jardin, Mark Brown a créé un univers où se reflètent son extrême sensibilité et son talent à manier les textures et les couleurs.

Private garden
In this garden, Mark Brown has created a universe which reflects his great sensitivity and talent for texture and colour.

Privatgarten
In dem Garten schuf Mark Brown ein Universum, das seine außergewöhnliche Sensibilität und sein Talent im Umgang mit Oberflächen und Farben beweist.

Le Vasterival

76119 Sainte-Marguerite
Tel. 02 35 85 12 05
Page/Seite 106–115

Accès: 9 km à l'ouest de Dieppe par la D 75
Heures de visite: toute l'année, sur rendez-vous et uniquement pour les groupes (15 à 20 personnes)
C'est l'œuvre de la princesse Sturdza qui a créé, au bord de la mer, un jardin de sous-bois. Il a la particularité d'être extrêmement beau en toute saison.

How to get there: 9 km west of Dieppe, via the D 75
Opening times: all year by arrangement, groups only (15–20 people)
This garden is the work of Princesse Sturdza. It is a woodland garden laid out by the seaside, and is, quite exceptionally, extremely beautiful at any season of the year.

Anfahrt: 9 km westlich von Dieppe über die D 75
Öffnungszeiten: ganzjährig nach Vereinbarung nur für Gruppen (15–20 Personen)
Dieser Gehölzgarten am Meeresufer ist ein Werk der Prinzessin Sturdza. Bemerkenswerterweise ist er zu jeder Jahreszeit von exquisiter Schönheit.

Limesy

Page/Seite 116–121

Jardin privé
Pour la marquise de Bagneux, le paysagiste Pascal Cribier a imaginé un potager original et très contemporain.

Private garden
The landscape gardener Pascal Cribier conceived a novel and very modern kitchen garden for the Marquise de Bagneux.

Privatgarten
Für Marquise de Bagneux entwarf der Landschaftsarchitekt Pascal Cribier einen originellen und sehr modernen Gemüsegarten.

Varaville

Page/Seite 122–127

Jardin privé
Associés à une maison résolument moderne incluse sur le territoire d'un haras normand, ces jardins à la fois architecturés et fleuris furent dessinés par Russell Page.

Private garden
These highly structured gardens, full of flowers, surround a resolutely modern house built on the land of a Norman stud farm. They were designed by Russell Page.

Privatgarten
Auf dem Gelände eines normannischen Gestüts legte Russell Page neben dem sehr modernen Wohnhaus mehrere Gärten an. Sie sind zwar architektonisch streng gestaltetet, dabei aber prächtig blühend.

Canon

14270 Mézidon-Canon
Tel. 02 31 20 71 50 et 02 50 44 00 06 | www.chateaudecanon.com

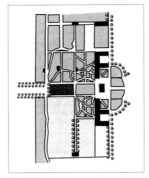

Page/Seite 128–133

Accès: 25 km à l'est de Caen par la N 13 et la D 152
Heures de visite: de Pâques à mai: les samedis, dimanches et jours fériés de 14 h à 18 h, de juin à septembre: tous les jours de 14 h à 18 h; groupes sur demande
Jardin de fabriques, il fut composé au XVIIIe siècle par Elie de Beaumont qui trouva en Angleterre ses sources d'inspiration. Sa beauté culmine dans les chartreuses où les fleurs et les pierres se mettent mutuellement en valeur.

How to get there: 25 km east of Caen, via the N 13 and the D 152
Opening times: Easter to May: Saturdays, Sundays and public holidays 2–6pm; June to September: daily 2–6pm; groups by arrangement
A garden of follies, it was laid out in the 18th century by Elie de Beaumont who sought his inspiration in memories of England. Its high point is the chartreuses in which stone walls and flowers are harmoniously juxtaposed.

Anfahrt: 25 km östlich von Caen über die N 13 und die D 152
Öffnungszeiten: Ostern bis Mai: samstags, sonn- und feiertags 14–18 Uhr, Juni bis September: täglich 14–18 Uhr; Gruppen nach Vereinbarung
Der Garten mit den Ziergebäuden wurde im 18. Jahrhundert von Elie de Beaumont nach englischen Vorbildern entworfen. Seine Pracht entfaltet sich besonders in den Kartausen, wo sich Blumen und Steine wechselseitig in Szene setzen.

Le parc et les jardins du Château d'Harcourt

14220 Thury-Harcourt
Tel. 02 31 79 72 05

Page/Seite 134–139

Accès: 26 km au sud de Caen par la D 562
Heures de visite: sur demande
Ce jardin d'été fut imaginé par le duc d'Harcourt qui déroula une guirlande de fleurs sur un tapis vert selon des lois d'équilibre et de justes proportions.

How to get there: 26 km south of Caen, via the D 562
Opening times: by arrangement
This summer garden was the inspiration of the Duc d'Harcourt, who set out a garland of flowers upon a carpet of green, meticulously observing the laws of balance and proportion.

Anfahrt: 26 km südlich von Caen über die D 562
Öffnungszeiten: auf Anfrage
Dieser Garten wurde vom Herzog von Harcourt entworfen. Er gestaltete auf dem grünen Rasenteppich eine üppige Blumengirlande, ohne jedoch die Gesetze der wohlproportionierten Ausgewogenheit zu vernachlässigen.

Le jardin botanique du Château de Vauville

50440 Vauville
Tel. 02 33 10 00 00 | www.jardin-vauville.fr
Page/Seite 140–145

Accès: 17 km à l'ouest de Cherbourg par la D 901
Heures de visite: avril: les samedis et dimanches de 14 h à 18 h; mai à septembre: tous les jours de 14 h à 18 h; octobre: le mardi et du vendredi au dimanche de 14 h à 18 h; groupes sur rendez-vous
Original entre tous pour un jardin normand, il bénéficie de la présence adoucissante du Gulf Stream et met en scène une étonnante collection de plantes subtropicales.

How to get there: 17 km west of Cherbourg, via the D 901
Opening times: April: Saturdays and Sundays 2–6pm; May to September: daily 2–6pm, October: Tuesdays and Fridays to Sundays 2–6pm; groups by arrangement
Most original of Norman gardens, it benefits from the temperate presence of the Gulf Stream in maintaining its astounding display of subtropical plants.

Anfahrt: 17 km westlich von Cherbourg über die D 901
Öffnungszeiten: April: samstags und sonntags 14–18 Uhr, Mai bis September: täglich 14–18 Uhr, Oktober: dienstags und freitags bis sonntags 14–18 Uhr; Gruppen nach Vereinbarung
Das milde Klima des nahen Golfstroms ermöglicht die Kultur einer erstaunlichen Vielfalt subtropischer Gewächse in diesem außergewöhnlichen normannischen Garten.

Les jardins de Chaumont-sur-Loire
Ferme du château
41150 Chaumont-sur-Loire
Tel. 02 54 20 99 22 | www.chaumont-jardins.com

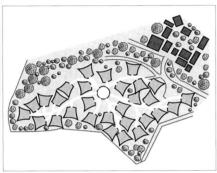

Page/Seite 148–155

Accès: 20 km au sud-ouest de Blois par la D 751
Heures de visite: tous les jours de 9 h 30 au coucher du soleil
Restaurant, librairie, exposition du Festival des jardins de Chaumont-sur-Loire
Les nouveaux jardins de Chaumont sont insérés dans le parc du château. Chaque année, dans le cadre d'un festival, ils sont plantés par un paysagiste renommé, français ou étranger.

How to get there: 20 km south-west of Blois, via the D 751
Opening times: daily from 9.30am to sunset
Restaurant, bookshop, exhibition on the "Festival des Jardins de Chaumont-sur-Loire"
The new gardens of Chaumont have been integrated into the landscape of the park. Each of them is designed by a renowned landscape gardener from France or elsewhere, according to the themes devised for the annual festival.

Anfahrt: 20 km südwestlich von Blois über die D 751
Öffnungszeiten: täglich 9.30 Uhr bis Sonnenuntergang
Restaurant, Buchhandlung, Ausstellung des »Festival des Jardins de Chaumont-sur-Loire«
Die neuen Gärten von Chaumont befinden sich im Schloßpark. Jeder einzelne Garten wird im Rahmen eines jährlich stattfindenden Festivals von namhaften französischen und ausländischen Gartenarchitekten neu gestaltet.

Les jardins du Château de Villiers
18800 Chassy
Tel. 02 48 77 53 20

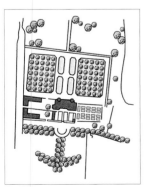

Accès: 40 km à l'est de Bourges par la D 976, près de Nérondes prendre la D 6 en direction de Sancergues
Heures de visite: sur demande
Ces jardins sont romantiques et féminins. Ils jouxtent le château. Dessinés selon un tracé géométrique, ils sont habillés de fleurs disposées à l'anglaise.

How to get there: 40 km east of Bourges, via the D 976, at Nérondes take the D 6 towards Sancergues
Opening times: by arrangement
These are romantic, feminine gardens. They surround the chateau. Laid out on a geometric plan, they are planted like an English country garden.

Anfahrt: 40 km östlich von Bourges über die D 976, bei Nérondes die D 6 in Richtung Sancergues

Page/Seite 156–161

Öffnungszeiten: auf Anfrage
Die an das Schloß angrenzenden Gärten sind romantisch und wirken ausgesprochen weiblich. Sie folgen einem geometrischen Grundriß, sind aber in englischer Manier mit Blumen übersät.

Le Parc floral d'Apremont-sur-Allier
18150 Apremont-sur-Allier
Tel. 02 48 77 55 00 | www.apremont-sur-allier.com
Page/Seite 162–169

Accès: 60 km à l'est de Bourges par la N 76, à 10 km de La Guerche-sur-l'Aubois
Heures de visite: de 10 h 30 à 12 h 30 et de 14 h 30 à 18 h 30 (toute la journée les dimanches et jours fériés): tous les jours d'avril à août; en septembre: tous les jours sauf le mardi
Réputé pour ses jardins de plantes vivaces et notamment pour son délicieux jardin blanc, il est aussi remarquable pour ses fabriques.

How to get there: 60 km east of Bourges, via the N 76, 10 km from La Guerche-sur-l'Aubois
Opening times: 10.30am–12.30pm and 2.30–6.30pm (Sundays and public holidays 10.30am–6.30pm), April to August: daily; September: daily except Tuesdays
Renowned for is evergreen plants and particularly for the beauty of its white garden, it is also notable for its follies.

Anfahrt: 60 km östlich von Bourges über die N 76, 10 km von La Guerche-sur-l'Aubois
Öffnungszeiten: 10.30–12.30 Uhr und 14.30–18.30 Uhr (sonn- und feiertags durchgehend), April bis August: täglich, September: täglich außer dienstags
Der Park ist für seine Stauden und besonders für den wunderschönen weißen Garten berühmt. Außerdem weist er bemerkenswerte Ziergebäude auf.

Les jardins du Prieuré Notre-Dame d'Orsan
(Le Prieuré d'Orsan)
18170 Maisonnais
Tel. 02 48 56 27 50 | www.prieuredorsan.com

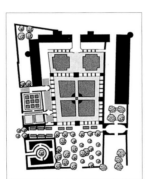

Page/Seite 170–181

Accès: 40 km au sud de Bourges entre Lignières et le Châtelet par la D 65
Heures de visite: de fin mai à début novembre: tous les jours de 10 h à 19 h; groupes à partir de 20 personnes sur demande
Au Prieuré Notre-Dame d'Orsan, Sonia Lesot et Patrice Taravella ont créé un jardin médiéval composé de plusieurs chambres à thème, qu'ils ont travaillé comme une enluminure.

How to get there: 40 km south of Bourges, between Lignières and le Châtelet, via the D 65
Opening times: end of March to early November: daily 10am–7pm; groups of more than 20 by arrangement
The medieval garden of the Prieuré Notre-Dame d'Orsan is made up of a series of enclosed, themed gardens. Sonia Lesot and Patrice Taravella have laboured over it like an artist over an illuminated manuscript.

Anfahrt: 40 km südlich von Bourges zwischen Lignières und le Châtelet über die D 65
Öffnungszeiten: Ende März bis Anfang November: täglich 10–19 Uhr; Gruppen ab 20 Personen nach Vereinbarung
Sonia Lesot und Patrice Taravella haben im Priorat von Notre-Dame d'Orsan eine Reihe von Gärten in mittelalterlichem Stil geschaffen. Jeder Garten befaßt sich mit einem eigenen Thema und wirkt wie eine kostbare Buchmalerei.

Les jardins de Villandry

37510 Villandry
Tel. 02 47 50 02 09 | www.chateauvillandry.com

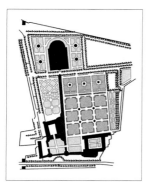

Page/Seite 182–189

Accès: 15 km à l'ouest de Tours par la D 7
Heures de visite: tous les jours de 9 h au coucher du soleil
Les jardins de Villandry se composent de jardins d'ornement et d'un potager dont la réputation a fait le tour du monde.

How to get there: 15 km west of Tours, via the D 7
Opening times: daily from 9am to sunset
The Villandry gardens comprise ornamental gardens and a kitchen garden whose fame reaches far and wide.

Anfahrt: 15 km westlich von Tours über die D 7
Öffnungszeiten: täglich von 9 Uhr bis Sonnenuntergang
Der Park von Villandry besteht aus Ziergärten und einem weltweit berühmten Küchengarten.

Le jardin du Château du Pin

49123 Champtocé sur Loire
Tel. 06 11 68 61 81 | www.lesjardinsduchateaudupin.com

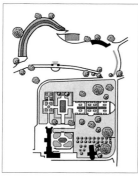

Page/Seite 190–193

Accès: à la sortie d'Angers, compter 15 minutes par la N 23 en direction de Nantes
Heures de visite: du 1er mai au 15 octobre sur rendez-vous; «La fête des Plantes» le dernier week-end de mai et de septembre: samedi et dimanche de 9 h à 19 h
Restaurant
Célèbre pour ses magnifiques topiaires en if qui jouxtent le château comme un jeu d'échecs imposant, il est désormais entre les mains de Jane de la Celle qui replante et recompose les jardins.

How to get there: 15 minutes from Angers, via the N 23 towards Nantes
Opening times: 1 May to 15 October by arrangement; "La Fête des Plantes" on the last weekend in May and September, Saturdays and Sundays 9am–7pm
Restaurant
Celebrated for the magnificent topiary of the yew trees which stand around the castle like a chess set, it is now in the hands of Jane de la Celle, who is replanting and reordering the gardens.

Anfahrt: von Angers aus 15 Minuten über die N 23 in Richtung Nantes
Öffnungszeiten: 1. Mai bis 15. Oktober nach Vereinbarung; »La fête des Plantes« am letzten Wochenende im Mai und September, jeweils samstags und sonntags 9–19 Uhr
Restaurant
Der Garten ist berühmt für seine zu wunderschönen Formen geschnittenen Eiben, die wie ein eindrucksvolles Schachspiel neben dem Schloß stehen. Er wird heute von Jane de la Celle mit kundiger Hand neu bepflanzt und wiederhergestellt.

Le Parc oriental de Maulévrier

49360 Maulévrier
Tel. 02 41 55 50 14 | www.parc-oriental.com

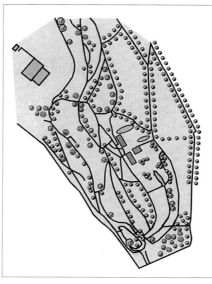

Page/Seite 194–197

Accès: 10 km au sud-est de Cholet par la D 20
Heures de visite: de mars à juin et de septembre au 15 novembre: du mardi au samedi de 14 h à 18 h, dimanche et jours fériés de 14 h à 19 h; juillet et août: tous les jours de 10 h 30 à 19 h 30; «Jardin de Nuit»: du 7 mai au 30 septembre, les samedis et veilles des jours fériés au coucher du soleil, en juillet et août: les mercredis au coucher du soleil; «Salon du Bonsaï» en septembre
Expositions et séminaires (entre autres sur le thème du bonsaï)
Ce parc oriental fut composé au tournant du siècle dernier par Alexandre Marcel, architecte fasciné par la Chine et le Japon.

How to get there: 10 km south-east of Cholet, via the D 20
Opening times: March to June and September to 15 November: Tuesdays to Saturdays 2–6pm, Sundays and public holidays 2–7pm; July and August: daily 10.30am–7.30pm; "Jardin de Nuit" at sunset from 7 May to 30 September Saturdays and preceding public holidays, in July and August at sunset on Wednesdays, "Salon du Bonsaï" in September
Exhibitions and seminars (including ones on bonsai)
This oriental park was composed at the turn of the century by Alexandre Marcel, an architect fascinated by China and Japan.

Anfahrt: 10 km südöstlich von Cholet über die D 20
Öffnungszeiten: März bis Juni und September bis 15. November: dienstags bis samstags 14–18 Uhr, sonn- und feiertags 14–19 Uhr, Juli und August: täglich 10.30–19.30 Uhr; »Jardin de Nuit« vom 7. Mai bis 30. September samstags und vor Feiertagen bei Sonnenuntergang, im Juli und August mittwochs bei Sonnenuntergang, »Salon du Bonsaï« im September
Ausstellungen und Seminare (u.a. zum Bonsai)
Der orientalische Park wurde um die Jahrhundertwende von dem Architekten Alexandre Marcel angelegt, der sich für China und Japan begeisterte.

Le jardin de William Christie

Page/Seite 198–203

Jardin privé
A la fois musicien, jardinier et grand esthète, le chef d'orchestre William Christie a mis toute son âme dans cette composition.

Private garden
Musician, gardener and great aesthete, the conductor William Christie has put his entire soul into this composition.

Privatgarten
William Christie, gleichzeitig Musiker, Gärtner und großer Ästhet, legte seine ganze Seele in diese Gartenkomposition.

Les jardins du Château de Hautefort

24390 Hautefort
Tel. 05 53 50 51 23 | www.chateau-hautefort.com
Page/Seite 204–211

Accès: 50 km au nord-ouest de Brive par la N 89 puis par la D 704
Heures de visite: en mars et du 1er au 11 novembre: samedi, dimanche et jours fériés de 14 h à 18 h; avril et mai: tous les jours de 10 h à 12 h 30 et de 14 h à 18 h 30; juin à septembre: tous les jours de 9 h 30 à 19 h; octobre: tous les jours de 14 h à 18 h; groupes à partir de 20 personnes, toute l'année sur demande
Librairie, possibilités pour réceptions et séminaires
Restaurés au début du siècle par le baron et la baronne de Bastard, les jardins de style classique se déploient autour du château.

How to get there: 50 km north-west of Brive, via the N 89, then D 704
Opening times: March and 1 to 11 November: Saturdays, Sundays and public holidays 2–6pm, April and May: daily 10am–12.30pm and 2–6:30pm, June to September: daily 9.30am–7pm, October: daily 2–6pm; groups of more than 20 by arrangement throughout the year
Bookstore, facilities for receptions and seminars
Restored at the turn of the century by the Baron and Baronne de Bastard, these classical gardens are laid out around the chateau.

Anfahrt: 50 km nordwestlich von Brive über die N 89, dann D 704
Öffnungszeiten: März und 1. bis 11. November: samstags, sonn- und feiertags 14–18 Uhr, April und Mai: täglich 10–12.30 Uhr und 14–18.30 Uhr, Juni bis September: täglich 9.30–19 Uhr, Oktober: täglich 14–18 Uhr; Gruppen ab 20 Personen nach Vereinbarung ganzjährig
Buchhandlung, Möglichkeiten für Empfänge und Seminare
Der klassische Barockpark rings um das Schloß wurde zu Beginn dieses Jahrhunderts von Baron und Baronin de Bastard restauriert.

Les Jardins de l'Imaginaire

Place du Foirail
24120 Terrasson-Lavilledieu
Tel. 05 53 50 86 82
Page/Seite 212–215

Accès: 16 km à l'ouest de Brive par la N 89
Heures de visite: d'avril à octobre: tous les jours sauf le mardi, de 9 h 50 à 11 h 20 et de 13 h 50 à 17 h 20; mai, juin et septembre: tous les jours sauf le mardi de 9 h 50 à 11 h 50 et de 13 h 50 à 17 h 20; juillet et août: tous les jours de 9 h 50 à 11 h 50 et de 13 h 50 à 18 h 10, uniquement visites guidées
Cafétéria, librairie
Avant-gardiste, le parc domine la ville de Terrasson et propose une succession de jardins à thèmes et d'effets originaux.

How to get there: 16 km west of Brive, via the N 89
Opening times: April to October: daily except Tuesdays 9.50–11.20am and 1.50–5.20pm, May, June and September: daily except Tuesdays 9.50–11.50am and 1.50–5.20pm, July and August: daily 9.50–11.50am, 1.50–6.10pm, guided tours only
Cafeteria, bookshop
Standing above Terrasson, these are avant-garde gardens presenting a succession of original themes and effects.

Anfahrt: 16 km westlich von Brive über die N 89
Öffnungszeiten: April bis Oktober: täglich außer dienstags 9.50–11.20 Uhr und 13.50–17.20 Uhr, Mai, Juni und September: täglich außer dienstags 9.50–11.50 Uhr und 13.50–17.20 Uhr, Juli und August: täglich 9.50–11.50 Uhr und 13.50–18.10 Uhr, nur geführte Besichtigungen möglich
Cafeteria, Buchhandlung
Der avantgardistische Park über dem Ort Terrasson besteht aus einer Reihe von Gärten, die jeweils ein anderes Thema mit originellen Effekten illustrieren.

Les jardins d'Eyrignac

24590 Salignac
Tel. 05 53 28 99 71 | www.eyrignac.com

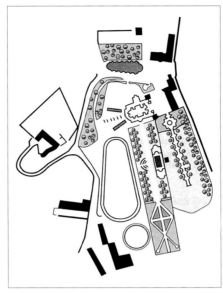

Page/Seite 216–223

Accès: 30 km au sud-ouest de Brive par la N 89, puis par la D 60
Heures de visite: de janvier à mars et d'octobre à décembre: tous les jours de 10 h 30 à 12 h 30 et de 14 h 30 au coucher du soleil; avril: tous les jours de 10 h à 19 h; du 1er mai au 13 juillet et du 21 août au 30 septembre: tous les jours de 9 h 30 à 19 h; du 14 juillet au 20 août: de 9 h 30 au coucher du soleil
Ces jardins très architecturés sont remarquables pour leurs jeux de sculptures végétales. Ils s'enrichissent de nouvelles scènes au fil des années.

How to get there: 30 km south-west of Brive, via the N 89, then D 60
Opening times: January to March and October to December: daily 10.30am–12.30pm and 2.30pm to sunset, April: daily 10am–7pm, 1 May to 13 July and 21 August to 30 September: daily 9.30am–7pm, 14 July to 20 August: 9.30am to sunset
These highly structured gardens are remarkable for their topiary. With each year that passes, the sum of their beauties is enhanced.

Anfahrt: 30 km südwestlich von Brive über die N 89, dann D 60
Öffnungszeiten: Januar bis März und Oktober bis Dezember: täglich 10.30–12.30 und 14.30 Uhr bis Sonnenuntergang, April: täglich 10–19 Uhr, 1. Mai bis 13. Juli und 21. August bis 30. September: täglich 9.30–19 Uhr, 14. Juli bis 20. August: 9.30 Uhr bis Sonnenuntergang
Das Besondere an diesem stark architektonisch geprägten Park ist das Spiel der Pflanzenskulpturen, die in jedem Jahr eine andere Gestalt erhalten.

Le Labyrinthe – jardin des cinq sens

Rue du Lac
74140 Yvoire
Tel. 04 50 72 88 80 | www.jardin5sens.net

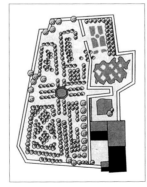

Page/Seite 224–229

Accès: à 20 minutes de Genève par la D 25
Heures de visite: du 12 au 30 avril: tous les jours de 11 h à 18 h; du 1er mai au 22 septembre: tous les jours de 10 h à 19 h; du 23 septembre au 12 octobre: tous les jours de 13 h à 17 h (dernier accès: 30 min. avant la fermeture du parc)
Créé dans l'ancien potager du château clos de murs, il s'articule autour d'une volière et illustre, pièce par pièce, le plaisir des sens.

How to get there: 20 minutes from Geneva, via the D 25
Opening times: 12 April to 30 April: daily 11am–6pm, 1 May to 22 September: daily 10am–7pm, 23 September to 12 October: daily 1–5pm (admission until 30 minutes before the park is closed)
Where the walled kitchen gardens of the castle once stood, the successive gardens illustrate the senses; at their centre stands an aviary.

Anfahrt: 20 Minuten von Genf über die D 25
Öffnungszeiten: 12. bis 30. April: täglich 11–18 Uhr, 1. Mai bis 22. September: täglich 10–19 Uhr, 23. September bis 12. Oktober: täglich 13–17 Uhr (letzter Einlaß 30 Minuten vor Schließung des Parks)
Der Garten wurde im eingefriedeten früheren Küchengarten des Schlosses um eine Voliere herum angelegt. Hier erfährt man anschaulich die unterschiedlichen Wahrnehmungen der fünf Sinne.

Les jardins d'Erik Borja
Page/Seite 232–241

Jardin privé
Son talent de sculpteur se reflète dans son jardin japonais où il a travaillé les formes, les volumes, les pensées.

Private garden
His talent as a sculptor is reflected in his Japanese garden, a Zen creation of shape, volume and concept.

Privatgarten
Das Talent des Bildhauers zeigt sich in dem japanischen Garten, wo Formen und Oberflächen in Anlehnung an die Gedankenwelt des Zen-Buddhismus gestaltet wurden.

La Bambouseraie de Prafrance
30140 Générargues Anduze
Tel. 04 66 61 70 47 | www.bambouseraie.com

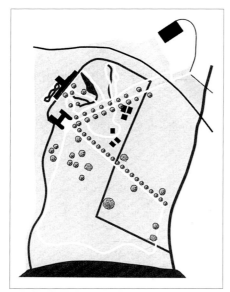

Accès: 44 km au nord-ouest de Nîmes par la N 106 et la D 910
Heures de visite: de mars à la mi-novembre: tous les jours à partir de 9 h 30
Librairie
Cette étonnante collection de bambous fut créée par Eugène Mazel au XIXe siècle au creux d'une vallée très protégée et bien irriguée.

How to get there: 44 km north-west of Nîmes, via the N 106 and D 910
Opening times: March to mid-November: daily from 9.30am
Bookshop
This astonishing collection of bamboos was created by Eugène Mazel in the 19th century in the hollow of a very sheltered and well-irrigated valley.

Page/Seite 242–247

Anfahrt: 44 km nordwestlich von Nîmes über die N 106 und D 910
Öffnungszeiten: März bis Mitte November: täglich ab 9.30 Uhr
Buchhandlung
Diese einzigartige Bambussammlung wurde im 19. Jahrhundert von Eugène Mazel in der Senke eines gut geschützten, wasserreichen Tals zusammengetragen.

Le Petit Fontanille
Page/Seite 248–253

Jardin privé
Anne Cox-Chambers aime passionnément son jardin provençal qu'elle a confié tour à tour à plusieurs paysagistes de talent.

Private garden
Anne Cox-Chambers greatly treasures her Provençal garden, which she has entrusted to successive talented landscape gardeners.

Privatgarten
Anne Cox-Chambers' leidenschaftliche Liebe gilt ihrem provenzalischen Garten, der im Lauf der Jahre von verschiedenen begabten Gartenarchitekten gestaltet wurde.

Les Confines
Page/Seite 254–263

Jardin privé
Brillante création de Dominique Lafourcade, ce jardin provençal s'inspire des jardins italiens.

Private garden
A brilliant creation by Dominique Lafourcade, this Provençal garden was inspired by Italian gardens.

Privatgarten
Dieser im Stil des italienischen Gartens gehaltene provenzalische Garten ist eine brillante Komposition von Dominique Lafourcade.

Longo Maï
Page/Seite 264–271

Jardin privé
Cette composition est en harmonie avec le paysage du Lubéron: avec ses plantes, son relief et ses couleurs.

Private garden
This composition is in harmony with the landscape of the Lubéron: with its vegetation, contours and colours.

Privatgarten
Die Komposition fügt sich mit ihren Gewächsen, ihren Farben und Oberflächen harmonisch in die Landschaft des Lubéron ein.

Le jardin de Nicole de Vesian
Page/Seite 272–279

Jardin privé
Nicole de Vesian nous a quittés, mais son jardin témoigne de son grand talent à comprendre et à sculpter la nature.

Private garden
Although Nicole de Vesian is no longer with us, her garden still testifies to her great talent for understanding and sculpting Nature.

Privatgarten
Nicole de Vesian weilt nicht mehr unter uns. Der Garten jedoch zeugt von ihrem großartigen Talent, die Natur zu begreifen und zu gestalten.

Le jardin du Château de Val Joanis
84120 Pertuis
Tel. 04 90 79 20 77 | www.val-joanis.com
Page/Seite 280–285

Accès: 25 km au nord d'Aix-en-Provence par la D 556, près de Pertuis par la D 973 en direction de Cavaillon
Heures de visite: tous les jours de 10 h à 19 h
Magasin de vins
Le potager ornemental de Val Joanis fut traité à la mode provençale par sa propriétaire Cécile Chancel qui s'est passionnée pour cette création.

How to get there: 25 km north of Aix-en-Provence, via the D 556, at Pertuis D 973 towards Cavaillon
Opening times: daily 9am–7pm
Wine store
The ornamental kitchen garden of Val Joanis was designed in the Provençal manner by its owner, Cécile Chancel, who is devoted to her creation.

Anfahrt: 25 km nördlich von Aix-en-Provence über die D 556, ab Pertuis D 973 in Richtung Cavaillon
Öffnungszeiten: täglich 10–19 Uhr
Weinhandlung
Der dekorative Gemüsegarten von Val Joanis wurde von seiner Besitzerin Cécile Chancel im provenzalischen Stil gestaltet.

Le jardin de la Villa Noailles

Montée de Noailles
83400 Hyères
Tel. 04 94 00 78 65

Page/Seite 286–289

Accès: 18 km à l'est de Toulon par les A 57 et N 98
Heures de visite: en été: tous les jours de 8 h à 19 h, en hiver: 8 h à 17 h
Il est composé de deux parties: un jardin cubiste créé par Gabriel Guevrekian associé à la villa dessinée par l'architecte Robert Mallet-Steven, et des jardins en terrasses qui descendent vers la ville.

How to get there: 18 km east of Toulon, via the A 57 and N 98
Opening times: summer: daily 8am–7pm, winter: 8am–5pm
It comprises two parts: a cubist garden laid out by Gabriel Guevrekian stands at the prow of the villa designed by the architect Robert Mallet-Stevens, and terraced gardens look out over the town.

Anfahrt: 18 km östlich von Toulon über die A 57 und N 98
Öffnungszeiten: Sommer: täglich 8–19 Uhr, Winter: 8–17 Uhr
Dieser Garten besteht aus zwei Teilen: einem von Gabriel Guevrekian entworfenen, kubistischen Garten, der direkt neben der Villa von Robert Mallet-Stevens liegt, sowie den Terrassengärten, die sich bis zum Ort hinab erstrecken.

Le Domaine du Rayol

Avenue des Belges
83820 Le Rayol Canadel
Tel. 04 98 04 44 00 | www.domainedurayol.org

Page/Seite 290–293

Accès: 50 km à l'est de Toulon, par les A 57, N 89 et N 559
Heures de visite: de janvier à mars et en novembre et décembre: tous les jours de 9 h 30 à 17 h 30; d'avril à juin et en septembre et octobre: tous les jours de 9 h 30 à 18 h 30; juillet et août: tous les jours de 9 h 30 à 19 h 30; visite guidée du Jardin marin du mardi au samedi
En bord de mer, le paysagiste Gilles Clément a créé des scènes avec des végétaux originaires de différentes contrées méditerranéennes.

How to get there: 50 km east of Toulon, via the A 57, N 89 and N 559
Opening times: January to March: daily 9.30–5.30pm, April to June 9.30am–6.30pm, July and August 9.30am–7.30pm, September and October: 9.30am–6.30pm, November and December 9.30am–5.30pm; guided tour of the "Jardin marin" (Marine Garden) Tuesdays to Saturdays
On the shoreline, the landscape gardener Gilles Clément has gathered plants from many different countries of Mediterranean climate to create astonishing vistas.

Anfahrt: 50 km östlich von Toulon über die A 57, N 89 und N 559
Öffnungszeiten: Januar bis März und November bis Dezember: 9.30–17.30 Uhr, April bis Juni und September bis Oktober: 9.30–18.30 Uhr, Juli bis August: 9.30–19.30 Uhr; Führung durch den »Jardin marin« (Meeresgarten) dienstags bis samstags
Der Gartenarchitekt Gilles Clément hat für diesen Garten am Meer Pflanzen aus verschiedenen Erdteilen zusammengetragen, deren Heimat ein dem Mittelmeer vergleichbares Klima aufweist.

Fontviel

Page/Seite 294–301

Jardin privé
Créé par l'architecte Jacques Couëlle, ce jardin est construit en terrasses magnifiquement architecturées qui dominent une vallée d'oliviers.

Private garden
Created by the architect Jacques Couëlle, this garden comprises magnificently structured terraces which overlook a valley of olive trees.

Privatgarten
Der von dem Architekten Jacques Couëlle angelegte Garten liegt auf wunderschön angelegten Terrassen hoch über einem Tal mit Olivenbäumen.

Les jardins du Château de Gourdon

06620 Gourdon
Tel. 04 93 09 68 02 | www.chateau-gourdon.com
Page/Seite 302–305

Accès: de Nice, suivre la D 2085 jusqu'à Magagnosc, puis la D 3 jusqu'à Gréolières; de Cannes par la N 85 et la D 3
Heures de visite: juillet et août: tous les jours de 15 h à 17 h; groupes toute l'année sur inscription
Construit sur un à-pic, le château de Gourdon s'orne d'un jardin vert et rafraîchissant classique dont une partie a été repensée par le paysagiste Tobie Loup de Viane.

How to get there: from Nice take the D 2085, at Magagnosc D 3 to Gréolières; from Cannes the N 85 and D 3
Opening times: July and August: daily 3–5pm; groups all year by appointment
Laid out on a steep slope, this garden surrounds the chateau in a green, refreshing, classical style. Parts of it have been redesigned by the landscape gardener Tobie Loup de Viane.

Anfahrt: von Nizza die D 2085, ab Magagnosc die D 3 bis Gréolières; von Cannes die N 85 und D 3
Öffnungszeiten: Juli und August: täglich 15–17 Uhr; Gruppen nach Vereinbarung ganzjährig
Dieser frische und grüne, klassische Garten schmückt das Schloß von Gourdon, das sich auf einem steilen Bergrücken erhebt. Die Gestaltung einiger Gartenbereiche wurde von dem Gartenarchitekten Tobie Loup de Viane überarbeitet.

La Casella

Page/Seite 302–305

Jardin privé
Ce jardin est l'œuvre raffinée d'un grand amateur de plantes qui a mis en valeur des espèces rares dans des scènes bien architecturées.

Private garden
This garden is the refined work of a great connoisseur of plants who has highlighted rare species by setting them in well-structured surroundings.

Privatgarten
Dieser Garten ist das raffinierte Werk eines großen Pflanzenkenners. In hervorragend komponierten Szenerien werden seltene Pflanzenarten zur Geltung gebracht.

Les jardins de la Villa Ephrussi de Rothschild

06230 Saint-Jean-Cap-Ferrat
Tel. 04 93 01 33 09 | www.villa-ephrussi.com

Page/Seite 314–319

Accès: 10 km à l'est de Nice par la Basse Corniche (N 98) en direction de Monaco
Heures de visite: de mi-février à mi-novembre: tous les jours de 10 h à 18 h; de juillet à août: tous les jours de 10 h à 19 h; de mi-novembre à mi-février: en semaine de 14 h à 18 h, les week-ends et pendant les vacances scolaires, de 10 h à 18 h (fermé le 25 décembre)
Salon de thé-restaurant, réceptions
Ces jardins égrènent des souvenirs de voyage. Ils jalonnent une promenade autour de la villa et se succèdent, chacun illustrant un thème.

How to get there: 10 km east of Nice, via the Basse Corniche (N 98) towards Monaco
Opening times: mid-February to mid-November: daily 10am–6pm; July and August: daily 10am–7pm; mid-November to mid-February: weekdays 2–6pm, weekends and school holidays 10am–6pm (closed on 25 December)
Tea salon with restaurant, facilities for receptions
These gardens are the record of travels past. They are set along a promenade that encircles the villa and each of them illustrates a particular theme.

Anfahrt: 10 km östlich von Nizza über die Basse Corniche (N 98) in Richtung Monaco
Öffnungszeiten: Mitte Februar bis Mitte November: täglich 10–18 Uhr, Juli bis August: täglich 10–19 Uhr, Mitte November bis Mitte Februar: wochentags 14–18 Uhr, an Wochenenden und in den Schulferien 10–18 Uhr (25. Dezember geschlossen)
Teesalon mit Restaurant, Möglichkeiten für Empfänge
Die Gärten sind als Erinnerung an zahlreiche Reisen angelegt worden. Auf einem Rundgang um die Villa erschließen sich die verschiedenen Bereiche, die jeweils einer anderen Region gewidmet sind.

Le Jardin exotique d'Eze

06360 Eze
Tel. 04 93 41 10 30
Page/Seite 320–327

Accès: 10 km au nord-est de Nice par la Moyenne Corniche (N 7)
Heures de visite: du 1er juillet au 31 août: tous les jours de 9 h à 20 h; du 1er septembre au 30 juin: tous les jours de 9 h à 17 h 30/18 h 30 (17 h 30 en hiver)
Située dans un site exceptionnel dominant la mer, cette collection de succulentes aux formes spectaculaires et variées est tout à fait étonnante.

How to get there: 10 km north-east of Nice, via the Moyenne Corniche (N 7)
Opening times: 1 July to 31 August: daily 9am–8pm, 1 September to 30 June: daily 9am–5.30/6.30pm; winter: 9am–5.30pm
With its wonderful site overlooking the sea, this collection of the most varied and spectacular succulents offers an amazing experience.

Anfahrt: 10 km nordöstlich von Nizza über die Moyenne Corniche (N 7)
Öffnungszeiten: 1. Juli bis 31. August: täglich 9–20 Uhr, 1. September bis 30. Juni: täglich 9–17.30/18.30 Uhr; im Winter: 9–17.30 Uhr
Wunderschön über dem Meer gelegen, versetzt diese reichhaltige und spektakuläre Sammlung von Sukkulenten und Kakteen den Besucher in Erstaunen.

Bibliographie | Bibliography

Ouvrages sur les jardins:
Histoire, Art, Guides

Books on gardens:
History, Art, Guides

Bücher zu Gärten:
Geschichte, Kunst, Führer

André, Edouard: *Traité général de la composition des Parcs et Jardins,* Paris 1879
Androuet du Cerceau, Jacques: *Les Plus Excellents Bâtiments de France,* Paris 1576
Bazin, Germain: *Paradeisos ou l'Art du jardin,* Editions du Chêne 1988
Benoist-Méchin, Jacques: *L'Homme et ses jardins ou Les métamorphoses du paradis terrestre,* Albin Michel 1975
Bisgrove, R.: *L'Art des jardins à l'anglaise de Gertrude Jekyll,* La Maison Rustique 1992
de Cayeux, Jean: *Hubert Robert et les jardins,* Herscher 1987
Chamblas-Ploton, Mic: *Saint-Jean-de-Beauregard,* La Maison Rustique 1996
Charageat, Marguerite: *L'Art des Jardins,* PUF 1962
de Chimay, Jacqueline: *Les Jardins à travers le monde,* Hachette 1962
– *Plaisir des Jardins,* Hachette 1953
Clarke, Ethne: *Le Secret des Jardins de Simples,* La Maison Rustique 1996
Colloque de l'Abbaye de Saint-Arnoult: *Le Jardin médiéval,* Adana 1988
Clément, Gilles: *Le Jardin en mouvement,* Sens et Tonka 1994
– *Thomas et le Voyageur,* Albin Michel 1997
Cox, Jeff: *Jardins des Sens,* Abbeville Press 1993
Delbard, Henri: *Mon carnet d'émotions,* Editions Delbard
Dezallier d'Argenville, Antoine: *Théorie et Pratique du Jardinage,* Paris 1709
Enge, Schröer, Wiesenhofer, Claßen: *Garden Architecture in Europe,* TASCHEN 1994
Fell, Derek: *Les Impressionistes et leurs jardins,* Flammarion 1995
Festival Des Jardins (tomes I, II, III), Conservatoire International des Parcs et Jardins et du Paysage de Chaumont-sur-Loire, 1992, 1993, 1994
Figes, Eva: *Lumière,* Rivages 1983
Fleurent, Maurice: *Le Monde Secret des Jardins,* Flammarion 1987
– *Vaux-le-Vicomte,* Editions Sous le Vent 1989
– *Villandry,* Editions Sous le Vent 1989
Fustier-Dantier, Nerte: *Les Bastides de Provence et leurs Jardins,* Serg/Berger-Levrault Paris 1977
de Ganay, F.: *Bibliographie de l'Art des Jardins,* U.C.A.D. 1989
Gaucher, Marcel: *Les Jardins de la Fortune,* Hermé 1985
de Givry, Jacques et Yves Perillon: *Versailles: Le Potager du Roi.* Les-Loges-en-Josas, JDG Publications 1993
de Givry, Jacques: *Lumières de Varengeville,* J.D.G. Publications 1994
Gouvion, C. et Marielle Hucliez: *Le Roman du Potager,* Editions du Rouergue 1993
Greenoak, Francesca: *Jardins de Rêve,* Flammarion 1990
Grimal, Pierre: *L'Art des Jardins,* P.U.F. «Que sais-je» 1974
d'Harcourt, duc: *Des jardins heureux,* Editions du Chêne 1991
Hobhouse, Penelope et Patrick Taylor: *Des jardins en Europe,* Ulmer
Hobhouse, Penelope: *Garden Style,* Little Brown and Co. 1988
– *Histoire des plantes et des jardins,* Bordas 1994
– *Jardins Modèles,* La Maison Rustique 1989
– *Jardins botaniques de France,* Pandora 1991
Howard, Adams: *L'Art des Jardins ou La Nature Embellie,* Abbeville Press 1992
Hucliez, Marielle: *Découvrir les Plus Beaux Jardins (Provence),* La Maison Rustique 1996
– *Découvrir les Plus Beaux Jardins (Berry-Gâtinais),* La Maison Rustique 1996
van der Horst, Jan: *Jardins et Symétrie,* Abbeville Press 1996
Jekyll, Gertrude: *Propos sur le jardin,* La Maison Rustique 1993
Jellicoe, Geoffrey and Suzan, Patrick Goode and Michael Lancaster: *The Oxford Companion to Gardens,* Oxford University Press 1986
Johnson, Hugh: *L'Art des Jardins,* Nathan 1980
Jones, Louisa: *Splendeur des jardins de la Côte d'Azur,* Flammarion 1993

– *Splendeur des Jardins de Provence,* Flammarion 1992
– *Le Potager,* Hachette 1995
Joyes, Claire: *Claude Monet et Giverny,* Editions du Chêne 1985
Keen, Mary: *Le Jardin et la Couleur,* La Maison Rustique 1993
Laroze, Catherine: *Une Histoire Sensuelle des Jardins,* Olivier Orban 1990
– *L'Ame Parfumée des Jardins,* A. de Gourcuff 1996
Le Dantec, Denise et Jean-Pierre: *Le roman des jardins de France,* Plon, 1987
Lieutaghi, Pierre: *Jardins des savoirs, jardins d'histoire,* Les Alpes de Lumière 1992
Lis, Michel et Jérôme Goust: *Le Coin Potager,* Bordas 1996
Lloyd, Christopher: *Un Jardinier Téméraire,* La Maison Rustique 1990
Louis XIV: *Manière de montrer les jardins de Versailles,* Edition de la Réunion des Musées Nationaux 1982
Mallet, Robert: *Jardins et Paradis,* Gallimard 1959
– *Renaissance d'un Parc,* Centre d'Art Floral 1996
Malnic, Evelyne: *Folies de Jardin,* Editions du Chêne 1996
Meiller, D. et P. Vannier: *Le Grand Livre des fruits et des légumes,* La Manufacture 1991
Murray, Elisabeth: *Monet's Passion,* Pomegranate Art Books 1989
Nitschke, Günter: *Le Jardin Japonais,* TASCHEN 2003
Page, Russell: *L'Education d'un jardinier,* La Maison Rustique 1994
Pascal, Marie-Claude: *Les Plus Beaux Jardins (Bourgogne),* La Maison Rustique 1995
Pereire, Anita: *Invitation, les Jardins privés de France,* Hachette 1991
Pereire, Anita et Gabrielle van Zuylen: *Jardins Privés de France,* Arthaud 1984
Philips, Roger et Martyn Rix: *Les Roses,* Solar 1988
Pigeat, Jean-Paul: *Parcs et Jardins Contemporains,* La Maison Rustique 1990
– *Festival de Jardins,* Editions du Chêne 1995
Prost, Charles: *Le Jardin de Claude Monet,* Casterman 1994
Racine, Michel et Françoise Binet: *Jardins de Provence et de la Côte d'Azur,* Editions Edisud 1987
Racine, Michel: *Le Guide des jardins de France,* Hachette 1990
Richert, Alain: *Parcs et Jardins Extraordinaires,* Duchamp Chevalier, Ramsay
Russell, Vivian: *Giverny,* Frances Lincoln 1994
Schinz, Marina: *Splendeur des Jardins,* Flammarion 1986
Schlienger, Isabelle: *Splendeur des Jardins d'Ile-de-France,* Flammarion 1996
– *La Route des Jardins Extraordinaires (Lyonnais-Dauphiné),* La Maison Rustique 1993
Sion, Georgia: *Monet, Les Jardins,* Collection Le Musée miniature, Herscher 1994
Teiji, Itho: *Jardins du Japon,* Herscher 1984
Thacker, Christopher: *Histoire des jardins,* Denoël 1981
They, Camille et Philippe Bonduel: *Lardins et Jardins,* Ellébore 1996
Valéry, Marie-Françoise et Georges Lévêque: *Jardins de France,* Editions du Chêne 1990
Valéry, Marie-Françoise: *Découvrir les Plus Beaux Jardins (Val de Loire),* La Maison Rustique 1995
– *Splendeur des Jardins de Normandie,* Flammarion 1995
Van Zuylen, Gabrielle: *Tous les jardins du monde,* coll. Découvertes, Gallimard 1994
Verey, Rosemary: *Jardins Secrets,* Flammarion 1995
de Vilmorin, J.B.: *Le Jardin des Hommes,* Le Pré Aux Clercs 1991

Ouvrages sur les plantes:
arbres, arbustes, plantes
vivaces et annuelles, bulbes

Books on plants:
trees, shrubs, perennials,
annuals and bulbs

Werke über Pflanzen:
Bäume, Sträucher, Stauden,
einjährige Pflanzen und
Zwiebelgewächse

20.000/25.000 Plantes, La Maison Rustique 1992/93
Austin, David: *Découvrir les Roses anciennes et anglaises*, La Maison
 Rustique 1992
– *Découvrir les Rosiers grimpants et buissonnants*, La Maison
 Rustique 1994
– *Les Roses anglaises*, Bordas 1995
Beales, Peter: *Classic Roses*, Collins-Harvill
de Belder, J. et X. Misonne: *Arbres et Arbustes pour Parcs et Jardins*,
 La Maison Rustique 1994
Beucher, P. et J.P.Collaert: *Le Jardin comme on l'aime*,
 Les Nouveaux Jardiniers 1995
Brickel, Christopher: *La Grande Encyclopédie des Plantes et Fleurs de
 Jardin*, Bordas 1990
Clevely, A.M.: *Topiaires – L'Art de tailler les arbres et les haies
 d'ornement*, La Maison Rustique 1990
Collectif: *Dans votre jardin des fleurs toute l'année*, La Maison
 Rustique 1995
Collectif: *Dans votre jardin des fruits toute l'année*, La Maison
 Rustique 1995
Collectif: *Dans votre jardin des légumes toute l'année*, La Maison
 Rustique 1995
Conder, Susan: *Feuillages panachés*
Couplan, François: *Retrouvez les légumes oubliés*, La Maison
 Rustique 1986
Couplan, François et Françoise Marmy: *Le Jardin au naturel*
Fairfeather, Christopher: *Rhododendrons, Azalées et Camellias*,
 Floraisse-Larousse 1990
Fish, Margery: *Journal d'un Jardin*, La Maison Rustique
Fuchs, Henry: *Les roses de nos jardins*, Larousse
Garnock, Jamie: *Treillages*, La Maison Rustique 1991
Goarant, Léon: *Que planter à l'ombre?* La Maison Rustique 1986
Goutier, Jérôme: *Découvrir les bulbes mois par mois*, La Maison
 Rustique 1996
Hewitt, Terry: *Cactus et Succulentes*, La Maison Rustique 1994
Hobhouse, Penelope: *Jardins de fleurs*, La Maison Rustique 1993
Innes, Clive et Charles Glass: *L'Encyclopédie Illustrée des Cactus*
Jacob et Grimm: *Roses anciennes et roses sauvages*, Ulmer 1993
Jekyll, Gertrude: *Couleurs et Jardins*, Herscher 1988
Joyce, David: *Les Meilleures Plantes*, La Maison Rustique 1996
Keen, Mary: *Le Jardin et la Couleur*, La Maison Rustique 1993
Lacey, Stephen: *Le Jardin et ses Parfums*, La Maison Rustique 1992
Lacy, Allen: *Splendeur des Roses*, Flammarion 1991
Laborey, Jean: *Les Plantes de terre de bruyère*, Larousse
Latymer, Hugo: *Jardins côté Sud*, La Table Ronde 1990
Lawson, Andrew: *Des Plantes Belles toute l'année*, Nathan 1994
Le Bon Jardinier, volumes I, II, III, La Maison Rustique 1992
Lis, Michel et Jérôme Goust: *Le Coin Potager*, Bordas 1996
Lord, Tony: *Massifs à l'Anglaise*, La Maison Rustique 1995
Mallet, Corinne et Robert, Harry Van Tirer: *Hortensias et autres
 Hydrangéas*, volume I, 1992, volume II, 1994
Mathew, Bryan et Philip Swindells: *Le Grand Livre des bulbes*,
 Bordas 1994
Osler, Mirabel: *The Garden Wall*, Simon et Schuster 1993
Paul, Anthony et Yvonne Rees: *Jardins d'Aujourd'hui*, Flammarion
 1988
Pellerin, Guillaume: *Outils de jardin*, Abbeville 1996
Pelt, J.M.: *Des Légumes*, Fayard 1993
Philips, Roger: *Fleurs de Méditerranée*, Bordas 1988
– *Légumes*, La Maison Rustique 1994
– *Les Arbres*, France Loisirs 1981
Philips, Roger et Martyn Rix: *Arbustes*, La Maison Rustique 1992
– *Les Roses*, Solar 1988
– *Histoire des roses*, La Maison Rustique 1994
Philips, Roger et Nicky Foy: *Herbes*, La Maison Rustique 1991
Pigeat, Jean-Paul: *Parcs et Jardins Contemporains*, La Maison
 Rustique 1990
– *Festival de Jardins*, Editions du Chêne 1995
Proctor, Rob: *Annuals*, Cassell 1991
Rice, Graham et Elizabeth Strangman: *Hellebores*, David and
 Charles 1993

Richert, Alain: *Le Jardin de tulipes*, Rustica 1980
– *Le Jardin d'iris*, Rustica 1980
Rivière, M.: *Le Monde Fabuleux des Pivoines*, Floraprint 1992
Stevens, John: *Fleurs sauvages et Jardins*, Hachette 1987
Stewart, Martha: *L'Art de Jardiner*, La Maison Rustique 1992
Strong, Roy: *Jardins de Charme Faciles à Entretenir*, La Maison
 Rustique 1995
Taylor, Jane: *Plantes tolérant la sécheresse*, La Maison Rustique 1994
Testu, Charlotte: *Les Roses anciennes*, La Maison Rustique 1984
The RHS Plant Finder, The Royal Horticultural Society 1996/97
Valéry, Marie-Françoise: *Le Jardin Potager*, Editions du Chêne
 1997
Vilmorin-Andrieux: *Les Plantes Potagères*, 1989
Verey, Rosemary: *Good Planting*, Frances Lincoln 1990
Zimmermann, Albert: *Jardins Alpins*, La Maison Rustique 1962

Remerciements | Acknowledgements | Danksagung

Mes plus chaleureux remerciements vont à Angelika Taschen et
à Deidi von Schaewen, sans qui cette belle aventure n'aurait pas
existé. A Ursula Fethke pour sa minutie et sa grande amabilité.
Aux propriétaires des jardins, jardiniers et paysagistes qui m'ont
si généreusement accueillie et instruite. A tous ceux que je n'ose
nommer de peur d'oublier quelqu'un.
*I would like to extend my warmest thanks to Angelika Taschen and
Deidi von Schaewen, without whom this wonderful project would never
have got off the ground; to Ursula Fethke for her meticulousness and ex-
treme kindness; to all the owners, gardeners and garden designers who
welcomed and instructed me so generously; and, finally, to all those I
dare not mention for fear of forgetting someone.*
Mein herzlicher Dank geht an Angelika Taschen und Deidi von
Schaewen, ohne die dieses schöne Abenteuer nicht zustande ge-
kommen wäre. Ursula Fethke danke ich für ihre Sorgfalt und Herz-
lichkeit. Dank auch allen Gartenbesitzern, Gärtnern und Garten-
architekten, die mich so großherzig empfangen und umfassend
informiert haben, sowie allen übrigen, die ich nicht namentlich zu
nennen wage, aus Angst, ich könnte einen von ihnen vergessen.

Marie-Françoise Valéry

Je tiens à remercier tous les propriétaires de jardins pour leur hospi-
talité et leur aimable assistance. Nous avons eu un plaisir fou à visi-
ter ces petits paradis sur terre. Je remercie également les paysagistes
et les jardiniers. Je remercie aussi mes amis pour leurs suggestions et
leur soutien moral, en particulier Claire de Bartillat, Christophe
Angot, Lillian Williams, Andrée Putman, Alexandra d'Arnoux,
Christine Grange Bary et Michèle Champenois.
*I would like to thank all the owners of the gardens for their kind wel-
come and assistance in the preparation of this book. It was a tremendous
pleasure to visit such fascinating places. My gratitude goes also to the
garden designers and gardeners. I am also grateful to those who helped
with suggestions and support: Claire de Bartillat, Christophe Angot,
Lillian Williams, Andrée Putman, Alexandra d'Arnoux, Christine
Grange Bary and Michèle Champenois.*
Ich möchte allen Gartenbesitzern für ihre Gastfreundschaft und
Unterstützung danken. Es war eine große Freude, all diese wunder-
schönen Fleckchen Erde zu besuchen. Mein Dank gilt auch den
Gartenarchitekten sowie allen Gärtnern. Ich danke auch meinen
Freunden, die mir Anregungen gaben und mich unterstützten,
vor allem Claire de Bartillat, Christophe Angot, Lillian Williams,
Andrée Putman, Alexandra d'Arnoux, Christine Grange Bary und
Michèle Champenois.

Deidi von Schaewen